THE PETRINE
REVOLUTION
IN RUSSIAN
IMAGERY

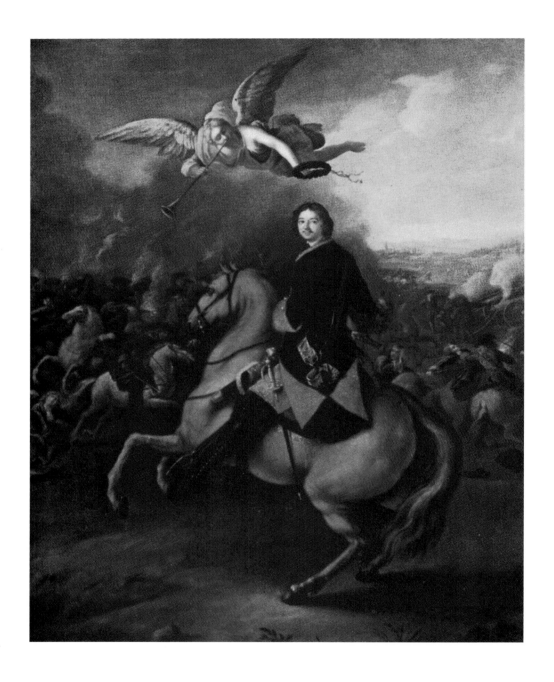

J. G. Dannhauer, *Peter I Crowned by Victory at the Battle of Poltava, 1709,* 1710s. Oil on canvas. State Russian Museum (GRM), St. Petersburg.

THE PETRINE REVOLUTION IN RUSSIAN IMAGERY

James Cracraft

The University of Chicago Press
Chicago and London

JAMES CRACRAFT is professor of history at the University of Illinois at Chicago. His other books include *The Petrine Revolution in Russian Architecture*, also published by the University of Chicago Press; *The Church Reform of Peter the Great*; and *Peter the Great Transforms Russia*, a collection of essays.

The University of Chicago Press, Chicago 60637
The University of Chicago Press, Ltd., London
© 1997 by the University of Chicago
All rights reserved. Published 1997
Printed in the United States of America

06 05 04 03 02 01 00 99 98 97 1 2 3 4 5

ISBN: 0-226-11665-4 (cloth)

This publication has been supported by a grant from the Campus Research Board of the University of Illinois at Chicago.

Library of Congress Cataloging-in-Publication Data

Cracraft, James.
 The Petrine revolution in Russian imagery / James Cracraft.
 p. cm.
 Includes bibliographical references and index.
 ISBN 0-226-11665-4 (cloth)
 1. Art, Russian. 2. Art, Modern—17th–18th centuries—Russia.
3. Peter I, Emperor of Russia, 1672–1725—Contributions in art.
I. Title.
N6986.C73 1997
709'.47'09032—dc21 97-6309
 CIP

This book is printed on acid-free paper.

For
M. C. W. C.
In memoriam

Contents

Figures

Photographs courtesy of the institution or service indicated; others taken by the author or various professional photographers.

Plates

Color slides by courtesy of the institution or service indicated. Gallery of plates starts after p. 292.

Frontispiece J. G. Dannhauer, *Peter I Crowned by VIctory at the Battle of Poltava, 1709*, 1710s. Oil on canvas. State Russian Museum (GRM), St. Petersburg.

Abbreviations

The full titles and other details of works cited anywhere in this volume in short-title form will be found in the Bibliography, which lists all works of direct relevance to the volume's main themes. (Repeat citations of works of only tangential relevance are sometimes also given in short-title form, usually to distinguish among works by the same author or authors, or otherwise for the reader's convenience.) In addition:

AKh	Akademiia Khudozhestv (Academy of Fine Arts), St. Petersburg
BAN	Biblioteka Akademii Nauk (Library of the Academy of Sciences), St. Petersburg
BL	British Library, London
GBL	Gosudarstvennaia Biblioteka im. Lenina (Lenin State Library, now Russian State Library), Moscow
GIM	Gosudarstvennyi Istoricheskii Muzei (State Historical Museum), Moscow
GME	Gosudarstvennyi Muzei Ermitazh (State Hermitage Museum), St. Petersburg
GOP	Gosudarstvennaia Oruzheinaia Palata (State Armory Chamber museum), Moscow
GPB	Gosudarstvennaia Publichnaia Biblioteka (State Public Library, now Russian National Library), St. Petersburg
GRM	Gosudarstvennyi Russkii Muzei (State Russian Museum), St. Petersburg
GTG	Gosudarstvennaia Tret'iakovskaia Galereia (State Tretiakov Gallery), Moscow
HCL	Harvard College Library

HL	Houghton Library, Harvard University
JGO	*Jahrbücher für Geschichte Osteuropas*
L.	Leningrad
LC	Library of Congress
M.	Moscow
NYPL	New York Public Library (Slavonic Division)
Opis. I	T. A. Bykova and M. M. Gurevich, *Opisanie izdanii grazhdanskoi pechati (1708–1725)* (M./L., 1955)
Opis. II	T. A. Bykova and M. M. Gurevich, *Opisanie izdanii, napechatannykh kirillitsei (1689–1725)* (M./L., 1958)
Opis. III	T. A. Bykova, M. M. Gurevich, and R. I. Kozintseva, *Opisanie izdanii, napechatannykh pri Petre I: svodnyi katalog. Dopolneniia i prilozheniia* (L., 1972)
PiB	*Pis'ma i bumagi imperatora Petra Velikogo,* 12 vols. (SPb./L., 1887–1975)
PSZ	*Polnoe sobranoe zakonov rossiiskoi imperii s 1649 goda,* 1st ser., 46 vols. (SPb., 1830–43)
RL	Regenstein Library, University of Chicago
Rbs	*Russkii biograficheskii slovar',* 25 vols. (M./SPb., 1896–1918)
SIRIO	*Sbornik imperatorskago russkago istoricheskago obshchestva,* 148 vols. (SPb., 1867–1916)
SPb.	St. Petersburg
Svodnyi katalog	E. I. Katsprzhak et al., *Svodnyi katalog russkoi knigi grazhdanskoi pechati XVIII veka, 1725–1800,* 5 vols. (M., 1962–67)
TODRL	*Trudy otdela drevnerusskoi literatury Instituta russkoi literatury*
TsGADA	Tsentral'nyi Gosudarstvennyi Arkhiv Drevnykh Aktov (Central State Archive of Historical Documents, now Russian State Archive of Historical Documents), Moscow
TsGIA	Tsentral'nyi Gosudarstvennyi Istoricheskii Arkhiv (Central State Historical Archive, now Russian State Historical Archive), St. Petersburg
ZAP	*Zakonadatel'nye akty Petra I,* ed. N. A. Voskresenskii (M./L., 1945)

Preface

This is the second volume of a comprehensive study of the cultural revolution in Russian history that is inseparably linked with the person and policies of Peter I "the Great." It recounts in detail how the visual arts were transformed under Peter following an intensive program of Europeanization and indicates how, in consequence, modern forms of imagery came into being in Russia along with allied techniques of image-making. The discussion is mainly about painting on various surfaces, about sculpture in bronze and stone, and about the birth in Russia of the modern graphic arts; but manuscript illumination is also considered, as are the minting of coins and medals, the production of flags and altar cloths, and the arrival in Russia of the new cartography and the new heraldry. The concurrent revolution in Russian architecture and interior decoration is on the whole not discussed, as that was the subject of the first volume.* A projected third volume of the study will deal with the emergence in Russia of modern science and modern literature, and with the cumulative impact of Peter's revolution on Russian language and behavior. In all three volumes, I should emphasize, an effort is made to situate the Petrine revolution in Russian culture in its wider political, economic, and social settings, an effort that necessarily entails some repetition.

I should also stress that this volume, like the first, was written by a general historian, not by a specialist in art; that it, too, grows out of an interest in the overriding question of how Russia became Russia—how medieval Muscovy became modern Russia; and that it similarly hopes to be judged, therefore, primarily as a work of history rather than art history. But readers may view it the other way around, in which case I apologize as before for any technical deficiencies, which can only be excused by reference to the overall project and the great question that it hopes to help resolve. On the other hand, the subject itself of this volume, its treatment of imagery as at once a sign and an instrument of the wider revolution, and its modicum of technical language may well attract readers not normally drawn to art history in the narrower sense of the term. In any event, that has been my intention in writing it.

*James Cracraft, *The Petrine Revolution in Russian Architecture* (Chicago: University of Chicago Press, 1988).

Like the first volume, this one draws on years of library, archival, and picture research in Russia, Europe, and the United States as well as extensive on-site inspection of visual monuments, work that was greatly facilitated by various people and grants. In particular, grants and fellowships from the National Endowment for the Humanities, the Russian Research (now Davis) Center of Harvard University, the International Research and Exchanges Board, the American Council of Learned Societies, the Bibliographical Society of America, and the Campus Research Board and Humanities Institute of the University of Illinois at Chicago enabled me to take time off from teaching, to travel as needed, and to pay for reproductions, for all of which I am deeply grateful. I am also grateful for their courteous and helpful service to the staffs of the many libraries and museums where I worked, particularly the Russian Museum in St. Petersburg and the Tretiakov Gallery in Moscow; the Fogg Art Museum and library, and the Houghton and Harvard College libraries, of Harvard University; and the Regenstein Library of the University of Chicago. Among scholars whose published work or private comments were especially helpful I must single out Daniel Rowland, Richard Stites, and Richard Wortman. Nancy Sairsingh, then a doctoral candidate in Fine Arts at Harvard, provided valuable assistance in the earlier stage of the project. Lastly, I must thank the wonderfully professional and supportive staff of the University of Chicago Press, especially Karen Wilson, Penelope Kaiserlian, Susan Bielstein, Paige Kennedy-Piehl, Martin Hertzel, and Lila Weinberg.

In this volume, as in the first, transliterations from Russian follow a simplified version of the standard Library of Congress system. Soft signs are dropped in the text in Russian proper names (e.g., Grabar, not Grabar') or when Russian words are anglicized (e.g., Posolskii Prikaz, from *Posol'skii prikaz*), but elsewhere they are retained. Common English equivalents of Russian names and other terms are used whenever possible, and dates are given in accordance with the Julian or Old Style calendar observed in Russia from Peter's time until February 1918, when it was superseded by the Gregorian or New Style calendar long since in use in Europe and America. In the eighteenth century the Old Style calendar was eleven days behind the New (twelve days in the nineteenth century, thirteen in the twentieth), a trivial difference for our purposes.

J. C.
Chicago
August 1996

THE PETRINE
REVOLUTION
IN RUSSIAN
IMAGERY

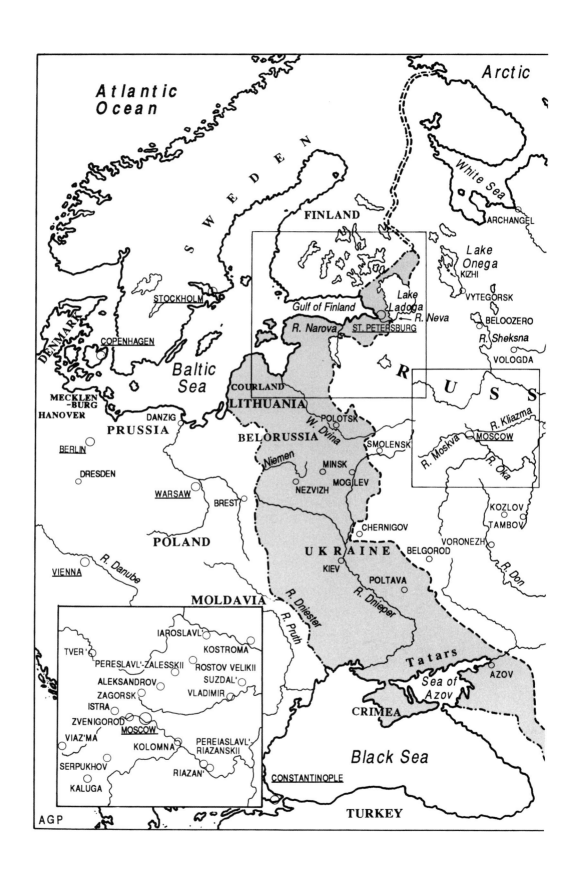

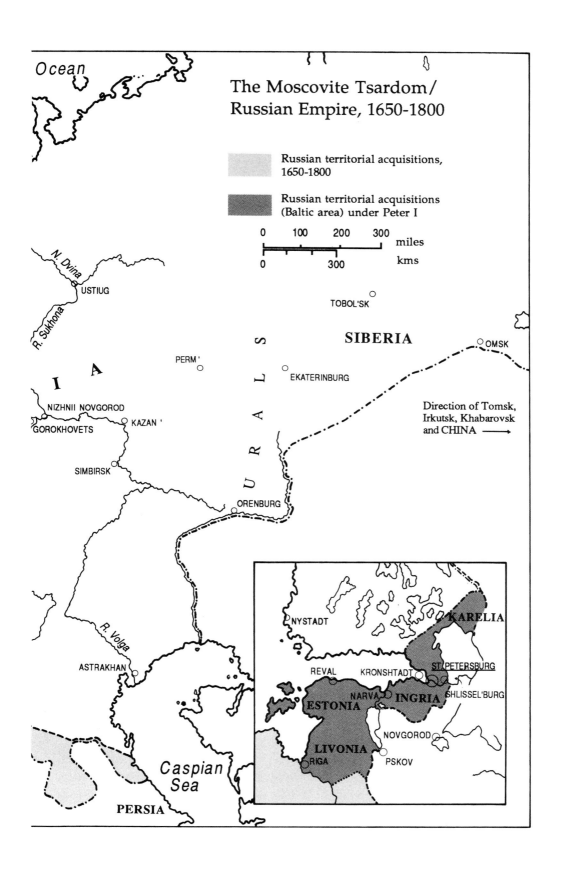

The Moscovite Tsardom/
Russian Empire, 1650-1800

Russian territorial acquisitions,
1650-1800

Russian territorial acquisitions
(Baltic area) under Peter I

```
0    100   200   300
                      miles
0          300        kms
```

Ocean

N. Dvina

USTIUG

R. Sukhona

TOBOL'SK

SIBERIA

OMSK

PERM'

U R A L S

EKATERINBURG

Direction of Tomsk,
Irkutsk, Khabarovsk
and CHINA ⟶

I A

NIZHNII NOVGOROD

KAZAN'

GOROKHOVETS

SIMBIRSK

ORENBURG

R. Volga

ASTRAKHAN

*Caspian
Sea*

PERSIA

NYSTADT

KARELIA

REVAL

KRONSHTADT

ST. PETERSBURG

NARVA

INGRIA

SHLISSEL'BURG

ESTONIA

NOVGOROD

LIVONIA

RIGA

PSKOV

1

Introduction

"Europe" is a culturally constituted entity, not a geographical one. It has no obvious physiographical or environmental boundary with "Asia," supposedly also a separate continent, but is in fact a small part of one "Eurasian" land mass, its westernmost extension, abutting there the Atlantic ocean as the other extremities of Eurasia abut in proper continental form the Arctic, Pacific, and Indian oceans. "Europe" may be described rather as an idea, one that has been given various geographical applications since its invention, or first recorded use, by ancient Greeks. As an idea, moreover, "Europe" has normally connotated some sort of superiority to, as well as distinctiveness from, its supposed antipodes, namely Asia, Africa, and, later, America.[1]

Russia before the time of Peter was not considered part of Europe—not by contemporary Europeans. Or rather, following, as heirs of the Renaissance, ancient Greek and Roman authorities, seventeenth-century Europeans were willing to locate the land of "Muscovy" in Europe but not the contemporary state—the ruler and people—of that name. And even then it was only the western territories of the Muscovite state that were so included, as seventeenth-century European geographers and mapmakers had reached a consensus in placing the eastern boundary of Europe along a south-north line marked by the lower Don, middle Volga, Kama, and upper Ob rivers. This was the line published in 1616 by a renowned scholar of Leiden University, Philip Cluver (Cluverius), who has been called the father of historical geography; and by the end of the century it had won wide acceptance, being described as "the most common opinion" on the subject in M. A. Baudrand's authoritative *Dictionnaire Géographique et Historique* published at Paris in 1705. But the line obviously left out of account—that is, left in Asia—the vast territories conquered and claimed by Russians since the fifteenth century that lay east of the lower Don, the middle Volga, the Kama, and the upper Ob, territories that included such important urban centers as the Caspian port of Astrakhan and Tobolsk, the capital of western Siberia, as well as most of Siberia itself. Russia's cartographical image in Europe, in short, was still vague—as vague as the country's reputation more generally. Indeed, neither the inhabitants even of western Russia, nor their "czar" or "grand duke," nor their

royal city of "Mosco" were considered European, or fully European, by seventeenth-century European writers. "Muscovia is the last region of Europe towards the east, and indeed stands a good part in Asia," was how the author of *A Prospect of the Most Famous Parts of the World* (London, 1668) put it, typically.

Now by the term "European" here we refer in the first instance to the merchants and missionaries and noble ambassadors from Britain, Holland, Germany, France, Italy, and elsewhere in Europe who directly encountered Russia and Russians in the course of the seventeenth century and left records of their impressions, records on which both contemporaries and later historians could draw in forming their own idea of Russia.[2] And it is surely remarkable that in spite of their confessional, class, and national or regional differences the overall view of these dozens of visitors is both so consistent and so consistently negative. In the words of the German scholar-diplomat, Adam Olearius, who was on mission in Russia in the 1630s and again in 1643, and whose account of his visits, first published in German in 1647, became a European bestseller (at least ten more editions in German to the turn of the century, nine in French, five in Dutch, three in English, one in Italian): "When you observe the spirit, the mores, and the way of life of the Russians, you are bound to consider them among the barbarians." There it was. Russians were "a people who differ from all other nations of the world in most of their actions," declared Samuel Collins, the tsar's English physician from 1660 to 1669, offering as one small example of their "odd customs" the fact that "they know not how to eat peas and carrots boiled, but eat them shells and all, like swine." Jan Struys, a Dutch visitor in 1668, was amazed to discover that log boats—"knoos"—were still commonly used in Russia, while Hans Moritz Ayrmann, an officer in the Swedish royal service, observed in 1669 that "their dwellings could sooner be compared with pens for cattle and pigs, than with houses." Guy Miege, a member of the English embassies of 1663 and 1664, found that not only the lesser towns of "Moscovie" but even Moscow itself were built almost entirely of wood and therefore "much subject to fire." Baron Mayerberg, the Austrian emperor's envoy in 1660–1661, complained that "the Muscovites block entrance to their churches to persons of any other religion, as if they were dogs; and should someone try to have a look on the sly, they take him by the arms and throw him out, shouting profanities after him." Even the townsfolk of Russia, Mayerberg reported, "not only the artisans and journeymen but even the merchants, are very far from civilized": a matter not just of their dress and manners but of their utter subjugation to their masters in a hierarchy of servitude ultimately dominated by "the Lord Czar and Grand Duke," who "rules all his subjects despotically, following the ancient custom." And so on. For all its growing commerce with its western neighbors Russia was still lacking, in the most tangible as well as "spiritual" ways, what Europeans had come to consider the basics of civilization. Bernard le Bovier de Fontenelle (1657–1757), a leader of the early Enlightenment, expressed the

prevailing view in his eulogy of "Peter the Great" delivered to the Paris Academy of Sciences in 1725. Before Peter's reign, said Fontenelle, "Muscovy, or Russia, was still in such ignorance and grossness as everywhere attend the first ages of nations. . . . The Muscovite nation, little known even to its nearest neighbors, was a nation apart, one which played no role in the system of Europe, had little connection with the other Powers, and little consideration among them."[3]

But the growing political importance in Europe of Russia under Peter I, an importance based mainly on Peter's military and naval victories over Sweden in the Baltic region and the Ukraine and his consequent domination of Polish politics, impelled Europeans to accept Russia as a member of the European state system. One marker of this development is the influential *Almanach Royal*, which in 1716 still ended its list of European countries with Poland but whose edition of 1717, the year of Peter's celebrated visit to France, lists "Moscovie" for the first time, following Poland.[4] Under Peter regular diplomatic relations were established between Russia and all the major European powers.[5] Peter also was hailed in Europe, naturally enough, for his Europeanizing domestic program, which had begun in the armed forces and related governmental institutions but had become as it gathered steam a wholesale cultural revolution. Fontenelle clearly understood this point too, as it constituted the ostensible reason for Peter's election to the Paris Academy in 1717. Peter's "vast project," Fontenelle told his colleagues in 1725, had been nothing less than "to create a new nation" in Russia, and "we honor the deceased Czar not only as a fellow Academician, but as the King and Emperor who established the Arts and the Sciences in his huge domain." In this role, Fontenelle emphasized, Peter had not only implanted European architecture and sculpture in Russia but had imported "numerous paintings from Italy and France, so as to teach this art to a people who had known it only from the wretched representations of their saints."[6]

European contempt for Russian visual art—for the icons to be seen everywhere in Russia—was longstanding. In fact, Russian imagery had long been considered by contemporary European observers proof that Russia was not truly European. "Temples stuft with idols that defile/The seats that sacred ought to be. . . . I never saw a . . . people so beset with saints, yet all but vile and vain": so wrote George Turberville, secretary of the English embassy of 1568–1569, in a verse letter from Moscow to a friend back home. "Their imagery is very pitiful painting, flat and ugly," observed Dr. Collins in the 1660s; "if you saw their images, you would take them for no better than guilded gingerbread." Olearius, a little earlier, had the same reaction—St. Nicholas in a Novgorod church was "naively and inartistically portrayed, like most of their paintings"—and Balthasar Coyet, a young officer in the Dutch embassy of 1675–1676, apart from remarking, like all European visitors, on the strange ubiquity of holy pictures in Russia, also noted condescendingly that "they honor only images done by Russians or Greeks, and want none by other mas-

ters, however well done; as if the faith of the master showed in the picture."[7]

Historians of Europe have been similarly reluctant to admit pre-Petrine Russia into their purview. Emmanuel Todd's massive study of Europe's common anthropological history over the past five centuries wholly excludes Russia, for instance, as does Dietrich Gerhard's essay on the institutional order of Europe to 1800, an order from which Russia "in almost all its features differs fundamentally."[8] Historians of the early modern period in particular have observed that even as Russia in the decades before Peter moved slowly towards Europe it remained, in the phrase of one, "un État terriblement archaïque" and counted for little in European affairs.[9] A specialist on Europe of the Enlightenment is frankly ambiguous about Russia's place in that world: a great power, from Peter's time, assuredly; but otherwise a European country?[10] Russia in the seventeenth century and even in the eighteenth "belongs to another cultural space-time," writes Pierre Chaunu, citing its vast open spaces, institution of serfdom, and Orthodox church as factors differentiating Russia from "classical Europe" and "Europe of the Enlightenment."[11] Georg von Rauch, in a wide-ranging essay of direct relevance here, points out that when Peter successfully claimed a seat in the European concert Russia was at first regarded as a "northern" rather than European—or eastern European—power, and that it was not until the nineteenth century that Russia was perceived as "unequivocally eastern European." This new perception was a result of the greatly accelerated internal "Europeanization" of Russia initiated by Peter, a transformation which in its turn, like the parallel processes in Poland or in the Danubian and Balkan regions, helped broaden Europe's consciousness of itself.[12]

Historians of European art are even more equivocal in their appraisal of the imagery produced in Russia before Peter's time. In fact, except as a provincial subset of medieval Byzantine art, Russian imagery is entirely absent from the familiar "story of art" as it unfolds in Europe until the advent of modernism around the turn of the twentieth century. Such is the case in the most widely consulted general art histories.[13] Such also is the case in either introductory or specialized works on seventeenth-century European art.[14] Neither omission is simply a matter of "Eurocentrism," it would seem. The well-nigh complete absence of Russia from the history of European art until the reign of Peter, and even, in varying degrees, until well after it, reflects qualitative decisions by scholars regarding form and content, technique and style, and meaning or significance as well as historical context. In this considered view, Russian visual art until Peter remained at once provincial and "medieval," just as Russian art history before the advent of modernism has remained almost exclusively the domain of Russian specialists.[15]

And so to the subject of this volume. The Petrine revolution in Russian visual art may be viewed as a process whereby contemporary European forms of imagery along with the means of producing them were deliberately brought to Russia, there to be so firmly implanted in the first decades of the

eighteenth century that they determined the subsequent course of Russian visual culture. In so saying, however, we define as necessary to an understanding of Peter's revolution in Russian imagery some understanding of contemporaneous European visual art. That art was dominated by the style or tendency known as Baroque, whose development, like that of "Mannerism," seems inseparable from the history of "Renaissance" art. Moreover, crucial to the general success of the Renaissance in European art, and of Mannerism and the Baroque, was a concurrent set of developments known to historians as the print revolution. In short, neither the Petrine revolution in Russian imagery nor the subsequent history of Russian visual culture are intelligible without reference to these earlier movements in European culture. Nor can this (or any other) aspect of Peter's cultural revolution be properly understood as less than an integral part of his wider program of political and economic Europeanization, or modernization, in Russia. The Petrine revolution in Russian imagery, as in culture more generally, was impelled by objective political and economic factors as well as by aesthetic or psychic ones.

Such at any rate are the basic considerations driving this and other chapters of this volume, whose overall purpose, like that of its predecessor on architecture, is to provide a concrete demonstration of cultural Europeanization in Petrine Russia in both its settings and its ramifications.

The New Imagery in Europe

Specialists customarily describe as "Renaissance" art produced in Italy in the fifteenth and sixteenth centuries which manifests a deliberate imitation of Classical patterns or a conscious return to Classical norms. The description accords with the original notion of a *rinascita* or "rebirth" of culture elaborated by contemporary scholars in Italy; it also underlines the centrality to the entire movement of ancient Greek and Roman written texts and particularly of surviving monuments of antique visual art, whether newly discovered or newly appreciated. With respect to painting and sculpture, the "Renaissance" entailed in this standard view a potent new tendency towards "naturalism" in imagery and the establishment correspondingly of a new manner or style, one which aimed at the actuality in sculpture, the illusion in painting, of three-dimensional reality. From Classical authors the Renaissance public learned to expect intimations of ideal form in visual art as well as a high fidelity to nature; but naturalism and idealism animated Renaissance artists as complementarities which mutually corrected each other, not as principles in conflict. Later "Mannerist" and "Baroque" artists, while deliberately departing from these principles, were still beholden to them in basic ways.[16]

These points are so familiar to Western students that it is almost embarrassing to raise them. Yet several aspects of Renaissance art in Italy, apart from those just mentioned, merit emphasis for students of Peter's revolution in Russia. One is the connection, still somewhat problematic, of Renaissance

with Byzantine art, which provided of course the original matrix of Russian art and retained influence right down to Peter's time. Byzantine canons in painting and mosaic were operative in Italy before the Renaissance to a degree that was not so elsewhere in Europe, and their grounding in this Byzantine tradition may well have assisted Italian painters, especially muralists, in their quest for that naturalism which so distinguished Classical sculpture. In particular, Byzantine painting and its Italian offshoots had preserved more traces of Classical imagery than had the corresponding art of "Gothic" Europe, notably the modeling in light and shade and the characteristic foreshortening apparent in our figures 1 and 2. Using methods of this kind Giotto painted numerous sainted figures on the walls of Florentine churches in a strikingly sculptural manner early in the *fourteenth* century. His fresco cycle covering the walls of the Arena Chapel in Padua (ca. 1305–1306) represents moreover the best preserved example of the newly revived ancient technique of *buon fresco* ("true fresco"), whereby colors are applied section by section to the artist's design while the thin plaster ground is still wet, making the images when dry one with the wall and extremely durable. Nothing like Giotto's frescoes had been accomplished for a thousand years, as Gombrich says; Giotto had rediscovered the art of creating the illusion of depth on a flat surface. Another authority credits Giotto and the contemporary sculptor Giovanni Pisano (see his *Madonna and Child with Two Acolytes,* ca. 1305, also in the Arena Chapel, Padua) with awakening "the urge towards naturalism which lay dormant in Tuscany, and ultimately this would lead to the annunciation of a great new day." Unlike Gombrich, however, Jestaz does not assign Byzantine art any positive role in this great awakening, or any role whatever.[17]

The relations between Byzantine and late medieval or proto-Renaissance art in Italy have been intensively studied by Otto Demus.[18] Demus sought to document for the first time the actual function in Italy of Byzantine artists as teachers and pacemakers and of Byzantine models as object lessons. He found that the transmission westward of superior examples of Byzantine icon painting, a process begun as early as the ninth-century Carolingian "renaissance," was greatly intensified by the Latin conquest of Byzantium in the thirteenth century and the establishment of Venetian control of the Greek islands. Following this conquest large numbers of Byzantine artists came to Italy, and Italian artists, seeing more Byzantine art in Venice or Rome, in Jerusalem or in Constantinople/Byzantium itself, filled books with sketches and notes for later use. Demus gives special attention to the treatise or handbook on painting compiled about 1400 by Cennino Cennini, calling it a work "full of recipes derived from Byzantine sources." A student of early Renaissance art describes this work not only as "a unique source book for almost every aspect of the technique and materials of late medieval Italian painting," but as one whose "intense conservatism is reflected in the fact that, in matters such as perspective, Cennini's prescription is well to the rear of Giotto's practice more than seventy-five years earlier."[19] At the same time, an authority on the history of

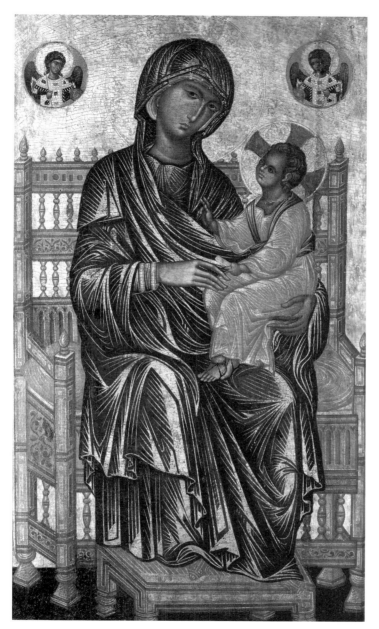

Figure 1 *Enthroned Madonna and Child*. Tempera on panel. Byzantine, thirteenth century (probably painted in Constantinople ca. 1280).

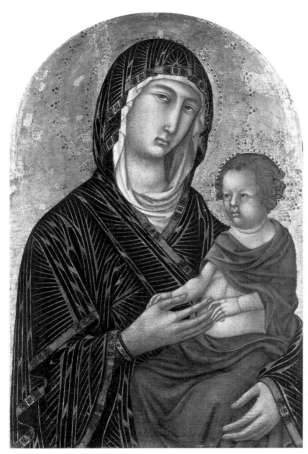

Figure 2 Segna di Bonaventura (Sienese school, active 1298–1328), *Madonna and Child.* Tempera on panel. The striations or patterns of gold bars marking the Madonna's robe here as in fig. 1 are typically Byzantine, as are the general composition of both pictures (icons), the gold background, the folds of the drapery, the modeling of face and hands by marking the shadows, and other details.

aesthetics treats Cennini as the first artist since antiquity to advocate imitating nature while adding a new term, *disegno,* to the vocabulary of art: "design" to mean now both a drawing and a project or intention, and thus heralding a new emphasis on the graphic foundation of painting as well as on the artist's own imagination.[20] That Cennini's handbook can be seen in retrospect as proof of persistent Byzantine influence in fourteenth-century Italian painting, as a conservative compendium of late medieval technique, and as a herald of Renaissance theory, suggests that the Byzantine role in the genesis of the new art was at once seminal and quite limited.

Demus sees the impact of Byzantine models on painting in Italy not just in formal matters but in a "sense of monumentality" typical of both thirteenth-century Italian and Byzantine murals. He sees it again in certain "humane qualities" of panel painting produced in the two worlds—in the more direct appeal of the image and in the "new empathy" to be found in thirteenth-century Byzantine art which, as transplanted to Italy, helped pave the way for

the Renaissance. Demus examples an icon painted (he says) in Constantinople in the thirteenth century (our fig. 1), suggesting that it was some decades before the best Italian painters succeeded in surpassing its "soft modeling and dreamy charm." [21] The same general point is rather more cautiously made by a student of early Renaissance painting (B. Cole), who says that thirteenth-century Italian artists may well have turned to the Byzantine style because it was more illusionistic than the art of their own recent past and because they could thereby learn certain realist conventions; then, in realizing the potential of such conventions, Italian artists began to "revivify" them. But exactly how this might have happened and precisely what models the Italian painters might have used have not been established: the resemblances in figure type and architectural forms between Byzantine and Italian thirteenth-century pictures, Cole concludes, are "generic rather than specific in nature." Hartt's latest edition concludes more pointedly that "for all their initial reliance on Greek models . . . even the earliest productions of *Italo*-Byzantine paintings show a vigor and tension that distinguish them from their Eastern models." [22] Students of Greek and Russian imagery are reminded that developments in Byzantium alone or within the Byzantine art tradition itself did not produce the Renaissance; not, in fact, by a long shot.

Demus makes another point worth noting here. Since Byzantine art was the "living continuation of Greek art," it was capable (at least indirectly) of leading Italian artists back to the Classical sources, sources which assisted them in seeing "the Greek behind the Byzantine" in Byzantine art. The crucial importance of this factor can be grasped, Demus postulates, if we think for a moment precisely about Russia, whose icon painters were as deeply influenced by Byzantine art as were medieval Italian artists but who had no possibility of referring back to the Classical sources of Byzantium: no Classical artworks anywhere to hand, nor any Classical writings. The Russians too were "disciples of Byzantium but they never became students of antiquity. Thus, their way did not lead to a renaissance or a new humanism" but rather "lost itself in the decorative mazes of folk art." [23] This generalization is certainly true, with few exceptions, until well into the seventeenth century, as we shall see. Then the similarities between examples of the best or cutting edge of late Muscovite painting and others of thirteenth- or fourteenth-century Italian painting, painting on the cusp of the Renaissance, become striking. [24]

Classical or "humane" values were central to the wider cultural movement of the Renaissance, which was marked by the cultivation in Italy and then in the North of lost layers of Classical learning (much of it transferred from Byzantium) [25] along with a boundless enthusiasm for the physical relics of antiquity, including medals and coins and jewelry as well as sculpture, architecture, and fragments of painting. The metaphor itself of a consequent "rebirth" of culture arose among the "humanist" followers and admirers of Petrarch of Arezzo (Francesco Petracchi, 1304–1374), the enormously influential poet and prolific writer (in both Italian and Latin) of historical, biographi-

cal, and philosophical works as well as editor of neglected Classical texts. With respect to art, the metaphor was systematically developed by the Florentine painter and architect Giorgio Vasari in his famous *Lives of the Most Excellent Painters, Sculptors and Architects,* first published in 1550 and again, extensively revised, in 1568. The *Lives* is in part a technical manual but more broadly a history of art in Italy from Cimabue (born ca. 1240) to Michelangelo (died 1564), a history Vasari viewed anthropomorphically, as a progression from childhood through youth to maturity, with painting as the paradigm. In Cimabue, Vasari declared, art was reborn after its near extinction following the fall of ancient Rome. It was Cimabue who "first attacked the hard angular lines of Byzantine mosaic and painting . . . the hard lines by which every figure was bound, the senseless eyes, the feet planted upright on their extremities, the sharp, formless hands, the absence of shadow, and every other monstrosity of those Byzantine painters"—some of whom (Vasari admits) had been Cimabue's first teachers. In this first new age, of which Giotto was the great hero, artists struggled to imitate the colors and forms of nature, to present the human body in the round, and to convey human emotion in its natural expression. The painter Masaccio was Vasari's hero of the succeeding age, from about 1400 to 1500, when further study of antique sculpture and new experiments in perspective and anatomy brought the artist's ability to depict "the truth of nature" close to perfection. Maturity came with Leonardo da Vinci, Raphael, and Michelangelo, whose splendidly harmonious art surpassed that of antiquity itself, to reach unrivaled heights (fig. 3). Vasari's history became, as it largely remains, the master narrative of the Renaissance in art. It implied moreover a full aesthetic theory based on such concepts or "categories" as right proportion, correct design, linear perspective (also known as scientific, single-point, or vanishing-point perspective), harmonious overall composition, verisimilitude in the imitation of nature, and the artist's necessary pursuit of a distinctive, and graceful, "manner" or style.[26]

Among the achievements of the Italian Renaissance in painting, as exemplified in what have been persistently considered its greatest works, are an entirely unprecedented mastery of perspective and anatomy, the result necessarily of intensive (scientific) study; a new mastery also of color and light and shade, as in the works especially of the Venetians Giovanni Bellini and Titian, or of Correggio; and an entirely new emphasis on drawing or design, not only as the basis now of all visual art but also as an art in its own right. The new, self-contained easel portrait acquired a wholly new naturalism and gravity; the landscape came into its own; and Classical mythology became a fit subject of painting (as famously in Botticelli's *The Birth of Venus,* ca. 1485). The arts of depicting images on flat surfaces by means of paint had been expanded far beyond anything known from antiquity, let alone the medieval world. There is a clear consensus among scholars even today that painting as it was produced by leading Italian artists at the end of "the Renaissance" had undergone revolutionary changes.[27]

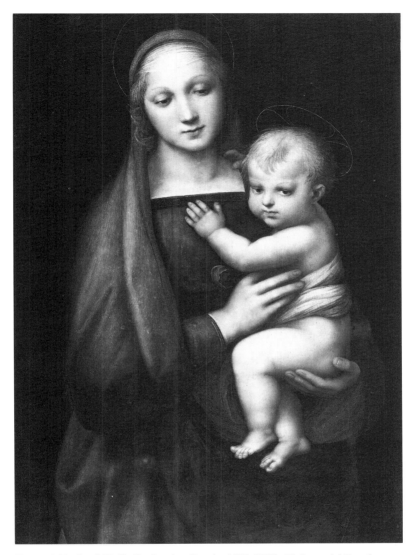

Figure 3 Raphael (Raffaello Santi or Sanzio, 1483–1520), *Madonna del Granduca*, ca. 1505. Oil and tempera on panel.

In our own effort to understand this revolution in imagery as it finally came to Russia, the Vasarian approach, with its focus on artists, may be helpful. Studies of Renaissance painting continue to offer examples of how the interests and abilities of the painter determined the new presentation of the image. Patrons or customers for sure had their input, determining the popularity of certain images or the inclusion of certain details or themes in commissioned works or the amount to be spent on materials. But by the end of the fifteenth century some patrons valued the skills of the artist above the precise content

of the imagery such skills produced, the great collector Isabella d'Este being a documented case in point. Leonardo da Vinci was acclaimed for his "new inventions" and permitted great licence.[28] A complex interplay of changing stylistic imperatives, new visual ideas, new materials, and new techniques drove the Renaissance in imagery—these techniques to include, apart from the revival of fresco, as already noted, and the greatly expanded use by artists of preliminary design sketches on paper, the introduction of oil-based paints in place of egg tempera and of canvas supports instead of wood; not to mention parallel or related revolutions in sculpture and book illumination, the rebirth of the medalist's art, and the debut of the print.[29] The Renaissance at its core was an often humdrum affair of long, hard, tedious, if frequently innovative work by artists themselves, whether anticipating or responding to changes in patrons' tastes, something that art scholars in Russia have tended to overlook in their focus on broader socioeconomic and political factors in history.

Further, the accumulating achievement of Renaissance artists helped raise their public status from that of anonymous artisan to that of poet or scholar, exceptionally a "genius" acclaimed for his singular artistic feats and the pride of his hometown. Artists of the Italian Renaissance besides Vasari also gave intellectual respectability to painting, as they did to architecture and sculpture, by writing books on their art and by insisting that practice be based on explicit theory: "by medieval standards," as Panofsky says, this was itself "a revolutionary postulate."[30] Alberti's *De pictura* of 1435, rewritten in Italian in 1436, like his companion treatise on architecture, had immense influence on both artists and patrons. It is divided into three books, the first on perspective, the second on the qualities of good painting, the third on the education of the painter; and it advocates throughout values later broadcast by, among others, Vasari.[31] Alberti projected here a "utopian vision," perhaps, a "new theory of the arts in which painting holds a place of honor and power" but a theory that was "addressed to a not-yet existent audience of painters and humanists" and was "only ratified by social practice over a course of centuries."[32] Nevertheless, his maxims formed the theoretical grounding of the academies of art established in Florence and elsewhere in Italy in the later sixteenth century and eventually all over Europe including St. Petersburg, and so helped to institutionalize the Italian revolution. And Alberti's self-consciously "modern" view of art and its values, as expressed again in Vasari's *Lives*, differed decisively from the typically medieval approach to image-making—a crucial point in our project.

Gombrich explains how the medieval artist was not concerned with imitating natural forms but rather with the arrangement of traditional sacred symbols, these being all that he needed to "tell his sacred story," a story that he seemingly related "not for its own sake but for the sake of its message, and for the solace and edification the faithful could derive from it." The medieval painting, as Gombrich and others have termed it, was a sermon in imagery. The medieval artist, or rather craftsman,

started by being apprenticed to a master [in the sense of a foreman], whom he assisted at first by carrying out his instructions and filling in relatively unimportant parts of a picture. Gradually he would learn how to represent an apostle, and how to draw the Holy Virgin. He would learn to copy and rearrange scenes from old pattern-books, and fit them into different frames, and he would finally acquire enough facility in all this to be able even to illustrate a scene for which he knew no pattern. But never in his career would he be faced with the necessity of taking a sketchbook and drawing something from life. Even when he was asked to represent a particular person, the ruling king or a bishop, he would not make what we should call a likeness. There were no portraits as we should understand them in the Middle Ages. All the artists did was to draw a conventional figure and to give it the insignia of office and perhaps write the name underneath so that there could be no mistake.[33]

This was precisely how even elite visual art was practiced in Russia right into Peter's time, as will be seen in following chapters. Baxandall quotes from a medieval source exemplifying the theory that underlay this practice, a theory closely congruent with the view which still prevailed, again, in early Petrine Russia. Baxandall's source is a late thirteenth-century writing by John of Genoa:

Know that there are three reasons for the institution of images in churches. *First,* for the instruction of simple people, because they are instructed by them as if by books. *Second,* so that the mystery of the Incarnation and the examples of the Saints may be the more active in our memory through being presented daily to our eyes. *Third,* to exite feelings of devotion, these being aroused more effectively by things seen than by things heard.[34]

Or, in the popular couplet,

Nec Deus est, nec homo, quam praesens, quam cernis imago;
Sed Deus est et homo, quem sacra figurat imago.

This told medieval viewers that the holy image they beheld was neither God nor man but God "figured" in the form of man.[35]

These qualitative distinctions between Renaissance and medieval art practice and theory are scholarly commonplaces, to be sure. So is the fact that as the Renaissance unfolded John of Genoa's three principles, or instructions, were not so much abandoned by image-makers as they were differently applied. Until about 1500 anyway most painting in Italy, like most sculpture, remained ostensibly religious in content as well as didactic in purpose, concerned to represent God to man. Indeed it is essential, thinking ahead to Russia and to the tenets of the prevailing scholarship, to stress this point, too. Wittkower some while ago exploded the fallacy that "the Renaissance produced a predominantly worldly art, that the Gods of Olympus replaced Christ and the host of saints. On the contrary, Renaissance art is first and foremost a religious art." He offered Renaissance funerary sculpture as a con-

spicuous example—"in one way or another every Renaissance tomb remains focused on the idea of salvation"—while reiterating that Renaissance painters produced an "endless number" of small easel pictures for private devotion in home or palace along with great altarpieces and cycles of frescoes for churches, Michelangelo's ceiling frescoes of the Sistine Chapel (1508–1512) constituting "the epitome of Renaissance religious imagery." The venerable storehouse of Christian iconography, to which Byzantium had contributed so much, continued to be exploited by Renaissance artists though with numerous and often complex references to theology as well as to Scripture, to devotional works new and old, and to local lore. Renaissance artists made themes or images and especially allegories taken from Classical history and mythology—like figures and stories from the Old Testament—serve Christian ends. Some contemporary or later churchmen may have criticized some works of Renaissance art for certain theological shortcomings, or on moral grounds. But the religious *content* of most of this art is undeniable, as scholars have increasingly taken pains to point out.[36]

On the other hand, the Renaissance or humanist *theory* of painting, which was to prevail in Europe until the eighteenth century, when new forces in critical thought and artistic practice began to bring it down, was something else again. It has been usefully summarized in this way:

> Everywhere in the theory is the fundamental assumption that good painting, like good poetry, is the ideal imitation of human action. From this it followed that painters, like poets, must express general, not local, truth through subjects which education in the Biblical narratives and the Graeco-Roman classics had made universally known and interesting; must deploy a rich variety of human emotion; and must aim not merely to please, but also to instruct mankind.[37]

From this it follows that Renaissance image theory was neither religious in essence nor secular but both—or either. Scholars accordingly have noticed that some modification of the religious regime in Italian art practice appeared around the beginning of the sixteenth century, by which time collectors had assembled considerable quantities of pictures, statues, bronzes, and medals that were not closely connected with religious rites or places and were not purely utilitarian in nature either: "They were more like works of art in our sense," says Cole, "objects to be valued for their physical beauty, their ideas, [their rarity,] and their cost." Artists as we noted were themselves becoming prestigious figures in society if not "friends of power";[38] even such religious furniture as altarpieces and church statues were being perceived as works of art. "The iconic, miraculous nature that so marked art in an earlier period was slowly giving way to a more dispassionate attitude," one that resorted to aesthetics and art history rather than to religion.[39] If the content of Renaissance art remained predominantly religious, in other words, the reasons for producing and collecting it were becoming steadily less so.

These observations point to multiple meanings or even ambivalences especially in later Renaissance imagery, and suggest that a kind of secular imperative was implicit in Renaissance innovation virtually from the outset.[40] We should bear this point in mind, too, when we come to consider the career of the new imagery in Russia.

Quite when the Renaissance in Italian art may be said to have ended, and the period or style called Mannerism to have begun, is a vexed question among art scholars. In the eyes of its champions, Mannerism was born in Italy with the disintegration of the Renaissance, in which it was thus "latent," as in the work of Raphael and his school or of Michelangelo and his. In this view, Mannerism was at first a "revolt" against Renaissance classicism; its works in both visual art and literature are characterized by an "alienation" and a "narcissism" arising from the "complex dilemma" presented to artists (after about 1500) by the competing claims of tradition and innovation: Mannerism's "imitation of classical patterns served as a refuge from the chaos of creativity in which men feared to lose themselves. Its exaggeration of the subjective, its ostentatious arbitrariness, the inexhaustible devices of its interpretation of reality, expressed the fear that form might fail in the face of the dynamism of life and become ossified in humdrum beauty." Mannerism was aided in its rise by an economic boom in sixteenth-century Europe and abetted by the Protestant and Catholic Reformations—hence its frequent extravagance, perverse iconoclasm, and the still ostensibly religious content of much of its imagery. Among its better known exponents with passing significance in our story are Veronese in Italy, Maerten van Heemskerck in the Netherlands, Dürer in Germany, and El Greco in Spain—the last marking "the climax of mannerism" in painting.[41]

Elegance, perversion, aestheticism, occultism, melancholy, sadism, caricature, ambiguity, and double meaning have been listed among the main themes of Mannerist imagery, as have allegory and symbol, natural history, mechanical devices, and dreams. But a preoccupation with style—*maniera*—seems to be the most salient characteristic, style as expressed in "extreme clarity of contours, lustrous forms, sculptural painting; a tendency toward cubism; use of geometric forms; deformation, elongation of figures, plays of perspective, and acromegaly [strange enlargements of body parts]; serpentine line; exaggerated or 'mannered' gestures; harsh metallic colors; [and] imaginative, evocative atmospheres, such as stormy twilights."[42] Lavish attention to appearances, in short, typified the high art of Europe between about 1520 and 1620. Mannerist artists were having a field day, their art often effectively subverted established authority, and it was rapidly disseminated throughout Europe owing to the increasing tempo of the print revolution. Indeed for our purposes Mannerism signals most importantly the enormous proliferation in all senses of the word—geographical, stylistic, iconographic—of Renaissance imagery, however exaggerated or deranged in form. Russians first encoun-

tered the new imagery in Mannerist forms, we shall see, although this was hardly unusual, since outside Italy the Renaissance in Europe was invariably nonindigenous, a sixteenth-century import which often arrived in the Mannerist styles then prevalent in Italy. And this factor, Jestaz reports, in turn "often led to imbalances and inconsistencies which cloud the picture in transalpine European countries. In view of their [artistic] development before the seventeenth century, it could even be argued that *their* Renaissance was a process of gradual dissociation from and control over Mannerism, which ultimately led to classicism—the reverse of what had taken place in Italy." Jestaz's "cloudy" paradigm helps explain the fate of the new imagery in Russia even though Jestaz himself, in describing how "all Europe" sooner or later embraced the Renaissance, does not consider the Russian case.[43]

The succeeding "Baroque" in European art, by contrast, has become not only a secure stylistic and period designation among historians but the name of a whole era or age in European cultural history comparable in its putative scope to the Renaissance itself.[44] Emerging, again in Italy, around 1620, the Baroque quickly became an international style and one that dominated European visual culture well into the eighteenth century.[45] Baroque art was the new art in Europe, or the prevalent high-art style, at the time of the Petrine revolution in Russia. It was in Baroque forms broadly speaking that the new imagery, like the new architecture, was implanted by Peter in Russia, wherefore certain features of Baroque art deserve once more our close attention.

Again, the Baroque was associated even more closely than the Renaissance or Mannerism with monumental architecture and the Roman Catholic church—as a recent case study of Archbishop F. Borromeo of Milan, founder of a famous art academy and author of a treatise advocating the propagandistic use of art, makes very clear.[46] This was the Catholic church of the Counter-Reformation struggle against Protestant iconoclasm and of the absolutist reign in Rome (1623–1644) of Pope Urban VIII Barberini. It was in papal service that the greatest of the Baroque builders—Bernini, Borromini, and Pietro da Cortona—fused painting and sculpture with architecture in ways that created church and palace interiors of unprecedented grandeur, decorative richness, and vitality. The Baroque later flourished among other places in the Habsburg empire of central and eastern Europe (getting closer to Russia); there, writes a Habsburg historian, the Baroque visual arts, "richly and extravagantly combined, became themselves a kind of thaumaturgy. They celebrated dynasty, church, and aristocracy in a great magical apotheosis."[47] Baroque visual art most fully realized was at once magnificent and monolithic; it entailed in its creation expenditure and skill on a correspondingly colossal scale, just as it projected on completion correspondingly powerful impressions of political authority and religious orthodoxy as well as sensuous beauty. The Baroque visual arts, far more than those of the original Renaissance, were "arts of power" or machines of display designed to glorify society's rulers and magnify their claims.[48] These features of the Baroque synthesis

were not lost on Tsar Peter of Russia, provincial interloper in the Baroque world, intent as he was on strengthening his state at home and enhancing its reputation in Europe.

We must not get bogged down in the period or stylistic distinctions of European art history. In fact, at the level of theory the Baroque added little to what had been worked out in the Renaissance, and the Italian pioneers of Baroque painting seem to have been aiming at a restoration of Renaissance visual values—correct design, naturalism, harmonious composition, reverence for antiquity, and the rest—perceived as abandoned by Mannerist artists.[49] Baroque artists mostly drew on the same sources as their Renaissance predecessors to produce mainly the same types of imagery: life-size marble statues for churches, tombs, and public squares or gardens; pictures designed to illustrate subjects taken primarily from the Bible but also from Classical history and mythology. Contemporaries of course did not use the terms Renaissance or Mannerist or Baroque to describe or label artworks. To them it was all "the new" or "the modern" in art—*arte moderna*—as distinguished from "the old" or the "Gothic." Or else, for admiring foreigners, it was simply art in the "Italian manner"; or it was, on other occasions, art in the style or "manner" of this or that master or school. Russians in the time of Peter I would begin to use all of these terms while Peter himself, a most vigorous proponent as we know of the "new style" in architecture, would be especially attracted to pictures of the "Dutch school."

He was in good company. In the Netherlands in the seventeenth century visual artists achieved a representational mastery that has been connected only in part with the Italian revolution. The gradual diffusion northward of the new, more vibrant and naturalist imagery, while everywhere progressively banishing the Gothic, in Flanders met with an indigenous tradition of manuscript illumination that flowered brilliantly after 1400, the finest examples being the illustrated devotional works (books of hours) made for the duke of Berry, with their humane and graceful portraits of the Madonna and Child, their rich coloring and fine drapery, their landscapes with distant vistas and castles and trees, all drawn with great care and an obvious delight in detail. From this tradition, now infused, in some measure, with the naturalist art of Italy, there arose a major school of painting dominated by Jan van Eyck (flourished 1430s) and Rogier van der Weyden (1400?–1464). The minute realism of their pictures—the famous altarpieces and images of the Madonna (fig. 4), all with strong secular elements, as well as their purely secular portraits—is striking even today, as are the meticulous naturalism of the indoor and outdoor settings and the emotional expressiveness of the faces. "Miracles of accuracy" Van Eyck's pictures have been called, notwithstanding—in part, because of—his quite original use of multi-point perspective.[50] He would be among the first European artists to be known to Russians by name.

Van Eyck has also been credited with being the first painter to design his own frames as integral parts of his pictures, with the object of heightening

Figure 4 Rogier van der Weyden, *Saint Luke Painting the Virgin*, ca. 1435. Oil and tempera on panel.

their separate reality.[51] Pictures in medieval Europe, like icons in Russia, were executed on the flat slightly hollowed-out surface of a wood panel whose raised rim became the barely distinguishable "frame"; for larger works architectural moldings were made of separate pieces of wood to which the panels were then attached, creating, at their most elaborate, the great Gothic altarpieces of fourteenth- and fifteenth-century Europe and, in a somewhat later and parallel rather than related development, the great iconostases of Russia.

But pursuant to a growing demand in Europe for small devotional images (the privatization of devotion) and for individual portraits, engaged frames became common in the fifteenth century—frames designed with and joined to the panel before it was prepared for painting—followed by separately molded frames, which in Italy again had become the rule by the beginning of the sixteenth century. Italian examples of the regular molded frame—often richly decorated, rectangular or square or even round in shape, professionally made—set the standards for framing easel paintings everywhere in Europe from the sixteenth century onwards, a development that was facilitated by the now rapidly growing practice of painting in oil on canvas stretched over a wooden carcass.

Flemish painters of the "Northern Renaissance" also achieved major advances in landscape and still-life as well as in portraiture. Pieter Brueghel (ca. 1525–1569) is perhaps the most important figure in the development of the landscape as an autonomous subject for painting, his efforts founded on pencil drawings he made on his travels which are remarkable for their accuracy of perspective and detail, their rendering of light and atmospheric effect: reality conveyed without color. His son Jan Brueghel (died 1625) helped create the fashion for exquisite little painted landscapes that raged in the seventeenth century; in still-life painting, especially of flowers, he was considered the greatest artist of the day and inspired countless imitations. Jan Brueghel worked for a time with Peter Paul Rubens (1577–1640), whose huge output of portraits and battle scenes, landscapes and historical works, altarpieces and mythological depictions, and vast decorative paintings covering walls and ceilings, all executed with the help of numerous assistants, brought Baroque painting in the north (Rubens had spent years studying in Italy) to its height—as Tsar Peter would personally discover. Peter could not have known, or perhaps cared, that with Rubens's passing and that of Anthony van Dyck, master of the finely flattering portrait, the great age of painting in Flanders had come to an end.[52]

The new art of Flanders and especially of Holland was to have a singularly powerful effect on Peter and his Russian associates. They were definitely in good company here, as modern students agree that it was in the northern or United Netherlands, dominated by the province of Holland, that seventeenth-century European imagery reached unrivaled degrees of perfection. Landscapes and still lifes, portraits and pictures on historical, biblical, and mythological themes were all favored, as were the so-called genre pictures of everyday life. Dutch art of the seventeenth century, dominated by painting, exhibits at the same time quite special characteristics, a matter undoubtedly of its special context. It has been said that while seventeenth-century Dutch people were not less religious than other Europeans, they were more patriotic, having won their independence from Spain (as Flanders and the southern Netherlands had not) in a long and bitter struggle and built what was at the time probably the world's wealthiest economy, an economy based on trade. This

patriotic prosperity was the source of much art, and merchants—not monarchs or aristocrats or churchmen—were the main patrons. Something of a mass market also developed. One historian of the Dutch Golden Age quotes a contemporary English visitor to Holland—"pictures are very common here, there being scarce an ordinary tradesman whose house is not decorated with them"—and himself adds: "It was common [too] for burgher families to own works of art. The walls of houses were covered with pictures of children at play, winterscapes, ships and Bible scenes . . . "; nor did "the rich stint in the [pictorial] decoration of their homes."[53] Evidently people in seventeenth-century Holland took to painted or engraved images like people in a later century took to televised ones.

Dutch artists of the seventeenth century excelled in portraiture, where they virtually invented the group portrait, and in painting their own towns and countryside as well as everyday scenes of ordinary people: in fact, the genre picture was also largely a Dutch invention. Biblical stories tended to be depicted in everyday imagery; portraits were simple yet dignified—or frankly informal and lively—and often included husband *and* wife. Landscapes captured the very light and air of a scene, likewise the movement of clouds. So great was the demand for pictures in Holland that artists became specialists and subspecialists, painting nothing but portraits or landscapes, flower pieces or other still lifes, marine pictures or architectural views, these last of a documentary accuracy, realistic down to the rendering of the individual bricks of a building and each rope in a ship's rigging. Willem van de Velde II (1633–1707) was the great master of marine painting, yet another Dutch invention; the Berckheyde brothers and especially Gerrit (1638–1698), of the architectural view; Jacob van Ruisdael (1628–1682), of the landscape; and Adriaen van Ostade (1610–1684) or Gerard Terborch (1617–1681), of the genre picture. Rembrandt (1606–1669), it scarcely needs adding, was master of them all (fig. 5). At the end of the century Tsar Peter and his Russian friends would begin to collect works by all of these painters, and more. It was an astonishing artistic age, an enormous efflorescence of imagery and one that entailed, it must be conceded, an absolute triumph of "realism"—realism whether of a surface kind, "heroic," romantic, or psychological.[54]

Overall, then, painting as the primary visual art was utterly transformed in the cultural centers of Europe between about 1300 and 1700, the result of a series of changes in technique and training, in iconography, style, and theory, and in patronage or purpose. The *Rinascita* in Italy constituted what everybody came to regard as the decisive break; thereafter Europeans of education and up-to-date taste scorned what survived of the old art, "medieval" as we would call it, "Gothic," pejoratively, as did they. This was as true in architecture and sculpture as it was in painting, all three of which had been elevated at their best to the status of art or "fine art" as distinct from the remaining crafts or trades, just as their best practitioners had risen in society to the rank of scholars or poets and often congregated, at a ruler's expense, in special societies or academies. The capacity of the new images to impress themselves

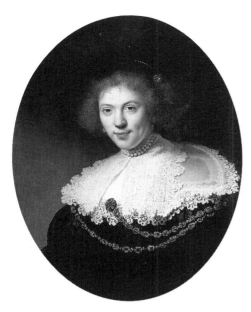

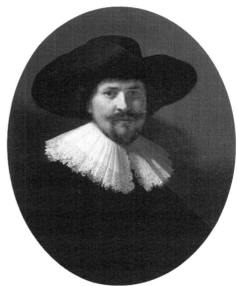

Figure 5 Rembrandt Harmensz. van Rijn, *Portrait of a Woman Wearing a Gold Chain* (left) and *Portrait of a Man Wearing a Black Hat* (right), 1634. Oil on panel.

on their spectators, to move and teach and entertain them, must have enormously increased as well—to judge from the huge sums invested in their production and the growing, eventually enormous popularity of pictures. These developments were of course closely interlinked with the deliberate use of art as propaganda especially by the Catholic church and newly assertive states, with the growing social prestige of art, with the print revolution, and with the rise of commercial capitalism.[55] But it is the ubiquity of the new imagery in Europe at the end of the seventeenth century that merits our special notice.

For by 1700 scarcely any of the new art had yet reached Russia. Shades of the new are to be detected in painting and architecture produced in and around Moscow in the later seventeenth century, to be sure, art that some scholars have dubbed "Moscow Baroque" and treated as a harbinger of the Petrine revolution. The point is certainly arguable. But at this juncture we will focus on the fact that the tentative appearance in Russian art of these forms from afar was owed largely to the revolutionary new medium of print, which was also the initial and in some cases the main agency of the Renaissance's earlier diffusion in Europe. The interaction of the print revolution with the

Europe-wide revolution in imagery, how the one was essential to the other, is a question of immediate concern to us.

The wider and speedier circulation of both ancient treatises on art and "modern" writings such as those by Alberti, much wider and faster than would have been possible in the scribal era, obviously facilitated, and greatly, the diffusion throughout the European world of the new concepts and techniques of painting, sculpture, and architecture. But it was the actual printing of images themselves, images to illustrate printed books and others printed separately, in booklets or single sheets with little or no text, that "ensured the triumph of the art of the Italian Renaissance in the rest of Europe," as Gombrich says.[56] Individual cases of the diffusion of Renaissance imagery northward have been studied, with the result that three verifiable paths have been identified: (1) via the activity of Italian artists at various northern courts (e.g., Leonardo da Vinci in France, 1517–1519); (2) via the travels of northern artists down to the major art centers in Italy, particularly Venice and Rome (Dürer in Venice in 1494–1495 and again in 1505–1507); and (3), most important, via the influence on northern artists of Italian models and prototypes, either works of art imported from Italy or, most frequently, printed pictures, the latter as purposely designed and even executed by leading contemporary Italian painters (Andrea Mantegna, active 1441/1445–1506, is an outstanding example) or as reproductions of famous works by other artists. Thus in his well-known advice to "novices of the art of painting" published in Flemish in 1604, Carel van Mander remarks that "we know of the great Titian" not only "through the very useful writings of Vasari" but from his "woodcuts [which] can teach us much in this field." Van Mander also recommended "the beautiful colors and excellent design of the paintings and prints of the clever Brueghel," boasting that in Flanders, now, Italian principles were "coming true on canvas, in stone, and on copper plates."[57]

More broadly still, the shift from script to print, with its capacity for nearly endless production of exactly duplicated pictorial statements, occasioned a communications revolution in Europe and beyond that underpinned every major intellectual or cultural movement of early modern times, from the Renaissance and the Reformations to the Scientific Revolution. Or so it has been forcefully argued.[58] It has even been argued that the modern nation-state is inconceivable without the print revolution.* Changes of such magnitude can

*B. Anderson, *Imagined Communities: Reflections on the Origin and Spread of Nationalism* (London, 1983). Anderson's argument goes something like this: the phenomenon of national consciousness in sixteenth- and seventeenth-century Europe resulted from the interaction of capitalism and the revolution of printing, which produced stabilized, unifying "print-languages" and "languages of power"; these then contributed crucially to the development in the nineteenth and twentieth centuries of "modern self-conceived nations and nation-states." It might be noted that Russia enters this analysis only in the nineteenth century, and then as the most egregious example of the invention and propagation of "official nationalism," defined as "the willed merger of nation and dynastic empire" and a phenomenon, Anderson stresses, which "developed after, and in reaction to, the popular national movements proliferating in Europe since the 1820s" (p. 83).

scarcely be grasped let alone briefly recounted. While mindful of this broader context, our attention must remain focused on the new ways of producing or reproducing images in Europe and on their distribution, always with an eye to later developments in Russia.

The printing of books by means of movable cast-metal types was achieved in certain German towns in the middle of the fifteenth century, as is well known. By the end of the century print shops with their presses and special-ized craftsmen were established all over Europe, mainly in towns in Italy north of Rome, in Switzerland, in other German towns along the Rhine and the Danube, and in the Netherlands but also in such places as Prague, Cracow, and Lübeck in the east and Lyon, Barcelona, Paris, London, and Oxford in the west. These were university towns, important ecclesiastical sees, and/or ma-jor commercial centers, all containing political, social, and economic elements which stimulated the necessary demand. The majority of the first titles printed—the so-called incunabula of these first fifty years (ca. 1450–1500)— were religious in content: editions of the Bible, devotional works, and lives of saints. But textbooks of grammar and rhetoric were also printed as were works by Classical authors, almanacs, chronicles, and popular fables. Hein-rich Quentell's print shop in Cologne, started about 1475, had produced more than 200 titles by 1500, a figure that was not unusual; Anton Koberger of Nuremberg published 237 titles between 1471 and 1500, while some twenty shops in Augsburg were printing hundreds of titles annually by the end of the sixteenth century. The 236 towns in Europe where print shops had been established by 1500 together are presumed to have printed from 10,000 to 15,000 texts in 30,000 to 35,000 editions, amounting to something like 15 mil-lion to 20 million books.[59] Such figures give weight to the concept of a "print revolution." We note in passing that printing did not reach Muscovy until the 1560s; that between then and 1600 some sixteen titles were printed; and that by 1700 fewer than 500 titles, at least 95 percent of them devotional in content, had been produced, nearly all in one official shop in Moscow.[60]

Two crucial factors fostering this print revolution in Europe were the avail-ability of cheap paper and the existence of an established alphabet the autono-mous letters of which were formed from a small number of pieces (the lack of such a simple, established alphabet constituted an impediment to the de-velopment of printing in China, where movable type had long been known; Chinese also invented paper). The Renaissance emphasis on proportion and symmetry and related calligraphic reforms helped to insure that by 1500 or so Italian roman and cursive ("italic") letters had become standard in printing in Europe; the rival "Gothic" lettering of Gutenberg and other printers sur-vived to some degree only in Germany. It was in Italy, too, that paper made from linen rags was produced cheaply and in growing quantity from the mid-fourteenth century—a development which itself presupposed the spreading use of linen in European households, the proximity of abundant clear water, and certain breakthroughs in milling.[61] A third factor which should be men-tioned was the thriving scribal culture in these university, ecclesiastical, and

commercial towns of Europe *before* 1450: the expanding production, going back a century and more, to meet the ever growing demand for *handwritten* editions of religious, Classical, and other works. In fact, the first printed books were closely modeled on contemporary manuscript books: "Hence we find spaces left in *incunabula* for the [handpainted] miniatures which were to adorn and enrich them; and their margins, too, are rendered gay by the art of the illuminator."[62] Similar phenomena are to be found, though incomparably fewer and dating to much later times, in Russia.

Indeed, these observations on the print revolution in Europe all point to economic and cultural factors the comparative absence of which inhibited the rapid and effective development of printing in Russia. Paper was not produced there in any quantity until Peter I—under whom, again, a Russian alphabet suitable for the rapid expansion of printing was finally established. Eisenstein brings up yet another factor, political and social in nature, of possible relevance here. Stressing that in its origins in Europe the print revolution (like the Renaissance) was an urban phenomenon, she writes: "The printing industries represented a 'forward-looking,' large-scale enterprise which flourished better in small, loosely federated realms than in well-consolidated larger ones," where censorship, especially, was a problem.[63] By 1700 the Muscovite tsardom was not only the largest contiguous territorial state in the world but arguably also the most autocratic in its government and one of the least urbanized. It has been estimated that with respect to population aggregates and the level of its administrative and commercial development Russia's "urban network" in the later seventeenth century resembled that of England in the late fifteenth century or that of France in the early sixteenth.[64]

As early as 1305 a German craftsman was printing holy images on paper in Bologna. Like most early single-sheet prints, these were simple woodcuts of Gothic design, images of popular saints to be stuck up on walls or pasted in book covers, on cabinet doors, inside traveling chests, in trunks or wardrobes. This practice, too, repeated a manuscript tradition except that now, thanks to "xylography," hugely greater numbers of more exactly duplicated copies could be made, sold, and distributed for the edification of pilgrims, the protection of beasts and crops, the salvation of Christians. At some point in the fifteenth century block books appeared, books in which each page with its pictures and letters was cut on a single block of wood for inking and then pressing on paper. About thirty-four different titles of block books have survived, the best of them published in Haarlem and Utrecht and the best known, perhaps, a *Bible of the Poor,* which was a rendition of the New Testament in pictures with captions that drew directly on handwritten prototypes. Again the initial, direct continuity from script to print, in both content and style, is underlined.

Block books were soon submerged in the flood of books printed by the more flexible, finer, and ultimately cheaper means of movable cast-metal types and their distinctive, mechanical presses. But well into the sixteenth

century and beyond woodcuts continued to be used for illustrating and orna-menting many printed books. The famous *Nuremberg Chronicle* first published in 1493 contained more than 1,800 illustrations of cities, monarchs, saints, popes, and civic events printed from 645 woodcuts produced by a team that may have included the young Dürer.[65] Famous artists like Dürer or Titian designed and themselves even cut woodblock prints which were greatly prized in their own day, passed among artists, and collected by grandees. More ordinary artists and craftsmen produced woodcut copies of celebrated paintings, some of which were pasted on boards and hung on walls instead of paintings in modest houses, churches, or chapels. Numerous editions of Aesop's *Fables* were illustrated with woodcuts, and countless numbers of play-ing cards were printed from cut woodblocks. Even when, in the sixteenth century, metal engravings became the preferred form of illustration, rough woodcut chapbooks and broadsides of satirical, religious, or fabulous content, often garishly colored by hand, proliferated in Europe, carried by peddlers to the furthest corners of the land. This fashion, too, reached Russia but only, again, in the time of Peter, where it would play a critical part in disseminating the imagery of the Petrine revolution to a mass public.

The techniques of engraving and then of etching images on metal, usually and then universally on copper plates, attracted Renaissance artists by their greater potential for rendering subtler, finer, more complex designs.[66] It may be enough to note here that Martin Schongauer (ca. 1435–1491) and then Dürer in Germany, along with Andrea Mantegna in Italy, were the first great masters of this new branch of Renaissance imagery, and that copperplate en-graving rapidly became the standard means of ornamenting and illustrating books. In the sixteenth and seventeenth centuries engravings and etchings were the main agents diffusing the new art (arguably also the new science) throughout the European world, whether as original works or as copies of paintings or drawings, whether in books or suites of prints or as single sheets. The seventeenth century has been called a period of graphomania in Europe, so avidly were printed pictures of all kinds sought by people at all levels of society, and not just in Holland as mentioned earlier. In fact, in seventeenth-century Europe, the period of the Baroque in art, imagery tended to prevail over text in printed books regardless of subject, leading to the inclusion of decorative and fantastic elements even in drawings or diagrams of a purely explanatory nature.[67] The "Renaissance harmony" of pictures and letters would be restored to books only in the eighteenth century, to be lost again in the industrialization of printing that took place in the nineteenth.

It was German, French, Italian, and Dutch painters and engravers or etchers imported by Peter I who actually implanted the new imagery in Russia. But engravings and etchings as well as woodcuts arriving from Europe in the preceding decades helped crucially to prepare the way. For instance, an en-graving depicting a moment in the life of St. Philip the apostle included in an illustrated bible first printed at Amsterdam in 1650, which engraving repro-

duced a drawing by Maerten van Heemskerck (1498–1574), inspired four different murals painted in Russia in the last years of the seventeenth century as well as two separately painted panel icons.[68] Here now were Russian artists and patrons reaching for that greater naturalism and finer design in imagery that had been attracting their counterparts all over Europe since the dawn of the Renaissance. It is time to focus directly on Russia.

RUSSIA BEFORE PETER

Both the Renaissance and the print revolution in Europe, as noted above, took place in cities. Indeed, it is safe to say that neither of these protean movements in European civilization could have occurred in other than an urban environment, with its concentrations of wealth and patronage, of supporting crafts and trades, of schools and learned societies, of consumers and distribution facilities: with its numerous public and capacious market. So we begin this brief survey of Russia on the eve of the Petrine revolution by looking at the urban scene, the better to understand the revolution's nature and course.

As already mentioned, with respect to population aggregates and to the level of its administrative and commercial development Russia's urban network in the later seventeenth century resembled those of England or France about two centuries earlier. These comparisons suggest a lag in Russia's urban growth, to be sure, yet incompletely so. For scarcely fifteen of Russia's approximately 250 fortified settlements (*goroda,* singular *gorod,* the basic Russian word for city or town) in the later seventeenth century had more than 1,000 inhabitants and only three, apart from Moscow, had more—but not much more—than 10,000. Russia's total urban population accounted at the time for at most 3 percent of its overall population of about 10.5 million, and fully a third of that total lived in Moscow; only the old Tatar city of Astrakhan, near the mouth of the Volga, contained as much as 10 percent of Moscow's population of between 150,000 and 200,000.[69] These figures may be contrasted with those for Italy in the mid-*sixteenth* century, with its overall population of about 11 million (about the same as in Russia, incomparably larger in territory, more than a century later) and its roughly 40 towns with 10,000 inhabitants or more, accounting altogether for 13 percent of the Italian population. As one historian of the Renaissance in Italy says, "Most of the leading artists and writers of the period came from one of these 40-odd towns. No cities, no Renaissance."[70]

The proportion of the overall population living in towns at the end of the seventeenth century was even greater in the Netherlands than in Italy, and nearly as great in large parts of Germany and France; in England and Wales in the 1680s, some 800 cities and market towns contained over 20 percent of the total population.[71] But it was not just in the number of towns of any size that late seventeenth-century Russia lagged in urban development, it should be emphasized. By the time Peter I assumed full power his realm lacked both the autonomous princely or episcopal urban courts of much earlier times in

Russia and a bourgeoisie such as had long since emerged in Europe: an economically and numerically substantial, largely self-governing, legally defined and politically protected urban class fully engaged in commerce and industry. On the contrary, as much as 50 percent of the urban population of later seventeenth-century Russia, Moscow included, were military or government personnel, while clergy and their dependents constituted another sizable group as did members of the nobility and theirs, leaving townsmen pure and simple (*posadskie liudi*) a distinct minority in their own towns (a total of perhaps 134,000 such people in all of Russia in 1678).[72] All classes in Russia, from nobility to peasantry, regularly engaged in trade and local or cottage industry, while the "commanding heights" of the economy—industry of any national importance, foreign trade, the internal trade in basic or especially valuable commodities—had become royal monopolies, farmed out by the tsar to selected members of the nobility, the few dozen top merchants, and foreigners. Owing to a shortage as yet of precious metals and hence of specie, money played a relatively small part in this Russian economy while barter and fairs— hundreds of periodic local or regional fairs—played a relatively large one. Banking and commercial credit were unknown. In fact, capitalism itself, that product of the Middle Ages in Europe, was still virtually unknown in Russia. And in spite of Peter I's considerable success in stimulating both commerce and industry, and of his attempts to enfranchise townsmen, their legal and social status remained closely circumscribed and state-dependent. After Peter, as before him, most of Russia's urban settlements were "little more than overgrown villages: the continuum between town and countryside was not only social and legal, but economic as well."[73]

By 1700, in short, Russia's urban network was not sufficiently developed either economically or socially to support, let alone to generate, a major "renaissance" in art. But it might seem that Moscow, with a population exceeded in size by few cities in the world and the seat of a great royal court, was an exception to this rule. Here other factors come into play, factors which can be subsumed in the word "education." It is a fact that the new art of the Renaissance, with its deep Classical underpinnings, only took hold in Europe where the new, Classically oriented learning also caught on—for the most part, that is, in cities which were princely capitals and/or centers of commerce and which boasted sufficient rates of literacy together with appropriate schools. Though a political and commercial center of international importance by the later seventeenth century, Moscow had little or no indigenous tradition of learning, its few scholars had little or no access to Classical literature, and few of its inhabitants could actually read. Even at this late juncture Russian society was "profoundly illiterate" by recent estimates, meaning that no more than 2 percent of the total Russian population could read and fewer still could write.[74] We compare these estimates with others again for western Europe showing that "substantial minorities" even of ordinary people could read by the late seventeenth century—29 percent of all French people in 1690, 30 per-

cent of all English people in 1642, 57 percent of Amsterdamers (male only) in 1630, or 61 percent of Venetians in 1450 (rising to an astounding 98 percent by 1650).[75]

Substantial and rising rates of literacy in early modern Europe were the result of spreading educational facilities, the result in turn of the efforts of religious reformers whose movements had reached Ukraine, Belorussia, and the Baltic borderlands of Russia by the later seventeenth century but not Russia itself. There were no royal or ecclesiastical schools of any size or distinction in Moscow or elsewhere in the Muscovite tsardom even for the elite before that time; neither Latin nor even Greek, in spite of Russia's Byzantine heritage, was studied. A few monastic, episcopal, and government schools in Moscow and a few other Russian towns (Novgorod, Rostov Velikii) provided elementary training in Slavonic grammar and numbers for future clerics, officials, and merchants. But two written languages existed side by side: (Church) Slavonic, at once archaic, alien, and cumbersome, which was regarded as the only literary language, and the "official tongue" (*delovoi* or *prikaznyi iazyk*) of government and business, which was much closer to the vernacular; and neither language—the one moribund, the other undeveloped, a "subliterary medium"—could have accommodated the literary forms of the new learning and served as a unifying "language of power." Following the Russo-Polish wars of the later seventeenth century and Russian annexation of Belorussian and Ukrainian territories, it is true, dozens of monks transferred from there to Moscow and elsewhere in Russia by the Russian authorities brought with them knowledge of the liberal arts, Polish, Latin, occasionally Greek, and some Roman Catholic theology, which they imparted to local students in a few schools established for that purpose, notably the academy founded in Moscow under patriarchal jurisdiction in the 1680s. This so-called Slavonic-Greek-Latin academy had 180 students by 1689 and was soon complemented in its modish curriculum by two other schools functioning in Moscow in the earlier years of Peter's reign—one operated by Czech Jesuits, between 1698 and 1719, with a few dozen well-born pupils, and the other run by a Lutheran pastor, between 1705 and 1715, which at its peak taught some seventy-seven students many of whom were subsidized by the tsar. To these may be added the episcopal school in Novgorod run by two Italicized Greeks—the Lichud brothers—after 1706. Viewed in the context of the Europe-wide spread of education since the Renaissance and Reformation, however, this was a modest beginning at best.[76]

Nor was the situation any different with respect to visual art, as will be demonstrated in later chapters. Until well into the reign of Peter I painting in Russia, like architecture, remained a craft acquired solely through practical experience in accordance with local traditions while sculpture, like graphic art, was scarcely practiced at all. Some sparks of the new art did flicker brightly in later seventeenth-century Russian painting, as mentioned, principally in works produced in Moscow and mainly, again, by outsiders. But nei-

ther in technique nor in theory had Russian painting moved beyond levels reached in late medieval Italy, with whose imagery it bears such striking resemblances.

Well into the later seventeenth century, in sum, various artistic, educational, linguistic, social, political, and economic factors impeded transmission to Russia of the new European art and learning. The Russian church, in particular, stagnating in relics of Byzantine scribal culture (in Slavonic translation) and traditionally hostile to innovations emanating from the Roman Catholic or Protestant West, was in no position to take the part played by Catholic institutions in Renaissance Italy or by Protestant foundations in the North. Questions of education and attitude aside, the Russian church hierarchy, consisting of the patriarch, about two dozen bishops, and the heads of perhaps thirty leading monasteries, lacked both the economic means and the political clout associated with great patronage.[77] Nor were there great secular lords to fill that role, as earlier noted, nor any burgeoning bourgeoisie. In fact, there was only one institution in later seventeenth-century Russia that could have taken such a lead and that was the tsardom—*tsarstvo,* the royal establishment—itself.

The political system inherited by Peter I has been aptly described as one having

> much in common with Max Weber's *Leiturgiestaat,* that universal regime of services and exactions under which the activities of most individuals are subjected to physical restrictions, economic constraints and bureaucratic controls for the benefit of the state. The members of various sections of society are kept in their hereditary stations in perpetuity: the peasants are bound to the land, the craftsmen to their trades, the office-holders to their posts. The most profitable sectors of the economy are monopolized by the state, the taxes are excessive and for their collection in full men of property are held personally responsible. The system as a whole is administered by a body of officials whose practices curtail personal freedom and economic enterprise.[78]

The system is similarly described by contemporary European observers, for example by Baron Mayerberg in 1660–1661 as quoted early in this chapter, or by J. G. Korb, the learned secretary of the Imperial (Austrian) mission to Moscow of 1698:

> The Czar will never want as long as he knows of his subjects having any gold and silver. For their riches and private valuables are his only mines. This absolute master uses his subjects at his will, and their wealth in what share he pleases. He arrogates to himself what part he likes of the spoils of the hunter; he sells their furs or makes presents of them at will. Air-dried fish are his munitions. At market nobody can sell unless the Sovereign's merchandise has been first sold. He rather dictates than bargains the prices of what belongs to him; and measures out for himself and takes whatever there is either good or precious in his dominions.[79]

Both contemporary European observers and later historians thus marveled at the absolute, centralized character of the Russian "autocracy" and its related control of the economy—an autocracy whose harshness, it seems, was tempered only by inefficiency and venality. In practice the system was in some degree perhaps also moderated by the religious or moral influence of the one Orthodox church to which both the ruler and all his faithful subjects were thought to belong, an influence which persistently enjoined the tsar to show mercy to his "children" and the "haves" among his subjects to show kindness to the "have-nots." Whatever their practical import, these themes are reflected, or refracted, in the traditional imagery of the church.

One clear indication of the tsardom's growing control of society is the virtual monopoly it had established by the later seventeenth century over the production of works of art, a subject to be discussed in detail in Chapter 3. The control was both direct and indirect, encompassing as it did art produced in workshops or on building sites owned and operated by organs of the tsar's state and art produced elsewhere, under state regulations and with state subsidies if not on commission from a state agency. It might be said that such a monopoly of art devolved naturally upon an institution that had come to regard itself as the ultimate lord and residual owner of the country and all its resources, both human and material. In any event, when Peter I personally assumed full power (in 1689) the tsardom was unquestionably the chief patron of art in Russia, a fact that is also reflected in the art—the imagery—itself.

The Russian autocratic state of the 1690s, in the overall view of historians, was at once monarchical, dynastic, patrimonial, and theocratic. Its church-sanctioned power was vested in the tsar-father, his family, and noble court and was exercised through a welter of some eighty offices (*prikazy*) located in Moscow whose officials, there and in their provincial departments, attempted to govern—exploit—in rudimentary fashion a vast domain of constituent tsardoms and principalities. Apart from the towns or fortified centers already mentioned, these latter were in turn composed mainly of landed estates controlled by the court, ecclesiastical, and noble elite and inhabited by peasants—the great broad bottom of the social pyramid—living under *krepestnoe pravo*, or the law of bonded servitude (serfdom). How this peculiar polity had come into being, over centuries of development, is naturally a complicated story. Here it is enough to recognize that when Peter assumed full power the institutional means were already in place for him to initiate and impose, should he so choose, a revolution in his realm's visual culture.

A word might be added about the class that provided the social matrix of the Petrine revolution, referred to here and in the pages that follow as "the elite." This elite may be thought of as the aggregated landholders, officials, clergy, and merchants of Russia and their respective families: several hundred thousand people or more, perhaps 3 or 4 percent of the total population. The rate of literacy among the men of these groups was apparently no higher than

the overall *average* in contemporary western Europe, perhaps about one-third; and their wealth and influence were concentrated in the few main towns, especially Moscow, their nearby estates, and the bigger monasteries. But in view of the absolutist as well as highly centralized nature of the Muscovite tsardom, the "decisive elite" within this elite was, of course, much smaller. The decisively influential elite of Russian society in the later seventeenth century included the tsar and his family, the senior officials and largest land-holders (often one and the same), some of the senior clergy, and a few top merchants and industrial entrepreneurs: at most several thousand men and their wives, nearly all resident in Moscow when the men were not serving as governors (or bishops or abbots) in the provinces, leading the army on cam-paign, conducting embassies abroad, trading in Archangel or Astrakhan, or running ironworks in the Tula region or saltworks in the Urals. It was mem-bers of this active or core elite, intermixed with the growing number of Euro-peans in Russian service, who more or less enthusiastically carried out the Petrine program of political, economic, and cultural Europeanization.

For Europe was encroaching. In any given year in the later seventeenth century there were perhaps 3,500 Dutch, German, Polish, British, and other Europeans resident in Russia, the bulk of them military officers in the tsar's service living in the special "German Settlement" (*Nemetskaia sloboda*) outside Moscow, the rest merchants, translators, technical specialists of various kinds, entrepreneurs and industrial workers living and working both there and else-where in the tsar's dominions. These Europeans were agents of the far more selective and limited policy of Europeanization enacted under Peter I's imme-diate predecessors, and of Russia's growing trade with Europe. That trade came mainly over the seas to Archangel, thence down the northern rivers to the towns of Ustiug, Vologda, Iaroslavl, and, finally, Moscow. European merchants concentrated in Moscow and the northern towns were principally responsible for the growing volume of graphic material entering Russia in these years, stimulating local attempts to emulate its contents and forms. In this way the northern towns as well as Moscow played a significant part in the coming of the Petrine revolution (fig. 6), a point to be pursued in the following chapter.

It was virtually inevitable that Russia under Peter should have become en-meshed in Europe's politics, too, whether by the pull of competing European interests or by the push of Russia's own, more immediate concerns (retention of Ukrainian and Belorussian territories taken from Poland between 1654 and 1667, irredentist claims against Sweden on certain Baltic lands, a desire for allies against the Turks and Tatars). Peter was encouraged by various Euro-pean princes—though he needed little encouragement—to launch a cam-paign against Sweden, Muscovy's traditional enemy and now a formidable military power; a campaign which precipitated (1700) a long and, for Russia, nearly disastrous war for preeminence in northeastern Europe. In the course of this "Great Northern War" (1700–1721) the ruler of Prussia opened the way

Figure 6 *"Germans" at the Last Judgment.* Detail of mural painted 1686–1688, cathedral of the Holy Wisdom (Sofiiskii sobor), Vologda. Cf. fig. 5.

for Peter's troops to march into Mecklenberg and Holstein, two minor German states with which Russia became dynastically linked for decades to come. Following Russia's final victory over Sweden (1721), an alliance with the new power was sought by several of the established European states in a bid to outflank their rivals. By 1728, with the convening of the Congress of Soissons, the first European peace conference with full Russian participation, the Russian Empire (*Imperiia*), as it was now styled, had become an integral part of the European state system.[80]

In the meantime, Russian raw materials were increasingly sought by Danish, Dutch, German, French, and especially British merchants, a commerce that Peter encouraged for his own political and military purposes and soon directed, against the wishes of nearly all concerned, away from the secure but extreme northern haven of Archangel to his vulnerable new Baltic port of St.

Petersburg. By the end of his reign Russian trade with Europe had expanded greatly, as mentioned, while remaining largely in the hands of European merchants and shippers. Similarly, it was with the help of European experts and in pursuit of his military aims against Turkey and Sweden that Peter modernized his army, created a navy, and built up the necessary supporting industries in metallurgy and armaments, textiles and shipbuilding. He also struggled to reform the Russian administrative and tax systems in accordance principally with Swedish models, and again with the help of foreign experts.[81]

Indicative of Russia's growing economic and political importance in Europe was a new attitude towards Russia among European intellectuals. Here, for one, is Leibniz, the famous philosopher, writing to Peter in 1712:

> It seems to be God's will that the sciences encircle the earth and now arrive in Scythia [Russia], and that Your Majesty is now chosen as the instrument because you are able to select the best from Europe on one side and from China on the other, and to improve on that which both have accomplished by means of wise measures. Since almost everything concerning the sciences in your Empire is new and blank, as it were, innumerable mistakes that have gradually and in an unnoticed way gained curency in Europe may be avoided. . . . I would deem it the greatest honor, privilege, and pleasure to serve Your Majesty in an undertaking so praiseworthy and agreeable to God, for I am not one of those who cling to the fatherland alone, but look to the advantage of the whole human race . . . ; I would rather accomplish much good among the Russians than a little among the Germans or other Europeans.[82]

Leibniz's view of Peter, and of Petrine Russia in relation to Europe, exemplifies the hopes aroused among their European contemporaries by news of Peter's military victories and domestic reforms. Russia was a great *tabula rasa* on which Peter would carve a new civilization with the help of European specialists, thus transforming both his own country and Europe itself, whose boundaries would now extend to China.

That Peter had the power to work such a transformation in Russia was never doubted by contemporaries: certainly not by Europeans who omitted to go there themselves and perceived him, from afar, as more nearly absolute in his authority than any European ruler. Among those who did make the journey, however, and have left us their impressions, the actual limitations on the tsar's power were sometimes perceived. Particularly to be noticed was the widespread opposition, both active and passive, aroused by Peter's reforms among his own countrymen: an opposition that was almost invariably seen by European visitors as the product of ignorance, sloth, or plain barbarism.[83] Less clearly observed was Peter's personal ambivalence in the face of wholesale Europeanization, an attitude that seems to have been rooted not alone in patriotic sentiment but in his perception of European notions of the "well-regulated police state." Their moral or spiritual justifications aside, these notions called for the supervision and control of public life in the name of politi-

cal and economic self-sufficiency. The well-being of the state had become the highest ideal for all of society; and European states sought to maximize their advantages in geography, population, or natural resources and to avoid enhancing those of their rivals in a perpetual contest for ever greater power, wealth, and glory waged both within Europe itself and beyond: a contest that was only mitigated by the participants' more or less voluntary acceptance of an international "balance of power." Such was the Europe that Russia, under Peter, sought aggressively to join.[84]

In sum, wielding the huge power that was his by inheritance, pure chance, and his own strenuous efforts Peter pursued over a period of nearly thirty years a program of intensive Europeanization, one that sooner or later affected virtually all spheres of Russian life. The conception and implementation of this program, as well as its immediate and longer-term consequences, in all of their variety and interconnections, have yet to be either comprehensively or systematically studied by historians. Yet its most tangible achievement indisputably was the creation of Russia's new capital, St. Petersburg, which was described by an Italian visitor of 1739 as "this great window recently opened in the north through which Russia looks on Europe."[85]

In the preceding volume it was shown how St. Petersburg became the principal site and then the embodiment of the Petrine revolution in Russian architecture, a revolution that eventually reached into every part of the Russian Empire, producing transformations in the built environment that would give it a more or less European—or "modern"—appearance. The present volume will show how, similarly, the Petrine revolution in the other visual arts came to be concentrated in St. Petersburg and with similar, or complementary, results. By the end of Peter's reign, as we shall see, the leading institutions, official trappings, and political elite of Imperial Russia also bore a modern, European appearance, all as reflected in the surviving imagery produced by and for the Petrine regime. Indeed in this respect, too, St. Petersburg from its founding proved to be less a "window on Europe" than a great funnel, one through which European ideas, models, and techniques poured into Russia with consequences scarcely to be dreamt of only a generation before.

PROBLEMS

Last among these preliminaries are certain historiographical and methodological problems that should be aired along with certain assumptions. It is no longer enough for historians to gather their evidence, announce their intentions, and get on with telling their story. History has been problematized.

To restate what should by now be clear, the primary object of this study is to track in sufficient detail, and in appropriate narrative and analytic modes, the Petrine revolution in visual art (excluding architecture) in Russia, thereby to demonstrate both its revolutionary nature and its historical importance. The most problematic terms here perhaps are "revolution" and its adjective,

"revolutionary." They refer, as in historical discourse they should refer, to major changes in culture that were consciously intended, at least by an active minority (at times a minority of one, Peter I); that happened relatively suddenly, making the postrevolutionary stage readily distinguishable from the prerevolutionary one; that were recognized as such by contemporaries; and that produced transformations which were lasting.[86] This much is indisputable, once the evidence has been properly laid out, as I hope to do in this volume, and sufficiently attended to by readers. But the question of the historical importance of these revolutionary changes, or lasting transformations, in Russian imagery, can only be settled by reference to the importance of the visual in history generally, not just in its Russian or Petrine settings. And this is not a matter with which modern historians, especially modern Russian historians, have much concerned themselves.[87] Hence the problematics of our project are enormously magnified—and are certainly not finally soluble here.

Art historians traditionally have been concerned with formal, stylistic, aesthetic, and/or biographical aspects of high or elite art. Some however have defined their subjects more broadly—as visual aspects of culture—and have studied them within still larger frameworks, concerned to show, for example, "how regimes of power correspond to regimes of symbolic practice or, more precisely, how different artistic styles and modes of picturing encode distinct political messages and ideologies. . . . In short, it has come to seem newly possible and pressing to see art as a form of power while at the same time charting the traces of power represented in the forms of art."[88] The *social* history of art, or socioeconomic, putting artists in their full social or socioeconomic contexts and interpreting art in social-historical terms, is of course well established.[89] There are in addition various psychological or psychoanalytic, feminist, perceptual, semiotic, and deconstructionist studies of art available to assist the historian—the most interesting of which, for our purposes, have been or will be cited. Yet in all such enterprise artworks remain the object of concern, not the society or polity or economy or culture embedding them; nor is the visual culture as a whole of a given society in a given period, including its popular or mass (or "second-rate") layers, customarily considered in these studies.[90] Such limitations, if they are that, while proper perhaps to art history, cannot be assumed by historians—for whom indeed the dialectic must work the other way around: imagery of all kinds, artistic or not, is interesting insofar as it illuminates, however problematically, its enveloping society, polity, economy, or culture, which is simultaneously or otherwise apprehended through written or other material remains. Evidentiary problems aside for the moment, we must agree that for all their "common preoccupations" and occasional "convergence" of interests, "historians and art historians will forever maintain distinct sets of priorities when they examine works of art."[91]

Source problems are indeed formidable here, owing first of all to the state of the visual remains of Petrine Russia and of the scholarship pertaining to

them. The widespread destruction by the Soviet authorities of the public monuments of preceding regimes is common knowledge, as is their confiscation and dispersal of private and especially ecclesiastical collections of artifacts. Obliterating visual reminders of the Russian past, especially of church and state, was a deliberate official policy pursued with varying degrees of intensity throughout the decades of Soviet rule, the recurrent iconoclasm itself constituting impressive testimony to the power of such images. But equally hampering for our project is the fact that almost all of the relevant scholarship, almost all of it in Russian, is art history of the most traditionally limited kind, quite valuable as far as it goes but highly specialized in approach when not simply catalogic. A rather coarsely materialist viewpoint also afflicts most relevant Soviet scholarship, as does a pronounced Russian nationalist bias. We will return to these points as needed in the chapters that follow; they are discussed at some length in the Introduction to our preceding volume, where the lack of a coherent and widely accepted periodization of Russian architectural history is also highlighted. The same can now be said, although it matters less, for the other (lesser) visual arts. Meanwhile general historians of Russia, it perhaps bears repeating, whether writing in Russian or other languages, whether Soviet or Western, have almost entirely ignored the visual remains of their periods except, on occasion, as mere illustration.

In the preceding pages of this chapter, as in the rest of the volume, the terms "art" or "visual art" and "image" or "imagery" are used rather interchangeably, and some clarification may be in order. Not all imagery is art, to be sure, as art historians traditionally have used the term, but all visual art is indeed imagery; and it is in this capacious sense that I use the word.[92] An image is any visual representation of persons or things, pictorial or figurative (or symbolic), as painted, drawn, engraved, etched, sewn, photographed, or otherwise rendered on a flat surface or as sculpted in stone, bronze, wood, ivory, or other material. We thus exclude from our purview so-called mental, verbal, or perceptual images. We also thus evade most of the purely formal, stylistic, aesthetic, and even iconographic questions of art history, because it is not as art that images interest us. We are mainly concerned, again, with the transmission to Russia of the new imagery of early modern Europe and with its reception there: that this imagery came mainly in the forms of high—or higher—or elite art, and was received and absorbed mainly at first at that level, are simply basic facts of the story, not matters of our selection. Aesthetic, formal, stylistic, and iconographic issues will be raised insofar as they help explain the attractions to Russians of the new imagery and the uses to which this imagery was then put in Russia. But it is on the processes of transmission and reception that we will focus, as on the initial production and consumption of new-style imagery in Russia, until such time as these activities can be said to have been institutionalized or industrialized there and the new imagery had become an integral part of Russian visual culture. Baxandall, the art historian, comments helpfully:

> We [art historians] are typically concerned to explain certain material and visible deposits left behind by earlier peoples' activity—for this is one of the things pictures are. It will be said, the historian too works with deposits from activity, physical records and documents, inscriptions and chronicles and much else, from which he must reconstruct both the actions or events he studies and their causes. This is clearly so. But his attention and explanatory duty are primarily to the actions they document, not to the documents themselves: otherwise one would say he was attending to an ancillary discipline, such as epigraphy. We by contrast, expect to attend primarily to the deposits, the pictures. We will certainly make inferences from these to the actions of man and instrument that made them as they are—these are involved in our language, in concepts like "design"—but this will usually be as a means of thinking about their present visual character.

We trust that Baxandall admits "pictures"—which may be thought of as concrete, representational objects in which images appear—to the deposits historians may work with: a little later he says that "real historians study all sorts of purposeful artefacts." In any case, just as he for his purposes wants to "disengage from unhelpful aspects of the method of history," so we for ours will evade unhelpful aspects of the tradition of art history.[93]

In an earlier section of this chapter we observed that what is called "naturalism" or sometimes "realism" has been universally regarded as an essential, even the salient, quality of the new imagery that arose with the Renaissance in Italy. This quality must lie at the heart surely of any general explanation of that imagery's arresting attractiveness and consequent spread (as would later manifestly be the case for photography). But we are coming to learn (if we did not always know) how slippery these terms can be. Norman Bryson has offered an extended critique of art history as the history of emergent realism, of "the 'traditional' account of the development of European painting as a series of technical leaps towards an increasingly accurate reproduction of 'the real.'" We need not swallow whole Bryson's own, semiotic solution to the problem to appreciate its effect, namely its implicit, sometimes explicit assertion of the historicity—the time-and-place bound character—of "realism" in art and its corresponding rejection of the notion that "realist" art is thus self-explanatory. On the other hand, in so "relativising" such art—or imagery—Bryson seems to preclude its transmission from its original cultural matrix to another, quite different one: the situation, such as we have in our study, where bearers of the recipient culture act as willing if not enthusiastic agents of the transfer. What then were they attracted to, if not to the transcultural "realism" of this "realist" imagery? Bryson:

> It is clear that the term "realism" cannot draw its validity from any absolute conception of "the real," because that conception cannot account for the historical and changing character of "the real" within differing cultures and periods. Its validity needs relativising, and it is more accurate

to say that "realism" lies rather in the effect of recognition of a representation as corresponding to what a particular society proposes and assumes as "Reality." The real needs to be understood not as a transcendent and changeless given, but as a production brought about by human activity within specific cultural constraints; a production which involves a complex formation of representations and codes of behaviour, psychology, social manners, dress, physiognomics, gesture and posture—all those practical norms which govern the stance of men towards their particular historical environment. It is in relation to this socially determined body of codes, and not in relation to an immutable "universal visual experience," that the realism of an image should be understood.[94]

This is all very well. But we still have to deal with the facts of the deliberate transmission under Peter I of the newly "realistic" European imagery to Russia and its revolutionary effects there. *Something* transcendent of early modern Italian or Dutch or German or French and Russian elite cultures—of so many "specific cultural constraints"—must have been at work. Though properly warned, we shall continue to call that demonstrably transcendent or beckoning quality realism or, perhaps better, naturalism, understood as "the capacity to depict persons, objects, places, and events in a form consonant with that found in natural sensory experience"; as "that kind of painting, preeminent from the fifteenth century on [in Europe], defined first and last in terms of its 'truth to nature,' that is, painters' success in capturing something of the look of the world as encountered in ordinary visual experience."[95] We shall find willy-nilly that this quality provided a potent motive for the transfer we are studying, just as it had surely fueled the rapid spread of the new imagery outwards from its Italian and Northern homelands all across Europe and eventually the world.

History has indeed been problematized. But we think none of the problems aired above, nor others still to be encountered, are insurmountable. We proceed to our project chastened but uncowed, confident that the proof of the pudding still lies in the eating.

2

The Heritage

The Byzantine heritage in art, as transmitted over the centuries to Russia, quite obviously remained an essential component of the visual environment in which the Petrine revolution took place. But Byzantine art itself has been characterized by historians as conservative if not stagnant in its adherence to set forms, techniques, and subjects, and its prolonged influence on the development of art in Russia has been seen accordingly as restrictive if not deadening in its overall effects. There are plainly two questions here: the quality over the centuries of Byzantine art in Byzantium, if one may thus generalize such a vast subject; and the quality of its prolonged influence, and cumulative legacy, in pre-Petrine Russia. We'll consider these questions in turn—before coming to the perhaps surprising conclusions that Byzantine art in Byzantium is not fairly characterized as conservative, let alone stagnant, and that anyway its influence on art in Russia, particularly its dynamic and Classical aspects, was minimal. Byzantium had ceased to exist artistically before Russia came of age artistically, we should always remember, so that the artistic relation of the one to the other can really only be posed in legatary terms.

No actual examples of Byzantine guidelines or rule-books for artists have been uncovered (with a partial exception to be discussed later), and Byzantine art theory, far from restricting the work of artists, was almost exclusively concerned with justifying art for religious purposes. Secular art—portraiture, say, or decorative painting—was largely left to its own devices throughout the millennium of Byzantine history. Further, important elements of the Classical legacy in image-making were preserved by Byzantine artists to Byzantium's end, as we saw in the preceding chapter: more elements, certainly, than were preserved in the Latin West.

The early church fathers—notably Tertullian and Origen, writing in the third century—were decidedly hostile to all visual art, regarding it as pagan, a dire threat to salvation, and therefore intrinsically evil. But the popularity of representations of saints and martyrs, representations which imitated in outline such contemporary and earlier non-Christian models as funerary stat-

ues and portraits and the whole range of official imagery, nevertheless grew among Christians, and with it a gradual revival of the ancient belief that in images as in relics some special form of divine presence and help was available.[1] By the end of the fourth century religious imagery was no longer considered idolatrous among the leaders of Christian thought—one sign of their fusion of Christianity with Hellenism and embrace of popular attitudes. St. Basil "the Great" of Caesarea (329–379) among the Byzantine fathers best reflected in his writings the emerging view: certain passages of the Bible suggested themes to him and Greek philosophy, particularly Neoplatonism, helped the arguments. Basil wrote, for instance, departing from *Genesis:* "'And God saw that his work was beautiful.' This does not mean that the work pleased his sight and that its beauty affected Him as it affects us, but that that is beautiful which is completed in accordance with the principles of art and serves its purpose well." Again: "We walk the earth as though we were visiting a workshop in which the divine sculptor exhibits his wondrous works. The Lord, the creator of these wonders and an artist, calls upon us to contemplate them."[2] Yet Basil only hinted at what was to come. By the sixth century the holy image or icon was an established fact, complementing or rivaling or even superceding in authority the sacred written texts. The opportune appearance of Christ's face in a number of images said to have been miraculously produced in Asia Minor (like the "Mandylion" of King Abgar of Edessa) made available for copying "true likenesses" of the Savior; it also transpired that the actual appearance of His Mother had been preserved, also miraculously, on several panels painted from life by St. Luke. These were potent images indeed.[3]

It remained for the iconoclast controversy of the eighth century, that prolonged and often violent dispute precisely over the validity of religious images, to define Christian thinking on the subject for centuries to come. The chief statements are found in a canon of the Second Council of Nicaea of 787 and in somewhat earlier writings by St. John of Damascus (John Damascene). The relevant Nicene canon reads:

> We declare with all accuracy and care that the venerable and holy images shall be set forth like the figure of the venerable and life-giving Cross, inasmuch as matter consisting of colors and small stones and other material is appropriate in the holy church of God on sacred vessels and on vestments, on walls, on panels, and in houses and by roads [in the form of] images of both our Lord God and Savior Jesus Christ and of our undefiled Lady the Holy Mother of God as well as those of the honorable Angels and of all holy and pious people. For the more frequently they are seen by means of artistic representation the more those who behold them [the images] are aroused to remember and long for their prototypes, and to salute and venerate them [the images], although not indeed to give them the true worship of our faith that befits the Divine Nature alone; and to offer them [the images] both incense and candles, as is done

to the figure of the Cross and the holy books of the Gospel and other sacred objects, following ancient custom.[4]

This canon was confirmed in 843 at the Council of Constantinople, and thereafter its authority in the Christian Church, Eastern and Western, was unquestioned—however variously it might have been interpreted or applied in practice.[5]

John of Damascus (ca. 675–ca. 749) in effect anticipated the Nicene canon, with much citation of Scripture and earlier fathers, in writings meant to expose the opponents of images as enemies of both church tradition and systematic thinking. His crucial argument was that in becoming man—the Incarnation—Christ forever altered the relationship between God and matter (John assumed that the centuries-long debate over the nature of Christ's person—at once human and divine—had been settled; but it actually continued, given new life by the iconoclastic controversy, into the ninth century). "We are not mistaken," John wrote, "if we make an image of God incarnate [Christ], who was seen on earth in the flesh, who associated with men and who, in His unspeakable goodness, assumed the nature, feeling, form and color of our flesh. For we yearn to see how He looked. Yet as the Apostle [St. Paul] says, 'We see through a glass darkly.' The image is also a dark glass, fashioned according to the limitations of our physical nature." John also appealed to common sense and even invoked politics; Christianity having long since become the state religion of the Byzantine empire, the question of images was inevitably politicized. "If you speak of pagan abuses, these abuses do not make our veneration of images loathsome. Blame the pagans, who made images into gods!" Further, quoting St. Basil: "The image of the [Byzantine] emperor [as on a coin] is also called the emperor, yet there are not two emperors. Power is not divided, nor is glory separated. Just as He [God] who rules us is one power, so the homage He receives from us is united, not divided, for the honor given to the image is transferred to the prototype." Or again, quite simply:

> An image is a likeness, or a model, or a figure of something, showing in itself what it depicts. An image is not always like its prototype in every way. . . . An image of a man, even if it is a likeness of his bodily form, cannot contain his mental powers. . . . A son is the natural image of his father, yet he is different from him, for he is the son, not the father.

And again,

> All images reveal and make perceptible those things which are hidden. For example, man does not have immediate knowledge of invisible things, since the soul is veiled by the body. Nor can man have immediate knowledge of things which are distant from each other or separated by place, because he himself is circumscribed by place and time. Therefore the image was devised that he might advance in knowledge, and that secret things might be revealed and made perceptible. Therefore, images

are a source of profit, help, and salvation for all, since they make things so obviously manifest, enabling us to perceive hidden things. Thus, we are encouraged to desire and imitate what is good and to shun and hate what is evil.

From all of this John concluded that "we use our senses to produce worthy images of Him [Christ], and we sanctify the noblest of the senses, which is that of sight. For just as words edify the ear, so also the image stimulates the eye." Indeed, "what the book is to the literate, the image is to the illiterate," this simile an echo of the concern shared by defenders and opponents alike of images concerning the needs or susceptibilities of unsophisticated Christians. Still more, John concluded, if images of Christ may be made and honored, then surely also images of both his Mother and the saints,

> who are God's friends. In struggling against evil they have shed their blood; they have imitated Christ who shed His Blood for them by shedding their blood for Him. I record the prowess and suffering of those who have walked in His footsteps, that I may be sanctified and be set on fire to imitate them zealously. St. Basil says, "the honor given to the image is transferred to its prototype." If you build churches to honor the saints of God, then make images of them as well.[6]

John Damascene's writings have been called the "coping stone of the edifice of iconophile thought"; in other words, "no other author had such an impact on the theoretical foundation of the [Christian] belief in holy images."[7] Thus rationalized, and then canonized, the holy images triumphed in the Eastern empire (no comparable challenge had yet been mounted in the West), a victory known since as "the Triumph of Orthodoxy" and still commemorated in Orthodox churches on "Orthodox Sunday," the first Sunday in Lent, the season of penitence before the feast of Easter.[8] "For the Christian East," as another authority puts it, "not only angels and men but also their symbols and images had gradually come to be incomparably more important than mere things of nature; and the victory of the Orthodox image doctrine in the iconoclastic controversy completed this development." Pelikan goes on to say that the victory marked "the recovery of the distinctive genius of Eastern Christendom."[9] Even so, it was also a victory for those less intellectual, more popular tendencies in the Byzantine world which regarded the holy images themselves as sacred, or magical, or charismatic: as things which themselves partook of the aura and power of their prototypes. "The sacred icon was not identical with its prototype," in the words of still another student (we tread carefully here), "but by the middle of the ninth century it had become a part of Orthodoxy that it could be a channel to *and from it* and as a reflection *signify its presence*." In short, "the conception of the 'wonder-working icon' had thus been officially authorized."[10] Yet the writings of John of Damascus notwithstanding, nor those of other church fathers, nor even the conciliar canons, questions concerning the validity and truth of icons would persist in the

Christian world ever after, to flare violently from time to time even in dis-
tant Russia.

We also observe, also thinking ahead, that in none of these authoritative
pronouncements on the validity of Christian imagery was an aesthetics pro-
claimed. Nor, to repeat, were specific guidelines for the makers of images laid
down. Evidently the fathers were content to leave questions of technique and
even of style to the artists themselves so long as Christian purposes were
pursued and Christian propriety was maintained. To be sure, a consensus
appears to have emerged in Byzantium that the creation of fully rounded
statues of Christian types, as in Classical funerary art, went too far in the
direction of pagan idolatry. The cultural reticence shown here, which perhaps
owed something as well to Semitic influence, did not prevail in the Latin West;
nor did it extend to low-relief carving in wood, stone, or ivory, which was
freely employed in Byzantium for both decorative and devotional purposes.[11]
But in general, when it came to matters of technique and style artists in the
Byzantine world worked well within the conventions of an uninterrupted
Greco-Roman—or Hellenistic—artistic tradition, a feature of Byzantine
art that is often missed by students who view it through modern (post-
Renaissance) European eyes.

On the other hand, with the official restoration of holy images in Byzantium
newly grave responsibilities devolved upon the producers of those images.
As Grabar says, "It was in the hands of these 'technicians' that the Byzantine
Christianity which issued from the [iconoclast] crisis placed itself, so as to be
assured according to its own reckoning of one of the most efficient means of
making direct contact with the divine." The religious responsibility of produc-
ing or rather reproducing a true and valid likeness of Christ, His Mother, and
the saints, Grabar suggests, in and of itself constrained artists and limited
their scope for individual expression. "Direct observation of nature," he re-
minds us, "is the act of an individual."[12]

As for the actual standards of Byzantine aesthetics, these have been sought
by scholars in the art itself of Byzantium. Mathew, in this way, isolates four
main factors at work:

> A recurrent taste for Classical reminiscence, which expressed a conscious
> inheritance of a Graeco-Roman past; an essentially mathematical ap-
> proach to beauty, which led to an emphasis not only on exact symmetry
> but on *eurhythmos* [rhythm] and balanced movements; an absorbed inter-
> est in optics, which led not only to many experiments in perspective but
> to a concentration on light—conceived as in itself incorporeal, though
> finding expression in contrasted colors; and finally, a belief in the exis-
> tence of an invisible world of which the material is the shadow—so that
> an image presupposes the Imaged just as a shadow presupposed the
> human body that casts it, and is as closely linked to it. A scene is not a
> mere representation of something that has once happened but a *mimesis*,
> a re-enactment.[13]

Artworks created over the centuries embodying these standards, especially holy images in mosaic and in paint on panels and walls, have often been acclaimed as masterpieces of world art (fig. 1). At the same time, a continuous *development* of Byzantine art over these same centuries has been noticed by scholars: variations in drawing and coloring, experiments in perspective and highlighting, additions to the iconography and the frequent incorporation of external influences: all signs of a living art. Both development *and* continuity may be said to characterize Byzantine art, with the continuity understood as a function of theology and aesthetic standards, and basic training, rather than of rigid technical or stylistic rules.[14] In this way, for example, the doctrine that in praying before the holy images Christians prayed as if through channels to their prototypes—one or more of the saints, Christ, his Mother—led to the "final victory of frontality" in imagery; only those figures with which worshipers would wish to make no contact were thereafter shown in profile, like Judas at the Betrayal of Christ. Hence also the typically soulful eyes of Byzantine portrait icons: these were not simply human features but, once again, channels to and from heaven. Yet the "soulful" eyes themselves and the principle of frontality, along with a taste for symbolical two-dimensional pictures suspended as it were in eternity, were among the devices inherited by Byzantine artists from Asia Minor and Syria and freely adapted by them to their Christian beliefs—beliefs with which these devices initially had nothing to do.[15] Religion informed Byzantine art and so, in varying ways, constrained it; but religion did not dictate artistic style or technique—not originally, and not always.

We labor to show that no more than in the case of medieval Italian art (*pace* Vasari) was the Byzantine heritage necessarily responsible for such stagnation as there was in the visual art of pre-Petrine Russia. A recent study of the "Painter's Manual" or *Hermeneia* of Dionysius of Fourna (born about 1670, died probably in 1745 or 1746) offers some further testimony in this regard. This manual, compiled on Mount Athos between about 1730 and 1734, was long thought by scholars to embody fixed and immemorial Byzantine practice, and thus to provide a clear guide to the stiff, unchanging conventions of a formalized religious art. But the *Hermeneia* remains the first and only such work on Byzantine painting that is known; its technical part represents at best a fragmentary tradition going back no earlier than the ninth or tenth century; and its iconographic section—hardly more than lists of subjects and saints, with more or less brief descriptions of how each might be depicted—is most likely an original compilation, considering, for one thing, that its Apocalypse sequence is based on sixteenth-century German woodcuts. The iconographic section of Dionysius's manual is a codification based apparently on the Byzantine paintings he himself saw on Mount Athos, in Istanbul, and on the Greek mainland, beginning with his native village of Fourna. Also, the manual's purely literary nature (no pictures whatever) separates it sharply from the few medieval pattern books or iconographic guides of a visual character sur-

viving from either the Greek East or the Latin West. A work simply of reference, a repository of all the information necessary to a late Byzantine (or neo-Byzantine) artist for the practice of his profession, the eighteenth-century *Hermeneia* of Dionysius of Fourna shows rather that the basic canon of subjects available to Byzantine artists had increased over time and that technical innovations continually occurred. At the same time, we have to agree that within its immediate, eighteenth-century cultural context—a Greek world now "torn between the old, authorized Byzantine culture and the new, revolutionary cultures of the Italian Renaissance, Baroque, and Enlightenment"—Dionysius's manual also exhibits an "intentional archaism," an at least implicit "insistence on a return to the traditions of Byzantine painting."[16] This manual exemplifies, in other words, the process whereby Byzantine art came to constitute, and be preserved as, the cult art of the Greek Orthodox church—a process that was paralleled, as we shall see, in post-Petrine Russia.

The whole history of Byzantine art in Byzantine times is best summarized perhaps in terms proposed by Otto Demus, terms that are attentive to its elements of both continuity and innovation, of repetition and change, as well as to the great length—nearly a thousand years—of its continuous development. Byzantine art, Demus writes,

> did not proceed in a straight line from abstract to naturalistic principles, or vice versa, or from Hellenistic to medieval methods of representation. It moved, so to speak, in spirals—and not in regular spirals at that—deviating from the ideals of Classical art and forever returning to them in a series of renascences which, at times, followed each other so quickly that scholars speak of a perpetual renaissance or of perennial Hellenism. Works produced in parallel phases may look so much alike that they are apt to be mistaken for one another, although their dates may be up to three hundred years apart. Examples are numerous and easy to find: what with the longevity of iconographic formulae and the cyclic recurrence of stylistic attitudes, almost every book on Byzantine art contains one or more mistakes of this kind.[17]

We do well to remember these points when dealing with Russian art of the Byzantine tradition—Byzanto-Russian art, as we will call it.

For some of the writings of St. John Damascene in defense of holy images, like some of the relevant canons of the Byzantine church councils, did make their way to the lands of the East Slavs, there to circulate in manuscript, slowly and in fragmentary fashion, in more or less adequate Slavonic translations.[18] Yet far more important in the early diffusion of Byzantine art to and among the East Slavs—ancestors of, among others, the Russians—were actual works by Byzantine artists, especially the mosaics and murals executed by Greeks in newly built East Slavic churches, any Byzantine illuminated manuscripts deposited in East Slavic monasteries and palaces, and, above all, the panel icons imported by East Slavs from Constantinople and other centers of Byzantine art (pl. 1), evidently in large numbers. Moreover, what Russians in their

northern remoteness eventually made of this combined written and especially visual Byzantine artistic heritage would prove to be largely a matter of their own devisings. Particularly was this so after the Turkish conquest of the Byzantine Empire, completed in 1453, and the attendant withering of Byzantine art in its homeland.[19]

MUSCOVY

A cultural revival in the East Slavic lands (the lands of *Rus'*) that would soon form Muscovy—Muscovite *Rus'* or Russia—began in the later fourteenth century, following the depredations and ensuing stagnation of the initial period of Mongol domination of these lands, a domination which lasted, but with declining force, from the mid-thirteenth to the later fifteenth century. This revival has been causally linked with the "Palaeologan renaissance" of the fourteenth century in Serbia and Bulgaria and in Byzantium itself and so named after the last Byzantine dynasty. But the links are more often inferred by scholars than documented. The revival which began in the later fourteenth century in the lands that became Muscovite Russia is perhaps better seen as an indigenous movement, one stimulated to be sure by Byzantine and South Slavic influences but occurring within what was by now an essentially autarkic culture.[20]

The attendant upsurge in the painting of holy images on walls and panels— the rebirth of the icon in northern *Rus'*—is our concern here.* In fact, panel icons and murals surviving from the later fourteenth and earlier fifteenth centuries constitute some of the best documentation available of the more general cultural revival in this region. Works attributed to the monk-artist

*The word "icon" (Russian *ikona*, from Greek *eikon* = "image") generally refers to a holy picture or image of the classic Byzantine type, especially one painted in egg tempera on wood panel, or seasoned board sized with gesso. In Byzantium and later in Russia, icons or holy images were of course also painted on plaster vaults and walls (producing a wall painting or mural or, if the plaster were kept damp when the paint was applied, a "true [*buon*] fresco") and on parchment or, later, paper (producing "illuminated" manuscripts). In Byzantium, too, holy images were fashioned in mosaic, usually on church walls, an art that did not survive the Mongol invasions of the thirteenth century in the lands of the East Slavs; and in enamel, sandstone (steatite), metals, and ivory (always in low relief)—arts which, except for the carving of (low relief) icons in stone and ivory, did take root in Russia, primarily in making church vessels. Finally, in Byzantium and later in Russia, holy images were painted on cloth, for example on military banners or altar shrouds; sewn or embroidered on ecclesiastical vestments; painted on furniture, for example on wooden chests for domestic use; and—but this gets ahead of our story—printed on paper from woodcuts and metal engravings. This chapter focuses on holy images painted on panels and walls, much the most widespread and socially important forms of depicting such images in Russia until the arrival of printing in, effectively, the later seventeenth century; it also discusses manuscript illumination, for reasons both historical and historiographical. We might further note that in Russian the word *obraz*—"image"—can be used interchangeably with *ikona* and that the word *freska* ("fresco") tends to be used interchangeably with *stenopis'*, meaning a mural or wall painting, and even with *rospis'*, which can mean "painting" more generally but also a mural or wall painting. There being considerable scholarly doubt as to how long and how widely true frescos were painted in Russia, the more inclusive "mural" or "wall painting," rather than "fresco," will be used here.

Andrei Rublev (ca. 1360/1370–1430)—his icons *The Old Testament Trinity* and *The Savior,* for example, the former painted for the Trinity–St. Sergius monastery, the latter for the cathedral at Zvenigorod, both not far from Moscow—have been judged masterpieces of medieval painting regardless of place of origin (pls. 2, 3). Rublev worked well within Byzantine iconographic, stylistic, and technical traditions but with notable individuality and refinement. He also exerted great influence on his own and succeeding generations of Russian artists (e.g., pl. 4).[21]

The direct but quite limited role of Greeks in the initial development of a Russian and particularly a Moscow school of painting is illustrated by the career of Feofan Grek (Theophanes "the Greek")—the little that is known about it.[22] Born around 1335, probably in Constantinople, he arrived in Novgorod (still the seat of an independent state with links to Moscow) not later than 1378, having become in the intervening years an accomplished if not celebrated painter in the Byzantine world. The only painting attributed to Feofan with any certainty, however, is the cycle of murals done in 1378 in the church of the Savior of the Transfiguration in Novgorod, impressive fragments of which can be seen today. The central image of these murals is a huge domical effigy of Christ the Pantocrator (Christ the Almighty, Christ in Majesty) surrounded by angels and archangels; elsewhere on the walls are depicted the great ascetics of the Eastern church, the Old Testament Trinity, the Mother of God and various saints and martyrs, and scenes from the Gospels—all reflecting long established Byzantine conventions and all painted in a style that has been rightly described as restrained, laconic, elegant, visionary, and monochromatic: as Byzantine, for sure, but odd, the product it would seem of the artist's "endless wanderings."[23] The Deesis rank of the iconostasis of the church of the Annunciation in the Moscow Kremlin, done in the 1390s, has also been attributed to Feofan. These nine icons—of Christ in Majesty, his Mother, John the Baptist, the archangels Michael and Gabriel, the apostles Peter and Paul, and Sts. Basil the Great and John Chrysostom—are lucidly painted against gold backgrounds in glowing, "typically Greek" colors: a princely work of art quite appropriate to the domestic church of the ambitious princes of Moscow.[24] More strictly Byzantine in character, these later icons appear to have little in common stylistically with the murals in Novgorod. At the same time, striking affinities between them and works soon to come by Andrei Rublev have often been noted by students.

The main source of information about Feofan's career is a letter addressed to Abbot Cyril of Tver by Epifanii Premudryi (Epiphanius "the Wise"), a monk of the Trinity–St. Sergius monastery who had once traveled to Mount Athos and the Holy Land. From Epifanii's letter, written about 1410, we learn that Feofan had decorated more than forty churches in his time, beginning with several in Constantinople and Chalcedon and ending with major churches in Novgorod, Nizhnii Novgorod (on the Volga), and then Moscow. Epifanii watched this "finest of iconpainters" as he worked in the churches

of the Kremlin and marveled at how, "as he was sketching and painting all this, no one ever saw him look at models [*obraztsy*]—as is done by some of our iconpainters who, understanding nothing, make constant use of them [models]. . . . But he, it seemed, painted on his own, all the time moving about and conversing with visitors; and while discussing remote and spiritual matters, with his outward gaze [normal sight] he saw the beauty of earthly things." Epifanii asked Feofan to paint for him a picture of the great church of the Holy Wisdom in "Tsargrad" (Constantinople), which Feofan did, having "boldly seized brush and quire and rapidly painted the image" as requested. Epifanii says that this picture "proved useful to other Moscow iconpainters, for many copied it for themselves, passing it from one to another." In fact, Epifanii himself (his letter concludes) copied it four different times in a book of biblical extracts that he compiled. And we know from other Russian sources, both written and graphic, that Feofan attracted numerous local pupils, one of whom, almost certainly, was Andrei Rublev.[25]

The painting of holy images on panels and walls fairly flourished in such early Russian centers as Novgorod, Pskov, Suzdal, Vladimir, Rostov, and then Moscow. Itinerant or immigrant Greeks as well as Serbian and Bulgarian refugees from the Turkish conquest took part in this artistic florescence, even at times a leading part. So did actual icons imported from the former Byzantine lands, most famously the icon of the Mother of God of Tenderness painted in Constantinople in the twelfth century and transferred from Kiev to Vladimir by 1155 and on to Moscow in 1395; known thereafter in Russia as the Vladimir Mother of God and regarded as wonder-working, it became "the most sacred palladium of the Russian state"[26] and the source of countless imitations (pl. 1). In fact, there is evidence in the Old-Russian chronicles that by the later fourteenth century a small Greek colony existed in Moscow centered in its own monastery with a major church and some sort of school. Greek hierarchs serving in the Russian church were the main agents and patrons of a kind of cultural Byzantinism that was feeding the political ambitions of the Muscovite grand princes. Particularly in the later fourteenth and earlier fifteenth centuries—the time of Feofan Grek—Greek and South Slavic clergy and painters were being drawn like so many bees to the nectar of Orthodox Moscow. But in image-making, it deserves repeating, it was mainly local artists who did the painting and repainting of icons in what one leading authority has called the first "Golden Age" in Russian visual art.[27] The influence of Italian Trecento and even early Renaissance imagery has also been spotted in Russian works of this period. But such influence is now generally thought to have been overstated as well, since it would have reached Russia through Greek, South Slavic, Cretan, and possibly Cypriot intermediaries and could have left at best only faint traces in these products of what was by now a demonstrably robust local culture.[28] Nor should we forget the still formidable isolation of the infant Russia of the Mongol domination (not finally repudiated until about 1480), an isolation as much political and cultural as geograph-

ical and only intensified by the Turkish conquest of both Byzantium (1453) and the Balkans.

Equally, no theory of art had been enunciated as yet in Russia, as far as we know: no formalized view of holy images that might have clarified and affirmed the classic Byzantine principles for the guidance of all concerned. Indeed, it is not at all clear that *any* of the Byzantine theology of images reached Russia before the *sixteenth* century. Meyendorff reminds us that while the New Testament, selections from the Old Testament, and Byzantine liturgical, legal, hymnographical, and hagiographical texts had become available in Slavonic translations through Serbian or Bulgarian intermediaries, Byzantine theology was accepted in early Russia "only passively, and on a very limited scale"; and knowledge of Greek itself was extremely limited—virtually nonexistent—until the later *seventeenth* century.[29] Nor have we reason to assume that the aesthetic factors animating Byzantine artists and patrons as adduced earlier in this chapter (quoting Mathew), particularly the consciousness of a Classical heritage, were as yet grasped by Russian artists and their patrons. In short, no sustained, conscious "Byzantinism" of any great significance is evident in this early flowering of imagery in Russia; no "intentional archaism" designed to preserve a great tradition against powerful external or internal pressures for change.

An "Epistle to an Iconpainter" dating from the end of the fifteenth century and tentatively attributed to the monk Joseph Volotskii (Joseph of Volokolamsk, 1440–1516) is the first Russian writing to refer at any length to images. Generated by the iconoclastic "Judaizer" movement of the 1480s in Novgorod and Moscow, it is sharply polemical in cast and, like the movement itself, its influence was limited to a small circle of clergy and officials. Its arguments are elementary when not plainly illogical, moreover, or even ludicrous; and it actually has little to say about images themselves. Its author seems to have been inspired in the main by sometimes erroneous Slavonic translations of certain texts of late Byzantine mysticism (but probably *not* Hesychasm). More than anything else, this "Epistle" of the 1480s or 1490s tends to confirm that image-making in Muscovy was still unencumbered by theory; indeed, that book learning more generally remained in a primitive state.[30]

The Moscow church council of 1551, on the other hand, was a major event in the history of holy images in Russia, and its proceedings offer the first extended evidence of Muscovite thinking on the subject. The proceedings were gathered in a book of 100 chapters, the so-called *Stoglav;* and several times in the course of the council's meetings, according to the *Stoglav,* the question of sacred imagery arose. On one such occasion the council ruled that "holy and honorable icons" were to depict the "image of God and of the most chaste Mother of God and of all the saints in accordance with the holy canons, following the image and likeness and essence of each; about this there is testimony in Holy Scripture. And in this matter great care should be taken that iconpainters live sensibly and virtuously, and that students be taught to paint

to perfection the essence of divine images."[31] This ruling contained, it turns out, the gist of all that the council formally had to say on the subject. But in view of its subsequent importance, or notoriety, chapter 43 of the *Stoglav,* which is devoted to imagery, should be quoted *in extenso:*

> The metropolitans, archbishops, and bishops, in royal Moscow and all the towns, with the tsar's [Ivan IV's] consent, are to administer the various ecclesiastical matters, especially the holy icons and the painters [*zhivopis-tsy*] and the other church matters, in accordance with the holy canons. And it is proper [for them to supervise] the painters and to be careful of [their] drawing of the fleshly [bodily, or human] representation of our Lord God and Savior Jesus Christ and his most chaste Mother and the heavenly hosts and all the holy saints who through the ages have pleased God. It is proper for a painter to be humble, meek, and pious; not a gabber, joker, shrew, or envious person nor a drunkard, thief, or murderer. Especially should he preserve chastity of soul and body from all temptation; but should he be unable to live so until his end, then he is to marry by the law and live in wedlock. He should go often to his spiritual fathers and confess all and live by their exhortations and instruction in fasting and prayer and maintain [himself] with humility and without any shame and dishonor. And he should paint with great care the image of our Lord Jesus Christ and of his most chaste Mother and of the holy prophets and apostles and martyrs and of the venerable women and bishops and venerable fathers in accordance with the image and likeness and essence [of each], looking to the example of the old painters, and [he should] draw following good models. And if painters, having been instructed, thus live and work, and have care for the things of God, the tsar will salary such painters and the bishops honor them above the common people. The painters should also take students and supervise them in all things and teach them piety and chastity and lead them to the spiritual fathers. The fathers should also exhort them, following the bishop's injunction, on how it is proper for the Christian to live without any shame and dishonor and on how to learn with attention from their masters. And if God reveals in some [student] the skill [of icon painting], take him to the bishop, who shall ascertain whether the student's work has been painted in accordance with image and likeness, and inquire as to whether he has lived in lawful chastity and piety without any dishonor; and having blessed [the student], [the bishop] shall exhort him to live piously henceforth and to uphold his holy work with all zeal, and shall honor him like his master, above the common people. The bishop shall also exhort the master never to favor either brother or son or near ones. But if God does not give such skill to someone [some student], if he learns to paint badly or does not live properly and says he is great and worthy in everything, and shows the painting of another and not his own, the bishop, having investigated, shall put the master [responsible] under the ban so that others, afraid, dare not do the same; and this student can nowise engage in icon work. . . . And if any of the masters or students lives improperly, in drunk-

enness and impurity and in any dishonor, the bishop shall put him under the ban and exclude him completely from icon work, mindful of the fearful prophesy, "Cursed be he who does God's work carelessly" [Jeremiah 48:10]. And they who hitherto painted icons not in accordance with the images but willfully and fantastically, and traded them cheaply with common ignorant village folk, shall desist until they have studied under good masters. And to him whom God gives it to paint in accordance with image and likeness, he shall paint; but he whom God does not so endow shall be forever excluded from such work, lest God be offended by it. And he who does not so desist shall be punished terribly by the tsar. . . . So the archbishops and bishops in all the towns and villages and monasteries are to examine the icon masters and inspect their paintings, and to choose each in his diocese special masters and order them to inspect all the iconpainters, so that none among them should be bad or dishonorable. The archbishops and bishops themselves are to supervise these special masters and closely examine them and their work and honor them above the common people. And the grandees as well as the common people shall honor these painters in all things and have respect for the nobility of icon work. Indeed the bishops are to take great care each in his own diocese that the leading iconpainters and their students paint from the old models, and not paint the Divinity out of their own invention and by guesswork. Christ our God is painted in the flesh but not the Divinity, as the holy John Damascene saith: "Do not paint the Divinity nor falsify, blind ones, for [the Divinity] is invisible and unseen. Before the image of the flesh I bow down and believe and glorify the Lord born of the Virgin." And whoever of the cleverer and leading masters hides what talent [*talant*] God gave him and does not teach others, will be condemned by Christ to eternal torment. Therefore painters are to teach students without any perfidy, lest they be condemned to eternal torment.[32]

This passage from the *Stoglav* of 1551, abridged here in translation only slightly, to eliminate still more repetition, is the first extended, public, and authoritative commentary on visual art to be found in a Russian source. And apart from an exclusive concern with the depiction of *religious* subjects, what do we find? An insistence on painting skillfully in accordance with certain standard images or likenesses, "looking to the example of the old painters," with the implication that these images were in some way the actual and only likenesses of the persons represented (Christ, his Mother, the saints); a corresponding condemnation of icons painted "willfully and fantastically," or out of painters' "own invention and by guesswork"; an emphasis on the need for painters to maintain strict standards of morality in their personal lives, above all in sexual matters; and an assumption that in both art and life the standards should be enforced by the leaders of the church backed by the authority— and largesse—of the tsar. Icon painting, in other words, was conceived of as normally a monastic calling, as a "noble" indeed a "holy work" and one requiring a special talent that was to be trained in apprenticeship to painters

certified by the local bishop. It was an art whose standards had been set by certain old masters and unnamed "holy canons." And the ultimate temporal reward for good work in this high calling, apart from a royal salary, was the esteem of the community, grandees and commons alike. At the same time, nothing said here advances a theory of art; not explicitly, in any case.

On the contrary, when these passages from the *Stoglav* are viewed together with the rest of the council's proceedings it is clear that their authors were concerned primarily to police the company of icon painters so as to exclude morally unfit and artistically ungifted or deviant members. Such miscreants were either unable or unwilling to produce images that conformed with established iconographic, stylistic, and technical norms: rogues who either would not or could not emulate or recreate the familiar "image and likeness" of the subjects given them by their patrons. It was thus an anxious, conservative, even ambivalent position that the council took. And its prescription for achieving its ends was strict administrative control of icon painters by the church hierarchy, a position fully consistent with the council's manifest overall concern, as conveyed by the *Stoglav,* to eliminate abuses in Russian ecclesiastical discipline.

Nor does the *Stoglav'*s garbled citation of St. John of Damascus, as quoted above, suggest that the Byzantine theology of images was yet understood in Muscovy. Ostrogorskij some time ago pointed out that this is the only explicit or direct citation of a Byzantine source on images to be found in the *Stoglav,* and that it is a spurious one at that (it refers to a fragment of an apocryphal work also evidently consulted by the author of the earlier "Epistle" attributed to Joseph Volotskii). Yet Ostrogorskij went on to argue that in view of "certain analogies and coincidences" between the decisions of the Moscow church council of 1551 and the Byzantine literature on images, the former, as recorded in the *Stoglav,* were "in close conformity with the Byzantine conception of images and faithfully upheld the traditions of Orthodox Byzantium."[33] That may have been so. But was this conformity actually anything more than a coincidence? Simply a result, on the Russian side, of the physical transmission from generation to generation of Russian painters, literally from icon to icon, of a certain iconographic, stylistic, and technical repertory that *we* know to have been ultimately Byzantine in origin? We cannot really say.

The *Stoglav* of 1551 contains passing references to the "holy canons" on images and to the "old painters" or to, quoting from another of its chapters, the "old traditions of the holy fathers" and the works of "renowned painters [both] Greek and Russian."[34] But if there is considerable evidence elsewhere in the *Stoglav* of extensive use by its authors of one or more Slavonic manuscript collections of Byzantine canon law (no book of canon law was printed in Russia until the seventeenth century), for instance on the question of marriage, there is no such textual evidence of any specific source, canonical or other, having been consulted in the matter of images.[35] Equally, the only "old painter" mentioned in the *Stoglav* by name is Andrei Rublev, as follows:

"Painters are to paint icons from the old images, as the Greek painters painted and as Andrei Rublev painted and other renowned painters [did]."[36] In its immediate textual setting this injunction refers even more specifically to the painting of icons of the Holy Trinity: *these* were to follow Rublev's example. But if we read this injunction mindful of the *Stoglav* as a whole, it does seem that in all things having to do with holy images the leaders of the Russian church assembled in Moscow in 1551 offered as the ultimate guide the works of their long deceased countryman, Rublev. These works adorned the edifices of the central authorities of the Muscovite polity (the churches of the Kremlin, of the Trinity-St. Sergius monastery, and others), and had been steadily imitated since they were originally painted roughly a century and a half before, establishing their own tradition (cf. pls. 2, 4; also pl. 3, fig. 7). On the evidence

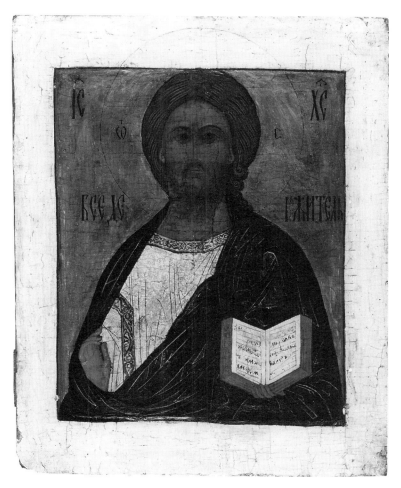

Figure 7 *Christ Pantocrator (Vsederzhitel').* Moscow, early sixteenth century. Tempera on panel. This icon is discussed in connection with the "Rublev style" inTemple, *Icons*, p. 69.

of the *Stoglav*, in other words, the painting of holy images in Muscovite Russia was a self-sustaining local tradition and one that was still devoid of theory.

The icon question soon rose again in Moscow at a council convened in 1553–1554 by Tsar Ivan IV and Metropolitan Makarii, the head of the Russian church. This council was to hear charges against a senior state official, I. M. Viskovatyi, who stood accused of blaspheming certain newly painted images. The "Viskovatyi affair" was embedded no doubt in contemporary politics and is perhaps finally explained in political terms. But Viskovatyi's elaboration of his views and Makarii's rebuttal of them, as contained in a contemporary (or nearly contemporary) account of the trial, provide further valuable evidence of the Muscovite understanding of imagery around the middle of the sixteenth century.[37]

The essence of the charges against Viskovatyi was that for several years he had publicly criticized as un-Orthodox the iconography of certain murals painted by royal commission in various buildings of the Moscow Kremlin. Among his other objections, Viskovatyi had cited the depiction of two persons of the Trinity—God the Father as a gray-haired elder, the Holy Spirit as a dove—for impermissible artistic latitude and had denounced two pictures of Christ—one as an angel, the other as crucified with his limbs in certain positions—for thus reflecting "Latin" norms. In support of his criticisms Viskovatyi referred to canon 82 of the Quinisext Council of Constantinople (met in 692), a canon (unidentified) of the Second Council of Nicaea (787), two passages from unidentified service books, a letter of St. Basil the Great, and several writings of St. John of Damascus: the only one of these writings since identified is an excerpt from John's fourth discourse on the Orthodox faith (*De fide Orthodoxa* IV). This excerpt from John, which summarizes the essence of the Byzantine theology of images, does not explicitly say that either God the Father or God the Holy Spirit may be represented but only, explicitly, Christ crucified, his Mother, and the "valiant deeds of saints"; from which it might be inferred, as did Viskovatyi, that only the latter three subjects were permissible in icons: an inference that could be supported, again following Viskovatyi, by reference to such other authoritative sources as canon 82 of the Quinisext Council, which could be read as forbidding the depiction of Christ in the guise of a sacrificial lamb.[38] Viskovatyi's testimony, in other words, indicates that he had absorbed basic elements of the Byzantine theology of icons and that he interpreted them strictly as well as deftly, and quite literally. By comparison, Metropolitan Makarii, his opponent, waxed subtle in defending what were undeniable innovations in contemporary Muscovite icon painting while only twice conceding that things had gone too far (depicting the Holy Spirit as a dove, or Christ crucified with closed palms) and were in need of correction. In neither case, we notice, did Makarii admit the "Latin" origin of the innovation—or of the image of Christ as lamb that Viskovatyi had also oppugned. In the end, Makarii simply invoked ecclesiastical authority (which implied the tsar's support) in condemning Viskovatyi, who then recanted his

accusations and accepted his spiritual punishment like a good son of the church.

Later scholars have suggested that in terms of Orthodox theology Viskovatyi was essentially right in 1553–1554 and Makarii, wrong. Ostrogorskij for one states that the main innovations at issue were definitely imported from the West and that Makarii's defense of them "represented a certain state of mind which was already distancing Russia from the iconographic traditions of Byzantium."[39] Andreev goes somewhat further. Seeing Makarii as the major influence at work in the *Stoglav's* earlier pronouncements on icons, Andreev found that in both instances, but particularly in his rebuttal of Viskovatyi, Makarii contradictorily argued for adherence to the Byzantine tradition and for acceptance of "Latin" innovations. In other words, Makarii was neither well grounded in the theology of images nor really interested in it. It is important to remember, says Andreev, that Makarii himself was an icon painter—hence a practitioner's attitude to theory—and that before coming to Moscow he had served as head of the church in Novgorod, the old city near Muscovy's western frontier which functioned as the main source of the growing "Latin" influence in Russian imagery. The isolation of Russian church art, we might add, its *zamknutost'*, was apparently breaking down.[40]

A third written source of sixteenth-century Muscovite thinking on images lies in what purport to be the records of a formal debate held in Moscow in 1570 between Tsar Ivan IV and Jan Rokyta, a minister of the Czech Brethren serving as chaplain in an embassy sent by King Sigismund August of Poland. Here "Ivan" went to considerable lengths to refute Rokyta's charge that making and worshiping images of God and the saints was as good as idolatry. His basic defense paralleled the classic Byzantine formulation of St. Basil the Great, as in this excerpt from his refutation of Rokyta: "Do not think that we idolize them [icons]; rather we worship honoring the source of the likeness; we honor neither the paint nor the panel, but the image painted of Christ and the Mother of God and of all the saints, raising the glory to the source [*pervoobraznoe;* prototype] of the likeness."[41] But two further points deserve mention. First, the only sources cited by Ivan (or his ghostwriter) here and throughout these highly polemical replies to Rokyta's questions are the Bible—frequent references to both Old and New Testaments—and the ninth-century Byzantine world chronicle compiled by the monk George Hamartolus: again, nothing—or nothing explicit—from the Byzantine literature on images. Second, the chronicle of Hamartolus, which had long been known in Moscow,[42] was the source evidently of Ivan's recounting of the old legend about King Abgar of Edessa (died A.D. 50), to whom Christ was said to have sent an image of his face impressed on a cloth. On receiving the portrait, so the story went, Abgar was cured of an illness, at which time the cloth disappeared for some five centuries until miraculously discovered in the Edessa city wall. The relic—known as the "Mandylion"—was eventually taken to Constantinople (944), where it was venerated as the true image of Christ

"made without hands" and thereafter frequently copied by painters for devotees of the cult: a cult, as Ivan indicates, which had also spread to Russia.[43] Invoking the Abgar legend and the "many miracles" to be attributed to this "divine image," and putting much store in the supposed miracle-working properties of various other icons, Ivan seemed to divinize icons as such, thus misunderstanding the Byzantine distinction between the proper Christian veneration of holy images and pagan idolatry. Rokyta, it might be thought, was vindicated. Meanwhile Ivan (or his ghostwriter) gave witness to the "tremendous increase" in the popularity of miracle-working icons that occurred in sixteenth-century Muscovy.[44]

So by the later sixteenth century, to judge from the written remains of the *Stoglav* council, the Viskovatyi trial, and the Rokyta debate, a theory of imagery was beginning to take shape in Russia. Byzantine in its origins, unquestionably, its expression nevertheless tended to interpret the tradition literally while not being noticeably well informed: Andreev points out that even Viskovatyi was "twice mistaken" in his theology of painting.[45] These verbalizations of Muscovite thinking on images were also pragmatic in outlook and more than tinged with credulity. Really, it was not much of a theory at all. The import of Metropolitan Makarii's formulations at Viskovatyi's trial and of the relevant provisions of the *Stoglav* was to insist on central ecclesiastical-royal control of icon painting and to set some sort of standards for this control, standards that had much more to do with who could paint than with what could be painted; our plate 5, dating from the late sixteenth or earlier seventeenth century, and incorporating "Latin" innovations condemned by Viskovatyi, is one of many examples that could be adduced showing that actual icon painting often proceeded eclectically: untouched, it would seem, by theoretical—or theological—concerns. Moreover, one leading historian of early Russian art has declared on aesthetic grounds that this regulation of icon painting by state and church had the effect of replacing creativity with imitation and repetition. Such regulation finally brought to an end, Alpatov says, voicing a prominent scholarly view, the "Golden Age" of icon painting in Russia.[46]

This trend towards central regulation of icon painting and a corresponding standardization of forms achieved graphic force in the pattern-books or *podlinniki* that began to appear in Muscovy in the later sixteenth century. These were collections of simple line drawings on paper depicting the saints—Byzantine and Russian—and major feast days of the church year compiled for the guidance of icon painters. Some of the drawings were actual tracings or stencils taken from existing icons that had been pierced and pounced for the purpose with soot mixed with garlic juice (which stencils could then be laid directly on prepared panels and traced in charcoal, thus outlining new icons); others were freehand drawings in ink copied from images painted on walls or panels or paper. In either case, the collections contained all the essentials of the figures and settings—patterns of dress and gesture, identifying sym-

Figure 8 Images from a *Podlinnik* of ca. 1600: (left) the Annunciation, feast day March 25; (right) Sts. Peter and Paul, Apostles, feast day June 29.

bols and captions, architectural and natural backgrounds, specific colors to be used—that painters would need when commissioned to make icons (fig. 8). The potential for an almost mechanical reproduction of images that use of these *podlinniki* represented is obvious.[47]

A Western student has suggested that pattern-books first appeared in Muscovy as a corrective response to "Western influences," which were causing painters to diverge from tradition; that they were "necessary disciplinary instruments at a time when for various reasons artists no longer could or would follow traditional methods."[48] The suggestion, plausible enough in itself, offers perhaps a partial rather than a sufficient explanation of the phenomenon. The growth in power of the state—of the tsar's court and bureaucracy, supported by the church—was an independent development which naturally extended itself to all major aspects of public life. Also, the growing use of pattern-books in icon painting as well as its increased regulation by the church were undoubtedly linked with an enormous increase in demand for holy images. This was a matter both of murals for churches—in the sixteenth century more masonry churches were constructed on Russian territory than in all of the preceding centuries combined—and of panel icons for domestic use, as the custom of maintaining private chapels spread among the Muscovite elite along with the practice of hanging several icons, rather than one or two, in the appropriate corner of the living room: the latter custom gradually reached all of society, as did the practice of carrying little icons about on one's

person and of placing personal icons in the local church. This proliferation of holy images in Muscovite Russia, which only intensified in the seventeenth century, regularly evoked comment from foreign visitors (Chap. 1); and meeting this demand would certainly have promoted that repetition and imitation which later students deplore even though, we might insist, it did not necessarily always entail a forsaking of artistic standards. Standards would change, to be sure, just as certain technical innovations—or variations—would occur. But aesthetic judgment then as now ultimately remains a subjective matter.

The main changes to be observed in Muscovite icon painting from the later sixteenth century include new and increasingly complex subject matter along with the use of more colors, more intricate floral decoration, and a somewhat more naturalistic depiction of forms. The resulting compositions may be described as didactic and narrative in nature by comparison with the simpler, otherworldly or even mystical character of earlier Russian imagery: as more philosophical, perhaps, in the secular sense of the word, and sometimes overtly political. Such icons may well reflect the contemporary decline of monasticism in Russia that historians have detected;[49] they certainly reflect the growing wealth and power of the Muscovite state and episcopal church as well as Muscovy's expanding relations with other states and cultures—not only "Latin" and South Slavic, now, but Armenian, Georgian, Persian, and Turkish, too (Persian in the trend to miniaturization, for example, and Turkish in the floral decoration). A certain decline in the quality of the drawing, a tendency towards formal rigidity, and a loss of coloric richness or intensity are also noticeable in Muscovite icon painting after the middle of the sixteenth century. The coincidence of these trends with the trend to increasingly complex subject matter has led some authorities to conclude that by the end of the century Russian visual art had entered a period of "crisis," one in which an earlier artistic integrity, represented at its best by the work of Andrei Rublev, had given way to a cheaper, more varied and utilitarian, even esoteric art.[50] But again, this notion of a crisis in imagery, like that of an aesthetic decline from an earlier "Golden Age," is essentially a subjective (or perhaps moral) judgment. Even were we sure of having sufficient accurate examples of the painting of the respective periods to compare, an art that was abundantly successful on its own terms and that would thrive for decades to come cannot really be described as one in "crisis."[51] Indeed, apart from its growing popularity on its home ground, Muscovite painting was achieving at this time an international reputation, as high-status patrons in the former Byzantine world—in Greece, Palestine, Serbia, Romania, Ukraine, or Constantinople/Istanbul itself—sought its products for their own churches and dwellings, evidently because of what they considered to be the undiminished grandeur and traditionally Orthodox qualities of Muscovite icons (i.e., still relatively free of "Latin" or Italian influence).[52] Students of the visual art of the Orthodox East, Byzantinists or Grecophiles (or local nationalists), have tended to ignore this turnaround in influence, this reversal of the path of artistic diffusion between Russia and the rest of the Orthodox East.

Sixteenth-century Muscovite imagery was synthetic as well as selective in its assimilation of both external and indigenous elements, in sum, while revealing a dynamism and expansiveness comparable to what we have observed in contemporary Muscovite church architecture.* We say comparable here because developments in sacred imagery and in church building were not necessarily or always interconnected, of course. Private or personal, that is, extraecclsiastical devotion was booming in Russia, too, by the end of the sixteenth century; so the iconic evidence itself would indicate, along with such written testimony as has been adduced.[53] Rublev and Feofan Grek at the beginning of the fifteenth century painted images in major public places, on the walls and for the icon screens of big churches; indeed Lazarev contends that together they actually created the huge multitiered, polygraphic, typically Russian iconostasis (*ikonostas* = icon screen) with its large-figured, clearly delineated, generally laconic imagery.[54] But by the end of the sixteenth century any number of local as well as court painters in Russia (e.g., the original Stroganov school at remote Solvychegodsk)[55] were producing countless small panel (and cloth) icons for a rapidly expanding lay public, albeit one that was limited as yet to the landholding or urban elite. These icons depict moral tales from the church fathers as well as biblical stories and saints' lives, with the narrative often carried from the central image into a surrounding border of smaller scenes (*kleima*) reflecting everyday life. These were icons to be studied up close, in church or chapel or at home, and, as such, their artistic and decorative qualities also came to matter. The surge in building in sixteenth-century Muscovy, on the other hand, was more directly related to the growth in wealth and power of church and state, whose leaders naturally favored the grander if more austere forms of traditional monumental painting for the walls and vaults of their official edifices.

Meanwhile, as Kondakov long ago pointed out, "serious regard for exact dogma in the details of representations" is still not discernable in Muscovite icon painting—not until the later seventeenth century.[56] Until then, indeed, the theory of images in Russia, as with learning itself, remained in a state of infancy. Nor should we really expect it to have been otherwise, given only the persistently low levels of education and literacy that were mentioned in Chapter 1.[57] In fact, the latter help to account for the increased use and control of imagery by the rulers of church and state and for the growing popularity of images among the subject laity. Students of Muscovite political history have made this point as well, confirming from their researches the huge political as well as social importance of imagery in Muscovy. As Nancy Kollmann puts it:

> In the absence of direct source testimony, other patterns of source evidence suggest that nonverbal means of communication were well developed in Muscovy, complementing the circumscribed nature of literacy in the sixteenth century. Only a small, generally ecclesiastical stratum could read, and what it had available to read was confined to the religious

Revolution in Architecture, especially pp. 51–52.

worldview displayed in ritual and visual imagery. With so self-contained a sphere for the written word, visual means of communication took on singular importance; frescos, icons, iconostases, liturgy, music, and cross processions were the primary means of transmitting God's word. The grand-princely [or royal] processions shared that message and symbolic medium. A Muscovite audience would have read these pilgrimages and processions as demonstrations of the splendor of the ruler, of the power of his entourage, of his intimacy with prelates of the church, of his devotion to the service of God.

Similarly Rowland:

An emphasis on audience leads to a study of visual rather than textual evidence. In a society that was overwhelmingly illiterate, images were accessible to many more people than written texts were, and there were many more of them. As objects, they were also more powerful. . . . One of the striking features of Muscovite literary life is that much more energy was spent on editing and compiling previously existing works than was expended on the composition of original works. Original texts on general or abstract political subjects are particularly hard to find. Under these circumstances, the mural cycles in the Kremlin and the increasingly complex and didactic icons that were closely related to them may represent the best evidence we have of Muscovy's historical imagination and her political image of herself. Further, it was far harder to copy a mural cycle from another time and place than it was to copy a text, which could be easily transported.

Rowland also notes that despite the virtual explosion of building and decorating in Muscovite Russia "historians have paid remarkably little attention to this visual evidence." In view of the potential gains to be made in our understanding of Muscovite political and social mores, we must hope that such inattention does not persist, and that his own example here as well as Kollmann's will be followed by other historians.[58]

Finally, we might observe that the political, social, and cultural importance of sacred imagery in Muscovite Russia indicates one major reason—perhaps the key reason—why the Protestant Reformation, rampant on Russia's western borders, never made much headway in Russia itself (not until the nineteenth century, anyway). This problem has been aired most helpfully by a Polish historian, in the context of a more general study of the image question in Orthodox-Protestant relations of the sixteenth century and thereafter, relations in which this question played a "more than considerable" role: indeed, "Other questions may have dominated in particular disputes or opinions, but in the long term none of them . . . was as important at the popular level as the image problem." Michalski finds that defense of the holy images—of their special place in the economy of salvation and of the rightness therefore of venerating them—assumed in the face of various Protestant challenges and of the indigenous if always weak iconoclastic ("Judaizing") current a lasting

patriotic stamp in Muscovy. He offers a telling example from a writing of 1567 by Metropolitan (later St.) Philip of Moscow justifying Ivan IV's long Livonian war for control of Baltic coastlands where Protestants lived, with its reference to "loathsome Germans" who had "succumbed to many various heresies, above all the fallacy of Luther, destroying holy churches and desecrating venerable images." Michalski allows that this attitude was unquestionably grounded in "authentic experiences and indignation connected with the iconoclasm of the Reformation"; but long thereafter, as he points out, "tsarist propaganda labelled all opponents of Russia iconoclasts."[59]

The patriotic was an important element of the artistic legacy inherited by Peter I and his friends, one that would bedevil accordingly their effort to reform Russian imagery along "German" lines and even, with respect to the cult art of the Russian church, help defeat it. Meanwhile, we should note, it was not until the later seventeenth century that a full theory of images emerged in Moscow—only then to be compromised, in the view of traditionalists, by the influence of Renaissance and Baroque values emanating from the Latin West. We resume this story in Chapter 3. Before proceeding, however, we might look at manuscript illumination for a singular test of the basic points being made here about imagery in Muscovy.

Manuscript Illumination

Muscovite manuscript illumination exhibits marked differences from that of either Byzantium or the medieval West. They are differences, viewed retrospectively, of timing (chronology or periodization), volume, function, and quality—the last always a somewhat slippery category, of course. Considered alongside the production of the other centers of the Christian world, that is, the illumination of manuscripts in Muscovy was slow to develop at all and late to achieve significant volume; tended for a long time to derive its images from panel and wall painting (rather than the other way around), and to accompany rather than illustrate the texts it adorned; and never came close to attaining the artistic quality of the best manuscript painting of either East or West. In the sixteenth century the art of illumination did acquire considerable political if not social importance in Russia, a status that it carried over into the seventeenth century, when it began to be superceded by the printing of images and was then overwhelmed by the Petrine revolution. Yet in Russia, again unlike developments in the West, the arrival of print did not completely extinguish manuscript illumination, which instead continued actively in existence, albeit as a provincial or sectarian craft, until the twentieth century.

We glanced in the previous chapter at the evolution of Western manuscript illumination through Carolingian and Ottonian times, the more varied Romanesque period, the increasingly voluminous early and late Gothic periods, when in France and Flanders it reached states of perfection that contributed in important ways to the Renaissance in art, and on into the Renaissance itself,

when it reflected the full range of pictorial and decorative innovations. We also saw that by the later Middle Ages changes in patronage, away from the near monopoly of churchmen in favor of students and burghers, aristocrats and monarchs, were widening the range of books produced: not only illustrated bibles and psalters as before but histories and chronicles, astronomical and medical treatises, literary and mathematical works, travel books or books of marvels (*livres des merveilles*), epic poems and chivalrous romances, the last including stories of the Trojan War, of Alexander the Great, of King Arthur and Charlemagne and their paladins, of the lovers Tristan and Iseult. In short, illustrated books still in the scribal age in Europe were becoming instructional and recreational as well as devotional, and increasingly popular. The first printed books closely imitated manuscript books in format and style and choice of subject, as was also mentioned earlier; but with the rapid spread from the later fifteenth century of both printed books and illustration by woodcut or copperplate engraving, illuminated manuscripts became a luxury that only a few patrons could afford. In the seventeenth century the illustration, indeed the production of manuscript books virtually ceased in Europe, even in Spain and Portugal, where ecclesiastical patrons had ensured the survival of fine illumination down to a comparatively late date.[60]

It is necessary to emphasize, as we proceed to Russia, the volume of production, variety of subject matter, and artistic finesse achieved by manuscript illumination in Europe by the fifteenth century. Referring just to the years 1380–1420, one student remarks that "hundreds of artists of the first order in every part of Europe were creating thousands of small masterpieces" *annually*.[61] Even Byzantine illumination at its best and most productive, fructifying as it periodically may have its Western analogue, did not rival this achievement. Byzantine illumination flowered in the sixth century and again, following official resolution of the iconoclast controversy, from the later ninth to the twelfth centuries, when the Latin conquest (1204–1261) largely put an end to artistic development in the Byzantine heartland until the "Palaeologan renaissance" of the fourteenth century. This splendid renaissance, in manuscript illumination as in other visual arts, no doubt contributed as we noted earlier to the onset of the Renaissance in Italy. But after Constantinople's capture by the Turks in 1453, Byzantine manuscript painting, already moribund, survived only in places like Crete, where artists concentrated their efforts on preserving earlier traditions. This is a constant theme of the concerned scholarship: by 1453 an era of retrenchment in Byzantine manuscript illumination, and then of stagnation, had set in. Moreover Byzantine illumination remained from beginning to end overwhelmingly religious in content, with Evangelist portraits predominating.[62]

Muscovy was something of a cultural colony of Byzantium in this as in other respects, certainly, and Moscow was one of those Orthodox centers in which Byzantine illumination perpetuated itself after 1453. But it was always a distant "center," its illustrated manuscripts revealing at best distant or be-

lated connections with the art of the metropolis, limited as that art was by comparison with contemporary Western illumination. Indeed it would be difficult to prove that Byzantine models directly inspired Muscovite illuminators until, once more, the *seventeenth* century, if only for the fact that no such models survive in Russian repositories. More precisely, it seems that all of the Byzantine illuminated manuscripts now in Russian collections were acquired only in the nineteenth and twentieth centuries.[63] Thus, of the 1,575 manuscript books preserved from the former Novgorod cathedral library, the oldest and always one of the most important libraries on Russian territory, only twenty-five contain miniatures; yet none of these is Byzantine: all are East Slavic or Russian productions, more than half of which seem to date to the seventeenth and eighteenth centuries.[64] Again, of some 500 Greek manuscripts on deposit in the Synodal, formerly the Patriarchal Library in Moscow in 1894, at least 350 had been purchased on Mount Athos by the monk Arsenii Sukhanov, who in 1653 was dispatched for that purpose by Patriarch Nikon and Tsar Aleksei with a purse of 3,000 rubles; in 1655 Arsenii returned to Moscow with his haul, surely one of the largest such transactions in history; but none of his purchases, many of which dated to the early, middle, and late Byzantine periods, is known to have contained miniatures. Of the remaining 150 Greek manuscripts in this library, which were acquired at various times, nearly 100 date to the sixteenth (thirty) and seventeenth (sixty-five) centuries; which leaves about fifty miscellaneous Greek manuscripts of undetermined date and provenance, none it seems with miniatures, in this, the oldest library in Moscow.[65]

The periodic devastations visited on Russian monasteries and towns between the thirteenth and seventeenth centuries, it is true, could well have destroyed any number of Byzantine illuminated books as well as local products. But we should also remember that before the seventeenth century scarcely anyone in Muscovy could read Greek, making it likely that original Byzantine writings were in any case few and far between. It is much more probable that in these centuries local artists drew for their models on earlier Russian or East Slavic illustrated manuscripts, especially the products of Novgorod (conquered by Moscow in the 1470s) and, still earlier, of Kiev (or on early Kiev works preserved at Novgorod). It is more likely still, as we will see, that Russian illuminators before the sixteenth century drew as a rule on local examples of panel and wall painting, creating their own tradition.

At all events, some 112 manuscripts illuminated on core Russian territory between about 1200 and 1430 have now been identified—nineteen of them produced in the thirteenth century, the rest between 1400 and 1430. At least forty of these manuscripts, all written in Church Slavonic, carry excerpts from the New Testament; another thirty-five are devotional works; five are collections of church canons; and the remainder are mostly lives of Byzantine and East Slavic saints together with a few sermons of the Eastern church fathers, notably St. Basil the Great. These data tend to bear out the point made earlier

in this chapter, citing Meyendorff, regarding the narrowness of the Byzantine literary heritage as it was transmitted to Muscovy, both directly and by way of South Slavic or earlier East Slavic intermediaries. The Russian art historian Vzdornov confirms that the number of illuminated manuscripts produced in Rostov, Tver, Iaroslavl, and Moscow—towns of the Russian core—before the fifteenth century is "not great" by comparison with Byzantium or even with Novgorod, and that the "quality" of these earliest Muscovite productions "leaves something to be desired."[66]

Similarly, O. S. Popova, perhaps the leading authority on early Russian miniatures, is struck by how few are to be found in Russian manuscripts produced before the sixteenth century relative either to contemporary Russian panel and wall paintings or to surviving Byzantine miniatures—"not to mention those of the Latin West." This paucity of early Russian miniatures, she suggests, is not sufficiently explained by the customary reference to the ravages of time, which were no less destructive of panel painting. The true cause lies rather "in the specific character of Russian artistic life": in the absence, more exactly, of that "ample urban culture so typical of the Gothic West" and in the "diffusion of literary activity to [a few] main monasteries," this "in contrast to its concentration, in Byzantium, in the scriptoria of the emperor." Moreover, until the sixteenth century the "Russian miniature as it were ignored both the traditions of book illustration properly speaking and the characteristic traits of the minor arts." As Popova explains it,

> The manner of Russian miniatures very often recalls that of murals, less often that of icons, but almost always indicates a transposition to parchment of the style of the "major" arts and the fidelity of the miniaturist to an iconographic type, a spiritual model, and numerous stylistic techniques borrowed almost literally from the art of panel or wall painting. Only rarely are manuscripts ornamented with miniatures which really illustrate the text, explaining the content while providing a decorative component [the examples cited are from the so-called Kiev or Spiridon Psalter of 1397, which was "probably illustrated in Moscow"]. But such works are not typical of Russian art; they are copies of Greek originals. Most Russian miniaturists, on the contrary, followed the principles of "major" painting.[67]

Popova thus seems to suggest that there were few models of any kind, Byzantine or East Slavic, available for Russian miniaturists to copy in these earlier centuries; equally, that the Russian artists, uninterested in the texts of their manuscripts (unable to read them?), had little choice but to copy from the icons and murals about them in their recurrent depictions of the Deesis, certain saints, and, above all, the Evangelists. Her story receives confirmation in Vzdornov's discovery that scribes were early (that is, always?) separated from illuminators in Muscovy, and that the illuminations in early Russian manuscripts were done by special artists working in special shops in those major ecclesiastical and political towns of Rostov, Tver, and Moscow.[68] In

short, copying manuscripts and producing images on paper (or parchment) to accompany them (or not) were from the beginning completely separate occupations in Muscovy, a finding that in its turn corresponds well with what scholars consider the generally low levels of Muscovite literacy and book learning.[69]

Popova also observes that Russian miniatures lack the "complexity of pictorial technique, the mastery of execution, the fidelity to the text, and the full integration within the page itself" of Byzantine miniatures, and that they emphasize rather "feeling" and the "general idea," pursuing didactic purposes directed to a wider public which were little suited to the reduced format and necessarily individualized reading of an illustrated manuscript. Russian miniatures, as she says,

> conserve the old traditions. They are archaic and austere, primitive [farouches] guardians of the ideals of yesteryear, even when the latter have lost their vital force. Throughout the thirteenth and fourteenth centuries the Russian miniature preserved the characteristics of an [earlier] style, a solemn and hieratic style, one full of reserve and deep significance, and seemingly oblivious to the passage of time.

That earlier style, to repeat, was not Byzantine strictly speaking but rather East Slavic; which means that the sources of this archaic art are to be sought not in works painted in Constantinople or one of the other major centers of Byzantine art, but in the East Slavic world of the eleventh century with its capital at Kiev. The miniatures of this "Kiev school," painted by local masters, exhibit a decided rusticalization of Byzantine norms—in Popova's words, "an enlargement of the image together with a simplification of manner," a new "ostentation" and a comparative lack of "dogmatism," a "grandiosity linked with a certain naivete," etc. Eleventh-century Kiev traditions informed all of East Slavic manuscript illumination, in all its variation, in the centuries immediately following the Mongol destruction of Kiev itself (1240s).[70]

With respect to Muscovy, however, a further and more important source of models for miniaturists to copy was Novgorod, which, like Kiev, had direct links with Byzantium but which, unlike Kiev, remained largely free of outside domination until conquered by Moscow in the 1470s. A scriptorium existed at the archbishop's palace in Novgorod from the mid-fourteenth century, a fact that explains the considerable stylistic uniformity of fifteenth-century Novgorod manuscripts. Feofan Grek arrived in Novgorod not later than 1378, as cited earlier in this chapter, contributing a fresh Byzantine impetus to this "Novgorod school." Lazarev proposes that when Feofan moved to Moscow in about 1390 he founded a workshop which in turn powerfully stimulated the budding "Moscow school" of illumination. He points in evidence to two works executed in Moscow in the 1390s or the very early fifteenth century (one being the well-known Khitrovo Gospel Lectionary), and argues that their headpieces, initials, and miniatures could only have been produced by local

artists working under the direct supervision of Feofan, since they all reflect Byzantine and Gothic norms previously unknown in Moscow. Numerous works produced by this school in the fifteenth century testify to its continued existence. The arrival from Novgorod of the prelate and icon painter Makarii (whom we also met earlier), to be head of the church in Moscow (1542–1563), then caused the Moscow school to flower, stimulated now by Metropolitan Makarii and artists from Novgorod. This is an altogether plausible explanation of the mechanics so to speak of the rise of miniature painting in Moscow, by now indisputably the Russian capital.[71]

In any case, Popova and others[72] agree that in the fifteenth century artistic life in Russia, increasingly centered in Moscow, experienced both greater uniformity and greater vitality than in the preceding period. The interpenetration of local and imported styles, the latter mainly Greek and South Slavic but also Western,[73] favored the appearance in Moscow of a style that was "truly Russian" and one that in time would become a "national style valid for all of Russia." This was the context that produced, by the end of the fifteenth century, a florescence of miniature painting which paralleled, not coincidentally, the much vaunted "Golden Age" of Andrei Rublev and others in panel and wall painting.[74] Indeed Popova considers that the finest examples of Muscovite illumination were painted by Rublev himself. These are the eight miniatures—four framed portraits of the Evangelists and four round medallions depicting their emblems (an angel for Matthew, a winged lion for Mark, a winged ox for Luke, and an eagle for John)—of the Khitrovo Gospel Lectionary (*Evangelie*) mentioned above and so-called because it was given in 1677 by Tsar Aleksei to Boyar B. M. Khitrovo, who then gave it that same year, for historic preservation ("radi drevnego pis'ma"),[75] to the Trinity–St. Sergius monastery near Moscow (whence it passed to the Lenin Library [GBL] in 1931). It is a richly decorated work on parchment of some 300 leaves, and in its setting it certainly represented a great achievement; the master of the Khitrovo miniatures was evidently acquainted with later Byzantine as well as Gothic painting.[76] Soon after its creation (ca. 1415), in proof of its prestige, the Khitrovo Gospel book was copied complete with its eight miniatures on orders from the head of the Muscovite church for deposit in his Dormition cathedral.[77]

Later in the fifteenth century imported paper began to be used in manuscript illumination in Muscovy, replacing, as it had in Europe generally, the much more expensive parchment. Yet it is premature to speak of the century as one that witnessed the rise of a "national" school in this or any other form of painting, whether we think of volume of production or level of artistic quality or of the underlying concept of nation. It was rather in the *sixteenth* century, that period of the first great boom in Muscovite church construction and of the first great debates in Moscow over the nature and proper depiction of holy images, that we find population aggregates, accumulations of wealth, and the concentration of political power reaching levels sufficient to support

a flowering of the visual arts on something like a truly national scale. This flowering was sponsored by grandees of the newly strengthened state and church, and it naturally owed something as well to Muscovy's expanding political and commercial relations with Europe.

The most imposing example in the whole history of Russian manuscript illumination is the celebrated chronicle of some 10,000 leaves and 16,000 miniatures compiled and illustrated in Moscow in the later sixteenth century under the auspices of the first tsar, Ivan IV.[78] This grandiose work on fine French paper presents in text and images a kind of world chronology culminating in the rise of the Muscovite monarchy (to 1567) based on various Russian, East Slavic, Byzantine, and Western chronicles, the Bible, and other sources. The pictures, in watercolor, predominate, and seek to illustrate the text. Many of them depict, in a sketchily realistic way, details of Muscovite architecture and of the economy, of contemporary social and political life.[79] In their abundance they attest to a new fluency if not facility in drawing and to a new freedom in combining or adapting conventional images, thereby expanding the repertory: many of the texts had not been illustrated before by Russians. At the same time, in their depictions of people and landscapes, of buildings and battle scenes, these thousands of miniatures exhibit an overall uniformity and formality as well as an abstract, two-dimensional, static quality that are decidedly medieval in any larger context. King David, the heroes of Troy, the Byzantine emperors, even the familiar Moscow princes are all represented in the image of the ideal Byzantine ruler: in sketchily sumptuous Byzantine dress, against a traditional architectural background, in virtually the same pose. Whatever its value as a political statement or, much later, as a historical source; whatever its influence on contemporary or later illustrators (presumed to have been great), this gargantuan project of the reign of Ivan IV marked in fact the culmination of a cycle of manuscript illumination reaching back two centuries and more. Other, smaller works done in these years in Moscow, particularly those registering the influence of the new European art, superceded it in various ways, setting standards that were to be followed in the decades to come.[80]

The European influence evident in many Muscovite miniatures of the sixteenth century, an influence that was exercised, presumably, through engraved prints circulating among Russian artists and patrons, is quite unmistakable. It is to be seen in certain architectural details and contours of landscape, in the depiction now and again of trees and clothes, in innovations in the organization of space, in more expressive faces and figures, in sharper drawing, in sporadic attempts at linear perspective, and so on: in an evident striving by Muscovite miniaturists for greater degrees of naturalism. This trend, coupled with a tendency now for manuscript illumination to influence panel and wall painting, reversing the traditional pattern, signaled an important new development in the mechanics of image-making in Russia.

We noted earlier that *zhitiinye* (biographical) icons had become popular in

sixteenth-century Muscovy, icons, that is, which represented the life of a saint or a moral tale in a series of discrete compositions or episodes—*kleima*—framing a central image. The style in which these *kleima* were painted as well as their small size and obvious narrative function all point to the direct influence of book miniatures. Meanwhile the murals in Muscovite churches were losing their monumental quality, as we saw, becoming smaller, more numerous, and more narrative in purpose, a trend that points in the same direction. Equally significant in this connection are those pattern books or *podlinniki* that began to appear in the later sixteenth century for the use of painters trying to meet the demand for icons of increasingly varied or complex imagery (fig. 8). Many of the images reproduced in these manuals are nearly identical to those found in contemporary and earlier illuminated manuscripts. By the end of the sixteenth century, it would seem, a kind of conveyer belt for images—from paper to panel or wall—had come into being, facilitating not only the emergence of a distinctive Muscovite style in painting but also its penetration by European influences. And this tendency was only intensified in the succeeding century, when, as scholars have remarked, the influence of miniatures on panel icons becomes indisputable and murals in turn "give the impression of [panel] icons transferred to walls."[81]

As it had in Europe generally, the introduction of bookprinting in Russia, comparatively belated and gradual though it was, considerably curtailed the production of manuscripts including illuminated manuscripts. The latter were now made primarily for special purposes or for special occasions: to endow a church or a monastery, or to commemorate a major state event. But we also notice that the quality and character of the best illuminated manuscripts change significantly, too. The highly intricate decoration of sixteenth-century works, a feature that surely is owed, at least in part, to Persian prototypes, gives way to bolder, simpler, heavier, relief-like ornaments reflecting, quite possibly, contemporary Muscovite jewelry and such other decorated objects as icon frames, ceremonial harness, tableware, and weapons: objects which reflect in turn strong Turkish as well as European influence.[82] Then again, in *later* seventeenth-century manuscript books more purely European decorative elements become pronounced, while the solid ranks of uncial and semi-uncial letters of the text itself are steadily displaced by waves of linear, fluttering cursive. More striking still, as the seventeenth century draws to a close the miniatures themselves of Muscovite manuscript books increasingly reflect the new European imagery in both content and style, with corresponding increases in the ratio of naturalism.[83] In other words, in this as in other forms of imagery we see the traces of Muscovy's growing contact with the outside world, particularly Europe.

A book on the election of Michael Romanov as tsar in 1613, written in semi-uncial letters on paper and illustrated in Moscow in 1672–1673, is considered a masterpiece of Russian illumination in its last high-art phase.[84] But the twenty-one miniatures interspersed on the book's fifty-seven leaves look ar-

chaic even in a Russian context: repetitious, linear, stylized, their distinctiveness lying in the multiplicity of human figures, the attempts at linear perspective, and the sketchily realistic architectural detail. Another political work produced at this time for the Ambassadorial Office by masters in its pay is the so-called *Tituliarnik* or *Book of Titles,* a sort of illustrated manual of diplomatic protocol which included a genealogy of Russian rulers from legendary figures of the distant past to the infant Peter I. Three contemporary copies of this work, and one done in the eighteenth century, survive.[85] But again, the many and often virtually identical pictures of Russian rulers, iconic in style, evoke medieval types, as do those of the Russian patriarchs; none of these pictures could be called portraits in any new sense of the term and only a few suggest, at best, a kind of caricature (fig. 9). On the other hand, the pictures of contemporary European rulers included in the book are naturalistic in varying degrees, having been more or less ably copied from Dutch, French, or Italian engravings some of which are still in Russian collections. But these portraits

Figure 9 *Parsuna* ("portrait") of Tsar Aleksei Mikhailovich (father of Peter I) from the *Tituliarnik* of 1672. Pen and watercolor on paper.

are persistently misidentified: that of "Charles VI, Spanish king" was copied in fact from an engraving of his predecessor, Philip IV; "Christian V, Danish king" is after an engraving of his father, Frederick III; the face of "Louis XV, French king" closely resembles an engraved portrait of Louis XIV; and so on.[86] It would seem that the Russian artists viewed these imported engravings, whose captions all clearly identified their subjects, *iconically:* as static, conventional images of European royalty rather than as portraits of particular rulers—of individual human beings.

The bulk of seventeenth-century Russian manuscript books remained, to be sure, religious in content. And it is here that we find, for example in a Gospel lectionary of 1678 given by Tsar Fedor Alekseevich (elder half-brother of Peter I) to a church in the Kremlin, hundreds of miniatures painted in a startling combination of established Muscovite and new European styles. Figures and architectural elements, taken undoubtedly from fairly recent European engravings, are mixed with ornaments both old and new, local and imported. A collection of edifying texts and pictures—*Dushevnoe lekarstvo (Soul Medicine)*—prepared at the Armory Chamber in 1670, presumably for the royal family, includes the first known Russian genre miniatures: miniatures that suggest nothing so much as the everyday figures and scenes common in European illustration from the fifteenth century and hence are of very doubtful value as representations of later seventeenth-century Russian life.[87] The same can be said for the approximately 4,000 miniatures illustrating a grandiose lectionary done for the Siiskii monastery (on the northern Dvina) in 1693. One authority remarks that all of these works reveal, "to one degree or another, currents flowing from the West." [88] These "currents" may be described rather as an incipient flood.

Contrary to what happened earlier in Europe, as mentioned above, the advent of printing in Russia and the collapse of elite patronage did not bring to an end the production of manuscript books. Particularly in conservative religious communities concentrated in remote northern or Siberian settlements, but also at middling levels of society in Moscow itself and throughout Russia proper, levels that included poor scholars working in monasteries and ecclesiastical colleges, books continued to be written and copied by hand—copied, often enough, from printed editions. The practice persisted down through the eighteenth and on into the nineteenth, even the twentieth, centuries. The many thousands of resultant manuscript books, devotional or polemical works for the most part but also folktales and grammars, frequently included pictures and decorations, albeit crudely painted by the standards of the best Muscovite illumination.[89] The underlying causes of this comparative anomaly were economic in nature (the relatively high cost of printed books), political (censorship and state control of printing facilities), and customary or psychological (the attitudes of Old Believers towards products of the state and official church). But here it is enough to register the persistence itself of a visual art—manuscript illumination—that had all but disappeared in Europe in the

wake of the print revolution, and well before the onset of the Petrine cultural revolution in Russia.

In sum, the case of manuscript illumination in pre-Petrine Russia, while not entirely typical of the visual arts as a whole, nevertheless reveals or confirms several points of continuing interest to us. One is the paucity, in this regard as in others, of the Byzantine heritage—and of book culture as a whole—in Old Russia. Another is the comparatively late date—the sixteenth century— at which manuscript illumination can be said to have flourished in Russia even at the elite or official level. A third is the role it then assumed as a source of imagery across the board, thus facilitating both the formation of a national visual culture and its penetration by European imagery—and in both ways preparing the ground for the Petrine revolution.

A last point worth noting in this connection is the office that manuscript illumination performed, along with the scribal tradition more broadly, in preserving Muscovite culture at a popular or mass level for decades, even centuries, after Peter. One may consider this feat of preservation a sign of persistent Russian backwardness vis-à-vis the main currents of European including Imperial or modern Russian civilization, a backwardness that is largely attributable to the persistent isolation of much of Russian society. Be that as it may, these deposits of the traditional scribal culture, like panel icons preserved from Muscovite times or painted in traditional styles, proved to be richly rewarding for later students and admirers of pre-Petrine or popular Russian culture, who professed to find in them precious remains of the authentic Russian spirit as well as material evidence of past realities. We are indebted in either case particularly to Old-Believer communities of the eighteenth and nineteenth centuries, animated as they were by visions of saving the world from modernity's corruptions.[90]

Contemporary European Views

Finally, in our effort to apprehend the visual heritage that was Peter's on the eve of his revolution, we turn to the assessments of contemporary European visitors, a subject broached in Chapter 1. We report these contemporary assessments in all their evident prejudice and subjectivity because the essence of Peter's revolution lay in a quite subjective change of attitude: in an assumption by him and members of the Russian elite that the new imagery of Europe was better in important respects than the old imagery of Russia. A convergence of taste as well as of purpose or interest motivated the rapid Europeanization of Russian culture that Peter undertook, in other words, a convergence that entailed acceptance by Russians of the European view of their art. Moreover the testimony of these foreign witnesses, vital as it thus is, has been almost entirely ignored by Russian students.

Europeans from well to the west began arriving in Muscovy in significant numbers in the middle of the sixteenth century, in the time of Ivan IV. They

came on diplomatic and especially commercial missions to establish links of growing importance between Muscovy and their home states and economies. Dutch and English merchants were the most active in this burgeoning Muscovite trade followed by Germans from such cities as Hamburg and Lübeck and by Swedes and Danes. The Russians usually referred to them all, with good enough reason, as "Germans" (*nemtsy*); they were all, or almost all, Protestants (Lutherans, Calvinists, Anglicans), meaning iconoclasts to a greater or lesser degree and for that reason alone likely to be viewed by iconodule Russians with suspicion if not outright hostility. In return, so to speak, their Protestantism tended to color these "Germans'" view of what they saw in Russia, a point that is clearly reflected in the accounts of their journeys which some of them left behind. There we find the first direct evidence of Western criticism of Russian imagery—criticism that Russians up to and including Tsar Peter (and many students thereafter) would eventually take to heart. Indeed it is worth stressing that under Peter the leaders of Russian society would swallow the criticism and its implied artistic standards more or less whole, producing a consensus that would effectively nullify, for them and their successors, the conventions of pre-Petrine Russian art.

Of the Russe Commonwealth, by Giles Fletcher, the learned English ambassador to Moscow in 1588–1589, has been judged the best foreign work on Russia before Peter's time.[91] In an extended passage on religion Fletcher states: "They have an image of Christ which they call *nerukotvornyi,* which signifieth as much as 'made without hands,' for so their priests and superstition withal persuadeth them it was. This in their processions they carry about with them high upon a pole enclosed within a pyx made like a lantern, and do reverence to it as to a great mystery" (pl. 6). Fletcher repeatedly refers to holy images in Muscovy as "their idols," at one point denouncing the "horrible excess of idolatry after the grossest and profanest manner" engaged in by Russians, "giving unto their images all religious worship of prayer, thanksgiving, offerings, and adoration with prostrating and knocking their heads to the ground before them as to God himself," and defending such conduct by saying that "because they do it to the picture, not to the portraiture of the saint, they worship not an idol but the saint in his image and so offend not God," thus "forgetting the commandment of God that forbiddeth to make the image or likeness of anything for any religious worship or use whatsoever." Fletcher reports that "their church walls are very full" of such icons, "richly hanged and set forth with pearl and stone upon the [panel], though some also they have embossed that stick from the board almost an inch outward": a reference to the growing practice in late sixteenth-century Muscovy of attaching jewels and gilt-metal halos or crowns to icons and of covering them with richly decorated frames (*oklady*) which often left exposed only the face and hands of the painting's subject (fig. 10). Muscovites called their icons, says Fletcher, "*chudotvortsy,* or their miracle workers."[92]

Fletcher obviously shared the iconoclastic position on images expressed not

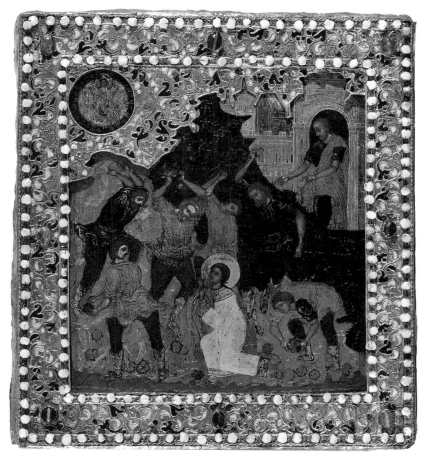

Figure 10 *The Martyrdom of St. Stephen.* Moscow school, later sixteenth century. Tempera on panel; attached silver and enamel frame studded with gemstones. St. Stephen (martyred ca. 35 A.D.) was one of the earliest and most popular saints of the Christian church, Eastern and Western, but his veneration was relatively recent in Russia, a product of late Byzantine influence.

long before, and directly to the tsar, by Jan Rokyta. He also attributed Russian "idolatry" to ignorance: to the fact that the Muscovite hierarchy was "void of all manner of learning" and the ordinary clergy, "utterly unlearned";[93] comments that we may construe as testimony to the predominantly visual nature of Muscovite religious culture. Yet other European visitors were less judgmental in the matter, if similarly disposed to criticism and attendant diagnosis. We have already met Adam Olearius (Oelschläger), the German Protestant scholar who served in several missions to Muscovy between 1634 and 1643 sent by Duke Frederich of Holstein, a patron of learning who was especially concerned that Olearius should describe in detail what he saw; the result was the big book first published at Schleswig in 1647 which thereafter achieved

enormous success in Europe, as attested by its numerous later editions and translations (Chap. 1). Olearius reports, for instance, that soon after entering the country he stopped at a monastery near Novgorod, where an old monk showed him the church, one wall of which displayed "what he called 'The Miracle of St. Nicholas,' naively and inartistically depicted, like most of their paintings." Since Russians believed that "coitus is not supposed to take place in the presence of icons," Olearius claims to have learned, the latter were "carefully covered" during sexual intercourse. A Scottish officer in Russian service fell into great trouble with his servants, Olearius was told, for not giving them enough time in the morning to venerate their icons, for which he was denounced to the patriarch of Moscow; but "most reprehensible of all" for the Russians involved was the fact that in her exasperation the officer's wife took an icon from the wall and threw it in a glowing oven, where it was consumed—"for the Russians, a great and terrible accusation." Olearius was induced by these and like observations to ask whether the Russians were actually Christians, and for himself concluded: "It cannot be doubted that their faith, or the substance of their belief (*Fides, quae creditur*), is Christian; but, as it is also said in the schools, the way they express this belief (*Fides, qua creditur*) is questionable, and turns out in fact to be very poor." Equally questionable was the fact, as Olearius found it, that "they revere no icons except those painted by Russians or Greeks, as if other peoples do not make them beautifully or artistically; or as if something of the artist's religion might be transmitted to the picture!"[94] We know from Russian sources already quoted, or still to be cited, that this was certainly true.

Olearius recounts various other instances of Russian credulity, naivety, or superstition regarding their icons but noted that "in general, when intelligent Russians, in keeping with their religion, revere and pray to their sacred images, they pray not to the material substance or because they equate them with a representation of God, but out of love and respect for the saints, who are in heaven. For the honor that they render to the icon is received by him whom the icon portrays." Olearius thus provides evidence that the classic Byzantine theology of images was now known in Russia, if only among "intelligent" people. A Russian merchant whom he met once took his handkerchief up to an icon and said, "'With this I may wipe off the paint and then may burn the wood. Am I to seek salvation in this?'" Hearing the merchant lament that "very many of his countrymen had no such understanding of religious matters," Olearius asked him "why he, who was so enlightened about God, did not teach his brothers the better way." To which the merchant replied that he "did not have the calling; besides, rather than believe him, they would take him for a heretic."[95]

We have also met Samuel Collins, born in Essex, educated at the universities of Cambridge and Padua, and physician to Tsar Aleksei (Peter's father) from 1660 to 1669; after returning to England he wrote an essay on the country whose ruler he had attended. In his essay Collins observes that "they follow

the Greeks, though lamely, in the architecture of their churches, whose chief ornaments are images adorned with rich stones and pearls, and wherein they admit no sculpture but only painting; for they look upon the Romish statue-worship as idolatry." Collins thus reminds us of a considerable psychological obstacle in Russia to the admission of the new European art, namely, the age-old prohibition of graven images. At the same time, he faintly reminds us of Vasari writing about painting in Italy before Cimabue: "Their imagery is very pitiful painting," as he says at one point, "flat and ugly, after the Greek manner." And then:

> I asking why they made their Gods so deformed, they answered me, they were not proud. When a picture is worn out, they bring it into the God-market, where laying it down they chuse out a new one, and deposite money for the exchange (for they must not be said to buy it); if the money be not enough, the God-maker shoves it back, and then the *Devoto* adds more, till the other be satisfied. . . . They bestow jewels upon them [icons] of great value . . . if you saw their images, you would take them for no better than guilded ginger-bread [fig. 10].[96]

This was imagery ripe for a Renaissance, in Collins's view, if not also for a Reformation.

Virtually all of the contemporary European visitors who recorded their views remarked on the "God market" in Moscow, where convention held that icons were not bought and sold but simply exchanged for a kind of donation, and on the Muscovite habit of referring to their icons as "gods." These were aspects of what a disgusted Dutchman in the tsar's service in the 1660s called the "image-worship" practiced by Muscovites,[97] but that other European visitors, like Olearius, were willing to view more dispassionately. Guy Miege, to take another example, secretary of the English embassy of 1663–1664, noticed that icons were frequently to be found posted in the streets of Moscow and other towns "over the porch" or "in the market places" or "over the city gates," and that "all who pass that way make a stand for a while before them, till they have made reverence to them five or six times one after another, which is performed by crossing themselves with three fingers of their right hand and by saying with a low voice, *God have mercy on me*." And so on. To Miege, Swiss in origin and perhaps Catholic in religion, the custom was less a case of superstition than of the Russians' "profound reverence to their images."[98]

Balthasar Coyet, secretary in the Dutch embassy to Russia of 1675–1676, also reported that the Russians prohibited sculpture, that "they honor only images painted by Russians or Greeks, and want none by other masters however tastefully done," and that in Moscow there was a long row of stalls where they continually "exchanged" icons for gold and silver. Coyet noted that the average Russian not only kept personal icons at home but also one in the local church, "before which he says his prayers; sometimes this icon, depending on the wealth of its owner, is decorated with gold and pearls." And if someone

committed a sin so grave as to merit excommunication, "then his icon must be removed from the church; he must take it home, and has no right to bring it back," until he had made amends. But Coyet also saw a full-length portrait of Patriarch Nikon at Nikon's New Jerusalem monastery (on the Novgorod road not far from Moscow) which was "very well painted by a German," and, in the tsar's palace at Kolomenskoe (next to Moscow), "two French pictures showing the nine muses or goddesses of art."[99] Representations of the new European imagery were beginning to appear in the innermost corridors of Muscovite power. The learned Italo-Greek clerical adventurer, Paisius Ligarides, in Moscow in the 1660s, similarly admired the very lifelike, even "stunning" portrait of Nikon "by my friend John, an exceptionally good German artist."[100] We noted earlier that this same Patriarch Nikon, a Russian of humble stock who had never left his native land, once forcefully expressed his disapproval of *icons* painted in the "Italianate" style.[101] It seems that a discreet distinction was now being drawn at the pinnacle of the Muscovite establishment between permissible standards of representation in holy pictures and the standards of what we would call secular art.

In general, then, Roman Catholic visitors to seventeenth-century Russia, when confronted by the ubiquitous and demonstrative Russian veneration of icons, were naturally more forgiving in the matter than their Protestant counterparts. The reaction of J. G. Korb, the Austrian secretary of legation, writing in 1698, is again indicative: "The Greek and Russian church venerates the images of saints with no less devotion than the church of Rome, and justly places much hope and confidence in their suffrages; not giving them that supreme worship of *latria* which belongs to the Majesty of the Almighty Creator of all that exists, but that far different worship which we are entitled to pay to them as friends of God and intercessors for us." It was the classic Christian doctrine on sacred imagery—Latin as well as Greek—as reaffirmed and proclaimed by the Counter-Reformation Council of Trent (December 1563); and it meant, as Korb wrote here, that the "signal honor which the Russians unanimously pay to saints and their images is not to be censured." At the same time, it was "a more knotty question" for Korb "whether particular practices which they use in honour of divers saints be not superstitious; as, for example, when the sick, the helpless, and those who are beyond the aid of human skill fly for refuge to images, which are placed upon their heads with sacerdotal rites."[102]

This brings us into the active reign of Peter I and the festering conflict in Moscow between adherents of the traditional Byzanto-Russian art and others, like Peter himself, who were increasingly attracted to the new imagery. The different standards at issue are more or less clearly reflected in the ensuing comments of European visitors who could now, owing to Peter's policies, reside for years at a time in Russia and become the better informed for it. Such visitors included the German diplomat F. C. Weber, representing King George I of Great Britain in his capacity as Elector of Hanover and resident in Russia

from 1714 to 1719; the engineer John Perry, hired by Peter in England to undertake ambitious building projects in the tsar's dominions, where he worked from 1698 until 1712; and the Dutch gentleman-artist and explorer Cornelis de Bruyn, who crossed and recrossed Russia on his way to Persia and beyond between 1701 and 1707. In writing up their experiences in Russia, all three took advantage of their unprecedented opportunities for observing Russian churches from the inside, Russian society at various levels, and the ruler himself and his family at close range.

Bruyn is the most straightforwardly descriptive of the three. On Tsar Peter's orders he was given a guided tour of the churches in the Moscow Kremlin, well known to be the most sacred in Russia. He found that "the whole" of the Dormition cathedral was "full of pictures of saints and the like, some of them in the Greek taste and not to be called bad." In particular, "a picture they say is by St. Luke is on one side of the high altar, and is a half length of the Virgin represented with Christ kissing her, their faces being close together"; but overall it was "very gloomy and almost black"; and "whether this proceeds from the effects of time, or the smoke of the tapers, or the fancy of the painter, certain it is there is no great matter in it, besides which it is all gilt but the faces and the hands," with "a fine crown of pearls and precious stones upon this Virgin's head, and a collar of pearls which hangs down from about her neck." Bruyn was describing of course the *Mother of God of Vladimir* (pl. 1), blackened with age and encrusted with jewels, the most celebrated icon in Russia, a fine product as we know of twelfth-century Byzantine art but now considered, by the new artistic criteria, "of no great matter." Bruyn then marveled to be shown "a great book, which, upon certain holidays, they carry in procession; it is adorned with precious stones, full of scripture stories in paint, and all in characters of gold": an illuminated manuscript, in short, such as had long since ceased being made in Europe. Bruyn found the other churches of the Kremlin similarly "full of pictures from top to bottom." In the church of the Annunciation he was shown thirty-six silver boxes of saintly relics—bones and "several heads," fragments of the True Cross and the hand of St. Mark, etc.—and would have been shown more "but my curiosity being satisfied, I excused myself, and thanked my conductor for the favour they had done me, which was quite unusual and perhaps without example in that country." [103]

These sights of the Kremlin were in remarkable contrast to things Bruyn saw and did elsewhere in Moscow; for example, in the palace in the so-called German Liberty or settlement (*nemetskaia sloboda*) that had been built for a close favorite of Tsar Peter, the Genevan François Lefort. "It is a great building, after the Italian mode . . . and in it are magnificent apartments, [including] a very fine salon which was hung with rich tapestry." In the salon, readied for the wedding reception of another of Peter's favorites, a rather Baroque scene unfolded: "Here you saw two great leopards with a chain about their necks and with their forepaws upon an escutcheon all of massy silver; as also a large

globe of silver upon the shoulders of an Atlas of the same metal, besides great vases and other pieces of plate. . . ." The two great silver leopards still exist, English made, and treasures today of the Kremlin's Armory museum; they were acquired by agents of the tsar from English merchants at Archangel in 1629.[104]

Bruyn recounts how he himself painted at Peter's request portraits of his three nieces, proceeding "with all the haste I could, and dressed them after the [contemporary] German mode, in which they commonly appear in public; but the heads, which were left to my choice, I dressed in the antique style." The portraits so greatly pleased the tsar and his sister-in-law, Tsaritsa Praskoviia, the girls' mother, that the Tsaritsa asked him to do it again. On another occasion he found himself discussing "the subject of pictures" with Alexander Menshikov, Tsar Peter's great favorite, who spoke "pretty good Dutch" (as did Peter, Bruyn frequently quoting him in Dutch). With the approach of Christmas 1702, Bruyn gave Tsaritsa Praskoviia "a picture I had drawn of the birth of Christ. . . . She seemed to be very much pleased at this." We can image the reaction of Muscovite traditionalists to such a picture, however, though they might have been mollified on touring with Bruyn the Tsaritsa's newly remodeled palace at Izmailovo near Moscow, where "the rooms of the apartment where I stopped were hung, above the doors and windows, with 17 different pictures in the Greek manner, representing their principal saints."[105]

There is ample evidence that the veneration of icons was still very much alive in Petrine Russia at the highest reaches of society as well as at the lowest. John Perry, the English engineer, retails at length various icon-related miracles which his Russian workers maintained to him were "proofs that their worshipping of pictures and sacred things is approved of by God." Perry learned that it was "as much as a man's life is worth to dispute the validity of these things with them," while noting craftily that "these stories very much promote the benefit of the painter's trade." He traveled all over Russia in the course of his nearly fourteen years in the tsar's service and dealt with all kinds of Russians; and everywhere he found manifestations of what he considered idolatry.

> It was the manner of the Russes (especially those that were rich and could afford it) to have their rooms, especially at the upper end and opposite to the doors, all covered with the images or pictures of their saints; and it is still the custom that when any person comes into a room to pay a visit or otherwise, the first thing they do is to cross themselves, saying *Lord have mercy upon me,* at the same time bowing with great reverence to the pictures, and then to turn and make their compliments to the master of the house and so round to the rest of the company. But if it be in a poor man's house and it happens to be a little dark in the room, and the print of the picture perhaps half worn off, and the stranger comes into the room and does not at first see the picture or image set up, he presently

enquires, *O gde Bog?* Where is God? Upon which somebody points at the picture on the wall, and he pays his devotions as aforesaid; and sometimes, as the humour takes them, they bow down to the very ground and knock their heads on the floor.

Perry tried to "reason with them against this idolatrous way of bowing down to mere pictures" but was told that it was "absolutely necessary to have something to cross themselves to, and that it is a thing both very reasonable and decent . . . for which they allege the direction of their holy saints and the customs of their fathers." Even "men of tolerable sense amongst them" would tell Perry that while they knew that "what they worship is a mere picture," still that "in doing this honor to them you do it to God," and that it was a "most modest and successful way" to seek God's favor. For "they make no question but that the saints in heaven do constantly make representation of their prayers to the Almighty."[106]

But Perry was happy to report that Tsar Peter, "who has a more rational sense of God and religion," and "seeing the stupid folly as well as bigotry of his subjects in these matters," meant to change the old ways, first by setting a good example.

> He has reduced the number of his saints in his own houses of residence to the cross or the picture of our blessed Saviour only. And the lords and other persons who are his favorites have been brought in a great measure to follow his example, excepting some few of the old lords.

More particularly, when Peter came on board the ships of his new fleet, in the summer of 1698, and found "the cabins of each ship full of pictures of their saints, according to their usual way," he told the Russian commanders responsible that "one of those pictures or images was enough to cross themselves to, and therefore ordered that all the rest should be taken away, for he would have no more than one in each ship; which has ever since been observed on board his fleet." It was a good story, and probably true, being consistent as we'll see with numerous of Peter's actions. Meanwhile Perry could observe with some satisfaction that "there is no great difference between the Russ religion and that of the Papists with respect to their adoration of saints," and be pleased to think that "were the Christian religion laid down to them in that purity as it was delivered by our Saviour and his Apostles, and as it is taught by the doctrine of the Church of England," all would be well.[107]

It is doubtless significant that, by comparison with Bruyn and Perry, F. C. Weber, the third of our witnesses, has little to say about holy images in his long and detailed memoir of his residency in Russia, which occurred in the later years of Peter's reign. It seems that he had scarcely noticed them, or scarcely would deign to describe them, commenting only that icons were still to be seen everywhere and that, like other such "superstitions among the Russians," Peter was trying to curb the practice of venerating them. At the Dormition cathedral in the Kremlin, Weber observed only that a "picture of

the Virgin Mary and other ornaments were set with such a quantity of pearls and precious stones that the whole value was reckoned to 50,000 crowns and upwards. The priests showed me another picture of the Virgin Mary, pretended to be drawn by St. Luke" (pl. 1). Prince Gagarin, the governor of Moscow, took Weber to the private rooms of his splendid mansion "and showed me his *Bog* or God, which was covered almost quite over with diamonds of great value"; in fact, it had cost the prince, Weber was assured by local jewelers, some 130,000 rubles. Apparently he saw icons as objects in a strange and superstitious cult, their real value a matter of their gold and silver and jeweled decoration. Weber was effusive meanwhile in praise of Peter's attention to the new art, citing the "great encouragements" he had given to artists of all kinds, a policy "calculated not merely for profit, but for delight also." Indeed Peter had neglected nothing that "might render his residences celebrated among the learned world," one great proof being "a collection of pictures that is inestimable"; but "inestimable" now not for the pictures' jeweled or other ornamentation (which, apart from frames, they probably lacked), but for their intrinsic artistic value, a matter of their makers' skills.[108]

Weber's overall view of things is echoed in the copiously detailed diaries of Friedrich Wilhelm von Bergholtz, gentleman-usher to Duke Karl Friedrich of Holstein, who in 1721 came to Russia seeking marriage with Anna, daughter of Peter I, finally winning his suit in 1726. Bergholtz's diaries remain the single best source of information on the life of the court in Peter's last years, and once again the omission of any extended reference to holy pictures is probably significant.[109] On the other hand, Bergholtz refers approvingly to Prince Menshikov's "lovely pictures" at his new-style country estate of Oranienbaum, and to the tsar's "many choice Dutch pictures" in his private retreat at the new-style Peterhof. In the main palace at Peterhof Bergholtz also admired "numerous fine pictures," including a great battle scene of Russian victory over the Swedes which sported "very life-like" depictions of Peter and his generals.[110] It would appear that by the end of Peter's reign the existence of such pictures in considerable numbers had all but obliterated in the eyes of European visitors what they now regarded as merely the cult art of the Russian Orthodox church. And this was an important, not to say graphic measure of how Russia had become in their eyes, at least in this respect, part of Europe itself. A northerner touring in Italy, an Englishman in France, indeed a member of the cultured European elite traveling anywhere in contemporary Catholic Europe, would have adopted a similar view. Religion was religion, art was art.

3

Revolutionary Conversions

We focus now on the preparatory or transitional stage in the history of Peter's Europeanization of Russian visual art, which deserves careful study for the light it can shed on the process as a whole. It was a stage in Russian art history—the later seventeenth century—which scholars can no longer dismiss as stagnant let alone retrograde in either production or imagination. But it was a preparatory or transitional stage nonetheless, and a tentative, groping, yet insistent Europeanizing gave it its dynamism. It was a stage, we might also say, of aesthetic or artistic, cognitive and/or psychic *conversion* among Russians who would prepare for and carry out Peter's revolution: conversion from a habitual willingness to create, accept, even admire, and then use traditional Russian imagery to an at least conditional willingness to create, accept, even admire, and then use, in Russia itself, virtually all the new European forms. Such a displacement of the familiar, customary imagery in favor of what had been previously feared or scorned could not have been a simple, inconsequential matter in a traditional, minimally literate society at the best of times. Nor would it be here. In fact, among Russians even centuries later the revolution still evoked controversy.

We may say flatly that the outstanding characteristic of Russian painting of the later seventeenth century compared with that of any earlier period is its manifest striving to incorporate as best it could various features of the new European art. The use made by Russian artists of engravings from Holland or Germany was one factor in this process, as was the work done in Moscow by sundry foreign masters. The changing taste of the topmost Russian elite including the artistic elite naturally also played a critical part, as did the changing circumstances in which artists lived and worked. Most important of all, perhaps, and subsuming all other factors, was the intensifying movement from central regulation of image-making in Russia by the authorities of church and state to the establishment of a virtual monopoly of artistic production under tsarist control. This simultaneously centralizing and Europeanizing trend in later seventeenth-century visual art, with attendant misgivings, is abundantly reflected in concurrent attempts in Moscow to articulate a theory of images. Three writings in this vein claim our attention, and we turn to them first.

Muscovite Misgivings

The earliest of these three works—it is also the longest by far and arguably the most important—was written by Joseph (*Iosif,* also *Osip*) Vladimirov between 1656 and 1666: there is some disagreement about a more precise date.[1] The work is entitled, in the fullest of its surviving manuscript copies, which dates to the 1680s, "Epistle of a certain iconpainter Joseph to the royal iconpainter and most skillful artist Simon Fedorovich [Ushakov]."[2] This "Epistle" was early recognized as an important document in Russian cultural history,[3] although its author's life and motives remain obscure.

It does seem that Vladimirov came from Iaroslavl and was active as a designer and painter of icons in Moscow from the 1640s to the 1660s. The only surviving artwork definitely attributable to him (signed on the back) is a depiction of the descent of the Holy Spirit on the apostles painted for the merchant church of the Trinity in Nikitniki, in the old commercial section of Moscow (*Kitai-gorod*). In its overall composition, architectural details, and treatment of the human figures the icon is essentially traditional; but traces of the new European art are visible particularly in the faces of the apostles and the relative finesse of the design.[4] Vladimirov is thought to have been a pupil of Simon Ushakov, generally considered the foremost Russian artist of the later seventeenth century. At any rate, his "Epistle" is not only addressed most respectfully to Ushakov; it appears to have been occasioned by criticisms of Ushakov's more innovative art ascribed in the "Epistle" to a certain Serbian archdeacon, Ioann Pleshkovich. One student has suggested, on the basis of evidence more circumstantial than direct, that Pleshkovich also lived in Iaroslavl, where his Serbian family, like others seeking refuge from the Turks, would have settled some time before; and that, with such a background, he was an especially zealous defender of Orthodoxy.[5] Whatever their basis, Pleshkovich's criticisms of Ushakov's "abuses" are never spelled out in Vladimirov's "Epistle." But to judge from his lengthy and spirited rejoinder, they evidently amounted to a wholesale attack on innovation in icon painting and thus echoed the points made by Viskovatyi roughly a century before (Chap. 2). Similarly, despite its greater display of erudition Vladimirov's defense of the new trends in painting echoes Metropolitan Makarii's century-old rebuttal of Viskovatyi's charges.

Or rather, a close reading of his "Epistle" suggests that Vladimirov was trying to have it both ways. He founded his defense squarely on the authority of the "*Stoglav* of Tsar Ivan Vasilevich" (Ivan IV), at one point citing all of its relevant passages and elsewhere twice quoting its admonitions on the proper painting of icons, in accordance with good models and with an eye to the old masters.[6] He also invokes St. John of Damascus (twice), various Byzantine precedents, numerous passages from the Old and New Testaments, hagiographical sources, recent polemical works of both Ukrainian and Polish origin, and the example of Patriarch Nikon, the reigning head of the Russian

church, whose "great zeal for the skillful painting of icons" as against the work of "crude and mindless iconpainters, whether Latin or Russian," Vladimirov heartily affirms. Earlier in his "Epistle" he alludes to Nikon's more general campaign to reform the "old [liturgical] customs" in accordance with "Greek [service] books," and with equal approval: "So also, sir, it is with icons: much Russian painting is not in accord with the good Greek models themselves."[7] In these ways Vladimirov asserted his loyalty to the Byzantine or Greek tradition of sacred imagery in Russia while revealing, by comparison with the authors of the *Stoglav,* a somewhat fuller grasp of the tradition's theology.

Yet in his "Epistle" Vladimirov more frequently defends the new or expanded iconography of his time—of his own painting and that of Ushakov, in fact—and by direct reference to the Bible rather than to Byzantine or Russian precedent, thus asserting his own authority as an interpreter of Scripture for the purposes of depicting its personages and scenes, its mysteries and truths. At the same time, he repeatedly emphasizes one element of the Byzanto-Muscovite tradition to the virtual exclusion of all others, namely, the principle of similitude or likeness (*podobie*) in icon painting. He insists in effect that the entire question was reducible to whether a likeness was well or badly rendered—and this with respect not only to any prototype it had, living or dead (or divine), but to such things as shading, coloring, "perspective [*perspektiva*]," and scale. In this connection, it becomes clear, Vladimirov's criteria were more generally European and reflective of the new art. It was badly painted "Latin" or "German" images that were to be condemned equally with badly done Russian or Greek works, whether new *or* old, and not foreign works as such. At one point Vladimirov upbraids his opponent for saying that only Russians could paint icons and that only Russian icons may be venerated, when marvelous images drawn from Scripture, including the "Apocalypse [*Apokalipsis*]," had been executed "as if from life" in "other lands." Here Vladimirov appended a full list of the engravings to be found in Piscator's *Illustrated Bible,* which was first published by Jan Visscher (Latin alias Piscator) in Amsterdam in 1643 and was famous throughout Europe for its selection of pictures mostly by Dutch and Flemish (Mannerist) masters.[8] The principle of *podobie* had become, modernistically, *zhivopodobie* or "life-likeness," a term that Vladimirov apparently invented.

So Joseph Vladimirov of Iaroslavl in Muscovy emerges from his "Epistle"—rhetorical, polemical, rambling, and repetitive though it is—as something of a Europeanizer on the subject of holy images. Though invoking the authority of Byzanto-Muscovite tradition, he nevertheless asserts, like a Renaissance man, the autonomy of the artist. Obviously sensitive to outside criticism of the quality of Russian painting, he urges that the latter be improved by the standards of what he knew, with Piscator's help, of the new European art. One might even say that in claiming, implicitly, the right to interpret Scripture and in denouncing, indirectly, the Russian tendency to idolize icons (that fre-

quent criticism of foreigners) Vladimirov reveals a Protestant aspect. The very language of his "Epistle" inclined him to the larger European world: often colloquial (Russian) rather than bookish (Church Slavonic) in the traditional style, its text abounds in Ukrainianisms and Polonisms, and features numerous Latin calques as well as outright borrowings and neologisms. Examples of the latter include *perspektiva,* as mentioned, and *personigrafiia,* meaning the art of depicting persons: "I would write to thee, sir [Ushakov], about the most skillful art of true *personigrafiia,* to thee who has spoken of the fine mastery [needed by] those who would be iconpainters."[9] Yet it is clear from his "Epistle," as from his own surviving painting, that when all was said and done Vladimirov shared the basic Byzanto-Russian (or medieval) conception of art as idealized imagery, however skillfully done. It was imagery of a more or less symbolical kind executed in accordance with certain technical conventions and purely religious in significance. Lamenting the widespread ignorance in Russia, even among "those who consider themselves grand and intelligent," of what constituted good painting, essentially a problem, he seems to have thought, of excessive deference to the "old ways," Vladimirov did not proceed to renounce his aristic heritage in favor of something he distantly perceived to be better. Perhaps he had gone as far as he could, as suggested nearly a century ago by Buslaev:

> The Russian artist [Vladimirov or Ushakov] could have had no conception of the different styles of Western art: could not have distinguihed works of the German school from those of the Flemish or Italian. But in everything that reached him from the West, he felt a new, refreshing breath of beauty. His eye was attracted to the fine drawing, the noble stance of the figures, the artful drapery, the vivacity of the colors. He was drawn in fascination to nature, the ruler of all art.[10]

And hence, in the words of a more recent student, the historically indeterminate or transitional character—*polovinchatyi*—of the "Epistle" (and art) of Joseph Vladimirov.[11]

Simon Fedorovich Ushakov (1626–1686), to whom the "Epistle" is addressed, replied in kind. Or so it would seem. G. D. Filimonov, author of the first full-length monograph devoted to Ushakov, found in a manuscript *podlinnik* of the later seventeenth century an "Address to a Lover of Iconpainting" which he then published (1874), tentatively attributing it to Ushakov;[12] and scholars since have more or less tentatively accepted the attribution.[13] Indeed, judging from its text alone there can be little doubt as to the document's approximate date (later 1660s) and origin in that Muscovite circle of erudites and aesthetes among whom Ushakov was a leading figure. The "Address" is a remarkable statement of the artist's vocation, moreover, albeit one that is still largely couched in religious terms. It might be paraphrased thus:

God, who created man in his image and likeness (*po obrazu i po podobiiu svoemu*), endowed him with a special capacity, called fantasy (*fantaziia*), to

represent in images all things; but some are able to use this natural gift with great facility while others must develop it by intensive study. Among the many and various arts and crafts known to man, only seven are considered liberal arts; and among these, according to Pliny, the ancient Greeks ("Hellenes") considered image-making (*ikonotvorenie*) preeminent. The latter is divided into six kinds: carving in gems, wood, ivory; working in various metals; sculpting in stone; modeling in clay, wax, etc.; and engraving on copper plates for reproduction on paper. Among these in turn the sixth kind, painting in colors (*sharopisatelnoe ikonotvorenie*), is preeminent, as it more exactly and vividly recreates the original and more fully conveys its likeness; it is also used (approved of) by the church (also an allusion to the traditional abhorrence of graven images). Image-making in its several forms has been honored in all ages, lands, and classes because of its great utility; for images are the stuff of memory, memorials of the dead, witness of the times, heralds of good deeds, immortal expressions of praise and glory. Images bring near that which is far. Therefore in ancient times this honorable art was so loved that not only the well-born learned it but even famous kings, thus joining brush to scepter (*kist' skipetru prisovokupl'she*). For if the King of kings and Lord of lords was the first creator of images (*obrazotvorets*), how could not earthly kings honor image-creating?[14]

Moreover (the "Address" continues), while it is true that in the Ten Commandments God forbade the making of (graven) images, this referred only to idols worshipped as divine and not to simple images, bearers of beauty, bringers of spiritual good, providers of glimpses of the Divine. Christian images are revered not as God nor in themselves but for their prototype (*pervoobraz*). Christ himself provided an image of himself (this refers to the Mandylion of the King Abgar legend, or icon of the "Savior not made with hands [*Spas nerukotvornyi*]" in the Russian tradition, a type Ushakov himself painted: pl. 6).[15] And not only is the Lord God himself a master of icon painting, but all living beings with the sense of sight possess this divine skill: if they stand before a mirror, they cast their image in it. More wonderful still, the likeness in the mirror reflects their every movement, although it has neither body nor soul. Similarly in water, in marble, and in other things we see good images emerge without effort. Thus not God alone, but man's own nature teaches him the art of icon painting. And thus the church has from its beginning blessed images of Christ, his Mother, and the saints, whence have come many miracles.[16]

The "Address" also cites the speech on the martyrdom of St. Barlaam in Antioch in the fourth century traditionally attributed to St. Basil the Great, in which Basil exclaims: "Arise now, O splendid painters of the feats of martyrs. Magnify with your art [Barlaam's] mutilated image. Adorn with your cunning colors [him] whom I have but dimly described. . . . Let Christ, too, who presides over the contest [scene of the martyrdom] be depicted on the panel"[17]— this an obvious as well as authoritative affirmation of the high value of the

painter's art. The "Address" then excoriates the "many of us" who for lack of sufficient training paint badly, attracting divine wrath and the scorn of foreigners; and with all due modesty its author proclaims his God-given "talent" (*talant*) for icon painting, which, recalling the *Stoglav's* injunction, he would fear to hide. The "Address" closes with the author's promise to produce an "alphabet [primer] of this art [*alfavit khudozhestva sego*]" that should include the parts of the human body needed in "our art" and be engraved on copper plates for printing, for the benefit of all lovers of icon painting. A lengthy final sentence forms a kind of icon painter's prayer;[18] its close correspondence with an inscription on an icon painted in 1685 by Ushakov is the main external evidence adduced for attributing the "Address" to him. But 1685 was well after the time—the 1660s—when the "Address" supposedly was written, and the inscription *proves* only that Ushakov, near the time of his death, was familiar with it.

In broadly European terms, of course, the "Address" is a curious pastiche of late medieval and Renaissance thought about painting intermixed with elements of the Byzanto-Russian tradition. But in its Russian context it is an altogether extraordinary effort, having come, so to speak, out of nowhere. Yet did it? The literary qualities of the "Address" as well as its explicit references to Pliny (the Elder, a main source of Renaissance art theory) and several Byzantine authorities (St. Athanasius of Alexandria and the Second Council of Nicaea in addition to St. Basil) suggest that if Ushakov the practicing artist wrote the "Address," he had a good deal of learned help. And such help was close at hand. A "Charter" (*Gramota*) issued in May 1668 by the patriarch of Moscow together with the patriarchs of Alexandria and Antioch, who had come to Moscow for a major church council, makes some of the same basic points but with a greater display of historical erudition and rhetorical finesse ("Indeed the skill of iconpainting surpasses in honor the other arts and crafts as the sun surpasses the planets, fire the other elements, spring the other seasons of the year, the eagle every bird, and the lion all beasts").[19] The patriarchs would have been assisted in this operation by various of the learned divines, Greek and Ukrainian or Belorussian, who had also assembled in Moscow for the church council; and their "Charter" is remarkable, too, for its call for the tsar's support and regulation of painters of both icons and "secular things"—meaning, no doubt, the portraits and decorative paintings that were now in favor at court.[20] Furthermore, the charter of 1669 of Tsar Aleksei Mikhailovich confirming that of the patriarchs and commending it to his subjects makes many of the references and points that are made in the "Address," and in very similar terms.[21] In his charter the tsar undertook to impose tighter supervision of icon painting, something that a church council had called for, as we've seen, as long ago as 1551.

The burden overall of these three documents of the later 1660s—of the "Address" attributed to Ushakov most obviously but also of the patriarchal and royal charters—was that improving the quality of Russian painting, still

mainly religious in subject, mattered more to the Muscovite authorities than did maintaining—or establishing—strict iconographic or stylistic standards. The same may be said for a second version of the "Address" which has been attributed to Karion Istomin (ca. 1648–1717), another learned divine who rose to become head of the Bookprinting Office in Moscow, patriarchal secretary, and head (from 1697) of the Simonov monastery. Istomin's version of the "Address" supplemented the original text with extracts from Tsar Aleksei's charter of 1669 and that of the three patriarchs of 1668, and thus dates to some time after 1669.[22]

There were of course others in Moscow who strongly opposed the new trends in icon painting, most notoriously Archpriest Avvakum, a spokesman of the dissident faction in what eventually became the great schism (*raskol*) in the Russian church. In the fourth of his ten "Discourses" (*Besedy*), which was composed in 1673–1675 while in exile in northern Russia, Avvakum denounced the "increase in our Russian land of improper iconpainting" and the protection of those responsible by unnamed "grandees." The heart of his complaint was that the relative austerity of traditional Byzanto-Russian sacred imagery was being abandoned in a quest for more artful depictions in the "Italian" or "German" manner. "They paint the image of the Savior with a plump face, red lips, curly hair, thick arms and muscles, fat fingers and hips, in all pot-bellied and stout like a German." The Virgin Mary in the Annunciation scene was depicted as already pregnant; the "hair of the saints is combed, their garments altered, and they make the sign of the cross incorrectly"; the "Crucifixion is painted in the Italian manner," that is, naturalistically; and so on. Italians and Germans were heretics, their art was therefore false, and "Why, O Russia, should you wish for [their] customs and deeds?!" Avvakum's attack on the new trends in icon painting was part of his more general opposition to Patriarch Nikon's Grecocizing liturgical reforms, an opposition for which he was condemned at the church council of 1666–1667 and eventually put to death (1682). His attack was neither theological nor aesthetic in character, as we see, but rather moralistic if not puritanical, and robustly patriotic. Apart from demanding strict adherence to past practices, Avvakum could only recommend that the offending icons, like the new church books, be put in a sack and thrown in the river (a traditional method of respectful disposal). "Then everything will have been done to the glory of God, and the man who does it will receive a victor's palm from Jesus Christ." Manuscript copies of Avvakum's "Discourse" circulated long after his death among Old Believers in Russia.[23]

The Moscow church council of 1666–1667, whose main business it was to depose Patriarch Nikon for overreaching his authority while sanctioning his ritual reforms, did prohibit certain iconographic innovations, some dating back a century or more, to which Avvakum and others (Viskovatyi) had objected. Representations of the gray-haired Lord of Sabaoth (God the Father or the Ancient of Days) were not to be painted except, "as need be, in [depicting]

the Apocalypse of St. John." Similarly, depicting the Holy Spirit as a dove, another image of undoubted Latin origin and long a point of contention in Moscow, was now forbidden—except in icons of Christ's baptism in the river Jordan, for which there was, again, some scriptural justification. The council also corrected two points of dress and gesture for future icon painters to observe in depicting saints. Otherwise, the council ordered that supervisors of icon painters be appointed, that they be members of the clergy as well as "skillful artists and good persons," and that they ensure that icons were well and correctly painted, bearing in mind the specific prohibitions and corrections just mentioned.[24]

In general, then, the church council of 1666–1667 did not much narrow the range of acceptable subjects in icon painting, said nothing whatever about technique or style, reiterated the longstanding concern about icon painters' personal status and morality, and evidently was as much if not more concerned with the quality of religious imagery in Russia as with its substance. The council thus reflected the basic concerns of the three other documents of the later 1660s discussed above. It cannot have been a coincidence: not in the small and closely interactive world of the later seventeenth-century Russian tsardom and state church.

The key figure here might well have been the controversial Paisius Ligarides (ca. 1610–1678), who had arrived in Moscow in 1662 and quickly become one of the tsar's most influential advisors on religious affairs. Born on the island of Chios, educated at the College of St. Athanasius in Rome (a special school for Greeks and Slavs in communion with the Catholic church), where he took degrees in philosophy and theology, Ligarides thereafter followed a somewhat checkered career mostly in Constantinople and the Balkans. Working at first as a Catholic (Uniate) priest for the Vatican's department for the Propagation of the Faith, he came to be so well regarded by various Orthodox hierarchs that eventually one of them made him metropolitan of Gaza in Palestine, in which dignity he descended on Moscow seeking alms. The level of his erudition was fairly high even by general European standards. This much is attested by his literary legacy, which includes replies to sixty-one questions on religion posed by Tsar Aleksei, a history of the patriarchs of Jerusalem (where he had served), and a detailed history of the Moscow church council of 1666–1667, in which he had played a leading role. Ligarides most probably was responsible for those adroit iconographic compromises enunciated by the council (as cited above) following proposals ostensibly submitted by the attending patriarchs of Antioch and Alexandria. He well might have provided historical, theological, and even aesthetic advice to Joseph Vladimirov and to Simon Ushakov in addition to Joasaph, the new patriarch of Moscow (1667–1673) in succession to Nikon.[25]

Another leading erudite in Moscow in the 1660s and undoubtedly a critical figure in the developments under review was Simeon Polotskii (1629–1680). Belorussian in origin (born in Polotsk), a graduate of the Kiev Academy and sometime student of the Jesuit college in Vilnius, Polotskii arrived in Moscow

in 1663 and was promptly taken up by Ligarides. Polotskii acted as interpreter for Ligarides, and through him would have made his own contributions to the deliberations of the church council of 1666–1667. In fact, he was specifically commissioned by the council to write a treatise refuting the petitions of two dissident priests who had complained of the new and "heretical" tendencies in the Russian church; the treatise was published in 1667 and soon denounced by Archpriest Avvakum.[26] Polotskii's knowledge of languages (his native Belorussian [or Ruthenian], Church Slavonic, Polish, Latin) and of theology and literature (in their contemporary Latin, scholastic, Jesuit-Baroque incarnations), not to mention his ability to declaim impressively on short notice (on royal deaths, births, and namedays, on major festivals, etc.), were exceedingly rare in Moscow and soon led to his appointment as tutor to the tsar's children. A thoroughgoing "Latinizer," in the term of the day, in matters both ecclesiastical and literary as well as a staunch supporter of the Muscovite monarchy, Polotskii could scarcely have been a less than enthusiastic promoter of the new trends in Russian church art. Indeed, one student goes so far as to suggest that his "philosophical-aesthetic ideas" dominated the debate in Moscow in the 1660s, finding expression equally in Ushakov's "Address," in the patriarchal and royal charters of 1668 and 1669, and in two works specifically written by Polotskii on the subject of icon painting, neither of which has ever been printed.[27]

In the first of these works, a "Memorandum" (*Zapiska*) of 1667 addressed to Tsar Aleksei, Polotskii criticizes the shortcomings of contemporary Russian religious imagery in terms that closely parallel those of Vladimirov's "Epistle" of some few years before.[28] But in the second of these works, a "Discourse on the Honoring of Holy Icons" which also dates to 1667, Polotskii is concerned to defend the practice itself of venerating icons against the attacks of unnamed "heretics" who clearly were inspired by Protestant ideas.[29] His defense is the classic Byzantine stand against iconoclasts complete with references to the Second Council of Nicaea and to various church fathers, particularly St. John of Damascus and St. John Chrysostom. Finally, it might be thought, the Byzantine theology of images was being enunciated in Moscow in something like its full form. But then Polotskii went on in his "Discourse" to discuss icon painting in terms borrowed from Baroque poetics, suggesting that *every* iconic image is nothing more than a painted sign or symbol—*znamenie*—of some spiritual reality or essence, and that to insist otherwise was nothing less than heresy. It was "especially obvious," he wrote, that "among the many thousands of images of the Savior not one approximates the living face of Christ . . . not one is completely like him." This began to stray from the classic Byzantine conception of images as special channels to and from their divine or saintly prototypes, and certainly struck a blow at the Muscovite habit of viewing icons as literally the images, often miracle-working at that, of their originals. Indeed, Polotskii thus opened the door to the widest possible use of symbols in icon painting, not just conventional symbols but also unusual or even superficially inappropriate ones; artists were to be free to depict the

Savior and the saints in any way they pleased so long as basic propriety (*chin tserkovnyi*) was maintained. He perhaps sought to justify the actual proliferation in recent Ukrainian, Belorussian, and now Russian religious art of new architectural, botanical, sartorial, and other details as well as whole emblems of an increasingly elaborate as well as stylized kind: emblems whose models if not actual sources are to be found in the Baroque art of Roman Catholic Europe. At a more practical level, Polotskii urged that even "clumsily painted icons," numerous as they were and needful of "correction," were worthy of veneration since they did not dishonor their prototypes but only the artist and anyway did not scandalize simple people. This was to rebuke, obviously, those in the Russian hierarchy who demanded strict control of icon painting even as it evoked, on the contrary, a kind of Catholic toleration of holy pictures in vernacular styles.[30]

Polotskii later wrote hymns and poems in honor of individual saints and icons, composing his own verbal "images" not only in verse but in typically Baroque word puzzles and patterns, anagrams and cryptograms. His musical psalter (*Psaltyr' rifmotvornaia*), published in Moscow in 1680, and his *Tale of Barlaam and Joasaph* (1680–1681) were both illustrated with engravings after designs by Ushakov, designs that went further than anything Ushakov ever painted in their adoption of Baroque imagery and style.[31] It might be said, in short, that in all of his work in Moscow Polotskii sought to reconcile his Byzantine or Orthodox heritage with his Catholic, or Jesuit, education, an effort that was familiar enough in the Ukraine or Belorussia of the time but not as yet in Muscovy.

Indeed the complex, ambivalent, and even contradictory amalgam of Byzantine or Byzanto-Russian and Baroque elements which Polotskii represented in words and Ushakov in pictures continued to provoke resistance within the ecclesiastical establishment, most notably now from Joachim Savelov, head of the Russian church from 1674 to 1690. Soon after his election as patriarch Joachim condemned the new tendencies in imagery, declaring in an encyclical of 1674 that "paper images printed by German heretics are being bought and sold [in Moscow, etc.], [images made] by Lutherans and Calvinists in accordance with their false and damnable opinions, and [depicting] persons like those of their country, in their peculiar German clothes, and not in accordance with the old *podlinniki* used by the Orthodox; and these heretics do not venerate holy icons, but revile and ridicule [them], and with their prints discount the holy icons done on panels, thus scorning icon-veneration; but venerating icons has long been commanded and established by holy church and the tradition of the fathers; and it is ordered that [icons] be depicted on panels, not paper."[32] Joachim drew on what by now was a long line of Muscovite thought in denouncing foreign and "heretical" imagery and in declaring that icons could only be painted following models provided in pattern books (*podlinniki*) whose images embodied, as we saw, later sixteenth- and early seventeenth-century norms (fig. 8). At the same time, he gives evidence here of the spread-

ing popularity in Russia of "paper images," a development that he obviously deplored and hoped to stop, not only because of the heretical origin of these prints but because an image reproduced on paper could not evoke the reverence due an icon. Joachim also testifies here to the growing Ukrainian and Belorussian influence in top Muscovite church circles (Simeon Polotskii was hardly alone). One of his known advisers was Evfimii, a monk of the Kremlin's Chudov monastery (hence Evfimii Chudovskii), the leading local pupil of the learned Ukrainian divine Epifanii Slavinetskii (in Moscow, resident mostly at the Chudov monastery, from 1649 to 1675) and himself author of a relatively judicious denunciation of the "Latin" and "German" tendencies in Russian icon painting.[33] Ukrainians congregated at the Kiev Academy, alma mater of both Polotskii and Slavinetskii, had long polemicized with Protestants in defense of holy images, albeit with considerable reliance on Latin as well as Greek sources. Joachim, with Evfimii ever at his side, was Epifanii Slavinetskii's "self-proclaimed intellectual heir" in Moscow.[34] It was during Joachim's tenure as patriarch that the Russian authorities finally obtained permission (1686) from the patriarch of Constantinople to subordinate the metropolitanate of Kiev to Moscow's jurisdiction, in effect incorporating within the Russian church the decidedly more European Ukrainian and Belorussian (or Ruthenian) Orthodox church.

The pressures from Europe were obviously growing. A few years later (1690), in his last will and testament, Patriarch Joachim enjoined the reigning co-tsars, Peter and his elder half-brother, Ivan, to preserve by any and all means their "Christian Orthodox realm from foreign heretics, from Latins, Lutherans, Calvinists" and all "their foreign, seductive ways." Particularly were the tsars to ensure that "icons of the God-man Jesus and of the most chaste Mother of God and of all the saints be painted after the old patterns from the Greek models, like the miracle-working icons of the old style; and that they nowise be painted after the seductive Latin and German models, most unseemly in their lusts and corrupting of our church tradition; and that wherever in churches there are improperly painted [icons], they be taken away." Joachim exampled what he meant: "Heretics paint the most chaste Mother of God, already lawfully betrothed to her husband Joseph and delivered of Jesus Christ, with uncovered head and dressed hair [as if unmarried], as they do many of the sainted women . . . ; in the old Greek and Russian [icons] such is not to be met with, and is not to be accepted now . . . in the Eastern church it is not permitted to do this."[35] We thus see, now with Joachim's help, how shocking such "Latin" or "German" imagery still was, or could be, in Moscow in 1690—as well as how difficult it might have been to resist its attractions.

In other words, from what we might call the conservative or perhaps patriotic Muscovite point of view Russian culture if not Russia itself as embodied in the holy images was under grave threat, a threat that was all the more insidious for being "seductive." Indeed the threat posed by the coming of the

new European imagery to Russia was potentially twofold: it would reduce holy images from the status of sacred channels to and from the divine to that of mere illustrations of saints' lives and biblical texts; and it would introduce morally corrupting as well as theologically false notions into the community of right believers, subjects all of the Orthodox tsar. In both respects the authority of the church, if not the cohesion of the state, would be undermined. How could the threat not be resisted? How could it be contained? In this view of things, clearly, imagery in Russia had come to a critical pass. What native iconoclasm, or Western Protestantism, had not yet accomplished in Russia the Renaissance or the Baroque might well bring about.

Image theory was thus born in Moscow in the later seventeenth century only to be penetrated at once by Renaissance and Baroque values reaching Russia, however circuitously, or confusedly, from Europe. The penetration, as already indicated, was also reflected in Russian imagery itself (e.g., pl. 5), a point that must be more fully discussed. At the same time, we shall see that in assessing this development Russian art scholars themselves reveal a remarkable ambivalence—misgivings that seem to reprise, oddly enough, those of contemporaries.

Historical Ambivalence

It was Buslaev, again, who in a lengthy essay first published in 1866 suggested that later seventeenth-century Russian painting "remained in a low state of artistic development" because, while "striving after the high aim of expressing religious ideas, of representing the Divinity and the saints according to image and likeness, in the words of the *Stoglav*, it lacked the indispensable means for achieving this aim, possessing neither correct drawing, perspective, or coloring [*kolorit*] nor a developed sense of light and shade. Attempting a proper image of the Divinity in its human embodiment, it did not understand the human body nor realize the necessity of studying its external forms from life." Seventeenth-century Russian painters "remained craftsmen" rather than artists, their efforts confined to "copying and imitating" older works or models to be found in pattern books and foreign engravings. Buslaev compared his Russian "craftsmen," more often than not only implicitly, to the masters of contemporary and earlier European art, a procedure that A. I. Uspenskii, writing in about 1913, considered "not quite right." On their own artistic terms, Uspenskii argued, meaning within the medieval or iconic tradition, individual Russian masters of the seventeenth century achieved in particular instances art of a high level both technically and aesthetically. In any case, he added, owing to frequent fires and inadequate restorations the greater part of seventeenth-century Russian painting had not survived, making it difficult to judge the matter at all.[36]

Thus was the issue initially joined, Buslaev's negative assessment reflecting the standards of the Renaissance tradition in art just as Uspenskii's rejoinder, still somewhat tentative, reflected the values of the Byzanto-Russian tradition.

But Buslaev's further interest in pre-Petrine (or Old-Russian) painting was ethnographic, almost philosophical, in character, while Uspenskii, like other of the founding fathers of Old-Russian art scholarship, was primarily concerned with collecting both visual specimens and written documents and with properly cataloging the results.[37] The first systematic history as such of Old-Russian painting was published by Grabar and others in 1916, another monument of Russian art scholarship that remains valuable particularly with respect to artworks that have since perished.[38]

In his survey of seventeenth-century Russian painting Grabar dealt first with portraiture. Noting that "rather many" portraits of Russian grandees dating to the later decades of the century were preserved in various, usually private, collections (rather few are known to survive today), Grabar stated that the "great majority" of these portraits were painted by foreign masters and only occasionally, though it was difficult to determine such cases with certainty, by their Russian students (pl. 7). Grabar also pointed to the significant German, or general European, influence to be seen in later seventeenth-century Russian painting more broadly: in certain styles and motives, for a start, and in whole new subjects—illustrations of the biblical *Song of Songs,* for instance, or of the theme, an old one in the Latin church, of the "Coronation of Mary." These innovations were introduced by foreign masters when painting panels and walls for Russian patrons and then adopted by admiring Russian artists. Though such innovations naturally provoked hostile reactions, the proponents of the so-called Italianate (*friazhskoe*) style (literally "Frankish" but meaning in context "Latin" or "Italian" or, perhaps best, "Italianate") were more important than its detractors; "and Russian iconpainting [thus] rapidly approached its end." Russian masters were increasingly infected by the *friazhskii* spirit not only by personal contact with foreign artists, but by their exposure to samples of the countless prints circulating in Europe at this time. Simon Ushakov was Grabar's outstanding case in point (pls. 6, 8, 9, 10): "The tragedy of Ushakov's art was that he was in essence neither a [traditional] iconpainter nor a [new style] painter from life [neither *ikonopisets* nor *zhivopisets*]; having ceased to be the first, he did not become the second." Nevertheless, Ushakov's "influence on the fate of Russian iconpainting was so great that we can call the entire second half of the seventeenth century, and even a good part of the eighteenth, the era of Ushakov."[39]

Grabar spoke thus mainly about painting in Moscow, for the decline that he saw there in the later seventeenth century was not so steep in the provinces and particularly not in wall painting. "At the very time that the court churches of Tsar Aleksei Mikhailovich and his successors were being filled almost daily with more and more new images in the feeble *friazhskoe* style, in the most wretched taste," murals were being painted in churches in the old towns north of Moscow—in Iaroslavl, Pereslavl-Zalesskii, Rostov, and Kostroma— the "beauty of which delights us to this day." These were the "last echoes of a great style," one that had flourished in the sixteenth century and again, following the disastrous Times of Troubles (1598–1613), early in the seven-

teenth. By the end of the seventeenth century, Grabar allowed, such murals had ceased being monumental in character—a few massive figures, relatively simple lines, three or four basic colors—and were now pictorially complex as well as richly colored. Yet they were still art of a high order. Row upon row of bright pictures, often of biblical episodes never seen before in a Russian church, now covered the walls and vaults of buildings which themselves were newly complex in plan as well as profusely decorated in brick and stone. And this exuberant art, new but still Russian, proliferated in the North well into the eighteenth century. "Not in any other country," Grabar declared, "not excluding Italy, are to be found so many frescoes painted in so short a time." [40]

In this last remark as well as elsewhere in his pioneering history Grabar was perhaps proposing that by 1700 or so Russian wall painting was on the threshold of a renaissance, one in which "Western" rather than Byzantine or Classical influence might have played the catalytic role. In any case, he did establish that the means of such external influence on seventeenth-century Russian imagery were the engravings that had been arriving from Europe in growing numbers since the middle of the previous century. These were primarily religious in subject, of course, depicting scenes from the Old Testament and themes like the Apocalypse, by now an old story in European imagery and one that quickly caught on with the Muscovite elite. [41] Indeed, subsequent research has fully confirmed that illustrated bibles published in Europe from the sixteenth century were the main source of the new subjects appearing in Russian art in the later seventeenth century, and that among such volumes Piscator's *Theatrum Biblicum* held pride of place. The latter, first published in Amsterdam in 1643 by Jan Visscher (Latin alias Johannes Piscator), as mentioned above, comprised hundreds of engravings after paintings and drawings by various artists, mostly Dutch and Flemish, of the late sixteenth and early seventeenth centuries (it also included some reengravings of original works by artists of similar background): engravings that illustrated scenes from the Old Testament and the Acts of the Apostles as well as themes suggested by the Lord's Prayer and the Apocalypse. Piscator's *Illustrated Bible*, which was published anew in Amsterdam in 1674 and from which separate sheets had been issued as early as 1639, became the "standard reference work [*nastol'naia kniga*]" of Russian icon painters in the later seventeenth century, a discovery Grabar proceeded to demonstrate with both verbal and visual evidence. Not only details of dress and of landscape and architecture but whole compositions drawn from Piscator's engravings began to appear in Russian icons and murals, he pointed out, reproducing nine church paintings of the 1670s to the 1690s which clearly were inspired by seven engravings, also reproduced, from the Piscator bible; even the latter's Latin verse inscriptions, duly translated, were incorporated in the Russian works (see our figs. 11*A*–*B*). Identifying Piscator's bible as a main source of the new elements evident in Russian painting of the last decades of the seventeenth century had proved to be a major discovery by Grabar and a Russian colleague. [42]

Grabar concluded his discussion of the growing "Western influences" in

Paruulus ad Patrem properans, dú forte per æstus,
Spicea dum grauidas diffundit Meßis aristas.

Confeßim tener heu morbo tentatur acuto,
Inq; sinu matris vitales deferit auras.

2 Regum cap 4. ver. 19.

3

3

Figure 11*A* Engraving of an Old Testament scene (2 Kings 4:18–20) by C. J. Visscher after painting by Martin de Vos (ca. 1531–1603), with Latin inscription, in *Theatrum Biblicum, hoc est Historiae sacrae Veteris et Novi Testamenti tabulis aeneis expressae. Opus . . . in lucem editum per Nicolaum Iohannis Piscatorem* (Amsterdam, 1643), p. 206.

Figure 11*B* Fragment of mural depicting same scene (fig. 11*A*), with Slavonic inscription, 1680–1681, church of the Prophet Elijah, Iaroslavl'.

seventeenth-century wall painting in provincial Russian churches with a vaguely melancholy reference to the "swan song of a great art," one whose imminent disappearance would complete the earlier "fall of the icon" in Moscow.[43] But A. I. Uspenskii, again, took issue with this view and particularly with Grabar's condemnation of the Ushakov or court school: "We cannot agree that [this] was a time of decline in Russian iconpainting; on the contrary, we consider it a golden period, an era of flowering in Russian art" and one that might have reached still grander heights had not Peter I "forcibly cut short its life and accounted as nothing the achievements of half a century of artistic development." Uspenskii concluded his own massive study of painting in seventeenth-century Russia by ruling out any significant distinction between court painting in Moscow and painting in the provinces: "everywhere one tendency ruled," he argued, and it was "precisely that worked out in Moscow." All artists of later seventeenth-century Russia of whom Uspenskii could find any record—who were responsible for painting of any significance—were formed in the "one great school" located at the tsar's Armory Chamber, where they all had worked for longer or shorter periods and thence were sent as needed to paint in the provinces without regard to their place of origin. Uspenskii's detailed researches in the archives of the Armory Chamber, work which remains unsurpassed, had made clear to him the extent to which a truly national school of painting had come into existence in Russia by the end of the seventeenth century, a school that was certainly fructified by Western models but was not controlled by them.[44]

For Uspenskii also provided data confirming the extensive use made by Russian artists of Piscator's *Illustrated Bible,* whose influence on icon painting in the second half of the seventeenth century, he too found, was simply "enormous."[45] Copies of Piscator's bible were in the possession of at least three of the most important painters in Moscow in the later seventeenth century (Stanislav Loputskii, Ivan Bezmin, and Bogdan Saltanov);[46] and we've seen that engravings from the Piscator were specifically recommended as models for his fellow Russian artists to follow by Joseph Vladimirov of Iaroslavl in his "Epistle" to Simon Ushakov of about 1660. Yet Uspenskii insisted, as had Grabar, that in using engravings from Piscator's bible Russian painters "did not slavishly copy" but rather "reworked" the material in "quite original ways," this even in cases where an entire composition as well as numerous details had been borrowed.[47] Their insistence would become dogmatic in Soviet art scholarship. But it could equally well be said that the "originality" of the Russian artists responsible for the painting in question[48] lay in simplifying and coarsening the images depicted, in eliminating linear perspective, in reducing three-dimensional space to two, and in overloading compositions with a mixture of familiar and innovative, not to say exotic, decorative conceits (cf. figs. 11*A–B*). In other words, this insistence on originality by Uspenskii and Grabar and their successors cannot still our natural doubts, raised by Buslaev at the outset of this discussion, as to whether later seventeenth-century Rus-

sian artists were technically competent to copy with any great degree of accuracy, let alone "slavishly," even fairly ordinary examples of the new European art.

Be that as it may, we should not let the differing historical assessments of later seventeenth-century Russian painting advanced at the dawn of Russian art scholarship obscure their points of agreement. Whether one considered it proof of a last golden age or evidence of artistic decline, there was no dispute that for all intents and purposes traditional Russian painting came to an abrupt end under Peter I. The growing susceptibility of this painting to the influence of the new European art was another basic point of agreement, both Grabar and Uspenskii having provided in their pioneering works considerable evidence in support of it. The importance of this influence was also emphasized by scholars in the 1920s, when discussion revived after the years of war and revolution in Russia. In a symposium of 1926, for example, it was generally accepted that the Baroque was the first major movement in European art to reach Russia, that it did so in the later seventeenth century, and that Baroque forms were then pervasive in eighteenth-century Russian art.[49] The early and critical role of Piscator's *Illustrated Bible* in conveying the new art to Russia received new emphasis, notably in essays of 1928–1929 by M. K. Karger and E. P. Sachavets-Fedorovich. Referring to wall paintings of the late seventeenth and early eighteenth centuries in eleven different churches in Iaroslavl, and observing that the "new subjects" to be seen in these paintings were usually depicted "in completely identical iconographical forms," Sachavets-Fedorovich pointed to Piscator's bible as the necessary "single original source" of all these images and concluded that the attraction of the Iaroslavl masters to the Piscator's "language of forms" was the inevitable end, the "completion" or "perfection," of the road they had been traveling—consciously or unconsciously, timidly or boldly—for quite some time. Sachavets-Fedorovich also observed the influence of Piscator's bible in Russian panel painting of the period and in the earliest Russian essays in engraving.[50]

Karger took the matter further. His research had revealed the "major part" played by direct imitation, indeed by the straightforward copying of "Western proto-originals" (prints of paintings or drawings) in seventeenth- and eighteenth-century Russian painting, even among "masters of the highest quality." To prove his point he selected a single example from Piscator's bible, this work which had had such "enormous if as yet poorly studied significance for Russian art" of the period. It was an engraving after a drawing by Maarten van Heemskerck which illustrated a moment in the career of St. Philip as recounted in the Acts of the Apostles (fig. 12). This picture in whole or in part had been more or less skillfully copied, Karger discovered, in murals (1) of the end of the seventeenth century in a church of the famous Monastery of the Caves in Kiev and (2) of 1685 in a major monastic church in Kostroma (pl. 11); in murals (3) of 1700 in another church in Kostroma and (4) of the late seventeenth century in a church in Iaroslavl (fig. 13); and in panel icons

Confpiectis conftanter aquis, ardefcere cępit *Æ. Cap. 8.38.* *Antiquos posuit lapsus, et nomine Chrifti*
Ennuchi fecunda fides, qui gurgite merfus *Teftatur totum purgatum lapfibus orbem.*

Figure 12 Depiction of a scene from the career of St. Philip (Acts 8:26–38): engraving by C. J. Visscher after drawing by Maarten/Maerten van Heemskerck (1498–1574), in *Theatrum Biblicum . . . Piscatorem* (as cited at fig. 11*A*), p. 480.

painted (5) about 1700 for a church in Novgorod and (6) in the first half of the eighteenth century, the latter having been acquired by the Russian Museum (GRM) in Leningrad in 1926 from an unidentified source. Karger indicated that he had uncovered much similar evidence of copying of prints by contemporary Russian and Ukrainian icon painters.[51] The 1920s we should remember were a time of major advances in scientific as opposed to religiously motivated icon restoration, something that had barely begun in Russia before World War I.[52]

As for Ushakov, a tragic failure in Grabar's estimation, hero of a golden age in Uspenskii's: late in the 1920s scholars proposed that the dominant external influence on his imagery was "Dutch realism." Concentrating on Ushakov's icon of the *Trinity*, only recently (1925) acquired by the Russian Museum (pl. 8), N. Sychev questioned whether Rublev's *Trinity* and its tradition (pls. 2, 4) were much of an influence and pointed to a painting by Paolo Veronese (ca. 1528–1588) as the source of Ushakov's architectural background, a painting the Russian artist could well have known from a print. Sychev wished to stress the gradual transition as he saw it in Ushakov's work from Muscovite principles to Flemish art forms and thence, in some degree, to those of the more realistic Dutch imagery (the ubiquitous engravings of Piscator's bible

having apparently served, again, as the guide). It was this "orientation" that made it possible for Ushakov to use Veronese's architectural imagery in such a mature work as his *Trinity*, which was painted in 1671 when he was forty-five years old. Sychev thus rejected the notion that Greek or Greco-Italian influences, or even Latin or Baroque forms, were decisive in Ushakov's development, a position that V. N. Nechaev had also recently taken adducing similar evidence.[53]

The onset of Stalinism in Russian art scholarship entailed a new emphasis on "realism" in Ushakov's imagery and that of his colleagues and predecessors—proof in current Marxist terms of Russian art's progressive maturity[54]—along with a new insistence, quite contrary to the evidence already accum-

Figure 13 Fragment of mural illustrating career of St. Philip (Acts 8:26–38), 1680–1681. Church of the Prophet Elijah, Iaroslavl' (cf. fig. 12, pl. 11).

ulated, that such realism was a largely indigenous phenomenon. Indeed Ushakov's reputation soared under Stalinism to the status of a prominent precursor of "Socialist Realism."[55] Russian art scholarship remained in the grip of such views until the later 1950s, with lingering traces thereafter—as in the multivolume history of Russian art published by Grabar and others between 1953 and 1969, a work that was intended to supplant the pioneering effort edited and largely written by the same Grabar.[56]

The fourth volume of this later history (1959) deals with art of the seventeenth century in Russia, and its basic approach is readily apparent in the volume's introductory essay, which states in part:

> The art of the seventeenth century is the last stage of Old-Russian artistic culture, and precisely as such it is marked by contradictory tendencies. The old, conservative forces struggled to hold back the process of development while the new forces only began to shake loose the foundations of the medieval world view. These new forces, which reflected the growth in influence of the democratic strata and especially of broad sections of the urban population, facilitated the advance over the course of the seventeenth century of an enormous critical work. Traditional church attitudes were frequently shaken and the ground was prepared for the freer development of the human personality; a general secularization of culture began, and the signs of progressive ideology became increasingly evident in literature and art. All of this unquestionably distinguished the seventeenth century. It was a transitional era; it laid the ground for the development of a secular culture, the successes of which would distinguish the following era—the era of the Petrine reforms.[57]

Such "contradictory" generalizations, to be found throughout this volume,[58] may be considered more misleading, perhaps, or simplistic, than untrue, a matter of their obscuring the actual complexity of the historical developments to which they call attention. The reference to an "enormous critical work" advanced by "new forces" in seventeenth-century artistic culture, for instance, seems to misunderstand as well as exaggerate the significance of the period writings (by Joseph Vladimirov and others) that were discussed earlier in this chapter. These writings constituted the first real attempt in Russia to consider imagery in theoretical terms, to be sure; but for all their ambivalence they remained largely in the Byzantine or Byzanto-Russian tradition and hence were essentially medieval as well as religious, rather than modern or "secular," in outlook. Nor could we agree that the influence on art of the "democratic strata" of seventeenth-century Russian society was decisive. It was the tastes and actions of the Muscovite elite, of top merchants and churchmen and particularly of the tsar and his circle, that precipitated the final crisis of Old-Russian culture and the onset of the Petrine revolution, not any popular or would-be bourgeois movement. It is true that in the later seventeenth century painters were drawn in the main—as they always had been—from the ranks of townsfolk, broadly speaking (sons of clergy and craftsmen, of artists

or artisans, of royal musketeers). But it was only in the degree to which they imbibed the air of the Moscow court, with its comparatively sophisticated patrons and plentiful funds, its visiting and resident foreign artists and teachers, and its relative abundance of foreign books and prints, that Russian painters became capable of contributing to that forward development of Russian art which the volume in question celebrates. It will also become clear as we proceed that in the interest apparently of maintaining an indigenous ground for the momentous changes of the Petrine era, both their revolutionary character and their European origins would continue to be minimized in Russian art scholarship.[59]

The most detailed and best documented account to date of painting in seventeenth-century Russia is by V. G. Briusova, published in 1984. This truly magisterial work advances the claim that several major artistic "schools and trends" are identifiable in the period and that one of them, that of the Upper Volga region (*Povolzh'e*), rivaled and eventually surpassed the Moscow court school itself in both artistic quality and historical importance. We were somewhat prepared for this claim by Grabar's volume of 1916 and by its successor of 1959, not to mention lesser studies of some relevance. But it is Briusova who makes a compelling case for it.[60]

Icon painting in Russia, as she says, had always been "controlled" by somebody (the church hierarchy, in principle). But the expansion of the Muscovite state and concurrent centralization of artistic forces in and around Moscow had led by the later sixteenth century to a severe weakening of the older cultural centers and the imposition on icon painting of a "state tutelage" that was "ruinous [*gubitel'naia*] for art." Such tutelage accounts for Ushakov's shortcomings as a painter: "The world of the court—his true element—did not facilitate the development of self-consciousness and an understanding of the responsibility of the artist before society on the social plane; having unswervingly placed his talent at the feet of the almighty Moscow rulers, Ushakov put himself in the position of a willing servant, receiving in return only noble rank and a salary better than his colleagues'." Similarly another leading artist of the time, Fedor Zubov, did not realize the "serious danger to artistic creativity" that he ran in assuming the privileged position of a court painter, whereby he "lost his right to his own interpretation." By the end of the seventeenth century the art of the royal painters had acquired "an ever more superficial character, an attraction to mastery for mastery's sake," and was "devoid of inspiration and creativity." More, seventeenth-century court painting as such was "purely external and mindless," its ideals were "moribund," its "sole aim a formal virtuosity"; it was an "ecclesiastical-salon art" and, at base, "sterile." Briusova does not deny the "obvious fact that precisely Moscow with its material and ideological tutelage of the cultural life of Russia created in this period all the necessary conditions for the development of art in both the capital and the periphery." But this did not mean that the "progressive role" in the development of seventeenth-century art belonged to the

royal painters. On the contrary, their degeneration as artists followed from their necessary commitment to two main tasks: restoration of the old art after the Time of Troubles (1598–1613), meaning essentially the art of the sixteenth century, which embodied the "religious-philosophical program of Muscovite Orthodoxy"; and glorification of the Muscovite monarchy (pl. 10). These tasks were carried out "with great zeal" by artists whose court patrons were "thus not concerned with protecting 'free' art"—and whose careers Briusova thus briskly eviscerates.[61]

There surely is something to be said, just at the level of description, for Briusova's account of Moscow court art in the last decades of the seventeenth century, which at other points she characterizes as "decadent-eclectic" and in a state of "crisis."[62] But we follow her to the towns of the Upper Volga with growing trepidation, sensing in her story so far more than a whiff of special pleading. She identifies not only a vibrant "Upper Volga school" (*shkola Povolzh'ia*) but distinct "schools" within it, notably those of Iaroslavl and Kostroma, the latter of which found its finest expression in the "school," again, of Gurii Nikitin. He was not just the leading Kostroma icon painter from 1660 to about 1690 but the greatest Russian painter of the age—even though, like the great majority of contemporary artists, he did not sign his works. Indeed our ignorance of Nikitin's biography extends even to the years of his birth and death, as Briusova admits. But on the basis of long and close study of the paintings of the region she can detect unmistakably his "style" or "hand."[63]

The *Povolzh'e* region embraced much of the Muscovite heartland, including the towns of Romanov-Borisoglebsk and Rostov Velikii, Vladimir and Suzdal, Pereslavl-Zalesskii and Iaroslavl, Kostroma and, further afield, Vologda and Nizhnii-Novgorod. These and the Dvina towns of Ustiug and Kholmogorii, considered by Briusova the next most important centers of seventeenth-century Russian provincial art, had undergone an economic upsurge beginning in the last years of the sixteenth century owing to the earlier opening of the "North Sea route" (greatly increasing trade with Europe) and the annexation of both Siberia and the Tatar khanates of Kazan and Astrakhan, on the middle and lower Volga (stepping up commerce with Persia). Briusova does not mention the obvious international dimensions of this economic upsurge or any of its cultural consequences; she is interested only in its contribution to the strengthening of the industrial and commercial classes within the Volga and Dvina towns and the role of these *posadskie liudi* as patrons of art. And her best examples of this art are those copious murals and related panel icons painted in 1680–1681 in the merchant church of the Prophet Elijah in Iaroslavl by a team of local and Kostroma artists—the team led, she is sure, by Gurii Nikitin (figs. 11*B*, 13). The aesthetic qualities and "progressive" character of these and other such murals, she repeatedly asserts, clearly surpassed the art of the court.[64]

How, in a few words, could this have been so? The *posad* art, as Briusova explains it, reveals in its greater breadth of subject matter greater artistic free-

dom; it displays greater stylistic variety and originality, implying greater vigor; it shows greater interest in conveying emotion, in the "spiritual expressiveness of the image" and in "psychological complexity"; it is more "realistic" in this and other ways, thus eluding the iconic strictures of the central authorities; and in its decorative motives and genre scenes, most important of all, it bears the direct influence of popular culture. The wall paintings of the church of St. John the Baptist in nearby Tolchkovo, executed in 1694–1695 by a new generation of local artists, surpassed even those of the Elijah church in Iaroslavl. Here the *posad* folk "realized itself as the true protector of the traditional national culture."[65]

There surely is also much to be said, again at the descriptive level, for Briusova's account of the best of later seventeenth-century Russian provincial painting. But we may regret her neglect of the patently religious aspects of this art, which speak no doubt to questions of purpose and meaning as well as influence. We also might think that the contrast in its favor with the best of contemporary court art is decidedly overdrawn—as Briusova herself, elsewhere in her large volume, as much as concedes. For instance: "On the whole, the Kostroma system of wall painting was more independent of Moscow's than that of Iaroslavl," even though "Gurii Nikitin, his closest helper Sila Savin, and other Kostroma painters were constantly called to Moscow to execute royal commissions or were sent commissions to paint icons for the tsar in Kostroma." Again: "The organization of the work shows that the provincial iconpainters were subordinated to the general regulation of the Armory Chamber in Moscow; the associations of iconpainters in Kostroma and the other towns were branches [*filialy*] so to speak of the tsar's icon school." Even Simon Ushakov, that outstanding exponent of the royal school, "nonetheless possessed undoubted creative individuality, as manifested in his special attention to the representation of the human face as bearer of the idea of the 'God-man' [Ushakov's icons of Christ, e.g., our pl. 6] and in his unending zeal to find in this respect every new nuance for the expression of spiritual and psychological character." For this and for his organizational abilities in a period of "maximal creative exertion" in Russian painting Ushakov achieved for all his shortcomings a "uniquely high position among the most important actors of pre-Petrine Russian culture."[66] This is to revive Grabar's original ambivalence in newly amplified form.

Talk of Ushakov unavoidably also revives the more general question of European influence on later seventeenth-century Russian painting, *posad* or court, as Briusova well knows. And although such influence is unmistakably present in numerous paintings of the period Briusova herself reproduces (e.g., our pl. 12),[67] she like her more recent predecessors among Russian art historians systematically minimizes or ignores it. We need not dwell on this feature of her work, which similarly minimizes or ignores the findings in this regard of the pioneers of Russian art scholarship and their immediate successors as summarized, and illustrated, earlier in this chapter. We need also only note

Figure 14 *Deesis*, Creto-Venetian school, seventeenth century. Tempera on panel.

in passing her persistent effort to find evidence of "independent artistic sources of the realistic strivings in seventeenth-century Russian portrait painting and of the originality of its technique," as in an iconic portrait of Tsar Fedor Alekseevich which she attributes, quite problematically, to the court painter I. A. Bezmin about 1680 (pl. 13). Nor will we more than mention her practice of anonymizing contemporary portraits of Russian grandees long since attributed to European artists working in Moscow or to their Russian students,[68] or of scarcely admitting that icons from the "Greco-Italian south" or of the "Italo-Cretan school" (fig. 14) might have influenced the likes of Ushakov, or of simply discounting conspicuous examples of late seventeenth-

century Moscow court art that are patently "Italianate" in both subject and style (pl. 14), or again of insisting without elaboration that icons painted by Fedor Zubov (pl. 15) somehow "example the developing Baroque style in seventeenth-century Russian painting."[69]

Rather, we observe that, as in one way or another Briusova herself concedes, it was the arrival of foreign artists and the spreading influence of new styles, techniques, and genres of painting imported from Europe that by 1690 had brought court art in Moscow to a "crisis." She also acknowledges that this displacement of traditional painting in Moscow by the "new trend" reflected the "sharp turn" in Russian culture as a whole brought about by the reforms of Peter I, which "put new tasks before art." Happily, the work of Petrine artists shows the "rapid success achieved by Russian painting in the new, realistic trend, drawing on the experience of Western European culture and of Russian art of the preceding time." For it was "thanks precisely to this fact," namely, that the best of the royal icon painters had "succeeded in organically synthesizing the iconpainting method with the new method of realistic painting," that the soil had been prepared for the growth of the new art in Russia— which art, once absorbed, "lifted Russian art to a new, on the whole higher level of artistic culture." At the same time, the "harshness of the [Petrine] reform," the "forcible break with the popular, national traditions," meant that the "centuries-old art of Russia was bled white and reduced to provinciality." And in a culminating footnote Briusova quotes with apparent approval the admittedly "extreme attitude" expressed by a Russian scholar in 1909: "'Had it not been for Peter's devastation [*razgrom*], our art would have developed still further, would have grown strong with Russian blood alone, by [the efforts of] the Russian people, and we would have had our own, original, characteristic art. But the thunder struck, and there was no such art; nor will there ever be.'"[70]

Thus does Briusova gloss the complex diffusion of the new European art to Russia in the decades before the Petrine revolution as well as the course of the revolution itself. Her study of seventeenth-century Russian painting, while unrivaled in its scope and detail, is plainly ambivalent in its assessment of developments and overcome in the end by a kind of nationalist nostalgia. This is an understandable response perhaps to the extraordinary difficulties impeding objective study of an art—Old-Russian visual art, especially icon painting—that was decisively repudiated, thanks to Peter's revolution, by succeeding generations of patrons, artists, and scholars in Russia: an art that, as art, is still alien—medieval, primitive, and/or religious—by prevailing standards of interest, knowledge, and taste. But it is also clear that Briusova's own interpretive framework, above all the narrowly nationalist motive of her narrative, itself impedes comprehension of both her own subject and, if she will, the Petrine *razgrom.*

Meanwhile, we do notice signs that since Briusova published not only the existence but even the importance of the role of new European art in late

Muscovite imagery is being accepted again by Russian scholars, even as its *decisive* significance either potentially or actually, with the onset of the Petrine revolution, has yet to be acknowledged and studied.[71] We also notice that a basic consensus unites Briusova with Uspenskii, Grabar, and the other pioneering students of seventeenth-century Russian painting. It was a period, they all say, of both decline and advance aesthetically, technically, and with respect to iconography, although the degree of either decline or advance is a matter of differing and in part subjective standards of judgment. Painting was increasingly dominated by an agency of the tsar's government in Moscow, a point that is documented in the next section of this chapter; but under this agency's overall sway local "schools" also flourished, especially in those economically rising towns of the North that were benefiting from the European trade entering Russia at Archangel, on the White Sea. Such commercial links, we must insist, were a principal channel of the growing if still very tentative European influence in Russian life generally, in Russian imagery in particular. And such influence, we would further insist, analogous in the practice of art to that which was affecting art *theory* in Moscow, did indeed precipitate a kind of great showdown or "crisis," a crisis that would be decisively resolved under Peter in favor of wholesale Europeanization.

We must therefore link this momentous development in Russia, the better to understand it, with the earlier and contemporary developments in Europe outlined in Chapter 1. That is, Russian artists and patrons of the later seventeenth century—the latter including wealthy merchants as well as leaders of church and state—were now also being drawn to the brilliant naturalism of the new imagery, which they were coming to know from imported engravings as well as from oil portraits painted by immigrant "foreign masters" (figs. 11*A*, 12, 15). A fundamental shift in taste was under way in Moscow and the northern towns of Russia in the later seventeenth century, a shift not unlike that which had already occurred over most of Europe. In the same way, the ensuing demand for the new art in Russia could not have been satisfied by employing traditional methods of image-making, a problem of basic techniques in drawing and painting as well as of aesthetic and iconographical norms. An incipient Europeanization was simultaneously affecting Russian architecture, with which so much of the art in question was closely connected; and a similar point of crisis had been reached.* This fundamental shift in taste, reflecting a perception by the Russian elite of the comparative superiority of the new art to anything previously known in Russia, helped crucially to set the stage, again following general European patterns, for the Petrine revolution. We should not let nationalism in any form, nor ambivalence about the revolution's outcome, nor indeed any extraneous consideration, obscure this altogether basic point.

**Revolution in Architecture,* especially chaps. 3, 4.

Figure 15 Portrait miniature of Tsar Aleksei Mikhailovich. Oil on enamel painted ca. 1668 by a European master in Russia (Nicholas Dixon[?]) and given by the tsar to the Earl of Carlisle, the current English envoy.

Tsarist Monopoly

The most important institution supporting and directing the work of artists in Russia in the last decades of the seventeenth century was the Armory Chamber (*Oruzheinaia palata*) in the Moscow Kremlin, with subsidiary workshops located elsewhere in the city. Its origins go back to the year 1511 if not earlier, when an office called the *Oruzheinyi prikaz* (Armory or Armaments Office) was founded to oversee the storage and manufacture of the grand prince's (later, the tsar's) arms, which included saddlery, banners, and campaign tents and furniture as well as hot and cold weapons. This office naturally attracted numerous craftsmen and artisans to its service, among them painters from Novgorod, who thus gravitated from the older art center in Russia to the capital of the rising Muscovite state, where they found work painting the ruler's banners and tents, decorating his weapons, or illuminating his charters and decrees. After the disastrous Time of Troubles (ca. 1598–1613), the Armory Office grew steadily in importance, chiefly because of an increase in the production of armaments and the growing demand at court for both painting and objects of silver and gold. Three workshops were created in an effort to cope with the new requirements and subordinated to the Armory Office: a Gold Chamber, a Silver Chamber, and an Armory Chamber, in the last of which the work of painting was concentrated along with the manufacture of arms. In the 1640s an Icon Office and "Iconpainting Chamber," first mentioned in the documents in 1621, were merged with the Armory Office

and Armory Chamber, making the latter preeminent in the work of painting for the court.[72]

Tsar Aleksei Mikhailovich, father of Peter I, took special interest in the Armory Office, and in 1647 he appointed a senior nobleman, Boyar G. G. Pushkin, to be its head. Pushkin was succeeded in 1654 by Boyar Bogdan Matveevich Khitrovo, who was mentioned in Chapter 2 in connection with the fine old Gospel book given him in 1677 by Tsar Aleksei, which Khitrovo then deposited at the Trinity–St. Sergius monastery near Moscow. He held various high positions in the tsar's government and household, including service in 1653 in an embassy to Poland and in 1658 in a mission to the Ukrainian hetman. In 1668 he was made a boyar, the highest court rank. His service in Poland and Ukraine may well have encouraged his interest in art including the new European art; he seems to have been a dedicated patron, even something of a connoisseur. At any rate, during Khitrovo's long tenure as head of the Armory Office (to 1680) the Armory Chamber flourished as never before, becoming the unrivaled center of Russian painting in both quality and quantity.[73]

The restoration of the wall paintings in the Dormition cathedral of the Moscow Kremlin, executed in 1642–1643 on the tsar's orders, is the first big job recorded in the account books of the Armory Chamber. One of the Chamber's regular icon painters working with seventeen assistants took tracings of the existing paintings over a period of five days; the job itself required 100 icon painters assisted by thirty gilders (*zolotie'shchiki*) and varnishers (*olifeishchiki*), thirty-five surface preparers (*levkashchiki*), twelve pigment grinders (*krasochnye tershchiki*), and corresponding numbers of carpenters, masons, smiths, and sundry other workers: preparations were made in the summer of 1642, and the painting was completed during the summer of 1643. The painters had been summoned from the major towns of Muscovy as well as appointed from the Armory Chamber; all were rewarded by the tsar in due proportion with gifts of sable, fine English cloth, and silver plate in addition to their fixed emoluments. The wall paintings of the Dormition cathedral were subsequently renovated by royal masters in 1680, 1682, 1684–1685, 1690—and then not again until 1737. These and similar data provide glimpses of the actual operations of the Armory Chamber—of image-making in the Muscovite tsardom—in the later seventeenth century, although the sources from which they are drawn cannot tell us all that we'd like to know.

Nevertheless, it is clear from the official records that considerable sums were being invested in artistic endeavor and that considerable specialization of labor had set in. Such specialization naturally resulted from, or was intensified by, the variety and volume of tasks imposed on the masters of the Armory by the tsar and his court, everything from illuminating manuscripts, executing panel icons, and painting murals in both churches and residences to designing and painting rough portraits on wood or linen and rough maps or architectural plans on paper. Royal painters were called upon to decorate hun-

dreds of Easter eggs annually and numerous toys for the royal children, countless utensils and weapons, chess sets, icon cases, banners, tents, and carriages. Some artists specialized in drawing or design (*znamenshchiki*), others in painting the foliage typical of late Muscovite ornamentation (*travshchiki*); others—the masters—painted only the faces and perhaps the hands of figures in icons, leaving their assistants to paint the clothes and other details, including the architectural and natural backgrounds. All these specialists worked alongside the gilders and varnishers, the preparers and grinders already mentioned. Painting was at once a collective effort and a highly departmentalized art. Leading painters not surprisingly had mastered more than one specialty—were designers and face-painters, typically—while aspiring painters performed the simpler tasks alongside those, forever craftsmen, who did nothing else. On the other hand, the records indicate that a grinder of pigments might also have mastered the techniques of sizing panels in preparation for the painters; and a master designer like Simon Ushakov not only planned complex icons and whole mural cycles but executed designs for silver plate, images on cloth, maps on paper, and, in the end, in his case, copperplate engravings.

The relative value attached to the several specialties and skills involved in Muscovite painting is indicated by the Armory Chamber's pay scales. The earliest archival references, from the 1620s, show that the top rank of artists, the full-time regularly salaried (*zhalovannye*) painters in the tsar's service, received between twelve and twenty rubles annually in cash and fifteen to twenty measures of rye and oats. By the 1680s, however, the scale ran from three rubles and six measures of grain per year at the low end to sixty-seven rubles and fifty-two measures of grain at the high (the salary of Simon Ushakov in 1678). This expansion both up and down the pay scale reflects no doubt a concurrent expansion of artistic activity (more artists needing to be paid) and perhaps also a corresponding lowering—at the low end—of standards (less time for training, perhaps, too much work to do); but at the higher levels it also clearly reflects a greater appreciation of artistic skill and, arguably, some greater or more frequent demonstration of such skill. In any case, these figures do not include the per diem and other allowances received by royal artists from the Armory Chamber (or some other branch of the tsar's government); the special rewards in cash or kind for work completed; or official assistance, up to full costs, in building or rebuilding (after a fire) an artist's house. The combined value of these other payments has been estimated at about three times that of the annual monetary salary itself—for a total pay package roughly equivalent, at the lower end, to that of a contemporary royal musketeer (*strel'ets*) or, at the high end, to that of a full professor at a Russian university in 1914 (as calculated by one such person).[74]

It should be remembered that all such compensation was doled out to artists in an economy and society dominated by an elite whose wealth was measured by the number, size, and location of the buildings and lands its mem-

bers possessed and by the number and quality of serfs working those lands. Very few artists, as we will see, reached the ranks of this elite in recognition of artistic merit (and of a certain courtliness), and only one of these fortunate few in the period before Peter received estates. Artists in and around the later seventeenth-century Moscow court remained overwhelmingly denizens of a kind of middle class, neither noble nor bonded peasant. It was the class of craftsmen and traders, of royal musketeers and lower clergy, of clerks and petty bureaucrats, the class in which most of them had originated; although there is some evidence from the 1690s that within this class artists lived comparatively well.[75]

Nor did the pay rates, rewards, and grants just mentioned apply to the lesser artists, artisans, assistants, and apprentices who worked at the Armory Chamber, often only part-time, or were summoned from the provinces to participate in a major project. As far as we can tell, they were markedly less well off than their certified superiors; particularly was this true of those who were brought from their homes to Moscow like so many military conscripts, sometimes under guard. Apart from a small daily living allowance, even a top provincial artist drafted temporarily into royal service might receive an annual salary, prorated for the time he actually worked (usually a summer), of one to two rubles. No wonder many such artists appear to have sought permanent positions at the Armory Chamber—or permission to stay home.

We saw how provincial artists were conscripted in 1642–1643 to help restore the murals in the Dormition cathedral of the Moscow Kremlin. In 1652 it was the turn of the wall paintings in the Kremlin's Archangel Michael cathedral, also built more than a century and a half before (though the murals of both churches had been periodically renewed since, particularly in the later sixteenth century). Some forty-two icon painters initially took part in the 1652 project, at least a dozen of whom, the records show, had come to Moscow from Kostroma, Iaroslavl, and Kaluga. In 1660, as the work dragged on, another fifty-seven icon painters were urgently summoned from Iaroslavl, Kostroma, Rostov, Pereslavl-Zalesskii, Vologda, Ustiug, Nizhnii-Novgorod, Kaluga, Pskov, and Novgorod among other, lesser towns; and three painters were seconded on the tsar's orders from the patriarch's staff. Similar calls went out in 1662, in 1664 (when twenty-three painters were conscripted from the Trinity–St. Sergius monastery), and in 1666, when fifty-five artists from the provinces joined twenty-five from Moscow in a final effort, directed by Simon Ushakov, to finish painting the walls of the Archangel cathedral following the outlines of the former murals (as the tsar had initially ordered) in anticipation of the great church council that was to begin later that year. In 1667 the tsar granted the usual rewards of fine cloth to the main artists involved, some of whom were selected by Ushakov and his senior colleagues to become salaried painters at the Armory Chamber. In 1676 the tsar ordered the murals in a church (we would say chapel) in his Kremlin palace repainted following the "old images"; Ushakov directed sixty-eight painters in completing the job

during the summers of 1676 and 1677, a number that included twenty-one painters summoned from Iaroslavl and sixteen from Kostroma.

Analogous efforts were mounted in these same years in new or important old churches in the provinces, for example in the Ilinskaia church in Iaroslavl in 1680, where artists from Moscow joined local painters and artisans and others summoned from Kostroma in completing murals which included a depiction of the dynastic tree of the tsars (cf. pl. 10). But Moscow remained the principal scene of such complex, high-level artistic operations: in 1684–1685, again, some twenty-one painters with their twenty-seven assistants working under Ushakov and Ivan Bezmin decorated the apartments in the Kremlin of the mother and sisters of Peter I, while the concurrent decoration of provincial churches and residences was left in the main to provincial teams—usually led, it should be noted, by painters who had worked in Moscow. Provincial artists of distinction could still receive commissions from Moscow, as in the tsar's decree of 1673 to the governor of Kostroma, ordering him to pass along a prepared panel and model icon to a local master, who was carefully to paint a new icon on the panel and to send it and the model back to Moscow. In the winter of 1670 artists at the Trinity–St. Sergius monastery copied by royal commission hundreds of miniatures from one codex to another. For the tsar's Easter of 1669 masters of this monastery painted 200 chiseled wooden eggs following a prescribed pattern. As these and other cases show, royal patronage was becoming crucial to the work even of artists who remained in the provinces.

Indeed, these details serve to illustrate the extent to which as well as the ways in which the tsardom of Moscow was taking control of artistic production in Russia, a control exercised mainly by Boyar Khitrovo in charge of the Armory Office and Chamber. The size of the permanent or regularly salaried staff of the Chamber is further evidence of this trend. Between 1663 and 1679 some sixty-eight pigment grinders and seven *levkashchiki* were employed by the Chamber along with dozens of full-time painters and their assistants or students. In 1667–1668, according to its account book, the Chamber's staff totaled 198, including seventeen icon painters and their ten students, forty other painters, twenty-one administrative and curatorial personnel, and more than 100 artisans and helpers of various kinds (many of them evidently working in armaments).[76] In 1695 a total of 136 artists, apprentices, artisans, and administrative personnel received a total of just over 3,878 rubles in salary.[77] These figures do not include the dozens more of painters and artisans and helpers who worked for the Chamber in these years on a part-time or piecework basis, with or without monetary pay. More generally, we know from the Armory Chamber's records the names of some 1,020 painters of all grades who worked on royal projects between about 1660 and 1700,[78] a figure that compares impressively with the total of 1,247 armaments and related specialists (250 in armaments proper) employed by the Chamber in the whole of the seventeenth century.[79] These and other data indicate that the number of arms-

makers and their helpers compared with the number of image-makers and theirs had steadily declined over the century, leaving painting in one form or another as the main business of the Armory Chamber. Indeed it had become a big business as well, and something of a royal monopoly.

As the seventeenth century wore on those other traditional employers of artists—the patriarch and the bishops, the great monasteries—increasingly appealed to the tsar not only for funds for painting (nothing new) but also for painters to work on their premises. In 1667 Metropolitan Iona of the proud old city-diocese of Rostov Velikii petitioned the tsar to grant that the artists from Iaroslavl and Kostroma who had decorated the walls of his cathedral the previous summer might return to restore them after a devastating fire; the tsar ordered the local governor to comply with the request, and some twenty-eight painters duly went back to work. Other such examples could be cited.[80] We saw earlier that the murals in the Kremlin cathedrals, which were under patriarchal jurisdiction, were painted and repainted between the 1640s and 1690s by artists in the tsar's service. By the late seventeenth century the patriarch seems to have had no more than two or three icon painters in his employ; while the artists maintained by the greatest of the monasteries, the Trinity–St. Sergius, were routinely executing, as also noted above, large commissions from the tsar. It had come to the point where only the open market in icons—the "god market" in Moscow and the main provincial towns described by contemporary foreign visitors (Chap. 2)—operated beyond direct governmental control, as dealers and painters' cooperatives, often family enterprises including many women members, strove to meet the ever growing demand for panel icons and for cheap holy pictures printed on paper, "German" or "Italian" in origin though the latter often were.[81]

By the late seventeenth century the Armory Chamber in Moscow had also become the most important repository of icons in Russia along with liturgical books and sacred objects of all kinds, all manufactured for the most part by its own masters. An inventory of the tsar's treasury (*Kazennyi prikaz*) compiled under Peter I listed among the icons at the Armory Chamber some 347 images of the Dormition and 290 of various Russian saints, and indicated that a total of 930 icons were being kept in storage "many" of which were "old."[82] These had accumulated for the use of the royal family but also to be dispensed as gifts from the tsar to churches, monasteries, individual subjects, and Orthodox emissaries from abroad. The last category of recipient reminds us that in this respect the Armory Chamber, together with other of the tsar's offices in the Moscow Kremlin, had become in effect a treasury of Orthodox art on a scale such as did not exist anywhere else at the time in the entire Orthodox East.[83] Icons from the tsar's treasury regularly served it seems as models for artists working at the Armory Chamber and elsewhere in royal employ: as witness the case, cited above, of the icon sent by the tsar for copying to a painter in Kostroma, who was obliged on completing his copy to return the original to Moscow.

In the previous chapter we discussed the renewed governmental effort under Aleksei Mikhailovich to enforce the standards of proper icon painting in Russia, this time as they had been laid down by the church council of 1666–1667. Tsar Aleksei's charter of 1669 to that effect embodied the wisdom of the contemporary Muscovite leadership and its foreign advisors, and was as much if not more concerned with raising the artistic level of Russian painting as it was with defining or enforcing iconographic norms. The same tendency is evident in a royal decree of October 1667 preserved in the Armory Chamber's archives. This decree is directed at artists who "for lack of artistry do not paint icons following the old patterns" or who willfully ignored the lessons of the "fine old models" and instead painted icons "without reflection or fear." The patriarchal administration was to ensure that in Moscow itself as well as in the provinces icons were executed only by the "most skilled iconpainters" following the old models, which fact was to be certified by masters chosen for their great skill and experience. And shopkeepers were to accept for "exchange" in the market only icons of "good workmanship, with certification" as such. The emphasis was as much on artistry or skill as on following the old masters (or established patterns). Like the charter of 1669, however, this decree of 1667 was vague in its actual requirements, more a declaration of policy than enforceable law.[84]

Nor should we be surprised, again, at this characteristic emphasis on form over content. Muscovites did not yet grasp fully the theological basis of icon painting, as records of the deliberations of the church council of 1666–1667, to take an important instance, discussed above, clearly reveal. Artists and patrons continued to be guided rather by the actual practice of icon painting, itself a mixture of classic Byzanto-Russian norms and various other—"Latin" or newer Greek, Cretan or South Slavic—influences. At the same time, there is considerable evidence, beyond the official acts just mentioned, of an unprecedented effort in Moscow to raise artistic standards, an effort that was directed by Tsar Aleksei and Boyar Khitrovo and vigorously supported, until his deposition (in 1666), by Patriarch Nikon. One apparent proof of this policy is the greater refinement observable in the best surviving Russian painting of the later seventeenth century (pls. 6–10, 12–15). The records of the Armory Chamber also play a part here, demonstrating as they do rising pay scales for artists that were linked to proven merit. The wholly secular rewards and honors accorded the most skillful among the painters also reflect the royal policy, as does the employment of artists by the Armory Chamber on either a full- or a part-time basis and the ranking of the latter into first, second, and third classes each once again with a different—and descending—rate of pay. We know that ill-prepared or unskilled artists arriving from the provinces were promptly sent home. Agents of the tsar might go so far as to purchase an artistically gifted bondsman from his master for as much as 100 rubles (as happened in 1668); and artists in the tsar's service enjoyed exemption from all taxes and dues. A rudimentary system of training painters at the Armory

Chamber came into being, a matter of lengthy apprenticeship to an acknowl-edged master followed by formal certification. Officially approved pattern books—those *podlinniki* referred to in Chapter 2—were to be used by provin-cial artists, the best of whom would have worked for a while, if not repeatedly, at the Armory Chamber in Moscow. Moreover painting was increasingly be-coming a hereditary profession, as the records of the Chamber also indicate; by the end of the seventeenth century as many as 40 percent of artists were themselves the sons of artists.[85] This had not been possible when icon painting was normally a monastic calling.

The growing number of foreigners active at the Armory Chamber surely also played a part in raising or refining artistic standards in later seventeenth-century Russia. Indeed Uspenskii concluded, on thorough investigation of the Chamber's records, that such improvement as took place was principally owed to outside, particularly Western influence and that the "chief perpetra-tors" here were the "foreign artists serving at the time at the Muscovite court." Already in 1662, by his count, sixty such foreigners were employed at the Armory Chamber as engravers and smiths, arms and instrument makers, painters and decorators: "It seems there was no branch of art or industry where their influence did not penetrate"; and the number only grew with each passing year. In painting, as Uspenskii saw it, the effect was a new "re-finement." Brighter, more lively coloring appeared as did finer drawing and a better disposition of figures, more artful drapery and greater plasticity of forms, more natural landscapes, and, not least, a much wider range of sub-jects.[86]

As already seen, Uspenskii's distinguished contemporary and sometime collaborator, I. E. Grabar, generally agreed with him on the importance of the new European influence on later seventeenth-century Russian painting however much he may have disputed the overall result. Grabar attributed a decisive turning towards the "new and the foreign" in icon painting in the middle of the century to the foreigners at the Armory Chamber, an institution he described as "at once the first Russian academy of fine art and a kind of ministry of culture." He pointed to the new needs and tastes arising at the Muscovite court which local artists, working in traditional ways, could not satisfy. The demand for painting intensified most especially: painting to fill the walls and vaults of churches (far more numerous than ever before) and of new mansions and palaces; painting to decorate furniture in its new abun-dance as well as books, banners, tableware, wall hangings, and toys. Above all, as Grabar pointed out and we can confirm, this newly luxurious, tenta-tively Europeanizing Muscovite elite demanded pictures of themselves, a *par-suna* or *persona* as they called them in the singular (from Latin *persona*), indi-cating their Western origin. This new and, for us, crucially important demand reflected at least two distinct streams of influence. One brought the rustic forms of the tomb or coffin images and "gala" portraits popular in greater Poland from the sixteenth century into Muscovy as early as 1610 (pl. 16; also

Figure 16 Posthumous "portrait" of Ivan IV, Moscow, ca. 1672 (before 1677, when it was given by Tsar Fëdor Alekseevich to the Danish envoy). Tempera on panel.

fig. 16), while the other brought the new portraiture directly from Italy, England, Denmark, and Germany; the latter arrived by more definite stages—specific portraits and then artists—from the very end of the fifteenth century until, by the 1620s for sure, royal portraits were being executed in Moscow itself (since no such portraits survive from before the middle of the seventeenth century, we rely entirely on verbal documents for earlier traces of this second stream). The still very iconic representations of living rulers included in the *Tituliarnik* of 1672 (figs. 9, 17) are other manifestations of this growing demand at the Muscovite court for *parsuny,* a demand that was approaching the dimensions of a mania (fig. 15; pls. 7, 13).[87]

The first foreign master to appear in the records of the Armory Chamber is Hans Dieterson (Deterson or Detterson; also, "Ivan" or "Ants Deters"), who was a German ("nemchin").[88] Dieterson entered the tsar's service in 1643 at the enormous salary of 240 rubles per year (nearly four times greater than the highest known salary paid a Russian painter—sixty-seven rubles to Ushakov in 1678—in the entire seventeenth century); a salary that was sweetened in 1644 with royal gifts of a silver *kovsh* and lengths of damask, taffeta, and "good" broadcloth. He evidently executed various commissions for the tsar and his family although no signed works by him survive, making the attribution to him of a full-length *parsuna* of Patriarch Nikon—severe and even brooding of face, with Slavonic inscriptions, and realistic in both proportions and detail—only a guess.[89] Dieterson had at least two Russian students, Isaak Abramov and Flor Stepanov, who in 1650 were certified by him as capable of doing "every painterly thing" and, should they remain under his care a further year and a half, of "mastering the art [portraiture?] word for word as

Figure 17 *Parsuna* ("portrait") of the infant Peter I from the *Tituliarnik* of 1672. Pen and watercolor on paper.

good as him." Dieterson died in 1655 and was succeeded by a Pole from Smolensk, "Stanislav Loputskii," who was judged worthy of an annual salary of 120 rubles.

Loputskii (or Lopucki) appears to have lent his hand to anything that came his way: painting a *parsuna* of Tsar Aleksei on linen, decorating clothes and furniture, gilding candlesticks, drawing maps and architectural plans, painting ensigns and banners, one with an image of the "pious Tsar Constantine." For his efforts—"for his much work and skill"—he received periodic gifts of fine cloth and measures of grain, wine, and salt; in 1666, when he petitioned the tsar for compensation following a ruinous fire (ever a danger in Moscow), he was promptly granted twenty rubles in cash, ten measures of flour, and five hams. By this time, however, Loputskii seems to have fallen ill as well as in trouble with two of his students, Ivan Bezmin and Dorofei Ermolaev, who complained to the Armory Chamber that he had not taught them how to paint but "only to apply gilt to wood and linen." Instructed to reply, Loputskii asserted that both "Ivashka" and "Doronka" had learned to paint everything except "faces," which they still did not do properly. Shortly thereafter (1667) the two were taken from his charge and assigned to the "newly arrived for-

eigner from the Imperial [Habsburg] lands," Daniel Wuchters. But Loputskii was not forgotten. In 1668 he was given more rewards of fine cloth "so that he should not leave with the Polish ambassadors"; and the next day, "for his service and his work," and "so that he should not leave with the Polish ambassadors but remain to serve the Great Lord in Moscow in perpetuity," his salary was raised to 144 rubles per year. In 1669, after petitioning the tsar for help in obtaining medicines, he died, and his widow was granted twenty rubles to cover the costs of his burial.

Another foreign master, Daniel Wuchters (Buchter or Vuchter or Vuchters), apparently Dutch in origin, entered the tsar's service in 1667 at an annual salary of 156 rubles, having impressed Boyar Khitrovo, in charge of the Armory Chamber, with a specimen of his work (a historical effort on "the capture of Jerusalem") and with the claim that he could paint "life-size *parsuny* and biblical histories" better than either Loputskii or Dieterson. In his petition Wuchters indicated that he had worked "in many monarchies and great states" and had come to Moscow some time ago in the suite of the Swedish ambassador; further, that at the urging of his merchant brother, full of praise for the tsar's generosity to "skilled people," he had stayed behind, settled down, and married. The only surviving work attributed to Wuchters is a full-length portrait of Patriarch Nikon, again, now in full regalia and raptly attended by a gaggle of clergy; it is thought to have been painted about 1660, at the height of Nikon's power. The faces in the picture, particularly Nikon's, are perhaps fair enough by contemporary European standards, but the rest—done then or later by Russian students?—is comparatively crude.[90]

Dieterson, Loputskii, and Wuchters are the first "masters of lifepainting" (*mastera zhivopisnogo dela*) from Europe known to have worked at the Armory Chamber in Moscow, and the salaries and perquisites granted them demonstrate how highly their skills were valued by their Russian patrons: far more highly, on this evidence, than those of any Russian painter of the time. But their title implies that they were not considered competent to paint icons (they were not *mastera ikonopisnogo dela*), probably by reason of religion alone, since no such restriction impeded their Russian students or the foreign masters who were, or became, Orthodox. The outstanding example of the latter is Bogdan Saltanov, a "foreigner from the Shah's realm of the Armenian faith" who entered the tsar's service in 1667 and became Orthodox in 1674, Boyar Khitrovo himself serving as godfather.[91] His contract obliged him to "teach his skill [*masterstvo*] to students of the Russian nation" as well as to paint on commission, for which he was granted an annual salary of 120 rubles and generous quantities of food and drink. Saltanov introduced a new, apparently superior kind of varnish at the Armory Chamber and otherwise was exceptionally active in the service of the tsar and his family, according to the Chamber's records. Over the next five or six years he painted at least two icons on copper (his innovation in Moscow?), hundreds of Easter eggs, various icon cases and frames "in the Greek manner," numerous boxes and banners, toys

for the royal infants (including Peter I), ceilings and walls in the royal palace at Kolomenskoe, and several royal *persony,* meanwhile training at least eight students. In the fall of 1674, now Orthodox, he petitioned the tsar to be enrolled in the ranks of the Moscow nobility, which was granted and followed (1675) by a raise in salary to 156 rubles per year; he was also given another 300 rubles "for his poverty" and for having "sought the Orthodox Christian faith," and 600 rubles to establish himself in a proper house. In subsequent years he would receive further grants of cash, fine cloth, handsome clothes, and, most remarkably, lands with peasant households (grants in 1682, 1683, 1684)—all "for his good skill and much work." The work included *persony* of the deceased Tsar Aleksei, his first wife Mariia Ilichna, and son Aleksei; an icon of the resurrected Christ on glass (another innovation here?), which Tsar Fedor so prized that he took it to his private rooms, where a *persona* of himself by Saltanov (pl. 13?) already hung as well as Saltanov's icon of the Crucifixion with images of Sts. Constantine and Helen, Tsar Aleksei and Tsaritsa Mariia, and Patriarch Nikon, all in splendid dress. Uspenskii detects in these data signs of a flatterer and opportunist who was successful beyond his merits as an artist. Saltanov's surviving paintings, while conventionally religious in subject, are quite sui generis, reflecting a kind of Italo-Greek influence in their rounded, naturalistic, yet rather eastern faces along with Persian influence, it may be, in their ornaments and floral settings.

Saltanov's last years in Moscow are indicative of wider trends and perhaps also of his quality as an artist. In 1688 and again in January 1690 he received royal commissions to paint various murals in the women's quarters of the Kremlin palace, projects that were to include illustrations of Solomon's *Song of Songs* as well as "*lenchavty* and flowers" (from German *Landschaft* = "landscape" or "scenery"). These projects never got beyond the planning stage, however, evidently because of Peter I's accession to full power (following the abortive coup attempt of 1689 on behalf of his half-sister, Sofia), whereupon Saltanov's style went swiftly out of favor. His name appears one last time in the records of the Armory Chamber, in 1702, in connection with the construction of Peter's vast new "Tseikhgauz" (from German *Zeughaus* or "arsenal") in the Kremlin. But one need not have feared for his welfare. It seems that throughout his years in Moscow Saltanov had dealt very profitably in "Persian goods": carpets presumably and objects of art, perhaps. And he appears to have retained possession of his estates.

That leaves "Vasilii Poznanskii" among the foreign painters working at the Armory Chamber in the later seventeenth century about whom we know very much.[92] He first appears in the records for 1670 as a painting apprentice; given his surname and later work as an icon painter, he was probably Orthodox Ukrainian or Belorussian (Ruthenian) in origin and had come to Russia from Polish territory with his father or another relative in the wake of Tsar Aleksei's successful campaigns there. His teacher was Ivan Bezmin, the former pupil of Loputskii and Wuchters, and he seems to have been exceptionally talented

(a brother was also a royal artist). Apart from the usual jobs, Poznanskii painted (1679) two *plashchanitsy* for Kremlin churches which survived:[93] these were images of Christ and his Passion on large satin "shrouds" (liturgical cloths) with inscriptions in Slavonic, and are remarkable for their mixture of late Gothic and Renaissance styles and motives, a mixture that was characteristic of imagery in the European hinterlands of the sixteenth century (and later). By 1682 Poznanskii had his own workshop in Moscow with at least five apprentices, in a house provided by the tsar in response to his petition: "A cottage is all I have," he had complained, "without a hallway [reception room], and with wifey and folks [servants] and pupils live tight, and nowhere to paint thy Great Lordly things." In a second petition to the tsar in 1681 he wrote, instructively for us:

> I am doing every kind of thy Great Lord's upper [residential] and office painting for 12 years, but of thy Great Lord's salary to me comes only a small daily food allowance, and nothing in grain or cash. But there are iconpainters, Lord, at the Armory Chamber to whom thy salary goes— grain and cash and food money. And there is a prespactive [*prespaktivnyi*] master at the Armory Chamber, Lord, who, apart from prespactive, does nothing else and gilders who, apart from gilding, do nothing else, because they don't know how. But I thy slave paint *persony* and biblical scenes [*pritchi*, literally "proverbs" as in the Book of Proverbs] in both iconic and lifelike style [*ikonnoe i zhivopisnoe pis'mo*] more than any of my brothers [colleagues], and I can do prespactive and gild saddles and bows in the Turkish manner and paint with gold.

Poznanskii told the tsar that written testimonials to his skill were lodged at the Armory Chamber, and asked him to command that he be certified and granted a salary commensurate with that of his colleagues Hans Walter and Dorofei Ermolaev, "since my skill is much greater than theirs." Bezmin and Saltanov duly certified that Poznanskii was as good a painter as Bezmin and "the foreigner Voltyr," and he received a modest raise in his daily pay. His basic problem it would seem was that he was neither fish nor fowl: neither an accomplished "lifepainter" from abroad nor a certified "iconpainter" in the Moscow tradition but rather an Armory generalist, something of this and something of that and a master of nothing.

Undaunted (he scarcely had any choice), Poznanskii produced in 1682 a series of paintings on canvas for a Kremlin church of which thirty-one survived for Uspenskii to reproduce (1906, 1916).[94] These are images of Christ, his Mother, Apostles, and saints all executed once again in a sort of provincial mix of late Gothic and Renaissance styles—some more the one than the other—now with an admixture so to speak of local, or Orthodox, elements. There are striking resemblances in these paintings, in some instances, to the works of Saltanov mentioned above.

Poznanskii's fate was not a happy one. Confined to a monastery in 1683 on grounds that he had gone mad, he was not released until 1695. By then Peter

I was deep in his shipbuilding projects, and in 1696 he assigned Poznanskii, who had been reinstated at the Armory Palace with an annual salary of fifty-four rubles, to the shipyards at Voronezh, there to copy ship designs. He does not appear in the records again until 1707, when he helped a Polish artist paint banners, following a new and much simplified model, for Peter's personal Preobrazhenskii regiment. He also helped decorate (1709) the palace of Peter's late favorite, François Lefort, located in the German Settlement beyond Moscow's outer walls. His last recorded appearance was in 1710, petitioning the tsar for relief from poverty. His son Matthew trained as an engraver at royal expense under Adriaan Schoonebeck, the Dutch master hired by Peter in Amsterdam in 1698 and one of the chief agents, as we'll see, of Peter's revolution in Russian image-making.

Other foreign painters who worked at the Armory Chamber in the later seventeenth century include Hans—or perhaps Johann—Walter from Hamburg, mentioned in Poznanskii's petition of 1681, who had entered the tsar's service in 1679 and did portraits as well as decorative work; Peter Engels, the "prespactive master" as he is called in the documents, who was hired for 120 rubles per year: we know of several Old Testament scenes painted by him, Poznanskii's aspersions notwithstanding; also two Swedish portraitists, an Orthodox Arab or two, and three Greeks. The total of such artists who can be identified in the Armory Chamber's records is seventeen—seventeen out of some 1,020 painters known to have served the tsar over the same forty years. These figures alone should give us pause in attributing too much influence to foreigners in seventeenth-century Russian image-making or in positing on their account any renaissance in pre-Petrine Russian art.

Moreover, while scholars have assumed quite reasonably that the output of the few foreigners who worked in Moscow in the later seventeenth century was large, especially in portraiture, the quality of this output is another question. Rather is it fair to conclude, from the little that survives of their work, that it was by European standards second-rate at its very best and otherwise quite provincial, old-fashioned, and deeply constrained by local norms. Imitated and admired though it evidently was, the "lifepainting" of the "Frankish" masters in later seventeenth-century Moscow was clearly insufficient in either quantity or quality to constitute a new stage in Russian imagery, a point we must insist upon. On the other hand, the work of these foreigners in Moscow, as well as their extraordinary salaries and emoluments and evident influence on their Russian pupils and imitators, prove unmistakably that the Muscovite elite of the time was moving steadily in the direction of the new European art, whether it was in forms we would call Late Gothic or Renaissance, Italo-Greek, perhaps even Mannerist or Baroque. This accelerating Western orientation among Muscovite patrons and artists can be regarded as a precondition of the Petrine revolution, to be sure: whetting appetites, as it certainly did, for the real thing; heralding the deluge to come. But it did not in itself constitute a revolution in Russian art nor anything close to a

revolution—no more than did the appearance of works by Cimabue or even by Giotto constitute a revolution in Italian painting in advance of, and distinct from, the Renaissance itself.[95]

As for the several dozen Russian students of the first foreign painters who worked in Moscow, the career of Ivan Artemeevich (or Artemonovich) Bezmin is one of the better documented.[96] His father, possibly of Lithuanian origin, was a metalworker in a town near Ustiug that was a dependency of the Armory Chamber when he was summoned in 1660 to the Chamber itself, where he was rewarded for "good work" and soon sent to the royal ironworks at Tula; there, in November 1661, he suddenly died, leaving a widow and four children. Ivan, a small boy who had evinced some aptitude for art, was apprenticed in 1662 to Stanislav Loputskii and given the Chamber's absolute minimum in daily food money. Whatever else, Bezmin's career illustrates the ambiguous status of the aspiring artist in Muscovite society, especially one who belonged to no monastery or secular landlord or protective urban guild and was wholly dependent for his subsistence, training, and eventual salary on the favor of the tsar and his designated officials. In the winter of 1664 we find him petitioning for clothes and being granted in response leather boots and enough green broadcloth to make a *kaftan:* the tsar's livery, in effect. In 1665 and again in 1666 "Master Stanislav" certified that Bezmin was progressing well in painting, illuminating state documents, and what not; indeed, that he had come so far as to produce the "face of a Roman Caesar in lifestyle" on canvas in oil as well as banners with the arms of various states. For this he received more clothes and a doubling of his daily food allowance. The same was accorded his fellow student, Dorofei Ermolaev, who had shown similar progress.

In 1667, as noted earlier, Bezmin and Ermolaev complained of their training under Loputskii and were transferred by the Armory Chamber to Daniel Wuchters's care. Thereafter Bezmin pursued the usual and varied tasks of a royal artist, decorating toys and tiles for stoves, painting chests and bedsteads and other furnishings, gilding chairs and crosses and candlesticks, painting murals in royal rooms and images of saints on military banners: also, fifty lances (in 1675) and (in 1676) an entire iconostasis. He took on students; Poznanskii, as we know, was one. Listing his many works and activities in a petition of 1677, Bezmin besought the tsar to grant him an annual salary equivalent to that of Ushakov, or just over sixty-five rubles (compare the 120 rubles per year given to Peter Engels in 1679). He got the salary, but within a year his wife had died. There is some little evidence that Bezmin was eventually enrolled in the Moscow nobility—on the strength of his claim that his father had been of noble birth.[97]

Three works by Bezmin survived for scholarly study (pl. 13 is questionable), three paintings on canvas done in 1680–1682 for the church of the Crucifixion in the main Kremlin palace.[98] Their style is remarkably similar to—some might judge it indistinguishable from—that of the surviving works of Vasilii

Poznanskii and especially of Bogdan Saltanov. In fact, it appears that two of these paintings—a *Resurrection* and a *Descent of Christ from the Cross*—were executed jointly with Saltanov. We are reminded that painting in Moscow remained to a striking degree a collaborative rather than an individual effort, the work of teams of artists and artisans each with his part to play and led by a senior painter or two.[99]

Karp Zolotarev was a painter working at Patriarch Nikon's New Jerusalem monastery when in 1667 he was summoned to the Armory Chamber, where he became a pupil of Saltanov and Bezmin, who in 1680 certified him as a painter equal in competence to Dorofei Ermolaev and "the foreigner Valtyr [Hans Walter]." He worked on the usual array of things first in Kiev and elsewhere in Ukraine and then at the Ambassadorial Office in Moscow, where by 1690 he was receiving the handsome salary (for a native artist) of sixty-six rubles a year. In 1694 he painted icons for the domestic church of A. A. Matveev, who, it will be seen shortly, was to become a leading supporter and indeed agent of the Petrine revolution in Russian art. At about the same time Zolotarev painted a series of icons for the church of the Intercession of the Mother of God at Fili, an estate near Moscow, under the patronage of L. K. Naryshkin, a maternal uncle of Tsar Peter himself. This church is an outstanding example of the so-called Moscow or Naryshkin Baroque in late seventeenth-century Russian architecture, a style that was much in favor among the topmost elite of the time and one that plainly embodied their preference for the new European art as distinct from traditional Russian forms.* This manifest dissatisfaction with the traditional, this reaching for the new, is evident equally in Zolotarev's recently restored paintings for this and other churches patronized by members of the innermost circle of power and prestige in Moscow—paintings that appear to have been inspired, again, by engravings in Piscator's *Illustrated Bible* (fig. 18; cf. fig. 8).[100]

Among the remaining Russian students of the first foreign masters, we know little more about Dorofei Ermolaev than what has already been said. Like Bezmin, whose early career closely paralleled his own, his father was a smith at the Armory Chamber, he had been apprenticed to both Loputskii and Wuchters, he took students himself while executing the usual variety of commissions, and he periodically received rewards in cash and kind "for his good skill and much work"; but he disappears from the Chamber's records in 1700. We do note the unusually large number of jobs carried out by Ermolaev for the young "Lord Peter" that provide early indications of the future emperor's abiding interests: decorating not only the customary toys for him but also a drum (1676), a gun carriage (1679), various arms as well as military equipment for his "dwarf Iakov" (1680), painting a campaign bed (1686), and designing (1694) the restoration of the iconostasis of the main church of the

**Revolution in Architecture*, pp. 79–109, fig. 40, pl. 18.

Figure 18 Karp Zolotarev, *The Apostles Peter and Paul*, 1690–1693. Tempera and oil, with gilt background, on panel. Church of the Intercession of the Mother of God, Fili, Moscow. Apart from the naturalistic clothing and faces of the figures, new-European influence is obvious in the Roman Catholic church (Basilica of St. Peter's in Rome?) depicted in the background.

Solovetskii monastery on the White Sea, where Peter stayed while learning to sail. Ermolaev might have died in 1700 or he might simply have lost his job at the Armory Chamber, whose activities were now being drastically curtailed by Tsar Peter or diverted to new purposes.

Thus in 1691 five icon painters of some distinction were suddenly "released from service" at the Chamber; in 1692 ten painters and students were sent to Pereslavl-Zalesskii, the town north of Moscow on whose lake Peter was also wont to sail, "for boating matters"—no doubt to decorate boats and sails; in 1696 a further, unspecified number of artists was sent with Vasilii Poznanskii to Voronezh, on the upper Don river, to assist in building Peter's new navy; and in 1697 six artists and eight students, all named, were similarly dispatched on the tsar's orders. In 1698 six more apprentice painters were transferred from the Armory Chamber to the Department of Masonry Affairs, which was in charge of new construction, especially military, in Moscow and elsewhere. In 1699–1701 various other aspiring artists were transferred to other governmental offices, sent as messengers to the provinces, assigned to learn engraving, or drafted into the army; at least one entered a monastery, and several (like Ermolaev) simply disappeared.[101] Even a painter as senior and accomplished as Bogdan Saltanov was ordered, as we saw, to help build the new arsenal in the Kremlin, a project directed by a master mason recently arrived from Germany. In short, if the salaried personnel of the Armory Chamber in 1687–1688 included twenty-seven icon painters and their students and forty other painters and theirs, by 1701 there remained only two icon painters (with no students) along with four other painters and apprentices, a drop of some 90 percent. In 1701 the largest salary by far at the Chamber (an incomparable 330 rubles per year plus allowances) was being paid to Adriaan Schoonebeck, Peter's newly arrived Dutch engraver, who also had several students on the payroll (Chap. 4). By this time, too, the Armory Chamber was supporting the staff, headed by three newly arrived British specialists, of Peter's newfangled "Navigation School" (*Navigatskaia shkola*) located in the huge Sukharev Tower of Moscow's outer wall.[102] Something quite extraordinary was clearly under way.

In retrospect, indeed, it seems that one Kirill Ulanov has the distinction of being the last icon painter in the employ of the royal Armory Chamber in Moscow, where he had been appointed a "master of iconpainting matters" in 1688 at an annual salary of twelve rubles plus grain allowances and daily food money. Several of his works are known,[103] including two recently restored panel icons that are somewhat more traditional in style and content than those of his foreign contemporaries or their Russian students (pl. 17). At the same time, Ulanov's works reveal the new influences informing Russian imagery in any number of ways: in their rather lifelike faces, relatively complex architectural forms and naturalistic scenery, and overall finesse, a quality which also recalls the "miniaturization" in Muscovite icon painting that dates back to the late sixteenth century. In the Armory Chamber's records for 1700–1701 we find

Ulanov restoring icons in the Kremlin's Dormition cathedral and painting a chessboard for Tsarevich Aleksei, Peter's son and heir. Thereafter, as far as is known, he became a monk, continued to paint icons (pl. 17), and eventually headed up one and then another monastery located far down the Volga. He died in 1751, the last of his kind: the last known "master royal of iconpaint-ing" in Russian history.

The last, but not the most distinguished. That honor belongs indisputably to Simon Ushakov (1626–1686), and before leaving the Armory Chamber and its virtual monopoly of painting in later seventeenth-century Russia we might look again at his career.[104] Earlier in this chapter he was depicted as a major, indeed pivotal artist, a figure comparable in his time to Andrei Rublev in his, although Ushakov's work, unlike Rublev's, continues to excite controversy among Russian specialists to this day.[105] He seems to have come not from a family of artisans and craftsmen, as was the case with the great majority of his eventual Armory colleagues, but from the Moscow nobility; and there is evidence from late in his life that his relatives included a merchant and several monks, one of whom was bishop of the honorable old see of Suzdal and founding abbot of a monastery. Ushakov took full-time service under the Ar-mory Office in 1648 at the age of twenty-two, having worked most likely on a part-time basis for several years before, and was appointed to the Silver Chamber with an annual salary of ten rubles plus allowances. He designed church vessels to be executed in silver, gold, and enamel for the patriarchal sacristy and for the sacristies of the great Moscow churches, working in the florid decorative style that had become standard in Moscow by this time[106] and was to exert, in one biographer's (Filimonov's) judgment, a decisive in-fluence on his artistic development. He also designed icons. In the later 1650s he worked for Patriarch Nikon, perhaps designing his pompous new mitre or "great crown"; decorated rooms in the private apartments of Tsar Aleksei; and executed certain other commissions, most notably the earliest of several great icons for the merchant Nikitnikov's church in Kitai-gorod, Moscow's commercial district (pl. 6). His own house and workshop were also located in this district, by the tsar's grace, who in 1659 raised his salary to twenty rubles per year plus allowances and bonuses.

Beginning in 1660 Ushakov was occupied with supplying new icons for various of the Kremlin churches (e.g., pls. 8, 9, 10) and with large commissions for restoring their murals, supervising in both instances dozens of other paint-ers and helpers. He signed many of these works, sometimes indicating who had assisted him and how. From these inscriptions we learn that Ushakov typically did the overall design and painted the faces of his figures, leaving the details of dress and setting, often very elaborate, to be painted and gilded by his assistants. He also designed rough maps for Tsar Aleksei, one of the course of the Don river from Voronezh to Azov, another of the kingdom of Sweden: reflections in either case of current military thinking and intimations, as well, of the early campaigns of Aleksei's son, Peter. Ushakov also painted

images or gilded crosses on those huge, traditional military banners that Aleksei favored but which son Peter would dispense with in favor of much smaller, and regular, European-style flags.

In December 1663 Ushakov was appointed by Boyar Khitrovo, pursuant to the tsar's decree, senior icon painter at the Armory Chamber with an annual salary of twenty-five rubles plus allowances. But in 1665 he passed under a cloud—it is not known why—and was incarcerated in a monastery. The matter had to do perhaps with some alleged doctrinal deviation in his painting, since "Italianate" or Italo-Greek influence was already evident in his images and this was as we know a moment, approaching the church council of 1666–1667, of heightened religious tension in Moscow. In any event, the incarceration apparently was brief, lasting less than a month, and Ushakov was soon back at work.[107]

The relatively ample evidence of Ushakov's career—more ample, usually by far, than that available for any contemporary or earlier Russian artist—indicates that for all his talent and growing reputation his approach to art remained largely conventional. That is to say, he painted well if not with distinction but always in deference to established Muscovite iconographic and stylistic traditions. He did what he was commissioned to do; he faithfully copied existing works; he drew for his images on standard pattern-books (*podlinniki*). In 1652 and again in 1662, for instance, he painted at patrons' behest versions of the Vladimir Mother of God (pl. 1) for two separate churches in the Moscow region (cf. pl. 10); in 1664 he was commissioned by Tsaritsa Mariia to make an exact copy of an old icon in the Dormition cathedral for her private church; in 1668 (or 1672) he was ordered by Boyar Khitrovo to execute murals in the tsar's main reception hall (the *Granovitaia palata*) following the outlines of the existing but now deteriorated murals of the late sixteenth century ("paint in this hall things as they are now painted").[108] Such commissions could have left little—only a little—room for innovation. In 1670 Ushakov painted a *persona* of Tsar Aleksei which was to be a gift for the visiting patriarch of Alexandria. It has not survived; but we may surmise from all contemporary Russian attempts at portraiture which have, and from Ushakov's other work (e.g., pl. 10), that his *persona* was iconic in composition, ornate in its one-dimensional treatment of the royal dress (elaborate ornamentation being a speciality of his), and naturalistic to some modest degree in its depiction of the royal face. Trenev, an early student in the field, thought that at their best Ushakov's faces reached those of the best medieval art of the West: of the late Gothic in northern Europe or the Italian *Trecento*.[109] This comparison looks reasonable enough to us, perhaps, though it seems to worry many Russian and particularly nationalist scholars, retroactively hoping as it were for more.

Trenev also praised the variety and richness of ornamentation in Ushakov's painting, which might be considered an original achievement. In somewhat similar fashion Filimonov attributed the special character of Ushakov's mature work, with its luminous, rather sophisticated combination of local and

friaz' styles, less to the taste or instructions of his patrons than to the "initiative of Ushakov himself."[110] We know that in designing one of his most famous pictures, the *Vladimir Mother of God and Tree of the Muscovite State* (pl. 10), Ushakov drew for his images and themes on recent Ukrainian scholarship, no doubt following consultations with Simeon Polotskii, the most prominent of the learned divines—as we've seen—attending the tsar.[111] The independence shown here and spirit of innovation or experimentation are confirmed by Ushakov's willingness to make designs for the new medium (new in Moscow) of copperplate engraving, an art he also may have learned himself. His design for the engraved title page of a book written by Polotskii (1681), with its severely Classical portal and personifications on pedestals of *War* and *Peace*, may also have been suggested by Polotskii. In any case, it is the first known example of the use of Classical symbolism by a Russian artist (fig. 19).[112] It is also a sign unmistakably of the direction in which this leading artist was moving.

Ushakov continued to receive valuable material marks of favor in Moscow even as rulers succeeded one another on the throne (Tsar Aleksei died in 1676, his son Tsar Feodor in 1682—to be succeeded, after a ruckus, by the co-tsars Ivan and Peter, also sons of Aleksei, under the regency of their sister, Sofia). He was confirmed in his status of Moscow nobleman sometime before 1677, when the title (*moskovskii dvorianin*) first appears by his name in the records; it was some indication, as with the closely contemporary promotion of Bogdan Saltanov, of a rise in the status of the visual artist in Russia. Ushakov also trained a sizable number of students: some fifteen are known by name. He may well have exercised "enormous influence" on these youths,[113] but it is surely significant that none became an artist of any great distinction. For this failure was no doubt a matter less of any shortage of energy or talent on their part than of the drastic alterations in taste and patronage taking place by this time in Moscow, alterations which were leaving traditional icon painters out in the cold. Ushakov himself died, as already mentioned, in 1686, not long before the onset of Peter's revolution and the complete reorientation of Russian imagery that it would entail.

By 1701, as the records of the Armory Chamber show, the Muscovite state's long-standing and then crucial support of icon painting in Russia had collapsed. This support, particularly in the closing decades of the seventeenth century, had led, we could say, to a certain professionalization of image-making. The training, testing, and formal certification of artists had been introduced or strengthened under the aegis of the Armory Chamber in Moscow, and their economic and social status improved. Specialization in the tasks of image-making had been promoted. It is also arguable that the products themselves of all this industry had thereby achieved a new finesse and a newly cosmopolitan character, evidence of a decided qualitative as well as quantitative boost in image-production. But the Muscovite state's virtual monopoly of image-making meant ultimate and, as likely as not, initial control

Figure 19 Title page of Simeon Polotskii, *History of Barlaam and Joasaph* (Moscow, 1681), designed by Simon Ushakov.

of the process. Not only individual artists but the whole enterprise itself was at risk should the state's support falter or undergo a sudden if not radical change of direction. This is precisely what happened under Tsar Peter, who, after the successful coup in his favor of 1689, which deposed Sofia and her party, began personally to assert the autocratic power.

It is tempting to conclude that the virtual collapse of state subvention of icon painting in Russia was a matter simply of economics—of the deliberate allocation of always scarce resources to new and largely pragmatic ends. Indeed some of the data so far adduced—those regarding the Armory Chamber's role in Peter's early steps to build a Russian navy, for example—support such a conclusion. But the role of taste in this collapse should not be underestimated either: of taste in the sense of personal attraction to imagery that was valued now not for its religious qualities, or only for its religious qualities, but for its beauty, style, and verisimilitude, its "lifelikeness" or naturalism; of taste in the sense of personal choices cumulatively and collectively expressed as fashion, fashion understood as a social *datum* that itself engenders compliance. We saw this happen in Italy and elsewhere in Europe in and with the Renaissance (Chap. 1). Why not here at last in Russia?

Members of the topmost Russian elite in the decades under review were choosing new-style images in the most direct and personal way, and were setting a new fashion: they were surrounding themselves with these images in the privacy of their living quarters, whatever they may have said and done as yet in public. The walls of the royal residences in the main Kremlin palace were being hung with new-fashion pictures (*kartiny*) as well as icons—where they were not being covered in murals and decorative painting reflecting varieties of European influence. Royal *parsuny* vied for attention with any number of *friazhskie listy* or "Italianate sheets"—woodcuts or single-sheet engravings—and of *estampy* (or *kunshty*), meaning German or Dutch or Italian prints some of which were framed. Paintings on paper called *zhivopisnye listy* ("life-painted sheets"), presumably done by local masters whether foreign or native, were also being favored.[114] The pleasure with which Tsaritsa Praskoviia, sister-in-law of Peter I, received the portraits of her daughters "dressed after the German mode," their hair "in the antique style," as painted in 1701 by the visiting Dutch artist, Cornelis de Bruyn (Chap. 2), is another case in point; so also her "very pleased" reaction, again as reported by Bruyn, to a Nativity scene he had drawn for her, no doubt in the current Dutch style. In 1669 the former Patriarch Nikon told a Dutch visitor to his New Jerusalem monastery, where he lived in retirement, that he did not publicly exhibit his new-style portraits lest he be accused of wishing to be taken for a saint—his portraits for icons—during his lifetime.[115] The portraits had been painted anyway and hung in Nikon's private quarters. Peter I's half-sister, Tsarevna Sofia, would-be "regent" in the 1680s, was less circumspect. Not only did she sit for her portrait in oil but she ordered others to be engraved in Amsterdam and in

Moscow, the former complete with Latin inscriptions "so that her glory should spread overseas."[116]

We may also consider the inventory of personal property seized from Prince V. V. Golitsyn, Sofia's chief minister, in the wake of their fall from power and then deposited in the Armory Chamber. The inventory included, apart from several icons, a lengthy list of *persony* and *listy*, among them portraits of various Russian rulers "on canvas in black frames," four more of the late Tsar Aleksei, one of the former Patriarch Nikon[117] and another of the reigning patriarch, Joachim (he who loudly denounced, in Chapter 2, Western influences in Russian icon painting); three *persony* of unnamed European monarchs, another of the Polish king on horseback, and one of a Polish royal couple; "12 German *persony* in round gilt carved frames," twenty gilded miniatures depicting various subjects, a "*persona* behind glass in a gilt frame of Prince Golitsyn" himself, biblical scenes painted on canvas in black frames, and "4 German *listy* in gilt frames, cost 5 rubles each"; also "12 printed German *persony* in gilt frames ... 5 printed German maps," nine more such maps, a "head [*lichina*] of a man painted on canvas" and "two stone figures," another portrait of Prince Golitsyn, and so on.[118] Golitsyn was praised by the French king's agent in Moscow in 1689 for sundry polite accomplishments, including the construction of a splendid palace in stone furnished inside with "rich tapestries" and "fine paintings."[119] In overthrowing Sofia and Golitsyn, we will see, Tsar Peter nowise repudiated their taste for the new art or their estimation of its political value.

This taste was only fortified when members of the Muscovite elite, Peter among them, actually traveled in Europe itself, there to behold that art in all its glory. Their conversion would be complete.*

Russians in Europe

"In this year [1697] His Majesty the Tsar himself resolved to do something never done before by a [tsar] ... to leave his sovereign throne for the sake of seeing the most important European kingdoms, dominions, and regions, and to observe the various manners, customs, means of life, and forms of government. And to do this he created a Grand Embassy, [which was] sent by His Majesty to many European courts seeking alliance against the Turks and which he himself accompanied *incognito*."[120]

Thus begins the appropriate section of a draft history of Peter's reign compiled by a German on his personal staff, Heinrich von (or van) Huyssen, who drew on the detailed "campaign journals" kept by the tsar and members of his entourage throughout the reign. Huyssen's (and Peter's) evident sense of the extraordinary importance of this "Grand Embassy" has been confirmed

*A parallel case for the elite's conversion to European (essentially Baroque) forms of architecture is made in *Revolution in Architecture,* especially chap. 4 and pp. 125 ff.

by later historians. Consisting of some 250 persons of various ranks and functions and led by three of Peter's closest associates (one of whom was François Lefort, his Swiss companion and tutor), the Grand Embassy may have failed in its ostensible goal of formalizing an alliance against the Turkish empire with one or more of the European powers. But a secondary purpose, that of hiring European technical experts for the tsar's employ, particularly shipwrights and naval officers, and of buying manufactured goods for shipment back to Russia, especially naval stores, was fully realized: hundreds of the former were hired and tons of the latter were purchased, all at great expense. And beginning in March 1697 Peter himself as well as various leading members of the Russian elite traveled, lived, worked, and entertained themselves in the Baltic states including Brandenburg, in Saxony, Austria, and Poland, and especially in Holland and England, where they stopped for a total of nearly ten months in and around those two world centers of shipbuilding and trade, Amsterdam and London. Peter would have proceeded from Vienna, his last major stop, to Venice and possibly Rome, spending still more time in Europe, had he not decided (in July 1698) to return to Moscow to deal with an uprising of his musketeers. He had been abroad by then for more than a year and a half.[121]

Peter's Grand Embassy of 1697–1698 proved to be a major factor in the program of intensive Europeanization that would dominate the rest of his long reign. For one thing, the naval stores and expertise acquired there and then would assist in eventually securing Russian control of the eastern Baltic Sea, its ports and coastline, a conquest that greatly facilitated Russian access to the commerce of northern Europe. More generally, events of the Grand Embassy led directly to that prolonged diplomatic and military struggle between Russia and Sweden for supremacy in northern Europe which broke out in 1700 and would finally end only in 1721, forcing Peter to abandon meanwhile his earlier struggle against the Turkish empire for supremacy over the Black Sea. Peter won the "Northern War," as it was called in Europe (the "Swedish war" in Russia), a victory that made Russia, as recounted in Chapter 1, a recognized European power; it was, in all its ramifications, his single greatest achievement. More to the point now, the experience of the Grand Embassy confirmed Peter and any number of his close associates in their attraction to the new European art, which was of course everywhere to be seen.

For Peter himself, not surprisingly, the attraction at this still early stage in his life and reign appears to have been mainly political. The case of the famous Kneller portrait is symptomatic in this regard: the portrait of the youthful Peter painted from life by Gottfried Kneller (1646–1723), the most famous portraitist of the day in England, where he had worked as court painter from the 1670s and was known, since being knighted in 1692 for his services to William III, as Sir Godfrey Kneller. Kneller was born in Lübeck and trained in Leyden and Amsterdam, in the latter as a student of Ferdinand Bol, from whom he assimilated the "Rembrandt technique." He later studied in Rome

under Carlo Maratti and the great Bernini, went on to Venice and his first success as an artist, returned to Germany in 1674 and in 1676 showed up in London, where he quickly became the rival of Sir Peter Lely in the booming business of portraiture. Over the ensuing decades he painted everybody who was anybody, poets and philosophers as well as persons of fashion and political grandees, the latter including Kings Charles II (who sent him to Paris to paint Louis XIV) and James II (fig. 20) as well as William III, who asked him to paint Tsar Peter. It is said that Kneller worked very rapidly and that this habit, coupled with the large volume of his commissions, "sometimes led to an *exécution lâchée*."[122] At any rate, he normally painted only the heads of his subjects, leaving the rest of his portraits for his pupils to paint according to set designs. Such was almost certainly the case with his portrait of Peter, if only because of Peter's well attested inability to sit still.

Kneller accompanied William III to Holland (where William was also *stadhouder*) in the fall of 1697, and apparently first sketched and/or painted Peter's likeness in Utrecht in September. Peter definitely sat for him in his London studio at the end of January 1698, soon after the tsar's arrival, at William's invitation, in the English capital. The resulting full-length portrait in oil on canvas (fig. 21), long a fixture at Windsor Castle, now hangs in Kensington Palace, London, where Peter actually visited the king. Bogoslovskii, author of the most detailed account of Peter's earlier life ever compiled, describes it as the "first genuine portrait of Peter painted from life" while observing that for all the painter's distinction the portrait "is not without a certain conventionality." Bogoslovskii had in mind the "fantastical military garb" in which the tsar is dressed—Baroque ceremonial armor such as Peter had never worn and perhaps had never seen before—and the "rather artificial pose, calculated for effect." Indeed it is unthinkable that Peter would have assumed such a stance, let alone got into such garb, customary though they were by current courtly standards (cf. figs. 20, 21; nevertheless, as Bogoslovskii also says, the face was considered a remarkable likeness by various contemporaries.[123] Cornelis de Bruyn, the Dutch artist and explorer, recounts in the book of his experiences in Russia how he recognized the tsar because of it. In January 1702, finding himself unexpectedly confronted by Peter in the Moscow house of the Dutch minister-resident, Bruyn

> was a little in confusion, though upon recovery I made my address to him [Peter] with a most profound bow. He seemed surprised at it, and asked me in Dutch, "How is it you know who I am?" I answered I had seen his picture at Sir Godfrey Kneller's in London, and that it made too deep an impression upon my mind to be effaced.

It turned out that Bruyn had had his portrait painted by Kneller, too, years before in Amsterdam, and had kept up the connection.[124]

That Peter himself was pleased with the Kneller portrait, cut back to head and upper body, or just to his head, is suggested by the fact that he soon

Figure 20 Godfrey Kneller, *James II*, 1684–1685. Oil on canvas.

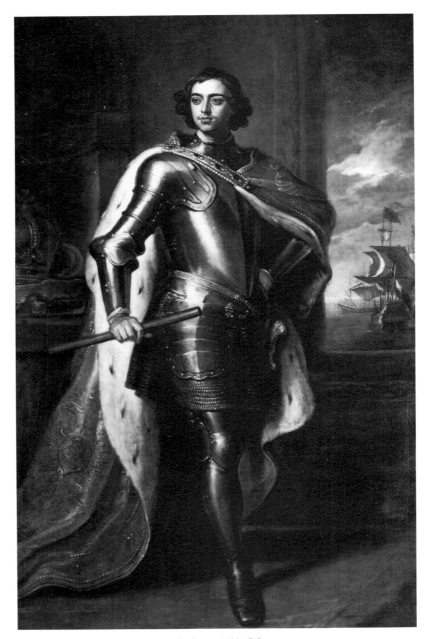

Figure 21 Godfrey Kneller, *Peter the Great*, 1698. Oil on canvas.

Figure 22*A* C. Boit, *Peter I*, ca. 1698. Miniature in oil on enamel on copper base.

Figure 22*B* I. Adol'skii(?), *Peter I*, ca. 1700. Miniature in oil on enamel on copper base in silver frame.

commissioned miniatures after it to be painted on enamel set in gold and decorated with gemstones: handsome presents, following the European fashion, for the monarchs, princes, and other high-ranking persons to be encountered on the diplomatic rounds. More specifically, Peter ordered a "large quantity" of such miniatures from Charles Boit (1663–1727), a Swedish artist working in England at this time. One of the Boit miniatures was brought back to Moscow, to serve as a model for others to be made at the Armory Chamber (figs. 22*A–B*); and still another was copied by several hands in Amsterdam, after Peter had returned there from London and before he left it for Vienna. Throughout the remainder of his Grand Embassy, and for years thereafter in Russia, Peter would confer such miniatures of himself on numerous worthies in recognition of their importance or service to him. And so was born the Russian fashion, eventually a veritable passion among the elite, of giving miniature portraits painted on enamel as keepsakes or mementos of loved ones

Figure 23 *Peter I.* Engraved frontispiece after Kneller (cf. fig. 21), in N. G. Ustrialov, *Istoriia tsarstvovaniia Petra Velikago*, vol. 1 (SPb., 1858). Ustrialov's five-volume work was the first modern documentary history of Peter's reign published in Russian.

as well as official marks of favor. Nor did it end there. Medals with representations of Peter after Kneller were also commissioned in Holland in 1698, as were, both then and later, engravings by Dutch and English artists for use in book illustration or for distribution in single sheets. Sir Godfrey could not have known what he had wrought. Not only was his face of Tsar Peter the first to become widely known in Europe, but a European image of the Russian ruler became for a time the official Russian one, and one that in either case would be perpetuated in various venues for decades, even centuries, to come (fig. 23).[125]

During the Grand Embassy of 1697–1698, it's worth noting, Peter himself took art lessons. His teacher was a local artist to whom he had given several commissions and whom he was to hire for his service in Russia; and the evidence is an etching bearing the inscription, in Dutch: "Peter Alekseevich, great Tsar of Russia, etched this with needle on copper under the supervision of Hadriaan [Adriaan] Schoonebeck in Amsterdam in 1698, in the bedroom of his lodgings on the wharf of the East India Company." Corrections by Schoonebeck are perhaps visible in the work, which shows an angel-like figure holding aloft a Latin cross against clouds and the rays of a Baroque sun while standing on a thin crescent moon, under and around which are depicted emblems of a Turkish defeat, notably four banners in a yielding gesture with crescent-shaped finials on their poles (fig. 24). The picture obviously evoked Peter's recent victory (1696) over the Turks at Azov, his first military success and a feat of which he was perpetually proud. His political preoccupations

Peter Alexewitz, de groote Czàr
der Rüssen, heeft dit met de naald
op koper geëtst, onder de directie van
Hadriaan Schoonebeek, tot Amsterdam,
den 1698, in sin logie en slaap-
kamer, op de Werf van de oostindise
Maaktschappÿ.

Figure 24 Etching by Peter I, *Allegory of the Russian Victory over the Turks at Azov in 1696*, 1698.

are thus emphasized but so equally is the strength of his interest in the new imagery.[126]

Otherwise, Peter's devotion to shipbuilding and related matters at the time of his Grand Embassy, not to mention his concern with architecture, engineering, commerce, and diplomatic affairs, left him little leisure for the purely visual arts. In Amsterdam in 1697 he was introduced to Adam Silo, who guided his essays in marine design and whose marine paintings he would eventually collect.[127] Here lie the origins no doubt of Peter's passion, later to be fully indulged, for such imagery. The "campaign journals" of the Grand Embassy indicate that somebody of importance in the embassy admired a church in Magdeburg for its "fine painting on the walls representing scenes from the Bible"; that in Amsterdam an "image of the Crucifixion of Our Lord" was bought for the embassy's traveling church (chapel); that in Vienna engravings were purchased depicting the emperor's recent wedding, the big event of the time. Numerous printed maps and atlases were also purchased by officials of the Grand Embassy, presumably also at Peter's direction; and it is clear from its account books that as time passed members of the embassy, Peter among them, increasingly took to wearing European—"German"—clothes, discarding the Russian garments in which they had arrived (figs. 25*A*–*B*).[128] We may consider this behavior symptomatic of their more general conversion, especially when we remember that on returning to Moscow Peter formally decreed that henceforth Russian elite society (excepting only the clergy) should dress in such clothes under pain of heavy fines, a decree that thus overrode, indeed contradicted, another by his father of 1675 forbidding courtiers to "adopt the customs of the Germans and other foreigners, cut their hair, or wear dress, robes or hats of foreign design."[129]

It may also be significant that during a series of often lengthy discussions in London in 1698 with a leader of the Anglican church, Gilbert Burnet, Peter "yielded that [icons of] saints ought not to be praied to." According to Bishop Burnet, who reported their discussions in a confidential letter to a clerical friend, Peter "was only for keeping the picture of Christ, but that it ought only to be a remembrance and not an object of worship."[130] Here we might also remember (Chap. 2) the words of John Perry, hired by Peter in England in 1698, recounting from his subsequent years of working as an engineer in Russia how the tsar

> reduced the number of his saints in his own houses of residence to the cross or the picture of our blessed Saviour only. And the lords and other persons who are his favorites have been brought in a great measure to follow his example, excepting some few of the old lords.

More specifically, Captain Perry recalled that when Peter came on board the ships of his new fleet in the summer of 1698 (soon after his return from Europe) and found "the cabins of each ship full of pictures of their saints, according to their usual way," he told the Russian commanders responsible that

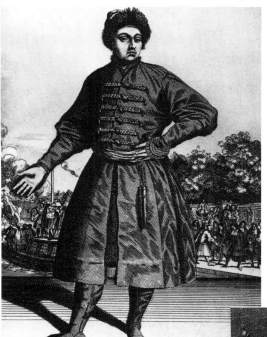

Figure 25A F. Ottens, *Peter I in Russian Dress*, ca. 1717. Etching after drawing by unknown (Dutch) artist executed during Peter's visit to Holland in 1697–1698; etching commemorates Peter's second visit to Holland, in 1717.

Figure 25B Pieter van der Werff, *Peter I*, 1697–1698. Oil on canvas. Peter is dressed here in the "Polish" style favored by Russian grandees of the later seventeenth century.

"one of those pictures or images was enough to cross themselves to, and therefore ordered that all the rest should be taken away, for he would have no more than one in each ship; which has ever since been observed on board his fleet."[131] Peter's attitude and then policy in this matter were obviously important steps in constraining if not undermining, at least in his official estab-

lishment, the traditional Russian veneration of icons: in freeing Russian imagery from its traditionally sacrosanct quality. We may reasonably conclude that if this attitude did not originate in the course of discussions conducted and of observations made during his Grand Embassy, it was certainly fortified by these experiences.

In the short term, however, only five artists (including Schoonebeck)—four engravers or etchers, the fifth a "lifepainter" (*zhivopisets*)—were among the hundreds of specialists hired by Peter or his agents in Holland and England in 1697 and 1698 for service in Russia.[132] This finding is consistent with the basically political and pragmatic interest in the new art that Peter otherwise exhibited at this time. The five artists, as our next chapter will show, immediately set to work in Russia depicting Russian military victories, illustrating technical manuals, producing official portraits, maps, and architectural views, and training Russian students to do the same. The wholesale diversion of resources at the Armory Chamber from icon painting to this new kind of image-making began soon after, in 1699, as recounted earlier in the present chapter. Something quite extraordinary was definitely under way.

Overall, then, the Russian Grand Embassy of 1697–1698 to Europe gave birth to the first important portrait of Peter himself (by Kneller); to the fashion in Russia for miniature portraits painted, typically, on enamel; and to Peter's first known essay as an artist—an etching in Baroque allegorical style depicting his recent victory over the Turks. The Grand Embassy also gave a crucial boost to the development of graphic art in Russia, which in turn was to be a critical factor, as it had been in Europe, in the spread of the new imagery more generally. At least a few pictures were purchased in Amsterdam, Vienna, and perhaps elsewhere by the embassy and brought back to Moscow, adding to the still small stock of imported new art in the Russian capital. And there is no reason to doubt that Peter himself and various members of his entourage had been deeply impressed by the Renaissance, Mannerist, and especially Baroque pictures, sculptures, gardens, and buildings that they saw particularly during the ten months or so spent in Holland and England. The Grand Embassy of 1697–1698 surely marked the completion of the preparatory phase of the Petrine revolution in Russian imagery, a phase in which a critical section of the Russian elite—one that included the tsar himself—were fully converted to the values of contemporary European visual art.

Other Russians traveling in Europe at the end of the seventeenth century left more detailed accounts of the art that they saw. The anonymous author of a notebook kept during a journey from Holland through Germany to Italy and back in 1697–1699, for instance, beheld an altar built "most splendidly of marble" in a church in Lübeck; "fine houses" everywhere in Amsterdam; a statue of Erasmus in Rotterdam, described by our traveler (almost certainly a member of the noble Apraksin clan) as a "*persona* of bronze, molded in human

form, with a bronze book in his hands"; and "marvellous decoration, elegant holy icons, [and] a great chandelier embossed with scenes from the Bible" in a church in Dusseldorf. In Mainz it was "great and elegant palaces" that this Russian visitor noted; in Augsburg, in a "very large church," an "altar richly made and [surmounted by] a hill made of marble, on the top of which stands an angel holding up a cup while Jesus Christ, below, on his knees, asks that if possible this cup might pass [from him]; and apostles stand here and there on the hill"—altogether an amazing work of sculpture. In Augsburg he also admired "two stone lions in marble of wondrous workmanship," while in Venice it was an "image of the Mother of God carved of white marble holding the Child," again a work of "wondrous skill." Here too he heard "music such as I never heard before—maidens sang in a choir and all kinds of instruments were played." Nor did this traveler, most likely one of the seventy-eight Russian noblemen sent by Peter in 1697 to study navigation and related subjects in Venice, fail to be impressed by the sights of Rome, with its "gorgeous painting" everywhere and its marble tombs of the popes, some with "*persony* made of bronze, others of marble." In Florence he went to the Pitti Palace, "where every sort of thing is collected in what is called a gallery [*gallereia*]," including "marvelous paintings." In the house of a certain cardinal in Rome he saw "such riches as I have seen nowhere." [133]

In fact, this notebook or diary of 1697–1699 exhibits overall an amplitude and attention to detail that is simply unprecedented when compared to the few written accounts left by Russians who traveled abroad before Peter's time, either as pilgrims or as members of official embassies. Such accounts consist, in the case of pilgrims, of pious if not credulous descriptions of shrines and relics seen and venerated, to the exclusion of anything else; or, in the case of officials, of dogged, equally minimalist recitals of their embassy's movements and expenses together with replications of official speeches and letters exchanged. In neither case, in the words of a later Russian scholar, do we meet Russians who in traveling to other countries were concerned to "satisfy their own curiosity," who exhibited a "desire for knowledge." [134] Thus the notebook from which we have just quoted is itself a sign of significant change in Russian elite culture, just as the account of his journey to Rome in 1697–1698 by B. P. (later Field Marshal) Sheremetev was already something of an anachronism, combining as it does the features of the traditional pilgrim's tale with those of an official *stateinoi spisok*. This case may be explained perhaps by the dual nature of Sheremetev's trip: ostensibly a private pilgrimage, it was also a mission on Peter's behalf to sound out the papacy on the question of war against Turkey and to prepare the ground for Peter's projected visit to Rome. [135] The unreserved enthusiasm for Roman shrines and relics and "icons" evinced by Sheremetev's account is further explained by the fact that during this trip he converted to Roman Catholicism, temporarily if not permanently. The same thing evidently happened to other high-ranking Russians who were sent in these years to Venice or Vienna as well as to Rome, no doubt the result, as a

later student says, of their exposure to a whole new world and of the powerful impressions it made on their minds.[136] Indeed, these religious conversions were doubtless facilitated in considerable degree by the aesthetic and more purely emotional impact on Russian visitors—the psychic impact—of the Baroque art which pervaded Catholic culture at this time.

Far and away the fullest of the surviving accounts written by Russians traveling in Europe at the end of the seventeenth century is by P. A. (later Count) Tolstoi, another of the noblemen sent by Peter to Venice to study navigation and "military science." Tolstoi left Moscow in February 1697, traveled through the Polish and Austrian dominions on his way to and from Italy, and returned to Moscow in November 1699. His diary of his journey is at once official but personal; reflects piety with respect to manifestations of his own "Greek rite" but interest all the same in monuments of the other "faiths" he met on his way (Roman Catholic, Uniate, and Jewish); shows its author to have been ceaselessly curious especially about architecture (broadly understood), but only once he was abroad; and is long: in its printed version Tolstoi's diary occupies some 300 deep pages.[137]

Judging by the adjectives employed, Tolstoi first reacted positively, not to say enthusiastically, to the art he saw on route when he reached the town of Mogilev (Mahiloŭ) in Belorussia (Belarus), which was located 100 kilometers and more beyond the Russian border and where he stopped for eight days. He records that the main church of the local Brotherhood monastery, Orthodox or "Greek" in religion, was of "fine construction," with "8 interior columns, much gilded carving, excellently painted walls, and a great carved and gilded iconostasis of fine workmanship." This church had been built in a variant of the Polish Baroque earlier in the seventeenth century and its iconostasis, similarly Baroque, would have exemplified a style that was transferred by Belorussian craftsmen in the last decades of the century to Moscow, where, favored by members of the topmost elite, including both the patriarch and the tsar, it helped pave the way for Peter's revolution in Russian architecture.[138] Tolstoi was already swimming with the Europeanizing tide. In the Roman Catholic church of the Bernardines in Minsk he heard "most wondrous music" by organ and choir; in the church of the Benedictines, the music was simply "stupendous." His conversion, like Apraksin's, would be aural as well.

In Warsaw Tolstoi admired the "great and rich cathedral," the "very high column of cut stone on which is placed a *persona* of a Polish king made of gilded bronze," the "numerous finely built rooms" of a great nobleman's house, with their "rich Italian plaster work," and a suburban garden with "marvellous fountains" and such "wondrous" ornamental structures as were "impossible to describe." The royal palace of Wilanów, only recently built (1677–1696) outside Warsaw, was the most wonderful he had ever seen owing to its great size, exclusively masonry construction, abundance of sculpted decoration "of most wondrous Italian workmanship," and numerous rooms with "many fine pictures in the marvelous Italian painting style." Words be-

gan to fail him. Vienna was splendid enough to merit frequent and repetitive superlatives, but Venice was altogether a "most marvelous place, more than twice as big as Vienna" and full of "most wondrous Italian" architecture, sculpture, and painting. In Milan he also found much to please, including a church "in which I saw wondrous pictures in Italian styles which had been bought at great cost." In a library in Milan Tolstoi beheld sculptures "of such marvellous skill as no one could describe," and "splendid paintings on copper and wood and canvas and other materials of a workmanship of which human language cannot speak in detail."[139]

In Rome, seemingly everything he saw amazed the veteran Muscovite courtier (in 1697, when he set off on his journey, Tolstoi was more than fifty years old). "In Rome there are two thousand churches and monasteries and all are most splendidly built, with astonishing ornamentation inside and gloriously decorated outside with wondrously carved magnificent alabaster and marble floral ornaments"; fountains "equipped with such magnificent figures that for their multitude nobody could truly describe them"; Bernini's "fine great rounded *pliatsa* [piazza]" of St. Peter, "around which stand masonry columns to the number of 576, extremely tall, large, and round, with fine promenades amidst them paved in stone, and with [balustrades] above on which stand images of saints all most handsomely wrought of alabaster, each holding a cross." Inside the basilica of St. Peter itself, the "largest church in the world and most marvelously constructed," the "decoration is magnificent . . . canopy and columns carved in the most marvelous fashion . . . wonderfully carved angels, all splendidly gilded. . . . The interior of this great church is all magnificently done in white marble, with the most wonderful alabaster carving. . . . The paintings on the walls and ceilings are in the most magnificent, glorious Italian style."[140]

Tolstoi's account of his travels in greater Poland, Austria, and especially in Italy in 1697–1699 make it abundantly clear that this prominent member of the Russian elite had been captivated by the new art. And if his many and extended effusions in this vein were not sufficient proof, we may note in contrast his laconic and restrained comments concerning icons or churches in the "Greek" or the "Muscovite" style (or "Russian" or "eastern") that he saw in Venice or the Polish lands, in the Balkans or in Russia itself.[141] The contrast is indeed striking, suggesting that Tolstoi's conversion was complete: in the words of his Russian biographer, he returned from Europe "fully prepared to take part in the general transformation of Russia."[142] Tolstoi went on to become one of the most important figures of the Petrine regime, serving successively as ambassador to Constantinople, senator, head of the Privy Chancellery, president of the Commerce College, and grand marshal of the coronation in 1724 of Peter's wife Catherine, who conferred on him and his descendents the new Petrine title of count. He also translated (from Italian) Ovid's *Metamorphoses* into Russian for the first time.

When Russians traveled in Europe only a few years after these journeys of

Tolstoi, Apraksin, Sheremetev, and the Grand Embassy, the new art was rapidly taking root in Russia itself, and its superiority to traditional Russian imagery was now taken for granted. We can sense as much in the diary of Ivan Nepliuev, a young naval student, recounting his movements in Spain and Italy between 1716 and 1720. In Florence in April 1718, for instance, he simply noted that Russians were studying painting there—"Ivan and Roman Nikitin and comrades"—and that in Livorno "in the grand duke's gallery" there were "various items of painting and sculpture [*ot piktury i ot skul'ptury*]," both ancient and modern, "from [the time of] Our Lord until now."[143] Nothing to be wondered at, it would seem; for Nepliuev such a gallery was to be visited routinely. Nor was it to be thought odd that Russians should be busy studying art in Italy, or that he should be dutifully observing all of this.

More impressive still, in this as in other connections, is the diplomatic evidence. Under Peter, as was noted in Chapter 1, representatives of the Russian state for the first time took up more or less permanent residence in various European capitals—in Vienna, Rome, The Hague, Berlin, Paris, and London; and some of these ambassadors left memoirs fully confirming their conversion to the new norms of imagery. Prince B. I. Kurakin, for one, resided in all of the cities just mentioned in the later years of Peter's reign, acting as his purchasing and hiring agent as well as ambassador and keeping diaries or making notes all the while. From these it is obvious that Kurakin understood and admired the *ensemble* of art that typified the Baroque as well as its individual manifestations: the integration of exterior and interior design for which the Baroque is famous, of architecture, painting, and sculpture into a dynamic whole, a conception that extended to the furnishings of a room. The royal palace in Berlin, "though not finished [in 1705] and not large, is properly built following the new architecture [*arkhitektura novaia*], its *salle* finished in glass set in wood." These are the words of a budding *amateur*. The ground-floor rooms of the house of Prince Louis of Baden, near Carlsbad (Karlovy Vary), were also beautifully finished in various materials, while the ceilings were "painted in the Italian style, on wet plaster, giving the effect of tapestries, most rich," and the rooms furnished with fine tables and chairs, columns and panels, all decorated in the "Italian manner" and "smoothly turned." The town hall in Amsterdam was "extremely fine—no doubt there is no better anywhere; the interior is all of sculpted alabaster . . . in various figures, superbly worked." In The Hague, "I saw the chambers where they receive ambassadors and seat the Estates—most fine. And in one chamber I saw a ceiling so fine, with its painting so marvelous, that little could compare." At a palace near Berlin in 1706 Kurakin discovered a room "decorated with porcelain and glass such as I had nowhere seen before."[144]

In London Godfrey Kneller painted Kurakin's portrait, too, he all elegantly turned out in peruke and fancy armor, the badge of Peter's newly founded order of St. Andrew, denoting the tsar's very special favor, prominently displayed on his chest.[145] He had earned it. When he was not negotiating some

4

Revolution

GRAPHIC ART

The Petrine revolution in Russian visual art struck first in the graphic realm. Drawing in any modern sense of the term, drawing as an art in itself and as the art underlying the other new forms of image-making as well as the new architecture: drawing in this sense was implanted in Russia under Peter I. So too were the arts of making prints from etched or engraved copper plates, a development that enormously increased the local capability for reproducing images of various and usually new kinds. Equally if not more important, the establishment under Peter of the arts of printmaking made possible that exact replication of images which was essential to the development in Russia, as it had been in Europe, of modern technology especially military technology, of science, and of architecture. In pursuit of these ends European masters of graphic art were first hired to work in Russia and to train local specialists, the importing of prints and illustrated books was enormously increased, and paper mills were finally established. Drawing schools were also founded and new printing presses set up. In short, the Petrine revolution in graphic art was both a precondition of the wider revolution in Russian imagery and itself a development of far-reaching consequences.

It was a development, a revolution, which had some local precedent. Woodcuts first appeared in Russia in the later sixteenth century, as decorations and illustrations of the first printed books. Leaving aside the decorations, few as they were, the illustrations in question are conventionally attributed to still shadowy local artists and amount to a total of four: two framed figures of King David serving as frontispieces to psalters printed in Moscow in 1568 and in Aleksandrov—north of Moscow—in 1577; and two framed St. Lukes serving as frontispieces to Books of the Apostles (*apostoly*: Acts plus Epistles) printed in Moscow in 1564 and again in 1597. The best of the four, the *St. Luke* of 1564, obviously reflects in both composition and detail the local tradition of manuscript illumination, except that its elaborate architectural frame, with its imposing arch and decorated columns on pedestals, obviously derives from an external source: in fact, or very possibly, from a woodcut *Joshua in Body Armor* executed by Erhard Schoen in 1524 after a prototype by Lucas Cranach the Elder, one of a series done by Schoen to illustrate a German *Old*

Testament printed at Nuremberg and a Czech edition of which (the Russian source?) was printed, also at Nuremberg, in 1540. Luke's head in the Moscow 1564 frontispiece might well have been modeled on Joshua's head in the Schoen print, too (figs. 27*A–B*). In any event, these modest efforts to establish book printing and woodcut illustration in Muscovy proved abortive. The presses were soon closed if not deliberately destroyed and the chief printer left the country. Nearly as devastating to the enterprise, the three or more paper mills organized and operated in Moscow with some success in the 1560s and 1570s by "Western masters" invited to do so by Ivan IV were also closed down. Russians reverted to importing all of their paper from Europe, until the time of Peter. Given the distances such paper had to travel (e.g., from France by way of Archangel) and its ensuing price in Moscow, this factor alone acted as a major brake on the development of printing in Russia.[1]

Book printing along with woodcut illustration revived in Russia after the disastrous Time of Troubles (1598–1613): the archives of the main new press in Moscow, the *Pechatnyi dvor* or Printing House, go back to 1620. A subsequent evolution of style in seventeenth-century Russian woodcuts has been posited, and we certainly do notice an elaboration of the decorative elements that is commensurate with trends in contemporary Russian architecture, wall and panel painting, metalwork, and manuscript illumination. But that being said, it is difficult to see any evolution in the sense of technical or aesthetic progress. On the contrary, a woodcut of a framed figure of St. John Damascene serving as the frontispiece to a devotional book printed at Moscow in 1666 is a decidedly cruder, much simplified copy of the frontispiece to an identical work printed at Lviv, in Polish Ukraine, in 1630—the latter itself a somewhat rusticalized version of a probable sixteenth-century German prototype (figs. 28*A–B*). Even Sidorov, our main authority here, was willing to admit that this among many such cases demonstrates a growing dependence in Moscow on Ukrainian models (rather than some sort of independent evolution of the Russian woodcut); also, that by the end of the century (the advent of the Petrine revolution) the "real creative forces in our art were concentrated in a new realm—engraving on copper."[2] An earlier Russian specialist—less nationalistic, more direct in approach—dismissed both sixteenth- and seventeenth-century Muscovite book illustration in whatever medium as "crude" and "extremely naive" by contemporary European (and later Russian) standards, and dated the effective beginnings of this art in Russia to "the era of Emperor Peter I."[3] It is impossible, all considered, not to agree.

Single-sheet woodcuts as distinct from woodcut book illustrations began to be printed in Russia only at the end of the seventeenth century (if then), and will be discussed in Chapter 6 in connection with the emergence of the popular print. But the printed *antimins* (also *antimis*), laid on a church altar to signify its consecration, may as well be looked at here. The *antimins* (antiminsion) had been known in the Russian church since the earliest times, having come from Byzantium, where it originally served as a portable altar (hence

Figure 27*A* Erhard Schoen, *Joshua in Body Armor, Seated in an Architectural Frame,* 1524. Woodcut.

Figure 27*B* *St. Luke.* Woodcut frontispiece to the *Apostol* printed at Moscow, 1564.

Figure 28*A St. John Damascene.* Woodcut frontispiece to an *Oktoikh* printed at L'viv, Ukraine, 1630.

Figure 28*B St. John Damascene,* Woodcut. Moscow, 1666.

its name in Greek, meaning "instead of a table") and consisted of a cloth of linen or silk to which relics were attached and on which scenes of the Passion, usually Christ's entombment, were depicted. In Russia traditionally *antiminsy* were pieces of linen about twenty centimeters square bearing inscriptions and a simple cross drawn in ink. From the middle of the seventeenth century— from Patriarch Nikon's time—*antiminsy* were also printed on linen or satin and sometimes on paper by means of woodcuts; and from 1675, by order of Patriarch Joachim, all churches in Russia were to have one of the "new printed consecrational *antiminsy*" on their altars, an order repeated by Patriarch Adrian in 1697.[4]

The new *antiminsy*, bearing the names of the reigning tsar and patriarch, were issued by the Moscow Printing House (*Pechatnyi dvor*) with blank spaces for inserting by hand the name of a particular church and the date of its consecration. The earliest preserved example (1652), approximately twenty-five centimeters square, features a central scene of Christ lying in his tomb bordered by vegetal decorations and symbols of the four Evangelists, all as fine as anything in contemporary Muscovite book illustration, with which it has obvious affinities (as it does with contemporary painted icons and *plash-chanitsy* or liturgical shrouds, whether painted or sewn). An *antimins* of 1678, nearly identical in composition with that of 1652 but everywhere finer in execution, was printed in Moscow from a tin plate or block by a process that remains obscure. Apparently a wax impression of a woodcut formed a mold or matrix for casting the plate or block, which then functioned like a huge piece of type: written references from the eighteenth century describe an object weighing about forty kilograms (the tin mixed with lead?), while the *antiminsy* it printed (1678) measured about thirty-two by forty centimeters. More to the point now, the same technique was used at the Moscow Printing House in the 1690s to produce an *antimins* strikingly different from its predecessors: the figures of the central entombment scene are depicted in new as well as more naturalistic poses, the Evangelists appear now in portrait, and the border is filled with realistic instruments of the Passion—pillar and whip, hammer and nails, ladder and lance, and so on. In fact, it has been shown that this *antimins* of the 1690s, thousands of copies of which were printed between then and the 1750s (the inscriptions altered to keep pace with changes in ruler), was copied from a Ukrainian original of the second half of the seventeenth century, an example of which is preserved at the Lviv Museum of Ukrainian Art.[5] The imposition by the central Russian authorities on all Russian churches of centrally manufactured *antiminsy* was part of a broader, well-documented centralization of church and state in late Muscovite times.[6] Similarly, the evolution of the *antimins* itself reflects the broader development of the graphic arts in seventeenth-century Russia.

Still more, a so-called Big Antiminsion (forty-eight by fifty-four centimeters) was printed at the Moscow Printing House in the mid-1690s from an engraved copper plate. A contemporary Russian source refers to its "Italianate

Figure 29 *The Holy Evangelist Luke.* Detail of the Big Antiminsion (*Bol'shoi antimins*) printed from a copperplate engraving, Moscow, mid-1690s.

workmanship" (*friazhskaia rabota*), meaning both the technique of copperplate engraving that produced it as well as its composition and style, which are much more directly reflective of the new European art than those of the tin-block "Ukrainian" print just mentioned (fig. 29). Evidently European graphic models were closely followed in Moscow when creating the Big Antiminsion of the mid-1690s, which became the standard for *antiminsy* printed in Russia until the end of the *nineteenth* century.[7] The new imagery had thus penetrated the liturgical core of the Russian Orthodox church.

The Big Antiminsion was one act as it were in the decidedly modest debut of copperplate engraving in immediately pre-Petrine Russia, *pace* the exaggerated claims of Russian nationalist scholars. In his recent history of reproductive engraving in Europe from the sixteenth to the twentieth centuries, for instance, M. I. Flekel speaks of an "independent school of engraving and then of etching" springing up in Moscow in the last quarter of the seventeenth century.[8] But what, in fact, is being referred to? A total of ten books with engraved illustrations printed in Moscow between 1647 and 1703, namely: a

military manual translated from a German original and published (1647–1649) with thirty-six illustrations previously printed, from copper plates, in Holland, the work, presumably, of a Dutch master or masters; a psalter and three books of religious prose and poetry authored by our friend the learned Belorussian monk Simeon Polotskii (Chap. 3), all four works printed (1680–1683) in a shop organized by Polotskii and each illustrated with one or two engravings (Polotskii's short-lived shop, the so-called *Verkhniaia tipografiia,* evidently included a roller as distinct from a screw press, which would have been needed for the proper printing of engravings in any quantity); two primers (*bukvari*), the first printed (1694) with forty-four engravings but the second (1697) with only two; a church service book printed in 1695, with one engraving; and Magnitskii's *Arifmetika* of 1703, the first arithmetic book ever printed in Russia, which was illustrated with three copperplate engravings as well as sixty-four woodcut diagrams and two other woodcuts.[9] Discounting the Dutch illustrations of the military manual of 1647–1649, and even allowing those in the *Arifmetika* of 1703, which is better seen as an early product of the Petrine revolution, we have here a total of something over fifty copperplate engravings (or etchings, the sources are not always clear) produced in Russia by local masters between 1680 and 1703. Moreover, of this total only one work, the title page of Polotskii's *History of Barlaam and Joasaph* (1681) designed by Simon Ushakov, with its Classical portico and personifications of *War* and *Peace* (fig. 19), can fairly be said to represent a breakthrough in Russian graphic art with regard to either style or theme. The rest of these fifty or so engravings (forty-four belonging to a single work, the primer of 1694) exhibit at best a combination of traditional motives and styles with various new elements plucked randomly from the European and particularly Ukrainian prints circulating in Moscow at the time (figs. 30, 31).[10]

Simon Ushakov is hailed as the first representative of a putative Moscow school of engraving and etching of the later seventeenth century, although his known *oeuvre* in this respect is miniscule as well as highly derivative. Afanasii (Athanasius) Trukhmenskii, another designer (*znamenshchik*) and silversmith who worked at the Armory Chamber until his death (sometime after 1689), is the second master of the school: some thirty engravings after drawings by Ushakov and others (fig. 30) have been attributed to Trukhmenskii. And Leontii Bunin (died after 1714), also of the Armory Chamber and author of the forty-four engravings illustrating Istomin's *Primer* of 1694 (fig. 31), is the third.[11] By any wider standard this was a "school" then of purely local and, as events proved, passing importance. On the other hand, its very modest achievements and more, its evident aspirations, demonstrate once again serious interest among the Muscovite elite—sponsors and patrons of Polotskii, Ushakov, Trukhmenskii, Bunin, and others—in the new European art.

A similar situation obtained in the basic art of drawing in seventeenth-century Russia, and the efforts of later students to characterize such drawing as truly new or modern are similarly exaggerated or mistaken. The patterns

Figure 30 Frontispiece to Simeon Polotskii's *History of Barlaam and Joasaph* (Moscow, 1681). Engraving by A. Trukhmenskii after design by Simon Ushakov (cf. fig. 4). Sidorov suggests that the faces of the hermit Barlaam (left) and of Prince Joasaph (right) represented here are in fact portraits of Simeon Polotskii and the reigning Tsar Fëdor Alekseevich, making this work a document in the movement of Russian art towards realism (*Drevnerusskaia graviura*, p. 270).

or tracings used as guides by painters of holy images in sixteenth- and seventeenth-century Russia, those *podlinniki* and *prorisi* (also *kal'ki*) referred to earlier in this volume, clearly exhibit, in their simplicity, frontality, and other characteristics, not modern but medieval or traditional norms (or those of folk art). This remained so even when such drawings done in ink on paper and

Figure 31 First page, illustrating the letter "A," of the *Primer (Bukvar')* compiled by Karion Istomin and printed at Moscow, 1694. Engraving by L. Bunin.

gathered in albums might reveal a certain "elegance" or "independence" and contain variants of heads and faces, of clothing, feet, or hands that might suggest drawing exercises. Sidorov again is our main authority and he proposes Ushakov, again, as the outstanding master in this field. Ushakov's lone surviving effort, a design for the frontispiece to another of Polotskii's books, is acclaimed by Sidorov as the "sole high-quality original drawing by a major artist of Old [pre-Petrine] Russia." Yet whatever one makes of this work—a rather typical mix of traditional and new (fig. 32)—it surely does not represent the arrival of Renaissance drawing in Russia. Moreover, Ushakov's design was done by the "wet method," that is, in ink using the age-old instruments of quill pen and squirrel-tail brush; charcoal sufficient for fine work (as distinct from simple tracing or outlining) was as yet unavailable in Russia and use of lead point scarcely known. It was truly a "major event in the history of drawing in Russia," as Sidorov says, when foreign masters hired by Peter I

Figure 32 Simon Ushakov, design for frontispiece to Simeon Polotskii's *The Banquet Spiritual [Obed dushevnyi]* (Moscow, 1681). Pen and brush on paper. The central figure of Christ, in a standard pose, is surrounded by scenes—*kleima*—from the Old and New Testaments. While the overall composition of central figure and surrounding scenes was common in seventeenth-century Russian icon painting, various of the scenes themselves clearly reflect, no doubt by way of imported engravings, the new European art.

introduced the graphic pencil, which had been overtaking lead point in Europe since the sixteenth century. Graphite was easier to use than lead and could be applied directly to paper, not requiring a specially treated surface. It could produce deeper, more pleasing tones than lead point and much greater variation in line. It was also easy to erase.[12]

Drawing as an art in itself did not exist in pre-Petrine Russia while drawing of a preparatory or subordinate kind, as in icon painting, manuscript illumination, or architecture, remained rudimentary.* In fact, the rare exceptions to this rule prove on analysis to anticipate at most rather than preclude the Petrine revolution. One such exception is the drawing depicting a scene from the career of St. Philip done evidently in Moscow at the end of the seventeenth century by Kornilii Kondrashenko, about whom nothing else is known but whose surname suggests Ukrainian or Belorussian origins (fig. 33); executed with pen and brush, the drawing is remarkable chiefly for the unprecedented fidelity and skill of its rendering of an engraving from Piscator's *Illustrated Bible* (fig. 12). Such faithful copying in the drawing and painting of European masterworks reproduced in etchings and engravings would shortly become standard in the training of graphic artists for the tsar's service. Eventually, as in Europe itself since the Renaissance, it would become standard in the training of virtually all professional artists in Russia. But at the end of the seventeenth century such skillful imitation was still a rarity even in Moscow.

Otherwise interesting in this connection is the album of 171 drawings and 138 engravings and etchings collected by Andreus Vinius and his son, Andrei. Andreus Vinius was a cultivated Dutch merchant and industrialist with enterprises in Russia, where his son was born in 1644 and where, in 1655, both father and son were received into the Orthodox church by Patriarch Nikon. Andrei Andreevich—"Andriushka"—pursued a career in the tsar's service, where he rose to the rank of *d'iak* on taking charge (in 1675) of postal affairs (his father had died in 1662). He was bilingual in Russian and Dutch, knew Latin and German, had worked for a time at the Ambassadorial Office in Moscow and at the royal pharmacy, and had traveled in Europe (1672–1673) as the tsar's envoy. In the 1690s he encouraged Peter's efforts to build a Russian navy, and in 1696 directed the ceremonial triumph in Moscow commemorating the Russian conquest of Azov, a victory in which Peter's fledgling navy had played a critical part: the celebration involved erecting for the first time in Russia triumphal arches patterned on European engraved models replete with the Classical imagery of monarchical absolutism.[13] Vinius spent the years 1706–1708 in voluntary exile in Holland, having fallen under an administrative cloud, and on his return to Moscow was sent as an advisor to the Ukrainian hetman. On completion of that assignment he moved, like virtually everybody else of any importance in Russia, to St. Petersburg, the new capital,

*Cf. *Revolution in Architecture,* especially pp. 66–67.

Figure 33 K. Kondrashenko, *The Baptism of the Eunuch by St. Philip,* end of seventeenth century (cf. fig. 12). Pen and brush on paper.

where he died in 1717, prosperous and honored. Moreover, in the course of a long life he had collected a library of some 400 volumes, one of the largest in Russia at the time, which he left to Tsar Peter; and like his father before him—like many a European and especially Dutch gentleman of the day—Vinius had also collected numerous prints and drawings, a collection that reflects his own interests, travels, and work as well as contemporary European tastes more generally.[14]

The great bulk of the prints and drawings in the Vinius album, not surprisingly, are of Dutch and Flemish provenance. Most of the drawings are sketches and studies, twenty-six by Jan Lievans (1607–1674), for example, a leading Amsterdam artist; others are diagrams of ships and boats, subjects dear to Tsar Peter; still others are decorative compositions, some in the high French manner, urban views (of London, Rome, etc.), and preparatory sketches for the Azov triumphal arches. The prints include a suite of ninety-five etchings of biblical scenes done by or after the Flemish master Peter van der Borcht (1545–1608), and may well have been taken from one of the seven editions of H. J. Barrefelt's *Imagines et Figurae bibliorum* first published at Leiden in 1580. Levinson suggests that the influence of the Borcht prints may be seen in Russian painting of the later seventeenth century, particularly in architectural details and more particularly still in the architecture depicted in Trukhmenskii's engraving, designed by Ushakov, of Barlaam and Joasaph (fig. 30). Levinson

Figure 34 Drawing from the *Kniga Viniusa* (Vinius album) of a man and a woman in Russian dress, Moscow, ca. 1700. Pen and brush on paper.

also attributes two drawings in the Vinius album in more traditional iconic style to Trukhmenskii and Ushakov. Equally if not more interesting to us are four portrait sketches evidently drawn from life, in an informal if not intimate style, of various folk in Russian dress (e.g., fig. 34). These may have been executed by foreign masters or even by Vinius himself but more likely, in their simplicity, by a local artist or artists struggling to work in the new European manner.[15]

The Vinius album alone offers compelling evidence of the diffusion to Russia in the later seventeenth century, by means of graphic art, of the new artistic norms and then of their positive reception, no less important, among the Muscovite elite. Other evidences of this trend appeared in our discussion of late Muscovite painting in Chapter 3 and again in Chapter 2, when the subject was later seventeenth-century Muscovite manuscript illumination; and the trend is also clear in contemporary Muscovite architecture, where a positive proliferation of Baroque (or Renaissance or Mannerist) decorative elements is traceable, in good part, to the use made by Russian builders of imported graphic material.* This point surely deserves emphasis. The growing penetration of Muscovite imagery by the new European norms obviously helped set

*Revolution in Architecture, chap. 4, especially pp. 100–102, 106–107.

in motion the Petrine revolution in Russian art, a revolution that has often been seen by later students as little more than the arbitrary and pragmatic exercise of a ruler bent on political aggrandizement. Andrei Vinius was his own man: he lived in the heart of Moscow (not in the suburban German Settlement), owned sizable country estates, moved about a good deal, and knew everybody who was anybody. His album of some 300 prints and drawings, like his large library of European books, eventually wound up at the St. Petersburg Academy of Sciences, where it was consulted no doubt by the first students of the new Academy's drawing school.

To be sure, the potential political uses of the new art could not have been ignored by Tsar Peter of Russia—no more than they had been by virtually every European ruler from the Renaissance on. Engraved official portraiture, indefinitely as well as exactly duplicable at relatively low cost, was an obvious instance of such use and again there was, for Peter in Russia, some direct precedent. The case of P. I. Potemkin comes to mind. Potemkin was sent to England in 1681 by the Muscovite government seeking an alliance against Turkey. The embassy was fruitless in this respect but in the course of his stay in London Potemkin's likeness was painted by the same Godfrey Kneller who was to paint Peter's portrait some sixteen years later (fig. 21). Kneller's portrait of Potemkin was then very handsomely engraved in London by R. White (fig. 35), and no doubt copies of this engraving were brought back to Moscow and admired by members of the court including the young Peter, who by the time of Potemkin's return had become nominal tsar. At the same time, decorative details of the portrait suggestive of "Moscovy" as a source merely of animal pelts as well as the careful portrayal of Potemkin's full beard and traditional Muscovite boyar clothes show clearly that Russia was still viewed in Europe as a political, economic, and cultural backwater.[16]

Yet Potemkin was a senior official of the Moscovite state, and circulation of his new-style portrait at home as well as abroad would have enhanced his own and his government's prestige among concerned elites. Prince V. V. Golitsyn, chief minister during the "regency" (1682–1689) of Peter's half-sister, Tsarevna Sofia, apparently took notice. In 1685 he dispatched an embassy to France bearing greetings to Louis XIV and news of the establishment in Moscow of the joint monarchy of Peter and his elder, ailing half-brother Ivan (full brother of Sofia and her main claim to power over them both; following Peter's coup against Sofia of 1689 Ivan remained nominal co-tsar until his death in 1696). At least two engravings were executed in Paris in connection with this embassy, following it seems designs brought by the embassy itself: both are somewhat fanciful portraits with inscriptions in French of the co-tsars, their Muscovite dress and other details suggestive again of the exotic status of "Moscovie" in Europe (fig. 36). In 1686 or 1687 Golitsyn went a step further and commissioned a portrait of himself to be engraved by a leading Ukrainian artist, Leontii Tarasevych, and printed at the episcopal press in Chernihiv. It was an oval portrait of the "gala" Polish type complete with heraldic arms,

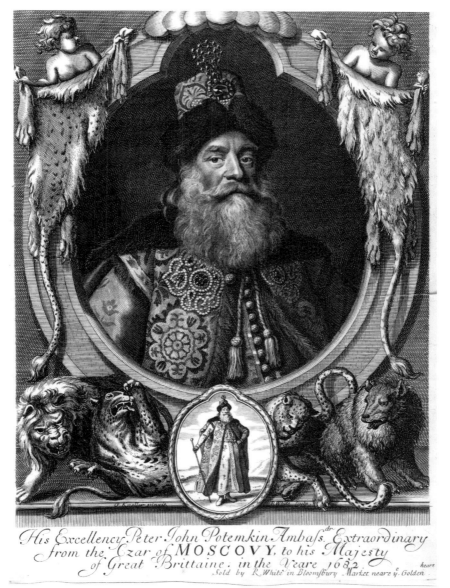

Figure 35 R. White, *His Excellency Peter John [Ivanovich] Potemkin Ambassdr. Extraordinary from the Czar of Muscovy to his Majesty of Great Brittaine*, 1682. Engraving after painting by Godfrey Kneller.

here the device of the Golitsyn clan, and with Golitsyn's resounding official titles printed in a ceremonial (Slavonic) Russian in the oval frame (fig. 37). Golitsyn is shown holding a *bulava* or mace, a Ukrainian and Polish symbol of high office, and beneath him are inscribed verses vaunting his supposed military and diplomatic exploits. It is not known how many of these portraits

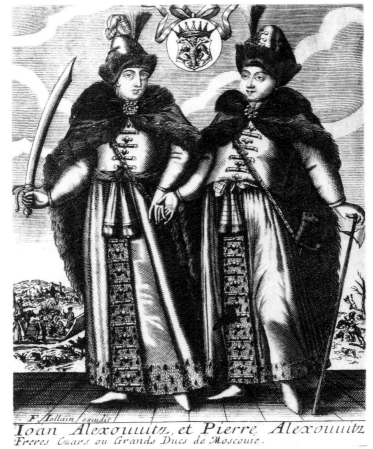

Figure 36 *Ioan Alexowitz et Pierre Alexowitz Freres Czars ou Grands Ducs de Moscovie*, 1685. Engraving by F. Jollain after drawing by unknown artist. Peter is on the right.

were printed or how widely they were distributed. But the portrait definitely played a part in the political promotion of V. V. Golitsyn in the late 1680s, when the contest for supreme power between Tsarevna Sofia and her party and the young Tsar Peter and his was joined.

A similarly promotional portrait of Sofia herself was also engraved by Tara-sevych, who brought the plate to Moscow in 1688 or early 1689, where some-thing over 100 copies were printed, evidently on Polotskii's roller press. In Moscow Tarasevych and his assistant were commissioned to engrave and print—in an edition of more than 200—a second likeness of Sofia, this a veri-table coronation portrait with the lady in full regal dress surrounded by full royal titles and by allegorical figures and subordinate verses praising her vir-tues as ruler (the whole scheme based perhaps on an Austrian imperial por-trait). A copy of this portrait was then sent to Amsterdam—quite likely

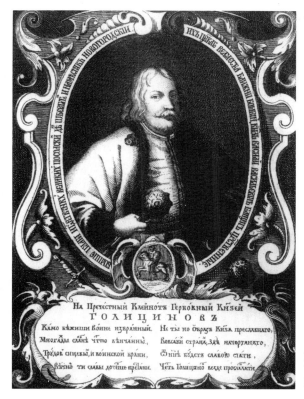

Figure 37 L. Tarasevych, *Prince Vasili Vasil'evich Golitsyn,* 1686–1687. Engraving.

through Andrei Vinius—where it was quickly reengraved by a local master, Abraham Bloteling, its inscriptions now in Latin and its imagery considerably refined (fig. 38). By July 1689 Sofia's people in Moscow had received about 100 copies of this second version of her "coronation portrait," which they distributed among actual and potential supporters, foreign merchants and envoys, and other important persons in a patent effort to bolster her cause. The contest with Peter finally came to a head in August 1689, resulting in the downfall of Sofia and her party, her incarceration in a convent, and the confiscation of Golitsyn's worldly goods (itemized in Chapter 3), among other dire consequences. In the extended investigations of the affair Sofia's "coronation portrait," political to the point of treason, figured prominently, and had to be suppressed. But in overthrowing Sofia and V. V. Golitsyn, it bears repeating, Peter nowise repudiated their taste for the new art or their estimation of its political value.[17]

Enough, indeed, of precedents. The Petrine revolution in graphic art can be traced as such directly to Peter's Grand Embassy to Europe of 1697–1698, which was described in the previous chapter. In Amsterdam in the spring of 1698, as noted there, Peter himself produced an etching (fig. 24) under the supervision of Adriaan Schoonebeck, a leading etcher and editor of prints

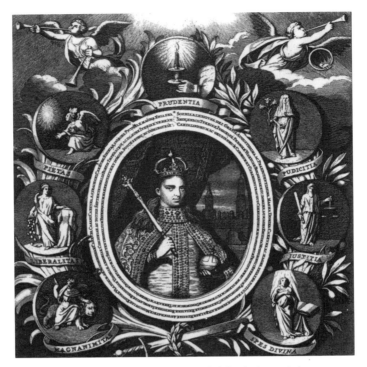

Figure 38 A. Bloteling, *Sophia Alexiovna Dei Gratia Augustissima . . .*
Magna Domina Carevna ac . . . Russiae Autocratrix, 1689. Engraving.

who had already executed several commissions for the tsar as well as count-
less portraits and battle scenes, architectural views and mythological depic-
tions, political allegories and scientific illustrations, for numerous other pa-
trons.[18] One of his first works for Peter, an etching depicting the elaborate
fireworks glorifying the Azov victory that were staged near Moscow in Febru-
ary 1697, on the eve of the Grand Embassy's departure, with inscriptions in
both Russian and Latin, was completed by Schoonebeck during the Embassy's
stay in Amsterdam presumably after descriptions provided by members of
the Embassy, perhaps by Peter himself, and was probably personally pre-
sented to the tsar (fig. 39). We may note in passing that Peter's budding pas-
sion for elaborately staged fireworks, Baroque in style and now graphically
recorded, was itself a telling demonstration of his incipient program of Euro-
peanization in Russia. The generally laconic journal of his Grand Embassy
contains relatively frequent references to fireworks mounted for his edifica-
tion, for example in Berlin one evening in May 1697, when his party "saw
flaming play representations in three different places, where the Name and
arms of the Tsar's Majesty were visible, the saintly horesman George [a Rus-
sian royal symbol], the [Russian] fleet before Azov [1696], and many other
figures and devices represented in elegant fire, and all to honor the Tsar's

Majesty."[19] Peter and his entourage had mounted their own fireworks in and around Moscow in 1693 in honor of his chief minister as well as in February 1697, in honor of the Azov victory; and during the rest of his reign more than fifty such displays, invariably designed by European artists in his service but usually staged by Russian pyrotechnicians, would mark every state event of any importance. Indeed, such spectacular "illuminations" of royal power, thoroughly European in their imagery (the court of Louis XIV at Versailles provided the paradigm), became after Peter a standard feature of Russian court life, attesting thereby to "the incontrovertible truth of the monarch's supremacy."[20]

In Amsterdam in 1698, as part of the tsar's tuition, Schoonebeck also prepared for him a little manual on etching (twenty-six leaves of text with seventeen pen drawings) which Peter took back with him to Russia, where it remained in his personal collection until transferred after his death to his new Academy of Sciences, in whose library it may be consulted today.[21] Also in Amsterdam Peter retained I. F. Kopievskii, a longtime resident of Belorussian origin, to translate into Russian (Slavonic-Russian) for printing there the texts of various illustrated books, another first for the Russian ruler. Kopievskii had been educated in Moscow, later converted to Calvinism, and now served in a Dutch church; linguistically as well as geographically he was well positioned to discharge the tsar's commission. His list of perhaps twenty-five titles printed from his own types over the next few years, consisting mostly of technical works, had little known impact in Russia (copies were sometimes simply lost on route). But the list apparently included Kopievskii's edition of a Dutch 1691 graphic description in twenty plates of the recent triumphal entry into The Hague complete with arches and fireworks of William of Orange, stadholder of Holland and now King William III of England, a Dutch national hero who by 1698 had become a personal hero of Peter.[22] Peter's harnessing of the new imagery in support of his own monarchy is an irrepressible theme of our story, though it is not assuredly the whole story.

In Amsterdam in May 1698 Peter also assented to the merchant Jan Tessing's request for permission to publish books and prints expressly for shipment to Russia (a brother of Tessing, also a merchant, resided in Vologda). Peter solemnized the agreement in a patent to Tessing issued in Moscow on February 10, 1700, according to which the latter was to publish "land and sea pictures [*kartiny*] and maps [*chertëzhy*] and all [kinds of] printed sheets [*listy*] and portraits [*persony*]" as well as "mathematical, architectural, townplanning, military, and other art [illustrated] books in Slavonic and Latin, or in Slavonic and Dutch, whence Our subjects shall receive much use and profit and be instructed in all the arts and specialties [*vedeniiakh*]." The illustrated books and prints were to be sent by sea to Archangel in the usual way and sold throughout Russia with appropriate duties paid to the state—the purpose of the whole project, as Peter formally stated it here, being to attract "glory to Our Tsarish Majesty's name and the entire Russian Tsardom among

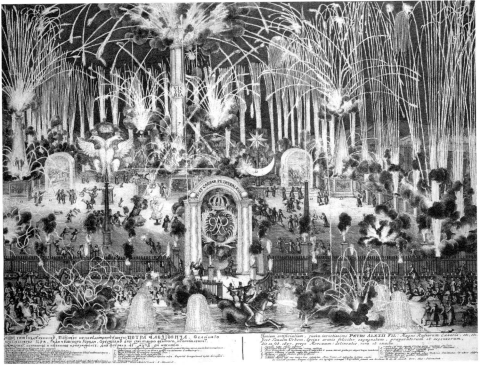

Figure 39 A. Schoonebeck, *Fireworks Near Moscow in Celebration of the Conquest of Azov*, 1697–1698. Etching, inscriptions in Russian and Latin.

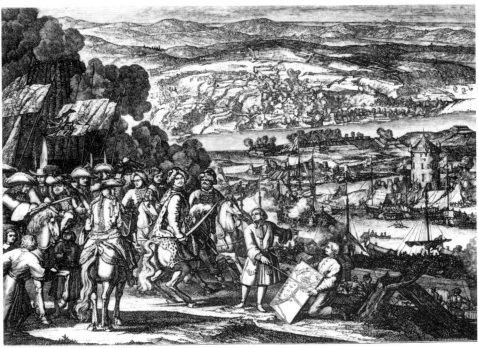

Figure 40 A. Schoonebeck, *Conquest of Azov in 1696*, 1699. Etching, inscriptions in Russian and Latin. Peter I is pictured in Russian dress with sword on horseback surrounded by his officers, several in European dress, notably, in foreground, Gen. Patrick Gordon, Peter's military mentor. His Austrian master of siegecraft stands before the tsar pointing to a plan of the siegeworks.

the European Monarchs" and to promote "the people's general benefit and good."[23] Not a great deal actually came of the Tessing scheme either: six text-books on mathematical, linguistic, and historical subjects, an edition of Aesop's fables, a religious calendar, and several other works were published in Amsterdam between 1698 and 1702, none of which appear to have arrived in Russia in any great number.[24] In fact, it was becoming clear to Peter that it would be necessary to establish the business in Russia itself. Yet his patent to Tessing of February 1700 provides the first explicit statement of his awareness of the enormous potential—political but also educational, even social and economic—of the new graphic art, just as his recruitment of Schoonebeck provides the first clear signal of his determination to install that art in Russia.

Hired by Peter in Amsterdam in May 1698 expressly to work in Russia, Schoonebeck soon departed for Moscow, there to set up the first real print shop in the country.[25] He arrived in October 1698, a mature artist, it should be stressed, with hundreds of published works to his credit and a considerable European reputation. He was promptly enrolled at the Armory Chamber and given housing and grain allowances as well as 330 rubles per year, a salary higher even than that (300 rubles) of the administrative head of the Chamber.[26] His work for Peter—usually personally commissioned—included etchings (usually touched up with the graver) of the victorious siege of Azov (fig. 40) and of Peter's proud new warship the "Predestination" (fig. 41), which was built at the new yards at Voronezh under Peter's personal direction and launched with much fanfare on April 27, 1700; drawn from life and then etched by Schoonebeck in Moscow in 1701, the etching was presented by the artist to the tsar, who in turn sent a copy to the master in Holland who had taught him shipbuilding.[27] Other works done by Schoonebeck for Peter include etchings of the storming of the castle of Noteborg, the first Russian victory in the long Swedish war (fig. 42); we remember here the importance of the Russian sieges of Azov and Noteborg in Peter's concurrent architectural revolution, demonstrating as they did the growing Russian mastery of modern fortification.* Schoonebeck also etched sundry portraits, more fireworks, maps and architectural views all as provided in his contract and for which he received on occasion sizable bonuses (sixteen rubles for an etching of the wedding feast of Peter's jester) in addition to a special grant in February 1702 of 136 rubles "for coming from beyond the sea to Moscow."[28] It is obvious that Peter greatly valued Schoonebeck's services, allowing no victory in his war against Sweden or public occasion of any moment to pass unrecorded by the deft hand of his Dutch "master of graphic work" (*master risoval'nago dela*). Late in 1703 the local painter Choglokov was ordered to go from the Armory Chamber to the Lefort palace in the German Settlement, there to paint, on a curtain of green taffeta, to be used as backdrop for a grand "comedia," the

*Revolution in Architecture, pp. 114–118 (with figs. 58–61), 122–124 (with fig. 63).

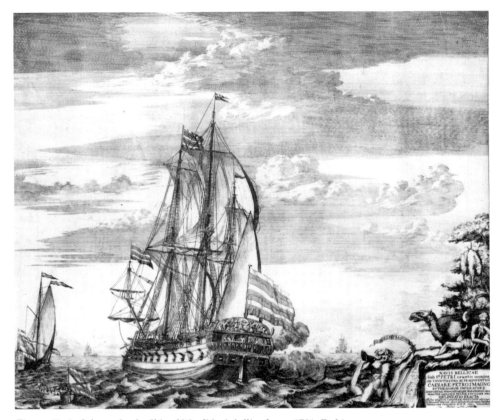

Figure 41 A. Schoonebeck, *Ship of War [Navis bellicae]* . . . , 1701. Etching.

"newly conquered town of Shliselburg [Noteborg] after the print [fig. 42] of Adr. Shonbek."[29]

In 1702, at Schoonebeck's urging, his stepson and former pupil Pieter Pickaerdt (Pickaert or Picart) was brought over from Holland to assist him, and was assigned to the Armory Chamber at an annual salary of 250 rubles plus housing.[30] Picart (or Pikart, as he is usually referred to in the literature, risking confusion with a contemporary French artist of this name)* remained in Russia, working first in Moscow and then (from 1714) in St. Petersburg, until his death in 1737. He was prolific in output if rather less skilled than his mentor, producing numerous etchings of maps and battle scenes, architectural views and models, triumphs and other public festivities, portraits and technical (but also a few literary and historical) book illustrations—all as had never been produced before, in such variety or such quantity, in Russia.[31]

In fact, Picart's work in Russia as a book illustrator played a considerable part in the educational and technological as well as the artistic and political

*As in *Revolution in Architecture,* p. 153: mea culpa!

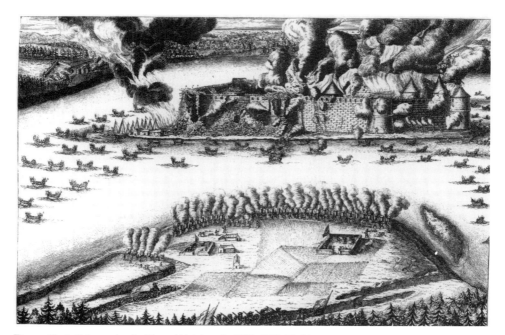

Figure 42 A. Schoonebeck, *Siege of Noteborg in 1702*, 1703. Etching.

aspects of the Petrine revolution, and directly reflected Peter's own realization and then insistence that to be fully effective textbooks and work manuals had to be properly illustrated. To this end a book on plane geometry published at the Moscow Printing House in 1709 carried 164 illustrations reengraved by Picart from those in the original German edition published at Augsburg in 1690 (fig. 43); the work was published again, with Picart's reengravings (now numbering 181), in St. Petersburg in 1725.[32] The first edition of this geometry book was actually published in Moscow in 1708 with illustrations made in Germany; but the latter were not sent in numbers sufficient for the press run (200 copies), a glitch that only emphasized the importance of doing the entire project in Moscow, as Peter himself, closely supervising things, now fully understood. The geometry of 1708–1709 is noteworthy, too, as the first book to be published in Russia in the newly designed "civil" type (a streamlined, latinized version of the older "church" or "Cyrillic" type), the actual printing carried out by three Dutch masters with equipment, including the new type, brought from Holland.[33] This was a signal event in the Petrine cultural revolution as a whole.

It was Picart, again, who supplied fourteen illustrations for the Moscow 1709 edition of a work on fortification reengraved from those in the Dutch original of 1702, a project personally supervised, again, by the tsar, who was involved from its inception to its publication in a press run of 1,000 (the usual run in the civil type at this time was from 200 to 300 copies).[34] Or there is the

Figure 43 P. Picart (Pickaerdt), illustration for *Priëmy tsirkulia i lineiki* . . . , Moscow, 1709. Etching. The Rhinelandish vignette is obviously unchanged from the German original.

Moscow 1709 edition in Russian of C. Allard's manual in Dutch on shipbuilding published at Amsterdam in 1705, with 188 engravings—etchings, more accurately—adapted by Picart from those in the Dutch original.[35] In 1708 and again in 1709 and 1710 a booklet on the successful Russian siege of Azov of 1696 was produced at the Moscow Printing House with text by an Austrian officer in Peter's service and with three etching-engravings by Picart; Peter, ever proud of this victory, ordered hundreds of copies of the booklet for distribution among his officials.[36] An artillery manual based on a Latin original by Ernst Braun printed at Danzig in 1687 was also published in a Russian edition at Moscow in 1709 with frontispiece and twenty-five illustrations reengraved by Picart and Henryk de Witte, another Dutch master recruited to work in Russia presumably by Schoonebeck. Other information about this manual,

Figure 44 P. Picart (Pickaerdt) et al.,
illustration showing G. B. Vignola
for the first Russian edition of
Vignola's *Regola delli cinque ordini
d'architettura (Pravilo o piati chinekh
Arkhitektury Iakova Barotsiia
devignola . . .),* Moscow, 1709.
Engraving.

which was published again in Moscow in 1710, indicates that 1,000 copies of
the first edition were printed and that the etchings were all done by de Witte.[37]

De Witte's collaboration here reminds us that Picart did not work alone at
the Armory Chamber or, from 1708, at the Moscow Printing House. In fact,
by the terms of his contract he was obliged to teach his skills to his Russian
pupils and assistants. That he did so is plain in the case of the Moscow 1709
edition of Vignola's famous *Rule of the Five Orders of Architecture (Regola delli
cinque ordini d'architettura),* one of the most popular textbooks of the new archi-
tecture in Europe: Ivan Zubov, Peter Bunin, and Egor Vorobev assisted Picart
in reengraving (or etching) the frontispiece and some 102 other illustrations
for this work (fig. 44), which appeared in two further editions in Peter's time
(1712, 1722) and became the single best known work on architecture in

Figure 45 P. Picart (Pickaerdt) et al., frontispiece to *Uchenie i praktika artilerii . . . Bukhnera*, Moscow, 1711. Etching and engraving. The Moscow Kremlin is represented in the background, replacing Nuremberg in the German original, as the tsar's two-headed eagle replaces the original heraldic device; but the rest of the scene, including the figures of Mars, Bellona, and Vulcan in the dominant architectural structure, remains.

eighteenth-century Russia.[38] Similar collaborations produced twenty-three illustrations plus a Baroque frontispiece (fig. 45) for the Moscow 1711 edition of J. S. Buchner's *Theoria et praxis artilleriae* (Nuremberg, 1685–1706; text in German, engravings by Hipschmann); sixty-seven illustrations plus frontispiece for the St. Petersburg 1718 and 1724 editions, printed in the church or Cyrillic type, of a little book on moral philosophy first published at Kiev in 1712; seventy-nine engravings or etchings taken from various sources for the *Kunshty sadov* (*Pictures of Gardens*), an introduction to landscape architecture published at St. Petersburg in 1718;[39] and the frontispiece plus 113 illustrations reengraved by Picart and pupils (including Ivan Miakishev, Semen Matveev, Ivan Liubetskii, Aleksei Rostovtsev) for the Russian version of a German edition of Ovid's *Metamorphoses* published at St. Petersburg in 1722.[40]

Nor was this all. Picart and his team in Moscow produced the first printed depiction of the Russian victory at the battle near Poltava, in Ukraine, on June

Figure 46 P. Picart (Pickaerdt) et al., *The Battle of Poltava, June 27, 1709*, 1710. Etching and engraving, on two plates. Peter I (center foreground on horseback facing viewer) and his officers and soldiers are dressed entirely in European-style uniforms, indicative of his ongoing reform, or modernization, of the Russian armed forces.

27, 1709 (fig. 46): the victory was recognized even then, and throughout Europe, as the turning point in Russia's long war with Sweden for supremacy over the eastern Baltic Sea and adjacent territory, including land on which Peter had already founded St. Petersburg. Picart also etched, perhaps with Aleksei Zubov's assistance and from a design by C. B. Rastrelli, the sculptor and architect who in 1716 had come to St. Petersburg from Paris at the tsar's invitation, the frontispiece to the *Naval Statute* (*Ustav morskoi*) published by the St. Petersburg Press (*Tipografiia*) in 1720 and frequently thereafter, remaining the basic manual of the Russian navy (founded by Peter) until well into the nineteenth century (fig. 47).[41] Picart contributed with his pupils A.

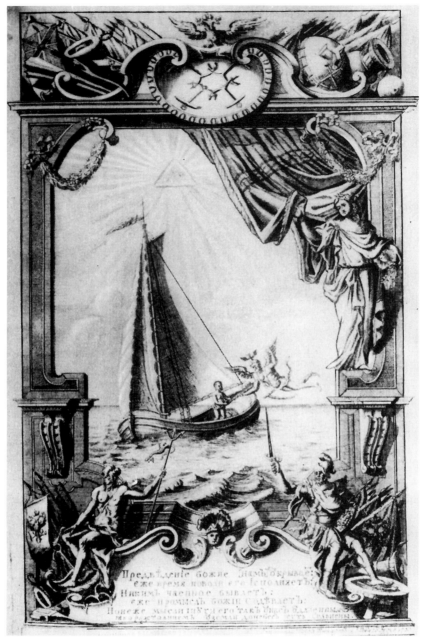

Figure 47 P. Picart (Pickaerdt) and A. Zubov(?), frontispiece to the *Naval Statute*
(Kniga Ustav morskoi), St. Petersburg, 1720. Etching and engraving. The verses
inscribed at bottom, written most probably by Peter I himself, suggest that the
work of Time reveals the will of Divine Providence, otherwise "as distant from us
as the earth from the heavens": a reference no doubt to Peter's divinely ordained
mission (as he saw it) to establish a Russian navy. The boy in the sailboat (center),
guided by a winged personification of Time and overseen by Providence (triangle
in the sky emitting rays), directly evokes Peter's boyhood essays in sailing, while
the figures at bottom of Neptune and Mars complete this important image of the
nascent Petrine mythology.

Rostovtsev and A. Zubov (among others) to the illustrated *Book of Mars or of Military Affairs* planned by Peter as a memorial to Russian victories in the long Swedish war and published in various compilations from 1712–1713 to (third edition) 1726–1727; this work also included eight illustrations of celebratory fireworks printed from plates etched by Schoonebeck.[42] Finally, among major works, Picart and members of his team—Liubetskii and Matveev, again, Martin Nesterov and Nikifor Ilin—contributed to the republication at the St. Petersburg Press in 1719 of the great handbook of *Symbols and Emblems* first published for the Russian market in Amsterdam in 1705, which in turn had been adapted from Daniel de la Feuille's *Devises et Emblèmes* published at Amsterdam in 1691. Both Russian editions—of 1705 and 1719—contained 840 standard European symbols and emblems printed on some 280 pages with explanatory inscriptions in Russian, Dutch, Latin, and German (also in French, English, and Italian in the Amsterdam 1705 edition); and the handbook in all three editions—of 1691, 1705, and 1719—served as a main source of imagery for Peter and his entourage when naming ships built for the Russian fleet, mounting their elaborate fireworks, and designing triumphal arches for Moscow and St. Petersburg.[43] Indeed, the handbook is a remarkable document in the diffusion to Russia of European symbolic imagery—including the image of Russia itself as a rising sun, its rays casting moon and stars into shadow (fig. 48, emblem upper left, with its inscription, "Others recede"). Also of interest is the noticeable qualitative difference in the engraving between the illustrations of the Amsterdam 1705 edition of the handbook and those of the St. Petersburg 1719 edition (fig. 49); it is only one of many such instances that could be adduced to show that graphic art in Russia had not yet reached the better European standards.

Picart's work as an etcher and engraver clearly was critical in the development of graphic art in Russia, as it was in the Petrine revolution more generally. Jacob Staehlin, a German member of the St. Petersburg Academy of Sciences from 1735, recorded that it was common knowledge that Picart was "as skillful as [he was] laborious" and "much beloved by the Tsar [Peter I]."[44] But his reputation in this respect should not obscure the finer art and more fructifying role of his mentor, Adriaan Schoonebeck. Schoonebeck died in Moscow in 1705, after less than six years on the job, yet not before founding a school, one of whose members, Aleksei Zubov, became the first Russian graphic artist of any real standing. Aleksei, his brother Ivan, and several other local students had been assigned to Schoonebeck in 1699, a contingent that had grown to nine by 1705, when Picart, following Schoonebeck's death, took charge. Picart thus superceded his fellow Dutch engravers, Johann van Blicklant and Henryk de Witte, both of whom had been recruited by Schoonebeck to contribute their skills, mainly as illustrators of translated books, to this first flowering of graphic art in Russia.[45]

Aleksei Zubov's career is illustrative if not paradigmatic of the deeper progress of the Petrine revolution—of its racination, so to speak, in Russia. His

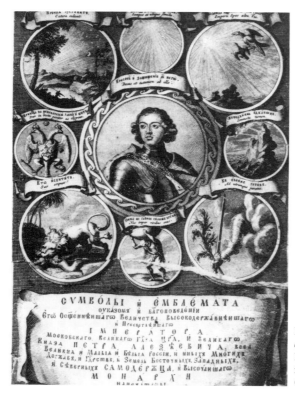

Figure 48 Frontispiece to *Simvoly i emblemata . . .*, Amsterdam, 1705. Engraving. The bust of Peter I (center) is obviously after the Kneller portrait (fig. 21).

father, Fedor Evtikhiev, came from a village near distant Perm and had painted murals in churches in Ustiug and Iaroslavl as well as in Moscow before being appointed (1662) to a full-time position at the Armory Chamber with an annual salary of twelve rubles plus allowances. There he discharged the usual variety of commissions and initially was much appreciated for his miniaturistic or "fine style" (*melkoe pis'mo*) in icon painting, a skill that won him a raise in 1668 to eighteen rubles per year plus allowances and a grant of land on which to build a house (in 1679 his salary was raised again, to twenty-four rubles per year). His icons painted in the 1680s for churches patronized by members of the royal family (e.g., pl. 15) were in the fashionable *friaz'* style, indicating a timely evolution. In 1689 he received a special grant of ten rubles in compensation "for a ruinous fire," always a hazard in Moscow, and later that year he died. It could be said that as a royal icon painter his death was also timely, a point confirmed by the careers of his two young sons, Aleksei and Ivan.[46]

Aleksei and Ivan Zubov were appointed students of icon painting at the Armory Chamber within days of their father's demise and for the next several years, by all accounts, they did the usual things, including painting and gilding Easter eggs in 1694 for the royal household. But in 1699 they were sud-

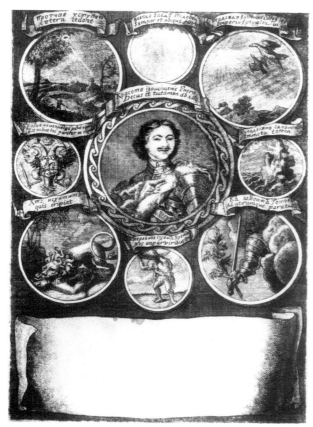

Figure 49 Frontispiece to *Simvoly
i emblemata . . .* , St. Petersburg,
1719. Etching and engraving.

denly assigned as students with several of their compeers to the newly ar-
rived Schoonebeck. They were now to learn etching, an art to which they
could have had little exposure at the Armory Chamber, although their initia-
tion in icon painting in the *friaz'* style would have provided some formal prep-
aration.

Aleksei Zubov proved to be Schoonebeck's best pupil.[47] In 1701 he was
granted an annual salary of twenty-nine rubles (up from eighteen rubles and
greater now than any his father had ever received); this on the strength of an
etching of *The Descent of the Holy Ghost upon the Apostles* which he had submit-
ted as proof of his skill (fig. 50) and which has since been almost entirely
ignored by historians. In the records of the Armory Chamber it is noted that
the work was done in *friaz'* style ("po friaski"); in fact, it was copied directly
from an engraving in Piscator's *Illustrated Bible* (fig. 51), presumably as as-
signed by Schoonebeck, a point that has not been made before. In December
1702 Schoonebeck rated Zubov "first" among his students, adding that he
was becoming "skillful." In 1703 Schoonebeck certified that Zubov had satis-
factorily executed two "printed sheets," as the records put it: a "Crucifixion

Figure 50 A. Zubov, *Descent of the Holy Ghost upon the Apostles,*
1701. Etching, signed (Latin letters) "Ale. Zubov."

of our Lord engraved on a plate and a *personka* [done] by shading," for which
proof of progress Zubov was given a raise in salary of fifteen rubles a year.[48]
Lebedianskii explains that the "*personka* done by shading," of which a single
copy is known to survive, is a mezzotint depicting a boy with locks falling
from either side of the hat on his head, and that it was thus both secular in
subject and the first Russian mezzotint; also, that the *Crucifixion* in question
was copied from an engraving of 1667 by Jean Leport.[49] Evidently Tsar Peter
himself liked Zubov's "paper icon" of the Crucifixion, so much so that he
ordered 300 copies for distribution among the garrison of his newly con-
quered fortress of Noteborg.[50]

The first Russian mezzotint, and more: Zubov's etching *The Descent of the
Holy Ghost upon the Apostles* of 1701 (fig. 50) may be taken to mark the true
birth of the new graphic art in Russia, especially in light of his subsequent
and fruitful career. Following Schoonebeck's death in 1705 he became, but
only in some degree, a pupil-assistant of Picart and then, when Picart was
transferred from the Armory Chamber to the Moscow Printing House (1708),
of Johann Blicklant. By 1710 Zubov had his own shop in central Moscow pro-
ducing prints on official commission (including a map or two) and perhaps

CREDO IN SPIRITVM SANCTVM.

Figure 51 A. Collaert, *Credo in Spiritum Sanctum*, 1643. Engraving after painting by Martin de Vos (ca. 1531–1603) in *Theatrum Biblicum . . . Piscatorem* (fig. 11*A*), p. 516 right.

also for the open market. The Russian victory at the battle of Poltava gave rise to elaborate celebrations in Moscow, not surprisingly, and Zubov along with Picart duly recorded them. Etchings by them both of two of the seven triumphal arches erected in Moscow in 1709 to mark the victory survive,[51] as do jointly etched depictions of the triumphal entry into Moscow of the Russian forces with their Swedish prisoners of war. These depictions are entirely in the conventional European fashion, with winding triumphal parade; we also note the closely similar dress of the Russian troops and their Swedish prisoners of war as they alternately pass under the several typically Baroque arches erected for the occasion.[52] From 1709 Zubov also participated in that revolutionary burst of bookprinting in Moscow referred to above, helping to illustrate various of the textbooks and manuals published by the Printing House. And by this time he was receiving an annual salary of ninety-five rubles, an unheard of sum for a Russian artist.[53]

In 1710 Tsar Peter ordered that equipment for printing be sent from Moscow to St. Petersburg, his new city located on the Baltic coast some 700 kilometers north and west of the old capital. The necessary staff of printers and apprentices were to be posted to the new press, too, a number which included Aleksei Zubov, now formally "master of graphic work." The St. Petersburg

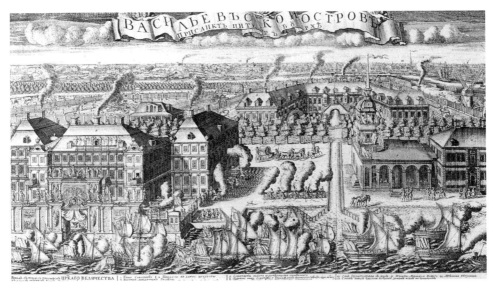

Figure 52 A. Zubov, *Vasilevskii Island, St. Petersburg*, 1714. Etching. The view is of the estate of Prince Alexander Menshikov on Vasil'evskii Island as ships celebrating a Russian naval victory pass in review. Four of Zubov's architectural prints are also reproduced in Cracraft, *Revolution in Architecture:* fig. 86 (p. 183), fig. 87 (p. 186), fig. 94 (p. 201), and fig. 97 (p. 204). Alekseeva, however, has since suggested that fig. 97, depicting Prince Menshikov's house on Vasil'evskii island, was etched (not engraved) not by Zubov but by A. I. Rostovtsev (in 1716, not 1717) and that my fig. 95, a view of the Admiralty, was done by Zubov rather than Rostovtsev (*Graviura petrovskogo vremeni*, pp. 148, 149). At the same time, Vasil'ev and Glinka suggest (*Pamiatniki*, p. 25 and no. 506) that my fig. 87, depicting the main palace at Peterhof in 1717, was also engraved (or etched) by Rostovtsev, not Zubov. The uncertainty of attributing unsigned prints of the time is thus emphasized.

Press (*Tipografiia*) operated between 1711 and 1727 (when most of its functions were assumed by the press of the new Academy of Sciences); and throughout these years Zubov was one of its two principal artists—the other being Picart, who arrived from Moscow in 1714.[54] Zubov collaborated with Picart in illustrating the technical and other books mentioned above (e.g., fig. 47) and by himself produced a series of architectural prints (fig. 52), naval scenes, portraits, and maps—some of the portraits in mezzotint, the rest etchings that he usually touched up with the graver, ever faithful to his teacher Schoonebeck's methods. In 1720 he was earning 195 rubles per year plus allowances, still well short of Picart's annual salary of 325 rubles but several times as much as any Russian artist had ever been paid.[55]

Among the more remarkable of the surviving works executed in St. Petersburg by Aleksei Zubov is his signed etching of 1712 of the wedding feast of Peter and his second wife, Catherine (the future Empress Catherine I). The event took place in the main hall of the first Winter Palace, and the etching is obviously modeled on one by Schoonebeck of 1702–1705 depicting the wedding feast of Peter's jester.[56] But Zubov's effort shows considerable independence even so (fig. 53); and again we note the coifed and bewigged, thoroughly European court that it seems to depict as well as the defiance of

Figure 53 A. Zubov, *Wedding Feast of Peter I,* 1712. Etching. Peter I sits at the table center rear, looking forward, while Catherine sits center bottom, turning our way.

Muscovite tradition the wedding itself represented (Peter's first wife, daughter of a boyar clan and mother of Tsarevich Aleksei, the heir apparent, was still alive and living in a convent in Suzdal). Zubov's etching of 1715 of a Russian naval victory over the Swedes, the "first representation of a naval battle in Russian art," also shows his teacher's influence if not his finesse.[57] Most remarkable of all perhaps is Zubov's huge panoramic view of St. Petersburg etched and signed in 1716, a monument in both the architectural history of the city and the history of Russian graphic art. Blicklant had etched a similarly large panoramic view of Moscow in 1707–1708 which Zubov certainly knew,[58] while Picart had been the first to design synoptic views of the new capital for use as book illustrations. Yet Zubov's *Panorama of St. Petersburg* of 1716 remains unique in its size, range, and overall historical significance, recording as it did, together with his smaller views, the birth of one of the

world's great cities. Gabriel Buzhinskii, a leading cleric of the day, was given one of the first thirty impressions of Zubov's *Panorama* and no doubt had it prominently in mind when in a speech of 1717 praising the new capital he specifically lauded Peter for introducing the "engraving art" in Russia, the means whereby the city's image was now "gloriously brought forth in pictures." [59]

After the St. Petersburg Press closed in October 1727 Zubov was unable to secure full-time employment at the new Academy of Sciences, which commissioned maps and botanical figures from him but nothing more. Apparently he was unable to meet the exacting scientific standards established by the academy's newly hired Dutch and German masters—one of whom, Zubov complained in a petition to the government of September 1728, had been given a salary (800 rubles) several times greater than his own. [60] Indeed, the institutionalization of the Petrine revolution in graphic art, first in the Academy of Sciences and then in the Academy of Fine Arts, a development to be discussed in the following chapter, had left Zubov behind. He soon returned to Moscow, where he worked independently until his death (about 1750) and where, in his modern biographer's words, his "style reverted to that of the old Armory Chamber," long since closed. [61] Whether the obviously cruder work of Zubov's later Moscow years was a matter of age or of his customers' requirements (or of his loss of close contact with masters and patrons in St. Petersburg) has not been resolved. In any case, in Moscow he was able to rejoin his brother, Ivan, who had remained behind in 1711.

Ivan Zubov's career illustrates the more limited opportunities for development as a graphic artist in Russia away from the European expertise concentrated after 1711 in St. Petersburg. He was among Picart's assistants in illustrating the various books published at the Moscow Printing House until Picart's departure for the new capital in 1714—which had been preceded, as we know, by the departure of some of the staff and equipment. Thereafter the Printing House, still under ecclesiastical jurisdiction, reverted to publishing mainly church books in the Cyrillic type, books frequently illustrated by Ivan Zubov, now its chief engraver. Examples of the latter include a volume of the commentaries of St. John Chrysostom first published in 1709; a translation of selections from Baronius's *Annales Ecclesiastici* (1588–1607), the well-known Roman Catholic history of the church, published in 1719; and the 1729 edition of *Kamen' very* (*The Rock of the Faith*) by the late Metropolitan Stefan Iavorskii, a Ukrainian "Latinizer" who had played a major if ambivalent role in Peter's drastic church reform. [62] Both the Iavorskii book and the edition of Baronius provide further evidence of the continuing Latin influence, by way of Poland and the Ukraine, in Russian ecclesiastical circles. In fact, in his work for the Moscow Printing House Ivan Zubov adopted that Ukrainian style of engraving which had been making headway in Moscow for some time, as in the book illustrations and engraved *antiminsy* mentioned earlier in this chapter (figs. 28–30) or the political imagery of Leontii Tarasevych (figs. 37, 54). [63]

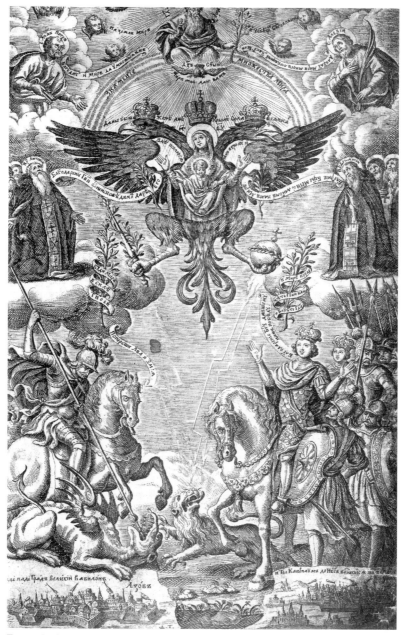

Figure 54 L. Tarasevych, frontispiece to the *Pateryk*, or book of the lives of the saints of the Kiev Monastery of the Caves, Kiev, 1702. Engraving. This edition of the *Pateryk* is dedicated to Peter I, who is shown (lower right) parading with his army and son, Tsarevich Aleksei, after the victory at Azov (1696): Peter is saying, "Thanks be to God for our victory." God the Father as the Ancient of Days and the Holy Ghost in the form of a dove (above center) look down on the tsar's two-headed eagle cradling the Mother of God and Christ Child while saints of the monastery look on from either side. St. George (below left) slays the dragon under the motto, "Be there Peace in Thy Strength," while a lion, representing presumably the tsar's enemies, is stayed by bolts of lightning. At bottom images of Azov under siege—"Fall of the Great Babylon"—and artist's initials "L. T."

The arrival in Moscow of the so-called *konkliuziia* is another example of this trend. The word itself, from the Latin *conclusion/conclusiones,* originally referred to the theses or *conclusiones philosophiae*—or *theologicae* or *logicae,* etc.—advanced in formal disputation in academies and colleges throughout Europe, a practice that had spread to the Kiev academy by the later seventeenth century and thence, in the 1680s, to the academy founded along similar lines in Moscow. At Kiev the disputations were major festive and civic as well as academic occasions, and elaborately decorated programs adumbrating the disputants' *conclusiones* and dedicated to distinguished persons were printed, posted, and distributed. In Moscow the first such *konkliuziia,* as the printed program itself came to be called, appeared in 1693, etched and engraved by an unknown artist probably after another such work brought from Kiev in 1691 (fig. 55). Ivan Zubov became something of a specialist in this new genre, producing most notably in 1709 in collaboration with two local artists a *konkliuziia* dedicated to Peter I as victor in the recent battle of Poltava. It was a large affair (170 × 124 centimeters) etched and engraved on twelve plates and replete with naval, martial, and Classical motives, with fireworks, triumphal arches, crowns, and royal monograms: with much of what was becoming standard Petrine symbolism. But the style is still "Ukrainian," with its simpler, indeed naive imagery evocative of sixteenth- and even fifteenth-century German and Italian models as compared with the more elaborate decorative program and finer, fuller, indeed Baroque execution of *konkliuzii* etched by Picart (1715) and especially Schoonebeck (1704).[64] As if to prove the point, in 1724 Ivan Zubov etched a *konkliuziia* in honor of the coronation as empress of Peter's wife, Catherine, whose imagery clearly reflects his struggle to catch up with the ever advancing norms of the Petrine revolution emanating now from St. Petersburg.[65]

Ivan Zubov supplied frontispieces for a series of calendars published by the Moscow Printing House in the 1720s (fig. 56) as well as single-sheet portraits for general sale that attempted to reproduce paintings done by foreign masters: the style throughout remains more "Ukrainian," however, or *friaz',* than new. Similarly the two *antiminsy* he engraved in 1722 on orders from the Holy Synod (which in 1721 at Peter's command had replaced the patriarchate at the head of church affairs); copies thereof were placed in newly consecrated churches in Russia for decades to come. Alekseeva describes the imagery of Zubov's *antiminsy* as "typical of the new Russian art," with nothing remaining of pre-Petrine traditions.[66] In fact, it departs little from the imagery established in Moscow in the 1690s under the influence of miscellaneous sixteenth- and seventeenth-century European engravings and was decidedly provincial, now, by St. Petersburg standards. Ivan Zubov was let go by the Moscow Printing House in 1728. He died in the old capital in 1744. His last work, executed jointly with his brother Aleksei that year, was a homely depiction of the Solovetskii monastery in the far north, still a popular place of pilgrimage.[67] It is a good example of the traditionalist cult art of post-Petrine Russia (Chap. 6).

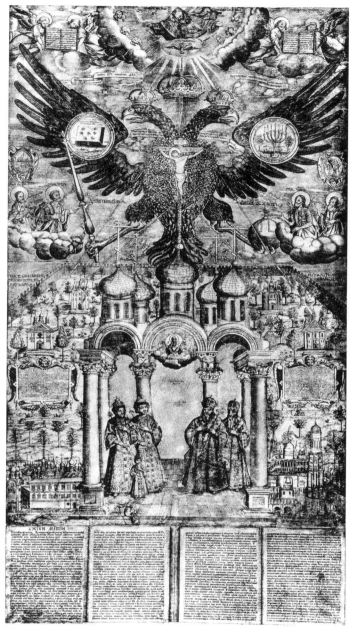

Figure 55 *Konkliuziia* published in Moscow, 1693, by Karion Istomin (cf. fig. 31), artist unknown. Etching and engraving. The figures under the "Moscow Baroque" structure at center are (left) the co-tsars Peter I and his half-brother Ivan V (died 1696) with Peter's son, Tsarevich Aleksei, and (right) Patriarch Adrian of Moscow with the metropolitan (bishop) of Kiev.

Figure 56 I. Zubov, frontispiece to a calendar for 1725 printed at Moscow, 1724. Etching.

As for the fine art of drawing itself, we should mention an artist who has been called, rather too grandly, the founder of a "national school" in Russia, Fedor Andreevich Vasilev (?–1737).[68] Vasilev, like the Zubov brothers, was initially trained under the old regime—in his case, by the icon painter I. A. Bezmin at the Armory Chamber in Moscow, where he took part in the customary mural work in the Kremlin and suburban palaces but also in some marine book illustration for Tsar Peter. From 1705 he worked in the shipyards at Voronezh, then, from 1712 to 1720 or so, in St. Petersburg, then in Kiev and then, again, in Moscow (from 1728 until his death). He seems to have become proficient at architectural design and is known to have built houses in St. Peters-

burg and Moscow. Gavrilova's claim, that Vasilev inaugurated the "national school of drawing" and one moreover of a "markedly democratic tendency," is based on her attribution to him of a unique—by subject and date—group of twenty-eight pen or brush and ink (or sepia) drawings on Dutch paper dating from the 1710s to the early 1720s and now at the Russian Museum (GRM). Most of the drawings previously belonged to a princely Russian family with Petrine connections; most depict genre-like scenes in early St. Petersburg; four have dates inscribed on them (1719 in three cases, 1721 in the fourth). Gavrilova speculates that in his earlier years in Moscow Vasilev had had access to the Vinius album and had been especially struck by the drawings therein of Jan Lievans, which he sought to emulate. Her attribution of the entire series of twenty-eight drawings to Vasilev, and her dating of them all to 1718–1720, is circumstantial at best.[69] But the skill and manner of their execution, in most cases, and the naturalism of their imagery, whether the work of Vasilev or of another artist or artists, local or foreign, further attest to the arrival in Russia under Peter I of the new art. No drawing remotely of this quality has ever been attributed to a pre-Petrine Russian hand.

One other aspect of Peter's graphic revolution should be dealt with now. Earlier it was stated that paper mills were finally, that is to say permanently established in Russia only under Peter—in part a response, it will now be obvious, to the huge increase in demand for paper created by the revolutionary burst of printing occasioned by his reign. In retrospect, indeed, as a leading authority has flatly declared, Peter "exerted an enormous influence on the development of the paper industry in Russia."[70]

More precisely, in the later seventeenth century anywhere from 4,000 to 8,000 reams of paper a year were expensively imported by Russians, mainly from France but increasingly also from Holland. By 1719, however, consumption of paper had risen by a factor of ten or more, to at least 50,000 reams a year, a rise that impelled Peter's drive to establish at last a domestic paper industry. As early as 1697, during his Grand Embassy, he had closely inspected a paper mill in Holland with such a project in mind. The first of three mills subsequently founded by him began operations near Moscow in 1708; the second, a wind paper mill set up in St. Petersburg on a site he had personally chosen, opened for business in 1718; and the third, established near the new capital under Admiralty auspices, began production in 1719. Two additional mills were founded by merchants in Kaluga province, southwest of Moscow, in 1718. In all five cases, Dutch, German, or Swedish craftsmen organized and initially operated the mill.

At first the Petrine mills produced cartridge and ammunition paper for making powder charges, then pressboards for use in making new-style uniforms for the reorganized Russian army. When sugar factories were established in 1719 and 1724, the two St. Petersburg mills supplied the needed wrapping paper. Yet paper for writing and printing was also being produced in quantities sufficient to reduce the demand for imports, on which high tar-

iffs were now set. Peter similarly issued orders requiring that governmental offices use domestic products exclusively. Although consumption of paper in Russia was exceeding 50,000 reams a year by 1719, as mentioned, imports by then had fallen to about 5,000 reams. Peter was well aware of the fact: a note in his hand written in 1723 on a sheet of paper with the watermark of the St. Petersburg wind paper mill states, "This paper was made here at the mill, and as much can be made [here/in Russia] as needed, and so do not just order [it] from France."[71] Fine paper might still be imported from France or Holland for use in drawing, in drafting royal charters and letters, for printing the best books, and so on, a practice that was common throughout Europe. But otherwise, Russia under Peter had become self-sufficient in the production of paper[72]—a necessary condition, it's safe to say, of his revolution in Russia's graphic art.

Painting

The Petrine revolution in Russian painting appeared first, or most obviously, in portraiture, that "most striking symptom of the triumph of humanism" in the Renaissance, as it has been called.[73] By the later seventeenth century individual likenesses of real, living persons, more or less naturalistic in style, fairly permeated European visual culture including sculpture and graphic art as well as painting, which remained the primary medium of portraiture. The phenomenon had even spread by then to distant Muscovy, where the young Tsar Peter and his entourage were quite naturally, we dare say irresistibly, drawn to it. We might consider these local precedents before focusing on Peter's whole painting program, the better to grasp its revolutionary character.

At several points in the preceding chapter attention was drawn to the growing appetite for portraiture at the late Muscovite court. The taste as we saw was for "portraits" or *persony* (or *parsuny*) painted in the traditional tempera on wood (fig. 16; pl. 13), in watercolor on paper (figs. 9, 17), and, a significant departure, in oil on enamel (fig. 15) or canvas (pl. 7), the method that had so expanded the potential for naturalistic portraiture in Europe but had only just arrived in Russia. The portraits in oil were in some cases definitely, in the rest almost certainly, the work of resident or itinerant foreign artists—Germans, Dutchmen, Englishmen, Poles, perhaps Ukrainians; although it is not inconceivable that a few such efforts were made by imitative local masters in the employ of the Armory Chamber (e.g., pl. 18; another good example of such a local effort is a full-length portrait of Peter's maternal uncle, Lev Kirillovich Naryshkin, dated 1685 and attributed to M. Choglokov, a pupil of Saltanov, and now at GIM). But otherwise, "portraits" executed in Moscow in the last decades of the seventeenth century remained so far as we know firmly in the iconic tradition whether in technique or content, as two further examples demonstrate. The first is an icon of the "Mother of God of Azov," newly designated patroness of the town conquered from the Turks by Peter in 1696, with

its stylized "portraits" of himself and his son, Tsarevich Aleksei, among the figures depicted (pl. 19). Though executed around 1700 by a painter or painters evidently working in Moscow, and artistically advanced by traditional Russian standards, this picture immediately evokes—in composition is virtually copied from—an iconic engraving by the Ukrainian artist Leontii Tarasevych (fig. 54). Or there is the more typical example of the mural painted by royal masters in 1689 in a monastery church in Moscow portraying Tsars Aleksei and Michael (Peter's father and grandfather) with golden halos around their nearly identical heads and dressed, again identically, as in the *Tituliarnik* of 1672 (cf. fig. 9). This painting is plainly iconic in a quite conventional Muscovite style.[74]

The very term *parsuna* as distinct from *portret* has come to designate in Russian a kind of effigy, iconic in type, and far more symbolic as such than realistic in representation: an artifact precisely of Old or pre-Petrine Russia. A pioneering study (1909) of the *parsuna* discusses the numerous images of Muscovite rulers up to and including Tsar Aleksei that were painted on the walls of the Archangel Michael cathedral in the Moscow Kremlin in the seventeenth century; the "tomb images" painted in the same church at this time, whether on the tombs themselves or on cloths to be laid on the tombs; also, the similar tomb or wall images found in other seventeenth-century churches depicting patriarchs and members of the royal family as well as the rulers themselves; and finally, the various royal persons represented in panel icons of the same period (e.g., pl. 10).[75] The study makes it clear that these images are all effigies or even icons rather than portraits, and that in some instances they were deliberately executed in iconic style so as to link the rulers of the new Romanov dynasty (on the throne since 1613) with the earlier Muscovite princes and tsars. With rare exceptions (pl. 10), these are all posthumous representations as well. More recent Russian scholarship has obscured these basic points, however, apparently for reasons of national pride, exaggerating meanwhile the degree to which such painting was "secular" in either subject or style.[76]

To be sure, the fashion for pictures of themselves spread rapidly among members of the Muscovite aristocratic-official and ecclesiastical elite in the last decades of the seventeenth century, obsessed as they evidently were with questions of honor and social standing and determined therefore to magnify themselves according to what they knew of the lifestyle of the grandees of the neighboring Polish-Lithuanian Commonwealth. In the 1660s Tsar Aleksei's English physician recorded that having "been in Poland"—meaning parts of Belorussia and Ukraine recently freed from Polish control—"and seen the manner of the princes' houses there," the tsar had begun to "model his court more stately,"[77] an effort that certainly included commissioning and hanging portraits, the more splendid the better (pl. 7). Aleksei's daughter, Tsarevna Sofia, raised this taste to a high political art, commissioning in addition to the engraved images of herself mentioned above (fig. 38) a grand "coronation

Figure 57 *Soldier Bukhvostov*, end of 1690s. Oil on canvas, artist unknown. S. L. Bukhvostov was reputedly the first regular recruit of the Preobrazhenskii regiment founded and commanded by Peter I, and a hero of the Azov campaigns of 1695–1696.

portrait" of similar type painted in oil.[78] Also dating to the 1680s is an oil portrait on canvas of Peter as a boy of perhaps ten, painted no doubt to assert his royal status.[79] Imitating Polish magnates, other Muscovite grandees in the 1680s and 1690s established "family" (*rodovye*) galleries in their houses in which they hung formal, usually full-length portraits of themselves painted in oil on large canvases, half a dozen of which can be seen today at major Russian museums. They are all *parsuna*-like images executed in the contemporary Ukrainian-Polish, Sarmatian or Cossack style—which fact probably points as well to the painters' identity. It was a style that conveyed the actual appearance of the subject much less than it vaunted the splendor or gravity of his or her dress and surroundings complete with appropriate inscriptions, coats-of-arms, and architectural props. Technically, too, such effigies, as they may better be called, were exceedingly provincial and even regressive by contemporary European standards of portraiture.[80]

By contrast, several *persony* of members of Peter's intimate circle painted in the 1690s exhibit significantly more features of the new European art (fig. 57). The painters of these portraits in oil on canvas are also unknown, and it became a conceit of Soviet scholarship to attribute them to local "masters of the Armory Chamber."[81] In view of their informal naturalism, however, which was quite unprecedented in a Russian context, and of their relatively fine technical quality, visiting European artists working with local assistants are much more likely candidates. This probability is strengthened on remembering that in the 1690s Peter increasingly consorted with Dutch, German, and English merchants, seamen, and soldiers both in Moscow's suburban German

Settlement and at the port of Archangel. Scholars have labeled these portraits the "Preobrazhenskaia series" because, though later dispersed, they all figure in an inventory of 1739 of the Preobrazhenskii palace, Peter's favorite residence in the Moscow area (long since destroyed, it was located near the German Settlement). Altogether, we may conclude, they offer compelling evidence of the degree to which the young tsar was being consciously drawn to the new imagery.[82]

Other such evidence from the 1690s is readily available. In July 1691, as previously mentioned, the young tsar directed that twelve "German *persony*" from the confiscated property of Prince V. V. Golitsyn be brought to his residence. In August 1694 he required artists of the Armory Chamber to "paint with the best skill in the lifepainting style [*zhivopisnym pis'mom*, i.e., not in iconic style]" some twenty-three pictures of battle scenes after a certain "German model," the pictures also to be framed "according to the German model." In June 1697, now abroad, Peter instructed the head of the Armory Chamber to arrange for the painting of eight marine pictures on the model either of certain "German" examples or of certain "Italianate prints."[83] In every instance Peter's personal attraction to the new art—and not only portraiture—is plain to see.

Still, the evidence thus far adduced evokes at best a trend, accelerating though it may have been, whose outcome was far from certain. It took the extended visits to Europe by Peter and a sufficient number of the Russian elite in the last years of the seventeenth century and the early years of the eighteenth to covert this uncertain tendency into solid, durable fact: into an informed and lasting preference for the new art and a commensurate determination to implant its norms in Russia. We observed a number of such personal conversions in the previous chapter, including, in preliminary fashion, Peter's own; and the case is clear enough, as seen earlier in the present chapter, with respect to graphic art, whose modern development in Russia dates directly from Peter's Grand Embassy of 1697–1698, particularly his time in Holland. A similar case can be made for painting.

Jacob Staehlin (Stählin), member from 1735 of the St. Petersburg Academy of Sciences, took intense interest in the cultural revolution that had brought him to Russia and especially, as a trained artist himself, in his new country's artistic progress. Staehlin was thus delighted to learn that Peter, when in Europe on his Grand Embassy, and despite his overriding concern "to acquire information concerning navigation, shipbuilding, commerce, and other matters of the greatest public utility," had "made good pictures and skillful painters the objects of his attentive observation" and had brought home a number of such works, "mostly sea pieces."[84] Dutch sources name three artists whom Peter spent time with in Amsterdam in 1697–1698: the first, a well-known marine painter of the day, Adam Silo; the second, an artist famous for her portrait-silhouettes; the third, a popular portraitist who painted some sort of representation of the tsar, perhaps allegorical, which has not survived.[85] The

young tsar's first known discussion of the new architecture with a European architect also took place at this time—as was noted in our previous volume. This was Simon Schijnvoet, a master of the Dutch Baroque, at least one of whose architectural writings Peter acquired; he was an expert draftsman and engraver, too, and a prominent collector of Classical antiquities.[86] Peter spent still more time with Nicolaas Witsen, a leading citizen of Amsterdam with extensive commercial interests and experience of traveling in Russia, who was also a draftsman and engraver of some distinction as well as a scholar and collector of art.[87] We may fairly surmise that Peter's passion for collecting art and antiquities, like his interest in the new graphic art, was powerfully reinforced, if not ignited, by these encounters. We may also fairly surmise that his lifelong attachment to Dutch painting was born during these months that he lived and worked in Amsterdam. Considering the directness and accessibility of that art, its luminous realism and, especially for Peter, its prominent maritime aspect,[88] his attachment is scarcely surprising.

During the Grand Embassy of 1697–1698, moreover, Peter had his own likeness painted, apparently for the first time from life, and not once but several times. There was of course the portrait done by Kneller in London in 1698, with preliminary sketches made in Utrecht in 1697 (fig. 21). Another, possibly allegorical portrait painted in Amsterdam was just mentioned. Two others, the first attributed to Pieter van der Werff (fig. 25*B*) and the second signed by Jan Weenix, were also painted in Holland in 1697–1698—the Weenix a very Kneller-like effort, complete with ceremonial armor and royal accoutrements, but three-quarters length rather than full and oval rather than rectangular: it is now at the Menshikov Palace Museum in St. Petersburg.[89] In Königsberg in March 1697, early in his westward journey, Peter also sat for his portrait, perhaps to a Polish artist in the elector of Brandenburg's service; this work is mentioned in a letter from a member of the elector's family sent to the philosopher Leibniz, who closely followed the Grand Embassy's progress. The letter reported that Peter's "curiosity is as great as his vivacity, which hinders him from keeping still and made it terribly difficult to paint him; nevertheless [the artist] succeeded in the end and the painting is a tolerable likeness."[90] But Kneller's majestic portrait of the young tsar (fig. 21) took pride of place. Copied and adapted by various English, Dutch, German, and then Russian artists; disseminated in countless painted miniatures (fig. 22), cast medals, etchings and engravings, the latter to illustrate books published in Moscow, St. Petersburg (figs. 23, 49), Amsterdam (fig. 48), London, Paris, and elsewhere in Europe as well as for distribution in single sheets: the Kneller portrait of Peter I was effectively the first official portrait of a Russian ruler and the first to be widely known.[91] And contemporaries considered it a good likeness, too, for all its ceremony. The story of how Cornelis de Bruyn, visiting Moscow in 1702, instantly recognized the tsar because he "had seen his picture at Sir Godfrey Kneller's in London," was recounted in Chapter 3. Observing the same work in London in 1711, when Kneller painted *his* portrait, Prince Boris Kurakin,

Peter's roving ambassador, who had known and served the tsar since child-hood, reported to Moscow that "nowhere have I seen such a likeness."[92]

Kurakin's commission from Peter included as we already know recruiting architects in Europe for service in Russia and buying books on all manner of subject for Peter's increasingly large library, the library which devolved on his death to his infant Academy of Sciences and which contained hundreds of illustrated items published in Europe including works on sculpture, tapestry, and painting. Kurakin also bought pictures. A list of those sent by him to Peter from Hamburg in 1708, for example, mentions dozens of "persony"—evidently engravings—of cardinals, popes, Roman emperors, Turkish sultans, and Polish, French, and Spanish kings; also, portraits of a Jesuit, a duke of Florence, and a Polish queen. In January 1724, just a year before his death, Peter ordered Kurakin to expedite the dispatch from Paris of a certain con-signment of "pictures large and small which were painted there."[93] Nor was Kurakin alone in this regard. Iurii Kologrivov, an officer in Peter's service who had studied architecture in Florence, was sent back to Italy in 1717 to oversee the training of several other Russian students; on his way he bought a total of 117 paintings for Peter in Brussels and Antwerp.[94] The direct purchase of pictures in Europe by agents of the tsar for export to Russia had never been undertaken before; not, for sure, in such numbers. And meanwhile, of course, Kurakin, Kologrivov, and other of Peter's representatives in Europe (Matveev) were buying pictures on their own account, eventually to adorn their own residences in Russia (Chap. 3).

As time progressed and his collections grew Peter evidently experienced a deepening, more discriminating interest in the new art, an interest reaching beyond its political or public value. One such indication dates to 1716. In March of that year he was in Danzig (Gdańsk) in connection with his war against Sweden, and stopped to visit the old church of St. Mary (Marien-kirche). There he saw the magnificent altarpiece depicting the Last Judgment painted about 1470 by Hans Memling, who had been a pupil of Rogier van der Weyden, master of the Flemish school of late Gothic/early Renaissance painting (fig. 4). Peter decided that he wanted the piece (official records say that the tsar was "especially pleased" by it), and in the fall of 1716 he in-structed Prince V. V. Dolgorukii, who was negotiating with the city for a con-tribution to the allied war effort, to request the triptych as part of the pay-ment. The city fathers categorically refused the request, which was submitted twice by Dolgorukii, who suggested that Peter would view their acquiescence as a special favor; Dolgorukii also wondered aloud whether as a Lutheran house of worship now St. Mary's altarpiece did not violate Luther's prohibi-tion of "icons" in churches. This clever thrust left the Danzig fathers un-moved, and Peter had to relent.[95] We are struck nonetheless by his calculated effort to acquire the painting, which depicted a theme that was familiar enough to him from Russian iconography and was one that accorded, indeed, with his Providential view of human history.[96] But the scope and minute real-

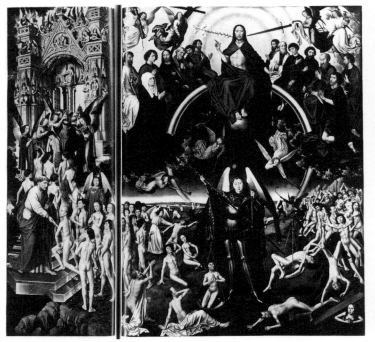

Figure 58 H. Memling, *Triptych of the Last Judgment,* ca. 1470. Oil on wood.

ism of Memling's work, the meticulous naturalism of the settings and figures, the emotional expressiveness of the faces, qualities broadly familiar by now in European art but still on the threshold of developments in Moscow, surely amazed him (fig. 58).

Peter spent much of 1716 and 1717 in Europe prosecuting the Swedish war, a matter of intense diplomacy now more than actual military conflict. Parts of Germany and the Baltic states, Denmark, the Netherlands northern and southern, and France were on his itinerary this time, thus adding several European countries and numerous cities to the list of those he had visited in 1697–1698. The "campaign journals" of this second grand embassy contain numerous entries recording appreciation of the visual art seen on route, as in the "fine paintings" noted in two private houses in Antwerp visited by the tsar or the "most splendid painting" admired in the city's Jesuit church;[97] the latter refers to the Baroque temple of 1615–1621 admired earlier by Ambassador A. A. Matveev (Chap. 3), with its two great altarpieces by Rubens representing the miracles of Sts. Ignatius Loyola and Francis Xavier and its magnificent cycle of thirty-nine ceiling paintings, also by Rubens assisted by Van Dyke, portraying biblical scenes and various saints of the early church. A modern student evokes the "overpowering impression" made by these paintings on the contemporary spectator standing below: "Overflowing with movement and colour, [they] so dominated his field of vision that he seemed

to be caught up in their swirling rhythms and to be sharing in their heady exaltation."[98] At the Luxembourg palace in Paris, according to another source, Peter was greatly moved by Rubens's similarly dynamic suite depicting the life of Maria de' Medici.[99]

Official account books of this second "grand embassy" (of 1716–1717) show Peter buying paintings for shipment home in Danzig, Amsterdam, Rotterdam, Dunkirk, and other, unspecified places while ordering portraits and portrait-miniatures of himself and of his wife Catherine, who accompanied him part of the way.[100] In Paris in 1717 both Hyacinthe Rigaud (who had painted portraits of Ambassador Matveev and his wife in 1706) and the still more fashionable Jean Marc Nattier accepted commissions. Hired by Peter's agent in Paris, Nattier had gone to Amsterdam to meet the tsar, who immediately ordered him to paint a picture of the crucial Russian victory over the Swedes at Lesnaia in 1708.[101] Peter then left for the French capital while Nattier stayed behind to paint Catherine (fig. 59); she so liked the portrait (so she wrote to her husband) that Peter ordered Nattier to bring it along with him to Paris, where he then painted the tsar himself, who also commissioned enamel miniatures of both works from the same Charles Boit who had painted miniatures after the Kneller portrait some twenty years before (fig. 60; also fig. 22A). Neither the Rigaud portrait of Peter nor the Nattier portraits of him and Catherine left Paris with the tsar, the first having been commissioned by the French government, whose property it remained, while the Nattiers remained in the artist's possession, eventually to be acquired by private collectors. But within a few decades, if not a few years, all three portraits were to be seen in St. Petersburg, where they inspired numerous copies.[102]

In Amsterdam in 1717 portraits of both Peter and Catherine were painted from life by Arnold Boonen, an artist to whom the tsar apparently became quite attached, and by Karl Moor (Carel de Moor), whose work Peter reputedly so admired that he took to locking him up between sittings lest he alter anything in Peter's absence—until the indignant Moor said he would paint no more unless the tsar desisted.[103] The Boonen portraits have disappeared without trace. A portrait of Peter now at the Rijksmuseum in Amsterdam (fig. 61) was long thought to have been painted at this time in Holland by Rembrandt's pupil Aert de Gelder (who would have been seventy-two years old in 1717 [died 1727]);[104] but it is possible that the portrait was painted either about then or somewhat later in St. Petersburg (by an accomplished artist, almost certainly a foreign master) and eventually brought to Holland as an official gift.[105] Technically it is finer than most known portraits of Peter, and it captures perhaps better than any other the military mein of the active field commander, which he certainly was.

The fate of the portrait of Peter painted by Karl Moor at The Hague in 1717, evidently the tsar's own favorite of his later years, is even less clear. On the one hand, it may have been acquired in 1718 by Prince Boris Kurakin who would promptly have sent it on to St. Petersburg, where it later was hung at

Figure 59 J. M. Nattier, *Tsaritsa Catherine Alekseevna* (wife of Peter I, later Empress Catherine I), 1717. Oil on canvas.

Figure 60 C. Boit, *Tsaritsa Catherine Alekseevna*, 1717, after Nattier (fig. 59). Miniature in oil on enamel in silver-gilt frame.

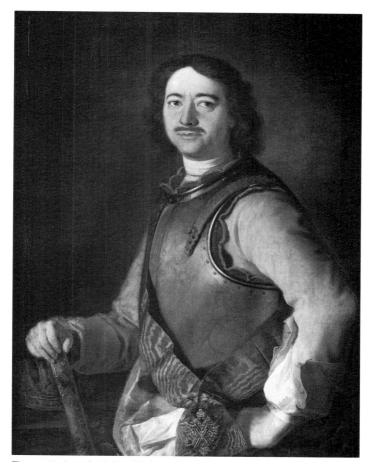

Figure 61 Aert de Gelder(?), *Peter the Great*, 1717(?). Oil on canvas.

the Academy of Fine Arts and eventually (before 1859) came to rest at what is now the State Hermitage Museum (GME). But the attribution to Moor of this portrait (fig. 62)—it is unsigned—has been challenged, most recently by V. G. Andreeva, who proposes that it was copied from Moor's original (done from life in 1717) in Moor's own studio in 1724–1725 by a Russian pupil, Andrei Matveev, sometime after which Moor's original disappeared (thus fig. 62, following Andreeva, is by Matveev, who would have brought it home to Russia on completion of his Dutch *stage*).[106] In either case, before it disappeared (or before it was sent by Kurakin to St. Petersburg) Moor's portrait was copied (1717) by the well-known Dutch engraver Jacobus Houbraken (fig. 63), which engraving has been repeatedly reproduced, in books published in Russia as well as abroad, ever since.[107] Meanwhile, the Moor/Matveev painting itself (fig. 62) was copied at St. Petersburg throughout the eighteenth century in oil on canvas, in tapestry and enamel miniatures, in etchings and en-

Figure 62 Carel de Moor (Karl Moor) or
Andrei Matveev, *Peter I*, 1717 or 1724–1725. Oil
on canvas.

gravings, and served as a model for generations of students at the Academy of
Fine Arts. In one form or another, it would seem, the Moor portrait eventually
became the single best known image of Peter I "Emperor of the Russians" in
the fullness of his power.

It may be worth noting that at The Hague in 1717 Moor also painted a
portrait from life of Peter's wife, Catherine, which Prince Kurakin definitely
sent back to St. Petersburg and whose attribution to Moor—it is signed "C.
de Moor"—has not been contested (fig. 64). But the portrait evidently re-
mained in the Kurakin family, and was not seen publicly until 1905, when it
appeared in an exhibition of "Russian portraiture" mounted in St. Petersburg.
In fact, it remained in private hands until acquired by the State Hermitage
Museum in 1956.[108] One may speculate as to why this portrait of Catherine
remained for so long unexhibited and unreproduced (Kurakin apparently
bought up all copies of an engraving done by Houbraken and all rights of
reproduction). Did Kurakin act at his own discretion or on orders from Peter?
Was the portrait considered unflattering?—a decidedly older woman than
that by Nattier (fig. 59) is portrayed. Or was it simply considered unfashion-
able by the ascendant standards of French academic portraiture as repre-
sented, again, by Nattier? Or was its suppression, if that were the case, a
function of Catherine's general unpopularity both then and since, considered
an upstart by much of the Russian elite and a foreigner (German Livonian,

Figure 63 J. Houbraken, *Petrus Primus Russorum Imperator,* 1717. The evident dissimilarities between the Peter represented in this engraving, known to have been done after Moor's original painting, and the Peter in fig. 62 are one reason for doubting the attribution of the latter directly to Moor.

and Lutheran, in origin) by the people? In any case, having remained for so long unpublished and largely unknown, the historical importance of Moor's portrait of Tsaritsa Catherine is limited to its potential biographical significance—not discounting of course its by now quite redundant evidence of Peter's conversion (and Kurakin's) to the new imagery.

Still other events which took place in Holland in 1717 proved critical to the Petrine revolution in Russian painting. In Amsterdam that summer, a Dutch student later wrote, summarizing contemporary sources, Peter was not so constrained (as in 1697–1698) by

> the study of shipbuilding and questions of trade. The arts and sciences now claimed his attention. He visited above all the principal painters, sometimes watching them work for hours on end. He discussed with

Figure 64 Carel de Moor (Karl Moor), *Tsaritsa Catherine Alekseevna*, 1717. Oil on canvas.

them their art and the works of the most celebrated painters, and in this way acquired a sure taste in the appreciation of pictures.[109]

Staehlin reports that Peter thus learned to esteem the work of the great masters of Flemish and Dutch painting: of Rubens, Van Dyck, Rembrandt, Jan Steen, Pieter and Jan Brueghel, Philips Wouwerman, and Adriaen van Ostade, among others. According to still another account, the tsar's appreciation now also extended to pictures by Willem van de Velde II (also the Younger), the greatest of Dutch marine painters, to those of his most famous follower, Ludolf Backhuyzen, and to those of David Teniers the Younger, master of the exquisite genre painting so much in vogue at the time.[110] Staehlin's informant was a "dealer named Xsel" whom Peter had met at an art sale in Amsterdam and had promptly retained to advise him. According to Staehlin, who got to know him well, "Mr. Xsel, a Swiss," was himself "a good painter of history pieces and still life and, above all, an excellent connoisseur, one well acquainted with the masters of the Netherlandish school" whose works "particularly pleased" the tsar. On Xsel's advice Peter bought an entire collection of pictures and then hired Xsel "to attend to the preservation of his purchases and even to augment his collection." Among these purchases Peter was especially fond of the "Dutch sea pieces" painted by Adam Silo, the all-around mariner who had instructed him in ship design at the time of the Grand Embassy. Once home, in St. Petersburg, Peter "furnished the antechamber of his Summer Palace with pictures by Silo," Staehlin further reports; "While at Peterhof, the tsar's new country estate near his new capital, where he formed

the first gallery of paintings seen in Russia, in the palace called Monplaisir, the sea pictures of Silo were placed in the most conspicuous situations."[111] Indeed the collection of seascapes, landscapes, portraits, still lifes, and genre paintings by Silo, Willem van de Velde II, Philips Wouwerman, Jan Fyt, even Rembrandt, and others which Peter hung at Monplaisir, a recent authority agrees, constituted the "ancestor of all other art galleries in Russia."[112]

So Master Xsel, as Staehlin tells us, helped Peter form his large collection of Dutch and Flemish paintings and served as the first curator of the first real picture gallery in Russia—thus elevating the Russian ruler to the highly fashionable firmament of royal art collectors in Europe.[113] Xsel's wife moreover was the daughter of a celebrated naturalist and herself, as Staehlin notes, a "painter of natural history" of some distinction. One of the items purchased by Kologrivov in Amsterdam early in 1717, as described in the official accounts, was a work by her mother, Maria Sybilla Merian: "2 large books of 254 parchment leaves on which are painted with the finest workmanship all kinds of flowers, butterflies, insects, and other living things"; a work for which Kologrivov paid the enormous sum of 3,000 Dutch guilders.[114] He need not have worried about the price. Tsar Peter was enormously pleased with the volumes—"kept them always in the drawers of his bureau," Staehlin was told, "and took great pleasure in looking at them." Staehlin found these "two thick portfolios containing upwards of two hundred leaves of vellum on which are representations of fruits, flowers, shells, butterflies, and insects admirably painted by the famous Mrs. Merian" among the prized possessions that Peter bequeathed to the St. Petersburg Academy of Sciences.[115]

Xsel and his wife, Dorothea Maria, lived on in St. Petersburg until their deaths in, respectively, 1740 and 1743, she painting natural subjects on paper or parchment for the Academy of Sciences and he, allegorical and biblical paintings for sundry patrons as well as still lifes in a highly naturalistic style. They both also taught: she, drawing at the school of the St. Petersburg Press and then at the Academy of Sciences, and he, both drawing and painting at the academy. These further details of Georg and Dorothea Maria Xsel (also Ksell, Gsell, Gesell, and Xell in the sources) are provided by Staehlin and his modern editor in Staehlin's remarkable *Notes on the History of Painting in Russia* composed in his later life, where we learn more particularly that Xsel painted numerous portraits as well as still lifes for both private persons and the court and a splendid altarpiece as well as separate holy pictures for St. Petersburg's main Lutheran church. Some of the latter survive, as do various paintings done by Xsel for Peter's Summer Palace and for the church of Sts. Peter and Paul founded by Peter in the central fortress of the new capital. The church became, with Peter's own burial there, the Imperial Russian mausoleum.[116]

Staehlin himself had come to Russia in 1735 from the University of Leipzig, where he had been a student of literature, languages, and the fine arts (and a close friend of the sons of J. S. Bach). He had come at the invitation of the president of the St. Petersburg Academy of Sciences, Baron Korf, who ap-

pointed him adjunct in eloquence and poetry in the academy's history class for five years at an annual salary of 400 rubles. His work in St. Petersburg for the academy was remarkably varied. Apart from teaching he edited the official *St. Petersburg Gazette* (*Sanktpeterburgskie vedomosti*) and various calendars published by the academy's press, composed odes in German to mark various public occasions, translated opera librettos (from Italian into German), wrote original works of scholarship—on Turkey, for instance, and on Classical philology and history—and designed some of those elaborate fireworks that from Peter I's time were such an integral part of Imperial court life. In 1737 Staehlin was promoted to professor of eloquence and poetry and membership in the academy itself; in 1742 he was named tutor to the heir to the throne, Grand Duke Peter Fedorovich; and when Peter—the future Emperor Peter III—married the future Empress Catherine II, in 1745, Staehlin became Imperial librarian. More to the point here, in 1738 he was also given charge of the Engraving Chamber (*Graviroval'naia palata*) of the Academy of Sciences, where his responsibilities included recruiting teachers of art from abroad. When the academy was reorganized into the Academy of Sciences and Fine Arts, he became director of the art departments, a post he retained for twenty years. Staehlin also compiled the first catalog of the picture collection at Peterhof, dabbled in interior decoration, and designed more than 150 commemorative medals. Nobody was better placed, in sum, to observe the progress of the new art in St. Petersburg between the 1730s and the 1780s, when he died. And his *Notes on the History of Painting in Russia* (hereafter, his *History*) make clear the radical and sweeping nature of Peter's program as well as the steps by which it proceeded.[117]

As Staehlin tells it, icon painting had prevailed in Russian art before Peter and was best preserved in certain illuminated manuscripts and in some admirable murals in the Moscow Kremlin's Archangel Michael cathedral executed "in the Greek church taste." It was only under Peter's father, Tsar Aleksei, that a "beginning was made to try to improve painting" in Russia, Staehlin's sole example of this effort being the *Tituliarnik* of 1672, some of whose illustrations he considered "beautifully drawn" (fig. 9). But that said, it was Peter who made all the difference, first of all by acquiring in Italy "marble statues and antquities" for display in his Summer Garden in St. Petersburg. We know otherwise that Iurii Kologrivov purchased sculpture in Italy on commission from the tsar, including, as Kologrivov himself advised Peter's personal secretary in June 1718, "five marble statues [*statui*] as big as life, done in the round, ancient; two marble statues somewhat smaller than life, ancient; one marble statue life-size, done in the round, new; altogether, eight." Kologrivov subsequently reported that he had acquired another "four marble statues of medium size, ancient; fourteen small marble statues, ancient; ten small marble statues, new; five waist-deep statues, or busts [*bustov*], alabaster, ancient; . . . eight waist-deep statues, heads of black stone, busts of rosy alabaster—in all, 25 waist-deep [statues]"; and, still later, "forty-two marble medallions [with]

portraits [*persony*] of various notable persons, ancient; eight carved panels or bas-reliefs [*bas relievov*), ancient; . . . one arm of a Colossus [*Kolossova*] much bigger than life . . . [and] ten marble doves, most natural, of the best workmanship." [118] Kologrivov was assisted in his purchases by a nephew of the pope and noted connoisseur, and by the papal architect Niccolo Michetti, whom he hired for the tsar's service. After considerable negotiation he also acquired for Peter a venerable statue of Venus, a major work of Classical sculpture that remains a treasure of world art. Shipped back to Russia for display in royal palace or garden, and studied by generations of Russian artists, Peter's collection of Classical and classicist sculpture played a crucial part, as Staehlin affirms, in the transfer of the new art to Russia. We are reminded of the critical importance of such sculpture in the advent of the Renaissance itself.

Staehlin's *History* next recounts how in Amsterdam Peter "himself attended an art auction with Mr. Xsel, connoisseur of painting and later painter of the Academy in Petersburg, and bought several hundred pictures for his new residence at Peterhof": all as we've already read, drawing on Staehlin's separately printed *Anecdotes*. Staehlin's larger point here is that the tsar's collecting was a crucial part of his whole program, one with wide ramifications. "From these pictures he created at his palace in Petersburg and in his suburban palace at Peterhof well arranged picture galleries"; and "the most notable of the courtiers," Staehlin's *History* further records, "imitated his taste and decorated their houses in Petersburg and in Moscow with beautiful paintings acquired from foreign merchants at Archangel and in Petersburg." We have indeed noted the activities in this respect of Kologrivov, A. A. Matveev, and Prince Boris Kurakin; though the most conspicuous of these imitative courtiers was A. D. Menshikov, long Peter's most powerful favorite, whose collections are now being wonderfully restored, or reconstructed, in St. Petersburg. [119] In short, the collecting and displaying of new art by the ruler and his close associates and the corresponding establishment of an embryonic market for such art were critical factors both in its further diffusion in Russia and in the institutionalization, as we will call it, of the Petrine revolution.

A third major step in Peter's revolution as recounted by Staehlin occurred when Peter "summoned to Russia" from Europe skilled artists and teachers of art to whom he then assigned Russian students. Among such artists and teachers Staehlin mentions first in his *History,* after Georg Xsel, the "excellent portraitist Dannhauer, a native of Bavaria [actually, Swabia] who had studied in Venice with Bombelli." Dannhauer's pictures, thought Staehlin, were distinguished by "correctness of design, expressiveness, and a warm, truly Rubenesque coloring." In Peter's last years, Staehlin notes separately, he "retained the celebrated Dannhauer about his person" as an artist who "excelled in painting portraits in the Italian manner. The coloring of his works was beautiful, and the art with which he employed the magic of light and shade wonderful; we have several portraits by him of the Emperor [Peter I] and his consort Catherine, in different attitudes, which are perfect likenesses." [120] This

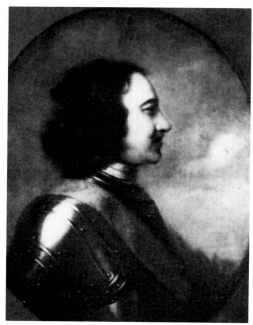

Figure 65 J. G. Dannhauer (Tannauer, etc.), *Peter I*, 1710s. Oil on canvas.

was the artist at the height of his career. Johann Gottfried Dannhauer (also Danhauer, Tanhauer, Tannauer, etc.), born in 1680, had studied and worked in Holland and Venice before being hired in Vienna in 1710 for service in Russia. After accompanying the tsar on his campaign of 1711 against the Turks (which ended in a Russian defeat, and so was not pictorially recorded), Dannhauer worked in St. Petersburg and Moscow as court painter, earning up to 641 rubles a year.[121] Following the death of Empress Catherine in 1727 he left for Poland, where he did not prosper. A later attempt at a comeback in St. Petersburg failed—his painting now "scarcely as good as that of the least of his students," Staehlin complains in his *History*—and Dannhauer died impoverished in 1738. Nor do more than half a dozen of the many pictures that he painted survive, at least two of which—a profile portrait of Peter and an equestrian battle portrait (fig. 65; frontispiece)—may well be considered the first of their kind ever executed in Russia. His is also the best surviving likeness of Peter's ill-fated son, Tsarevich Aleksei (who was arrested in 1715 and died under sentence of treason in 1718). And like the major portraits of Peter painted abroad, particularly those by Kneller and Moor, Dannhauer's became the source of numerous copies and engravings in Russia, including coin and medal adaptations.[122]

 In his *History* Staehlin discusses two other important painters hired under Peter to work in Russia, Bartolomeo Tarsia (Staehlin's own former teacher) and Louis Caravaque. Tarsia, from Venice, arrived in St. Petersburg in the 1720s and quickly made a reputation as a painter of ceilings in the highly decorative Italian manner. Staehlin says that his old mentor could cover an

area of about sixty-five square meters in less than a month: "Never did an artist paint so much so quickly." He sometimes also painted portraits, "knowing how to flatter his clients and friends," including the Italian wife of Peter's agent in Italy, S. V. Raguzinskii. But ceilings were Tarsia's specialty, "many" of which he decorated in and around St. Petersburg until his death in 1765. Caravaque, on the other hand, was a rather more central figure, although it is clear that Staehlin did not like him, whether for his coarse manners, opportunistic court politics, or the quality of his art. In Staehlin's judgment, Caravaque's portraits were "rough," weak in design, "muddy in coloring," and "always somewhat, but never completely, like their subjects." Only some of the ceilings that Caravaque painted in Imperial palaces in Moscow and St. Petersburg met with Staehlin's praise. What was more, in his later years Caravaque "did almost nothing, though he continued until his death to receive his court salary." [123]

Caravaque's long career in Russia (1716–1754) is the best documented among those of the painters imported by Peter. Born into an artistic family in Marsailles in 1684, he evidently trained and worked there as a painter and decorator until signing a contract with the tsar's agent in Paris in November 1715. In return for an exemption from all taxes, provision of an apartment and studio, and an annual salary of 500 rubles, Caravaque undertook to paint as required "historical pictures, portraits, battle scenes, forests and trees and flowers and beasts in both large and small sizes, also very small portable portraits and histories," and "to teach painting to such persons of the Russian nation as His Majesty shall send to him." [124] On his arrival in 1716 he was assigned first to the St. Petersburg city government and then, in 1718, to the Chancellery of Construction, which had been founded by Peter in 1706 to direct the building of the new capital and whose charge had steadily expanded to include responsibility for the foreign artists and craftsmen hired to decorate the city's new-style architecture. For several years, it seems, his work went well. But in a petition to the authorities of April 1723 Caravaque asserted that while he had fulfilled his contract faithfully he had not been regularly paid (a chronic complaint at all levels and in all branches of the tsar's, now emperor's, service). More interesting, Caravaque intimated that he would return to France unless in addition to paying up his salary there were established "here in St. Petersburg an academy of painting like that in Paris." [125] Peter himself was receptive to the project, as we will see in Chapter 5, although it would be years before anything much came of it.

Meanwhile, faced with a niggardly bureaucratic response to his initial complaints, Caravaque petitioned again (November 1723), this time including a list of all the works he had executed between 1716 and 1722 by express command of the tsar or one of his senior officials. The list was sizable: several portraits of Peter's children and a dozen portrait panels for a triumphal column designed by C. B. Rastrelli (the Italian sculptor and architect who had entered Peter's service in 1716); a great canvas depicting Peter at the battle of Poltava which hung (1718–1754) in the main palace at Peterhof; pictures and

a painted wardrobe for Peter's small palace—Monplaisir—at Peterhof; emblems of victory for a monumental pyramid; and more portraits of Peter's daughters, Anna and Elizabeth, of Peter himself and of Catherine, and of one of Peter's orderlies (possibly a bastard son). "Please judge," Caravaque addressed himself to the emperor, "whether I have been idle." Furthermore (he went on), had he been given more to do, and been properly paid for it, even more would have been accomplished.[126] The matter was settled at last early in 1724 when Caravaque signed a new contract with the head of the St. Petersburg Chancellery of Construction according to which he was to receive an annual salary of 1,000 rubles plus lodging and several assistants and the "command and direction of all painting." Financial provision was also made for four students to spend two years under Caravaque in St. Petersburg followed by six years in Paris and certification by the Paris Academy, "so that they might become good masters in His Imperial Majesty's service."[127]

Caravaque's contract of 1724 was interpreted then and later as tantamount to appointment as the first regular court painter in Russia on the model of the contemporary courts of Europe. He continued to receive major commissions (fig. 66), which continued to be copied by local artists (fig. 67), and he did get some sort of art school going in St. Petersburg. But after Peter's death in January 1725 he worked mainly as a decorator until the accession in 1730 of Empress Anna (Peter's niece) and the signing of a new contract, this time for an annual salary of 1,500 rubles with provision for housing and a school.[128] Indeed Caravaque prospered under Empress Anna, receiving now the actual title of court painter (*pridvornyi khudozhnik* or *moliar'*: cf. German *Maler*) with the rank of colonel and numerous commissions to decorate the Imperial palaces and paint portraits of the empress and her favorite minister, the notorious Count Biron: "so many portraits large and small of this monarch and of Countess and Count Biron," Staehlin remarks acidly, "that all the walls of Petersburg are hung with them." Staehlin adds that in the reign of Empress Elizabeth (1741–1762), when artists "one better than the other" began to appear in St. Petersburg, Caravaque's wings were finally clipped.[129] His mediocrity as a portraitist cannot be denied. Yet he retained his salary and the status of court painter until his death in 1754, and painted numerous portraits of the new empress for display in her embassies abroad. He also continued to train students—no doubt his most important contribution, all told, to the Petrine revolution in Russian art.[130]

In fact, a fourth big step in that revolution, likewise discerned by Staehlin in his *History* of painting in Russia, was the "dispatch of Russian students to Holland and Italy in order to study painting." Staehlin refers first to Kologrivov's project of 1716 for sending architectural students abroad to complete their training, which proved to be a pivotal move in Peter's establishment of the new architecture in his country.* In keeping with prevailing European

Revolution in Architecture, pp. 164–165.

Figure 66 L. Caravaque, *Tsesarevna Anna Petrovna* (daughter of Peter I, mother of Peter III), 1725. Oil on canvas, inscribed on back "Carewacc pinxit 1725."

views, Kologrivov considered architecture the all-encompassing art, with "piktura," like "skulptura," among its "parts"; he thus recommended to the tsar that of the students to be sent abroad two should train in architecture proper, one in sculpture, one in engraving, and one in painting. The painter was to be selected from among the most promising of the young artists in Russia and taught first to mix paints properly—something that was "most incorrectly done among our painters"—and then to paint battles and sieges commemorating the tsar's victories "to the eternal glory of Russia"; next he was to study languages so as to be able to read the "histories and fables" necessary for the proper depiction of persons, animals, and things; and at last he would be ready to study in Europe, preferably Italy.[131] The project, or

Figure 67 A. Matveev(?), *Tsesarevna Anna Petrovna,* after 1725
(cf. fig. 66). Oil on canvas.

proposal, was accepted in the main by Peter, and later that year eight young
Russians of the service nobility were duly dispatched, four to study in Hol-
land and four in Italy.

The "Italians" spent several years studying architecture under Kologrivov's
overall supervision, first at the famous Academy of St. Luke in Rome and
then at the still more illustrious Academy of Design in Florence. They were
soon joined by another group of four fledgling Russian artists sent specifically
to Italy to study painting, which they did under the general supervision of
P. I. Beklemishev, deputy to the tsar's trade representative in Venice, S. V. Ra-
guzinskii (whose Italian wife's portrait was later painted by Tarsia, as men-
tioned above). The idea was that all eight of these Russian students should
end up in Florence, as Tsar Peter wrote to Grand Duke Cosimo III of Tuscany,
"for training in the art of civil architecture and of painting [*maliarstvo:* cf.
German *Malerei*]." By the same letter Peter introduced Beklemishev to Duke

Cosimo and formally requested that he grant the Russians admittance to his academy—"most famous in all the arts and sciences"—and afford them his princely "protektsiia."[132]

Beklemishev himself had studied in Europe, knew languages, and was now also commissioned by Peter to buy artworks in Italy—which he did, bringing home a sizable haul in 1720.[133] His reports to Moscow from Italy are quite informative about the progress of his student-charges. The group traveled overland from Russia (Kologrivov's charges had traveled mostly by sea) through Poland, Germany, Austria, and across the Alps to Italy, where their first extended stop was Rome; we can imagine their pleasurable discovery of the art on route from the accounts of the Russian travelers discussed in Chapter 3. In Rome Beklemishev's group not only toured the city but got into the Vatican to see and copy pictures. By June 1716 they had settled in Venice and enrolled at the local academy, where they were "not wasting their time," Beklemishev assured Peter, and were "learning Italian well." In June 1717 the group moved on to the academy at Florence, as planned, so as to study under the "best masters" by means of "drawing and models," which was, Beklemishev knowingly advised the tsar, the "best way to learn" the art of painting ("maliarstvo").[134]

These first Russian artists to study painting in Italy (in fact, in Europe) included Fedor Cherkasov, Mikhail Zakharov, and the brothers Ivan and Roman Nikitin. Ivan Nikitin has been called the first Russian portraitist and his career, for all its lacunae, is the best documented as yet of any Russian artist of the Petrine period.[135] He was born about 1680, the son of a priest serving at the royal estate of Izmailovo, probably as confessor to the widow of Peter's half-brother, Tsar Ivan. He seems to have sung for a while in the patriarchal choir in Moscow, then to have studied mathematics and perhaps languages at Peter's new artillery school, and then, having shown some artistic talent, was assigned to the Armory Chamber, where he would have apprenticed in icon painting and the correspondingly traditional skills of designer and decorator. In Moscow or at Izmailovo he perhaps met and even assisted the Dutch artist and traveler Cornelis de Bruyn, who in 1702 painted portraits of his father's patroness—Tsar Ivan's widow—and her daughters (as recounted in Chap. 2). In view of the skill Nikitin later manifested, he perhaps studied drawing in Moscow under Adriaan Schoonebeck. At any event, sometime in 1711 or 1712 he was sent to work at the new St. Petersburg Press; and from there he may well have been apprenticed to Dannhauer, recently arrived from Vienna, whose influence is more than probable in the series of royal portraits that Nikitin began to produce as early as 1714 (fig. 68). Then he went to Italy (1716)—to return early in 1720 bearing certificates from the academies at Venice and Florence and his own collection of Italian pictures. In the 1720s he actively painted portraits in St. Petersburg, but of the dozen or more surviving works that have been attributed to him (with extravagant praise) only two are signed (pl. 20).[136] Whatever his merits, at 200 rubles a year his salary in these

Figure 68 I. Nikitin, *Tsarevna Natal'ia Alekseevna* (sister of Peter I), not later than 1716. Oil on canvas. The tsarevna is dressed in the new European style; compare the portrait of her mother in traditional dress at pl. 18.

years was considerably less than that of his European colleagues, Dannhauer (600 rubles) and Caravaque (1,000 rubles), indicating that his work was considerably less valued by his official patrons than was theirs.

Following Emperor Peter's death Ivan Nikitin's fortunes declined, it seems for personal and political rather than artistic reasons. In 1737, after a lengthy judicial process, he was formally exiled to Siberia, having somehow offended the powers of the day. He settled in Tobolsk, where in the 1740s, now legally rehabilitated, he died. Staehlin saw "life-size" icons painted by Nikitin before his exile in various churches in Moscow and St. Petersburg and thought that they "stand out from all other icons, showing what a fine artist" he was.[137] He

may well have painted more icons in Tobolsk, in his last years, his artistic career thus ending as it had begun.

Ivan Nikitin's rival among the first Russian painters in the new style was Andrei Matveev, who additionally has been acclaimed as the first Russian teacher of painting in any modern sense of the term: "the first to be concerned in a serious and methodical way with the training of talented youth."[138] Unfortunately, even less is known about his life. But it seems that he was born about 1701, that Tsaritsa Catherine, Peter's wife, was his chief sponsor, and that in 1719, having proved himself in St. Petersburg, he was sent to Amsterdam for further study. There he worked under the famous portraitist Arnold Boonen, for whom both Peter and Catherine had sat in 1717; indeed as part of his training Matveev may well have copied one or both of these lost portraits. In 1724 he moved to The Hague, apparently, to study with Carel de (Karl) Moor, who had also as we know painted from life both Peter and Catherine. It was also mentioned above that the portrait of Peter now at the State Hermitage Museum and often attributed to Moor (fig. 62) may be a copy of Moor's original done by his pupil, this same Matveev, in 1724–1725. By the autumn of 1725 Matveev had moved on to the Academy of Art at Antwerp,[139] where the following year he won the second prize in life drawing. Late in 1727, following the death of Empress Catherine, he returned to St. Petersburg.

Two paintings by Andrei Matveev survive from his years abroad—apart from the contested portrait after Moor of Peter I. Both are modest academic exercises, the one an allegory of painting with several nude or partly clad figures, the other a study of Venus and Cupid in which echoes of Van Dyck have been discerned.[140] They are the first such paintings—allegorical, mythological, classicist—by a Russian artist that we know of, and, paltry as they are, they symbolize well the distance Russian art had traveled by the time of Peter's death. More impressive is Matveev's *Self-Portrait with Wife* of 1729 (pl. 21). The work is unfinished, and remained in Matveev's family until bequeathed in 1808 to the St. Petersburg Academy of Fine Arts; and its theme was well established in the Netherlands by the time he studied there. Yet in its Russian setting the work was the first self-portrait ever executed, and may be taken to mark a large step forward in personal self-awareness and possibly also in gender—or conjugal—relations: a "striking symptom," indeed, of the arrival of humanism in Russia if only among a tiny elite.

In St. Petersburg after 1727 Matveev also painted portraits of various grandees (three survive), religious pictures for prominent churches, battle scenes for the Summer Palace, decorative works for the other Imperial residences, panels for triumphal arches, stage sets, and so on—an unending struggle to meet the demands of a court fully converted to European standards of taste—until his lamentably premature death in 1739. He was assisted throughout by the artists and apprentices of the painting department or "command" (*zhivop-isnaia komanda*) of the Chancellery of Construction, which had been formed some time before on the model of the Chancellery's several architectural com-

mands and over which, on his return from Europe, he had been given charge. Within his command, in the 1730s, Matveev set up a school. Its best pupils lived in his own house and proceeded from lessons with the pencil to copying prints and then to drawing "ancient statues." They also learned to grind pigments, prepare canvases, paint ornaments, and eventually to paint from live models: all the basic lessons of the contemporary European art school. Matveev's school attracted students from the workshops supported by other governmental agencies in St. Petersburg and from at least one episcopal school (that founded by Feofan Prokopovich, archbishop of Novgorod); and it produced more painter-decoraters in the 1730s than did the art department of the Academy of Sciences. Matveev's school, in short, like the similar one run by Caravaque, was crucial in rooting the Petrine revolution in Russian soil in the years immediately following Peter's death.

Very little is known about the other three painting students sent to study in Europe in the later years of Peter's reign: Roman Nikitin (Ivan's brother), Mikhail Zakharov, and Fedor Cherkasov. Soon after his return from Italy Roman certainly helped decorate the triumphal arches raised in St. Petersburg to celebrate the Russo-Swedish peace of 1721. Between then and 1724 he painted a portrait of the widow of G. D. Stroganov, the prominent merchant-industrialist whose own portrait he may have painted earlier: the lady is in traditional dress, though with a new-style miniature of Peter at her throat, and the quality of the painting is good if not up to the best of brother Ivan's work.[141] Thereafter the darkness gathers. Roman shared his brother's political troubles and Siberian exile, which similarly cut short his career; in 1742 he returned to Moscow, where he painted icons and took students and continued his decorative work until his death in 1753 (his son, P. P. Nikitin, became an architect). Meanwhile Mikhail Zakharov, the son of a painter-decorator, began his career at the Armory Chamber in Moscow in 1701 and from 1711 worked at the St. Petersburg Chancellery of Construction, to which on returning from Italy in 1723 he was reassigned and where Caravaque, in recognition of his Italian training, certified him as exceptionally well qualified. In practice this meant that Zakharov painted biblical and "historical" (mythological or allegorical) pictures, designed decorative schemes for the major churches and Imperial residences of St. Petersburg, and trained students, for which by 1730 he was paid an annual salary of 250 rubles. He died in 1739. As for Fedor Cherkasov, the last of these *pensionery,* we know only that following his time in Italy he studied miniature painting with Dannhauer in St. Petersburg and later worked briefly under Xsel at the Academy of Sciences, from which he was discharged in September 1729 allegedly for drunkenness.[142]

Andrei Matveev and Ivan Nikitin were the only Russian painters trained and promoted under Peter to achieve any lasting distinction. It is worth emphasizing that both had studied for several years in various of the leading art schools of Europe following their training under European masters in Russia,

and that both had returned from Europe with sizable picture collections for their own and their students' use. We may then agree with their Russian scholarly champions that their artistic achievement, or what we know of it, measures up well by contemporary European standards. Nor was their work at its best—Nikitin's portrait of Baron Stroganov (pl. 20), Matveev's *Self-Portrait with Wife* (pl. 21)—simply copied or imitated from European proto-types. Russian by birth and upbringing but "European by artistic formation," as Matveev has been described,[143] both artists proved beyond doubt that the new art of painting, especially portraiture, could succeed in Russia, too.

Other painters active in Russia during the Petrine period proper include a second Ivan Nikitin (also the son of a Moscow priest, but no relation to the brothers already discussed) who began work in Moscow, where, as he later reported, he taught himself the new "lifepainting science [*zhivopisnaia nauka*]." In 1718 he was called to St. Petersburg and appointed an apprentice painter at the so-called Special Wharf (*Partikuliarnaia verf'*), where he labored until his death in 1729 decorating the smaller river and coastal craft built and main-tained there; in these years no fewer than fourteen artists spent much of their time painting the many state barges, fancy as palaces, that emerged from the wharf. These painters, Nikitin prominent among them, also helped to deco-rate churches and palaces in St. Petersburg under the supervision of the French, German, and Italian architects and artists hired by the Russian gov-ernment; painted portraits and other pictures for various public functions; and earned for their efforts, in Nikitin's case, as much as 120 rubles a year. But with one possible exception, a portrait of Count B. P. Sheremetev, none of this Nikitin's work survives; his career has been resurrected from the archives of the Admiralty, which had jurisdiction over the Special Wharf.[144]

Then there were the Adolskii (also Odolskii) brothers Grigorii and Ivan (also Ivan the Elder—Ivan Bolshoi—to distinguish him from his son, Ivan the Younger—Ivan Menshii—who became a painter, too). Grigorii was on the payroll of the Armory Chamber in Moscow from 1681, where he learned the various techniques and worked at the various tasks described in Chapter 3. Yet he lived long enough (until 1725 at the earliest) and was skillful enough to adapt to the Petrine revolution in a modest way, painting "battle pictures" for Peter in the 1690s and at least one portrait of a senior official in the Ukrainian-Polish style—something more than a simple *parsuna*, for sure, but less than a proper portrait. Grigorii Adolskii went on to paint landscapes, biblical scenes, and allegories for the Moscow residence of Prince A. D. Men-shikov, Peter's leading favorite; flags for Peter's new regiments; and, in 1723, on commission from the Holy Synod (which now administered the Russian church), a portrait of Peter himself, presumably after a reproduction—painted or engraved—of one of the portraits of the tsar-emperor executed by Kneller, Moor, Dannhauer, or Caravaque.[145] Ivan Adolskii, on the other hand, left Mos-cow for St. Petersburg in 1712, having already painted equestrian portraits of both Peter and Menshikov modeled on European prototypes. In the new capi-

tal, like all of his peers, he helped decorate the new palaces designed by Domenico Trezzini, J. B. A. Le Blond, and the other European architects hired by Peter, painted portraits on commission from various grandees, and copied portraits of the tsar-emperor and his consort. He is particularly noted for his portrait of Empress Catherine I painted in 1725 or 1726 fully in the new style; indeed, it was more or less directly copied from Dannhauer's effort of 1715, known in various versions. In 1728 Ivan Adolskii went back to Moscow, where he remained until his death (not before 1750).[146] His and brother Grigorii's contrasting careers, the one pursued entirely in Moscow, the other partly in St. Petersburg, recall those of Aleksei and Ivan Zubov; and like Aleksei Zubov at about the same time, it seems that Ivan Adolskii was obliged to return to Moscow because he was unable to meet the steadily more exacting artistic standards of the new capital.

Those standards were being set, as we know, by the European artists who worked in St. Petersburg with the support of Peter I and his closest associates, particularly Prince Menshikov, the first governor-general of the St. Petersburg region. But it should be stressed that Georg and Dorothea Maria Xsel, Johann Gottfried Dannhauer, Bartolomeo Tarsia, and Louis Caravaque were only the most prominent of the artists and artisans imported under Peter to decorate the new palaces and churches of St. Petersburg and its suburbs, to produce the props for the increasingly elaborate festivities mounted by the European-izing Russian court (triumphal arches, fireworks, funeral catafalques, and so forth, as well as theatrical sets), and to paint portraits: portraits that were meant not only for domestic consumption, to enhance the monarchy's prestige and nobiliar self-esteem, but also to help establish the European credentials of the Russian "Empire," as the revolutionized tsardom was now being called (from October 1721). The crucial role played by resident European artists in launching the new art in Russia, not only but particularly portraiture, is simply undeniable.[147]

In his *History* of painting in Russia, Staehlin adds another name to his list of Peter's leading image-makers, Johann Heinrich Wedekind (also Wendekin), a German portraitist (1674–1736) who had worked in various Baltic towns before settling in 1720 in St. Petersburg. Of the numerous commissions executed by Wedekind for Peter, his court, and his immediate successors there survive portraits of Catherine I (obviously inspired by the Nattier, fig. 59) and of Tsar Michael, Peter's grandfather and the first of the Romanov tsars. The latter is interesting for its archaicizing effort—traditional dress and regalia, more modern face and pose—to enhance the image of the dynasty's founder. Staehlin describes Wedekind somewhat dismissively, yet significantly, as a "mediocre painter but a clever and industrious copyist" who "filled almost all the walls in St. Petersburg's houses with his copies of portraits of the Imperial family and [other] distinguished personages."[148] Staehlin again provides evidence, in other words, that the new imagery was spreading out from the court into the homes now of the lesser elite.

Indeed, Staehlin's last remark confirms that the success of the Petrine revolution in painting was a matter of quantity as much as quality: of a portrait on every wall, as it were, however indifferently it may have been painted or, more likely, copied. Similarly, the *volume* of paintings purchased in Europe for exhibition in Russia, most notably by Tsar Peter, was in itself and in its ramifications entirely unprecedented in Russia, and mattered more in the short term arguably than did the artistic quality of any or all of those paintings. Equally, if only five Russian painters were sent to Europe under Peter himself to complete their training, that was five times more than had ever been sent before, regardless again of the precise quality, when judged by European standards, of their ensuing work. The new standards in art had to be disseminated in Russia, in representative rather than excellent examples, before they could be raised. This quantitative dimension was both characteristic of the Petrine revolution in Russian art and essential to its success, something that should not be lost sight of when discussing and evaluating individual artists or works.

It also bears repeating that portraiture was not the only genre of the new painting to be established in Russia in Peter's time. Enough perhaps has already been said, here and in our previous volume, about the decorative painting which came to St. Petersburg hand in hand with the new architecture and which was the work, in the first instance (and for many years thereafter), of dozens of Italian, German, and especially French artists assisted by their countless Russian students. In fact, it appears that the practice of covering palatial ceilings and walls with the delicate floral designs and abundant mythological and allegorical motives typical of Baroque decorative painting had spread from St. Petersburg to Moscow already by the 1720s, producing programs altogether different from the gaudy vegetal ornamentation and symbolic wild animals, birds, and religious compositions typical of seventeenth-century Muscovite design. By the later eighteenth century the new fashion had penetrated deep into the provinces as well, avidly pursued by self-promoting courtiers and their kinsfolk and clients, to adorn even the houses of the only modestly well-off. In the rapid diffusion beginning under Peter of the new decorative painting, it could be argued, the new European art first took root in provincial Russia.[149]

In other respects, however, other than portraiture and interior decoration, we may speak at best of tentative beginnings under Peter. In the case of landscape painting, quite obviously, discussion of pre-Petrine "tendencies" in that direction and of "preconditions" established in the Petrine period cannot obscure the fact that this art was not seriously cultivated in Russia until the *end* of the eighteenth century (pl. 33).[150] Similarly, the still life did not prosper in Russia until the beginning of the *nineteenth* century, although interesting Russian examples date to the 1730s (pl. 22). Marine painting, much beloved by Peter himself, as evidenced by the numerous Dutch examples that he hung in his favorite residences, was first mastered in Russia by M. N. Vorobev

(1787–1855), who has been authoritatively described as the "first Russian artist to paint marine pictures [*mariny*] including battle scenes . . . not occasionally but throughout his life." Before him the only "occasional" marine painter worth mentioning is Vorobev's teacher, M. M. Ivanov (1748–1823), painter of a series of Crimean watercolors in which the Black Sea appears.[151]

As for history painting, including mythological and nondevotional biblical scenes, this sovereign genre of the new art in Europe was also established in Russia only in the later eighteenth century, in connection with the rise of the St. Petersburg Academy of Fine Arts, an institution whose foundations were laid to be sure in the Petrine period. But partial exceptions to this generalization are known, namely, four separate paintings of the battle of Poltava commissioned by Peter himself: one each from the French painters J. M. Nattier and P. D. Martin (of the Gobelins tapestry manufactory) while he was abroad in 1717, and one each from Dannhauer (our frontispiece) and Caravaque in St. Petersburg at about the same time. All four artists worked presumably from the earlier etchings of Picart (fig. 46) and Aleksei Zubov and from whatever sketches as well as written and oral descriptions of the battle were provided them; and all four paintings were thereafter copied again in oil on canvas, in tapestry, and in engravings. Yet "battle painting" (*batal'naia zhivopis'*) as such really took hold in Russia, again, only in the nineteenth century.[152]

This lag is understandable. For if the new-style portraiture and decorative painting were firmly established in Russia by the time of Peter's death, implanting the other major forms of the new art, including that depiction of scenes from daily life known as genre painting,[153] had to await the formation of a full-scale academy of fine art. And in this respect, too, Russians only followed a pattern that had become normal in post-Renaissance Europe, where royal or princely or ecclesiastical patrons had founded academies to train artists capable of meeting their needs for new-style imagery and of matching if not surpassing the art produced for their rivals. It was to realize more fully the potential of the Petrine revolution in Russian art, to capitalize on its gains, that the plans made during Peter's reign for a Russian art academy were carried to completion. In painting as in graphic art (and architecture), Petrine initiatives constituted at once the decisive break with the Russian past and the incommutable basis of what was to come.

The truth of this central proposition of our enterprise may be gauged again, and quite simply, at the level of technique. An as yet unique scholarly survey of the subject in Russia makes it clear that it was during the Petrine period and in connection with the "radical break in the whole way of life" which these years witnessed that painting in oil on canvas replaced painting in tempera on wood as the painting of choice among the Russian elite. The changeover was not accomplished easily; Russian artists had to adapt anew even familiar materials. Boiled oil, hitherto used only as a varnish for covering icons painted in tempera, was now the basic binding agent in painting itself; canvas,

scarcely used before in painting (except in the case of painting on linen banners), was now the basic support, and had to be properly stretched and sized and then primed, primed not with the thick white chalk paste of the icon painter but with a thinner, colored coating usually mixed with oil. New ways of glazing had to be learned, as did the endless ways of realizing the deeper, finer, glossier, more naturalistic effects achievable with oil-based paints. In short, the "whole character of painting was new." Luzhetskaia concludes her exposition by suggesting that between the 1690s and the 1730s Russian artists had "mastered the new technique" of painting, offering the careers of Ivan Nikitin and Andrei Matveev as her outstanding cases in point.[154] The former, as we know, had spent years studying painting in Italy, the latter, in Holland; and the decades in question are roughly coterminous with the reign of Peter I.

Finally, we have referred in passing in both this and the preceding chapter to a Russian passion for portrait miniatures painted on enamel based usually on bronze or gold and sometimes decorated with diamonds or other precious stones. This is a minor branch of painting, rather literally so, but historically important for its political and social significance (e.g., fig. 15). And the origins in Russia of this art, too, as we've seen, can be dated very precisely: to Peter's stay in England in 1698, where he ordered Charles Boit to execute a "large quantity" of miniatures after Kneller's portrait of himself, one of which then served as the model for the earliest known miniature painted (about 1700), again on Peter's order, at the Armory Chamber in Moscow (figs. 22A–B).

At least two Russians mastered this art in Peter's time: G. S. Musikiiskii (ca. 1670–1737) and A. G. Ovsov (ca. 1678–1740s), both of whom began work at the Armory Chamber and were later transferred to St. Petersburg. More than twenty miniatures signed by Musikiiskii are known (fig. 69), some ten by Ovsov (pl. 23). Tsar Peter, enamored of the new art, commissioned numerous miniatures after portraits by Kneller, Moor, Nattier, Dannhauer, Caravaque, and other artists, many of considerably lesser skill, for distribution as marks of his favor, marks the recipients were expected to display. Most miniatures surviving from the period depict Peter and members of his immediate family (also fig. 60). But his passion in this instance, too, quickly communicated itself to the Russian elite (Prince Menshikov, again, a notable enthusiast: pl. 24), where it dovetailed with the period's boom in engraved and painted portraiture and could draw moreover on well-established local traditions of enamelry. Both Musikiiskii and Ovsov are known to have painted miniature holy images for episcopal pectoral crosses (panagias)—a Pieta, a Crucifixion—also entirely in the new style. Once more tradition yielded to the new imagery, as painted enamels became a staple in the decoration not only of pectoral crosses but of episcopal crowns (mitres) as well, altar crosses and Gospel books, chalices and other Russian church objects (pl. 34). Enamel miniatures also figure prominently in the insignia of the European-style knightly orders instituted by Peter and in other official paraphernalia of the time (Chap. 5). And framed on their own or worn as badges or necklaces, or attached to watches, snuff-

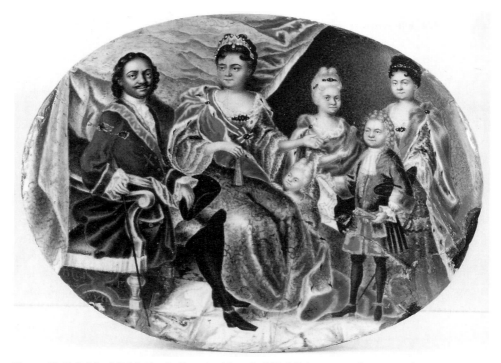

Figure 69 G. S. Musikiiskii, *Family Portrait of Peter I*, 1720. Miniature in oil on enamel on copper base. Pictured with Peter are his wife Catherine (after Nattier: cf. figs. 59, 60) and their daughters Anna (left), Elizabeth (the future empress), and Natal'ia (small child at Catherine's knee). The boy is either Peter Petrovich (died August 1719) or Peter Alekseevich, later (1727–1730) Emperor Peter II. This miniature portrait is a unique document of the Europeanization (and humanization) of the Russian ruling family.

boxes, Easter eggs, and what not, such enamel (or ivory) miniatures, especially those bearing portraits, would become in the eighteenth century a conspicuous feature of elite Russian visual culture—another indication, perhaps, of its progressive humanization.[155]

SCULPTURE

Peter's reign also occasioned the birth of the new or modern sculpture (*skul'ptura*) in Russia. By this we mean of course sculpture in high relief if not fully in the round and derived as such from Renaissance Italy. We refer particularly to the now universally familiar naturalistic representations of human forms that were inspired by antique models and designed to personify allegorical, mythological, or religious themes as well as actual people—rulers, most often, but also cultural, military, and religious heroes. Such sculptures were carved in marble preeminently or cast in bronze, using various ancient and modern techniques; or they were modeled in wax, plaster, alabaster, or clay (terracotta), from which models the sculpted figures might also have been cast in plaster or lead. Italian Renaissance lords were wont to adorn their residences

and parks and gardens as well as their churches with such sculpture, whence the taste spread to rulers, grandees, and more ordinary gentlemen living in France, Spain, England, Germany, and beyond. Such sculpture came to be applied, often lavishly, in the interior and exterior decoration of buildings: to be incorporated in the very fabric of architecture. A similar Classical inspiration and somewhat similar techniques, both ancient and new, helped give rise to the parallel fashion for low-relief commemorative medals, and thence to modern coinage. But it is the major high-relief sculpture and especially the free-standing statuary of Renaissance, Mannerist, and/or Baroque art in Europe that concern us at the moment.[156]

The archaeological discovery or recovery of antique sculpture in Rome in the sixteenth century led as is well known to the establishment of sculpture courts or galleries for its display: the Belvedere at the Vatican, for example, or the Villa of the Medici. Some of the best of the Medici pieces were later moved to the Uffizi in Florence, and by the end of the seventeenth century Louis XIV had acquired one or two important works for his palace of Versailles. So, for the Prado, had the king of Spain. But the supply of marble or bronze antique originals from Rome or later from Florence and Naples was naturally limited, and for the most part the rulers of sixteenth- and seventeenth-century Europe had to satisfy their passion for Classical sculpture with expensive reproductions. The first large-scale, full-size copy of an antique sculpture executed since antiquity itself was done on commission from the king of France in the mid-sixteenth century; copies of other antique originals in the Belvedere were executed in marble or bronze for the kings of Spain and England in the earlier seventeenth century—and were more highly esteemed by them, contemporary inventories show, than paintings in their collections by Velazquez or Van Dyck. Louis XIV ordered numerous plaster casts of antique statues in Italy from which bronze and marble copies were then made to adorn the gardens at Versailles and nearby Marly. And from Versailles, of course, the fashion quickly spread to virtually all the remaining courts of Europe.[157]

Peter was the first Russian ruler to acquire Classical sculpture in Italy. As already recounted, his agent Kologrivov purchased dozens of marble and alabaster statues for shipment back to St. Petersburg, some of which were genuinely "ancient," most notably the marble figure that became known as the *Venus of Taurida* from its later residence (from about 1790) in the Taurida Palace of Prince Potemkin, Catherine II's great favorite, whence it was moved (in 1850) to what is now the State Hermitage Museum (fig. 70). Identified since as a Roman copy of the first century A.D. of a Greek original of the third century B.C.,[158] the *Venus of Taurida* was initially positioned in an open gallery just inside Peter's Summer Garden, where its fame immediately attracted the attention of European visitors to St. Petersburg. F. W. von Bergholtz, gentleman attendant to the duke of Holstein, noted in his diary soon after arriving in June 1721 that "the tsar so values [the *Venus*] that he has posted a guard to

Figure 70 *Venus of Taurida*, Roman copy, first century A.D., of Greek
original, third century B.C. Marble.

watch over her," adding that "she must be 2,000 years old and was bought from the pope. . . . She is in fact magnificent, if slightly damaged from lying so long in the ground."[159]

The *Taurida Venus*, to repeat, was only one, albeit the most important, of a large number of sculptures collected by Peter to adorn his Summer Garden: already in 1710, when the Garden had scarcely been laid out, the Danish envoy counted "thirty marble statues" there.[160] Peter's attraction to this branch of the new art in Europe may be traced, yet again, to his Grand Embassy of 1697–1698 and particularly to his stay in Holland. We know about two major collections of antiquities—*antikvitety,* as Peter would learn to say in Russian—which he inspected in Amsterdam, that of Nicolaas Witsen, the old friend mentioned earlier who had spent time as a merchant and amateur scientist in Russia, and especially that of Jacob de Wilde, whose "museum" of antique coins and gems was much celebrated at the time.[161] Peter signed the visitors' book at Wilde's museum twice, first in 1698 and again in 1717, during his second grand embassy to Europe. In fact, Wilde's daughter published an etching in 1700 showing Peter in Russian dress sitting at a table in her father's museum while the latter explains the various antique objects placed upon it; atop bookcases, against the walls, and elsewhere in the room appears a sizable collection of what look like small bronze reproductions of Classical statues. Among the goods that the tsar shipped home from Europe in 1698 were several antique art objects, including a "clay head."[162]

Peter deposited the books, prints, instruments, and *antikvitety* collected abroad in his personal "cabinet," whose holdings grew to such an extent that in 1714 he appointed Johann Schumacher "Librarian and Superintendent of Rarities" to look after them. Schumacher assisted the tsar in further building up his collections, for instance by purchasing in Hamburg an important set of antique coins. He made sure that when Peter traveled in Europe in 1716–1717 he saw the main public and private museums, and he subsequently undertook to visit those in Germany that Peter had missed and to report to him in detail about their contents. European diplomatic convention was involved here but so was Peter's omnivorous, well-attested curiosity. Meanwhile, the tsar's example stimulated at least six of his senior associates to form their own collections of "curiosities," collections that included antiquities and especially antique coins. In a related development, Peter's growing passion for antique art and archaeology stimulated the search for antiquities in his own dominions, particularly Siberia. He personally supervised these efforts beginning in 1715, demonstrating once again his conversion to what we might call Renaissance ideals. All of these collections ended up initially in Peter's *Kunstkamera,* officially opened in St. Petersburg in 1719 as Russia's first museum, and later, by the end of the nineteenth century, in the Hermitage Museum.[163]

With regard more specifically to sculpture, Peter's most important acquisitions, as already indicated, were made in Italy.[164] At first he worked through his commercial agent in Venice, P. I. Beklemishev, whom in 1716 and 1717 he

instructed to buy cheap but who advised him in return that "good antique statues" were not to be found in Venice at virtually any price. Instead, Beklemishev bought pictures for the tsar, works of decorative art, and various instruments.[165] Peter also turned to Savva Raguzinskii, his commercial and diplomatic agent in Venice between 1716 and 1722, who also did not succeed in buying the "good antique statues" that Peter sought. "The best [statues] of old Roman work are not to be found here," Raguzinskii informed the tsar in a letter of January 1717 from Venice, advising both him and Prince Menshikov, who was also pressing the matter, to buy good new copies instead.[166] With the tsar's backing Raguzinskii commissioned or otherwise purchased in Venice a large number of statues for shipment to St. Petersburg, where they sooner or later adorned the Summer Garden as well as the suburban parks and gardens established by Peter and his successors. Between 1718 and 1721 another of Peter's agents in Venice, Matteo Caretta, attempted to buy a major collection—100 items—of antique and modern sculpture from a certain Italian grandee. The attempt was unsuccessful in the end but it demonstrates the scale of Peter's ambition in this arena, an ambition that was no doubt powerfully reinforced by sculpture he saw on his visit to Paris in 1717 and especially at Versailles. And then there was Kologrivov, sent to Italy by Peter mainly as an art agent and active in Rome in 1718–1719. Most of the "ancient" statues listed among the dozens of sculptures he bought for Peter were no doubt copies of originals to be found at the Vatican and elsewhere in Rome. But in acquiring the *Taurida Venus* for his master Kologrivov had got the real thing.

Importing quantities of sculpture from Europe to adorn his new residences in and around St. Petersburg, itself an undertaking without precedent in Russia, was one of two main ways in which Peter established this art in his homeland. The other sensibly enough was to hire sculptors who should work and teach in Russia. And here, as with Schoonebeck in graphic art or Caravaque in painting, the field was initially dominated by one man: Carlo Bartolomeo Rastrelli.[167] His career was emblematic of the age. Born in Florence in 1675, he studied there and in Rome (1698–1700) and then in Paris, where he was deeply influenced by the strongly classicizing trend exemplified in the work of the celebrated sculpture, Antoine Coysevox (1640–1720). In October 1715, still in Paris, he signed a three-year contract with Peter's agent whereby he was to come to Russia "to work in all the arts and crafts that he knew" and to train such Russians as the tsar assigned to him. In return for his labors he would receive an annual salary of 1,500 rubles, bonuses on signing and leaving, free housing in St. Petersburg, and so on: the details are from a series of official Russian documents of 1727 concerning Rastrelli's attempts to obtain the compensation owed him and permission to leave the country.[168] He also brought to St. Petersburg his son and student, Bartolomeo Francesco Rastrelli, who was destined to become the most famous architect in Russia of his own or virtually any other time.[169]

Figure 71 C. B. Rastrelli, *Equestrian Statue of Peter I,* 1716–1744. Cast bronze with chased details. St. Petersburg.

C. B. Rastrelli—the father—arrived in St. Petersburg in 1716 and was appointed to the Chancellery of Construction, which by this time was under Peter's more or less direct supervision. He at once set to work designing and executing both portrait and decorative sculpture, the latter for the palaces that were springing up everywhere in the new capital and its environs. His first major individual project was a great equestrian statue of Peter, a revised and much-belated realization of which can be seen in St. Petersburg today (fig. 71). The idea of creating such a monument was suggested to Rastrelli by Peter himself, who doubtless was influenced in turn by a proposal submitted by F. S. Saltykov, one of the 122 noblemen he had sent in 1697 to study navigation and shipbuilding in Venice, Holland, and England, where Saltykov himself ended up. He returned to England in 1711, commissioned by Peter to buy

ships for the fledgling Russian navy, and from there in 1714 he sent a series of innovative projects to his master "for the improvement of the state." One such project was that Peter should "order to be poured [cast] from bronze or carved out of marble or similar stone *statui* of Your Royal Majesty in armor [*v armaturakh*] on horseback, and to stand such statues on pedestals [*piedesta-lekh*], with Your enemies lying vanquished at your feet; and around this pedestal to depict your victory at Poltava over the Swedish king, with inscriptions in Latin and Greek, as the Latin tongue is known by all the European peoples and the Greek by the Asiatic; and to erect such statues in the main places in Piter-Burkh. . . . Such a practice was anciently done by the Roman caesars, and even to this day by the French and English kings."[170] Saltykov's proposal, remarkably revelatory of the motives of Peter's revolution as a whole, proved remarkably similar to Rastrelli's monumental project: the latter's initial sketches show a complex group sculpture on a huge, hexagonal pedestal topped by the tsar on horseback being crowned with laurel by a winged glory. The design was, to be sure, quite typical of the Baroque political art of contemporary Europe and in form was obviously much influenced by Coysevox's relief equestrian portrait of Louis XIV situated then, as now, at Versailles.[171] The design of Rastrelli's monument as it subsequently emerged was also much influenced by François Girardon's famous equestrian statue of Louis XIV, unveiled in Paris in 1699, and by Andreas Schlüter's similar monument to Elector Frederick William of Brandenburg, erected in 1703, which Rastrelli saw in Berlin on his way to St. Petersburg—not to mention the prototype of all the great equestrian statues of modern times, that in Rome of Marcus Aurelius, in bronze, dating to the second century A.D. The monumentalized Peter, as Saltykov had supposed, would join a distinguished European company.

Rastrelli preferred to work in bronze, and his project dragged on, the lack of an adequate foundry constituting one major difficulty. A French consular official reported to Paris from St. Petersburg in September 1717 that plans shown him by a French sculptor working on the project revealed "the most superb and most magnificent monument that I shall ever see"; indeed, a structure so elaborate as to defy completion.[172] After several false starts at casting parts of the thing a small wax model of the whole was made, on Peter's orders, in 1720. What happened next is not clear. Bergholtz, the assiduous diarist attending the duke of Holstein (who was assiduously seeking the hand of Peter's daughter, Anna), noted in April 1723 that Rastrelli had paid a call on his master and had particularly urged him to come and see the wax model—with which, Bergholtz also noted, Peter was said to be "very pleased." In February 1724, now in Moscow, Bergholtz learned that Rastrelli was still at work on a "large metal statue of the emperor [Peter] on horseback, which will be bigger than the statue of Louis XIV in Paris," and that he hoped to finish it soon. Bergholtz himself saw the model later that month and thought it "especially fine." Meanwhile Rastrelli had presented the duke of Holstein

Figure 72 C. B. Rastrelli, *Peter I*, 1723. Cast bronze with details chased in low relief.

with "a bust of the emperor he had made from a special kind of plaster and decorated with a metallic paint"; the bust "very much pleased" the duke, who gave Rastrelli 100 rubles in return.[173]

Busts of Peter I, and of grandees like Menshikov, became a Rastrelli specialty. The well-known bronze of the tsar-emperor now at the Hermitage Museum (fig. 72) is perhaps the finest example; in fact, it is the finest monumental sculpture executed by Rastrelli—or by anybody else—during Peter's reign. Peter died before ordering Rastrelli's equestrian statue of himself to be cast in bronze and the grandiose project, like so many others of Peter's last years, languished under his successors. His daughter Empress Elizabeth, quite characteristically, revived it in 1743, and a full-size wax model, just of the statue itself, was completed under Rastrelli's direction; but then he died, in Novem-

ber 1744, before it could be cast. That task was completed by his son, in 1747, which still left the pedestal to be executed. And that was done only under Emperor Paul (1796–1801). In 1800 Rastrelli's equestrian statue of Peter I was finally erected in St. Petersburg in the square before Paul's new Mikhailovskii Palace. Paul had the dedication *Pravedu Pravnuk*—"Great-grandson to Great-grandfather"—inscribed on the pedestal, a clue, no doubt, to the deeper personal as well as political motives animating him here. Paul evidently thus wished to assert (albeit falsely, it would seem)[174] that unlike his much disliked mother, Catherine II, he, Paul, was a direct blood descendant of great Peter, the founder of the Empire.

In any event, Rastrelli's equestrian statue has Peter dressed as a Roman caesar wearing an ermine mantle embroidered with Russian two-headed eagles and holding a marshal's baton in his right hand, the horse's bridle in his left (fig. 71). It is the portrait, scrupulously detailed, of a conquering ruler; the image of the stately military monarch made fashionable by the absolutist French court. Peter's chest and head are proportionately larger than in actual life (Rastrelli had taken close measurements of the living tsar), and the whole monument was obviously intended to be more a symbolic or emblematic representation of the first Russian emperor than a realistic one. Compared to the more famous equestrian statue of Peter executed and erected under Catherine II—Falconet's *Bronze Horseman* (Chap. 5)—this by Rastrelli surely "possesses greater genuine monumentality and conveys with greater authenticity and brilliance the spirit of the great epoch to which it owes its creation."[175]

N. N. Vrangel, writing early in the twentieth century, was the first historian of sculpture in Russia, and his main points have stood the test of what the meager subsequent scholarship on the subject has had to say.[176] As Vrangel observed, if wood carving was widely practiced in pre-Petrine Russia for decorative as well as practical purposes, few "interesting examples of sculpted representation" were executed: "interesting," that is, by modern—post-Renaissance—standards, however charming they might be as folk art. Surviving examples of pre-Petrine Russian carving are exclusively religious in character, moreover: either low-relief icons reminiscent of provincial Byzantine works or flat, elongated statues in wood reminiscent of the statuary of Gothic or, better, Romanesque Europe (fig. 73).[177] Decorative sculpture in plaster or alabaster began to appear in Muscovite churches patronized by leading members of the court in the 1680s and 1690s, the work, it seems, of anonymous Italian masters.[178] Like the churches themselves of the contemporary "Moscow Baroque" architecture, however, this sculpture is best considered transitional in significance, signifying as it did a burgeoning taste for the new art among the Muscovite elite and a corresponding demand for more—much more.* In sculpture as in the other visual arts, in Vrangel's words, the "great change came with great Peter." And the effective agents of that change once

Revolution in Architecture, chap. 4.

Figure 73 *St. Nicholas of Mozhaisk,* eastern Russia (Perm'), seventeenth century(?). Limewood, tempera, gilt.

again were the numerous European masters hired by Peter to work in St. Petersburg—French and German for the most part, but also Dutch and Italian. C. B. Rastrelli was only the most distinguished sculptor of a phalanx that numbered, in a period of little more than ten years, in the dozens.

The case of Nicolas Pineau (1684–1754) is relatively well documented.[179] Hired in Paris by a representative of Peter in 1716, he arrived in St. Petersburg that summer with two French assistants and a contract promising 1,200 rubles a year in return for all manner of ornamental carving in the latest Paris style. He is particularly famous for the relief panels still to be seen in Peter's "cabi-

Figure 74 *Scourged Christ*, village of Pashiia (Perm' region), eighteenth century. Pinewood, tempera. Life-size. The type is also known as the "Northern Savior."

net" or study in the main palace of Peterhof.* He also designed everything from lamps, tables, and armchairs to ship figureheads, triumphal arches, and sarcophaguses, the last including one for the corpse of Peter himself.[180] On returning to Paris, by 1729, Pineau enjoyed great success as an ornamental sculptor in part because of the reputation he had earned in St. Petersburg, a fact that suggests the beginnings of artistic reciprocity between Russia and Europe if not of artistic integration.

Among the European masters who worked with Pineau and passed on their skills in some measure to their Russian assistants, the Italian sculptor

*Revolution in Architecture, fig. 88 (p. 187).

Carlo Albaghini was prominent. At some point Albaghini, too, executed a wax bust of Peter which he later (1722) copied in marble. This now forgotten work has a history indicative in some respects of the more general course of the Petrine revolution. The wax bust was sent by the tsar to Rome in 1719 as a present to a leading Vatican politician who had helped expedite a shipment of Italian sculpture to St. Petersburg (the bust was officially returned in 1861); and the marble copy was owned successively by several Russian grandees until 1822, when it was placed in the library of the new General Staff building in St. Petersburg, thereafter to inspire countless Imperial officers in the dispatch of their duties. Meanwhile, from 1722 numerous other copies of the bust were made to adorn various noble residences and other official buildings, there similarly to perpetuate the memory of both Peter I and the birth of modern sculpture in Russia.[181]

After Peter's death his sculptural program proceeded fitfully, until receiving a new burst of energy under Empresses Elizabeth and especially Catherine II. This revival was closely connected, as we'll see in the following chapter, with the foundation of the St. Petersburg Academy of Fine Arts and the arrival from Paris of a distinguished teacher, Nicolas Gillet. But between the last years of Peter and the first years of the Academy, that is, from the 1720s until the 1750s, sculpture in its decorative and theatrical aspects flourished at court in typically Baroque and then Rococo forms. There was no turning back to the days before Peter in this visual art, either. Nor was it solely a matter of elite taste and practice. The new norms and techniques of three-dimensional naturalism were spreading downward and outward in society, as may be seen in the religious art of provincial churches. There, not only did old saints receive new clothes but whole new images were appearing, like the seated figure of the scourged Christ (*Bichuemyi Khristos:* fig. 74).[182] Unfortunately, there is as yet little published research detailing such obvious links between elite and popular or cult art in post-Petrine Russia, a theme that we nonetheless take up in our concluding chapter. For now we simply register the fact that by the time of Peter's death the new sculpture, like the new painting and graphic art, had become an integral part of Imperial Russian visual culture.

.

5
The Revolution Institutionalized

Peter's revolution in visual art was made permanent in Russia, or institution-alized, in a number of ways. Leading members of the Russian elite, starting with Peter himself, formed sizable collections of the new art which they pur-chased in lots or by item directly from artists and dealers and others in Eu-rope—mainly in the Netherlands but also in France and Italy, Germany, En-gland, and Austria. These prizes were displayed by their new owners in their palaces and houses, usually newly built in the new-style architecture and located in St. Petersburg and its environs, Moscow and its, but also, as time went on, in the provinces. Peter's own collections inevitably formed the core of the first public art galleries in Russia—meaning Imperial or state-owned, state-operated premises whose artworks were more or less readily accessible for viewing and study by members of the elite. Such displays of the new imagery, in new-architectural settings and within a culture—elite Russian cul-ture of the Petrine era—undergoing correlative changes in dress, work, speech, and other social codes, both demonstrated and fostered a burgeoning interest in and demand for the new art, rather as had already happened in much of Europe (we begin to say, elsewhere in Europe). Procedures for train-ing Russians in the new arts of image-making were instituted, at first tenta-tively as we've already seen and on an ad hoc basis, then with the goal of permanence in mind. European artists of some talent and repute were hired to work in Russia on the explicit condition that they trained Russians in their art; Russians trained in these "schools" were sent to Europe to complete their education. It was a very different matter from training image-makers only a decade or two earlier in Russia, when image-making was treated as a craft to be learned on the job in apprenticeship to a master artisan and the content and forms of the imagery itself as well as artistic techniques were constrained by tradition in multiple ways. Now, foreign languages were needed and knowledge of subjects like Classical history and mythology together with a grasp of new-art theoretical principles and mastery of the techniques of draw-ing including drawing from life, of painting in oil, of copperplate etching and engraving, or of sculpture in bronze or stone. Such an education took much more time before the student could be expected to produce new-style images of acceptable quality, as well as expert instruction. Profound cultural change

no less than commensurate economic or political change is usually costly and burdensome to those most directly involved.

At least since the time of Peter's father the state—the tsardom, the tsar's government, by far the most powerful and wealthy of Russian institutions—had taken the initiative in promoting major changes in Russian life, amalgamating in this regard functions formerly also performed by the church or semi-feudal grandees (or by elements of the mainly peasant masses in recurrent, largely inscrutable "movements"). Peter hardened this centralizing, hegemonic tendency into immutable historical fact. Responding to the pressures on his state of European expansion but also to more personal imperatives, Peter and his associates pursued over a period of nearly thirty years a program of intensive Europeanization, one that sooner or later affected every sphere of Russian life; and protecting if not advancing this program became the concern of the Petrine "party" in Russian court politics after the first emperor's death. This was as true of imagery—of the rulers' and elite's ways of imaging themselves in their world—as of anything else in the Petrine program. Although it was not alone among institutions in this respect, the St. Petersburg Academy of Fine Arts (*Akademiia Khudozhestv*) became the chief agency perpetuating the Petrine visual revolution in post-Petrine Russia. During approximately its first century in operation it produced nearly 2,000 visual artists, a raw quantitative indication of the importance the Academy rapidly assumed in shaping the visual culture of the Russian Empire. We therefore turn first to its origins and early history in our study of the institutionalization of Peter's revolution.[1]

THE ACADEMY

Academies of art in Europe go back to sixteenth-century Italy and particularly to Florence, where in about 1560 the Academy of Design was formed by Grand Duke Cosimo de' Medici for the purpose of uniting under his protection the best architects, painters, and sculptors of the day: "best" meaning those artists who shared to an exemplary degree an interest in Classical "design." Duke Cosimo's artists were thus freed from the restrictions of the medieval guild system and able to disregard the economic aspect of their art, which was now being thought of less as a handicraft or manual skill to be learned at the master's elbow and more as a science or spiritual expression, like poetry or physics, requiring considerable theoretical study (Chap. 1). The academy in Florence was followed by the Academy of St. Luke in Rome, established in 1593; by numerous lesser, often private academies founded elsewhere in Italy in the seventeenth century; and by the Royal Academy of Painting and Sculpture in Paris (1648) and its offshoot, the Academy of Architecture (1671). The operations of the French academy reflected the centralizing and authoritarian methods and aims of the French monarchy, and it soon developed the now familiar panoply of publications, prizes, exhibitions, and traveling scholar-

ships while closely regulating the teaching and other work of its members. It was the model for the art academies which sprang up in Vienna, Berlin, Copenhagen, Madrid, and elsewhere in Europe in succeeding years and in which teaching the Classical tenets of the three "fine arts" remained a fundamental purpose—the *arts nobles* or *beaux arts* as they were now called, to distinguish them from the humble *arts mécaniques* or *moindres métiers* with which architecture, painting, and sculpture had once been confused.[2]

We saw in previous chapters how under Peter I young Russian artists were sent for the first time to study at both the Academy of St. Luke in Rome and the Academy of Design in Florence, while other of Peter's *pensionery,* as they came to be called, studied at the academies of art in Venice and Antwerp. We also saw that Peter's envoy to France in 1705–1706, A. A. Matveev, wrote a detailed description of the Royal Academy of Painting and Sculpture in Paris complete with a brief history and the names of its leading painters—one of whom, Hyacinthe Rigaud, painted portraits of Matveev and his wife (fig. 26) and later (1717) of Peter himself. These were some of the ways in which Peter learned of the existence and purposes of the European art academy, and they no doubt fueled an ambition to found one of his own. In the later years of his reign several concrete proposals were put to him to do just that.

Leaving aside several minor precedents, the first such proposal was drafted in the spring of 1721 by M. P. Avramov, a senior official in his service. In an earlier report to Peter, Avramov had invoked the tsar's order to found a "small Academy [*Akademiia*]" for the purpose of "proper training in drawing . . . and the other arts . . . following the custom of the European realms"; and he now requested approval to proceed with the scheme. Peter's response to the proposal was positive, as a document of January 1724 found among his private papers clearly indicates.[3] The proposal was in essence repeated in December 1724 by A. K. Nartov, another of Peter's close associates in such matters, who urged the creation of a central academy that would provide training in architecture, painting, sculpture, and engraving.[4] Nartov and Avramov were among those relatively obscure figures of the Petrine era whose conversion to the new art and whose personal experiences in Europe were also crucial to the success of Peter's revolution.

Following an apprenticeship in protocol and languages at the old Ambassadorial Office (*Posol'skii prikaz*) in Moscow, Mikhail Petrovich Avramov (1681–1752) had been appointed a secretary in the Grand Embassy to Europe of 1697–1698, an experience which proved to be a major turning point in his life. He remained in Holland for five years, and apart from discharging his diplomatic duties studied drawing and painting; thanks to the "excellent training" thus received, as he later told it, he became so proficient that some of his pictures were used to illustrate the news reports or *kuranty* periodically sent from Europe to Russia.[5] On returning home he was made a senior official at the Armory Chamber, presumably in recognition of his new-art expertise. In 1711 he was transferred to St. Petersburg, where he was commanded to

build up the printing and engraving facilities of the new Press, in which connection he instituted a "drawing school [*risoval'naia shkola*]": it has been called the first regular art school in Russia.[6] The Press and its school were placed under the jurisdiction of the Holy Synod, the newly created administrative head of the Russian church, in February 1721, and soon thereafter Avramov requested permission to proceed with his plan to organize "for the public benefit" an "academy for proper training in drawing, painting, and the other arts." Ninety suitable students thirteen to fifteen years of age were to be recruited "in Moscow and the other towns," according to Avramov's scheme, and several master painters—one German, the rest Russian (including Ivan Nikitin, "well trained for this in Florence")—as well as a certified architect were to be appointed teachers. The tsar's government (naturally) was to provide the necessary building and funds.[7]

It is clear that in proposing a Russian academy of art Avramov was consciously following European models (there were, just in Holland during his time there, art academies both at The Hague and in Utrecht, as he no doubt knew; another was formed in Amsterdam in 1718). Similarly, in a report to the Synod of 1726 he stressed how in his own training no less than in his efforts to build up the St. Petersburg Press and its drawing school the assistance of "foreign masters" had been essential—and would continue to be so if Russians were to master the new art.[8] In 1725, following Peter's death, Avramov proposed to Empress Catherine that a "full academy of the lifepainting science [*zhivopisnaia nauka*]" should be established in St. Petersburg with a director, seven professors, and a "korpus" of twelve students on state stipends. Here he also stressed the importance of teaching anatomically correct drawing from life, to the point of instituting a system of prizes "for the best drawing on paper from a Model [*Model*], that is, a human body"; his academy was also to have a picture gallery where students could copy works of the "best old masters."[9] In one way or another, it transpired, Avramov was determined that the principles of the new art should take root in Russia.

The career and expertise of Andrei Konstantinovich Nartov (1680–1756), by contrast, were more in the applied arts including shipbuilding, minting, and medaling, all of which he studied abroad (1718–1720) on leaving the school of mathematics and navigation founded by Peter in Moscow. In 1712 Nartov was named Peter's personal lathe man or turner, so interested was the tsar in this craft, and in 1720 he was elevated to the new post of director of the turning shop or studio (*tokarnaia masterskaia*) located in Peter's Summer Palace in St. Petersburg; from 1725 he was also responsible for teaching turning and metalwork in the new school of the Academy of Sciences.[10] In spite of this background, or perhaps because of it, Nartov proposed to Peter in December 1724 that he create an academy devoted primarily to the fine arts:

> Most Merciful Emperor and Lord!
> Since in many states, by acquiring an academy of the various arts, many

arts have been diffused, to the states' benefit, while being sustained by the monarchs' personal care; therefore Your Majesty, our invincible monarch, most august Emperor, great father and founder of Russia's glory . . . might be pleased to fulfill this same intention, namely to establish an academic corpus of the various arts, and thus augment his glory throughout the world.

Nartov insisted that without such an "Imperial academy of the various arts" not only could "artists have no genuine foundation in their arts" but no real benefit could accrue to the state therefrom, and what art there was might be "extinguished." Peter was asked to issue orders for recruiting the necessary artist-teachers, Russian and foreign, and staff and students, the latter to be obliged to pursue their courses under pain of punishment. He was also asked to provide an appropriate building, which should also house a press for printing books and engravings. In addition, "a person for a model [*dlia modeli*], who will be drawn," should be hired. The higher classes in this projected "Imperial academy of the various arts" would be conducted by an "architect of civil architecture," a "mechanic of mills and sluices," a "painter of all the various forms" of painting, a "sculptor of all the various kinds" of sculpture, and an "engraver of all the various kinds" of engraving. Only in the inclusion of a higher course in mechanics—and of lower courses in subjects like optics, printing, and carpentry—did Nartov deviate from the standard European art academy of the time, apparently for purely pragmatic reasons.[11]

The idea of founding an academy of art was also put to Peter by European specialists in his service. The correspondence of 1720–1721 of his German physician, Laurentius Blumentrost, refers to a project for establishing in St. Petersburg "an Academy of Sciences and, under it, another institution [a school] in which persons of rank could study the sciences and in which, at the same time, the arts and crafts would be taught."[12] Blumentrost's references are arresting, as the idea of combining arts and sciences in a single academy would prevail in the short term in Russia, apparently, once again, out of purely practical considerations. Projects drafted in 1724 list as subjects within the one academy's purview everything from medicine, optics, watchmaking, "sluices," and turning to architecture, painting, and sculpture.[13] In September 1724 Peter himself advised his roving ambassador in Europe, Prince Boris Kurakin, that "we have ordered an academy of sciences and arts to be organized here and have ordered our personal physician [Blumentrost] to seek out and hire the necessary people," wherefore Kurakin was bidden to fulfill Blumentrost's requests "promptly."[14] But meanwhile, as we know, the French painter Louis Caravaque, in Russian service since 1715, was urging Peter (April 1723) to establish "here in St. Petersburg an academy of painting like that in Paris."[15] Caravaque actually ran a small art school located in the St. Petersburg Post Office building for several years even as he periodically renewed his proposal to found a purely art academy on the French model. That nothing came of Caravaque's scheme—or of Nartov's or Avramov's—while

Peter lived, and for some while after his death, seems to have been a matter of court politics, insufficient funds, and a shortage of suitable Russian candidates for membership in such an institution. Still, training in the new drawing and painting continued apace in the schools supported by the Chancellery of Construction and by the Admiralty; in those run by Caravaque and Avramov (until 1727) at the St. Petersburg Press and Post Office, respectively; in the little school for orphans conducted (1721–1738) at the St. Petersburg residence of the leading member of the Holy Synod, Archbishop Feofan Prokopovich; and in, most significantly for the future, the appropriate departments of the St. Petersburg Academy of Sciences, as provided by its founding statute of January 1724.[16]

From the time it opened for business in August 1725 (Peter had died the previous January) the St. Petersburg Academy of Sciences promoted, we might say necessarily promoted, study of the fine arts. Lessons in drawing, for instance, were conducted in the academy's "gymnasium" by Georg Xsel (Chap. 4). His students went on to illustrate scientific works for the academy, to engrave maps and architectural plans, to design scientific or medical instruments, and to fill orders from the court for "illuminations" (fireworks) and official portraits. By the end of the 1730s a high level of teaching and production in the art of copperplate engraving had been achieved under the academy's aegis, and draftsmen and engravers were thus supplied for the Chancellery of Construction, the Naval Academy, the Holy Synod, the office of the Master Herald, the Imperial porcelain and tapestry factories, and the College of Mines (an administrative department of state, not school), among other official establishments.[17] But pressure for a proper arts academy continued to build. In 1730–1731 Caravaque was joined by V. N. Tatishchev, later famous as a historian but then in charge of Empress Anna's coronation, in urging the formation of such an academy to be headed by Tatishchev himself with Caravaque, C. B. Rastrelli, and P. M. Eropkin (who had studied in Italy) to teach, respectively, painting, sculpture, and architecture.[18]

On September 7, 1733, the St. Petersburg Academy of Sciences met in extraordinary session at the call of its president, Baron H. C. von Kayserlingk, to debate whether instituting an academy of arts was in the state's best interest and, if so, whether it should be subordinate to the Academy of Sciences. The record of the debate indicates that there was general agreement on the first point but not on the second, leaving advocates of the status quo to prevail: Professors Beckenstein, Duvernoy, Goldbach, Bayer, Euler, Krafft, and Amman, arguing in the affirmative, emphasized financial considerations and/or the convenience of the Academy of Sciences, while Professor Delisle, hopelessly outvoted, urged that a separate arts academy had been the intention of Peter I, that it would promote the greater public good, and that the arts would thus be spared the "dishonor and damage" hitherto done to them by the Academy of Sciences.[19] One student has asserted that the government of Empress Anna (1730–1740), dominated by a "German Party" of high-level ap-

pointees from the Baltic provinces and beyond, was disinclined to promote the arts in Russia or anyway felt bound to support its fellow Germans in the struggling new Academy of Sciences.[20] Be that as it may, funding for the academy's art departments was increased in 1734, A. K. Nartov was put in charge of a new "Turning and Instrument" department, and in 1738 a "nature class" was inaugurated. The departments of drawing and of engraving were further strengthened by the appointment of the Italian painter, Bartolomeo Tarsius (Staehlin's former teacher), to head the first and of the German engraver, C. A. Wortman (also Wortmann, Wordmann), to head the second.[21]

The accession in 1741 of Peter's daughter, Empress Elizabeth, ever conscious of her father's legacy, inspired new efforts on behalf of the arts led by Delisle and Nartov and joined now by a newly appointed "adjunct" of the Academy of Sciences' physics class, M. V. Lomonosov, who had just returned from several years of study abroad. The dominance of the Academy by Germans, the failure to appoint or promote Russians to responsible positions within it, alleged deficiencies in its administration and teaching, and a perceived need to separate the arts from the sciences all played a part in the campaign they mounted in the 1740s. In an appeal to the Senate of September 1743, for example, Nartov renewed his proposal of 1724 for an independent arts academy, maintaining that such had been the will of Emperor Peter the Great.[22] But when, in 1747, the St. Petersburg Academy of Sciences at last received its formal charter (*Reglament*) from the state, it was as the "Imperial Academy of Sciences and Arts," and teaching in the latter was assigned if anything a still more subordinate position.[23] Not until Lomonosov got the ear of the leading court favorite of the day, I. I. Shuvalov, and of the Academy's young president, Count K. G. Razumovskii (he had been appointed by Empress Elizabeth in 1746, at the age of eighteen), did things begin to change.

The many faceted career of M. V. Lomonosov (1711–1765), worthy scion, figuratively speaking, of great Peter, whom he idolized in various literary efforts, is well known. Born to simple folk in the Kholmogorii region near the White Sea, he was educated in Russian ecclesiastical schools (passing as the son of a priest) and at the St. Petersburg Academy of Sciences until sent in 1736 to study mining and chemistry in Germany. There, in the universities of Marburg and then Freiburg, he pursued his Classical studies as well as scientific subjects, read contemporary German literature, and traveled extensively, returning home in 1741 with an education that was, for a Russian of the time, quite extraordinary. He went on to achieve distinction as a scientist, man of letters, and mosaicist, an art he single-handedly introduced in Russia. He became a protege of Shuvalov, whom he assisted in promoting the creation of a university in Moscow as well as an academy of fine art (fig. 75). But the university took precedence, as far as they were concerned.[24]

In 1754–1755 the charter of the St. Petersburg Academy of Sciences was revised by a specially appointed commission, which included Lomonosov, to allow some greater freedom of action to its art departments. Meanwhile

Figure 75 Frontispiece to M. V. Lomonosov, *Rossisskaia grammatika*
(Russian Grammar), St. Petersburg Academy Press, 1755. Etching and
engraving, artist unknown. The cipher of Empress Elizabeth in the sun
(top right) casts its rays on the cipher of her heir presumptive, Tsarevich
Peter Fëdorovich (the future Emperor Peter III), and on the figure of
a regal woman in antique dress complete with scepter and laurels
(Elizabeth herself) seated at a table holding an open copy of the
Grammar. Crowding near the table, anxious to learn, are representatives
of her subjects, including peasants and townsmen in traditional dress as
well as nobles in European costume.

Shuvalov, preoccupied with launching Moscow University (founded in January 1755) and its subordinate gymnasium, saw to it that provision was made for teaching art therein. He also agreed to upgrade the art departments of the St. Petersburg Academy of Sciences, mainly by appointing a new overall director with authority to hire first-class artists in Europe, but left the matter in charge of the academy's president, Razumovskii, who had little conception of how to proceed. Moreover the director of the academy's art departments, our friend Jacob Staehlin, did what he could, in time-honored bureaucratic fashion, to block the creation of any rival institution. Shuvalov then proposed that an independent arts academy be founded not in St. Petersburg, but in his beloved Moscow. He was persuaded to drop this idea only when it was pointed out to him, as he himself reported to the Senate late in 1757, that the "best masters" to be hired in Europe simply were not willing to move to Moscow, much preferring instead to work for the Imperial court and live in St. Petersburg. At the same time, Shuvalov realized, creating a fully fledged arts academy in Russia was the only way to break the dependence on often "quite mediocre" foreign teachers, who, "receiving big money, enrich themselves, and return home leaving not a single Russian knowledgeable in any art."[25] This argument finally prevailed. And such in brief was the immediate political background to the founding of an arts academy in Russia.

The Senate promptly responded to Shuvalov's submissions of late 1757 by resolving in November "to establish an Academy of Fine Arts here in St. Petersburg" and by directing Shuvalov, as "Curator [*Kurator*]" of Moscow University, to draw up an organizational plan. In so doing the Senate reiterated Shuvalov's concern about mediocre foreign teachers and agreed that the academy had to be located in St. Petersburg because "the best masters do not want to go to Moscow." The Senate also appropriated 6,000 rubles for the new academy, as Shuvalov had proposed, and approved his suggestion to hire at once two French masters—"both Members of the French Academy"—and to transfer to St. Petersburg "able students" from Moscow University's gymnasium, students "who have studied languages and sciences and are inclined to art."[26] Sixteen such youths were duly sent to the new capital, where they joined twenty young men chosen there; by May 1758 the total of students enrolled in the Academy of Fine Arts stood at thirty-eight, eleven of them identified in the records as "of the nobility," a sure sign of the new art's rising social prestige in Russia.[27] Lomonosov was moved by these developments to compose a "Grateful Oration on the Dedication of the Academy of Fine Arts" in which he confidently predicted that it would conduce to the "adornment of the Fatherland, the happiness of the people, the introduction in Russia of wondrous things esteemed of old the world over." Indeed, "As a most important member of the all-European system," Lomonosov declared, "Russia requires for her majesty and power the permanent and uniform splendor which can only be obtained from the esteemed arts."[28]

Lomonosov was of course right: he expressed forcefully aspirations of the

Russian elite that reflected in turn a standard view of the visual arts in Europe itself (in the rest of Europe). Yet the relevant records show that Shuvalov rather than Lomonosov, the much vaunted polymath of Soviet scholarship, was the real angel of the early St. Petersburg Academy of Fine Arts. And no less than Lomonosov's life story does Shuvalov's (1727–1797) bear witness to Russians' successful assimilation of the new art and culture within a generation of great Peter's death (pl. 25).

A son of the minor Moscow nobility and educated at home, we know little more of I. I. Shuvalov's early circumstances until he appears as a court page in 1742, thence to make a brilliant career under Peter's daughter, Empress Elizabeth. Becoming an influential member of her innermost circle, he greatly impressed European diplomats with his fluent French and "vivacious Francophilia" in his role as the empress's de facto "minister of culture and education," as one student puts it. From this position, as well as championing Moscow University and the Academy of Fine Arts, he oversaw preparations for Voltaire's celebrated *Histoire de l'Empire de Russie sous Pierre le Grand*, commissioned by Elizabeth from Europe's most famous writer and first published in 1760. In prefaces to successive editions of this contemporary best-seller Voltaire called Shuvalov "possibly the most learned man in the Russian Empire," recording that it was Shuvalov "who provided me with all the materials on which I have based my writing. He was far more capable than I of composing this *History,* even in French; all his letters to me testify that it is only through modesty that he has left the task to me."[29] During nearly fourteen years of voluntary "exile" in Europe (1763–1777) following Elizabeth's death, Shuvalov became a familiar figure in the literary salons of Paris—"Russian ambassador to the European literary realm," in the words of a younger Russian contemporary—and stayed with Voltaire at Ferney. From Rome he sent some fifty-eight casts of Greek statues back to the St. Petersburg Academy of Fine Arts, significantly augmenting its crucial teaching collections.[30]

The earliest years in the Academy's history can justifiably be called the Shuvalov period (1757–1763). Apart from his crucial role in definitively separating it from the Academy of Sciences, its records show that he closely supervised its initial activities, provided its first premises, and paid many of its expenses out of his own pocket.[31] Successive administrators regularly reported to him, particularly A. F. Kokorinov, the Academy's first professor of architecture and one of the few Russians to be so elevated so soon. The two French academicians nominated by Shuvalov, the sculptor N. F. Gillet and the painter L. J. Le Lorrain, were duly appointed professors of their specialties and were joined shortly by a certain Valois, also in architecture, and then by J. L. De Velly (Duvely) and J. B. M. Vallin de la Mothe, the first appointed to replace the suddenly deceased Le Lorrain as professor of painting, the second to take over from Valois as senior professor of architecture. Both Gillet and De Velly executed portraits of Shuvalov, the one in marble, the other in paint. Gillet's portrait bust of 1759, long in the possession of the Shuvalov family

and now at the Hermitage Museum (GME), portrays splendidly the noble art patron and connoisseur that Shuvalov had become.[32]

With Shuvalov's blessing the French artist-professors promptly imposed a French discipline on the St. Petersburg Academy of Fine Arts. They divided the students into drawing, engraving, painting, sculpture, and architecture classes, dressed them in appropriate uniforms, introduced exam competitions, ranked students by the results, supplemented the art classes with courses in foreign languages, mathematics, anatomy, history, geography, mythology, and Russian church catechism, and organized the entire school according to a strict daily and hourly timetable. Shuvalov also shrewdly sought additional high-level patronage for the Academy, and in 1758 its first two honorary members were named: Count A. S. Stroganov, scion of the fabulously rich family raised to prominence by Peter I and a notable connoisseur (his father is portrayed in our pl. 20), and Shuvalov's own cousin, the powerful Count A. I. Shuvalov.

In 1761, despite an official finding of shortages and irregularities in its operations, the Academy had sixty-eight students in residence and held its first public examinations. The judges, mainly foreigners, included Lomonosov, who was shortly to become an honorary member; and at least six Russians were promoted to positions within the Academy in recognition of their work. In recognition of the Academy's own newly won stature, Shuvalov himself was elected that year an honorary member of the Royal Academy of Fine Arts in Madrid. All in all, it was an impressive beginning, a noble effort to honor and implement great Peter's legacy—as Lomonosov rather typically boasted, in flowery Baroque periods, in a speech of 1763. Shuvalov's last budget, before leaving for exile in 1763, showed an estimated annual income of 26,000 rubles (from state sources) to be expended in support of a director and deputy director, five professors (one, the professor of engraving, a Russian—Evgraf Chemesov), seven teachers (of French, Italian, Russian, history, mathematics, anatomy, and catechism), twenty-seven assisting staff, and some eighty students at various stages, including several *pensionery* living and working in Paris and Rome.* And in a crowning gesture before his departure Shuvalov gave to the Academy both his considerable library and his collection of paintings and drawings, which was described as "une quantite d'éxcelents tableaux et de desseins rares" by a contemporary French observer and is known to have included works by Bassano, Tintoretto, Veronese, Giordano, Rubens, Rembrandt, Van Dyke, Poussin, and Claude Le Lorrain, among others.[33]

The Shuvalov period in the Academy's rise was succeeded by the triumphal era of Catherine II (reigned 1762–1796), a ruler at least as conscious as Empress Elizabeth of following in Peter's footsteps and an era of relative prosperity such as the Academy would not know again until the reign of Nicholas I

*The Academy's 1763 budget of 26,000 rubles was roughly equivalent to the annual payroll of a regiment of musketeers (2,093 men): J. P. LeDonne, *Ruling Russia: Politics and Administration in the Age of Absolutism, 1762–1796* (Princeton, 1984), p. 228.

Figure 76 "Seal of the Imperial Academy of Painting, Sculpture, and Architecture": engraved frontispiece to *Privilegiia i ustav Imperatorskoi Akademii trekh znatneishikh khudozhestv, Zhivopisi, Skulptury i Arkhitektury,* St. Petersburg, 1765.

(1825–1855), another self-proclaimed follower of great Peter.[34] Within the first month of her reign Catherine paid the Academy a formal visit, and in November 1764, taking up a draft left by Shuvalov, she completed Elizabeth's unfinished business by granting it an Imperial charter outlining its organization, duties, and privileges once and for all (fig. 76). On June 28, 1765, this newly independent and reorganized Imperial Academy of Fine Arts was formally inaugurated in the presence of Catherine herself, various officials, the higher clergy and foreign ambassadors, and sundry artists, writers, and scholars: a notable gathering of representatives of the entire Imperial elite (only Shuvalov was missing). This was also the day of the formal groundbreaking for the Academy's new building, a grandiose structure designed by Vallin de la Mothe with the assistance of Kokorinov. The building, still standing and still the Academy's home, "exudes the principles of Neoclassicism, which, owing to the influence of the Academy, were then to dominate Russian architecture until the end of the century."[35]

Alexander Sumarokov, "the first truly modern writer in the history of Russian literature,"[36] and Alexander Saltykov, the Academy's new secretary, both spoke at the Academy's inaugural ceremonies and their speeches, like the Academy's new charter, offer important evidence of the extent to which the new culture had taken root. Both told of how the Academy embodied Russia's assumption of a European and particularly a Classical heritage. From the Academy, said Sumarokov, architects would go forth to transform the face of Russia and turn St. Petersburg into a "northern Rome"; while Saltykov, avering that "many peoples have risen to the height of their glory through the Arts and the Sciences," gave as his prime example and model the Romans

under Caesar Augustus. Saltykov invoked the civilizing role of the new culture, a view owed more to the Enlightenment perhaps than to the Renaissance: "It is known to every reasonable person that the Arts and Sciences are the first tamers of barbarism in the human race," he said, a line that compares closely with one in the relevant entry of the *Encyclopédie* (1778) of Diderot and D'Alembert (which Catherine offered to publish).[37] Sumarokov assigned a major educative role to the new painting and sculpture in particular while suggesting discreetly that the artist's necessary creative freedom bore no direct relation to political freedom, which he termed *svoevolie* or "willfulness" (or "license"). This accorded well with Petrine principles of political absolutism, which Catherine not only adhered to but considerably embroidered and which it remained the duty of all Russian artists favored by the state to promote.[38]

The organization of the St. Petersburg Academy of Fine Arts and its school as laid down in its new charter largely confirmed its French or, by now, generally European character. Titles and terms of office, curriculum and exam procedures, dress code and disciplinary matters all drew on standard European models. French, Italian, and German were to be studied by fledgling Russian artists from an early age; "the best foreign masters"—French, Italian, and German—were still to be recruited and, in effect, to dominate the teaching; and the best students were still to complete their training abroad, preferably in France or Italy, all at Imperial expense. All the visual arts were to be practiced and taught in the Academy but also such ancillary subjects as "Perspectives and Optics [*Perspektivy i Optiki*]," anatomy "as much as an artist needs to know," metalwork, and cabinetry; drawing was to be considered fundamental to the three "most distinguished arts"—painting, sculpture, architecture—as well as to engraving; theory was to be joined to practice, particularly in architecture; and painting, that is, "the art of lifepainters [*iskusstvo zhivopistsov*]," was to include all known forms: "portraits [*portrety*], battle scenes [*batalii*], landscapes [*landshafty*] and all kinds of views, flowers, fruits, beastial and architectural decorations, also miniatures [*v miniature*] on enamel." Acquiring the new art for Russians had of course meant acquiring a new vocabulary, among other stresses and strains. And although graduates of the Academy were not to be thought beholden to the Imperial government in any way, they were at the same time to be given preference in all official and public works throughout the Russian Empire.[39] This was privilege indeed in this society at this time.

The Academy was also to have a fully developed preparatory or junior school, according to an Imperial announcement of April 1764; and by June 1764 the first class of sixty-four boys, all five to six years of age, had been selected (a new class was to be enrolled every three years).[40] The boys were to be instructed in the catechism, "good morals, and honorable conduct" as well as in drawing and appropriate academic subjects: "Russian grammar, foreign languages, arithmetic and geometry, history, mythology, and geogra-

phy." The idea was that if after nine years in the school any of its pupils was judged unready to move up to the Academy's regular art classes, he would stay behind and prepare for a trade such as metalworking or cabinetry. The art historian Pevsner thus finds two features of the St. Petersburg Academy that made it unique among the dozens of such institutions already established in Europe (and America). The first is the combination under one roof of what were in effect elementary and trade schools with a proper art academy, suggesting "a country where public education of all kinds was still undeveloped"; and the second is the extent of state control exercised over the whole enterprise, which can be explained "only by the particular coincidence of a nation grown up outside Western civilization being suddenly forced into it with an epoch in Western history in which absolutism and its commercial corollary, mercantilism, were ruling."[41] Pevsner's comparative remarks duly remind us of the still very different social and political setting in which the Petrine revolution was being institutionalized. Indeed, the point is confirmed by the 1764 charter of the St. Petersburg Academy and related legislation, which guaranteed that its certified graduates, their children and descendants could not be enserfed by any lord, however high in rank—a provision paralleled by the injunction against accepting sons of serfs (the majority of Russian subjects) as either members of the Academy or students in its schools.[42] Instead, as the Academy's records indicate, its students would be drawn from middling merchant, official, and clerical along with petty noble families—the "official" families to include now those of certified artists themselves.[43]

The social peculiarities, indeed injustices of the Imperial system in Russia must not distract us from the success achieved by the Imperial Academy of Fine Arts in bringing Russian visual art and its practitioners, if not invariably its patrons, firmly into the European mainstream. Raw quantitative data offered at the beginning of this chapter—nearly 2,000 graduates of its thoroughly European program over the Academy's first century in operation—provide one measure of this success. It may also be gauged from the fact that the tradition of artistic *pensionerstvo,* founded by Peter I, flourished under the St. Petersburg Academy, which between 1760 and 1790 sent at least fifty-eight of its graduates to complete their studies on state scholarship at that most prestigious of cognate institutions in Europe, the Académie des Beaux Arts in Paris.[44] Individual careers offer further evidence substantiating the Academy's early claim to a place in Europe's art world.

Anton Pavlovich Losenko (1737–1773) was one of its first *pensionery* to study in Paris. Born into a merchant family in Glukhov/Hlukhiv, capital of Russian Ukraine, in 1744, he was appointed to sing in the chapel choir at the Imperial court, a position he lost in 1753 when his voice changed, at which point he was apprenticed to the painter I. P. Argunov, who prepared him for entrance to the Academy's school (1758). There he studied under L. J. Le Lorrain, newly arrived professor of painting, and then under the latter's successor, J. L. De Velly. In or about 1760 he painted more than passable portraits of angel-president Shuvalov (pl. 25) and of the writer Sumarokov, and was sent the

same year to Paris. Nearly three years in Paris were followed by three more in Rome, after which he returned to St. Petersburg (1769). During his Paris *stage* Losenko had compiled a journal for submission to his sponsors at home recording his observations of "distinguished works" of art. It is filled with comments like these: "splendid composition and natural expressiveness," "fine attitudes [poses] and true drawing," "composition true to subject," "distribution of light and shade extremely fine," "natural coloring," "figures finely dressed." A "statue in bronze" was "finely proportioned," while located in the Royal Library was a "print room [*kabinet estampov*] containing works by various artists that is open to the public twice a week, where I make notes for my work." In 1770 he was named a full member and professor of the St. Petersburg Academy on the strength of his *Vladimir and Rogneda* (pl. 26), a picture showing, as required by the Academy's set theme, the medieval "Russian prince Vladimir before Rogneda, daughter of Rognold, prince of Polotsk, after the defeat of this prince for refusing Vladimir's request to marry [Rogneda]." It was the first genuine historical painting ever executed by a local artist, and on a putatively Russian historical theme at that (Lomonosov had dealt with the theme in his historical work, Sumarokov in his plays), and has been so honored by Russians ever since. At the Academy, however, according to old Staehlin, the painting's "conception, composition, and drawing met with greater approval than did its rather gaudy coloring"; Staehlin also noted that in Paris Losenko had won medals from the Académie des Beaux Arts not for painting but for two of his drawings (more than a hundred of which survive). To make matters worse, Losenko's new duties as professor at the Academy seem to have distracted him from his art. Later in 1770 a resident French artist, the distinguished sculptor Falconet, advised Empress Catherine that, "pestered, fatigued, tormented, overwhelmed by a thousand academic trifles which have never concerned a professor in any academy in the world, Losenko cannot make a brush-stroke. He is the first capable painter in the nation; [but] one is unconscious of this, one sacrifices him. One will only have mediocre artists so long as they are not better treated." In spite of this admonition, or perhaps because of it (highly qualified Russian artists were still rare), Losenko was promoted to director of the Academy in 1772. But he subsequently fell from the empress's favor, the victim it seems of a foreign artist's intrigue, and died in poverty. The sad end of his story, if not the bulk of it, had of course plenty of parallels in contemporary Europe.[45]

Losenko was one of several painters born in the Russian Empire in the years before or soon after the first emperor's death whose careers, however checkered, both reflected and carried forward the Petrine revolution. His first teacher, Ivan Petrovich Argunov (1729–1802), is another such painter, the more remarkable for being unique among major Russian artists of the eighteenth century in his serf peasant origins. Count B. P. Sheremetev acquired him by marriage in 1743 and became his generous patron as well as the subject of several of his later portraits. In 1746 Argunov was assigned to the "command" under the Chancellery of Construction in St. Petersburg headed by Georg

Christoph Grooth (1716–1749), the portraitist and son of the Stuttgart court painter who had entered Russian service in 1741 at Staehlin's instigation.[46] From Grooth, apparently, Argunov learned to paint in the Rococo style much favored by the court of Empress Elizabeth, and he helped decorate the great churches and palaces of her reign designed by the celebrated B. F. Rastrelli. His *oeuvre* includes a self-portrait, brush in hand, of the 1750s, and a portrait, painted much later (1784), of an unnamed peasant woman. Losenko is one of three students Argunov is known to have trained in the 1750s at the empress's request. Thereafter, while three sons went on to the Academy and moderately successful careers as artists, Ivan Argunov himself lived out his life in the Sheremetev family's employ, overshadowed by more illustrious compatriots, invariably foreign trained, and by the foreign masters clustered at the Imperial court.[47]

Or there is Aleksei Petrovich Antropov (1716–1795), whose father, like his grandfather, had worked at the Armory Chamber in Moscow and then at the Printing House and then, after service in one of Peter's guards regiments, in the tsar's own turning and cabinetry shop in St. Petersburg. In the 1720s father Antropov enrolled his four sons in the school of the Chancellery of Construction, and from 1732 Aleksei studied painting with those leading exponents of the Petrine revolution, Louis Caravaque and Andrei Matveev. In 1739 he was transferred to the Chancellery's new command headed by the painter I. I. Vishniakov, another of Peter's fledglings, and in the 1740s and 1750s worked in St. Petersburg, Moscow, and Kiev on various commissions: religious paintings for Rastrelli's great Baroque Church of St. Andrew in Kiev, decorative paintings for the Imperial palaces of St. Petersburg and environs, portraits of elite personages (pl. 27), designs for *antiminsy* and religious book illustrations. Antropov was a diligent rather than distinguished artist, perhaps, yet a thoroughly Petrine product all the same, the character of his *oeuvre* unthinkable in a Russian artist even of his father's generation.[48]

As for his sometime teacher Ivan Iakovlevich Vishniakov (1699–1761), he similarly was trained in Russia and mainly by Russians in the years before the Academy's dominance (where both of his sons, Ivan and Alexander, were to study).[49] First encountered in documents of 1730 as a member of Matveev's command and pupil of Caravaque, Vishniakov served from 1739 until his death as de facto director of all decorative painting in the Imperial residences while also working as a portraitist. Most noteworthy in the latter connection are his wedding pictures of one M. S. Iakovlev and wife, he the son of a merchant-industrialist later ennobled for his successes as such, and now making a career in the Imperial service; she the daughter of a merchant (pl. 28). Whatever their artistic merit, both works testify to the spread of the new portraiture outwards from the court, a point raised in our previous chapter. In fact, by the middle of the eighteenth century, initial research in this neglected area has shown, such portraiture, however rusticalized, had become a fixture of the cultural life of provincial Russian society—a society that in

this respect included merchants, clergy, officials, prosperous tradesmen and artisans, even better-off peasants, in addition to noble landowners (pls. 29–32).[50] Thus did portraiture, as well as the new decorative painting, take root in deeper Russia.

In the physically more demanding new art of sculpture, the Imperial Academy of Fine Arts also successfully carried forward the Petrine program, until monumental sculpture, especially ruler statues, became a central component of Imperial Russian imagery. We think immediately of the *Bronze Horseman:* not only the endlessly reproduced Falconet-Collot equestrian statue of Peter I dedicated by Catherine II in 1782, but also the famous poem of that title by Alexander Pushkin (1833). Indeed, one student proposes that sculpture offers "the most vivid illustration" of the rapid Europeanization of Russian art in the eighteenth century, and observes that virtually all prominent sculptors of the period were graduates of the Academy.[51]

Here, too, of course, collecting was a vital first stage in the process. Following Petrine initiatives, statues in the Classical mode continued to be purchased and occasionally commissioned in Europe for display in the Imperial residences and parks of St. Petersburg and environs; equally important, collections of plaster casts continued to be acquired for the use of students at the St. Petersburg Academy of Fine Arts and its predecessors. In June 1747, for instance, a report to the chancellery of the Academy of Sciences from its drawing master—J. E. Grimmel—indicates that twenty-one plaster specimens had recently been acquired, the collection including "1 warrior, 1 Venus with cloak, 1 youth lying on a pillow, 1 Greek Venus, 1 Flora, 1 Fortuna, 1 Sabine despoiler, 1 Mercury, 1 Roman soldier"; these to complement a newly acquired collection of some sixty-one new-art paintings (*zhivopisnye kartiny*) including several "sea pieces," seven "landscapes [*landshafty*]," one "Apollo and Mars," and two "feasts of Bacchus."[52] The Shuvalov donations—major collections of both casts and pictures—were mentioned earlier in this chapter; soon after his arrival in St. Petersburg in 1766 the French sculptor Étienne Falconet presented still more statues to the Academy of Fine Arts.[53] During Empress Elizabeth's reign relief sculpture in highly decorative Rococo style, executed by masters of the Chancellery of Construction, was the rage (fig. 77). But under Catherine II, with the Academy's now sizable collection of statuary providing models to emulate, monumental sculpture and sculpture in the round flourished as never before in Russia, achieving in some instances European standards of excellence.

Several individual careers provide proof of this point. The first is that of Nicolas François Gillet (1712–1791), who had been a pupil and then a member of the Paris academy before being appointed (on Shuvalov's nomination) the first professor of sculpture at its new St. Petersburg counterpart (1758). For the next twenty years Gillet worked in Russia, executing first-class portrait busts of various grandees (including Shuvalov) and other sculptures. But it

Figure 77 Portrait Room, main palace, Peterhof (*Petrodvorets*); detail of decoration designed by B. F. Rastrelli, 1750s. Linden wood, carved and gilded.

was as a teacher that he made his greatest mark. He introduced the principle of sculpting from nature at the St. Petersburg Academy and otherwise insisted that his students copy directly from full-scale casts of antique statues, yet another collection of which he ordered from Rome (it arrived in 1769). He also sent his best pupils to complete their training in Paris and/or Rome, where he had also studied. The requisite journal of his Roman *stage* (1773–1778) compiled by one of these pupils, M. I. Kozlovskii (1753–1802), survives replete with enthusiastic references to all the art that he saw. Kozlovskii studied in Paris (1779) as well, where he later served as resident supervisor of Russian students (1788–1790). He became an honorary member of the Academy of Marsailles in 1780 and a full member of the St. Petersburg Academy in 1794, where he taught until his death. He left a corpus of work that has earned him repute as the outstanding Russian sculptor, international in stature, of Neoclassical heroic themes, worthy examples of which include his monument in bronze to Field Marshal Suvorov, dedicated in 1801 and still standing in St. Petersburg's *Marsovo pole* (Champs de Mars), and his statue of Samson and the Lion in the pool of the Great Cascade, designed under Peter I, at Peter's beloved Peterhof. Greatly admired by V. I. Lenin, Kozlovskii's work was prototypical of the heroic sculpture of the Soviet era; it thus forms

Figure 78 F. I. Shubin, *Bust of Catherine II*, 1771. Marble. This bust (done in Rome, now at the Victoria and Albert Museum, London) is the first of several Shubin did of Catherine; another, of 1783, is at GRM (cf. Angremy et al., *France et Russie*, p. 261 [no. 401]).

a remarkable link in the often fragile chain of modern Russian cultural continuity.[54]

Then there was Fedot Ivanovich Shubin (1740–1805), who has long been considered Gillet's most distinguished Russian student.[55] The son of a simple freeman of the far north, where he is thought to have imbibed the local manner of carving in wood and ivory,[56] he somehow made his way to St. Petersburg, entering the Academy in 1761. He studied under Gillet until 1767, winning silver and gold medals for his work, and then on Imperial pension in France and Italy until 1773, when he was elected an honorary member of the Bologna Academy of Fine Arts. In 1774 he became a full member of the St. Petersburg Academy on the strength of his portrait bust of Catherine II (fig. 78), and in 1794 was appointed professor of sculpture at the Academy in rec-

ognition of his full-length statue of the empress (GRM). Shubin executed numerous busts of other Russian grandees as well as decorative sculptures for various Imperial palaces and for Starov's Neoclassical church of the Trinity at the Alexander-Nevskii monastery in St. Petersburg.

Other notable sculptors of the time in Russia include I. P. Prokovev, M. P. Pavlov, F. G. Gordeev, and I. P. Martos, all of whose work is Neoclassical in style and technically excellent, as may be seen in surviving examples preserved in various Russian museums.[57] But it has to be said that in sculpture as in painting the most important commissions under Catherine II still tended to go to foreign masters, like the celebrated Houdon (who could not be persuaded to come to Russia),[58] a matter more now of snobbery perhaps than of purely qualitative considerations. Étienne Falconet, also of the Paris academy, has been mentioned. Already famous in France, he was brought to St. Petersburg in 1766 to create a major new monument to Peter the Great, on which he labored for the next twelve years. His chief assistant in this enterprise was his pupil and daughter-in-law, Marie Anne Collot, who executed a model for the head of their widely acclaimed *Bronze Horseman* (fig. 79).[59] Catherine's historian tells us that with this statue, captioned in Russian and Latin "To Peter the First from Catherine the Second," she "boldly asserted her claim to equality" with the first emperor. It was certainly, as De Madariaga goes on to say, "the most remarkable single work [of sculpture] produced in Catherine's reign,"[60] a matter not alone of its design but also of its huge granite base, magnificent architectural setting, and total cost (424,610 rubles). Catherine herself reported being moved to tears at the statue's unveiling, and was inspired by it "to try to do more in the future, if I can."[61] At any rate, it remains in its Neoclassical glory the most familiar symbol of the Petrine revolution in Russia, appropriated for their purposes by successive regimes including Soviet but never as such diminished.

The St. Petersburg Academy of Fine Arts similarly played a crucial role in the institutionalization, or industrialization, of the Petrine revolution in graphic art. Sidorov reminds us that it was "precisely from Peter's time that graphic works hitherto virtually absent from our art began to appear in large quantities: drawings from nature; school drawings copied from foreign models; scientific, architectural, geographical, and other technical drawings and engravings;* decorative designs, battle scenes, history pictures and portraits; allegories and popular prints."[62] To this already sizable list (see again figs. 40–49, 52, 75) we must add the new heraldic representations of various kinds discussed later in this chapter; graphic works illustrating various court ceremonials—coronations, fireworks, and so on (figs. 39, 53; fig. 80); packing labels and trademarks for new Russian industrial products; and works of purely religious significance, like the new-style consecrational *antiminsy* de-

*Dating to Peter's time, the Russian word *graviura* can mean either an engraving or an etching, or just a print; although sometimes *ofort* (from French *eau-forte*) is used to designate an etching (hence also *ofortnoe gravirovanie*).

Figure 79 M. A. Collot, *Bust of Peter I*, 1770. Bronze.

scribed in the previous chapter (fig. 29), the countless paper icons whose circulation in Russia dates back at least to the 1670s (Chap. 2), and the illustrations for church service and other religious books (figs. 27, 28, 30, 32, 33, 54, 55) whose production was as old as—coterminous with—graphic art itself in Russia (Chaps. 2, 4). Together these religious works almost certainly constituted, *pace* Sidorov and other Soviet scholars, the most widely disseminated of all the new *grafika*. And here, in this great florescence of print production, were opened whole new and rapidly expanding channels of communication between the regime and its subjects, between the church and its people, among members of the elite, and even among ordinary folk.

The techniques for producing regularly these many thousands of graphic works—drawn, etched, and/or engraved—were firmly established under

Figure 80 I. A. Sokolov after J. E. Grimmel, *Mascarade*, 1744. Etching and engraving. From an album commemorating the coronation of Empress Elizabeth, *Obstoiatel'noe opisanie torzhestvennykh poriadkov . . . koronovaniia eia Avgusteishego imperatorskago velichestva . . . Elisavety Petrovny*, St. Petersburg, 1744.

Peter, particularly at the St. Petersburg Press and then at the Academy of Sciences (Chap. 4). A succession of foreign masters—Georg Xsel, Ottomar Elliger, J. E. Grimmel, C. A. Wortman, C. B. Rastrelli, among them—perpetuated the Petrine policy of linking graphic art in Russia with the latest graphic developments in Europe while meeting the steadily greater demand for imagery of the Europeanizing Imperial system (fig. 80). Building on the huge collections left by Peter himself, the volume of European graphic works assembled in Russia for pedagogical and other purposes also continued to grow; a single donation to the Academy of Fine Arts, brought by Gillet from France, comprised some 3,000 engravings and etchings.[63] In 1734 a manual on drawing was prepared and published in St. Petersburg, the first such event in Russian history. The manual was translated and illustrated directly from a German original by J. D. Preissler published at Nuremberg in 1732, and in its successive Russian editions (again in 1734, in 1740, 1747, 1750, 1755,

1781, 1795) it became the "basic textbook of Russian artists of the eighteenth century."[64]

The quality, too, of Russian graphic art increased in the years after Peter's death. Specialists have detected a "new realism," for example, in the well-known architectural views of St. Petersburg and environs drawn in the 1750s by M. I. Makhaev, a pupil of Giuseppe Valeriani who had come from Rome and worked in Russia from 1742 until his death in 1761.[65] While still heavily dependent on foreign models and teachers, Russian graphic art, like Russian painting and sculpture, was also assuming a certain autonomy in subject or theme, as witness the frontispiece to Lomonosov's *Russian Grammar* printed in St. Petersburg in 1755 (fig. 75). But it was under the aegis of the St. Petersburg Academy of Fine Arts, to repeat, that graphic art in Russia and particularly engraving reached European and especially French qualitative standards, as works of individual artists—two in particular—readily attest.

Nikolai Iakovlevich Kolpakov (1741/1742–1771) and Evgraf Petrovich Chemesov (1737–1765) both entered the Academy's school in the 1750s and were soon enrolled in the engraving class newly organized by G. F. Schmidt of Berlin, who simultaneously directed the Engraving Chamber at the Academy of Sciences. Chemesov evidently was the more gifted as well as the older of the two, and from 1760 he became Schmidt's assistant and then professor himself and director of the class; Kolpakov in turn became one of Chemesov's students. But Kolpakov had earlier studied with Grimmel at the Academy of Sciences, and so had a dozen years of solid training behind him when called to assume Chemesov's position at the Academy of Fine Arts on the latter's sudden retirement in 1765 owing to illness. It proved to be a temporary measure. A. F. Radigues, who had come from Paris in 1764, soon took over both the engraving class and the Engraving Chamber at the respective St. Petersburg academies, and Kolpakov himself soon retired also for reasons of health. Yet in spite of their relatively brief careers and lack of foreign training, both Kolpakov and Chemesov created art of enduring value, not least as evidence of the success of Peter's revolution. Kolpakov's engraved portrait of A. A. Matveev after the Rigaud painting of 1706 (fig. 26) won the gold medal at the Academy of Fine Arts in 1766, while Chemesov has long been recognized as "the leading representative of Russian engraving of the eighteenth century" (fig. 81).[66] Radigues meantime prospered as an engraver in Russia particularly of grandee portraits, working privately from 1769 until becoming head once more of the Academy's engraving class in 1789 and a full academician in 1794.[67]

In architecture, too, the subject of our earlier volume, the foundation of the St. Petersburg Academy of Fine Arts ensured that the revolution set in motion under Peter would triumph. Training in architectural theory and draftsmanship was definitively separated by the Academy from the workshop or building site and given a central, authoritative, and privileged position in the preparation of builders. The techniques and classicist norms of the new architecture in Europe thus became dominant at all levels of building in Russia,

Figure 81 E. P. Chemesov, *Self-Portrait,*
1764–1765. Etching, dry point,
engraving. This is Chemesov's last
known work, executed after a portrait
of himself painted in oil on canvas by
J. L. De Velly, his close friend, as the
inscription around the self-portrait
indicates.

even down to the peasant village. During the reign of Catherine II, Peter's
self-conscious successor in this as in so many other ways, a grand *pereplani-
rovka* was undertaken whereby Imperial officials and architects directed the
planning or replanning and renovation of more than 400 cities and towns,
producing a deliberate uniformity of urban design throughout the Russian
Empire. The Russian built environment was quite literally and visibly trans-
formed—so as to be given, in Catherine's own words, "a more European ap-
pearance." By the end of the eighteenth century Russians possessed individ-
ual buildings and ensembles of buildings, parks and gardens, squares and
other public spaces, whole townscapes and landscapes that rivaled even the
best of architecture anywhere in the European world. Indeed the success of
the Petrine revolution in architecture was such that by 1800 or so Russia had
become, in this respect, an integral part of that world.*

Much the same can be said now for the other visual arts in Russia, thanks
also to the St. Petersburg Academy of Fine Arts, its members, teachers, gradu-
ates, and patrons. By the end of the eighteenth century, at least at the higher
official and social levels, Russian imagery had been utterly transformed, refer-
ring to the techniques and aesthetic or artistic norms of image-making if not
necessarily to content. Russian persons—rulers and grandees most often but
also more ordinary people—were now routinely depicted in European dress
and pose by Russian artists trained in Russia in the new art; and the resulting

Revolution in Architecture, pp. 243 ff.

images or "portraits" (*portrety,* not *persony*) were hung on innumerable official and domestic walls or, in the case of miniatures, were worn about the person or placed atop new-style furniture. Historical pictures painted or engraved by Russian artists in contemporary European modes soon joined the countless portraits, as did landscapes, marine and genre pictures (both watercolors and oil paintings), battle scenes and still-lifes. By 1800 or so the whole range of the "new" or "modern" imagery—in Russian the word (*novyi*) is the same— was more or less ably represented in Russia, with subjects taken either from the standard European repertory or from Russian life, whether past or present (pl. 33).

Equally, the rising official and perforce social status of the new artist (*khu-dozhnik*)—whether an architect (*arkhitektor*), a painter (*zhivopisets*), a sculptor (*skul'ptor*), or an engraver (*gravër*)—was formalized by the St. Petersburg Academy. This much is attested by the Academy's statement of 1768 to Catherine II's Legislative Commission, for instance, which defined as artist/ *khudozhnik* one whose work was "worthy of esteem" and combined "prak-tika" with appropriate "teoriia," such as "painters, sculptors, architects, engravers . . . in a word, all who are distinguished in such arts as require understanding and knowledge of geometry, astronomy, optics, perspective, chemistry, and so on." Furthermore, "None can be called artist but who has testimony of his artistic competence from the Academy of Fine Arts or has acquired sufficient renown for his art and created such benefit that he has been awarded the privilege of artist [*pravo khudozhnika*] by the Government,"[68] the stipulation so worded as to accommodate, no doubt, properly qualified foreign artists who had come to work in Russia.

For a century or more, in sum, the St. Petersburg Academy of Fine Arts was at the center of an enormous expansion of new image-making in Russia. The Academy "directed the entire artistic life of the country in the eighteenth and first half of the nineteenth centuries," in the words of one student; its history, resumes another, "is in large part the history of Russian fine art; almost all the major Russian artists of the eighteenth and nineteenth centuries passed through its school."[69] A. N. Olenin, the Academy's president from 1817 to 1823 and its first historian, proudly calculated that between 1767 and 1827 some 701 artists had been trained there, many of whom completed their studies abroad and produced work which could be compared favorably (Olenin was nicely cautious) with that of "many of their worthy contemporaries in Europe."[70] It was a stunning achievement, the result of an altogether extraordinary convergence of power and taste and the project, ultimately, of one quite extraordinary man.

OFFICIAL IMAGERY

Not much of the visual art produced in Russia under Peter I and his immediate successors—not much of that which has survived for study—was not somehow official in character. This was inevitably the case in an autocratic

system which since well before Peter's reign had exercised a virtual monopoly of image-making; and it would remain so in Russia until well into the nine-teenth century, when alternate sources of patronage, other high-calibre art schools, and a free market in art had fully emerged.[71] By the term "official imagery" here we mean not high art emanating from the Academy or pro-duced on official commission for more or less official purposes, but certain visual representations of its status and power projected in new and expanded forms by Peter and his Imperial successors with a view to enhancing their international prestige and reinforcing their domestic hegemony: symbolic representations of themselves and their state on seals and medals and coins most prominently but also in flags or banners, new knightly orders, and the new noble heraldry. The Imperial elite were the prime consumers or benefici-aries of this imagery although reflections of it can be found, often interest-ingly distorted, in popular culture (Chap. 6). Indeed, we will posit that all of the new imagery in Russia, but especially that which we are designating offi-cial, constituted a vital factor in the cultural unification of the upper ranks of Imperial Russian society: in their coalescence in the eighteenth century into a distinctive Imperial elite with a vision of itself as the cultural, social, and political core of the state. Unfortunately, this focus means that we must omit as tangential any discussion of Imperial projections in porcelain and tapestry, two high-status European arts with a significant visual component that were also industrialized in Russia, again pursuing Petrine initiatives, under Impe-rial sponsorship. Neither porcelain nor tapestry obtained anything like the social impact of the new coinage, say, or the new heraldry.[72]

The most official of official images, in Russia as elsewhere, was the state seal, whose attachment to documents gave the acts they recorded their final sanction and legitimacy. Lacking the fully feudal past of contemporary Euro-pean states, however, and the attendant heraldry, the Muscovite state lacked the appropriate symbolic fund on which to draw in devising figures of itself for use in official European concourse. Living moreover in relative isolation on the northern Eurasian plain, Muscovite rulers with few exceptions—Ivan III at the end of the fifteenth century, Ivan IV in the mid-sixteenth—had little incentive to care. This situation changed rapidly in the course of the seven-teenth century, to be sure, as Russia became increasingly involved in Europe's politics and trade. Yet on the eve of Peter's reign a jumble of Russian state symbols existed, of which the most familiar then as later were the two-headed eagle and the lancer on horseback.[73]

The second of these images undoubtedly originated in the ancient legend, embroidered and widely disseminated in medieval Christendom, of St. George the dragon slayer, patron of princes and soldiers and savior of damsels in distress as well as other innocent victims. In Russia a popular cult grew up around St. George as the valiant protector of folk from all manner of evil, and as such the image was appropriated by the rulers of Moscow to bolster their power. By the sixteenth century the figure of a horseman with lance slaying a

dragon—the horseman evidently thought to represent the ruler himself—had become a central feature of the Russian state *gerb,* a word borrowed about this time from Polish *herb* (ultimately German *Erbe*), perhaps via Ukrainian or Belorussian, and denoting a crest, shield, or escutcheon, arms or a coat of arms. This royal lancer appeared on Russian state seals and coins (themselves descended from both Byzantine and Western prototypes) down to Peter's time; indeed the only coin minted in Russia before Peter, the kopeck (*kopeika*), took its name from the rider's lance (*kop'e*). But while European visitors interpreted the image as a representation of St. George, Russians apparently understood it as a figure of the tsar himself or his successor (see the rider's crown) or simply as a man on horseback (who nevertheless somehow symbolized the Muscovite state). As late as 1709, in the frontispiece to a book published in Moscow to celebrate the Poltava victory, Peter is depicted as an equestrian lancer (a very Roman one now) slaying a dragon representing his vanquished foes (cf. fig. 54).[74]

Peter himself, according to a note in his hand dating to before 1712, had come to believe that the mounted lancer was St. George and that it had served as the *gerb* of the old princes of Vladimir until appropriated by Ivan IV, who positioned it on the breast of his two-headed eagle, now the *gerb* (for the last several decades) of the Muscovite monarchy.[75] In fact, the two symbols were first conjoined as early as 1497, on either side of a pendant wax seal of Ivan III, the first internationally important ruler of the Muscovite state who seems also to have been the first to adopt the two-headed eagle as his royal symbol, this done in imitation probably of the Habsburg emperor in Vienna with whom he had established diplomatic contact and as a way of asserting his equality with the latter as would-be heir to the defunct Byzantine monarchy.[76] In any event, this conjunction of the two images on Muscovite royal seals continued in use for the next two centuries, with the later addition of a third crown suspended between the eagle's two crowned heads, this new crown, like the previous two, unclear in its symbolism but also Western rather than Byzantine, Tatar, or Turkish in style. In the later seventeenth century a scepter and orb were placed in the eagle's claws, further indications of Muscovy's growing contact with Europe, where such symbols of royalty were widespread. We thus can trace in its seals the Muscovite monarchy's tentative assumption, in the decades before Peter, of a European identity.[77]

Under Peter, masters of the Armory Chamber were ordered to "correct" the seals of previous regimes and to make new seals, the tsar himself taking an active role in this renovation of the symbols of Russian state power. Perhaps the most conspicuous of Peter's new emblems was the cross and collar of the Order of St. Andrew the First-Called, founded by him in 1698–1699 in imitation of European knightly orders so as to honor, like them, outstanding service to the state or to the monarch personally. In 1714 Peter founded a second such order for women, that of St. Catherine, named after his wife, its first recepient, and planned a third, that of Alexander Nevskii, named for the me-

dieval warrior-saint and conqueror of "Germans" to honor exceptional military achievement: it was instituted shortly after his death.[78] But the Order of St. Andrew, named for the "first-called" of Christ's apostles and the object of a Byzantine and then a Russian cult (according to which St. Andrew had converted early Russians to Christianity and hence was "the Apostle of the Russian Land"):[79] this remained the highest and most prestigious of the knightly orders founded by Peter and his Imperial successors, and its collar composed of crowned two-headed Russian eagles and pendant badge with St. Andrew impaled on his X-shaped cross became under Peter part of the Russian regalia, appearing on coins and medals and flags and in official book illustrations (fig. 56) and then on the definitive form of the Russian state seal. This seal was designed for Peter by an Italian, Count Francesco Santi, who was appointed in 1722 to "heraldize" the entire Russian state system.

Santi (1683–1758) was born in the Piedmont, raised in Paris, and had served as *Hofmarschall* to the archduke of Hessen-Hamburg before seeking his fortune in St. Petersburg, where he was commissioned in the rank of colonel and assigned to the newly opened office of the master herald (*gerol'dmeister*).[80] The great state seal that he designed for Peter included the two-headed eagle with crowns, St. George slaying the dragon emblazoned on the eagle's chest and, on either wing, the arms of Kiev, Vladimir, Novgorod, Kazan, Astrakhan, and Siberia (historically the foremost dominions of the Muscovite tsardom, its proudest possessions; this was another Petrine innovation): the whole device surrounded by the collar and badge of the Order of St. Andrew the First-Called. This design was then fixed by a Senate decree of 1726.[81] In the 1730s it was engraved by a renowned Swiss medalist invited to work in St. Petersburg, and the resultant great state seal was employed by successive Russian monarchs until the middle of the nineteenth century. The design was also reproduced with variations on countless coins, medals, and lesser seals produced in Russia, making Francesco Santi in effect the codesigner with Peter I of the key symbol of the Russian Empire and its ruler.

But this was scarcely the end of Santi's work in St. Petersburg. His assignment called for him to devise or regularize *gerby* for "all of the kingdoms, principalities, and provinces of the Russian Empire," a project that had in fact begun before his arrival. As early as 1692 Peter had shown concern that the administrative subdivisions of his state should have their own seals for the proper conduct of their affairs, and in 1724 at last a Senate decree generalized this trend: "In all judicial places there are to be seals, namely, in *gubernii* and provinces and towns; those which have *gerby,* engrave these on [seals], and those which do not, draw up something seemly at the Heraldmaster's Office, and then take all these drawings to the Justice College for distribution to all the judicial places."[82] But what were these hundreds of new seals to depict? The Senate's decree and related legislation[83] made it clear that every administrative locale was to have a specific *gerb* with which to seal all judicial papers processed by it, and two sources of appropriate imagery did exist: (1) the

Tituliarnik of 1672, which contained, Polish-style, some few dozen *gerby* of the older town-principalities of the Russian state: typically, round escutcheons bordered with flora depicting for example an iconic Archangel Michael for Kiev, two standing bears with impedimenta for Novgorod, a stag for Rostov, a bear with halberd or pike for Iaroslavl, and so on; and (2) the regimental *gerby* already designed pursuant to Peter's legislation of 1708 dividing his state into eight great governments (*gubernii*), the latter or their subdivisions to support the regiments assigned to them, so that the regiments assumed the names of their localities—a major town, a province, or the *guberniia* itself—with the *gerby* thereof serving as their regimental flags. The Armory Chamber in Moscow had been given charge of this operation and had accordingly drawn up a regimental flag emblem-book (*Znamennii gerbovnik*); it was filled with devices drawn from the old town *gerby* but mostly perforce from that great handbook of 840 European *Symbols and Emblems* printed at Peter's order in Amsterdam in 1705 and thereafter regularly used by his associates in symbolizing their regime (Chap. 4; figs. 48, 49).[84]

Both the *Tituliarnik* of 1672 and the *Znamennii gerbovnik* of 1712 were forwarded to the Heraldmaster's Office in 1722, but Santi alas did not find them very helpful as he set about heraldizing the principal towns of the Russian Empire: too few towns were represented in these sources, he advised Peter, and the *gerby* of those that were needed "correction" in accordance with "the laws of blazonry and the customary European usages."[85] Santi devised a questionnaire to be sent to all local government offices requesting information about the history, names, external appearances, natural settings, and population of their towns and whether there were any *gerby* of which drawings or descriptions could be provided. Replies eventually came in from four *guberniia*, about two dozen provinces, and several towns: few reported any existing *gerby* and those that did not surprisingly were in the newly conquered Baltic territories or the old *Rus'* lands.[86] Nevertheless, Santi and his team managed to create *gerby* from all these sources for 137 provinces and towns (ninety-seven fully completed) before their work was interrupted by Peter's death, with some 220 jurisdictions on their list left to go. For the far northern town of Archangel (*Arkhangel'sk*), for example, they had devised the figure of an archangel in vaguely Classical dress slaying a winged demon; for the Baltic stronghold Shlisselburg (from German *Schlüssel* plus *burg*, or "Key-stronghold"), a key with Imperial crown and fortress; three bows (*luki*) for the town of Velikie Luki, an old woman for the town of Staritsa (literally, "Old Woman"), tools for the industrial town of Tula, and so forth. Santi had sought to give visual expression to Peter's dream of somehow activating a vibrant urban network in Russia, with local citizens proudly displaying their town emblems as so many symbols of their distinctive urban identities. But the vision was only realized, at least at this symbolic level, during the reign of Catherine II, when several hundred urban emblems were devised and established under her German master herald in connection with her local govern-

ment reform of 1775 and her Charter to the Towns of 1785. Indeed the process of *gerbo-tvorshestvo* would continue unabated down to the end of the Empire, reflecting its expansion[87]—an immense proliferation of official imagery such as Peter himself had not perhaps dreamt of.

Santi was promoted after Peter's death by Empress Catherine I to *Ober-tseremoniimeister,* but soon was enmeshed most unluckily in court politics and then banished (1727) to Siberia; he was released in 1742 by Empress Elizabeth and given new rank, though he never resumed his heraldic activities. Even so, in addition to his crucial work for Peter on the Russian state seal and urban emblem projects, Santi had done much to heraldize the Russian nobility, the official-social class usually designated *shliakhetstvo* under Peter (straight from Polish *szlachestwo,* with precedents going back into the seventeenth century) and *dvorianstvo* from 1762 (as in the Manifesto of Peter III of that year abolishing compulsory state service for the nobility). But here we must digress for a moment.

The class in question constituted what one historian terms "the ruling class" of eighteenth-century Russia, a class that he and other historians have meticulously described especially in its political and legal dimensions.[88] The burden of this scholarship, Western and Russian, older and more recent, is that state service defined the Muscovite nobility and gave it whatever "class cohesiveness" it possessed; but that under Peter, as LeDonne puts it, unprecedented mobilization for extended war with attendant reforms and battlefield losses "accelerated the internal integration of the ruling class until its three constituent elements [the higher court or Duma, the Moscow, and the provincial nobilities of pre-Petrine times] could be fused into a single nobility," a "consolidation" of all state servitors that was "ratified" by Peter's Table of Ranks of 1722. We would demur in this formulation only with the term *"ruling class"* and its strict identification with "the nobility." E. V. Anisimov in a vigorous exposition refers to a "solidifying of the noble estate's domination of all spheres of the country's life" under Peter and to its final emergence under Empress Elizabeth "as a cohesive corporation acutely aware of its dominant position [in society at large] and determined to exploit it to maximum benefit"; Anisimov thus prefers the terms "corporation" or "estate" (or the contemporary "corps") to "class" and to describe the nobility's position in society as "dominant [*gospodstvuiushchii*]" rather than "ruling"; indeed, he notes that if in the eighteenth century "there were even noble pretensions to supreme political power," the "significance of this tendency should not be exaggerated, since the regime of absolute monarchy as a whole corresponded to the interests of the nobility."[89] This more flexible, historically sensitive formulation is preferred here.

In fact, in this volume we have referred to "the elite" rather than "the ruling class" or even "the nobility" in order to include among the privileged strata of eighteenth-century Russian society—privileged in the sense of enjoying at least "honorific privileges" and "access rights"[90]—persons who were non-

noble and/or had little or no direct role in running the system (in ruling). Such persons included middling or petty nobles (possessing few if any serfs, landless), lower-ranking officials, most if not all clergy, and the upper and middle layers of townsfolk, who were known formally from 1721 as *grazhdane* of the first or second guild (*gil'di*) and were distinguished as such from the "base [*podlye*]" people at the bottom of urban society.[91] Such persons, while not of the ruling class or even of the nobility, might nevertheless exert influence, even great influence, on the incumbent regime, the ruling elite, or within society more generally. And such indeed were the social origins and status of our newly trained and certified *khudozhniki*, ranked officially as *grazhdane* of the first guild, privileged precisely in their access to the necessary education as well as in their exemption from either military conscription or the soul tax, and influential in their prolific creation and dissemination of the new imagery in all its many forms, including the more strictly official images now being discussed.

Our term "the elite" perhaps also implies, more emphatically than either "the ruling class" or "the nobility," the undoubted if admittedly quite limited upward social mobility that was also characteristic of Petrine and post-Petrine Russia: upward from the "free" or state peasantry into the lower merchantry or clergy or junior officer corps, thence perhaps into the higher merchantry, guards regiments, senior officer corps or upper civil service, and there with luck to acquire, following the Table of Ranks or simply by monarchical decree, hereditary noble status with the right to own serfs. Military service remained by far the most common route from nonnoble to noble status, to be sure; but the nonmilitary careers of any number of court favorites, of clergy and outstanding administrators or industrialists, of men like Lomonosov and our more successful *khudozhniki*, testify to the upward mobility available in eighteenth-century Russian society—if not all the way up to noble serf-owning status in most cases, or in a single generation, then to positions of comparative wealth, considerable honor, and definite influence. Nor can we forget that execution of the Petrine program of intensive Europeanization in Russia obviously depended greatly on such people, meritocrats or *arrivistes* as we might call them—a factor which also explains, simple snobbery aside, the continued success in higher Russian society of foreigners—Europeans—of doubtful social background.

At all events, it cannot be denied that the nobility, however fluid in its boundaries, motley in background, and varied in its wealth and education, constituted the dominant socioeconomic stratum in eighteenth-century Russia (and long thereafter); nor that this was the result, however intended, of a series of measures taken by Peter and his Imperial successors defining and regulating the status of nobles and their dependents and favoring their interests.[92] One such measure, to return to our project, was the granting of coats of arms (*gerby*). We know that Russian knowledge of European state heraldry (viz., the *Tituliarnik* of 1672) dates to the reign of Peter's father, a matter of

Russia's coming-of-age in European diplomacy; equally, that by the 1680s some Muscovite grandees were submitting family *gerby*, invariably Polish-Lithuanian in origin, in support of their claims to inclusion in the official genealogical register (*Rodoslovnaia kniga*) being compiled at the Muscovite government's office of noble-servitor affairs, the *Razriadnyi prikaz*. Indeed, the claims became such a clamor that in 1686–1687 the Ambassadorial Office, with jurisdiction over the conduct of foreign affairs and budding expertise, therefore, in heraldry, compiled for everyone's guidance a book "on the geneology and arms of various leading Russian noble [*shliakhetskikh*] families;" the book unfortunately did not survive for scholars to study.[93] These were further signs quite literally of the creeping and then rampant Europeanization among the uppermost Russian elite at the turn of the seventeenth century: in this case, as in others (noble portraiture, reflecting also dress), of the rapid spread of Polish fashion. And in this as in so many other areas of elite taste and custom (the burgeoning preference for Baroque architecture),* Peter seized control of the matter, regulated and institutionalized it. The nobility of the Russian Empire, like those of the leading European states, would have a fully fledged heraldry (*geral'dika*) with which to distinguish itself from the rest of society.[94]

At first Peter bestowed *diplomy* bearing *gerby* piecemeal on senior officials of his regime who had been granted the title of prince or count by his ally the Holy Roman emperor, in so doing either ratifying or imitating the actions of his Imperial "brother." Then, after the worst of his wars was over and his definitive reform of the state had begun, he entrusted a seasoned factotum, Baron Heinrich Huyssen, with the task of drawing up a detailed protocol for the entire service nobility—mobilized, ravaged, and otherwise imposed upon as it had been over the past twenty years. The Essen-born German nobleman (1666–1739)—multilingual (German, Latin, French, Russian), university-educated (Duisburg, Cologne, Leipzig, Halle), and well-traveled in Europe (Germany, Switzerland, Italy, France, Bohemia, Denmark, Poland)—had begun his Russian service (1702–1732) as tutor to Peter's son and heir, Tsarevich Aleksei, whom he aspired to educate as a modern European prince. He had also served as Peter's representative in Vienna, publicizing the Russian cause, and had advised the tsar on a wide range of administrative, tax, historical, and legal matters:[95] not a bad choice, given Peter's overall program, for the job of assisting him in regularizing his nobility. The legislative fruits of their collaboration, with subordinates, were the acts creating the Office of the Master Herald (January 12, 1722) and the Table of Ranks (January 24, 1722), and the official Instruction (*Instruktsiia*) to the first master herald, Col. Ivan Pleshcheev.[96]

The gist of this legislation was that the Heraldmaster's Office, under the Senate, was to succeed the Razriadnyi Prikaz as the central agency of noble

Revolution in Architecture, chap. 4.

personnel; that, accordingly, "all noblemen [*dvoriane*]" both "high and low, former and present, of military, civil, and court ranks, and their children [sons]," were to register there; that the heraldmaster was to certify their nobility (*shliakhetstvo*) and provide for each family a coat of arms (*gerb*); and that, thus officially identified, noblemen were to be appointed by the Senate to responsible positions throughout the Imperial system (but especially in the armed forces) and their sons assigned to suitable schools in preparation for like service. The heraldmaster's Instruction also stated that since heraldry was a "new business" in Russia, appropriate books "of other states" (Prussia, France, and England are mentioned by name) should be consulted and translated for guidance. Later in 1722 Count Santi was appointed to assist the master herald in devising the hundreds of needed noble *gerby;* his annual salary of 1,600 rubles plus living quarters and a paint allowance of two rubles per *gerb* indicates the importance that Peter attached to this assignment.

Over the next five years or so Santi worked hard to establish, following standard European and essentially French forms (from the reign of Louis XIV), the heraldry of the Russian nobility. The task was scarcely a simple one and was not completed in Santi's time—nor for decades thereafter. Yet by the end of the eighteenth century at least 350 grants of arms to newly titled families—prince, count, baron—had been executed by the Master Herald's Office in St. Petersburg, while the total of noble *gerby* in circulation, flaunted by their possessors on every possible occasion, was in the thousands.[97] Here was visual testimony indeed to the Europeanization, or European aspirations, of the Imperial Russian elite. More, these precious symbols of both noble and European status provide us with unmistakable evidence, such as is not available from before Peter's time, of their holders' group cohesiveness. They offer, with their uniform shields and standard heraldic devices, their mottoes of service and loyalty, their frequent appropriation of the two-headed eagle, so many visual proofs of the noble elite's new consciousness of itself as at once a distinctive and a distinctly superior element in Russian society: as the ongoing embodiment, together with the ruler, of Imperial Russia itself.

The new heraldry found further expression in the countless flags, primarily military flags, which were raised under Peter and which thereafter constituted such a conspicuous manifestation of the Imperial system in Russia.[98] The word itself in Russian—*flag*—was borrowed under Peter from the Dutch *vlag* and/or English "flag" (also German *Flagge*) for use at first in military and naval contexts to replace the older *znamia* or "banner" (itself a sixteenth-century replacement of the still older *stiag*): yet another example of the lexical invasion of Russian occasioned by Peter's program. Pre-Petrine Russian military banners, often huge (from four to twelve square meters) and magnificently sewn, bore almost exclusively religious symbols: icons especially of the Savior, with quotations from Scripture or common prayers. Peter's first known original banner, devised for his newly founded Preobrazhenskii regiment in

1695 and still huge in size (nearly nine square meters), bore a mix of religious and secular emblems: on one side an icon, but on the other the two-headed eagle holding in one claw a sword bearing a biblical inscription in Latin: this device was then made the common figure, often with a Latin motto, of all the regimental flags, uniformly small in size, assigned to his reorganized army. Similarly, in 1701 Peter established *flagi,* wholly European (Dutch and English) in style, for the ships of the three squadrons—the white, the blue, and the red—of his new fleet: the three colors combined on the Dutch model in descending parallel bands—white, blue, red—to form the flag of the fleet itself, which flag, by a decree of 1705, was also to be flown by all Russian commercial vessels (this flag much later became the Russian national flag). Peter also adopted the cross of St. Andrew, blue on a white field, as a naval flag; in time it became the principal flag of the Russian navy. Otherwise, a wide variety of European heraldic devices unknown to traditional Russian iconography—armor, ships, palm branches, swords, crowns, castles, the "all-seeing eye," the figure of Hercules—were attached to naval and especially regimental flags under Peter, until in their uniform colors (especially white, blue, and/or red), standard sizes, Latin and/or secular mottoes, as well as their distinctive images, these symbols of the Russian armed forces, these unifiers and morale boosters, rallying points and identifiers of friend versus foe, had been thoroughly Europeanized, too. A wholly similar development took place of course in the clothing and insignia worn by these forces, as it had in their training and drill.[99]

Medals and coins were still other means by which the Petrine regime disseminated compelling new images of itself among both its subjects and foreign states. This assuredly is not the place to investigate the complex fiscal, financial, or specifically monetary history of Peter's and successive reigns in Russia,[100] but only to register that in numismatic as in so many other matters—in the actual designing and minting of medals and coins—Peter's reign was of decisive importance.[101] The scale of this numismatic revolution is readily gleaned from recently compiled figures relating to the numbers, kinds, and quality of medals and coins produced before Peter's reign as compared with those produced both during and after it.

In Russia before Peter there existed a single mint, in the Moscow Kremlin, controlled naturally by the tsardom, which thus exercised an absolute monopoly of coinage (legal coinage). This mint produced in effect only one coin, the silver kopeck (the copper mintings of 1654–1662 proved disastrous), whose official value was pegged to the German thaler at a ratio of 50:1; the purchase in Russia of thalers, subsequently overstruck and issued as *efimki,* was also a state monopoly. All other Russian coins—the *rubl'* (= 100 kopecks), *poltina* (= fifty kopecks), *polupoltina* (twenty-five kopecks), *grivna* (ten kopecks), *altyn* (three kopecks), and so on—existed only as units of account. Moreover the silver kopeck was crudely made, from recycled silver rolled into a wire that was clipped vertically, the resultant bits then flattened and

struck with a pair of die hammers, stamping the image of a mounted lancer on one side (obverse) of the new coin and the name of the ruler on the other. This coin was also easily counterfeited, with tens, even hundreds of thousands of fake copper or even tin kopecks in circulation at a time. Figures from the 1680s and 1690s indicate that anywhere from 140,000 to over half a million rubles' worth of silver coins (almost all wire kopecks) were legally minted annually, a marked increase over previous decades and evidence of greatly stepped up foreign trade (since Russia produced as yet no silver, it had to be acquired from foreign dealers—where the state again exerted a near monopoly—and from customs duties). Even so, there was still an acute shortage of coin. Russia at the time of Peter's accession was badly in need of a much greater volume of money in various denominations and of a quality that could not be easily counterfeited and was respected abroad. Furthermore, apart from their basic monetary-economic functions (as measures of value, units of exchange, means of payment), as Iukht says, "coins performed a proclamatory role, as a means of propagating specific ideas"—in this case, ideas or indeed images of the Muscovite tsar's power. This was a role for which the tiny, primitive kopeck of pre-Petrine times was poorly suited, especially by comparison with the almighty German thaler.[102]

Effective change seems to date, here as so often in our story, to Peter's Grand Embassy to Europe of 1697–1698. He showed intense interest in local monetary matters and mint operations particularly when in England, at the Royal Mint in the Tower of London, supposedly under the tutelage of its current warden, Isaac Newton. The English government had recently undertaken a massive monetary reform, one which involved the substitution of new, machine-milled coinage for the old hammered stuff; and Peter seems to have been greatly impressed both by the beauty and regularity of the new coins, immune from clipping and much harder to counterfeit, as well as by the prospects they thus afforded for monetary stability.[103] In Moscow very soon after this visit a new mint began producing, in addition to silver wire kopecks, regular circular coins of larger denominations by the new mechanical means. A second new mint was opened in 1699 and began production of round copper *den'gi* (half kopeck) and *polushki* (quarter kopeck) and, from 1704, whole kopecks; a third mint, founded in 1700, produced 30,000 rubles' worth of silver kopecks in its first year; a fourth, created by Peter's decree in 1701, was short-lived, but a fifth, also established in Moscow, in 1701, minted the first silver ruble (1704) as well as other silver, copper, and—also for the first time—gold coins, many by the use of machines. The last of the Petrine mints, located in the Peter-Paul Fortress in St. Petersburg, and fully mechanized, began operations in 1724. Other new features of Peter's regularized coinage—"money" (*moneta*) as it was being called, as distinct from the traditional *den'gi* (a word of Tatar origin)—included dating by year of production and the minting mainly in silver of a full series of denominations—coins worth 3, 5, 10, 25, 50 kopecks—crowned by the ruble, which was made equal in weight (twenty-

eight grams) to the thaler; likewise the new gold coin, the *chervonets*, was made equal in weight and fineness—gold content—to the gold ducat, the standard international coin, and reserved for foreign trade. The fine metal content of the new coinage was not maintained consistently by Peter or by his successors, to be sure, a matter of their perennial shortage of precious metals (gold and silver mines were only gradually established in Russia, in the Urals and Siberia, from Peter's time on) versus their ever-pressing need of funds to wage war and pay for the expanding state; and their periodic devaluations led of course to price inflation. Yet a regular decimalized monetary system, as embodied in an up-to-date coinage minted in unprecedented quantities, had been created. Between 1701 and 1724 anywhere from half a million to 4.5 million rubles' worth of the new silver coins alone were minted annually (much smaller amounts in copper and especially gold), or five to ten times the annual mint totals of immediately pre-Petrine times.[104]

But here we are mainly concerned with the images stamped on these millions of new coins put into circulation by Peter's regime. Early in his monetary reform (1699) he rejected the design by a Russian master at the Armory Chamber of a poltina showing the tsar in traditional Muscovite dress in favor of one by a Dutch master depicting him in profile as a Roman emperor, in laurels and armor and mantle. The first of these pattern coins carried the two-headed eagle on the reverse but a second showed the eagle, thaler-like, on a heraldic shield topped by an elaborate crown and surrounded by the collar and badge of Peter's new Order of St. Andrew the First-Called; it was an altogether more European and up-to-date specimen, and Peter was delighted.[105] A series of foreign masters beginning with Salomon Gouin, specially brought from France in 1701, would design similarly European images for his new coinage, drawing for their figures on the work of fellow foreign artists in Peter's pay—Dannhauer's portraits of the tsar, for example (fig. 65)—as well as on standard European monetary forms. The most notable of the new coinage in this respect was the series of silver rubles designed by Gouin and others and minted in Moscow from 1704 depicting Peter as tsar and then emperor in profile bust in more or less Classical garb (obverse) and, on the reverse, either the two-headed eagle (most often) or a cross formed from four Cyrillic initials "P" (fig. 82).[106] The silver kopecks minted in Peter's time showed the two-headed eagle on the obverse and the work kopeck—*kopeika*—with the mint year on the reverse; Peter's regular copper kopeck retained the mounted lancer of his predecessors, though now with a sort of Classical helmet or cap in place of the traditional crown.[107] In such ways were the newly redesigned Russian state symbols—the mounted lancer and especially the two-headed eagle, with crowns and scepter and orb—disseminated among the broad masses and the new-style image of Peter as tsar-emperor impressed upon the rubled elite.

More elaborate in their symbolism if much less widely dispersed were the medals struck in Russia and abroad to commemorate the major events of

Figure 82 *Tsar Peter Alekseevich, of All Russia Autocrat* (in Russian). New-style silver ruble minted in Moscow, 1720. Obverse (left) and reverse (right).

Peter's reign. In this Peter vastly developed a practice barely begun by his predecessors, one that is to be traced in Europe back to the Renaissance and was most artfully articulated in contemporary France.[108] Fine medals in silver and gold were cast for instance in Holland in 1696 to commemorate Peter's conquest of Azov; in Saxony in 1698 to mark his Grand Embassy; in Nuremberg in 1709 to celebrate his victory at Poltava; and in Paris in 1717 to honor his visit to the mint, all with inscriptions in Latin.[109] In the iconology of Peter's reign, we might note, these medals are variously significant. The obverse of that cast in Holland in 1696, for instance, presents a purely Classical image of Peter as a young "Caesar," while its reverse, symbolizing his victory over the Turks at Azov, was the model no doubt for Peter's only known essay in etching (fig. 24); similarly, that cast in Saxony in 1698 depicts (reverse) a fully plumed knight slaying a monstrous dragon (the conqueror of Azov: cf. fig. 54) and (obverse) a quite Germanic image of the tsar, who had come to visit, the motto reads, "the most civilized parts of Europe [*cultiores Europae regiones*]." The medal cast in Nuremberg in 1709 displays (obverse) a motto from Ovid "They will envy us this honor" above a splendid equestrian Peter in laurels and full armor slaying the Swedish enemy, St. George-like, with his lance (cf. fig. 54): here and in the equally splendid reverse, a figure of Hercules in triumph, with a legend lavishly praising Peter, can be seen the electrifying effect in Europe of his victory at Poltava. The medal cast at the Paris Mint in 1717, in Peter's presence, depicts a fully fledged European ruler in fine Neoclassical style and links him with figures of Fame and, again, St. George: Peter is said to have kept his presentation copy of this medal close to him for the rest of his life.[110] Above all, these medals record in different stages and aspects Peter's acquisition in Europe of a European identity, especially that of heroic military monarch on the model of Louis XIV—who had of course modeled himself on his father, Louis XIII, and on Philip IV of Spain, and who in turn inspired such other royal imitators as Leopold I and Joseph I of the Holy Roman (Austrian)

Figure 83 *By Lightening and Waves the Victor* (in Russian). Reverse of medal struck ca. 1701 in Moscow to commemorate Peter I's conquest of Azov in 1696. Silver, unknown Russian medalist.

Figure 84 *Vicit Fortunae Atque Herculis Aedem (Victorious [Peter] on the Temple of Fortune and Hercules).* Reverse of medal struck in Moscow to commemorate the Russian victory at Poltava, June 29, 1709. Silver, unknown European medalist.

Empire, Philip V of Spain, and Charles II as well as William III—Peter's personal hero—of England.[111] Peter had joined symbolically a highly exclusive club.

But the fifty-eight medals struck in Russia and bearing Russian (sometimes also Latin) inscriptions, albeit often relatively crude in execution, especially at the start, provide better images of the progress of Peter's regime as viewed by itself.[112] The obverse of the medal commemorating the conquest of Azov struck in Moscow in about 1701, for instance, carries a bust portrait of Peter after Kneller with the addition of laurels, and on the reverse emphasizes the role played in the victory by the new Russian artillery and fleet (fig. 83). The medals struck in Moscow from 1702 marking successive Russian victories in the war against Sweden, and designed by both Russian and foreign masters, also exhibit pride in Russia's new martial capacities while often employing full-blown Classical conceits as well as Latin legends (fig. 84). Often we find inscribed on these medals attributions to Peter of titles—emperor, father of his country, the great—that were only years later formally accorded him by his government (1721) and recognized abroad. The obverse of the gold medal engraved by an unknown Russian master to commemorate the Peace of Nystadt (1721) ending the "deluge of the Northern War" shows Noah's ark (Russia) on a wavy sea, a dove flying above with an olive branch grasped in its beak, and a rainbow arcing across the sky to link representations of St. Petersburg and Stockholm: a clear demonstration of Russian (Petrine) feeling about the war and aspirations to the status of European power. Another gold medal, presenting conjoined profile busts of Peter and his wife Catherine (obverse)

struck to honor her coronation in May 1724 and designed by a Russian pupil of Gouin, shows (reverse) Peter in Roman dress crowning in Moscow a curtsying Catherine in stately robes and styles them (obverse legend), in Russian, emperor and empress. Apparently the succession was thus being prepared should Peter suddenly die without adult male issue (as he did, less than a year later). The increasingly European character of these images of Russian royal and then imperial majesty and of Russian military or naval prowess stamped on these medals is remarkable. Likewise, the medal executed by an unknown Russian engraver to mark Peter's death, the obverse portraying a Roman emperor with Petrine features surrounded by the legend in Russian, "Peter the Great All-Russian Emperor and Autocrat," while the reverse shows, as Spasskii says, a complex image of "eternity in the form of a woman with a coiled serpent in hand bearing heavenwards on a cloud Peter I in antique dress. Below, on the seashore, a seated female figure, crowned and wearing imperial robes, personifies Russia; at her feet are attributes of the arts and sciences. The legend reads (above) 'See how/in what condition thou art left' and (below) 'Passed away 28 January 1725.'"[113] Our friend Staehlin reports that Feofan Prokopovich, Peter's favorite prelate and collaborator in church reform, was responsible for this medal and its design; the legend certainly encapsulates the theme of Prokopovich's widely published eulogies of "Peter the Great" delivered at his funeral and on another state occasion later that same year.[114]

These fifty-eight Russian-made medals were issued in anywhere from a few to a few thousand copies, to senior officials or foreign ambassadors or other grandees, or for distribution among victorious Russian troops. Following European custom and Peter's own example, leading Russian nobles established "mint cabinets" to conserve their collections of Russian and foreign medals and coins. But we can be sure, given only their intrinsic value, that the medals as well as the coins struck and circulated in Russia during Peter's reign were treasured by their recipients irrespective of rank. Peter's initiatives in coinage and the issuing of commemorative medals were followed by all of his Imperial successors—by some (Catherine II) more lavishly than by others. Here indeed an iconology of the Russian Imperial system might well begin.

Mapping Russia

We return now to a theme adumbrated in Chapter 1 of this volume, namely the vague cartographical image of Russia that was available before Peter in Europe: it was even vaguer, it may now be said, in Russia itself. There are really two, even three subjects here: European attempts to map Russia—"Muscovy," "Tartary"—before Peter came on the scene; Russian attempts to do so; and the connections, if any, between these efforts.[115]

But first, it should be mentioned that recent work in cartographic history has given us a better appreciation of the unique power of maps over time to

shape human conceptions of space and hence of their political importance as means of codifying and legitimizing as well as actually effecting territorial expansion and control (this refers to geographical maps, not cosmological, the emanations usually of ecclesiastical elites and designed to codify purely religious outlooks).[116] A map presents geographical information in visible form. For historians it also "constitutes a composite of graphic elements that reveals the cultural context of the map's origin." Maps as artifacts can represent "a visual summa of contemporary knowledge, power, and prestige," collected and valued and displayed as such in Europe from the Renaissance onwards; or they may figure in other visual media, as in seventeenth-century Dutch paintings of interiors, where they often function as symbols of political or military power, of science and learning, or of worldliness (*vanitas*).[117] But here we are concerned mainly with the acquisition by Russians under Peter of the actual skills of mapmaking that had evolved in Europe since about 1500, and of the more geographically accurate and comprehensive maps of their country that could be produced thereby. In the Russian case, acquisition of such maps and the skills to produce them were obviously vital to Peter's ambition both to establish his state as a European power and to administer it more effectively. Members of the Russian elite would be able to see their empire as never before, moreover, and Europeans in turn could better visualize Russia, indeed conceptualize it, as a spatial reality.

Bagrow has shown that it was only in the sixteenth century, thanks to budding commercial and political contact, that European maps of Russia were based on any first-hand knowledge of the country, mostly data gathered by Europeans traveling there but also information supplied by the few Russians who ventured west; also, that it was only from the middle of the sixteenth century that scholars and others, utilizing this knowledge, began to participate in making such maps (fig. 85). At the same time, Russian rulers, notably Ivan IV, sought with very limited success to have their own maps made of their realm. The lack of Russians qualified to do so and the unwillingness or inability of invited European experts to undertake the task in Russia largely defeated Russian attempts to "put their land on a map," in the words of a contemporary German source. To the end of the sixteenth century, in Bagrow's summary, "maps of Russian lands were made principally by foreigners, even if the latter at times used material—which may not have been exact—supplied by Russians who resided abroad." The few maps (*chertëzhi*) that Russians made on their own were treated as "state secrets, embracing, moreover, only small special territories."[118]

A Russian cartography did begin to develop in the seventeenth century, when original Russian cartographic knowledge also began to find its way west. Descriptive archival lists compiled in the nineteenth century together with surviving pre-Petrine Russian maps or charts indicate four main areas of Muscovite government concern: (1) to map the tsardom's borders and major fortified centers; (2) to chart newly settled lands or lands into which Russians

Figure 85 *Russiae, Moscoviae et Tartariae Descriptio (Map of Russia, or Muscovy, and Tartary).* Map by Anthony Jenkinson published London, 1562, and frequently thereafter. Jenkinson, a leading merchant-adventurer of London's Russia Company, sea captain, and amateur geographer, made four extended trips between 1557 and 1572 to Russia, where he "won the respect of Ivan IV and was therefore able to visit the court as an honored guest and travel freely through the country" (L. E. Berry and R. O. Crummey, eds., *Rude & Barbarous Kingdom: Russia in the Accounts of Sixteenth-Century English Voyagers* [Madison, WI, 1968], pp. 43 ff.).

were migrating in large numbers, particularly Siberia and Ukraine; (3) to conduct cadastral surveys; and (4) to map both the entire tsardom and its main constituent parts.[119] Mapmaking in pre-Petrine Russia not surprisingly was almost entirely practical and political in purpose[120]—satisfying the immediate needs of the state and landed elite. Yet in meeting these needs seventeenth-century Muscovite cartography retained by contemporary European standards an essentially medieval character, as surviving specimens plainly show. The view of areas large or small is either vertical or oblique, often from a position unobtainable in reality; scale, or the observance of a fixed proportion between distances on the map and distances on the ground, plays no part; any details above ground—buildings, landmarks—are almost always shown pictorially, not in plan, and then are sketched roughly or indicated by means of a single symbol or sign.[121] The Old-Russian word for "map"—*chertëzh*—meant any rough drawing or sketch and was used in various contexts, notably in building; this terminological ambiguity reflected the lack of specialization

as yet among *chertëzhniki,* "draftsmen" as we would say or, on occasion, "map-makers."[122] With two or three negligible exceptions, furthermore, none of the "maps" produced in seventeenth-century Russia was printed, a factor that severely restricted diffusion; most were drawn or copied by hand on cloth or paper (all paper was still imported), some on calfskin or bast (or with sticks on the ground).

Late Muscovite efforts to map Siberia, which have been intensively studied, provide compelling evidence of the medieval state of Russian mapmaking well into Peter's reign, the claims of nationalist Russian historians notwithstanding. Noteworthy here are the well-nigh heroic cartographic and related ethnographic, geographical, historical, and architectural labors of a self-taught Siberian government official, S. U. Remezov (ca. 1642–ca. 1720). In fact, Remezov's prodigious career is in part a tale of deep frustration, as he sought to comply with Moscow's cartographic demands without, as he came to realize, up-to-date European expertise or adequate financial and material support. His dozens of surviving maps or map fragments, both copies and originals, exhibit a jumble of symbols and scales, various oblique and vertical viewpoints, and a methodology based on river systems rather than astronomical points (rivers are first depicted in sequence, without regard to actual distances between them, and then towns and fortified centers are located in rough relation to the rivers). Remezov's maps, however valuable as historical sources, were soon supplanted as maps by those of various Europeans who lived or traveled in Siberia, notably P. J. T. Strahlenberg, a Swedish prisoner of war who resided in Tobolsk from 1711 to 1721 and with whom Remezov probably had some contact.[123]

Indeed, throughout the seventeenth century and on into Peter's time Europeans in their insistent way continued to draw on their own observations and whatever Russian sources they could obtain to produce new or revised maps of the country.[124] Yet by their own best standards Russia continued to be poorly mapped, an overall judgment in which Peter himself fully concurred. The turning point, yet again, seems to have been his Grand Embassy to Europe of 1697–1698 and particularly his time in Amsterdam, where he commissioned what Bagrow has designated the first modern map ever printed in Russian.[125] The map was of southern Russia, the Crimea, and the Black Sea, the location of Peter's current strategic interests and site of his Crimean campaigns of 1695–1696 and resultant conquest of Azov. It was based evidently on sketches and information provided by Peter himself and two of his officers, both of European parentage, Jacob Bruce (Iakov Villimonovich Brius) and Georg Mengden (Georgii Famendin); and it was engraved and printed in Amsterdam in 1699 in a Latin as well as a Russian version by Jan Tessing, to whom Peter in January 1700 formally granted exclusive rights to print "land and sea maps"—literally, "land and sea pictures and drawings [*zemnyia i morskiia kartiny i chertëzhi*]," Peter searching for the right word—along with other graphic works and books on various subjects "in the Slavonic and Latin or

Dutch languages" for sale in Russia.[126] Neither the Russian nor the Latin version of this map was printed in more than a few single sheets, apparently, so neither enjoyed a wide initial circulation.[127] But it marked, as Bagrow put it, "the first step in the break with old cartographic traditions."[128] It also can be seen, looking ahead, as the harbinger in Russia of the typically large-scale topographical map of modern times: carefully graphed and plotted, geographically informed, accurately measured, elegantly decorated (the large cartouche in the Latin version of the Tessing map reproduces a bust of the Kneller portrait of Peter surrounded by new-style figures of rejoicing angels and heralds of victory); as at once an instrument of rule and an advertisement of power (of knowledge as power).[129]

On his return to Russia in 1698 Peter ordered his newly hired graphics master, Adriaan Schoonebeck (Chap. 4), to engrave and print a series of maps and plans from Russian and Dutch originals. Schoonebeck's plan of the siege of Azov (1701) was the first map to be engraved (actually, etched) and printed under Peter, and it "marked the beginning of a highly fertile period of map production" in Russia.[130] We need not recount in detail the ensuing surveying and mapping of the Don River area, the Baltic and Caspian Sea regions, Siberia and northern Russia by a series of foreign officers in Russian service and their local assistants, except to note that the new cartography constantly reflected Peter's strategic plans and expansionist foreign policy as well as his manifest need to boost Russian prestige in Europe, where many of the new maps were actually printed.[131] All this cartographic activity was of course closely associated with the concurrent development under Peter of Russian schools of mathematics, astronomy, navigation, geodesy, and geography, which came to be centered in his Naval Academy and Academy of Sciences, both founded in St. Petersburg.[132] Under the Academy of Sciences, too, special workshops were established and were soon producing the necessary cartographic devices among other scientific and technical instruments of "the finest workmanship, as in England or France, but much cheaper," as the academy reported to the Senate in 1731.[133] We also note that the general European word for map was naturalized in Russian—as *karta*—at this time.[134]

It would take much effort, as Peter well knew, to establish the new cartography in Russia for good. Recruiting enough outside experts to get the business going, training sufficient numbers of native surveyors and cartographers, providing adequate engraving and printing facilities, adequately staffed and supplied with paper: these were formidable obstacles to overcome, especially for a country the size of Russia. Particularly was this so with respect to the natural summit of Peter's cartographic ambitions, achieving a more or less reliable map of his empire as a whole. And here he found help once again in Europe.

During his eventful visit to Paris in 1717 Peter met the distinguished royal cartographer Guillaume Delisle, whose "Carte de Moscovie" of 1706 had circulated quite widely in Europe and thence, in one form or another, in Russia.

Delisle's sources had included, in addition to well-known French and Dutch maps of Russia, information gleaned by his father, a historian, from Peter Postnikov, sometime agent of the tsar in France, and detailed advice given to Delisle personally by A. A. Matveev, Peter's ambassador in Paris (Chaps. 3, 4), to whom the map was dedicated.[135] Peter considered Delisle's map as good as any he had seen; St. Petersburg was mislocated and other points needed correcting, to be sure, but it and two maps Peter had brought with him provided the basis of a lengthy discussion. It was agreed that the tsar's entire realm had to be properly surveyed and mapped—its eastern borders were still unknown!—and that monarch and mapmaker would collaborate in realizing this noble aim. In 1721 Peter sent his librarian, Schumacher, to France with a copy of a new map of the Caspian Sea by a Dutch cartographer, Carl van Verden, which he had commissioned; the map was for the attention of the Paris Academy of Sciences (of which Peter had been elected an honorary member on his visit in 1717) and particularly for the perusal of Delisle, who declared himself, on behalf of the academy and indeed of the entire "République des lettres," very glad to have it. Acting on Peter's instructions, Schumacher invited Delisle's younger brother, Joseph Nicolas, an astronomer who was also a member of the academy, to come to St. Petersburg to help found an observatory. The invitation was renewed by Peter's widow and successor, Empress Catherine, in 1725, and relayed by Ambassador Boris Kurakin in Paris. By March 1726 Joseph and another brother, Louis, also an astronomer and academician, were in the Russian capital. They had thought that apart from their work in astronomy they would facilitate brother Guillaume's cartographical project in Russia, as he had declined to undertake the journey himself. But Guillaume suddenly died; so Joseph took over that project, too.[136]

Meanwhile Peter, late in 1720, in one of those typically grandiose measures of his intensely reformist later years, had ordered some thirty young "geodesists" recently trained at his Naval Academy to leave St. Petersburg for the provinces, there to conduct detailed surveys as soon as possible and to send the resultant *karty* back to the Senate, the supreme administrative organ of the state, which was thus made responsible for mapping Russia. The geodesists were to be paid six rubles a month and otherwise supported by the provincial governments.[137] Sure enough, "cartographic material" soon started coming in, and one of the Senate's senior secretaries, I. K. Kirilov, took personal charge of the matter.[138] This is how he met Joseph Delisle.

Kirilov was another Petrine prodigy.[139] Born in Moscow of clerical parentage in 1695, little else is known of his life and career until 1712, when he began to work in the Senate's Moscow office; in 1715 he was transferred to St. Petersburg, promoted to Senate secretary in 1721 and to Senate *ober-sekretar'* (one of two or three) in 1727. Bagrow found evidence that from as early as 1715 Kirilov was de facto in charge of all mapping activities in Russia, and that he was behind Peter's massive geodesic project of 1720 and the detailed instructions

which the young geodisists were given: "Determine latitude in each city with the aid of a quadrant and then select a road along which to go, crossing various rhumbs, to the district boundary. Measure and record by items [landmarks] how far it is from that city to the first village, and from the first village to the next, and so on, until the boundary of the district is reached. . . . Enter on maps the latitude degrees which you will establish with the quadrant and the longitude degrees from the Canary Islands, as . . . taught to you in the [Naval] Academy. . . . Enter on maps every city, village and hamlet, and river, stating where it rises and into which river it falls; and the lakes, indicating which rivers flow from them; and forests and fields; all in the proper manner of mapdrawing." Bagrow also thought that Kirilov was behind the invitation to Delisle.[140]

The work of surveying and mapping all of Russia including Siberia and coastlands inevitably went slowly, and it was only in 1727, two years after Peter's death, that Kirilov felt ready to propose the compilation of a complete atlas of the Russian Empire, which Empress Catherine so ordered. But he and Delisle were of two minds as to how to proceed. Apparently Delisle insisted on using the most modern, and time-consuming, astronomical methods in preparing the general map of the country that should crown the project, while Kirilov, anxious to get on with the job, was content to draw on existing surveys; in Bagrow's words, "He held that the map could be based on geographical features—rivers, prominent landmarks, etc.—and could be brought into accord with exactly determined astronomical points at a later time." Delisle disagreed, and he and Kirilov went their separate ways. Apart from prodigious labors for the Imperial government on the economy and geography of Russia, and from his continuing supervision of the geodesists surveying the country, Kirilov put together at his own expense an *Atlas composed for the benefit and use of youth and all readers of Newspapers and historical books*, which was published by the academy in 1737. This first atlas of Russia printed in Russian consisted of a general map and some twenty-six local maps, many of which had been printed separately over the previous eight or so years, and was intended as its title indicates to serve as an elementary atlas of Russia; a much shorter version of the work published in 1734 was used by students as a kind of geography textbook for the next half-century. In introductory remarks to his *Atlas* Kirilov invited the reader to look at the general map and "see the vastness of the Empire"; and for all its admitted shortcomings Bagrow found this map more accurate and less cumbersome than any of its predecessors.[141] Kirilov died of pneumonia in April 1737 while on a geodesic expedition to Samara.

Delisle in the meantime proceeded most deliberately with his atlas from his advantageous position as the first professor of astronomy at the St. Petersburg Academy of Sciences, whose responsibilities preoccupied him.[142] In 1727 he was appointed by the academy to coordinate preparations for a general map

of Russia. That same year he dispatched his brother Louis on an expedition to northern Russia to collect detailed astronomical and geographical observations, which he did, filling large notebooks and returning in 1730. In 1733 Louis was sent to Siberia for the same purpose, and in 1740 Joseph himself went on an expedition to the Ob, all the while gathering and sorting his observations.[143] But the academy, impatient with his progress (and goaded by Kirilov), decided against Delisle's wishes to speed up completion of the official atlas. It was finally published by the academy's press in 1745 in Latin, French, German, and two Russian editions (a third Russian edition, also dated 1745, was published in 1760) under the title, *Atlas Rossiiskoi, comprised of 19 special karty representing the All-Russian Empire with borderlands, compiled according to geographical rules and the latest observatsii, with an appended General karta of this great Empire, by the endeavors and labors of the Imperial Academy of Sciences at St. Petersburg.*[144] Delisle returned to France, in something of a huff, in 1747—also frustrated no doubt by his concurrent and equally unavailing attempts, as briefly recounted early in this chapter, to secure the establishment of a proper, French-style academy of fine arts in Russia.

It is hard to exaggerate the importance of the visual conquest of Russia represented by Kirilov's *Atlas* and especially, given its much broader diffusion, by the official academy atlas of 1745. "Now Russian cartography occupied its due place in the European mapmaking field," concluded Bagrow.[145] But it was more, much more than a cartographic achievement of the first rank, the grandest product of the Geography Department of the St. Petersburg Academy of Sciences, which between 1739 and 1765 published some 250 maps of many previously uncharted or vaguely charted areas of Russia and the world.[146] For Russia had been at once mapped more or less in accordance with the best contemporary European standards and "put on the map," in both Russian and European eyes. Kirilov's general map of Russia and especially the academy's of 1745 (which almost immediately underwent correction and improvement) soon appeared in atlases published in such European cartographical centers as Amsterdam, Berlin, London, and Paris. The real "vastness" of the Russian Empire was now plain for all to see, as were its eastern borders (cf. figs. 86, 87). The term "Muscovy" disappeared from cartographic usage—or survived only with reference to the city and province of Moscow. The Urals were herewith proposed, and would rapidly gain acceptance, as the continental boundary between Europe and Asia, with the Russian Empire clearly divided into a European heartland and colonial or semicolonial Asian provinces. A critical question of Russian national identity, and of Europe's as a whole, was being visibly resolved. Maps of Europe made in Europe from the 1750s, incorporating Russian pretensions, now showed Russia—"European Russia"—as an integral part of Europe, a stunning graphic demonstration of the Petrine achievement (we struggle to imagine Turkey, once compared with Muscovy by Europeans, in a similar position). The line between Russia and Europe had faded into geographical insignificance, while that between Eu-

Figure 86 "Mappa Generalis Totius Imperii Russici [General Map of the Entire Russian Empire]," from *Atlas Russicus/Atlas Rossiskoi*, St. Petersburg, 1745.

Figure 87 "Partie Septentrionale de La Russie Européenne [Northern Part of European Russia]" (above) and "Partie Méridionale [Southern Part] de la Russie Européenne" (below), both "after the *Atlas Russien* [of 1745]," from Robert's *Atlas Universel,* Paris, 1757.

rope and Asia had become much less ambiguous, if not perfectly clear.* And so they have remained.

Contemporary European Views

It was noted in earlier chapters that the great collections of artworks or artifacts to be viewed in St. Petersburg in later years were founded by Peter I. These collections—of paintings, sculptures, prints and drawings, medals and coins, etc.—and the buildings in which they were housed and displayed, particularly the Kunstkamera, the Summer Palace, and the palaces at Peterhof, were from the outset the chief repositories of the new art in Russia. Indeed, their protected existence as such and continual expansion after Peter's time constitute enduring proof of his successful establishment of the new imagery in his homeland in its main artistic forms. In the short run, perhaps, the establishment was more successful in the immediately useful arts of architecture, copperplate engraving or etching, and drawing; the new arts of painting and of sculpture took longer to take root, and it was here especially that the St. Petersburg Academy of Fine Arts, envisaged in Peter's time, played such a critical role. So, more generally, did the regime of Catherine II. Immediately after her accession Catherine resumed on a Petrine scale the purchase of artworks in Europe for installation and more or less public display in the Russian Imperial capital, turning her Hermitage, which she had built adjacent to the Winter Palace, into one of Europe's great galleries. All told, one historian argues, with supporting documentation, Catherine was a "wise, consistent, and impressive" patron of the visual arts in her adopted country. Not only thanks to her did the Academy become "the center of Russia's artistic life for a century" and more, but "she inspired in Russian society enthusiastic support of the arts as a matter of noblesse oblige."[147]

Grandees like Menshikov under Peter or Shuvalov under Catherine imitated their sovereigns as collectors of European art for exhibition in their residences, and the Academy of Fine Arts built up impressive teaching collections

*Robert's standard *Atlas Universel* (Paris, 1757) is explicitly indebted to the St. Petersburg Academy *Atlas* of 1745 for its two maps of "la Russie Européene" (introduction, p. 22; maps 21, 22: see our fig. 87); its overall map of the world (map 1) shows Europe, outlined in green, clearly divided from Asia, outlined in red, by a line stretching north roughly from the eastern Black Sea along the lower Don River and the Ural mountains to the Arctic Ocean. Similarly the world map published by the Prussian Royal Academy of Sciences in its *Atlas Geographicus*, ed. L. Euler (Berlin, 1753), with "Europa" including "Russia" in green bordering "Asia" including "Siberia" in mauve (map 1): a prefatory note to this map says that in depicting the "eastern extremities" of the Russian Empire it drew on the St. Petersburg Academy's *Atlas* (p. v); these territorial designations and the Europe/Asia division are then repeated in the map here of Europe (map 6), while the "Map of the Empire of Russia" (map 32) was "taken entirely from the Atlas Russicus recently published by the Imperial Academy of Petersburg" (p. x). Again, the same Europe/Asia division and territorial designations are found in the well-known *Atlas méthodique* published by J. Palairet at London, Amsterdam, Berlin, and The Hague in 1755: here "Muscovy or Russia" with St. Petersburg and Moscow and such provinces as Ingria, Estonia, Livonia, Novgorod, Vologda, and Archangel are shown in maps of Europe (maps 4, 5, 6, 7) and of European Russia (maps 26, 27), while "Siberia or Russian Tartary" is shown as a part of "Grand Tartary" depicted in turn as part—the lion's part—of Asia (maps 8, 9).

owing to their benefactions as well as to those of the rulers, as we've seen. Again following Imperial example, also as already noted, a steadily growing demand for portraits and new-style interior decoration among the elite fueled the steady growth of the new painting; and in both cases Russian artists trained in Russia and sometimes also abroad became the mainstays of the business despite the dazzling successes at court of fancy Italian or French masters. The beginnings of a public market for artworks, focused in St. Petersburg auctions patronized by resident Europeans as well as members of the Russian elite, have been traced to the 1730s, the artworks on sale—paintings especially—the property of various deceased or condemned persons or of departing foreign diplomats. Similarly, the Academy of Sciences from the 1730s and the Academy of Fine Arts from the 1760s regularly sold quantities of inexpensive prints to the public—official portraits, to be sure, but also pictures on historical, Classical, and biblical themes. And by the late eighteenth century art sales were commonly held at the St. Petersburg Bourse both before and after trading sessions. This emergence of a Russian art market is recorded in announcements published by the two academies and in the contemporaneous *St. Petersburg Gazette* (*Vedomosti*), another Petrine foundation.[148]

By the beginning of the nineteenth century a Russian art magazine was regularly published in St. Petersburg. It featured news of art developments—new artworks, new projects—in Russia and abroad, translations of works by the likes of Winckelmann and Raffael Mengs, biographies of famous artists (Raphael, Michelangelo), original essays on such subjects as "The Relation of Ancient and Modern Painting to Poetry" or "The Essence, Aim, and Benefit of the Fine Arts," and a section of criticism—"Kritika"—devoted for example to analysis of a work by Caravagio in the Imperial collections or of the Parthenon at Athens. From its pages we learn that a Society for the Encouragement of Artists was formed in St. Petersburg in 1820 and that by the end of the society's fifth year it had sixty-three patron members who had contributed close to 130,000 rubles for the support of dozens of Russian visual artists, a considerable portion of which money had come from the sale of commissioned artworks.[149]

Yet indisputably the single most important patron and collector of art well into the nineteenth century in Russia, this being Russia, was the monarch, the institutional center and personal embodiment of the Imperial system and hence arbiter and model in this as in all public aspects of the life of society, meaning especially "society" (*obshchestvo*) in the sense of high or elite society. Countless Russians, assuredly most of them members of the elite, viewed Peter's collections of paintings, sculptures, medals, antiquities, and other artworks at his Summer Palace and Garden, in the palaces and grounds of Peterhof, and in his Kunstkamera; but it was a motley, fluid, relatively numerous elite at its broadest who frequented these precincts, we must remember, not just the tiny self-perpetuating elite inherited from Muscovite times. Peter's huge collection of prints and drawings went to the Academy of Sciences at

his death and thence, in parts, to other Imperial institutions (Library, Winter Palace, Academy of Fine Arts), where scholars and artists and their students had ready access to them. Catherine quite deliberately opened the Imperial painting and drawing collections, which she hugely augmented, to inspection and copying by students of the Academy of Fine Arts as a regular part of their training.[150] These collections consisted almost entirely of works by European—Western European—artists of the Renaissance and succeeding periods and styles, a bias that would persist in the Imperial household until the later nineteenth century; and it is impossible to estimate how many aspiring Russian artists and patrons, social climbers and careerists, in the eighteenth century or thereafter, were thus exposed to the new visual art in all of its principal forms. We can say that their numbers must have been enormous: enormous not in proportion to the total population of the Russian Empire, of course, but in relation to the total number of that motley, expansive Imperial elite.

Some quantitative evidence of the size of the Imperial collections in these years is available. Later compilations indicate that Peter I's collection of prints and drawings totaled thousands of items; that there were 200 major paintings in the Kunstkamera alone by the end of the eighteenth century, in addition to the thousands of other artifacts conserved there; that Catherine added more than 5,000 original drawings by European masters to the Imperial collection; that at her death the Imperial collection of paintings, still overwhelmingly Western in provenance and located in the various palaces of St. Petersburg and its environs, numbered 3,996.[151] But for ready *qualitative* measures of these collections we must turn to the writings of knowledgeable European visitors who recorded for readers back home detailed descriptions of the art that they saw. Russia and particularly St. Petersburg were now on the European Grand Tour, and no self-respecting tourist in this age of grand tourism could afford to pass them by. Historically minded as well, in the progressivist Enlightenment way, some of these same visitors first articulated what came to be the master narrative of the Petrine revolution in Russian art. This narrative was anticipated to be sure in texts dating to Peter's own time, most notably in eulogies of the recently dead emperor pronounced by Fontenelle in Paris (Chap. 1) or Prokopovich in St. Petersburg (here above), and was elaborated in the middle decades of the century by Academician Staehlin (Chap. 4). But credit should also be given to the witnesses who first fully advanced it—and thus to close our discussion of the institutionalization of the Petrine visual revolution.

Although incidental observations in the memoirs of Western visitors to Russia of the earlier eighteenth century testify to the ubiquity of the new imagery in the new residences, offices, and academies of the Imperial elite,* it was only later in the century that the more extended and better informed

*Cf. *Revolution in Architecture,* chap. 7.

commentaries of European grand tourists began to appear. William Coxe, for instance, the well-traveled English scholar who toured Russia in 1778–1779 and again in 1784, left a voluminous account of his experiences that was published in six successive English editions between then and 1803 (it also appeared in French and German editions and was later translated into Russian). Two leading themes of Coxe's account are (1) the extent to which Russia, that is, St. Petersburg, had become a major repository of European visual art; and (2) the extent to which traditional painting in Russia, particularly Moscow and Novgorod, recalled that of pre-Renaissance Italy—and elicited accordingly a "medieval" response from the local folk.[152]

As Coxe said:

> The places of divine worship at Moscow are exceedingly numerous. . . .
> In the body of the [typical] church are frequently four square and massive piers, which support the cupola: these piers, as well as the walls and cielings [sic], are painted with numerous representations of our Saviour, the Virgin Mary, and different saints. Many of the figures are enormously large, and executed in the rudest manner; some are daubed upon the bare walls, others [embossed] upon large massive plates of silver or brass, or enclosed in frames of those metals. The head of each figure is invariably decked with a glory [halo or nimbus with crown], which is a massive semicircle resembling an horse-shoe, of brass, silver, or gold, and sometimes composed almost entirely of pearls and precious stones. Some of the favorite saints are adorned with silken drapery fastened to the walls and studded with jewels; some are painted upon a gold ground and others are wholly gilded but the face and hands.

These "representations" were hardly paintings at all, in Coxe's view, but rather "rude" works of display or decorative art that were also objects of worship:

> It is contrary to the tenets of the Greek religion to admit a carved image within the churches, in conformity to the prohibition of Scripture, "Thou shalt not make to thyself a graven image," etc. By not considering the prohibition as extending to representations by painting, the Greek canonists, while they follow the letter, depart from the spirit of the commandment, which positively forbids us to worship the likeness of any thing under whatever form or in whatever manner it may be delineated. Over the door of each church [in Moscow] is the portrait of the patron saint, to which the common people pay homage as they pass by taking off their hats, crossing themselves, and occasionally touching the ground with their heads; a ceremony which I often saw them repeat nine or ten times in succession.[153]

The spirit of Protestant iconoclasm obviously informs this passage from Coxe, which recalls in essence remarks made by European and especially Protestant visitors to Russia going back to the sixteenth century (Chap. 2). But the Rev. Dr. Coxe, a graduate of Cambridge University ordained in the Anglican

church, had more to say on the subject, as in his description of the Dormition cathedral in the Kremlin, where he saw the *Vladimir Mother of God* (pl. 1):

> Many of the painted figures which cover the walls are of a colossal size, and were executed as early as the close of the sixteenth century. This church also contains a head of the Virgin supposed to have been painted by St. Luke, and greatly celebrated in this country for the power of working miracles. The face is almost black; the head is ornamented with a glory of precious stones, and the hands and body are gilded, which gives it a grotesque appearance. It is placed in the skreen [iconostasis] and enclosed within a silver case, which is never removed but on great festivals or to gratify the curiosity of strangers. This Madonna, according to the tradition of the [Russian] church, was brought from Greece to Kiof [Kiev], transferred from thence to Volodimir [Vladimir], and afterwards to Moscow. It seems to have been a Grecian painting, and was probably anterior to the revival of the art in Italy.

Coxe notes that he had seen "several representations of the Virgin in the north of Italy similar to this painting: some were called the productions of St. Luke, others of Cimabue or his pupils."[154] He was of course referring, here as just above, to the dawn of the Renaissance in art as narrated by Vasari (Chap. 1; figs. 1, 2).

In old Novgorod Coxe inspected the medieval cathedral of St. Sophia, whose piers and walls were also

> thickly covered with representations of our Saviour, the Virgin Mary, and of various saints. Some of these paintings are of very high antiquity, and probably anterior to the revival of the art in Italy. Many of the figures are finished in a hard flat style of colouring upon a gold ground, and exactly similar to those of the Greek artists by whom, according to Vasari, painting was first introduced into Italy.

Coxe then retells Vasari's account of the Renaissance, which he thus links to the history of art in Russia. In his words:

> Towards the latter end of the thirteenth century, some Greek artists invited to Florence painted a chapel in the church of Santa Maria Novella. Although their design and colouring were hard and flat, and they chiefly represented the figures in a field of gold, yet their productions were much admired in that ignorant century. Cimabue, who was then a boy, struck with their performance, was accustomed to pass all the time he could steal from school in contemplating the progress of their work. His enthusiasm being thus kindled, he turned his whole attention to the study of an art to which his genius seemed inclined. His first compositions had all the defects of the masters whom he imitated; but he gradually improved as he advanced, and laid the first rude foundations of that astonishing excellence which the schools of Italy afterwards attained.

Coxe seemingly had decided that at least some of the icons to be seen in the cathedral of Novgorod were of considerable historical interest, as illustrating

the "introduction of painting into this country."[155] He also seems to have thought that in Italy as opposed to Russia it was only the accident of Cimabue's genius that had propelled painting from the restrictions of the Byzantine tradition to the "astonishing excellence" of the Renaissance. He perhaps did not know that most of the murals and panel icons he saw in the churches of Moscow, Novgorod, and elsewhere on his Russian tour did not date from "high antiquity" or even "the close of the sixteenth century" but were painted or repainted in the seventeenth, indeed also the eighteenth (his own), centuries. To be sure, Coxe could not have dated icons observed in Russia with any precision because their careful study and dating by the learned of Russia itself, as we've noted, only began in the later nineteenth century. Yet dated or undated, Coxe plainly implied, painting in Russia had long stagnated, a perpetual "rude daubing" that had awaited the Petrine "revival." That revival, in so many words, was Russia's Renaissance.

Thus the interior paintings of the church of Sts. Peter and Paul in St. Petersburg, the central monument of Peter's architectural revolution, struck Coxe as entirely "more elegant and less gaudy than those in the churches of Novgorod and Moscow," executed as the former were "in the modern style of the Italian school."[156] He referred with evident satisfaction to murals on biblical themes painted in 1728–1731 with his Russian assistants by the Swiss artist Georg Xsel, hired by Peter in Amsterdam in 1717, murals that were very much in the contemporary "Italian" manner (Chap. 4).[157] Coxe was however much less interested in church art in St. Petersburg than he was in the holdings of the Imperial "cabinet of pictures" housed in the new "Hermitage" adjoining the Winter Palace. Among the hundreds of items on view, purchased in the main by Peter and Catherine II, Coxe singled out "several by Teniers, and a Christ bearing the cross by Ludovicio Caracci"; a "Holy family by Watteau" and "an Ecce Homo by Caravagio"; "several landscapes by the Dutch masters" and "some excellent paintings by Rubens and Van Dyke"; "two by Ferdinand Bol," "several by Rembrandt, in his strong but uncouth manner, and two lovely groups of children's heads, in the character of angels, by the inimitable Corregio." Coxe also saw "three capital pictures by Raphael" in the Hermitage collection as well as others painted by Titian and Veronese; "several fine landscapes by Claude Lorraine" and two by Poussin, "that poetical painter"; "celebrated" works by Salvator Rosa and a few by Battori and Mengs (1728–1779), "with whom the genius of the Roman school seems to have expired." It was a collection at once "magnificent" and "superb" in Coxe's estimation, and altogether exemplary of the best of modern European art. It did not contain as yet a single picture by a Russian artist; not one that Coxe noticed.[158]

Among other artworks to be found in St. Petersburg, Coxe was particularly struck by the Falconet-Collot equestrian statue of Peter, "cast at the expense of Catherine II in honour of her great predecessor, whom she reveres and imitates" (fig. 79).[159] The monument had only recently (1782) been formally dedicated "To Peter the First from Catherine the Second," as its inscription

reads, in both Latin and Russian. In his evidently awestruck admiration of the *Bronze Horseman* and what it symbolized, Coxe anticipated the reaction of both Russian and foreign observers for generations to come.

Indeed, the visual transformations of Russia effected by the Petrine revolution in the century after Peter's death invariably evoked applause from the numerous European visitors who have left us written accounts.[160] For our purposes the single best of them all is by Robert Ker Porter, a graduate of the school of the Royal Academy in London, where he had studied under Benjamin West, who was famous by the 1790s for his huge history paintings of the British in India. Ker Porter had been invited to St. Petersburg by Catherine II's grandson, Emperor Alexander I, to paint depictions of the victories of Peter the Great for display in the grand new building projected to house one of Peter's favorite foundations, the Admiralty. He arrived in September 1805 and remained in Russia for more than two years. His account of his stay took the form of a series of highly detailed letters to a close friend in England, apparently also a person much interested in the visual arts. These "sketches," filling a large volume, were promptly published (London and Philadelphia, 1809); at least two of Ker Porter's Admiralty paintings also survive, in the Central Naval Museum in St. Petersburg. In 1811 he returned to Russia, married Princess M. F. Shcherbatova, and settled down to a long and apparently happy life among the Imperial elite. He died in St. Petersburg in 1842.[161]

Ker Porter was remarkably well-informed about the progress of the new art in Russia from Peter I's time, whom he specially researched in connection with his commission from Emperor Alexander.

> The founder of this great empire was the first in the country who introduced a love of pictures. . . . I am told that it was in Holland and France that Peter the Great imbibed his taste for painting. . . . His favourite painters were of the Flemish school, particularly those who excelled in naval subjects. . . . Adam Silo, being not only an artist but an old seaman, delighted [Peter] much by the exactness with which he depicted the ocean and its warlike scenes. Many of Silo's pictures may be seen in the Summer Palace at St. Petersburg; and for accuracy in the shipping, and spirit in the sea-fights, I never saw him excelled.

Further, Ker Porter learned,

> It was at the palace of Peterhof that Peter framed the first general gallery of pictures that was known in Russia. The paintings were chosen and arranged by one Xsel, an artist who had followed the emperor from Holland, and who died painter to the empire about sixty years ago. He was more celebrated for judgment than for genius, being little more than a copier of still life; but though as an artist he was insignificant, as a candid and liberal *connoisseur* he was of the first respectability.

And it was "from this great monarch's collection [that] the present admirable collection at the Hermitage has arisen."[162]

In the picture galleries of the Hermitage, Ker Porter continued, "I pass many hours in culling the flowers from this wilderness of sweets; and I see enough to convince me that were it weeded with judgment, a collection might then be drawn together which would be unrivalled in any nation." Obviously the "weeding" he had in mind consisted of correcting doubtful or erroneous attributions and of eliminating what he judged to be, in such a collection, inferior works of art. His further remarks on the Hermitage's paintings echo or amplify those of Coxe in some respects, in others they reflect the continuing evolution of European taste, and in either case they need not be repeated here. Far more interesting, for their rarity as well as acuity, are Ker Porter's comments on sculpture in St. Petersburg and on the St. Petersburg Academy of Fine Arts, which he could readily compare with the analogous institution in London of which he was a graduate.

Prince Potemkin, Catherine II's great favorite, had formed a sizable collection of sculpture in his St. Petersburg residence, the Taurida Palace, which had been built between 1783 and 1789 under the Russian architect I. E. Starov (1744–1808), a graduate of the St. Petersburg Academy (1762) who had gone on to study in Italy (to 1768). The palace was to commemorate Potemkin's conquest of the Crimea ("Taurida"); it remains by any reckoning one of the architectural masterpieces of the city and another great monument to the Petrine revolution.[163] Ker Porter toured this "noble mansion" with a constant eye to the sculpture on display, which included "some of the finest specimens of antiquity which have been preserved," most prominently the *Venus of Taurida* (as it was now called) that Peter had acquired from agents of the pope (fig. 70). He was simply amazed:

> The Venus de Medici [in Rome], the standard of perfection in female form, does not, in many points (if I dare make this assertion!), surpass this of the Taurida . . . ; so much refined and natural beauty I never before gazed upon. The body is that of the most perfect outline of a lovely woman: its gradual stealing undulations impart such enchantment to the eye in dwelling on its forms that it is only the want of colour which dissolves the illusion, and reminds you that it does not exist. So far it excels the Venus de Medici; and as a whole is certainly the most pleasing; but . . . do not fancy from this comparison that the Venus [de Medici] is fallen in my esteem. Far from it; I do not think her less beautiful, though I may consider her rival more so. . . . Perhaps it will support my opinion when I tell you that Mr. Martauze [Martos], the justly celebrated Russian sculptor, regards this statue [the *Taurida Venus*] with an admiration equally enthusiastic as my own.* However, your eyes shall be your own judge, as I intend to bring a cast of it to England and present it to the Royal Academy.[164]

*Ker Porter refers to I. P. Martos (1754–1835), another graduate of the St. Petersburg Academy and the first native Russian artist to achieve a European reputation—a fact Ker Porter here confirms.

Ker Porter describes the other "classic treasures of Russia" to be seen in the Taurida Palace as well as the great building itself:

> Before you enter the hall or gallery of the palace, you pass through a saloon of great magnitude which is supported by immense white pillars and ornamented with candelabrums, sarcophaguses, busts, vases, and other decorations of the classic ages. . . . On leaving this enormous vestibule, the hall opens at once upon the eye, and excites an emotion which must be felt to be imagined; to describe it is beyond my powers. . . . A double range of Ionic columns rise like a forest on either side; and when you look up to their capitals, the height is so great as almost to pain the eye. . . . Between the pillars are placed statues, most of them modern and of indifferent merit. Some fine imitations of the Barbarini [Classical vase preserved in the Roman palace of that name] and other celebrated vases are mixed with them; and at each end of the gallery, at some distance from the wall, are two excellent copies of the Laocoon and Cleopatra [famous Classical statues also preserved in Rome].[165]

The intense enthusiasm animating Ker Porter's account of sculpture in the Taurida Palace also enlivens his description of the Imperial Academy of Fine Arts, one of St. Petersburg's "proudest ornaments."* Again,

> The first idea of such a foundation was projected by the father of his country, the immortal Peter the Great. The Empress Elizabeth made many advances towards the fulfilment of his plan, but . . . the present extensive scale of the institution [by now the largest in Europe] was designed and executed by the patriotic mind of the great Catherine.

Ker Porter outlines the academy's "establishment," including "six professors of painting, sculpture, and architecture, each with an assistant," followed by "an adequate number of professors of perspective, anatomy, geography, history, mythology, and iconology; and a number, unlimited, of academicians, admitting artists of all nations to that honour." He found much to praise in the organization of the Academy's school or "college," and something to criticize, especially an excess of discipline, certain shortcomings of the teachers, and a puzzling failure among both teachers and students to avail themselves sufficiently of the "invaluable saloons of the Hermitage, ever open to [them]; there they may study from morning until night, imbibing from the sublime works of Michael Angelo and Raphael, the very fountain of taste and improvement." Still, the St. Petersburg Academy could lay claim to a special greatness: "Must we not pause to admire so excellent a plan! How broad are the views on which it is founded! Not merely to teach youth to be artists, but to be men, to be useful citizens, to bless the country in which they were born, and to spread her glory with their own fame! . . . Nothing little, or contracted, is found in this munificent establishment!"

*Cf. *Revolution in Architecture,* pp. 245–249, figs. 122*A–B;* pl. 83.

Figure 88 O. A. Kiprensky (1782–1836), *The Wounded Great Prince Dimitrii Donskoi Receives News of the Russian Victory over the Tatars [at Kulikogo pole, 1380].* Engraving of 1805 by the student Petrov after Kiprensky's painting in oil on canvas, which painting won the gold medal in the history class of the St. Petersburg Academy of Fine Arts' student competition of September 1805.

The Academy's system of examinations drew Ker Porter's particular praise:

> From the report of the masters, and specimens of the young people's efforts in the different departments of their study, a register is made of their conduct and abilities; and they are accordingly either praised for assiduity or reprimanded for neglect. Rewards are distributed in the form of prints, etc. Having passed from the college into the Academy of Fine Arts (which is considered the last stage of their education), they are then carefully examined once every month, and their progress duly entered in the records. As an incitement to emulation, medals of silver and gold are distributed of various sizes and weights, according to the merit of the candidates [fig. 88]. When the whole of their education, both in the college and in the Academy, is completed, the assembly, or council, honours them with the gift of a sword accompanied with an attestation of their freedom; in virtue of which they are authorized to exercise their profession wherever they may deem it proper.

Ker Porter also took notice of the Petrine tradition of *pensionerstvo*, now firmly established at the Academy, which he naturally also praised:

> This foundation, like our own [the Royal Academy in London], sends a certain number of artists to study in those countries which we regard as the native seat of the arts. The term of their election is every three years.

Twelve is the number selected; and they are chosen out of the students who have already been distinguished with medals. When abroad, they keep a journal, and every four months send the Academy a regular account of their progress and occupations. At the expiration of a stated time they send to St. Petersburg specimens of their improvement, either a design of their own or some excellent copy of a statue, picture, or building; after which money is sent to enable them to return. From that period they cease to be pensioners of the Academy, and are eligible to become members or professors in the institution.[166]

The unusual breadth of the St. Petersburg Academy's educational program was noted earlier in this chapter and this feature, too, caught Ker Porter's eye. He was assured that for all graduates of the Academy's schools who failed to pass muster in one of the three "finest arts," positions were found "under respectable tradesmen and artisans." So "to give you a just idea of the magnitude of this institution, you must remember that it embraces in the fullest extent the several arts"—meaning not only architecture, sculpture, and painting but "casting in bronze, medals, and engraving in every branch, including gems." From this one could readily imagine the wealth of the Academy's resources, for

the finest models and drawings of every celebrated architectural relic are here to be found. Casts of the most admired statues of antiquity are placed in large saloons; and for pictures, the precious gallery of the Hermitage is open to their study. A handsome chapel for the devotions of the students is in the interior of the edifice, as is a well-furnished and extensive library. Nothing is omitted as too minute which can promote their improvement or awaken the virtuous ambition of talents deserving distinction.

Ker Porter's reservations regarding the current quality of the Academy's instruction in painting, his own specialty, were mentioned above, and he returns to the point in his concluding remarks on the "growing state of the arts" in Russia:

At present I can only pronounce with any certainty upon sculpture and architecture, and they appear to be in a very promising state. The little that I have seen of the students in painting gives me an opposite impression; and that, when we consider the institutions of their Academy, is rather inexplicable.

In fact, Ker Porter went on to blame the current professors of painting for this assuredly temporary state of affairs, and especially for failing themselves to provide "excellent pictures" for their students to emulate—for neglecting even to send them regularly across the river to the Hermitage to study the numerous masterworks displayed there. But "no one who looks around this superb city will say that architecture is in its infancy," and sculpture "seems to me to have been even more rapid in her advances." Here Ker Porter named

Martos again, who "might be regarded with honour by any nation." Indeed, "I must say that, distinguished as similar talents are in England, we have not a superior sculptor to Mr. Martauze."[167] What more could he have said? What greater praise?

We leave Ker Porter in Moscow, where he was as laconic and negative in his appraisal of traditional Russian painting as Dr. Coxe had been some twenty years before, if not more so. Ker Porter viewed this art as both primitive and alien—either "gothic" or "Asiatic." The interiors of Muscovite churches were "embellished with gothic ornaments, and pictures imitated from Albert Durer in a style not likely to rescue the fame of the Russian artists"[168]—a shrewd reference perhaps to the influence of sixteenth-century European graphic material on seventeenth-century and later Russian religious painting (Chap. 3). In its advance beyond St. Petersburg, Ker Porter (and Coxe, and all other contemporary European commentators) seemed to be saying, the Petrine revolution had not transformed Russian church art: not fully, not yet. Nor would that ever happen, in fact, a point that we'll take up in our concluding chapter.

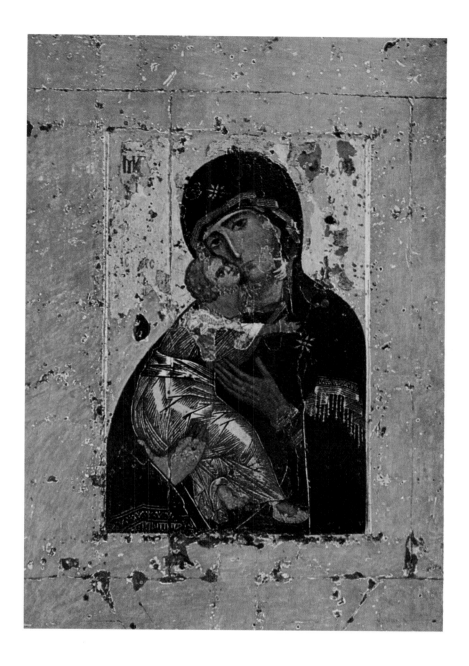

Plate 1 *Mother of God of Vladimir*, Constantinople, ca. 1100. Tempera on panel. The icon was brought to Vladimir, northeast of Moscow, by 1155, thence to Moscow in 1395, where it was installed in the Kremlin Dormition cathedral. Faces of Mother and child original; extensive repainting in the rest of the work.

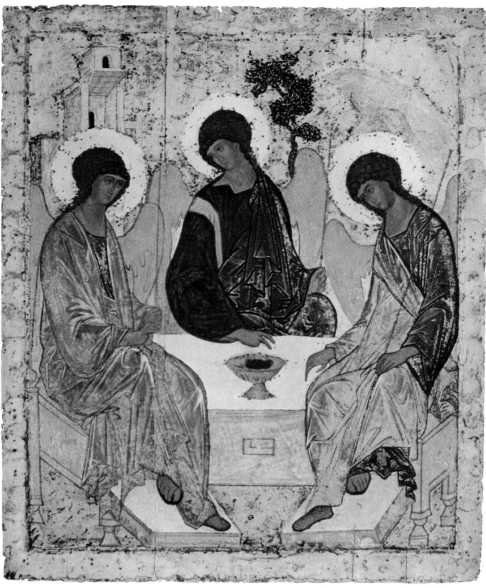

Plate 2 Andrei Rublëv, *Old Testament Trinity*, early fifteenth century (1422–1427[?]). Tempera on panel. The scene is an illustration of Genesis 18:1–15, describing how God appeared to Abraham by the "oaks of Mamre" in the form of three men (or angels), to whom Abraham and his wife, Sarah (not shown here), provided refreshment. In Byzantium the three men were taken to symbolize the Trinity as finally revealed by Jesus Christ, and the iconography of the "Hospitality of Abraham" was established already in early Christian times. The iconographic type on which Rublev draws here was most probably formulated in Constantinople in the Paleologan period: cf. M. Acheimastou-Potamianou, *Holy Image . . .* (Athens, 1988), pp. 220–221 (note by D. Mouriki) and pl. 64 (Byzantine icon of "The Hospitality of Abraham," fifteenth century, Byzantine Museum, Athens).

Plate 3 Andrei Rublëv, *The Savior,* early fifteenth century. Tempera on panel.

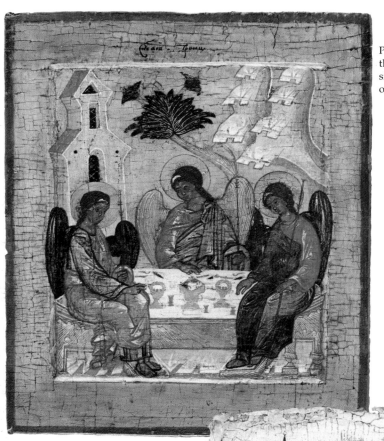

Plate 4 Russian icons of
the Old Testament Trinity,
sixteenth century. Tempera
on panel. Cf. pl. 2.

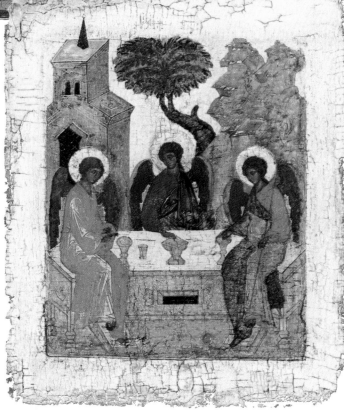

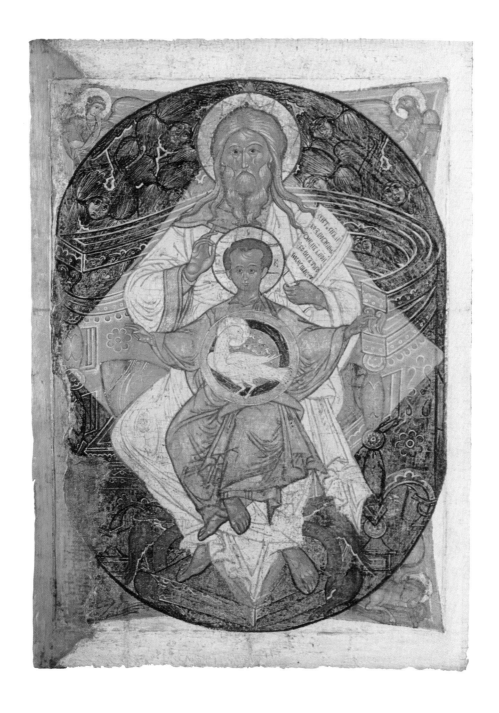

Plate 5 New-style icon of the *Trinity,* showing God the Father as the "Ancient of Days" and the Holy Spirit in the form of a dove. Moscow(?), late sixteenth-early seventeenth century. Tempera on panel.

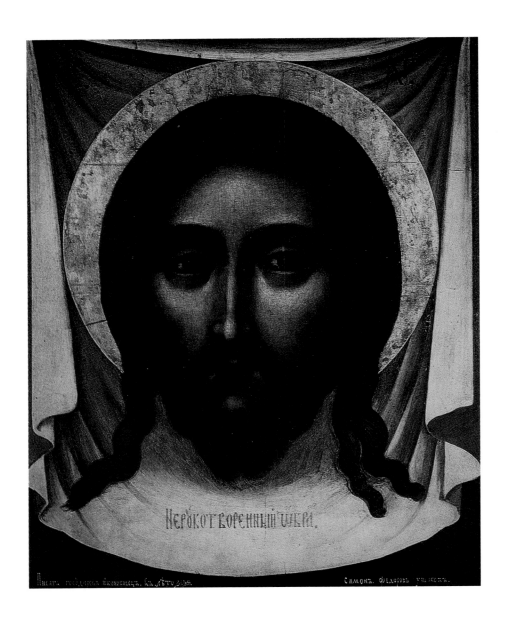

Plate 6 Simon Ushakov, *The Savior Not Made with Hands (Nerukotvornyi)*, 1658. Tempera on panel. GTG, from the church of the Trinity in Nikitniki, Moscow.

Plate 7 Portrait of Tsar Aleksei Mikhailovich (father of Peter I), 1670s. Oil on canvas, artist unknown. Formerly in the collection of Prince B. A Kurakin, now at GIM. Inscription in Cyrillic reads: "Image/Icon [*Obraz*] of the Great Lord Tsar and Great Prince Aleksei Mikhailovich of All Great and Little and White [*Belo-*] Russia Autocrat."

Plate 8 Simon Ushakov, *Old Testament Trinity*, 1671. Tempera on panel.

Plate 9 Simon Ushakov, *Kition [Kikskaia] Mother of God*, 1668. Tempera on panel. Detail.

Plate 10 Simon Ushakov, *Vladimir Mother of God and Tree of the Muscovite State*, 1668. Tempera on panel. The icon depicts, around the image of the Mother of God of Vladimir (cf. pl. 1), the saints and rulers prominent in the state's history, with the current ruler, Tsar Aleksei and his family (first wife), standing behind the Kremlin walls at bottom.

Plate 11 Fragment of mural illustrating career of St. Philip (Acts 8:26–38), 1685. Church of the Trinity, Ipatevskii monastery, Kostroma. Cf. figs. 12, 13.

Plate 12 Moscow (Court) School, *Christ Carrying the Cross*, end of seventeenth century. Tempera and oil on panel. Cf. Briusova, *Russkaia zhivopis' 17 veka*, pl. 33.

Plate 13 Ivan Bezmin(?), *Tsar Fedor Alekseevich* (half-brother of Peter I), 1680s. Tempera on panel. As Fedor died in 1682, this is perhaps a posthumous "portrait." Cf. Briusova, *Russkaia zhivopis' 17 veka*, pl. 36.

Plate 14 Moscow (Court) School, *The Last Supper*, 1695. Tempera on panel.

Plate 15 Fëdor Zubov et al., *St. Sophia*, 1685. Detail of mural in the main church of the Novodevichii convent, Moscow.

Plate 16 Funerary "portrait" of Prince M. V. Skopin-Shuiskii, early seventeenth century (1620–1630s), Moscow. Tempera on panel.

Plate 17 Kirill Ulanov, *Christ Pantokrator,* 1728. Tempera on panel.

Plate 18 *Tsaritsa Natal'ia Kirillovna* (mother of Peter I), 1680s. Oil on canvas, artist unknown.

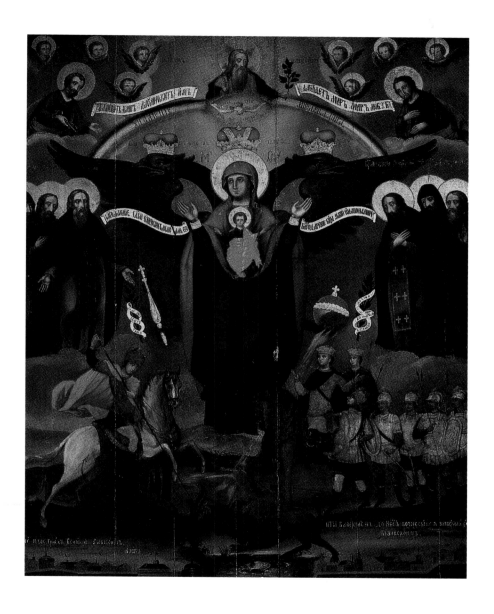

Plate 19 *Mother of God of Azov,* Moscow (Court) School, ca. 1700. Tempera and oil on panel.

Plate 20 I. Nikitin, *Baron S. G. Stroganov*, 1726. Oil on canvas, signed. This is the youngest son (here age nineteen) of the merchant-industrialist G. D. Stroganov, a strong supporter of Peter I, who made him a baron; this younger Baron Stroganov went on to form one of the best collections of paintings of the time in Russia.

Plate 21 A. Matveev, *Self-Portrait with Wife,* 1729. Oil on canvas.

Plate 22 G. N. Teplov (1711–1779), *Still Life*, 1737. Oil on canvas, signed and dated. The printed page (top center, off shelf) indicates that the work was painted at the St. Petersburg Academy of Sciences.

Plate 23 A. G. Ovsov, *Peter II*, 1727.
Miniature in oil on enamel in gold
frame, signed and dated.

Plate 24 *A. D. Menshikov*, 1710s.
Miniature in oil on enamel in gold
frame, artist unknown.

Plate 25 A. P. Losenko, *Portrait of I. I. Shuvalov,* ca. 1760. Oil on canvas. The portrait is of Shuvalov as first president of the St. Petersburg Academy of Fine Arts, where it remained until 1923, when it was transferred to the Russian Museum. GRM.

Plate 26 A. P. Losenko, *Vladimir and Rogneda*, 1770. Oil on canvas.

Plate 27 A. P. Antropov, *Portrait of M. A. Ruminatseva*, 1764. Oil on canvas.

Plate 28 I. I. Vishniakov, portraits of S. S. Iakovleva (left) and M. S. Iakovlev (below), ca. 1756. Oil on canvas.

Plate 29 M. L. Kolokol'nikov (died 1758), *Portrait of Prince Lt.-Col. I. T. Meshcherskii*, 1756. Oil on canvas. Tver' Regional Picture Gallery.

Plate 30 *Portrait of an Unknown Woman,* second half of eighteenth century. Oil on canvas. Novgorod Museum of History, Art, and Architecture. The painting has been attributed to F. S. Rokotov (1735/36–1808). Cf. Iamshchikov, *Russkii portret,* p. 102.

Plate 31 G. Ostrovskii, *Portrait of E. P. Cherevina,* age twelve, 1773. Oil on canvas. Kostroma Regional Art Museum.

Plate 32 *Portrait of the Merchant V. G. Kusov,* 1772. Oil on canvas. Artist unknown.

Plate 33 F. Ia. Alekseev (1753/54–1824), *View of the Winter Palace Embankment, St. Petersburg*, 1790s. Oil on canvas. Alekseev was deeply influenced by the prominent French landscapest and pioneer of the cityscape, Hubert Robert (1733–1808), whose works were avidly collected by Catherine II, Emperors Paul and Alexander I, and innumberable Russian grandees (cf. L. Réau, "L'Oeuvre d'Hubert Robert en Russie," *Gazette des Beaux-Arts,* ser. 4, 11 (1914), pp. 173–88).

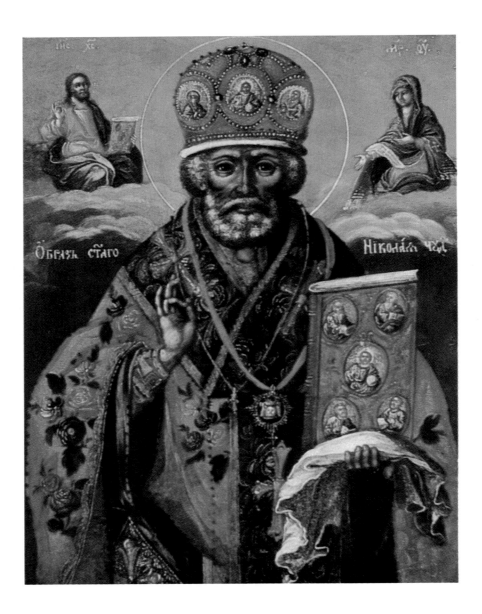

Plate 34 *St. Nicholas the Miracleworker.* Russian, eighteenth century. Tempera on panel.

6
Conclusion

The first two chapters of this volume argued that Russia before Peter could not have spontaneously undergone either a renaissance in imagery or a print revolution owing to comparatively insufficient levels of urbanization, literacy, and education, to the relatively impoverished state of its scribal culture, to its relative shortage of interested patrons and dearth of cheap paper, and to its lack of a Classical past: a historical lacuna by comparison with European countries which the Byzantine heritage, weak and faltering as it almost always was in Russia, did not begin to fill. The argument proceeded by negation and inference, unfortunately, but necessarily so, in order to clarify the revolutionary nature of the Petrine changes in Russia's visual culture and some of the factors impelling those changes (like the irresistible attraction of the new imagery at the most basic optical and psychic levels). Chapter 2 further emphasized the geographical and especially cultural distance separating pre-Petrine Russia from contemporary Europe as perceived both in Europe and in Russia, whose cultural isolation was reinforced by a patriotic iconoduly that had sacralized traditional forms of imagery and related techniques of image-making. These forms and techniques, ever meager by European standards, were now "medieval" or "gothic" by the standards of the new imagery. Chapter 3 showed how in the later seventeenth century Muscovite isolationism began to break down and with it the hold on elite Russian society of its traditional imagery, a matter essentially of two internal developments: the growing infiltration of "seductive" printed images from Europe, particularly by way of the northern trade route, and the monopoly of image-making increasingly assumed by the Muscovite tsardom. Their "conversion" to the new imagery by members of the "decisive elite" including Tsar Peter himself was at once enlarged and cemented by their travels in Europe, especially the Grand Embassy of 1697–1698 (also Chapter 3); Chapter 4 followed by Chapter 5 documented in some detail the ensuing visual revolution and its institutionalization and industrialization in Russia.

So far, perhaps, so good. With the help of contemporary European verbal testimony, Russian official and various other written texts, and any number of images generated in contemporary Russia or Europe, we have tracked the emergence by the later eighteenth century of a visibly new Russia: new by comparison with the Russia of the later seventeenth century and new as a

result documentably of the Petrine revolution. The working out of this revolution is more easily seen perhaps in the realm of architecture, in the transformation of the Russian built environment recounted in our first volume. But it is also quite readily apparent in the rulers' and elite's new perception of themselves as registered in the new academic art and the new official imagery studied in this volume. There anyone with eyes to see could have glimpsed if not perhaps immediately understood the new system's pretensions to European political status and newly absolute rule: its overriding commitment to Europeanize as much of Russian life as could be involved in the project. "See how he has left you [Russia]," proclaimed the medal marking the death of "Peter the Great, All-Russian Emperor and Autocrat": Peter represented, here as in countless other images circulating by this time, in the pan-European (Baroque) guise of imperial Roman power. This was the dress of modern monarchical absolutism, unencumbered by ecclesiastical, nobiliar, or other controls, as found in contemporary Prussia, the Habsburg empire, or France;[1] and it was in the corresponding guise of a patented, titled, armigerous elite that the newly reconstituted "All-Russian" service nobility, especially at its upper levels, now strove to present itself. Similarly, the Imperial Russian bureaucracy and armed forces now flew the flags and wore the uniforms, decorations, and knightly orders of a modern European state—all as figured in the easel portraits, battle pictures, statuary, miniatures, and medals adorning de rigueur their persons, offices, barracks, and homes. With a certain imaginative leap we can begin to picture to ourselves the *visible* transformation of elite, official Russia occasioned by the Petrine revolution.

Visibly co-opted, too, if more discreetly so, were the publicists of the new Imperial system, including its certified *khudozhniki;* the Empire's leading townsfolk, with their newly devised titles and rankings and corporate *gerby;* and even the clergy of the ancient Orthodox church. In controlling these groups Peter and his Imperial successors sought to control still further the production of images in Russia. Their effort, perhaps inevitably, met with little immediate or direct success the further one got from court. But the cult art and popular imagery of Imperial Russia experienced the "shock of the new" nonetheless.

Cult Art

Peter's church reform, enacted in his last years, envisioned the Russian clergy as a kind of "ecclesiastical army [*eine geistliche regulirte Miliz*]," as the contemporary Prussian ambassador to St. Petersburg knowingly put it.[2] The vision was to be substantively realized, starting in Peter's own time, by a new Imperial office, the Holy Synod, which he founded in 1721 to administer "all ecclesiastical affairs in the All-Russian Church." This Synod was composed of a group of senior clerics who served at the ruler's pleasure, were guided by his officer (the Synodal *ober-prokuror,* Col. I. V. Boltin), and worked through a

mini-bureaucracy modeled on that of Peter's new Senate. As explicitly stated in the Synod's founding legislation, the overall purpose of this drastic reorganization of ecclesiastical administration, which entailed abolishing the centuries-old headship of the Russian church (the metropolitanate, then patriarchate, of Moscow), was to reform the church as well as to run its affairs more efficiently. And high on Peter's list of "irregularities" to be thus eliminated by his Synod were the supposedly improper painting and venerating of icons. This was truly a tall order, given what we know of the ubiquity of holy pictures in Russia, Russians' attachment to their icons, and the attempts by previous regimes to regulate their production and sale.

Peter had long exhibited sensitivity to European or "German" criticism of his subjects' "superstitious" or "idolatrous" regard for their coarsely painted holy pictures (Chap. 2). In England in 1698 he confided to an approving senior Anglican divine, in the latter's words, that "saints ought not to be praied to" and that he "was only for keeping the picture of Christ, but that it ought only to be a remembrance and not an object of worship."[3] An engineer whom Peter hired while in England, John Perry (he worked in Russia until 1712), was as much vexed to discover "the stupid folly as well as bigotry" of his Russian coworkers in matters of religion, and particularly their "idolatrous way of bowing down to mere pictures," as he was pleased by Peter's attitude. "He has reduced the number of his saints in his own houses of residence to the cross or the picture of our blessed Saviour only," Perry reported; "and the lords and other persons who are his favorites have been brought in a great measure to follow his example."[4] In 1714 Peter pointedly urged the acting head of the Russian church, Metropolitan Stefan Iavorskii, to add to his newly composed defense of the Orthodox faith "moral instruction for the simple folk concerning holy icons, so that they should know what is against the teaching of the church . . . and the humiliation caused us by our enemies might be done away with."[5] The "Latinizer" Iavorskii soon lost Peter's favor owing to his strident anti-Protestantism, among other causes; we note in passing that his treatise defending Orthodoxy, the *Rock of the Faith* (*Kamen' very*), which was deeply indebted to Roman Catholic sources and was only published after both his own and Peter's death (1729), contains the first extended exposition of the "*dogmata* on holy icons" ever published in Russia.[6]

Iavorskii's successor as Peter's chief clerical advisor, the "Protestant" Bishop (later Archbishop) Feofan Prokopovich, lost no opportunity to express views that Iavorskii considered iconoclastic. In 1716 Prokopovich helped Peter devise a new consecration oath for bishops according to which they swore to make annual visitations of their dioceses to ensure among other things that "holy icons are not idolatrized and false miracles attributed to them, which gives cause for slander by the enemies of Orthodoxy."[7] In a catechetical primer first officially printed at St. Petersburg in 1720 (and frequently thereafter), Prokopovich expressly condemned the rendering of "true worship" to icons instead of mere "respect." He was also the main author of the *Ecclesiasti-*

cal Regulation of 1721, the charter embodying Peter's church reform, in which bishops again were enjoined to ensure that in their dioceses "false and invented miracles are not attributed to holy icons," a provision that was to be enforced by the newly established regime of central and diocesan "inquisitors" (*inkvisitory*).[8]

The provisions of the *Ecclesiastical Regulation* against "image worship," as the Protestant friends of Peter and Archbishop Feofan would call the practices in view, were vigorously enforced by the Holy Synod during its first few years in operation. Successive synodal rulings in cases brought before it required that "miracle-working icons" found in private houses be seized by the local authorities and taken to the nearest important church or monastery, there to be certified, or not, as genuine. Again, the "great number of little domestic icons" cluttering parish churches, the Synod ruled, were to be removed by their owners and the custom of taking them there discontinued, as this did not "beautify" the churches in question but rather treated them as "icon repositories." In another instance Peter's Synod condemned to death a certain minor cleric of the Novgorod diocese for claiming miraculous powers for the icons in his church while "enticing light-minded and imprudent people" to believe him; in still another case, it ordered that a chest containing "pieces of ivory in the guise of relics" kept by a certain church official in St. Petersburg be taken from his house and deposited in the Synod's own "Cabinet of curiosities [*Kunshtkamera*]." On this occasion (January 1, 1723) the Synod further resolved that a notice be circulated "with this declaration: that these and similar superstitions [*superstitsii*], which were practiced before there were ecclesiastical inquisitors, and which were brought to Russia by Greeks, are now being eradicated by the Synod with great care."[9]

We should note that in thus condemning the "superstitious" and "idolatrous" veneration of icons the Synod represented itself as acting in the true Orthodox tradition. At a joint meeting with the Senate in August 1722, Emperor Peter himself presiding, the latter commanded that "icons are to be painted in accordance with ecclesiastical customs and the Acts of the Council"—a clear reference to the Moscow church council of 1666–1667 discussed in Chapter 2. The Council, as we saw, prohibited certain iconographic innovations of Latin origin, some dating back a century or more, corrected two points of dress and gesture for icon painters to observe in depicting saints, and ordered that supervisors of icon painters be appointed to ensure that icons were well and properly painted. Now Peter ordered, to the same end, that a "superintendent of iconpainters" responsible to the Synod should be named.[10]

Peter's order, like his previous and subsequent legislation on the subject, reveals that he too was far more concerned with the quality of religious imagery in Russia than with its content. As early as 1707, having virtually abolished the Armory Chamber in Moscow, he had established a new office—an

Izugrafskaia kontora or *palata*—to supervise artists: something of a neologism in Russian, *izugraf* or *izograf* (also *zugraf* or *zograf*, from Greek *zografos*) meant icon painter in the first instance, painter more generally (Chap. 3).[11] One Ivan (I. P.) Zarudnyi, a draftsman and wood carver of some distinction, was named to head the office with instructions to "improve the beauty and honor of holy icons" by improving the "art of iconic and lifepainting representation [*iskusstvo ikonnago i zhivopisnago izobrazheniia*]."[12] He was to see to it that anyone wishing to paint icons, including foreigners, was certified by his office as qualified to do so and registered in the appropriate rank: master of iconic or lifepainting affairs, submaster, simple iconpainter or lifepainter, or student-apprentice (*uchenik*). Thenceforth only such artists, certified and registered on payment of specified fees, could paint icons or portraits, which works the said artists were herewith required to sign and date (proper portraiture as well as proper icon painting was obviously also at issue). And only such certified and registered masters, on payment of another fee, could now teach the figurative art. And only icons inspected and certified by the Izugrafskaia Palata could be traded: it was thereafter absolutely forbidden to buy or to sell, "in Moscow and in the towns and country districts, in shops and in the streets and squares, inartistic and poorly painted icons without certification, as also icons of Russian engraving printed on paper." But neither were "overseas sheets [*zamorskie listy*] on which are painted images of saints" to be sold; and thenceforth anyone wanting "to print for sale by copper and wooden plates *listy* of anything" was to bring the plates to Zarudnyi's office for certification. As for what constituted proper icon painting, interested parties were referred to the patriarchal *gramota* of May 1668 "given to the chief *izugraf* of the tsar's [Armory] Chamber, Simon Ushakov," which embodied the views of the cosmopolitan Moscow court school (Chap. 3).[13] Ushakov, the Russian Cimabue, as we like to think of him, had died more than twenty years before, his artistic legacy in some doubt. Now he and his school were being certified as models for icon painters (pls. 6, 8, 9, etc.), not Rublev and the "old Russian and Greek masters" whose work (pls. 2, 3, 4; figs. 7, 8), once officially vaunted, was now venerated mainly if not exclusively by Old Believers—those descendents of the dissident minority in the great church schism of the 1660s who had never wavered in their devotion to the earlier iconic traditions.

So the invasion of Russian cult art by the new imagery (figs. 11, 13, 18, 27, 28, 29, 50, 54, 74; pls. 5, 6, 8, 9, 11, 12, 14, 15, 17, 19) had been officially sanctioned by Peter's government a dozen and more years before his creation of the Holy Synod, which institutionalized his church reform. True to form, the Synod acted at once to carry out the policy of its "Supreme Judge": an aesthetic as well as a bureaucratic revolution was under way. A handbook of extracts from the relevant counciliar rulings together with sample images was printed (1721) at the Synod's direction for the guidance of icon painters. Zarudnyi was confirmed in his post, and by the autumn of 1722, as he duly

reported to his new synodal masters, his reinvigorated office had certified thirty-six painters; by 1725, that total had jumped to 107 icon painters, sixteen lifepainters, and five miniaturists: one indication, possibly, of where demand for imagery in Moscow proportionately lay. Zarudnyi also moved to implement Peter's decree of January 1723, conveyed to him by the Synod, to collect up all the "pictures of His Imperial Majesty and the Empress which out of ignorance have been unskillfully painted" and to bring them to the Synod's Moscow office. By the same decree he was somehow to ensure that thereafter Imperial portraits were "skillfully painted by lifepainters of certified mastery."[14] This was a largely unenforceable provision, to be sure, particularly in Moscow and the Russian hinterland, where the writ of the St. Petersburg government held progressively less sway. The provision remains nonetheless another sign of Peter's intentions, or hopes, regarding his reform of imagery in Russia.

Indeed, it is clear looking back that the effort under Peter and his immediate successors to standardize the cult art of the Russian Orthodox church in accordance with new-art criteria never fully overcame the force, whether inertial or deliberate, of tradition. We know this already from the reports of foreign observers of the later eighteenth century quoted in the previous chapter; other such witnesses could be called. Jonas Hanway, an English merchant who had done business in Russia in the 1740s, reported in 1753 that "the number of churches in Mosco [sic] is hardly within belief . . . but many of them are very mean and most of the paintings were done when this art was in its infancy."[15] Similarly, in a letter to his family of March 1788, another English visitor described Moscow's churches as "in general the most tawdry tempery structures you can form an idea of. . . . They are painted all the colours of the rainbow, many ornamented with paintings which I suppose are meant to represent saints & virgins; but a man must have the intelligence of a saint to know by the pictures what beings they are meant to represent."[16] Even the best informed of these witnesses, the Rev. Dr. John Glen King, chaplain to the British community in St. Petersburg in the 1760s and 1770s, a man who assiduously studied, with local assistance, the "doctrines, worship, and discipline" of the Russian church, in part to refute "the many falsehoods and ridiculous stories" told about it: even Dr. King had to allow that "religious pictures" in Russia, which were "not only an indispensable ornament" of every church but "necessary in its worship," and were likewise to be found "in every public office or college, in a corner of every apartment in private houses, and in every shop at public markets"—even Dr. King had to admit that Russian cult imagery, wherever it was to be found, was still seriously deficient by European standards.

> Though the number of these pictures is so great [King writes], and though religion was the cause which called forth such excellency and perfection in painting and sculpture in popish [Roman Catholic] countries, and in all countries where these works were consecrated to the ser-

> vice and the temples of the Dieties; yet the same cause has not been so
> lucky as to produce one good painter or one capital picture in Russia: on
> the contrary, these are the most wretched dawbings that can be conceived.

King's readers were not to wonder that in Russia "the national taste should
be so depraved as to bear, nay, perhaps be delighted with such miserable
performances, without colouring, drawing, or perspective, if we reflect that
this people were for ages sunk in ignorance, and looked upon the making of
pictures rather as a manufacture than a fine art." But King was optimistic that
"this art will in time become flourishing in Russia, for the natives are by no
means wanting in quickness of parts, which will not fail to exert and shew
themselves from the encouragement given by her present Imperial Majesty
[Catherine II]: this great princess, who is attentive to every object which can
conduce to the happiness and glory of her country, has established a most
noble institution for the *beaux arts* [the St. Petersburg Academy of Fine Arts],
and introduced a cabinet of very capital paintings into her country [the Her-
mitage], as well as models of the most precious busts and statues of antiquity,
to form the taste of her subjects."[17]

Unfortunately for Dr. King's prediction, not even great Catherine's efforts
to "form the taste of her subjects," following on and extending those of great
Peter, succeeded in transforming Russian cult art by the standards of the new
imagery. The subject has scarcely been studied, it must be said; indeed the
cult art resurrected, restored, and celebrated by Russian scholars since the
later nineteenth century has belonged mainly to pre-Petrine times, leaving
that of the intervening Imperial period to languish in a state of comparative
neglect.[18] Yet from partial or preliminary studies already undertaken we find
that the influence of the new religious imagery emanating from the ecclesias-
tical academies and elite churches of St. Petersburg and Moscow continued
after Peter to penetrate the cult art of provincial and popular Russia—a pro-
cess that had begun, as we saw in Chapter 3, just before his active reign. The
antiminsy discussed in Chapter 4, those printed altar cloths or papers depos-
ited in every Russian church to signify its consecration, and which by the
1690s were notably "Latin" in style, directly reflecting the new imagery (fig.
29), offer a clear case in point. So do the careers of the Zubov brothers and
other newly trained artists of the Petrine period, whose surviving works in-
clude numerous holy pictures painted or etched for particular churches or
church presses (also Chapter 4). So, too, do the hundreds of provincial icons
dating from the eighteenth century so far collected for restoration and study
(fig. 89, pl. 34);[19] and so do the many thousands of "paper icons" which evi-
dently circulated in Russia at this time, as we shall see shortly. In all such
cases the influence of the new art was not limited to more naturalistic depic-
tion of figures and landscapes, attempts at linear perspective, a greater variety
of color, or the occasional use of oil on canvas; subject matter was also af-
fected, as in the numerous icons of the Imperial period of the Coronation
of Mary as Queen of Heaven, a popular subject in the Latin West since the

Figure 89 *The Miraculous Catch of Fish [John 21:1–13].* Russian (Kostroma[?]),
eighteenth century. Tempera on panel.

Middle Ages but not before Peter in Russia.[20] At the same time, the degree to
which old forms held on and the new prevailed, or the extent of rusticaliza-
tion, varied considerably, as it did in church architecture.* And even in the
later eighteenth and earlier nineteenth centuries, periods of optimum cultural
Westernization, the cult art of Russia was never *transformed* by the standards
of the new imagery (figs. 89, 90A–B; pl. 34) such as it had been in Europe
itself, where the new art had first risen indeed *within* the orbit of the church
(figs. 3, 4).

One might speculate as to why the cult art of post-Petrine Russia, in imag-
ery as in architecture, ultimately resisted such a transformation, Peter's own
apparent intentions and those of succeeding Imperial regimes notwithstand-
ing. From a general, not to say universal, perspective, the reason is clear. "The
sacred," says Max Weber, "is the uniquely unalterable." Religion, though "an
inexhaustible spring of artistic expressions," is intrinsically resistant to
change. The "first and fundamental effect of religious views upon the conduct
of life . . . was generally stereotyping"; and the "religious stereotyping of pic-

Revolution in Architecture, p. 260.

Figure 90A *Mother of God of Tikhvin.* Russian (Karelia), eighteenth century. Tempera on panel.

Figure 90B *Mother of God of Smolensk.* Russian (Karelia), nineteenth century. Tempera on panel.

301

torial artifacts, the oldest form of stylization, was directly determined by magical conceptions and indirectly determined by the fact that these artifacts came to be produced professionally for their magical significance." Such stylizing "tended automatically to favor the production of art objects based upon design rather than upon representative reproduction of natural objects." Then too, "the more art becomes an autonomous sphere, which happens as a result of lay education, the more art tends to acquire its own set of constitutive values, which are quite different from those obtaining in the religious and ethical domain." In fact, "there is a sharp contrast between the esthetic attitude and religio-ethical norms. . . . The religious devaluation of art . . . is intensified by the rational and literary character of both priestly and lay education in scriptural religions."[21] Weber's generalizations, while they appear to apply less well to Renaissance and Baroque Roman Catholicism than to Islam, rabbinical Judaism, and Calvinist or Puritan Protestantism, seem also to fit, in some intermediate fashion, our Russian case. They also accord well with our account (Chap. 1) of what we called the secular imperative implicit in art of the Renaissance tradition.

Official Russian Orthodoxy, certainly a "ritualistic religion" in Weber's terms and "inclined" therefore "towards the pictorial arts," had certainly "stereotyped" its imagery well before Peter's time, and thus favored pictures "based upon design rather than representative reproduction." But in the decades immediately before Peter, as evidenced by the career of Simon Ushakov or by Muscovite grandee patronage of foreign artists, visual art in Russia was becoming an "autonomous sphere" with its own set of constitutive or aesthetic values—those of the new art arriving from Europe. This feeble trend was enormously accelerated, and then institutionalized, by the Petrine revolution—just as the late seventeenth-century trend to improve Russian clerical education according to modern (post-Reformation) European norms was sharply accelerated, and then institutionalized, by Peter's church reform. In both respects, it deserves emphasis, drastic change was suddenly imposed on the church from without, by Peter. The result in due course was that "religious devaluation of art" in Russia described by Dr. King in 1772, after he had spent more than eight years consorting with Russian "clergy of distinction"—"not one" of whom, he found, "has distinguished himself in the knowledge of natural philosophy, mathematics, chymistry, civil law, poetry, painting, music, architecture, or natural history," though "in general they understand the Greek and Latin languages, and some also the Hebrew: they are much versed in the Fathers, and in ecclesiastical history and antiquities; and are very assiduous and punctual in their attendance on the public worship, and the duties of their calling." Here was the increasingly literate priesthood, again in Weber's terms, of a traditionally ritualistic religion.[22]

After Peter's time, in sum, and owing in large measure to his church reform as well as to his art revolution, Weber's "sharp contrast between the esthetic attitude and religio-ethical norms" was greatly intensified in Russia. Old Be-

Figure 91 *Pilgrims*. Drawn ca. 1790 and etched by J. A. Atkinson, as printed by Atkinson at London in 1804. One of a series of drawings done by Atkinson during extensive travels in Russia in the 1780s and 1790s, this one is captioned: "It is very usual in Russia for the peasantry of both sexes to undertake pilgrimages to any favourite saint or monastery, however remotely situated it may be. In those parts where water in not easily found, wells are carefully provided, near which images of saints are erected, to which they invariably pay their devotion, both before and after refreshing themselves."

lievers adhered to pre-Petrine norms in their religious imagery, for their own religious reasons, while abhoring the world; but otherwise, as far as we can tell, Russians followed a looser, more eclectic line, accepting as holy icons whatever appeared to them as such regardless of aesthetic or technical considerations. This much is attested by the mainstream religious art itself of the Imperial period (e.g., figs. 74, 89, 90; pls. 17, 34) as well as by the observations of Western visitors, who continued to marvel at the "idolatrous" attitude of Russians towards their holy pictures (fig. 91)—a charge from which, said one such observer, only "some of the nobility must be exempted."[23] Beginning in the 1830s, in connection with the emergence of "theological consciousness," a full theory of holy images based on Byzantine tradition was at last elaborated in Russia, a development which permitted in turn a more discriminating attitude towards the images themselves.[24] Yet such images, newly stereotyped

N.° VI

Figure 92 *Crucifixion.* Engraving by student Skotnikov after a painting by
Charles Le Brun (1619–1690) at the Hermitage, and winner of a gold medal
in the student competition of September 1805 at the St. Petersburg Academy
of Fine Arts.

(or restereotyped) in accordance with the requirements of the new theology,
remained cult objects only. No longer did they constitute the exclusive or
predominant form of imagery in society, as before Peter, but merely one kind
of imagery among others, including official imagery as we have defined it,
that of the academy, and that which is often designated popular art, the sub-
ject of the next section of this chapter.

Any number of images of religious content were produced in post-Petrine
Russia by these other systems of representation, to be sure: academic paint-
ings on biblical themes (fig. 92), official badges involving religious symbols
(the Order of St. Andrew the First-Called), popular prints depicting saints

(see below), and so on. But such images were never imbued, it seems, with sacral significance. Rather should they be considered manifestations of the visual culture of Imperial Russia, which was of course mainly if not wholly secular in its motives, ideals, and forms. The secular imperative implicit in the new imagery from its Renaissance beginnings had done its work here, too. The icon became the icon in Russia, the stereotype of modern Orthodox cult imagery, thanks, at least in part, to the Petrine revolution.

We find this fact reflected in the modern literature on icons as well as in the icons themselves.[25] It is also reflected in authoritative statements of Russian Orthodoxy as it had evolved by the twentieth century. There we may read, for instance, that

> The true icon is not only a holy picture, it is something greater than a mere picture. According to Orthodox belief, an icon is a place of the Gracious Presence. It is the place of an appearance of Christ, of the Virgin, of the saints, of all those represented by the icon, and hence it serves as a place of prayer to them. This semblance . . . [is] made only of wood and color, materials necessary for that representation. . . . The making of icons (which in mass production tends to become mere trade) is, in its original purity, a work of religious creation. . . . In its purpose of revealing the mysteries of the spiritual world, [icon painting] has its special characteristics. First of all it is foreign to that naturalism or realism which gained the ascendancy in the Renaissance. The painting of icons does not permit sensuality in its pictures; they must remain formal, abstract, schematic; they consist only of form and color. . . . Hence icons do not know a third dimension; they have no depth. . . . [The icon] attained the highest degree of development in the fifteenth century at Moscow and Novgorod. . . . The influence of the West is clearly felt in iconpainting when its decadence begins, about the sixteenth century. . . . In the eighteenth century the influence of Western taste on Russian art lowered the standards of the latter. Traits of naturalism and dilettantism appeared; the characteristic Russian style was wiped out. . . . It is only in these latter days that the comprehension of iconpainting as an art has begun anew . . . a knowledge of the true and elevated aims of that art.[26]

So the cult art of the Russian Orthodox church had become, in the view of its learned elite, art of a special, necessarily pre-Petrine, non-Western kind. The Petrine revolution in Russian imagery, or visual art in the Renaissance tradition, was thereby summarily rejected for devotional purposes as a matter of religious, or religio-nationalist, principle.

POPULAR IMAGERY

Not unlike the icon for students of Russian cult art, the *lubok* has become the focus of attention for students of Russian popular imagery. The term itself (plural, *lubki*) and its adjective, *lubochnyi,* evidently derive from an old Russian word meaning "bast" (*lub*), or the fibrous outer layer, even the bark, of the trunks of certain trees, particularly birch and linden, on pieces of which

(*lubki*) letters were written or plans drawn in Muscovite times and from strips of which footwear as well as various utensils were made—boxes, baskets, even rafts or sleighs. In the Imperial period the terms were also applied by literary persons to printed pictures in wide, then mass circulation that were made from coarsely cut, etched or engraved wood blocks (also *lubki*) or metal plates; such cheap prints—inexpensive to buy as well as coarsely executed—were and are also called, more properly, *narodnye kartinki* ("popular pictures"). As such, the *lubok* or *lubochnaia kartinka* attracted the attention of students of nationalist or populist outlook, and an enormous literature ensued.[27] These popular prints interest us here insofar as their history is connected with the Petrine revolution.

The beginnings of that history are suitably obscure. In previous chapters we rehearsed the print revolution in Europe as it affected imagery and then recounted in some detail the subsequent rise of the new graphic arts in Russia, from their "modest debut" in the later seventeenth century to their institutionalization and industrialization under Peter. But that story, itself only now becoming available in its entirety,[28] concerns only what Russian scholars designate "professional art," or that produced by artists on commission from, if not as salaried employees of, agencies of the state: the Armory Palace of Peter's father, the relevant offices and presses founded by Peter, the Imperial Academy of Fine Arts, and so forth. As Alekseeva says bluntly, "Printing in Russia was from the outset a state business; so was graphic art."[29] Thus left out of account, however, are the designing, printing, and distributing of images on private initiative and by private, or nonstate, means. It was in this shadowy world—such is Russian history—that the *lubok* arose.

Vasilii Koren has been acclaimed as the founder of the *lubok* tradition in Russian imagery, a claim based solely on the thirty-six woodcut illustrations—twenty of the Book of Genesis, sixteen of the Apocalypse—which he executed in the 1690s and which were then printed, it is not known where, on paper made in Amsterdam, colored by hand, and eventually bound. This "bible," which survives as a unique work, seems to have belonged to various humble folk until acquired by Count F. A. Tolstoi (1758–1849), the antiquarian and collector, who sold it to the Imperial Library (GPB) in 1830, where it remains.[30] Ten of the woodcuts are signed by Koren, one by a designer (*znamenshchik*) "Gri." (Grigorii, or perhaps Gurii); and nine of them are dated (in Slavonic numerals): 1692 (2), 1695 (2), 1696 (5). This is perhaps slender support for such a large claim, except that numerous "descendants" of one or another of the Koren woodcuts have been identified among *lubki* printed in the eighteenth and nineteenth centuries. The pictorial sources of these woodcuts have also occasioned learned investigation, with Sakovich, the leading authority, ascertaining that they included not surprisingly Piscator's seventeenth-century picture bible and various European prints of the Apocalypse cycle established in 1498 by Dürer; Farrell points out further that the Koren Apocalypse series corresponds closely with woodcuts executed by the Kievan monk Prokopii

between 1646 and 1662, which in turn were based on the Piscator bible or other European prototypes.[31] This further identification, apparently unnoticed by Sakovich, reinforces our earlier point about the mediating role played by Ukrainian artists in early Russian, or Muscovite, graphic art.[32] Meanwhile, regarding Koren himself we know for certain only that he was born about 1640 in Belorussia, that he came to Russia in 1661—no doubt attracted, like dozens of other contemporary Belorussian and Ukrainian craftsmen, by Moscow's growing importance in the East Slavic Orthodox world—and that he thereafter worked as a printer in Moscow. His son, known as Aleksei Korenev, was also a maker and painter of woodcuts.

At all events, the direct or indirect function of the new graphic imagery in igniting the *lubok* tradition in Russia, which Rovinskii long ago posited, can hardly be denied. Nor can it be denied that this tradition of "low-art" imagery was founded—just barely—before the Petrine revolution took hold. On the other hand, it cannot be accepted that the *lubok* in its origins was either "secular" or "popular" in nature—staple as these assertions are in the Soviet scholarship. Like the vast bulk of imported prints (like the Koren "bible" itself), the relatively few single-sheet woodcuts or metal engravings (or etchings) produced in Russia (Moscow) before the eighteenth century were overwhelmingly religious in content. They were in fact "paper icons," whose allegedly impious or heretical character was regularly denounced by the authorities of both church and state, and they circulated among the relatively tiny upper and urban classes of Russian society, not yet the popular masses.[33]

Equally, it was precisely the religious character of early *lubki* that precipitated the effort by Peter's Synod to control their production and sale, an effort that paralleled its drive to register and certify painters of icons. In March 1721, for instance, "independently [*samovol'no*]" printed sheets displaying "various images and prayers" that were being sold in Moscow without authorization were now by Imperial order to be collected up and brought to the Synod's Prikaz of Ecclesiastical Affairs, while those who sold them were to be arrested and interrogated as to where these *listy* had been composed and printed.[34] One of Ivan Zarudnyi's original tasks as head of the Synod's Izugrafskaia Kontora, as we've seen, was to certify the propriety of "paper icons" produced and/or sold in Moscow, a charge renewed in November 1722 with the addition that Zarudnyi was somehow to halt outright the independent trade in prints.[35] He had reported that "on wooden planks they carve and print things similar to holy images, and many people, buying them, bring them to church instead of images"; two years later he complained that despite the Synod's directives artists were not bringing in their planks for "correction" and certification, and that certain tradesmen in Moscow were printing *listy* from them anyway and selling these prints in Red Square.[36] It is clear from these reports and orders that the Synod was concerned about the spread of uncanonical images especially of Old-Believer provenance. It is also obvious that its remedies were unavailing. In 1731 Archbishop Feofan Prokopovich himself, the

Figure 93 *Image of the Most Blessed Virgin Maria. . . .* Engraving printed at Moscow in 1711 (Rovinskii, *RNK, Atlas* 3, pt. 2, no. 1315); the image clearly derives from a Polish Catholic prototype (cf. Rovinskii, *RNK,* 3:526).

Synod's leading member, was outraged to discover on his way to a meeting in the Kremlin a peddler openly selling religious prints. The peddler proved to be a worker at the mint and the son of a minor cleric; he was seized with fifty-five such prints in his possession, brought in for questioning, and obliged to identify his supplier—who was in turn arrested in Red Square in the act of selling prints (thirty of forty-six on religious themes). This man acknowledged dealing in small goods including used books and all kinds of prints, but he denied knowing where the latter were made.[37] His case was far from unique.[38]

The Synod's efforts to control the independent production and sale of prints proved futile—inevitably so, one might have thought, given the intrinsic dynamics of the print revolution. But its concern with the uncanonical or un-Orthodox nature of many of these prints was apparently justified. Any number of paper icons of Western origin or Old-Believer provenance were thus being widely disseminated in these years (fig. 93),[39] considerably augmenting, we may assume, the spread of un-Orthodox notions in Russian society. This was a process which had begun, to repeat, before the Petrine revolution took hold and which now persisted in spite of repeated government attempts to reverse it. In fact, thanks to Peter's print revolution the religious imagery circulating in Russia only grew in both volume and variety from his time for-

ward, an unquenchable flow so to speak of ungovernable piety.

Have we thus reached the limits of the Petrine revolution's impact on popular imagery? Not quite. The *lubok* of secular rather than religious content also owes its development, indirectly, to the Petrine regime, as Rovinskii and succeeding scholars have shown.

It is from Peter's time that figures in European dress, European furniture and gadgets, and imitations of European graphic style began to appear in *lubki,* all to illustrate either traditional or newly imported tales or themes. This development was no "purer" than that which occurred in paper icons: traditional and new, medieval and modern were it seems almost randomly integrated in an art that became steadily more popular in both production and dissemination. Medievalist festival and parody appear to have been dominant thematically in secular *lubki* of the earlier eighteenth century, modernistic social satire and genre tales in those of the later—a visual manifestation, presumably, of the progressive Europeanization of Russian "unofficial" culture after Peter. At the same time, proportionately more *lubki* became secular in content rather than religious or devotional: from some two-thirds of all *lubki* produced in the first half of the eighteenth century, to judge from Rovinskii's still basic collection (*RNK*), to about three-fourths of all those produced in the second. The new imagery of Europe and now of St. Petersburg, of Imperial or official Russia, circulating in separate sheets or in illustrated books (the 1717 St. Petersburg edition of Aesop's fables is a prime example), provided inspiration for the urban, evidently quite literate makers of this unofficial, secular imagery. Such image-makers also listened to the buzz of the marketplace in their quest for subject or theme, attended popular celebrations, and were "especially interested in Peter the Great," creating "some prints about him that were evidently admiring and others notably parodying his behavior"[40] (fig. 94).

Artists trained in Petrine schools (like the Zubov brothers), insufficiently employed by official agencies, were among the known makers of early *lubki.* In 1744 one I. I. Akhmetev, using inherited plates originally made by such artists, started a print-producing business in his Moscow home with two presses and paper somehow obtained, most probably, from state enterprises. Buying up still more plates and woodblocks, Akhmetev's business had become a "factory" operating twenty presses when in 1766 his output was judged tolerable "for simple people" by the St. Petersburg Academy of Fine Arts. This judgment was based it appears on the large collection of prints bought that year on the Moscow market by our old friend Academician Jacob von Staehlin (the collection became, for later students, a precious source of pre-1766 *lubki*). The Academy thus bowed to the inevitable, certifying as acceptable to officialdom that which had become widely popular anyhow.

Eighteenth-century unofficial or uncertified or "popular" prints—*lubki*—influenced in turn imagery to be found in contemporary items of ceremonial folk art or craft like distaffs and chests, lace and embroidery, toys and table-

Figure 94 *The Valiant Warrior Anika Does Battle with the Grim Reaper.* 1808 popular print of the legendary Russian hero here with distinctly Petrine features, an image repeatedly reproduced in "countless numbers" from the mid-eighteenth through the mid-nineteenth centuries (Rovinskii, *RNK, Atlas* 3, pt. 1, no. 751[a]: also ibid., 3:126–28; 4:553–57; 5:175, 177–78).

ware, house carvings and combs.[41] These many objects in turn provide evidence of the proliferation of village printshops using blocks or plates bought in town, just as they offer proof of the distributive reach of itinerant peddlers and local fairs. Hundreds of individual popular images of secular content and many thousands of unofficial prints were in mass circulation by the end of the eighteenth century, it is safe to say, the sporadic efforts of Imperial agencies to regulate their production and trade notwithstanding.

And there, in the countless villages of rural Russia, the new imagery gradually fused with longstanding forms of folk art—suns, flowers, birds, animals, sirens and mermaids—to generate "a host of images in motion," as one student describes Russian peasant art of the later eighteenth and the nineteenth centuries: so many "contemporary scenes in ancient poses." Peasants thus had before them, especially on ceremonial occasions, "an array of kindred designs, theirs and their neighbors', new and worn, expert and homemade," an array of ever shifting montages that imperturbably incorporated "fashions and forces imposed on them from without."[42] Similarly, another student has pinpointed an "increasing ornamentalism" in eighteenth-century Russian folk art attributable to Baroque models as well as new genre scenes—tea drinking, promenading, riding in carriages or sleighs—and new details of

costume, gesture, and surroundings that again are attributable to "high-art" influences. Moreover, it was precisely the appearance of these new features that "gave to Russian folk art the vitality and spontaneity so highly valued by late nineteenth- and twentieth-century admirers."[43]

In such variegated, circuitous ways, via *lubki*, did the new imagery penetrate the figural and decorative arts and crafts of urban and peasant Russia in the eighteenth and earlier nineteenth centuries, creating a fund of visual epithets that would fascinate scholars and artists ever after. The Petrine revolution was emphatically not in its origins or intentions a popular revolution. But in its impact, directly and indirectly, it sooner or later reached into the homes and workplaces as well as the churches of Russians everywhere. It may be hoped that this wider process of diffusion, like Russian popular culture itself, will attract more scholarly attention.

Towards an Iconology of the Russian Empire

As a whole this volume has argued, if not fully demonstrated, that in Russia in the time of Peter a revolution took place in the content and forms of imagery as well as in allied techniques of image-making; that the crucial precipitating factor here was the new art emanating from Europe as it was received, piecemeal at first and then wholesale, by the Russian elite, both patrons and artists; and that the effects of this revolution in Russian visual culture, elite and then popular, were extensive and possibly even profound. The argument was very hazily sketched in the revolution's own "master narrative" as it emerged in the eighteenth century; and it found sustenance, as we've also seen, in the pioneering researches of Grabar and others of the later nineteenth and earlier twentieth centuries. But the case was not advanced by students in Russia thereafter, as a lack of scholarly interest in the subject or the adoption of Marxist and/or nationalist paradigms in approaching it obscured to the point of negation the revolutionary character of Peter's program, the breadth and possible depth of its effects, and the absolutely critical part played throughout its course by European artists and models. We sampled this reluctance or even refusal to hear the evidence, or ambivalence in the face of it, most directly in Chapter 3.

The ending of Soviet rule in Russia assuredly has brought a new openness to Russian historical scholarship, but along with a strengthening of the nationalist paradigm at the expense of the Marxist. This trend is manifest in a recently published volume on *Russian Art of the Petrine Era* that is fairly described by its authors as the first book ever to offer such a comprehensive and authoritative brief survey of its subject. According to these distinguished specialists, the Petrine era "occupies a special place in the history of Russian art." For

> this was the time of radical transformations as a result of Peter's reforms, which exerted an immense influence on all aspects of political, social and cultural life in Russia. These transformations, however, had been pre-

pared by the entire earlier development of the country and especially [by] the changes which had taken place in the second half of the seventeenth century.

In other words, the "transformations" of Russian life resulting from Peter's "reforms," however radical in nature, are to be seen as the outgrowth of internal processes and previous internal "changes," and we need look for their roots accordingly only in Muscovite soil—even though,

> in the sphere of culture, the [Petrine] changes were so fundamental that one can regard them as a new stage in the evolution of art, which then burst into an amazingly rapid flowering.

Their amazement at the rapid florescence of the new art in Russia does not blind these students to the contributions, which they frequently specify, made by numerous European artists and models to this fundamental process of change, although such contributions are never characterized by them as critical let alone catalytic. Rather is it the brilliance as well as the rapidity of the Russian adoption of the new art that impresses them—to the point of excluding from their volume any discussion of the European background of these same artists and models, any comparative framework, or anything more than perfunctory reference to the international context and cosmopolitan nature of the new art itself. Without such discussion and reference, quite obviously, that art can scarcely be understood in *any* of its local manifestations; nor can, just as surely, the Petrine revolution in Russia be fully and accurately grasped. Instead, these same authorities prefer to emphasize how in Peter's time art "became secular rather than religious as before" and how, then,

> The growth of the people's self-consciousness, the ideal of loyalty to the state, the spirit of struggle and creativity, and the sense of pride in all things Russian permeated art and endowed it with a special significance and patriotic ardour. Another remarkable feature of art of the Petrine age was its generally enlightening and inculcating qualities, which essentially arose from the ideology of the nobility, its main goal being the support of absolutism, the consolidation of the state and the protection of Peter's reforms. . . . Developing within the framework of European Baroque [a rare such reference], Russian art of the [Petrine period] had all the distinctly national traits.

We thus both agree and disagree with our Russian colleagues here, finding in such formulations as well as in their preceding factual survey of the subject much that is consistent with our own investigations, but also much that is mistaken or falls short of an accurate and comprehensive account of Peter's revolution in Russian visual culture.[44]

And we must insist on the term "revolution"; that the "fundamental changes" in Russian imagery resulting from Peter's program constituted not just a suddenly brilliant "new stage" in an age-old evolution of the national art but a full-scale revolution. In Chapter 1 were posited four historical criteria

by which major changes in culture may be judged revolutionary: that they were consciously intended, at least by an active minority; that they happened relatively suddenly, making the postrevolutionary stage readily distinguishable from the prerevolutionary one; that they were recognized as such by contemporaries; and that they produced transformations which were lasting.[45] We consider that by these criteria the case for the revolutionary character of Peter's program has now been amply made. We also think that *evaluating* the Petrine visual revolution by aesthetic, nationalist, or other essentially subjective criteria is an entirely separate matter—for historians a confusing and even desultory exercise that we should therefore wish to avoid.

It was further suggested in Chapter 1, or rather admitted, that the question of the longer-term historical importance of the Petrine revolution in Russian imagery is immensely problematic, involving as it does questions about the importance of the visual as distinct from the verbal in any period of human history—in human life itself. These are not questions with which modern historians including modern Russian historians have much concerned themselves, as also noted in Chapter 1. Indeed, what may well be needed before any such questions can be answered, referring only to our Russian case, is a fully fledged "iconology" of post-Petrine periods of Russian history and eventually of Imperial Russia as a whole. Such an iconology, or systematic study of the imagery of the chosen period, would aim at interpreting the symbolic universe of particular images or of an entire set or system of images. It would hope thereby to uncover the ideology (or perhaps mythology) underlying and connecting the images of any such set or system: the structure of values and interests, of drives or compulsions, that informs *any* representation of reality.[46]

An iconology of the Russian Empire would begin perhaps with an analysis of the imagery of the Petrine era along the lines attempted in this volume. Then, with it or something like it serving as the point of departure, such an iconology would aim to organize some and eventually all of the images surviving from the Imperial era with a view to eliciting the system's ideological or mythological, ethical or aesthetic, religious and/or psychic underpinnings—a task that has proved difficult to accomplish, at some points impossible, for historians drawing on purely verbal sources. Such an iconology would concentrate initially on images created expressly by and for successive regimes of the eponymous Imperial system itself, given its persistently hegemonic position in society and determinative role in cultural development.[47] But the imageries of subordinate or minority groups as of the popular masses more generally would of course also have to be studied, or studied more intensively, before this projected iconology of the Russian Empire could be considered complete. Its findings could then be integrated with those derived from more conventional study of purely verbal sources in the greater cause of discovering and indeed demonstrating how the Russian Empire actually worked: the actual mechanisms of both coercion and compliance, of consen-

sus as well as dissent, by which from Peter's time the Imperial system was upheld. We should then be in a much better position to address two great historical questions of the twentieth century, namely: Why did the Russian Empire collapse in 1917–1918? and, How much of it survived, or was revived, in the Soviet Union that succeeded it?

This volume thus ends as it began, by posing large problems for historians to resolve. I can only hope that on route from beginning to end the volume itself has contributed something worthwhile to the necessarily collective effort of reconfiguring the common field.

Notes

Chapter 1

1. W. H. Parker, "Europe: How Far?" *Geographical Journal* 126, pt. 3 (1960), pp. 278–97, is a detailed historical survey of this huge question. See further D. Hay, *Europe: The Emergence of An Idea [to the eighteenth century]* (Edinburgh, 1968); D. de Rougemont, *The Idea of Europe,* trans. N. Guterman (New York, 1968); G. Barraclough, *European Unity in Thought and Action (Vogelenzang Lecture 1963)* (Oxford, 1963); and two essays by W. H. Roobol, "What is Europe?" *Yearbook of European Studies/Annuaire d'Études Européennes,* vol. 1 (Amsterdam, 1988), pp. 187–204; and "The Shaping of Europe," ibid., vol. 6 (1993), pp. 15–33. A "theoretically informed historical sociology [critique] of the idea of Europe" from antiquity to the present, with extensive bibliography, is offered in G. Delanty, *Inventing Europe: Idea, Identity, Reality* (New York, 1995).

2. See H. W. Nerhood, comp., *To Russia and Return: An Annotated Bibliography of Travelers' English-Language Accounts from the Ninth Century to the Present* (Columbus, OH, 1968): items 39–64 date to the seventeenth century; also the appended "Bibliography of Bibliographies," pp. 321–26 passim. A selection of original texts is in A. G. Cross, ed., *Russia under Western Eyes, 1517–1825* (New York, 1971); and, with extensive scholarly commentary and further bibliography, in M. Keller, ed., *Russen und Russland aus deutscher Sicht: 9.–17. Jahrhundert,* 2d ed. (Munich, 1988).

3. S. H. Baron, ed. and trans., *The Travels of Olearius in Seventeenth-Century Russia* (Stanford, 1967), p. 130; S. Collins, *The Present State of Russia: In a Letter to a Friend at London* (London, 1671), p. 68; J. Struys, *Voyages of Jan Struys: Through Italy, Greece, Lifeland, Moscovie . . . ,* trans. (from Dutch) J. Morrison (London, 1688), p. 311; K. Schreinert, ed., "Hans Moritz Ayrmanns Reisen durch Livland und Russland in den Jahren 1666–1670," *Acta et Commentationes Universitatis Tartuensis (Dorpatensis)* (B Humaniora) 40, no. 5 (1937), p. 34; *A Relation of Three Embassies from His Sacred Majestie Charles II to the Great Duke of Muscovie . . . Per-* formed by the Earl of Carlisle in the Years 1663 to 1664: Written by an Attendant [Guy Miege] on the Embassies (London, 1669), pp. 112, 135; [A. Mayerberg], *Voyage en Moscovie d'un Ambassadeur . . . Envoyé par l'Empereur Leopold au Czar Alexis Mihalowics Grand Duc de Moscovie* (Leiden, 1688), pp. 68, 137, 208; *Éloges des Académiciens de l'Académie royale des sciences . . . par M. de Fontenelle,* vol. 1 (Paris, 1766), pp. 174–77 (Fontenelle's eulogy of Peter was first published at Paris in 1725, thereafter in numerous French, English, and other editions).

4. See also the *Abrégé de l'histoire du Czar Pierre Alexiewitz, avec une relation de l'état présent de la Moscovie . . . ,* specially prepared (by P. F. Buchet) to mark Peter's visit to France and published in journal as well as book form in Paris, 1717.

5. A. Bohlen, "Changes in Russian Diplomacy under Peter the Great," *Cahiers du monde russe et soviétique* 7 (1966), pp. 341–58; E. Amburger, "Das diplomatische Personal des russischen auswärtigen Dienstes unter Peter I," in R. von Thadden et al., eds., *Das Vergangene und die Geschichte: Festschrift für Reinhard Wittram zum 70. Geburtstag* (Göttingen, 1973), pp. 298–311; Dan Altbauer, "The Diplomats of Peter the Great," *JGO,* n.s., 28 (1980), pp. 1–16; and intro. W. E. Butler to P. P. Shafirov, *A Discourse Concerning the Just Causes of the War between Sweden and Russia, 1700–1721* (Dobbs Ferry, NY, 1973), pp. 1–39.

6. Fontenelle, pp. 185, 174, 205; also A. Galitzin, "Pierre Ier, membre de l'Académie des sciences," *Bulletin du Bibliophile,* ser. 14 (September 1859), pp. 611–17; and Charles B. Paul, *Science and Immortality: The Eloges of the Paris Academy of Sciences (1699–1791)* (Berkeley and Los Angeles, 1980).

7. L. E. Barry and R. O. Crummey, eds., *Rude & Barbarous Kingdom: Russia in the Accounts of Sixteenth-Century English Voyagers* (Madison, WI, 1968), p. 83; Collins, pp. 24, 29; Baron, *Olearius,* p. 50; [B. Coyet], *Historisch Verhael, of Beschryving van de voyagie, Gedaen onder de suite van den Heere [Ambassador] Koenraad van Klenk . . .* (Amsterdam, 1677), as reprinted with Russian translation in *Po-*

sol'stvo Kunraada fan-Klenka k tsariam Alekseiu Mi-khailovichu i Fedoru Alekseevichu (SPb., 1900), pp. 170/470.

8. E. Todd, *L'Invention de l'Europe* (Paris, 1990), with a single reference to Russia—as a factor "constraining" European unity (p. 10); D. Gerhard, *Old Europe: A Study of Continuity, 1000–1800* (New York, 1981), p. 7.

9. C. Michaud, *L'Europe de Louis XIV* (Paris, 1973), pp. 11–12, 217, 223. Cf. W. Doyle, *The Old European Order, 1660–1800* (Oxford, 1978), especially "The Emergence of Russia," pp. 278–79: Russia before Peter was "not a European power. . . . Peter was determined to make Russia a first rate power. . . . Even then it was not clear how permanent the growth in Russian power and importance would be. Many expected or hoped that it would disappear with Peter."

10. J. Meyer, *L'Europe des Lumières* (Le Coteau, 1989), pp. 73, 81.

11. P. Chaunu, *La Civilisation de l'Europe classique* (Paris, 1966), pp. 48–51; and Chaunu, *La Civilisation de l'Europe des lumières* (Paris, 1971), pp. 267, 54.

12. G. von Rauch, "Political Preconditions for East-West Cultural Relations in the Eighteenth Century," trans. K. and D. Griffiths, *Canadian-American Slavic Studies* 13, no. 4 (1979), pp. 391–411. See also L. Wolff, *Inventing Eastern Europe: The Map of Civilization on the Mind of the Enlightenment* (Stanford, 1994), which demonstrates at length how the modern definition of Europe as composed of Eastern and Western segments was "the intellectual work of the Enlightenment," rendering anachronistic the earlier division into Northern and Italian worlds favored by Renaissance writers following Classical precedents: "Eastern Europe [to include Russia, or western Russia, from Peter onwards] is a cultural construction, an intellectual invention, of the Enlightenment" (pp. 5, 356).

13. E.g., H. W. Janson, *History of Art*, 5th ed. (New York, 1991), pp. 242–43, 772 ff.; or E. H. Gombrich, *The Story of Art*, 15th ed. (1989), pp. 101, 451 ff.

14. E.g., M. and R. Mainstone, *Cambridge Introduction to the History of Art: The Seventeenth Century* (Cambridge, 1981); or M. Kitson, *Landmarks of the World's Art: The Age of the Baroque* (1966).

15. As a glance at the bibliographies of the (few) general works in English confirms: e.g., Hamilton, *Art and Architecture of Russia*; Milner-Gulland and Bowlt, *Introduction to Russian Art and Architecture*; Milner, *Dictionary of Russian Artists*; etc.

16. B. Jestaz, *Art of the Renaissance*, trans. I. M. Paris (New York, 1995; original French ed. Paris,

1984), splendidly illustrated, is now perhaps the single best introduction. Another basic work, also splendidly illustrated, and now in its fourth edition, is F. Hartt, *History of Italian Renaissance Art: Painting, Sculpture, Architecture*, ed. D. G. Wilkins (New York, 1994).

17. Gombrich, pp. 143–44; Jestaz, pp. 19, 30. Jestaz sees the Renaissance as a movement first of all against Gothic art, "which had ceased to please and also had never been fully satisfying in Italy, where its derivation from the barbarians who had brought about the ruin of Roman civilization was not forgotten" (p. 19); a more complex view of the role—never prominent—of the Gothic in Italy, which in turn casts doubt on Jestaz's anti-Gothic emphasis, is V. Pace and M. Bagnoli, eds., *Il Gotico europeo in Italia* (Naples, 1994). On other matters raised here, see also G. Basile, *Giotto: The Arena Chapel Frescoes* (New York, 1993), with magnificent reproductions; R. Ling, *Roman Painting* (Cambridge, 1991), for antique painting in Italy; and J. Boardman, ed., *The Oxford History of Classical Art* (Oxford, 1993), which is a complete survey-catalog, fully illustrated, of the subject.

18. O. Demus, *Byzantine Art and the West* (New York, 1970). See also K. M. Setton, "The Byzantine Background to the Italian Renaissance," *Proceedings of the American Philosophical Society* 100 (1956), pp. 1–76; J. H. Stubblebine, "Byzantine Influence in Thirteenth-Century Italian Panel Painting," *Dumbarton Oaks Papers* 20 (1966), pp. 85–102; E. Kitzinger, *The Art of Byzantium and the Medieval West: Selected Studies*, ed. W. E. Kleinbauer (Bloomington, IN, 1976); and several essays in P. Nordhagen, *Studies in Byzantine and Early Medieval Painting* (London, 1990).

19. J. White, in J. R. Hale, ed., *A Concise Encyclopaedia of the Italian Renaissance* (London and New York, 1981), p. 77. Cf. J. Dunkerton et al., eds., *Giotto to Dürer: Early Renaissance Painting in the National Gallery* (London, 1991), who describe Cennini's handbook as our "main source of information about painting techniques in Italy in the fourteenth century. Examination of paintings has confirmed that the techniques described were indeed used" (p. 395).

20. W. Tatarkiewicz, *History of Aesthetics*, vol. 3: *Modern Aesthetics*, ed. D. Petsch, trans. (from Polish) C. A. Kisiel and J. F. Besemeres (The Hague, 1974), pp. 28–29, 31. For Cennini's original work in Italian with English translation (by D. V. Thompson), see Cennini, *The Craftsman's Handbook/Il Libro dell'Arte* (New York, 1954).

21. Demus, pp. 15, 18, 212, 216–18.

22. B. Cole, *Sienese Painting From Its Origins to the Fifteenth Century* (New York, 1980), pp. 18–19; Hartt, p. 44; also E. Carli, *Sienese Painting* (New

York, 1956), especially pp. 15–18. A. Smart, *The Dawn of Italian Painting, 1250–1400* (New York, 1978), refers dismissively to "Byzantinizing art" or "style," the "Byzantine idiom" and "Italo-Byzantine style" in thirteenth-century Italian painting (pp. 2, 8, 9, 18); similarly, "Byzantine style and influence" are presented as longstanding, static factors to be overcome in R. Oertel, *Early Italian Painting to 1400* (New York, 1966), pp. 11 ff. and passim.

23. Demus, pp. 239–40.

24. For examples of the Italian painting in question, see, in addition to titles already mentioned, C. Pirovano et al., eds., *La pittura in Italia: Il Duecento e il Trecento*, 2 vols. (Venice, 1986); M. Boskovits and S. Padovani, *Early Italian Painting, 1290–1470: The Thyssen-Bornemisza Collection* (London, 1990); C. Seymour, *Early Italian Paintings in the Yale University Art Gallery* (New Haven, 1970); and, in a broader context, J. Gagliardi, *La Conquête de la peinture: L'Europe des ateliers du XIIIe au XVe siècle* (Paris, 1993).

25. L. Vranoussis, "Post-Byzantine Hellenism and Europe: Manuscripts, Books and Printing Presses," *Modern Greek Studies Yearbook* 2 (1986), pp. 1–71, is a detailed survey showing the extent of the transfer, eventually two-way, with numerous further references. The transfer is a dominant theme of the work of D. J. Geanakoplos: *Greek Scholars in Venice: Studies in the Dissemination of Greek Learning from Byzantium to Western Europe* (Cambridge, 1962); *Byzantine East and Latin West: Two Worlds of Christendom in the Middle Ages and Renaissance* (Oxford, 1966); *Interaction of the "Sibling" Byzantine and Western Cultures in the Middle Ages and Renaissance* (New Haven, 1976); and *Constantinople and the West: Essays on the Late Byzantine (Paleologan) and Italian Renaissances and the Byzantine and Roman Churches* (Madison, WI, 1989).

26. *Vasari's Lives of the Artists*, ed. B. Burroughs (New York, 1946), p. 42; cf. G. Vasari, *Lives of the Artists*, ed. and trans. G. Bull (Baltimore, 1965), pp. 50–51. T. S. R. Boase reminds us that "of Byzantine art or history [Vasari] knew practically nothing. . . . To Vasari the achievements and progressive changes of Byzantine art were unexplored and remote fields, and he had no conception of their influence upon the West" (*Giorgio Vasari: The Man and the Book* [Princeton, 1971], p. 76). On the "categories" of Renaissance art theory, M. Baxandall, *Painting and Experience in Fifteenth Century Italy: A Primer in the Social History of Pictorial Style* (Oxford, 1980), pp. 118–51, is very useful. R. LeMolle, *Georges Vasari et le vocabulaire de la critique d'art dans les "Vites"* (Grenoble, 1988), a thorough textual analysis, elicits inconsistencies, "fra-

gilities," and layers of signification in Vasari's book that do not for quotidian historical purposes negate its use as a source of Renaissance historiography and aesthetics.

27. Cf. S. J. Freedberg, *Painting in Italy 1500–1600* (Baltimore, 1971).

28. Dunkerton et al., pp. 68–76; Baxandall, pp. 1–27; also Baxandall, *Patterns of Intention: On the Historical Explanation of Pictures* (New Haven, 1986), especially chap. 4; and Jestaz, passim.

29. Cf. B. Cole, *The Renaissance Artist at Work: From Pisano to Titian* (New York, 1983), pt. 2, "The Materials of Renaissance Art" (pp. 57–134).

30. E. Panofsky, "Artist, Scientist, Genius: Notes on the 'Renaissance-Dämmerung,'" in W. K. Ferguson et al., *The Renaissance* (New York, 1962), p. 131.

31. Leon Battista Alberti, *On Painting*, trans. J. R. Spencer (New Haven, 1956). See further K. Clark, "Leon Battista Alberti on Painting," in Clark, *The Art of Humanism* (New York, 1983), pp. 79–105.

32. C. Hulse, *The Rule of Art: Literature and Painting in the Renaissance* (Chicago, 1990), pp. 54, 65; cf. M. Baxandall, *Giotto and the Orators: Humanist Observers of Painting in Italy and the Discovery of Pictorial Composition, 1350–1450* (Oxford, 1971), pp. 121 ff.

33. Gombrich, pp. 128, 138, 141.

34. Baxandall, *Painting and Experience*, p. 41. U. Eco, *Art and Beauty in the Middle Ages*, trans. (from Italian) H. Bredin (New Haven, 1986), provides a more complicated yet commensurate account of medieval art theory (see especially pp. 92 ff.).

35. M. Camille, *The Gothic Idol: Ideology and Image-making in Medieval Art* (Cambridge, 1989), p. 203.

36. R. Wittkower, "The Arts in Italy," in G. R. Potter, ed., *The Renaissance 1493–1520* (vol. 1 of *The New Cambridge Modern History* [Cambridge, 1964], pp. 127–53). Cf. P. and L. Murray, *The Art of the Renaissance* (New York, 1985): "The fact is that Italian art of the fifteenth and sixteenth centuries, even when treating a 'classical' subject, is entirely Christian in its roots and meaning" (p. 10). The religious function of virtually all Italian Renaissance art is emphasized by Cole, *Artist at Work*, pp. 35 ff.; and it is the central theme of the symposium edited by T. Verdon and J. Henderson, *Christianity and the Renaissance: Image and Religious Imagination in the Quattrocento* (Syracuse, NY, 1990): "Where 'Renaissance iconography' once meant almost exclusively analysis of antique literary and visual sources, scholars are now exploring the meaning of those religious works that in quantity alone continued to constitute the bulk of what Renaissance artists made and the public

saw" (Verdon, introductory essay, p. 2). Again: "Rarely has there been a time more deeply concerned with religion, more preoccupied with salvation, and more imbued with faith" (Jestaz, p. 20).

37. R. W. Lee, *Ut Pictura Poesis: The Humanistic Theory of Painting* (New York, 1967), p. vii.

38. On this point see further G. Careri, "The Artist," in R. Villari, ed., *Baroque Personae*, trans. L. Cochrane (Chicago, 1995), pp. 290–313.

39. Cole, *Artist at Work*, p. 38.

40. This is a major theme of Gagliardi, *La Conquête de la peinture* (see n. 24 above).

41. A. Hauser, *Mannerism: The Crisis of the Renaissance and the Origin of Modern Art* (Cambridge, MA, 1986), p. 23 and passim. See also F. Würtenberger, *Mannerism: The European Style of the Sixteenth Century*, trans. (from German) M. Heron (New York, 1963).

42. J. Bousquet, *Mannerism: The Painting and Style of the Late Renaissance* (New York, 1964), pp. 25–26.

43. Jestaz, pp. 119 ff. Cf. T. D. Kaufmann, *Court, Cloister and City: The Art and Culture of Central Europe, 1450–1800* (Chicago, 1995), where Kaufmann in effect supplies detailed proof of Jestaz's paradigm in countries from Slovakia to Russia.

44. Synthetic works include Kitson, cited above (n. 14); V. -L. Tapié, *The Age of Grandeur: Baroque Art and Architecture*, trans. (from French) A. R. Williamson (New York, 1960); J. R. Martin, *Baroque* (London, 1977); P. N. Skrine, *The Baroque: Literature and Culture in Seventeenth-Century Europe* (New York, 1978); Y. Bottineau, *L'Art Baroque* (Paris, 1986); J. A. Maravall, *Culture of the Baroque: Analysis of a Historical Structure*, trans. (from Spanish) T. Cochran (Minneapolis, 1986); and G. C. Argan, *The Baroque Age* (New York, 1989).

45. Specialized studies include R. Wittkower, *Art and Architecture in Italy, 1600 to 1750*, rev. ed. (Baltimore, 1973); S. J. Freedberg, *Circa 1600: A Revolution of Style in Italian Painting* (Cambridge, MA, 1983); E. J. Sullivan and N. A. Mallory, *Painting in Spain 1650–1700* (Princeton, 1982); E.J. Sullivan, *Baroque Painting in Madrid* (Columbia, MO, 1986); J. A. Levenson, ed., *The Age of the Baroque in Portugal* (New Haven, 1993); M. Brusatin and G. Pizzamiglio, eds., *The Baroque in Central Europe* (New York, 1992).

46. On this point see generally E. Mâle, *L'art religieux du XVIIe siècle* (Paris, 1984); and P. M. Jones, *Federico Borromeo and the Ambrosiana: Art Patronage and Reform in Seventeenth-Century Milan* (Cambridge, 1993), which focuses on the intersection of Baroque art and Counter-Reformation Catholicism as exemplified in the Ambrosian Library, Art Academy, and Art Museum founded 1607–20 by F. Borromeo (1564–1631) when archbishop of Milan (1595–1631): this tripartite diocesan institution's official purpose was to reform religious scholarship and visual art in response to decrees of the Council of Trent (1545–63, with interruptions). Such art was to be "naturalist" in style, Roman Catholic in subject matter, and devotional, didactic (like sacred oratory), and/or documentary in function: it was to project and record the truth of Roman Catholic doctrine in imagery that was as attractive—as artful—as possible. Borromeo himself wrote a treatise *De pictura sacra* (published by his Ambrosian press in 1624) whose introduction noted that the Council of Trent "impresses bishops to teach the populace the truth of the Faith and sacred history not merely with words, but with painting and whatever other representation succeeds in inspiring the souls and senses of the faithful to the mysteries of religion" (Jones, p. 31).

47. R. J. W. Evans, *The Making of the Habsburg Monarchy, 1550–1700* (Oxford, 1979), p. 443. See further G. Brucher et al., *Die Kunst des Barock in Österreich* (Salzburg and Vienna, 1994).

48. R. Starn and L. Partridge, *Arts of Power: Three Halls of State in Italy, 1300–1600* (Berkeley and Los Angeles, 1992); J. Southorn, *Power and Display in the Seventeenth Century: The Arts and Their Patrons in Modena and Ferrara* (Cambridge, 1988); F. Haskell, *Patrons and Painters: A Study of the Relations between Italian Art and Society in the Age of the Baroque* (New York, 1971).

49. Freedberg, *Circa 1600*, pp. 2 ff. On the question of theory, see J. Białostocki, "Y eut-il une théorie baroque de l'art?" in J. Ślaski, ed., *Barocco fra Italia e Polonia* (Warsaw, 1977), pp. 29–56 (which concludes that a theory of Baroque art did not develop until the mid-eighteenth century, and only then by negation).

50. Gombrich, pp. 172–74. On the early spread north and east of Italian Renaissance imagery, and its reception there, see Dunkerton et al., and Gagliardi, both cited above (nn. 19, 24); L. D. Ettlinger, "Art and Artists in Northern Europe," in D. Hay, ed., *The Age of the Renaissance* (London, 1967), pp. 300–320; J. Białostocki, *The Art of the Renaissance in Eastern Europe* (Ithaca, NY, 1976); M. Prokopp, *Italian Trecento Influence on Murals in East Central Europe, Particularly Hungary*, trans. (from Hungarian) A. Simon (Budapest, 1983); K. Löchner, "Panel Painting in Nuremberg: 1350–1550," in *Gothic and Renaissance Art in Nuremberg* (Metropolitan Museum of Art, New York, 1986), pp. 81–86; J. C. Campbell, *Albrecht Dürer: A Biography* (Princeton 1990); C. S. Wood, *Albrecht Altdorfer and the Origins of Landscape* (Chicago, 1993). For more comprehensive treatment of these and sub-

sequent developments, see G. von der Osten and H. Vey, *Painting and Sculpture in Germany and the Netherlands 1500 to 1600,* trans. (from German) M. Hottinger (Baltimore, 1969); portions of H. Gerson and E. H. ter Kuile, *Art and Architecture in Belgium, 1600–1800* (Baltimore, 1960); P. Philippot, *La peinture dans les anciens Pays-bas XVe–XVIe siècles* (Paris, 1994); and Kaufmann (n. 43 above), with numerous further references.

51. H. Heydenryk, *The Art and History of Frames: An Inquiry into the Enhancement of Paintings* (New York, 1963), p. 25.

52. W. Gaunt, *The Golden Age of Flemish Painting* (Ware, England, 1983); also, for its numerous illustrations and biographical details, P. Courthion, *Dutch and Flemish Painting* (Secaucus, NJ, 1983).

53. S. Schama, *The Embarrassment of Riches: An Interpretation of Dutch Culture in the Golden Age* (New York, 1987), pp. 318–20.

54. Cf. J. Rosenberg, S. Slive, and E. H. ter Kuile, *Dutch Art and Architecture: 1600 to 1800* (New York, 1986); for painting alone, the splendid B. Haak, *The Golden Age: Dutch Painters of the Seventeenth Century,* trans. E. Willems-Treeman (New York, 1984); also, S. Alpers, *Rembrandt's Enterprise: The Studio and the Market* (Chicago, 1988), which perhaps emphasizes unduly the artist's economic motives.

55. I allude here to a large, unusually elusive subject. The main point is put quite succinctly by the English translator (A. Luchs, from German) of M. Wackernagel's pioneering *The World of the Florentine Renaissance Artist: Projects and Patrons, Workshop and Art Market* (Princeton, 1981; first published 1933), who refers to Wackernagel's fascination here with "two related factors: the widespread demand for art in the Renaissance and the functional role of most of the works, even while the idea of art as a collectible and marketable commodity was developing. In [Wackernagel's book] Renaissance art, in its multitude of media and variations, emerges as a constant and necessary presence for Florentines of all classes as they worshipped, worked, celebrated, and conducted their government and diplomatic relations. It confronted them as they went about the business of daily life in their homes and walked the streets of their city. It played a fundamental role in the rituals and observances of birth, marriage, and death" (ibid., "Translator's Preface," p. xix). See further, for the situation just in Italy in the centuries in question, several chapters of P. Burke, *Culture and Society in Renaissance Italy 1420–1540* (London, 1972); R. S. Lopez, "Hard Times and Investment in Culture," in Ferguson et al., *Renaissance,* pp. 29–54; D. S. Chambers, ed., *Patrons and Artists in the Italian Renaissance* (Columbia, SC,

1971), especially pp. xxx–xxxiv; Baxandall, *Painting and Experience,* pp. 1–23; and Haskell, especially pp. 13–17, 120–45. On the role of visual art in public life, see also A. R. Blumenthal, *Italian Renaissance Festival Designs* (Madison, WI, 1973) and *Theater Art of the Medici* (Hanover, NH, 1980); E. Muir, *Civic Ritual in Renaissance Venice* (Princeton, 1981); and Starn and Partridge (n. 48 above), among other studies.

56. Gombrich, p. 208.

57. W. Stechow, ed., *Northern Renaissance Art 1400–1600: Sources and Documents* (Englewood Cliffs, NJ, 1966), pp. 67, 64–65, 58.

58. E. L. Eisenstein, *The Printing Press as an Agent of Change: Communications and Cultural Transformations in Early-Modern Europe,* 2 vols. (Cambridge, 1979); also, R. Chartier, ed., *The Culture of Print: Power and the Uses of Print in Early Modern Europe,* trans. (from French) L. G. Cochrane (Princeton, 1989). With respect to printed pictures Eisenstein's work is deeply indebted to W. M. Ivins, *Prints and Visual Communication* (Cambridge, MA, 1953); other works on the subject, well illustrated, include A. H. Mayor, *Prints and People: A Social History of Printed Pictures* (New York, 1971); and S. Lambert, *The Image Multiplied* (London, 1987).

59. Major, p. [4]; other figures from F. Eichenberg, *The Art of the Print* (New York, 1976), pp. 72–73. C. Clair, *A History of European Printing* (New York, 1976), provides a comprehensive list of incunabula (appendix 2, pp. 435–46) and of presses established by 1500 (appendix 1, pp. 431–34).

60. Hence in Clair's solid history of printing in Europe Russia hardly rates more than a mention (see Clair, pp. 249–53). For the Russian figures cited, see further G. Marker, *Publishing, Printing, and the Origins of Intellectual Life in Russia, 1700–1800* (Princeton, 1985), p. 19.

61. L. Febvre and H. J. Martin, *L'Apparition du livre* (Paris, 1958), especially pp. 27–46.

62. W. D. Orcutt, ed., *The Book in Italy during the Fifteenth and Sixteenth Centuries Shown in [129] Facsimile Reproductions* (London, 1928), pp. 18–19; J. J. G. Alexander, ed., *The Painted Page: Italian Renaissance Book Illumination, 1450–1550* (New York, 1995); also, more generally, F. Barberi et al., "Graphic Arts," *Encyclopedia of World Art,* vol. 6 (New York, 1962), cols. 666–705. J. H. Beckman and I. Schroth, eds., *Picture Bible of the Late Middle Ages* (Constance, Germany, 1960), reproduces in facsimile a manuscript picture bible on paper produced around 1400 in the upper Rhineland or Alsace that is typical of the picture bibles which flourished in Europe from the fourteenth century until made obsolete, though only gradually, by the print revolution.

63. Eisenstein, 2:703 and passim.

64. G. Rozman, *Urban Networks in Russia, 1750–1800, and Premodern Periodization* (Princeton, 1976), pp. 56–57.

65. A. M. Hind, *An Introduction to a History of Woodcut*, 2 vols. (Boston, 1935), contains a list of early printed books illustrated with woodcuts (2:783–814).

66. A. M. Hind, *A History of Engraving and Etching* (London, 1923).

67. P. Hofer, *Baroque Book Illustration: A Short Survey* (Cambridge, MA, 1951), with 149 plates.

68. Karger, "Iz istorii zapadnykh vliianii," with nine illustrations.

69. Figures (more or less cautious estimates) from H. L. Eaton, "Decline and Recovery of the Russian Cities from 1500 to 1700," *Canadian-American Slavic Studies* 11, no. 2 (1977), pp. 225–27; Rozman, pp. 58, 59, 60; Ia. E. Vodarskii, *Naselenie Rossii za 400 let (XVI-nachalo XX vv)* (M., 1973), pp. 22–27, 34–36; and Vodarskii, *Naselenie Rossii v kontse XVII–nachale XVIII veka* (M. 1977), passim.

70. P. Burke, "Population," in J. R. Hale, ed., *A Concise Encyclopedia of the Italian Renaissance* (New York, 1981), pp. 263–64; elsewhere Burke reports that some twenty-three cities in northern and central Italy had a population of 20,000 or more apiece by the year 1300 (*Renaissance Italy*, p. 1). But observe the cautionary remarks regarding all population statistics before the nineteenth century in F. Braudel, *Capitalism and Material Life 1400–1800*, trans. (from French) M. Kochan (New York, 1973), pp. 2–24.

71. Rozman, pp. 222–23.

72. Vodarskii, *Naselenie v kontse XVII veka*, p. 130.

73. R. Hellie, "The Stratification of Muscovite Society: The Townsmen," *Russian History* 5, pt. 1 (1978), p. 160. See also R. A. French, "The Early and Medieval Russian Town," in J. H. Bater and R. A. French, eds., *Studies in Russian Historical Geography*, vol. 2 (New York, 1983), pp. 249–77; chapters by L. N. Langer and by D. H. Miller, in M. F. Hamm, ed., *The City in Russian History* (Lexington, KY, 1976); remarks by R. Hellie, reviewing J. M. Hittle, *The Service City: State and Townsmen in Russia, 1600–1800* (Cambridge, MA, 1979), in *Journal of Modern History* (April 1982), pp. 197–201, with further references; and the stimulating discussion of the Russian town and its inhabitants in a comparative European framework, in R. Pipes, *Russia under the Old Regime* (New York, 1974), pp. 191–211 or so. For the economy, see A. Kahan, *The Plow, the Hammer, and the Knout: An Economic History of Eighteenth-Century Russia*, ed. R. Hellie (Chicago, 1985); and the cautionary remarks by

M. E. Falkus, reviewing this work, in *Economic History Review* (August 1987), pp. 484–85.

74. G. Marker, "Literacy and Literacy Tests in Muscovy: A Reconsideration," *Slavic Review* 49 (Spring 1990), pp. 74–89.

75. P. Burke, *Popular Culture in Early Modern Europe* (New York, 1978), pp. 250–52.

76. M. J. Okenfuss, "The Jesuit Origins of Petrine Education," in J. G. Garrard, ed., *The Eighteenth Century in Russia* (Oxford, 1973), pp. 106–30; L. R. Lewitter, "Introduction," in I. Pososhkov, *The Book of Poverty and Wealth*, ed. and trans. L. R. Lewitter and A. P. Vlasto (Stanford, 1987), pp. 40, 80–81; A. P. Vlasto, *A Linguistic History of Russia to the End of the Eighteenth Century* (Oxford, 1986), especially pp. 356–74; and A. P. Bogdanov, "Iz predystorii petrovskikh preobrazovanii v oblasti vysshego obrazovaniia," in F. V. Shelov-Kovediaev et al., eds., *Reformy vtoroi poloviny XVII–XX v.: podgotovka, provedenie, rezul'taty: sbornik nauchnykh trudov* (M., 1989), pp. 44–63.

77. Cf. J. Cracraft, *The Church Reform of Peter the Great* (Stanford, 1971), especially chap. 2.

78. Lewitter, p. 15.

79. J. G. Korb, *Diary of an Austrian Secretary of Legation at the Court of Czar Peter the Great*, 2 vols., ed. and trans. from the original Latin by the Count MacDonnell (London, 1863; facsimile reprint, London, 1968), 2:153.

80. H. Bagger, *Ruslands alliance-politik efter freden i Nystad (1721–1732)* (Copenhagen, 1974), with English summary; and review of same by R. M. Hatton, *English Historical Review* 92, no. 362 (1977), pp. 150–51. See also A. Lossky, "International Relations in Europe," in J. S. Bromley, ed., *The New Cambridge Modern History*, vol. 6: *The Rise of Great Britain and Russia, 1688–1715/25* (Cambridge, 1970), pp. 154–92; and D. McKay and H. M. Scott, *The Rise of the Great Powers, 1648–1815* (New York, 1983), especially pp. 80–93, 124–34, and, for a useful chapter on "Diplomacy and the European States System," pp. 201–14. A more ambitious analysis of the emergence by the end of the eighteenth century of a "competitive, diplomatically regulated, European multistate civilization" (or system of "permanent war states") is M. Mann, *The Sources of Social Power*, vol. 1: *A History of Power from the Beginning to A.D. 1760* (Cambridge, 1986), pp. 373–517. On the question of Russia's entry into, and responsibility for, the Northern War, V. E. Vozgrin, *Rossiia i evropeiskie strany v gody Severnoi voiny: Istoriia diplomaticheskikh otnoshenii v 1697–1710 gg.* (L., 1986), argues that from early in his reign Peter I was intent on a war against Sweden for access to the Baltic and therefore needed little encouragement to begin it. On the ending of the war the standard work

from the Russian standpoint is S. A. Feigina, *Alandskii kongres: vneshniaia politika Rossii v kontse Severnoi voiny* (M., 1959).

81. C. Peterson, *Peter the Great's Administrative and Judicial Reforms: Swedish Antecedents and the Process of Reception*, trans. M. Metcalf (Stockholm, 1979); Kahan, work cited (n. 73 above); E. V. Anisimov, *Podatnaia reforma Petra I: Vvedenie podushnoi podati v Rossii 1719–1728 gg.* (L., 1982); and the more extended analysis in J. P. LeDonne, *Absolutism and Ruling Class: The Formation of the Russian Political Order, 1700–1825* (New York, 1991). For the development of the Russian navy in the eighteenth century—a task begun by Peter I, continued under Catherine II, and crucial to the goal of linking Russia with Europe and making it a great power—see A. Bode, *Die Flottenpolitik Katharinas II und die Konflikte mit Schweden und der Türkei (1768–1792)* (Wiesbaden, 1979); and for Peter's military reforms in their historical context, J. L. H. Keep, *Soldiers of the Tsar: Army and Society in Russia, 1462–1874* (Oxford, 1985), especially pp. 95 ff.

82. Quoted in G. von Rauch, "Political Preconditions for East-West Cultural Relations in the Eighteenth Century," *Canadian-American Slavic Studies* 13, no. 4 (1979), p. 394 (trans. K. and D. Griffiths).

83. A good example in all respects is the memoir of his nearly fourteen years in Russia, working as an engineer, written by John Perry and published in London in 1716: *The State of Russia under the Present Czar [Peter I]* (facsimile reprint, London, 1967).

84. M. Raeff, "The Well-Ordered Police State and the Development of Modernity in Seventeenth and Eighteenth-Century Europe: An Attempt at a Comparative Approach," *American Historical Review* 80, no. 5 (1975), pp. 1221–43; also, J. Cracraft, "Opposition to Peter the Great," in E. Mendelsohn and M. S. Shatz, eds., *Imperial Russia, 1700–1917: State, Society, Opposition* (DeKalb, IL, 1988), pp. 22–36.

85. *Lettres du comte [Francesco] Algarotti sur la Russie* (London and Paris, 1769), p. 64.

86. Cf. R. Porter and M. Teich, eds., *Revolution in History* (Cambridge, 1986), especially essays by P. Burke and E. J. Hobsbawm.

87. Wortman, *Scenarios of Power*, is a happy, if limited, exception. So are works by R. Stites, e.g., *Revolutionary Dreams: Utopian Vision and Experimental Life in the Russian Revolution* (New York, 1989), especially pp. 19–24 and chaps. 3 and 4; and *Russian Popular Culture: Entertainment and Society since 1900* (Cambridge, 1992), chap. 1. N. Riasanovsky, *The Image of Peter the Great in Russian History and Thought* (New York, 1985), employs

the term "image" entirely in its secondary mental, verbal, or perceptual senses, and makes no use of the huge fund of Petrine imagery.

88. R. Starn, "Seeing Culture in a Room for a Renaissance Prince," in L. Hunt, ed., *The New Cultural History: Essays* (Berkeley and Los Angeles, 1989), pp. 205–6. See further Starn and Partridge, as cited above (n. 48).

89. E.g., A. Boime, *Art in an Age of Revolution, 1750–1800* (Chicago, 1987); several books on nineteenth-century French painting by T. J. Clark; and two books by Baxandall, cited above (nn. 26, 28). A classic example of the approach is F. Antal, *Florentine Painting and Its Social Background* (London, 1948; Cambridge, MA, 1986); another is Haskell, as cited above (n. 48). A. Hauser, *The Social History of Art*, 4 vols. (New York, 1951), is a comprehensive as well as pioneering work in the field; similarly his *The Sociology of Art*, 2 vols. (Chicago, 1982), and his work on Mannerism, cited above (n. 41). See also P. Paret, *Art as History: Episodes in the Culture and Politics of Nineteenth-Century Germany* (Princeton, 1988), which examines German historical painting for evidence of political consciousness particularly in the middle class.

90. For which art historians are vigorously criticized by D. Freedberg, *The Power of Images: Studies in the History and Theory of Response* (Chicago, 1989). At the same time, Haskell, in a major new work, emphasizes the technical and other difficulties impeding attempts to utilize the evidence of (high) art for historical purposes: F. Haskell, *History and Its Images: Art and the Interpretation of the Past* (New Haven, 1993). S. Schama's study of Dutch culture in the seventeenth century (cited above, n. 53) is the most ambitious recent attempt to make use of visual art in evoking a whole culture at a given time; but Haskell criticizes Schama's effort precisely in this regard: F. Haskell, "Visual Sources and *The Embarrassment of Riches*," *Past & Present: A Journal of Historical Studies,* no. 120 (August 1988), pp. 216–26.

91. T. K. Rabb and J. Brown, "The Evidence of Art: Images and Meaning in History," *Journal of Interdisciplinary History* 17, no. 1 (Summer 1986), pp. 1–6. Cf. Haskell, *History and Images*: "Fruitful cooperation between the historian and the art historian can be based only on a full recognition of the necessary differences between their approaches" (p. 10).

92. As does Freedberg: "In order to understand our responses to 'high' art we need the general and specific evidence supplied by responses to 'low' images. The history of art is thus subsumed by the history of images. . . . [which] takes its own place as a central discipline in the study of men and women; the history of art stands, now

a little forlornly, as a subdivision of the history of cultures" (*Power of Images*, pp. 23, xxv).

93. Baxandall, *Patterns of Intention*, p. 13. I must also acknowledge a debt to the not readily classifiable work on imagery of W. J. T. Mitchell, especially *Iconology: Image, Text, Ideology* (Chicago, 1986); and his *Picture Theory: Essays on Verbal and Visual Representation* (Chicago, 1994).

94. N. Bryson, *Word and Image: French Painting of the Ancien Regime* (Cambridge, 1981), chap. 1 (p. 8); also Bryson, *Vision and Painting: The Logic of the Gaze* (New Haven, 1983), chaps. 1–2.

95. C. Braider, *Refiguring the Real: Picture and Modernity in Word and Image, 1400–1700* (Princeton, 1993), pp. 5, 9, etc. (see p. 267 n.4 for Braider's rejection of Bryson's "overzealous criticism" of traditional realist claims. He also offers R. Wollheim, *Painting as an Art* [Princeton, 1987], as another antidote to Bryson on the question of "meaning in painting").

Chapter 2

1. J. Pelikan, *The Christian Tradition: A History of the Development of Doctrine*, vol. 2: *The Spirit of Eastern Christendom (600–1700)* (Chicago, 1977), p. 104. On early Christian imagery itself and its antecedents, A. Grabar, *Christian Iconography: A Study of Its Origins*, trans. (from French) T. Grabar (Princeton, 1968); P. Du Bourguet, *Art paléochrétien* (Paris, 1970); M. Gough, *The Origins of Christian Art* (New York, 1973); A. Effenberger, *Frühchristliche Kunst und Kultur* (Munich, 1986); and titles listed in n. 15 below.

2. Texts in W. Tatarkiewicz, ed., *History of Aesthetics*, vol. 2: *Medieval Aesthetics* (The Hague, 1970), p. 23.

3. Cf. H. Belting, *Likeness and Presence: A History of the Image before the Era of Art*, trans. (from German) E. Jephcott (Chicago, 1994); W. Kemp, *Christliche Kunst: Ihre Anfänge, Ihre Strukturen* (Munich, 1994).

4. Quoting with modifications the translation in G. Mathew, *Byzantine Aesthetics* (London, 1963), pp. 103–4; cf. P. Schaff and H. Wace, eds., *A Select Library of Nicene and Post-Nicene Fathers of the Christian Church*, 2d ser., vol. 14: *The Seven Ecumenical Councils* (New York, 1900), p. 550. On the Council and the question of sacred imagery, see further F. de'Maffei, *Icona, Pittore e arte al Concilio Niceno II* (Rome, 1974), and F. Boespflug and N. Lossky, eds., *Nicée II, 787–1987: Douze siècles d'images religieuses* (Paris, 1987); on the whole iconoclast controversy, J. Pelikan, *Imago Dei: The Byzantine Apologia for Icons* (Princeton, 1990), and, more critically, A. Grabar, *L'iconoclasme byzantin: le dossier achéologique*, 2d ed. (Paris, 1984).

5. Cf. M. Camille, *The Gothic Idol: Ideology and Image-Making in Medieval Art* (Cambridge, 1989), especially pp. 203 ff.; H. Belting, *The Image and Its Public in the Middle Ages*, trans. (from German) M. Bartusis and R. Meyer (New Rochelle, NY, 1990).

6. St. John of Damascus, *On the Divine Images: Three Apologies against Those Who Attack the Divine Images*, trans. D. Anderson (Chestwood, NY, 1980), pp. 52–53, 32, 36, 73–74, 27, 28–29; cf. C. Mango, ed., *The Art of the Byzantine Empire, 312–1453: Sources and Documents* (Englewood Cliffs, NJ, 1972), pp. 169–72. On the christological context of John's *Apologies*, see Pelikan, *Eastern Christendom*, pp. 37–90, 114–17, 127–31.

7. G. B. Ladner, "The Concept of the Image in the Greek Fathers and the Byzantine Iconoclastic Controversy," *Dumbarton Oaks Papers* 7 (1953), pp. 1–34; M. Barasch, *Icon: Studies in the History of an Idea* (New York, 1992), pp. 185–253.

8. T. Ware, *The Orthodox Church* (Baltimore, 1963), p. 39.

9. Pelikan, *Imago Dei*, p. 182.

10. Mathew, p. 105 (italics mine).

11. Cf. C. Mango, "Antique Statuary and the Byzantine Beholder," *Dumbarton Oaks Papers* 17 (1963), pp. 55–75.

12. Grabar, *L'iconoclasme*, pp. 299–302.

13. Mathew, p. 1.

14. N. P. Ševčenko, *The Life of St. Nicholas in Byzantine Art* (Turin, 1983), surveying fifty-six images of the St. Nicholas cult surviving in the church art of Greece and the Balkans from the eleventh to the fifteenth centuries, concludes that the "remarkably consistent iconography" found therein is owed to the "basic workshop education" of the artists (see especially pp. 155, 172).

15. J. H. Breasted, *Oriental Forerunners of Byzantine Painting* (Chicago, 1924); M. Rostovtzeff, *Dura-Europos and Its Art* (Oxford, 1938); C. R. Morey, *Early Christian Art: An Outline of the Evolution of Style and Iconography in Sculpture and Painting from Antiquity to the Eighth Century* (Princeton, 1953); and K. Weitzmann, *Byzantine Book Illumination and Ivories* (London, 1980), noting (p. 3) that Byzantine hieratic composition—strict frontality, abstractionism, "intentional restraint of motion," all expressing "dignity, remoteness, awe, sanctity"—"ultimately derived from the ancient orient." See also K. Schubert, "Jewish Pictorial Traditions in Early Christian Art," in H. Schreckenberg and K. Schubert, *Jewish Historiography and Iconography in Early and Medieval Christianity* (Minneapolis, 1992), pp. 139 ff., for an introduction to this neglected topic.

16. Quoting S. Vryonis, Jr., "The Byzantine Legacy in the Formal Culture of the Balkan Peoples," in J. J. Yiannias, ed., *The Byzantine Tradition after the Fall of Constantinople* (Charlottesville, VA,

1991), pp. 29–36. For the manual itself, P. Hetherington, ed. and trans., *The "Painter's Manual" of Dionysius of Fourna* (London, 1974), which is based on a Greek manuscript of unknown provenance probably of the second half of the eighteenth century preserved at the State Public Library (GPB), St. Petersburg. See also, on Byzantine and Western pattern books, O. Demus, *Byzantine Art and the West* (New York, 1970), pp. 31–44, with illustrations.

17. Demus, p. 3.

18. The theme of Murphy, "Theory of the Visual Arts in Old Russia."

19. The literature on Byzantine imagery is immense, as the catalog by J. S. Allen, *Literature on Byzantine Art,* 2 vols. (London, 1973, 1976), amply demonstrates. A good introduction, beautifully illustrated, and focused on painting, is Weitzmann et al., *The Icon.* Standard surveys in English include D. Talbot Rice, *Art of the Byzantine Era* (London, 1963); A. Grabar, *The Art of the Byzantine Empire,* trans. B. Forster (New York, 1967); and S. Runciman, *Byzantine Style and Civilization* (Baltimore, 1975); but see also R. Cormack, *Writing in Gold: Byzantine Society and Its Icons* (New York, 1985). In addition to more specialized works cited earlier in this chapter, see C. Walter, *Art and Ritual of the Byzantine Church* (London, 1982), which is concerned mainly with iconography; and I. Kalavrezou-Maxeiner, *Byzantine Icons in Steatite,* 2 vols. (Vienna, 1985). On the decline of the Byzantine empire, see D. M. Nicol, *The Last Centuries of Byzantium, 1261–1453,* 2d ed. (Cambridge, 1993), which stresses (following the standard view) the central role of the Orthodox church in keeping alive "the Byzantine spirit"—through its liturgy, icons, and monasteries—after the fall of Byzantium itself (p. 411); and further, S. Ćurčić and D. Mouriki, eds., *The Twilight of Byzantium: Aspects of Cultural and Religious History* (Princeton, 1991). On the Byzantine diaspora in the Slavic world, see D. Obolensky, *The Byzantine Commonwealth: Eastern Europe, 500–1453* (New York, 1971), and A. Ducellier, *Byzance et le monde orthodoxe* (Paris, 1986): also, various essays in Vagner, ed., *Vizantiia i Rus';* in I. Ševčenko, *Ideology, Letters and Culture in the Byzantine World* (London, 1982), and Ševčenko, *Byzantium and the Slavs in Letters and Culture* (Cambridge, MA, 1991); in Clucas, ed., *Byzantine Legacy;* and in Yiannias, as cited above (n. 16, this chapter). For the artistic diaspora specifically, see Millet et al., *L'art byzantin chez les Slaves;* W. F. Volbach and J. Lafontaine-Dosogne, *Byzanz und der christliche Osten* (Berlin, 1968); A. Papageorgiou, *Icons of Cyprus,* trans. (from Greek) J. Hogarth (New York, 1970); M. Chatzidakis, *Études sur la peinture postbyzantine* (London, 1976), and Chatzi-

dakis, *Icons of Patmos: Questions of Byzantine and Post-Byzantine Painting* (Athens, 1985); A. Bozhkov, *Bŭlgarskata ikona* (Sofia, 1984); A. J. Wharton, *Art of Empire: Painting and Architecture of the Byzantine Periphery* (University Park, PA, 1988); M. Acheimastou-Potamianou, ed., *Holy Image, Holy Space: Icons and Frescoes from Greece,* trans. D. A. Hardy (Athens, 1988), for Crete and Macedonia as well as Greece; and A. E. Laiou and H. Maguire, eds., *Byzantium: A World Civilization* (Washington, DC, 1992) (essays by Maguire and G. Vikan).

20. Likhachëv, *Kul'tura vremeni Rublëva,* is a general introduction to the subject; pp. 116–38 concern the revival of painting, on which see also Popova, *Iskusstvo chetyrnadtsatogo veka.* For the problematics of the icon's earlier history in *Rus' /* Russia, see the refreshingly frank discussion by G. Vzdornov, "Frühe russische Ikone," in Haustein-Bartsch, ed., *Russische Ikonen,* pp. 73–118; for those of the *Rus'*-Byzantine relationship in art, essays by V. N. Lazarev in his *Vizantiiskoe i drevnerusskoe iskusstvo,* pp. 211–26, and by O. Popova, "Medieval Russian Painting and Byzantium," in Grierson, ed., *Gates of Mystery,* pp. 45–59.

21. See Lazarev, *Andrei Rublëv i ego shkola,* and Alpatov, *Andrei Rublëv,* both with numerous illustrations; also, specialized essays by Demina in her *Rublëv i khudozhniki ego kruga.* Plugin, *Mirovozzrenie Rublëva,* surveys historiographical problems, many unresolved, arising from study of Rublëv.

22. The main study is Vzdornov, *Feofan Grek,* magnificently illustrated; but see also Lazarev, "Etiudy o Feofane Greke," and Lazarev, *Feofan Grek i ego shkola.*

23. Vzdornov, *Feofan Grek,* pp. 11, 8; and for a thorough description of the Novgorod murals, ibid., pp. 59–78 and pls. I./1–73. For the latter, see also Vzdornov, *Freski Feofana Greka.*

24. Vzdornov, *Feofan Grek,* pp. 12–13; and for the icons in question, ibid., pp. 79–84 with plates II./1–9.

25. One early Russian chronicle—the so-called Trinity Chronicle of 1409—states specifically, in an entry dated 1405, that Rublëv worked under Feofan decorating the church of the Annunciation in the Moscow Kremlin (M. D. Priselkov, ed., *Troitskaia letopis': rekonstruktsiia teksta* [M./L., 1950], p. 459); but the degree to which Feofan influenced Rublëv remains a matter of dispute: see Sh. Ia. Amiranashvili, "Feofan Grek i Andrei Rublëv," in Alpatov, ed., *Rublëv i ego epokha,* pp. 171–80, and, more generally, Lazarev, *Feofan Grek i ego shkola.* The surviving passages of Epifanii's letter to Abbot Cyril, written about 1410 but preserved in a seventeenth-century manuscript (at GPB), are printed in Vzdornov, *Feofan Grek,* pp. 40–49; cf. Arkin and Ternovets, *Mastera iskusstva,* pp. 15–18.

26. Popova, "Medieval Russian Painting," in Grierson, ed., *Gates of Mystery,* p. 49; also E. Smirnova, "The Schools of Medieval Russian Painting," in ibid., p. 64.

27. Alpatov, *Drevnerusskaia zhivopis',* p. 12. On Greek or South Slavic vs. indigenous factors in the rise particularly of a Moscow school of painting, see R. Croskey, "Byzantine Greeks in Late Fifteenth- and Early Sixteenth-Century Russia," in Clucas, *Byzantine Legacy,* pp. 33–56; and Lazarev, *Russkaia ikonopis',* pp. 84 ff.

28. Kondakov, *Russian Icon,* is the classic statement of Italian influence on Russian art of the fifteenth and sixteenth centuries (see pp. 8–9, 72–82, 119–23, etc.): a view which even Minns, Kondakov's English translator and himself a specialist, found exaggerated (ibid., p. 82 n. 1, and "Translator's Preface," pp. viii–ix). Kondakov's view is more fully elaborated in his *Ikonografiia Bogomateri.*

29. J. Meyendorff, *Byzantium and the Rise of Russia: A Study of Byzantino-Russian Relations in the Fourteenth Century* (Cambridge, 1981), pp. 18, 21–23, 125; also Meyendorff, "Remarks on the Byzantine Legacy in Russia," in Yiannias (work cited n. 16 above, this chapter), pp. 45–60.

30. *Poslanie ikonopistsu . . . :* a critical edition of the text is in Ia. S. Lur'e and N. A. Kazakova, *Antifeodal'nye ereticheskie dvizheniia na Rusi XIV–nachala XVI veka* (M./L., 1955), pp. 320–73. For analysis of its (mainly Byzantine) sources, see Murphy, "Theory of the Visual Arts in Old Russia," pp. 44–86; also Goleizovskii, "'Poslanie ikonopistsu,'" which argues rather exaggeratedly that the "Epistle" is at once an "antiheretical polemic," an "original treatise on questions of religious art," and an attempt to synthesize the Byzantine defense of icon-veneration with Hesychasm (the influential system of mysticism propagated by monks of Mount Athos in the fourteenth century). The initial, properly epistolary part of the Lur'e-Kazakova 1955 edition of the *Poslanie* has been reprinted in Gavriushin, ed., *Filosofiia russkogo religioznogo iskusstva,* pp. 34–36 (see also editor's notes, pp. 385–86, which remind us that the work has been attributed to Nil Sorskii [d. 1508] as well); Gavriushin also prints three sermons in defense of icons also attributed to Joseph Volotskii (ibid., pp. 36–44), all of them aimed at "the Novgorod heretics who say it is not seemly to bow down to things created by human hands" or "to depict the One and Holy Trinity on icons," etc.

31. *Stoglav* (Kazan', 1862), pp. 51–52. The primary source for this standard edition (and for the Kazan' 1887 and 1912 editions) was a seventeenth-century manuscript of the council's proceedings then preserved at the Kazan' Theological Academy: another edition is by D. E. Kozhanchikov, *Stoglav* (SPb, 1863); further details in D. Stefanovich, *O Stoglave. Ego proiskhozhdenie, redaktsii i sostav* (SPb., 1909), and in Jack E. Kollmann, Jr., "The *Stoglav* Council and Parish Priests," *Russian History/Histoire russe* 7 (1980), pp. 65–66. E. Duchesne, ed. and trans., *Le Stoglav, ou les cent chapitres: Recueil des décisions de l'assemblée ecclésiastique de Moscou, 1551* (Paris, 1920) is based on the Kazan' 1887 ed., but the translation is excessively liberal.

32. *Stoglav* (1862), pp. 202–10.

33. G. Ostrogorskij, "Les décisions du 'Stoglav' concernant la peinture et les principes de l'iconographie byzantine," in Millet et al., *L'art byzantin chez les Slaves,* 2:394–400.

34. *Stoglav* (1887), p. 81.

35. Cf. I. Žuček, *Kormčaja Kniga: Studies in the Chief Code of Russian Canon Law* (vol. 168 of *Orientalia Christiana Analecta* [Rome, 1964]), especially pp. 158–64; and Stefanovich, pp. 196–316. It is sometimes suggested that "Maxim the Greek" might have influenced the authors of the *Stoglav* on the matter of images, among other questions. An Orthodox monk who had spent much of his youth in Italy, Maxim (born Michael Trivolis) came to Moscow from Mount Athos in 1518 and spent most of the rest of his life in monastic confinement for alleged heresy; a scholar of considerable learning who wrote several works in defense of holy images, his influence on the *Stoglav* has not been demonstrated. See A. I. Ivanov, *Literaturnoe nasledie Maksima Greka* (L., 1969), nos. 146, 148, 149, 150, 151, 279, 280, 297 (with thanks to Dr. Hugh Olmsted, who doubts several of Ivanov's attributions); also, more generally, J. Y. Haney, *From Italy to Muscovy: The Life and Works of Maxim the Greek* (Munich, 1973), especially pp. 87–88, 130; D. Obolensky, "Italy, Mount Athos, and Muscovy: The Three Worlds of Maximos the Greek," *Proceedings of the British Academy* 67 (1981), pp. 143–61 (reprinted in Obolensky, *Six Byzantine Portraits* [Oxford, 1988], pp. 201–19); H. Olmsted, "A Learned Greek in Muscovite Russia: Maksim Grek and the Old Testament Prophets," *Modern Greek Studies Yearbook* 3 (1987), pp. 1–73, with full critical apparatus; and J. V. Haney, "Maksim Grek: A Humanist in Russia," *Modern Greek Studies Yearbook* 4 (1988), pp. 266–70, concluding: "The task of evaluating the impact of Maksim on Russian culture of the sixteenth and seventeenth centuries has just begun" (p. 270). Various brief writings in defense of icons attributed to Maxim have recently been published in Russian: Gavriushin, *Filosofiia,* pp. 45–48 and editor's notes, pp. 386–87.

36. *Stoglav* (1887), p. 79.

37. The sixteenth-century account of the Viskovatyi trial is printed in *Chteniia v Imperatorskom obshchestve istorii i drevnostei rossiiskikh pri Moskovskom universitete*, 1858, no. 2, sec. III, pp. [1]–[42], with preface (pp. iii–viii) by O. Bodianskii. See further Miller, "Viskovatyi Affair."

38. Mango (n. 6 above, this chapter), pp. 169–71, 139–40.

39. Ostrogorskij, "Les décisions du 'Stoglav,'" p. 402.

40. N. Andreev, "Mitropolit Makarii"; and N. Andreev, "O 'Dele Viskovatago.'" See also L. Uspenskii, "Rol' moskovskikh soborov v iskusstve" (reprinted in Gavriushin, *Filosofiia*, pp. 318–49): Uspenskii criticizes both church councils—of 1551 and 1553–1554—from the standpoint of "Orthodox Tradition" for their "passive conservatism" in the face of obvious Latin incursions in Russian icon painting of the time.

41. V. A. Tumins, ed. and trans., *Tsar Ivan IV's Reply to Jan Rokyta* (The Hague, 1971): see p. 484 for Rokyta's charge, and pp. 324–25 for the quoted excerpt from Ivan's refutation (Russian original on pp. 271–72).

42. A Slavic version produced in Tver about 1400, preserved at GBL, reproduces an earlier translation probably made in Kiev, or a copy of the latter made in Vladimir; at any rate, this splendid work on parchment, with 129 miniatures, evidently belonged to the Trinity–St. Sergius monastery at the time of Ivan IV. See Popova, *Russian Illuminated Manuscripts*, pl. 17 (with extended caption opposite); Vzdornov, "Illiustratsii k khronike Amartola"; Podobedova, *Miniatiury russkikh istoricheskikh rukopisei*, pp. 11–48; and M. M. Kopylenko, "Gipotakticheskie konstruktsii slaviano-russkogo perevoda 'Khroniki' Georgiia Amartola," *Vizantiiskii vremennik* 12 (1957), pp. 232–41.

43. Cf. K. Weitzmann, "The Mandylion and Constantine Porphyrogennetos," in Weitzmann, *Studies in Classical and Byzantine Manuscript Illumination*, ed. H. L. Kessler (Chicago, 1971), pp. 224–46.

44. As documented by P. Bushkovitch, *Religion and Society in Russia: The Sixteenth and Seventeenth Centuries* (New York, 1992), pp. 100 ff. Ivan's ghostwriter has been identified as one Parfiemii Iurodivyi of Suzdal, who around 1560 wrote a "Letter to a Stranger against the Lutherans," a copy of which was given by Ivan IV to Rokyta in 1570 and then published abroad (Speyer, 1582) with Rokyta's reply as Ivan's work: see Michalski, *Reformation and the Visual Arts*, pp. 136–37, citing L. Müller, *Die Kritik des Protestantismus in der russischen Theologie vom 16. bis zum 18. Jh.* (Wies-baden, 1951), pp. 28–29. To us it matters only that the work came from within core Muscovite circles.

45. N. Andreev, "O 'Dele Viskovatago,'" p. 237. Likhachëv has noted the quality of literalness with respect to holy images appearing similarly in early Russian literature, where fictions translated from Byzantine sources "were understood first and foremost as historically authentic narratives, as historical documents of a kind. However much fantasy entered them, they appeared to the [Russian] narrators to be only the truth, and were believed in as were the miracles related in translated lives of saints" (D. S. Likhachev, "Foreword" to D. C. Waugh, *The Great Turkes Defiance: On the History of the Apocryphal Correspondance of the Ottoman Sultan in Its Muscovite and Russian Variants* [Columbus, OH, 1978], p. 4).

46. Alpatov, *Drevnerusskaia ikonopis'*, especially pp. 8, 12, 18, 60. The Muscovite concern with proper form in icon painting and relative indifference to content is in striking contrast to the *opposite* attitude towards religious art prevalent in contemporary (Reformation) Europe, where theology was of course comparatively well developed: cf. T. D. Kaufmann, *Court, Cloister, and City: The Art and Culture of Central Europe, 1450–1800* (Chicago, 1995), especially chap. 5.

47. Kondakov, *Russian Icon*, pp. 42–43. For published *podlinniki* see the *Stroganovskii ikonopisnyi litsevoi podlinnik*, which lithographically reproduces a manuscript original dating to ca. 1600 then (1869) in the collection of S. G. Stroganov; also, Bol'shakov and Uspenskii, *Podlinnik ikonopisnyi*, which is a second edition of this "Stroganov" *podlinnik* expanded to include other material on icon painting of the late sixteenth and early seventeenth centuries. See further Gur'ianov, *Litsevye sviattsy*, which photographically reproduces an early seventeenth-century manuscript menologion illustrated in fine *podlinnik* style; Rovinskii, *Obozrenie ikonopisaniia*, pp. 57, 81–90, 92–108; and Buslaev, "Literatura russkikh ikonopisnykh podlinnikov."

48. Hamilton, *Art and Architecture of Russia*, pp. 103–4.

49. Bushkovitch, pp. 10–31, with numerous further references.

50. Podobedova, *Moskovskaia shkola zhivopisi*, pp. 5–9; Lazarev, *Moskovskaia shkola ikonopisi*, pp. 50 ff.; etc.

51. Smirnova, *Moscow Icons*, apparently agrees: see especially pp. 41–43, where the transition from sixteenth- to seventeenth-century Muscovite painting is accomplished without reference to a crisis or decline.

52. A. Grabar, "L'expansion de la peinture

russe," pp. 65–93. See also Podobedova, *Moskov-skaia shkola zhivopisi*, p. 9; Svirin, *Iskusstvo knigi Drevnei Rusi*, pp. 151–52; and Briusova, *Russkaia zhivopis' 17 veka*, pp. 28–29.

53. See Bushkovitch, pp. 35, 48, 52, 100 ff., for reference to written evidence of the rise of private devotion in sixteenth-century Russia.

54. Lazarev, *Russkaia ikonopis'*, p. 158. On the rise of the Russian iconostasis, see further L. V. Betin, "Ob arkhitekturnoi kompozitsii drevnerus-skikh vysokikh ikonostasov," in Lazarev et al., eds., *Drevnerusskoe iskusstvo . . . Moskvy*, pp. 41–56; and Labrecque-Pervouchine, *L'Iconostase.*

55. A sample of Stroganov icons on panel and cloth dating from the late sixteenth to the middle seventeenth century is reproduced with expert commentary by T. Vilinbakhova and others in Grierson, ed., *Gates of Mystery*, pp. 277–99 (nos. 85–94).

56. Kondakov, *Russian Icon*, p. 153.

57. See again G. Marker, "Literacy and Literacy Tests in Muscovy: A Reconsideration," *Slavic Review* 49 (Spring 1990), pp. 74–89.

58. N. S. Kollmann, "Pilgrimage, Procession and Symbolic Space in Sixteenth-Century Russian Politics," in Flier and Rowland, eds., *Medieval Russian Culture*, pp. 163–81; D. Rowland, "Biblical Military Imagery in the Political Culture of Early Modern Russia," ibid., pp. 182–212. In this same collection M. S. Flier carries the visual cause forward into the seventeenth century, in a case yielding impressive historical as well as methodological results: Flier, "Breaking the Code: The Image of the Tsar in the Muscovite Palm Sunday Ritual," ibid., pp. 213–42. See also, for another rare instance of the use of visual sources in Muscovite historiography, Crummey, "Court Spectacles."

59. Michalski, *Reformation and the Visual Arts*, pp. 99–101, 131 ff.; also, overall, M. V. Dmitriev, *Pravoslavie i Reformatsiia* (M., 1900), with cautious analysis of significant texts; and, on Protestant iconoclasm in its Western context, H. Feld, *Der Ikonoklasmus des Westens* (Leiden, 1990). For Metropolitan later St. Philip (Filipp) of Moscow, a Novgorodian nobleman (born Fedor Kolychev) and probable veteran of the Livonian war who lived 1507–1569 and reigned 1566–1568, until deposed and then murdered at the instigation of Ivan IV, see entry by S. Rozhdestvenskii in *Rbs* 21 (1901), pp. 116–21; A. A. Zimin, *Oprichnina Ivan Groznogo* (M., 1965), pp. 212–59; and R. G. Skrynnikov, *Nachalo oprichniny* (L., 1966), pp. 339–409. Philip, then head of a major monastery, was also an active participant in the *Stoglav* council of 1551, so presumably was relatively well versed on the question of icons.

60. This is another subject with a large literature: J. J. G. Alexander, *Medieval Illuminators and Their Methods of Work* (New Haven, 1992), with full bibliography (pp. 187–203) is a good start; but see also G. Bologna, *Illuminated Manuscripts: The Book before Gutenberg* (New York, 1988); and C. de Hamel, *A History of Illuminated Manuscripts* (Boston, 1986), which are more deliberately introductory. See further essays by Otto Pacht in his *Book Illumination in the Middle Ages: An Introduction*, trans. K. Davenport (New York, 1986); the older D. F. Bland, *A History of Book Illustration: The Illuminated Manuscript and the Printed Book* (London, 1958); and two visually splendid as well as learned guides, L. B. Kanter et al., *Painting and Illumination in Early Renaissance Florence, 1300–1450* (New York, 1994), and J. J. G. Alexander, ed., *The Painted Page: Italian Renaissance Book Illumination, 1450–1550* (New York, 1994).

61. M. Thomas, *The Golden Age: Manuscript Painting at the Time of Jean, Duke of Berry*, trans. (from French) U. Molinaro and B. Benderson (New York, 1979), p. 7.

62. G. Vikan, "Survey of Style," in Vikan, ed., *Illuminated Greek Manuscripts from American Collections* (Princeton, 1973), pp. 18–19. Cf. K. Weitzmann, *Illustrated Manuscripts at St. Catherine's Monastery on Mount Sinai* (Collegeville, MN, 1973), citing a richly illustrated codex of 1469 written by a Cretan scribe (in Venice): Weitzmann suggests that its miniatures "neither continue the latest phase of Palaeologan art nor lead to any basically new form of expression, but rather reflect an attempt to hold on to the more distant past and to fight for the survival of a culture whose very existence was threatened" (pp. 30–31 and fig. 44). See further, for the history of Byzantine manuscript illumination, K. Weitzmann, "The Study of Byzantine Book Illumination, Past, Present, and Future," in Weitzmann, *Byzantine Book Illumination and Ivories* (London, 1980), pp. 1–61; Weitzmann, *Aus den Bibliotheken des Athos: Illustrierte Handschriften aus mittel- und spätbyzantinischer Zeit* (Hamburg, 1963); J. Ebersolt, *La Miniature byzantine* (Paris, 1926); W. H. P. Hatch, *Greek and Syrian Miniatures in Jerusalem* (Cambridge, MA, 1931); P. S. Christou et al., *The Treasures of Mount Athos: Illuminated Manuscripts*, 3 vols. (Athens, 1974–75, 1980); V. D. Likhachëva, *Iskusstvo knigi: Konstantinopol' XI vek* (M., 1976), and Likhachëva, *Vizantiiskaia miniatiura*, both with numerous examples from Russian collections. A particularly fine set of Byzantine miniatures taken from a manuscript *Menologion* in the Vatican Library dating to the early eleventh century was published by M. I. and V. I. Uspenskii: *Litsevoi mesiatseslov grecheskago im-*

peratora Vasiliia II († 1025 g.): mesiats oktiabr' (SPb., 1903). Other individual examples of distinction include the famous Khludov Psalter of the ninth century now at GIM (M. V. Shchlepkina, ed., *Miniatiury Khludovskoi Psaltyri: grecheskii illiustrirovannyi kodeks IX veka* [M., 1977]); and the twelfth-century chronicle of John Scylitzes now at the National Library in Madrid: A. Bozhkov, ed., *Miniatiuri ot Madridsiia r"kopis na Ioan Skilitsa* (Sofia, 1972). N. P. Ševčenko, *Illustrated Manuscripts of the Metaphrastian Menologion* (Chicago, 1990), catalogues forty-three surviving illuminated Byzantine menologia of the tenth and eleventh centuries, with 466 illustrations reproduced on microfiche.

63. Likhachëva, *Vizantiiskaia miniatiura,* pp. 10–11 and nn. to pls. 1–62 passim. These sixty-two miniatures are taken from fifteen Greek manuscripts in Russian collections dating from the ninth to the sixteenth centuries, of which only three were acquired by Russians before the nineteenth century (two in the seventeenth century; the provenance of the third, an eleventh-century *Menologion,* is uncertain). See also B. L. Fonkich, "Antonin Kapustin [1817–94] kak sobiratel' grecheskikh rukopisei," in Podobedova, ed., *Drevnerusskoe iskusstvo: rukopisnaia kniga,* 3:368–74, with an appendix listing ninety-four Greek manuscripts of the ninth to the nineteenth centuries acquired by Kapustin and now in repositories in Kiev, St. Petersburg, and Moscow (pp. 375–79); or E. E. Granstrem, "Grecheskie srednevekovye rukopisi v Leningrade," *Vizantiiskii vremennik* 8 (1956), pp. 192–207, which notes that the major collections of medieval Greek manuscripts in Leningrad (at GPB, incorporating the former Imperial Library, the library of the former St. Petersburg Ecclesiastical Academy, etc., and at BAN) were all formed in the nineteenth and twentieth centuries (pp. 192–93). Detailed lists of these manuscripts are provided by Granstrem in successive issues of this journal: see her summary with index in *Vizantiiskii vremennik* 32 (1971), pp. 109–30.

64. O. V. Zvegintseva, "Rukopisnye knigi Biblioteki Novgorodskogo Sofiiskogo sobora," in Podobedova, ed., *Drevnerusskoe iskusstvo: rukopisnaia kniga,* 3:252–66. This collection is now at GPB.

65. Data from Arkhimandrit Vladimir, *Sistematicheskoe opisanie rukopisei Moskovskoi Sinodal'noi (Patriarshei) Biblioteki* (M., 1894): collection now at GIM. A catalog of fifty-eight Byzantine illuminated psalters in various world repositories lists a twelfth-century codex with fourteenth-century miniatures now at GIM (Kod. gr. 407): the earliest reference to this codex is in an "inventory of 1631

of the effects of the Patriarch Filaret of Moscow," and from the Patriarchal later Synodal Library it came in 1920 to GIM (see A. Cutler, *The Aristocratic Psalters of Byzantium* [Paris, 1984], no. 33 [p. 53], citing information provided by G. I. Vzdornov). See also S. [A.] Belokurov, *O biblioteke moskovskikh gosudarei v XVI stoletii* (M., 1898), which notes (pp. 117–18) that in contemporary (early 1630s) inventories of their contents all of the offices under Patriarch Filaret contained a total of five Greek manuscripts, one of which evidently was illuminated (no doubt the codex just referred to, by Cutler from Vzdornov). Belokurov's exhaustive study attempts to determine the existence and content of the tsar's library in the sixteenth century, particularly under Ivan IV; he concludes that in about 1600 it consisted of forty-one manuscripts and seventeen printed books, and that there is no evidence that any of these works was Greek (p. 323). Belokurov is also the source of the information that Sukhanov was given 3,000 rubles in 1653 to buy, as it turned out, a total of 498 Greek manuscripts: for these and other details of Sukhanov's mission, see Belokurov, *Arsenii Sukhanov,* vol. 1 (M., 1891), chap. 5; Fonkich, *Grechesko-russkie kul'turnye sviazi,* pp. 68–104; and T. G. Stavrou and P. R. Weisensel, *Russian Travelers to the Christian East from the Twelfth to the Twentieth Century* (Columbus, OH, 1986), p. 50.

66. Vzdornov, *Iskusstvo knigi,* p. 132 and, for the other details mentioned, passim; J. Meyendorff, as cited above (n. 29, this chapter).

67. Popova, *Miniatures russes,* pp. 7–8. This work later appeared in its original Russian, edited somewhat (e.g., to eliminate comments cited above regarding the comparative paucity of Russian miniatures), as O. S. Popova, "Russkaia knizhnaia miniatiura XI–XV vv.," in Podobedova, ed., *Drevnerusskoe iskusstvo: rukopisnaia kniga,* 3:9–74. A shortened English edition of this work has also appeared: Popova, *Russian Illuminated Manuscripts.* The English and French editions are handsomely illustrated, the Russian less so. The provenance of the Psalter written in Kiev in 1397 by Archdeacon Spiridon, with miniatures thought to have been painted somewhat later in Moscow, tends to confirm points being made above: from the early sixteenth century to the 1870s the Psalter was in private or church collections in Lithuania and Poland, first coming into Russian hands in 1874; in 1932 it was acquired by GPB (see Popova, *Miniatures russes,* p. 8 and pls. 51–53; Popova, *Russian Illuminated Manuscripts,* pls. 28–29 [with extended captions]; and, more generally, Vzdornov, *Issledovanie o Kievskoi Psaltyri*).

68. Vzdornov, *Iskusstvo knigi,* p. 132.

69. Cf. W. R. Veder, "Old Russia's 'Intellectual Silence' Reconsidered," in Flier and Rowland, *Medieval Russian Culture,* pp. 18–28, and references therein to work by Francis Thomson.

70. Popova, *Miniatures russes,* pp. 8, 10.

71. V. N. Lazarev, "Feofan Grek i moskovskaia shkola miniatiury 90-kh godov XIV veka," *Vizantiiskii vremennik* 8 (1956), pp. 143–65; also Svirin, *Iskusstvo knigi Drevnei Rusi.*

72. E.g., Popov, *Zhivopis' i miniatiura Moskvy,* with 197 plates.

73. Cf. A. I. Nekrasov, "Les frontispieces architecturaux des manuscrits russes avant l'époque de l'imprimerie," in Millet et al., *L'art byzantin chez les Slaves,* 2, pt. 2:253–81, providing evidence of Western influence at this early stage.

74. Popova, *Miniatures russes,* pp. 76 ff., 154–60; pls. 54–71.

75. Quoted in Svirin, *Drevnerusskaia miniatiura,* p. 66.

76. Popova, "Russkaia knizhnaia miniatiura" (n. 67 above, this chapter), author's prefatory note, p. 9; Popova, *Russian Illuminated Manuscripts,* pls. 36–39 (with extended captions). But cf. Lazarev, "Feofan Grek" (n. 71 above), who argues that while the master of the Khitrovo illuminations was more likely a local artist than Feofan Grek himself, the former would necessarily have worked under the "direct supervision" of the latter, producing an "original fusion of Byzantine, Western, and Russian forms" (p. 162).

77. See the *Rukopis' iz Uspenskogo sobora,* a packet of twelve photoreproductions in color of six of the miniatures and of various ornamental details, with accompanying text by T. Ukhova (L., 1972); this codex is now at GOP.

78. See S. O. Shmidt, "K izucheniiu Litsevogo letopisnogo svoda," in Podobedova, ed., *Drevnerusskoe iskusstvo: rukopisnaia kniga,* 3:204–11; and the more extended analysis by Podobedova, *Miniatiury russkikh istoricheskikh rukopisei,* pp. 102–314.

79. On this point, see particularly Artsikhovskii, *Drevnerusskie miniatiury,* pp. 41–154.

80. The last point is clearly brought out in Podobedova, *Miniatiury russkikh istoricheskikh rukopisei,* passim; and in Svirin, *Drevnerusskaia miniatiura,* pp. 94–119. See also Vladimirov and Georgievskii, *Drevnerusskaia miniatiura,* with 100 reproductions.

81. I. E. Danilova and N. E. Mnëva, "Zhivopis' XVII veka," in Grabar' et al., *Istoriia russkogo iskusstva,* 4 (1959): 354.

82. A fine selection of such objects is displayed in Boldov and Vladimirskaya, eds., *Treasures of the Czars;* and more fully in Bobrovnitskaia et al., *Gos. Oruzheinaia palata,* pp. 71–94 (essay by M. V. Martynova) and passim. See also I. A. Bobrovnitskaia,

"The Golden Age of Russian Jewelry: Moscow Metalwork, 1500–1800," in Allenov et al., *Moscow Treasures,* pp. 88–103, also handsomely illustrated.

83. Svirin, *Iskusstvo knigi,* pp. 135–52.

84. *Kniga ob izbranii na tsarstvo . . . Mikhaila Fedorovicha* (M., 1856): manuscript preserved at GOP.

85. *Bol'shaia gosudarstvennaia kniga ili Koren' rossiiskikh Gosudarei . . . :* see Kostsova, "'Tituliarnik,'" pp. 16–40. See also Z. E. Kalishevich, "Khudozhestvennaia masterskaia Posol'skogo prikaza v XVII v. i rol' zolopistsev v ee sozdanii i deiatel'nosti," in N. V. Ustiugov et al., *Russkoe gosudarstvo v XVII veke: Sbornik statei* (M., 1961), pp. 392–411; M. D. Kagan-Tarkovskaia, "'Tituliarnik' kak perekhodnaia forma ot istoricheskogo sochineniia XVII v. k istoriografii XVIII v.," *TODRL* 29 (1971), pp. 54–63; and M. M. Rogozhin and E. V. Chistiakova, "Posol'skii prikaz," *Voprosy istorii,* 1988, no. 7 (July), pp. 113–23.

86. Kostsova, "'Tituliarnik,'" especially pp. 27–32.

87. A. Uspenskii, "Russkii zhanr XVII veka," pp. 87–97. See further N. E. Mnëva, "Izografy Oruzheinoi palaty i ikh iskusstvo ukrasheniia knigi," in Bogoiavlenskii and Novitskii, eds., *Gos. Oruzheinaia palata,* pp. 217–46, with twenty-three illustrations; and A. Smith and V. Budaragin, *Living Traditions of Russian Faith: Books and Manuscripts of the Old Believers* (Washington, DC, 1990), p. 23, reproducing an illustration from a Gospel book of the 1680s with pronounced "Baroque ornamental elements" that was illuminated by Kremlin masters for Tsarevna Sof'ia, half-sister of Peter I.

88. Svirin, *Iskusstvo knigi,* p. 142 and passim. See also, for lesser examples of later seventeenth-century illuminated manuscript *sinodiki* (devotional works), Golyshev, ed., *Al'bom risunkov,* with thirty excellent reproductions; and, more generally on the same subject, A. Uspenskii, *Tsarskie ikonopistsy,* 3:1–16.

89. Cf. A. G. Sakovich, "Miniatury iz russkogo apokrificheskogo sbornika serediny XVIII v.," in *Pamiatniki kul'tury: Novye otkrytiia. Ezhegodnik 1982* (L., 1984), pp. 329–33; Pokrovskii and Romodanovskaia, eds., *Rukopisnaia traditsiia.* One of Pokrovskii's articles on the subject has been translated by J. S. G. Simmons into English: see N. N. Pokrovskii, "Western Siberian Scriptoria and Binderies: Ancient Traditions among the Old Believers," *Book Collector* (Spring 1971), pp. 19–24, with eight plates. I have personally examined numerous manuscript books of the seventeenth to nineteenth centuries in Russian collections, most memorably with the late V. I. Malyshev at the Institute of Russian Literature (Pushkinskii dom) in St. Petersburg, many of which were of Old-Believer provenance and had only recently (1972)

been found by him in the far north: e.g., Sob. Pukhal'skogo No. 5, a beautifully decorated hymnal of ca. 1700 with later additions; Sob. Tumilevicha No. 2, an illustrated grammar probably of the later eighteenth century; or Ust'-Tsilemskoe nov. sob. No. 221, a late nineteenth-century illuminated copy of a tale of Old-Believer martyrdom dating to 1743. A selection from these manuscript books is reproduced with commentaries in Smith and Budaragin, as cited above (n. 87).

90. Cf. Vzdornov, *Istoriia otkrytiia,* especially pp. 47 ff.; also Itkina, *Russkii risovannyi lubok,* with reproductions of 113 pictures drawn and painted by Old Believers mainly in the nineteenth century and preserved into the twentieth by Old-Believer communities in northern Russia.

91. First published in London in 1591; see the scholarly edition by L. E. Berry and R. O. Crummey, *Rude & Barbarous Kingdom: Russia in the Accounts of Sixteenth-Century English Voyagers* (Madison, WI, 1968), pp. 87–246.

92. Ibid., pp. 234, 109, 237.

93. Ibid., p. 214.

94. S. H. Baron, ed. and trans., *The Travels of Olearius in Seventeenth-Century Russia* (Stanford, 1967), pp. 50, 172, 244, 233–34, 253.

95. Ibid., pp. 256–57.

96. S. Collins, *The Present State of Russia: In a Letter to a Friend at London* (London, 1671), pp. 3, 24, 25, 29.

97. J. Struys, *Voyages of Jan Struys through Italy, Greece, Lifeland, Moscovie . . . ,* trans. J. Morrison (London, 1688), pp. 151–52.

98. G. Miege, *A Relation of the Three Embassies from his Sacred Majestie Charles II to the Great Duke of Muscovie . . . in the Years 1663 and 1664* (London, 1669), pp. 70, 71.

99. B. Coyet, *Posol'stvo Kunraada fan-Klenka k tsariam Alekseiu Mikhailovichu i Fedoru Alekseevichu* (SPb., 1900), pp. 470, 540, 465, 516; this Russian translation is printed together with the text of Coyet's Dutch original, *Historisch Verhael, of Beschryving van de voyage, Gedaen onder de suite van den Heere Koenraad van Klenk . . .* (Amsterdam, 1677).

100. From a letter quoted in H. T. Hionides, *Paisius Ligarides* (New York, 1972), p. 69.

101. See again Meyendorff, *Russia, Ritual, and Reform,* p. 51.

102. J. G. Korb, *Diary of an Austrian Secretary of Legation at the Court of Czar Peter the Great,* 2 vols., ed. and trans. (from Latin) the Count MacDonnell (London, 1863; facsimile reprint, London, 1968), 2:286.

103. C. Le [de] Bruyn, *Travels into Muscovy, Persia, and Part of the East-Indies . . . ,* 2 vols. (London, 1737; 1st ed. Amsterdam 1711, in Dutch), 1:70, 71, 72.

104. Boldov and Vladimirskaya, *Treasures of the Czars,* p. 120.

105. Bruyn, pp. 26, 29, 30, 37, 51, 52.

106. J. Perry, *The State of Russia under the Present Czar* (London, 1716), pp. 174–77, 221–23.

107. Ibid., pp. 223–24, 230, 226–27.

108. F. C. Weber, *The Present State of Russia,* 2 vols. (London, 1722–23), 1:236–37, 130, 152, 185.

109. The diaries were first published in successive issues of *Buschings Magazin für die neue Histoire und Geographie* printed at Halle between 1785 and 1787 (Bergholtz had met Busching in Wismar, where he lived from 1746 until his death in 1771). A Russian translation of this German edition, by I. F. Ammon, was published in four parts in Moscow between 1857 and 1860 and again between 1859 and 1862. In 1902–3 a third Russian edition of the Ammon translation, by P. Bartenev, was published in Moscow, still with the title *Dnevnik Kamer-iunkera F. V. Berkhgol'tsa, 1721–1725.*

110. Ibid., 1:90, 91, 92.

Chapter 3

1. See Saltykov, "Esteticheskie vzgliady Vladimirova," pp. 272–73, which argues for 1656–58; but another student suggests that the work was in preparation in 1660–64 and completed not before 1665–66: E. S. Ovchinnikova, ed., "Iosif Vladimirov. Traktat ob iskusstve," in Lazarev et al., eds., *Drevnerusskoe iskusstvo: XVII vek,* pp. 17–21.

2. "Poslanie nekoego izugrafa Iosifa k tsarevu izugrafu i mudreishemu zhivopistsu Simonu Fedorovichu," as printed in Ovchinnikova, ed., "Vladimirov Traktat," pp. 24–61. The manuscript, in seventy-eight quarto leaves, is now at GIM (Sobr. Uvarova No. 915).

3. Buslaev, "Russkaia estetika XVII veka" (1910).

4. Ovchinnikova, *Tserkov' Troitsy v Nikitnikakh,* p. 10; Fedorov-Davydov, "Iosif Vladimirov," in Arkin and Ternovets, *Mastera iskusstva,* p. 25; and Briusova, *Russkaia zhivopis' 17 veka,* pp. 27–28 and fig. 18.

5. Briusova, *Russkaia zhivopis' 17 veka,* pp. 167–70.

6. "Poslanie izugrafa Iosifa," Ovchinnikova edition, pp. 24–25, 55–56.

7. Ibid., pp. 53, 57 (for John of Damascus), and pp. 55, 25 (for Patriarch Nikon and his reforms).

8. Ibid., pp. 48, 45, 11 (and n. 3).

9. Ibid., p. 24.

10. Buslaev, "Russkaia estetika XVII veka," p. 429.

11. Saltykov, "Esteticheskie vzgliady Vladimirova," p. 288.

12. "Slovo k liubotshchatel'nomu ikonnago pisaniia," in G. [D.] Filimonov, ed., *Vestnik Obshches-*

tva drevnerusskago iskusstva pri Moskovskom publichnom muzee (M., 1874), "Materialy," no. 4, pp. 22–24; manuscript now at GPB (No. O. XIII-4); text reprinted in Gavriushin, *Filosofiia*, pp. 56–60, with editor's notes, p. 387. See also Filimonov's monograph, *Ushakov* (1873).

13. See Dmitriev, "Teoriia iskusstva," pp. 98–99, for a survey of the literature on the question of attribution.

14. "Slovo k liubotshchatel'nomu ikonnago pisaniia," Filimonov edition, p. 22.

15. The Abgar legend was invoked in the preceding chapter by Ivan IV; icons painted in this tradition were common in Russia from the fourteenth century. Vladimirov in his "Epistle" to Ushakov also refers to the legend (Ovchinnikova edition, p. 30). It might be noted that St. John of Damascus recounts the "story" without comment in his *De fide Orthodoxa*: see C. Mango, ed., *The Art of the Byzantine Empire, 312–1453: Sources and Documents* (Englewood Cliffs, NJ, 1972), p. 169.

16. "Slovo k liubotshchatel'nomu ikonnago pisaniia," Filimonov edition, p. 23.

17. Mango, p. 37.

18. "Slovo k liubotshchatel'nomu ikonnago pisaniia," Filimonov edition, p. 24.

19. P. P. Pekarskii, ed., "Materialy dlia istorii ikonopisaniia v Rossii," *Izvestiia Imp. Arkheologicheskago obshchestva* 5, no. 5 (1865), cols. 320–25 (col. 323 for the passage quoted).

20. Ibid., col. 325.

21. Printed in ibid., cols. 326–29.

22. A. Nikol'skii, ed., "Slovo k liubotshchatelem ikonnago pisaniia," *Vestnik arkheologii i istorii, izdavaemyi Imp. Arkheologicheskim institutom* 20 (1911), pp. 65–77.

23. Original text with editor's notes in N. K. Gudzii, ed., *Zhitie protopopa Avvakuma, im samim napisannoe, i drugie ego sochineniia* (M., 1960), pp. 135–37, 380–81; and in A. N. Robinson, ed., *Zhitie Avvakuma i drugie ego sochineniia* (M., 1991), pp. 253–55, 352–53. See further Andreyev, "Nikon and Avvakum on Icon Painting," pp. 42–44; also B. A. Uspensky, "The Schism and Cultural Conflict in the Seventeenth Century," in S. K. Batalden, ed., *Seeking God: The Recovery of Religious Identity in Orthodox Russia, Ukraine, and Georgia* (DeKalb, IL, 1993), pp. 106–43: Uspensky sees in Avvakum's and the Old Believers' attitude to icons evidence of a typically Muscovite literalness or "conjunction of form and content."

24. N. Subbotin, ed., *Deianiia Moskovskikh soborov [1666] i [1667] godov* (M., [1893]; reprinted The Hague, 1970), pp. [4], 22–25] (Slavonic numerals used throughout). See further the large collection of documents edited by N. Gibbenet, *Dela Pa-*

triarkha Nikona, 2 vols. (SPb., 1882, 1884), which confirms that the image question figured as little at the council as it did in the entire "Nikon affair." There is some evidence—mainly the testimony of a single foreign witness—that Nikon earlier (in 1654) had publicly remonstrated against icons painted in "Italianate" style, an action offensive to the tsar and high officials which may then have contributed to Nikon's eventual downfall: see Meyendorff, *Russia, Ritual, and Reform*, p. 51.

25. For Ligarides and his history of the Moscow church council of 1666–67, see the still authoritative edition by W. Palmer, which forms vol. 3 of Palmer's *The Patriarch and the Tsar* (London, 1873). See also E. Legrand et al., *Bibliographie hellénique, ou Description raisonée des ouvrages publiés par des Grecs au dix-huitième siècle*, vol. 4 (Paris, 1928), pp. 8–61; and H. T. Hionides, *Paisius Ligarides* (New York, 1972).

26. *Zhitie Avvakuma*, Gudzii edition, p. 135.

27. Bylinin, "K voprosu o polemike"; Bylinin advances the discussion well beyond the pioneering work of Maikov, "Polotskii o russkom ikonopisanii." See also Bylinin and Grikhin, "Polotskii i Ushakov"; and P. Bushkovitch, *Religion and Society in Russia: The Sixteenth and Seventeenth Centuries* (New York, 1992), pp. 163–72 and passim. Citing the close correspondence between a passage in Ushakov's "Address" and an earlier Latin treatise on art by a Jesuit author, D. C. Murphy argues that Polotskii must have written the longer, theoretical portion of the "Address" and Ushakov, only its brief practical section (Murphy, "Cicero and the Icon Painters: The Transformation of Byzantine Image Theory in Medieval Muscovy," in Clucas, ed., *Byzantine Legacy*, pp. 155–60). Murphy argues similarly for Polotskii's authorship of the patriarchal charter of 1668 (ibid., p. 164, n. 45) while failing to establish, in either case, that Polotskii knew the Jesuit treatise in question. Other promising leads are suggested by the contents of Polotskii's large library, its titles mostly in Latin, including a 1635 edition of Pliny's *Historia naturalis*: see A. R. Hippisley, "Simeon Polotsky's Library," *Oxford Slavonic Papers* 16 (1983), pp. 52–61.

28. Polotskii's manuscript *Zapiska* is now at GBL (Sobr. Rumiantseva No. CCCLXXVI, ll. 12–20).

29. *Beseda o pochitanii ikon sviatykh*: autograph manuscript as well as a closely contemporary copy in the hand of Polotskii's student S. Medvedev at GIM (Sinod sobr. No. 660, ll. 80–95, and No. 289, ll. 95–112). Three other copies of the work dating to the end of the seventeenth century or the beginning of the eighteenth are at BAN (Arkhang. sobr. No. 459, No. 460; Olonets sobr.

33.7.4). An extract is printed in Bylinin, "K voprosu o polemike," pp. 287–89.

30. Cf. Bylinin, "K voprosu o polemike," especially pp. 285, 286, 288.

31. Cf. Anan'eva, *Ushakov,* p. 18.

32. *Akty sobrannye v bibliotekakh i arkhivakh Rossiiskoi Imperii Arkheograficheskoi ekspeditsei imp. Akademii Nauk,* vol. 4 (SPb., 1836), no. 200 (pp. 254–55).

33. Text in Gavriushin, *Filosofiia,* pp. 49–55, with editor's notes, p. 387.

34. Bushkovitch, pp. 152 ff., 172–73, and passim; also, J. Cracraft, "Theology at the Kiev Academy during Its Golden Age," *Harvard Ukrainian Studies* 8, no. 1/2 (June 1984), pp. 71–80.

35. Joachim's testament is printed in N. G. Ustrialov, *Istoriia tsarstvovaniia Petra Velikago,* vol. 2 (SPb., 1858), appendix 9, pp. 467–77 (see pp. 472, 476 for passages quoted).

36. F. I. Buslaev, "Obshchiia poniatiia o russkoi ikonopisi," in Buslaev, *Sochineniia,* vol. 1 (SPb., 1908), pp. 23, 9; Uspenskii, *Tsarskie ikonopistsy,* 2:21–22, 26.

37. E.g., Uspenskii's four splendid volumes of 1900–1916 on seventeenth-century Russian painting (*Tsarskie ikonopistsy*). See also M. I. and V. I. Uspenskii, *Materialy* (1899), with 101 plates; N. P. Likhachëv, *Kratkoe opisanie* (1905), and *Materialy,* 2 vols. (1906), the latter with photographic reproductions of 864 icons then in private as well as public collections; and Muratov, *Drevne-russkaia ikonopis'* (1914), with seventy-six illustrations. Kondakov, *Russkaia ikona,* 4 vols. (1928–33), also well illustrated, is concerned primarily with iconography.

38. Grabar' et al., *Istoriia russkago iskusstva,* vol. 6: *Istoriia zhivopisi: Do-Petrovskaia epokha* (M., [1916]); the first eleven chapters of this volume, on painting in the early seventeenth century, were written by P. [M.?] Muratov, the remaining six chapters, on the seventeenth century, by Grabar'—with the exception of chapters on foreign painters in Moscow at this time (by Grabar' with A. I. Uspenskii) and on Ukrainian painting of the period (by E. Kuz'min): throughout the volume attention is confined to wall and panel painting. In his introductory chapter here Muratov refers respectfully to Rovinskii, *Obozrenie ikonopisaniia* (1903), a somewhat abbreviated version of which was first published in 1856, making it the first serious history of Old-Russian painting to appear. The fuller, 1903 edition of Rovinskii's essay is printed without illustration but with an extended appendix of documentary material.

39. Grabar' et al., *Istoriia zhivopisi,* pp. 411–12, 422, 425, 440. This negative view of Ushakov and

his period persisted, to be echoed, most prominently, by Alpatov, *Drevnerusskaia ikonopis',* especially pp. 48–50.

40. Grabar' et al., *Istoriia zhivopisi,* pp. 481–82, 495, 512–14, 497. For outstanding examples of the murals Grabar' was talking about, see Vakhromeev, *Tserkov' vo imia Ilii v Iaroslavle* (1906).

41. Cf. F. van der Meer, *Apocalypse: Visions from the Book of Revelation in Western Art* (London, 1978), with 282 illustrations; and A. Chilingirov, "Vliianie Diurera i sovremennoi emu nemetskoi grafiki na ikonografiiu postvizantiiskogo iskusstva," in Lazarev et al., eds., *Drevnerusskoe iskusstvo: zarubezhnye sviazi,* pp. 325–42.

42. Grabar' in Grabar' et al., *Istoriia zhivopisi,* pp. 518–33, citing the research of I. M. Tarabin (p. 519, n. 1).

43. Ibid., p. 534.

44. Uspenskii, *Tsarskie ikonopistsy,* 4:274–75.

45. Ibid., 4:19–22; also 2:315.

46. Ibid., 3:17; also Uspenskii, "Ivan Artem'evich Bezmin," p. 205; and I. E. Zabelin, *Domashnyi byt russkikh tsarei XVI i XVII stoletii* (M., 1895), p. 192.

47. Uspenskii, *Tsarskie ikonopistsy,* 4:19; Grabar' et al., *Istoriia zhivopis',* 6:520.

48. For which see also Vakhromeev, *Tserkov' vo imia Ilii,* with seventy-five large-format plates; and various more recent works on seventeenth century painting cited below, especially Briusova, *Russkaia zhivopis' 17 veka.*

49. Nekrasov, ed., *Barokko v Rossii,* with contributions (three specifically on painting) by Nekrasov, N. I. Brunov, and M. V. Alpatov among others.

50. E. P. Sachavets-Fëdorovich, "Iaroslavskie stenopisi i bibliia Piskatora," in Shmit et al., *Russkoe iskusstvo XVII veka* (1929), pp. 85–108.

51. Karger, "Iz istorii zapadnykh vliianii" (1928), with nine illustrations.

52. See Grabar' and Anisimov, *Voprosy restavratsii,* 2 vols. (1926–28); and Bobrov, *Istoriia restavratsii,* pp. 65 ff.

53. Sychev, "Novoe proizvedenie Ushakova" (1928); Nechaev, *Ushakov* (1927). On Veronese and his architecture, see S. Martinelli et al., *Veronese e Verona* (Verona, 1988).

54. Nekrasov, *Drevnerusskoe iskusstvo* (1937), pp. 329–66; Mikhailovskii and Purishev, *Ocherki istorii drevnerusskoi zhivopisi* (1941), especially pp. 83–84, 97 ff.

55. Cf. Leonov, *Ushakov.*

56. Cf. Grabar' et al., *Istoriia russkogo iskusstva,* 13 vols. (M., 1953–69), and Grabar' et al., *Istoriia russkago iskusstva,* 6 vols. (M., [1910–16]).

57. Grabar' et al., *Istoriia russkogo iskusstva,* vol.

4 (1959), pp. 7–54 (intro. Iu. N. Dmitriev and I. E. Danilova).

58. See ibid., pp. 345–466, for an extended essay (by I. E. Danilova and N. E. Mnëva) on seventeenth-century Russian painting.

59. Cf. the relevant sections of Lazarev et al., eds., *Drevnerusskoe iskusstvo: XVII vek;* or Iu. G. Malkov, "Zhivopis'," in Artsikhovkii et al., eds., *Ocherki russkoi kul'tury XVII veka*, pp. 208–38. We're heartened here by the sustained critique of nationalist interpretations of art history to be found in T. D. Kaufmann, *Court, Cloister and City: The Art and Culture of Central [and Eastern] Europe, 1450–1800* (Chicago, 1995), which touches on Russia.

60. Briusova, *Russkaia zhivopis' 17 veka.* See also Briusova's earlier monographs listed in the Bibliography.

61. Ibid., pp. 9, 42, 44, 49, 51–52, 172.

62. Ibid., pp. 176, 30.

63. Ibid., pp. 77–88, 94 ff.

64. Ibid., pp. 96–100, with figs. 87–93, 96, 97, 143, 145; and pls. 51, 55–59, 63, 66, 126, 131–36, 144, 148, 171–78, 180, 181.

65. Ibid., pp. 173–74, 98–99, 123.

66. Ibid., pp. 69, 78, 42.

67. Ibid., pls. 33 (pl. 11 here), 37 (attributed to "unknown master," 1670s), 39 ("Moscow school," beginning of the eighteenth century), 104 ("Moscow school," 1670s), 126 ("Workshop of Gurii Nikitin," ca. 1680), 131–35 ("Gurii Nikitin and associates," 1680–81), 158 ("Dmitrii Grigor'ev and associates," 1686–88), 172 and 174 ("Fëdor Fëdorov, Fëdor Ignat'ev and associates," 1697), etc.

68. Ibid., pp. 20, 54; pls. 36–38 and figs. 44–47.

69. Ibid., pp. 46–47.

70. Ibid., pp. 29–30, 33, 55, 59, 171–76 and n. 27 (p. 188), quoting Trutovskii, "Boiarin Khitrovo," p. 381.

71. E.g., appropriate passages in Allenov et al., *Moscow Treasures*, especially pp. 82 ff. (essay by T. V. Tolstaya); in Grierson, ed., *Gates of Mystery*, especially pp. 266–69, 274–76 (by A. Maltseva), and pp. 300–308 (N. Turtsova); or in Boldov and Vladimirskaya, eds., *Treasures of the Czars*, especially pp. 52–159 passim (by M. V. Martynova, O. B. Melnikova, I. A. Bobrovnitskaya, and I. I. Vishnevskaya): these are exhibition catalogs annotated by Russian scholars for Western audiences; or Floria, "Nekotorye dannye"; etc. The economic situation in Russia in recent years has of course seriously impeded scholarly publication.

72. The voluminous papers of the *Oruzheinaia palata* are at TsGADA, principally in Fond 396, and inventoried in A. Viktorov, *Opisanie zapisnykh knig i bumag starinykh dvortsovykh prikazov 1584–*

1725 g., 2 vols. (M., 1877, 1883), vol. 2, sec. 4 (pp. 377–490), which remains the basic guide to the collection. With respect to painting, the major work based on these holdings is Uspenskii, *Tsarskie ikonopistsy:* the following discussion draws variously on these sources, which are hereafter specifically cited only in the case of direct quotation. It might be noted that in armaments the Armory Office dealt chiefly with small arms as distinct from artillery, which was administered by another office, the *Pushkarskii prikaz.* For the history and contents of the Armory Chamber as a modern museum (GOP), see Bobrovnitskaia et al., *Gos. Oruzheinaia palata*, splendidly illustrated.

73. Trutovskii, "Boiarin Khitrovo."

74. Uspenskii, *Tsarskie ikonopistsy*, 4:16.

75. Moleva, "Tsekhovaia organizatsiia," p. 47.

76. TsGADA, F. 396, op. 2, d. 964, l. 192.

77. Ibid., d. 967, l. 151.

78. Calculation based on Uspenskii, *Tsarskie ikonopistsy,* 1: passim.

79. M. N. Larchenko, "Novye dannye o masterakh-oruzheinikakh Oruzheinoi palaty pervoi poloviny XVII veka," in *Gos. Muzei Moskovskogo Kremlia: Materialy i issledovaniia*, vol. 2 (1976), pp. 24–25.

80. Cf. Poliakova, "Novootkrytye ikony," which studies eight icons from a village in central Russia painted in the 1670s for local churches by royal masters from Moscow; or Petnitska et al., *Zhivopis' Vologodskikh zemel'*, which features (pp. 66–67, 71, 72) several icons done by royal masters for Vologda patrons in the late seventeenth–early eighteenth centuries. For the latter, see more generally Vzdornov, *Art of Ancient Vologda*, passim, with numerous illustrations.

81. Moleva, "Tsekhovaia organizatsiia," p. 46.

82. Viktorov, *Opisanie zapisnykh knig,* 1:45, 49; also Uspenskii, *Tserkovno-arkheologicheskoe khranilishche*, pp. ii–vi, 7–83.

83. Cf. Uspenskii, *Tsarskie ikonopistsy,* 4:17–18.

84. Ibid., 2:83–84.

85. Cf. Moleva, "Tsekhovaia organizatsiia," p. 47.

86. Uspenskii, "Sobranie drevnerusskikh ikon," pp. 55–57.

87. I. Grabar' and A. Uspenskii, "Tsarskie ikonopistsy i zhivopistsy 17-go veka," and I. Grabar', "Zhivopistsy-inozemtsy v Moskve," in Grabar' et al., *Istoriia russkago iskusstva*, 6:409–24, 425–54; see also ibid., 1:49. On the arrival of portraiture in Moscow see now, most helpfully, Floria, "Nekotorye dannye," analyzing verbal evidence of the direct route; for the rustic portraiture of greater Poland, see numerous samples in *Mille ans d'art en Pologne* (Paris, 1969), nos. 101–29; A. Fischinger,

ed., *Sztuka dworu Wazów v Polsce/Court Art of Vasa Dynasty in Poland* (Cracow, 1976); M. Matusakaite, *Portretas XVI–XVIII a. Lietuvoye* (Vilnius, 1984); and the earlier portions of L. I. Tananaeva, *Pol'skoe izobrazitel'noe iskusstvo epokhi prosveshcheniia* (M., 1968). The tendency in Soviet scholarship to minimize if not deny the importance of European influence in seventeenth-century Russian portraiture is especially obvious in Ovchinnikova, *Portret*, pp. 3–8 passim. Nationalist sensitivities presumably also led Ovchinnikova to deny that the corruption "parsuna" appears in seventeenth-century archival documents (Ovchinnikova, *Portret*, p. 3, n. 1): in fact, among many such examples an inventory of the Armory Chamber compiled in 1687 lists a "*Parsuna* of [tsar] Michael Fedorovich, painted on panel. . . . *Parsuna* of Ts. Aleksei Mikhailovich, painted on linen. . . . [Another] *Parsuna* of Tsar Aleksei. . . . [And a] *Persona* of the Metropolitan of Kiev, Peter Mogila" (TsGADA, F. 396, op. 2, d. 936, l. 651). As Russians learned Latin, it seems, *parsuna* was gradually replaced by *persona*; as they absorbed the standards of the new European art, the latter term was in turn superseded, by the mid-eighteenth century, by *portret*, the modern Russian for "portrait" and obviously a direct borrowing from French and/or German (cf. Grabar' et al., *Istoriia russkago iskusstva*, 6:410).

88. Information about the foreign masters is taken from Uspenskii, *Tsarskie ikonopistsy*, 1: passim, and 2:23–27; Grabar' et al., *Istoriia russkago iskusstva*, 6:412–22; Novitskii, "Parsunnoe pis'mo," pp. 384–403; and other sources cited hereafter.

89. The attribution became standard: cf. V. Trutovskii, "'Romanovskaia' tserkovno-arkheologicheskaia vystavka v Moskve," *Starye gody* (June 1913), pp. 39–40; Trutovskii rated the artist "one of the best" and the portrait itself a work of the "first importance" in this era of artistic flowering in Moscow. The portrait, then (1913) at the New Jerusalem monastery at Istra (founded by Nikon) and reproduced by Trutovskii (ibid., opposite p. 38), was destroyed in World War II. It also might be noted that an official of the Dutch embassy to Moscow of 1675–76, Balthasar Coyet, observed on his visit to the New Jerusalem monastery "a full-length portrait of Patriarch Nikon, very well painted by a German" (B. Coyet, *Posol'stvo Kunraada fan-Klenka k tsariam Alekseiu Mikhailovichu i Fedoru Alekseevichu* [SPb., 1900], p. 465).

90. Full-page reproduction in Grabar' et al., *Istoriia russkago iskusstva*, 6:417 (picture now at the Moscow Regional Museum at Istra). Ovchinnikova suggests that the entire picture was done in the 1680s, after Nikon's death, by a "brigade of

Russian artists" headed by Ivan Bezmin (*Portret*, pp. 95–96, 98–99), an attribution apparently accepted without question by Briusova (*Russkaia zhivopis' 17 veka*, p. 54) and by L. Hughes (*Sophia, Regent of Russia 1657–1704* [New Haven, 1990], p. 139 and n. 38 [p. 297]). The lack of any but circumstantial evidence—slight, at that—as well as Ovchinnikova's nationalist bias do not encourage acceptance, even tentative, of this suggestion. On Wuchters, see also A. Miller, "Daniel Wuchters," *Oud Holland* 57 (1940), pp. 40–48.

91. Uspenskii, "Tsarskii zhivopisets Saltanov," pp. 75–86, with six reproductions of paintings, all religious in subject, by Saltanov; also Lavrent'ev, "K biografii Ushakova," p. 14.

92. Uspenskii, "Zhivopisets Vasilii Poznanskii," pp. 63–85.

93. Until 1910, at least: see photographs in Uspenskii, *Tsarskie ikonopistsy*, 1: opposite pp. 210, 212.

94. Uspenskii, "Zhivopisets Vasilii Poznanskii," pp. 63–73; twenty-two of these are also reproduced in Uspenskii, *Tsarskie ikonopistsy*, 1: between pp. 204–5 and opposite pp. 206, 208.

95. Hughes's is a lone voice in the literature arguing, with a little support from Russian scholars, that a revolution or renaissance in Russian art did occur in the later seventeenth century, more specifically in the 1680s: "Painting, applied art and architecture, even literature all display to a greater or lesser degree elements of a distinctive style commonly referred to as 'Moscow Baroque,' which heralded not only the death of Old Russian culture but also the beginning of a prolonged stylistic era which came to an end only with the turn to Classicism in the 1760s" (*Sophia*, pp. 134 ff.). I dealt with the claim for architecture, which is basic to the whole argument, in *Revolution in Architecture*, especially chap. 4: my refutation, essentially, there as now, is that one swallow does not make a summer; in Hughes's own words, that "elements" which in retrospect "herald" something surely do not themselves constitute the thing heralded.

96. Uspenskii, "Ivan Artem'evich Bezmin," pp. 198–206; and Briusova, *Russkaia zhivopis' 17 veka*, pp. 53–55.

97. Lavrent'ev, "K biografii Ushakova," p. 14.

98. Reproduced in Uspenskii, *Tsarskie ikonopistsy*, 1: opposite pp. 28, 30, 32; also in Uspenskii, "Ivan Artem'evich Bezmin," between pp. 198–99, 200–201, 204–5. A full-length "portrait" of Patriarch Nikon now at GIM, its vestments made of colored silk and cloth of gold applied to a panel, its face and hands painted in oil on the panel, was first published by Ovchinnikova, in *Portret*, p. 87;

see pp. 86–101 for her discussion of this work, which she attributes to Bezmin in the early 1680s, after Nikon's death. The attribution is not conclusive; Bogdan Saltanov, for one, is as likely a candidate.

99. A point also made by A. Maltseva, in Grierson, ed., *Gates of Mystery,* pp. 266–69, where she also cites V. G. Briusova for unsubstantiated attribution of icons of the time or *kleima* thereof to individual painters (p. 269).

100. Pavlenko, "Karp Zolotarev"; also Il'enko, "Avtograf Karpa Zolotareva."

101. Uspenskii, *Tsarskie ikonopistsy,* 4:23–24; G. V. Esipov, ed., *Sbornik vypisok iz arkhivnykh bumag o Petre Velikom,* vol. 1 (M., 1872), no. 591 (p. 162).

102. TsGADA, F. 396, op. 2, d. 964, l. 3; F. 396, op. 2, d. 986, ll. 5ob., 15ob., 44.

103. Reproduced in Uspenskii, *Tsarskie ikonopistsy,* 1, between pp. 278–79. But see also Gordeeva and Tarasenko, "Literaturnye istochniki dvukh ikon"; and Briusova, *Russkaia zhivopis' 17 veka,* pp. 49–52.

104. Uspenskii, *Tsarskie ikonopistsy,* 1:321–69. See again Filimonov, *Ushakov;* Nechaev, *Ushakov;* Anan'eva, *Ushakov;* and Bekeneva, *Ushakov.* See further Uspenskii, *Piat' ikon Ushakova;* Trenev, *Ikony Ushakova;* Gur'ianov, *Ikony Ushakova;* Grabar' et al., *Istoriia russkago iskusstva,* 6:427–54; Briusova, *Russkaia zhivopis' 17 veka,* pp. 38–42, with figs. 24–26, 28, 29, and pls. 15–17, 20–22; and interesting new details in Lavrent'ev, "K biografii Ushakova," and in Grierson, ed., *Gates of Mystery,* pp. 266–69, 274–76 (commentary by A. Maltseva), with two plates.

105. E.g., E. S. Smirnova, "Simon Ushakov: 'Historicism' and 'Byzantinism': On the Interpretation of Russian Painting from the Second Half of the Seventeenth Century," forthcoming in a volume edited by S. H. Baron and N. S. Kollmann.

106. Cf. Korsh, "Russkoe serebrianoe delo XVII veka."

107. Uspenskii, *Tsarskie ikonopistsy,* 1:337. Filimonov reports the incident with palpable indignation, remaining mystified as to its cause (*Ushakov,* p. 30). Danilova and Mnëva state without documentation that Ushakov was incarcerated "in the mid-1660s . . . for two years," suggesting an iconographic transgression "against church dogma or the official code of morals" as the cause (Grabar' et al., *Istoriia russkogo iskusstva,* 4:376).

108. On the basis of a fresh look at the records, E. M. Kozlitina argues that in 1672 (not 1668, as thought) Ushakov made careful descriptions of the murals in question but did not actually repaint them—that task being accomplished only

in 1882 following Ushakov's descriptions: Kozlitina, "Dokumenty XVII veka po istorii Grannovitoi palaty moskovskogo kremlia," in *Gos. Muzei Moskovskogo Kremlia: Materialy i issledovaniia,* vol. 1 (1973), pp. 95–110.

109. Trenev, *Ikony Ushakova,* p. 7.

110. Filimonov, *Ushakov,* p. 19.

111. Chubinskaia, "Ikona Simona Ushakova."

112. Anan'eva, *Ushakov,* p. 18.

113. Filimonov, *Ushakov,* p. 67.

114. I. E. Zabelin, *Domashnii byt russkikh tsarei XVI i XVII stoletii,* vol. 1 (M., 1918), pp. 216, 221, 223; A. [I.] Uspenskii, "Obstanovka teremov kremlevskago dvortsa v Moskve," *Starye gody* (April 1907), pp. 127–33.

115. A. M. Loviagin, "N. Vitzen iz Amsterdama i patr. Nikona," *Istoricheskii vestnik,* 1899, no. 9, p. 879.

116. *Rozysknyia dela o Fedore Shaklovitom i ego soobshchnikakh,* vol. 4 (SPb., 1893), cols. 595–98; also, more generally, L. Hughes, "'Ambitious and Daring Above Her Sex': Tsarevna Sophia Alekseevna (1657–1704) in Foreigners' Accounts," *Oxford Slavonic Papers,* n.s., 21 (1988), pp. 64–88. The "Latin" print of Tsarevna Sofia is at our figure 38.

117. Ovchinnikova says that this was the "taffeta portrait" attributed by her to Bezmin and now at GIM (*Portret,* p. 88).

118. TsGADA, F. 396, op. 2, d. 938, l. 5ob. See also the more extensive inventories of the Golitsyn properties printed in *Rozysknyia dela o Fedore Shaklovitom,* passim.

119. Foy de la Neuville, *Relation curieuse et nouvelle de Moscovie* (Paris, 1698), pp. 175–80, especially p. 178. On Golitsyn the "Westernizer," see further L. A. J. Hughes, *Russia and the West: The Life of a Seventeenth-Century Westernizer, Prince Vasily Vasil'evich Golitsyn (1643–1714)* (1984).

120. "Zhurnal Gosudaria Petra I s 1695 po 1709," in F. Tumanskii, ed., *Sobranie raznykh zapisok i sochinenii, sluzhashchikh k dostavleniiu polnago svideniia o zhizni i deianiiakh gosudaria imperatora Petra Velikago,* vol. 3 (SPb., 1787), pp. 21–22.

121. The most complete account of the Grand Embassy of 1697–98 is M. M. Bogoslovskii, *Petr I: Materialy dlia biografii,* vol. 2: *Pervoe zagranichnoe puteshestvie* (M., 1941; reprinted The Hague, 1969), 624 pp. Bogoslovskii indicates that 81,000 rubles were sent by order of Peter I from the treasury in Moscow to Amsterdam to pay for hiring experts and purchasing goods (ibid., p. 397); that more than 800 such experts were hired, mainly English and Dutch (pp. 398–99); that four ships were dispatched from Amsterdam to Archangel loaded with everything from "260 chests of firearms" and "48 bales of sailcloth" to "8 trunks of carpen-

ter's tools," 2,000 pounds of cork, and 800 slabs of marble (p. 404); etc. Further study of the Grand Embassy's account books indicates that the purchases also included clocks, compasses, and other gadgets; books, clothes, and wigs; preserved foods, wines, and liquors; eighteen trunks of silver plate; etc.: see N. A. Baklanova, "Velikoe posol'stvo za granitsei v 1697–1698 gg. (ego zhizn' i byt po prikhode-roskhodnym knigam posol'stva)," in A. I. Andreev, ed., *Petr Velikii: sbornik statei* (M./L., 1947), pp. 28–29. Peter's confidential instructions to his ambassadors about hiring experts and buying goods are printed in *PiB*, vol. 1, no. 140 (pp. 135–37). For "Heinrich van Huyssen [1666–1739]" and his activities in Russia (1703–39), see *The Modern Encyclopedia of Russian and Soviet History*, vol. 14 (Gulf Breeze, FL, 1979), pp. 105–8 (entry by P. Petschauer); and Petschauer, "In Search of Competent Aides: Heinrich van Huyssen and Peter the Great," *JGO* 36, no. 4 (1978), pp. 481–502.

122. E. Bénézit, *Dictionnaire critique et documentaire des Peintres, Sculpteurs, Dessinateurs et Graveurs*, vol. 6 (Paris, 1976), pp. 252–53.

123. Bogoslovskii, pp. 310, 583–84.

124. C. de Bruyn, *Travels into Muscovy . . .* , vol. 1 (London, 1737; 1st ed. Amsterdam, 1711, in Dutch), pp. 21–22: the frontispiece to both editions is an engraved portrait of Bruyn after the painting by Kneller. On Kneller, see further M. Killanin, *Sir Godfrey Kneller and His Times* (London, 1948), p. 97 (Bruyn portrait); J. D. Stewart, *Sir Godfrey Kneller* (London, 1971), especially no. 97 (Peter portrait); and Stewart, *Sir Godfrey Kneller and the English Baroque Portrait* (Oxford, 1983), especially pp. 9 (n. 38), 41, 46–47, pl. 42, and cat. no. 570 (p. 123).

125. Bogoslovskii, pp. 583–84, 377–78, 434, 582; also Baklanova (n. 121 above, this chapter), pp. 13–14; and A. I. Andreev, "Petr I v Anglii v 1698 g.," in Andreev, ed., *Pëtr Velikii*, pp. 102–3. The Kneller portrait serves as the frontispiece for the first volume of Peter's collected letters and papers (*PiB* [SPb., 1887]); and is reproduced again by Bogoslovskii, between pp. 310–11, who also uses a contemporary engraving after Kneller as his volume's frontispiece. Wassiltschikoff, *Portraits russes*, lists sixty-five separate portraits of the "Kneller type" engraved in Russia and elsewhere in the earlier eighteenth century, as found in Russian collections ca. 1875 (2:82–104).

126. Cf. Bogoslovskii, pp. 579 (fig. 51), 584; also Baklanova, p. 18. The whole episode of Peter's essay in art is missing from the most recently published study of the Grand Embassy, which concentrates on Holland and draws on Dutch sources

previously overlooked in the Russian literature: V. F. Levinson-Lessing, "Pervoe puteshestvie Petra I za granitsu," in Komelova, ed., *Kul'tura petrovskogo vremeni*, pp. 5–36.

127. J. Scheltema, *Anecdotes historiques sur Pierre le Grand et sur ses voyages en Hollande . . .* (rev. ed., Lausanne, 1842; 1st ed., Amsterdam, 1814, in Dutch), pp. 114–15.

128. Baklanova, pp. 53, 57, 58–59, 44; "Zhurnal Gosudaria" (n. 120 above), p. 42. On Peter's adoption of "German" dress, which had begun in the 1680s with the help of tailors in Moscow's German Settlement and was completed during the Grand Embassy, see E. Iu. Moiseenko, "Mastera-portnye 'nemetskogo plat'ia' v Rossii i ikh raboty," *Trudy Gos. Ermitazha* 15 (1974), pp. 141–51 (drawing on the "Garderob Petra I" at GME consisting of some 300 items).

129. *PSZ*, vol. 4, p. 182, overriding *PSZ*, vol. 1, p. 607.

130. J. Cracraft, *The Church Reform of Peter the Great* (Stanford, 1971), p. 33, citing the original manuscript at the Bodleian Library, Oxford (Add. D. 23, f. 10).

131. J. Perry, *The State of Russia under the Present Czar* (London, 1716), pp. 223–24.

132. Four "masters of carving matters" are listed among the hired specialists in the official records of the Grand Embassy, as reproduced in N. G. Ustrialov, *Istoriia tsarstvovaniia Petra Velikago*, vol. 3 (SPb., 1858), pp. 576–82; a "lifepainter" (*zhivopisets*) is mentioned (ibid., p. 580) among a group of 101 "Greeks and Slavs," mostly naval personnel, hired for the Russian service in Amsterdam in 1698.

133. *Zapisnaia knizhka . . . osoby stranstvovavshei . . . v 1697 i 1698 godu* (SPb., 1788), 50 pp., passim; reprinted with editorial intro. I. F. Gorbunov, as "Zhurnal puteshestviia po Germanii, Golandii i Italii v 1697–1699 gg.," in *Russkaia starina* 25 (1879), pp. 101–32. On the notebook and its probable author, identified as A. M. Apraksin, see further F. Otten, *Der Reisebericht eines anonymen Russen über seine Reise nach Westeuropa im Zeitraum 1697/1699* (Wiesbaden, 1985).

134. P. Pekarskii, *Nauka i literatura v Rossii pri Petre Velikom*, vol. 1 (SPb., 1862), pp. 139–67 (especially 144–45). On the Russian pilgrimage literature before and after Peter, see apposite remarks in T. G. Stavrou and P. R. Weisensel, *Russian Travelers to the Christian East from the Twelfth to the Twentieth Century* (Columbus, OH, 1986), pp. xl–xlii.

135. "Stateinoi spisok . . . B. P. Sheremeteva," in N. Novikov, ed., *Drevniaia rossiiskaia vivliothika*, 2d ed., vol. 5 (M., 1788), pp. 360–432. See further E. F.

Shmurlo, "Poezdka B. P. Sheremeteva," in *Sbornik Russkago Instituta v Prage*, vol. 1 (1929), pp. 5–46; and, on Sheremetev more generally, A. I. Zaozerskii, "Feld'marshal Sheremetev i pravitel'stvennaia sreda Petrovskogo vremeni," in N. I. Pavlenko et al., *Rossiia v period reform Petra I* (M., 1973), pp. 172–98. Zaozerskii speculates that as a popular figure of the old Muscovite nobility Sheremetev was sent in "honorable exile" to Rome by Peter lest he become the object of a plot to replace Peter as tsar while Peter was away on his Grand Embassy. Zaozerskii also emphasizes Sheremetev's traditional Muscovite formation and outlook.

136. A. Florovskii, "Moskovskie navigatory v Venetsii v 1697–1698 gg. i rimskaia tserkov'," in H. Mohr and C. Grau, eds., *Ost und West in der Geschichte des Denkens und der kulturellen Beziehungen* (Berlin, 1966), pp. 194–99. Zaozerskii's essay, cited above (n. 135), does not refer to Sheremetev's possible conversion nor to his account of his trip to Rome (nor to the relevant scholarship by Florovskii and Shmurlo, cited here and above [n. 135]).

137. "Puteshestvia Stol'nika P. A. Tolstago, 1697–1699," *Russkii arkhiv*, 1888, no. 2 (pp. 161–204); no. 3 (pp. 321–68), no. 4 (pp. 505–52), no. 5 (pp. 5–62), no. 6 (pp. 113–56), no. 7 (pp. 225–64), no. 8 (pp. 369–400). An English edition of the diary is M. J. Okenfuss, trans., *The Travel Diary of Peter Tolstoi: A Muscovite in Early Modern Europe* (DeKalb, IL, 1987), with helpful introduction and notes. For Tolstoi see further N. P. Pavlov-Sil'vanskii, "Graf P. A. Tolstoi," in Pavlov-Sil'vanskii, *Sochineniia*, vol. 2 (SPb., 1910), pp. 1–41; and N. I. Pavlenko, *Ptentsy gnezda Petrova* (M., 1984), pp. 110–232.

138. See Cracraft, *Revolution in Architecture*, especially pp. 97–102 (with illustrations).

139. Tolstoi, "Puteshestvie," no. 2 (pp. 176, 186, 192, 194); no. 3 (pp. 340–41, 351); no. 4 (pp. 528–29).

140. Ibid., no. 7 (pp. 231–33, 256–64).

141. Ibid., no. 2 (pp. 176, 185, 199); no. 3 (pp. 345–47, 357, 359, 366); etc.

142. N. P. Pavlov-Sil'vanskii, as quoted in Okenfuss, p. xvi.

143. *Zapiski Ivana Ivanovicha Nepliueva (1693–1773)* (SPb., 1893; reprinted Cambridge, 1974, ed. H. Leventer), p. 48.

144. *Arkhiv Kurakina*, vol. 1 (SPb., 1890), pp. 117, 123, 132, 136, 169.

145. The portrait is known from an engraving of ca. 1717: see Kaliazina and Komelova, *Russkoe iskusstvo*, p. 11.

146. *Arkhiv Kurakina*, vol. 3 (SPb., 1892), pp. 364–65; vol. 4 (SPb., 1893), p. 6.

147. I. S. Sharkova and A. D. Liublinskaia, eds., *Russkii diplomat vo Frantsii (Zapiski Andreia Matveeva)* (L., 1972), p. 35. We return to the Jesuit church in Antwerp in Chapter 4.

148. Ibid., pp. 64–67.

149. Ibid., p. 7; and for the description of Versailles, pp. 223–36. Cf. A. Fébilien, *Description du chateau de Versailles, de ses peintures et d'autres ouvrages . . .* (Paris, 1696), a probable source for Matveev; and remarks by Sharkova and Liublinskaia, *Zapiski Matveeva*, p. 271 (n. 265).

150. Ibid., p. 5; and for Matveev's description of the "Royal Academy of the Painting Art," pp. 221–22. For further details of the portraits of both Matveev and his wife attributed to Rigaud and now at GME, see Kozhina, "Dva portreta"; and Angremy et al., *France et Russie*, no. 256 (p. 169). A later, official-looking portrait of Matveev painted in oil on canvas by an unknown artist is also at GME (from the former Sheremetev palace in St. Petersburg): Kaliazina and Komelova, *Russkoe iskusstvo*, no. 125.

151. *Dnevnik Kameriunkera F. V. Berkhgol'tsa, 1721–1725*, trans. I. F. Ammon, ed. P. Bartenev, vol. 2 (M., 1902), pp. 69–70. Two copies of a 1733 catalog of Matveev's library are at TsGADA (F. 17, op. 1, no. 25; F. 1239, no. 317).

Chapter 4

1. Ia. Dashkevich, "Bumagi dlia tsaria ili gosudareva bumaga? O nachale proizvodstva bumagi v Moskovskom gosudarstve XVI v.," *Russia Mediaevalis* 6, no. 1 (1988), pp. 221–47: this article supplements E. L. Keenan, "Paper for the Tsar: A Letter to Ivan IV of 1570," *Oxford Slavonic Papers*, n.s., 4 (1971), pp. 21–29. Elsewhere Dashkevich adduces figures showing the enormous lag in the establishment of bookprinting in the East Slavic lands (Russia, Ukraine, Belorussia) by comparison with the Latin, Germanic, or even West Slavic countries: e.g., by 1600 only about 100 books had been printed in Cyrillic compared to 25,000 titles in Paris alone, 45,000 in Germany, 10,000 in England, etc.; see Ia. Dashkevich, reviewing Ia. D. Isaievych, *Pershodrukar Ivan Fedorov i vynyknennia drukarstva na Ukraini*, 2d ed. (L'viv, 1983), in *Russia Mediaevalis* 6, no. 1 (1988), pp. 302–7. Nor did the situation significantly change in the seventeenth century, as noted in Chapter 1. On the beginnings of printed book illustration in Russia, Sidorov, *Drevnerusskaia graviura*, despite frequent and florid expressions of Russian nationalism, provides most of the essential information, with illustrations: for the sixteenth-century developments referred to above, see pp. 37–159 and figs. 8, 38, 43, 45. For the 1564 Moscow frontispiece portraying St. Luke, see also A. Smith and V. Budaragin, *Living Traditions of Russian Faith: Books &*

Manuscripts of the Old Believers (Washington, DC, 1990), p. 14 (from the copy at LC).

2. Sidorov, *Drevnerusskaia graviura*, pp. 160–249 (p. 248 for the words quoted).

3. Solov'ev, "Russkaia knizhnaia illiustratsiia," p. 416.

4. K. Nikol'skii, *Ob antiminsakh pravoslavnoi russkoi tserkvi* (SPb., 1872), pp. 41, 270; *PSZ*, vol. 3, no. 1612 (p. 414).

5. Alekseeva, "Maloizvestnye proizvedeniia," pp. 430–37, with illustrations.

6. J. Cracraft, *The Church Reform of Peter the Great* (Stanford, 1971), chap. 2.

7. Alekseeva, "Maloizvestnye proizvedeniia," pp. 437–38, with illustrations; and further, M. A. Alekseeva, "Graviury antiminsov po risunkam A. P. Antropova," in Gavrilova, ed., *Russkaia grafika*, pp. 43–53, also illustrated.

8. Flekel', *Ot Markantonio Raimondi*, pp. 268–69; cf. Flekel' and Alekseeva, *Russkaia graviura*, an album of twenty-seven large-format plates/examples which makes the same claim.

9. From data tabulated in Sidorov, *Drevnerusskaia graviura*, pp. 362–89; Polotskii's roller press is mentioned in Flekel', *Ot Markantonio Raimondi*, p. 269.

10. Sidorov, *Drevnerusskaia graviura*, pp. 260–302. Cf. Ia. P. Zapenko and Ia. D. Isaievych, *Kataloh starodrykiv, vydanykh na Ukraïni (1574–1800)*, 2 vols. (L'viv, 1981, 1984), for numerous examples of engraved book illustrations produced in Ukraine (vol. 1 covers the period 1574–1700); and Stepenovik, *Ukrains'ka hrafika*, which is a thorough, well-illustrated study of the development of graphic art in Ukraine in the seventeenth and eighteenth centuries. The influence of Ukrainian on Russian graphic art and of Ukrainian artists working in Moscow particularly in the later seventeenth century has not been systematically studied; some new information is in Alekseeva, *Graviura petrovskogo vremeni*, pp. 8–12.

11. Flekel', *Ot Raimondi*, p. 269.

12. Sidorov, *Risunok*, pp. 46, 31–45, 35, 61–62, amplified by me from standard works on drawing.

13. Details in Wortman, *Scenarios of Power*, pp. 42–44.

14. Levinson, "Al'bom Viniusa."

15. Ibid., pp. 80–83, 85–91; also Sidorov, *Risunok*, pp. 50–54.

16. Cf. Rovinskii, *Podrobnyi slovar'*, 2: col. 1561. On Potëmkin's embassy, I. Vinogradoff, "Russian Missions to London, 1569–1687: Seven Accounts by the [English] Masters of the Ceremonies," *Oxford Slavonic Papers*, n.s., 14 (1981), pp. 51–52, 54–63. The Potëmkin embassy also visited Paris in 1681, an event recorded in a contemporary French engraving, which is captioned: "L'Audience donnée par Louis le Grand aux ambassadeurs du Grand Duc de Moscovie" (copy at GIM). No doubt at least one copy of this engraving (that at GIM?) was brought home by Potëmkin, too.

17. My account of the engraved portraits of both V. V. Golitsyn and Tsarevna Sof'ia follows Bogdanov, "Politicheskaia graviura," pp. 225–46; also Stepenovyk, *Leontii Tarasevych*, pp. 114–17, 231. But cf. Alekseeva, "Portret Tsarevny," pp. 240–49, which disputes some details; and L. Hughes, *Sophia, Regent of Russia* (New Haven, 1990), pp. 139–44, 169–70. On the portraits of Sof'ia and of the co-tsars, see also Alekseeva et al., *Portret petrovskogo vremeni*, pp. 204–5, 222; and for the contest between Peter and Sof'ia, M. M. Bogoslovskii, *Petr I: materialy dlia biografii*, vol. 1 (M., 1940), pp. 68–88.

18. Cf. K. G. Boon, ed., *Hollstein's Dutch & Flemish Etchings, Engravings and Woodcuts ca. 1450–1700*, vol. 26 (Amsterdam, 1982), pp. 23–46, illustrated and with further references.

19. F. Tumanskii, ed., *Sobranie raznykh zapisok . . . o zhiznii i deianiiakh gos. imp. Petra Velikago*, vol. 3 (SPb., 1787), p. 36.

20. Quoting Wortman, *Scenarios of Power*, pp. 7, 45. See further D. A. Rovinskii, *Opisanie feierverkov i illuminatsii, 1674–1891 gg.* (M., 1903), pp. 179–97 (pagination continuous with Rovinskii's jointly published *Obozrenie ikonopisaniia* = pp. 1–174); Vasil'ev, *Starinnye feierverki*; Maggs, "Firework Art," pp. 24–40; and Röhling, "Fireworks and Illuminations," pp. 94–100.

21. "Korte maniere om de Ets-Konst volkomen te leeren," at BAN (Sobr. Petra I. Q No.196).

22. *Opis. II*, pp. 278–92, 299–300, and appendix 4 (pp. 318–41); Iu. K. Begunov, "A Seventeenth-Century Russian Translation on William of Orange and the 'Glorious Revolution,'" *Oxford Slavonic Papers*, n.s., 20 (1987), pp. 69–70. For Peter's admiration of William, which apparently predated their meetings in 1697–98, see G. Barany, *The Anglo-Russian Entente Cordiale of 1697–1698: Peter I and William III at Utrecht* (Boulder, CO, and New York, 1986).

23. *PSZ*, vol. 4, no. 1751; *PiB*, vol. 1, no. 291.

24. *Opis. II*, appendix 4 (pp. 318–41) and appendix 1, nos. 5–7, 9–15, 17–19.

25. Alekseeva suggests that Schoonebeck had visited Moscow in 1696–97 (where he would have personally witnessed the Azov fireworks that he later etched to Peter's delight), and then returned to work indefinitely in 1698: Alekseeva, *Graviura petrovskogo vremeni*, pp. 15–17, 20–22.

26. TsGADA, F. 396, op. 2, kn. 986, l. 5ob.

27. Bogoslovskii, vol. 4 (M., 1948), pp. 345–47; ibid., vol. 3 (M., 1947), pp. 167, 434–36.

28. TsGADA, F. 396, op. 2, kn. 986, l. 116; kn. 987, ll. 4, 8, 22, 72, 115, 127, 350; kn. 1001, ll. 193–95. Etchings by Schoonebeck preserved at GME are listed and described in Vasil'ev and Glinka, eds., *Pamiatniki russkoi kul'tury,* nos. 49, 492–94, 523, 524, 527–30, 532, 568–608, 648–50, 654–56, 659, 662, 723, 724, 741–48, and pls. 30, 34, 39. For the same or other items in the collection of Peter I at BAN, see Andreev, ed., *Istoricheskii ocherk Biblioteki Akademii Nauk,* 2, pp. 25, 32, 44, 62, 63, 95, 97, 122, 184, 190, 191, 195, 216. References to individual works by Schoonebeck and reproductions of same are scattered throughout the literature on the Petrine era, but no systematic, critical study of his Russian period has been published: Alekseeva, *Graviura petrovskogo vremeni,* pp. 19–50, with notes and illustrations, constitutes the most detailed survey to date.

29. TsGADA, F. 396, op. 2, kn. 990, l. 215.

30. Ibid., kn. 1001, ll. 193–95; kn. 995, l. 353. In Russia Pickaerdt was known and signed himself as "P. Picard" or "Pikart" or "Pikard."

31. See again Vasil'ev and Glinka, eds., *Pamiatniki russkoi kul'tury,* nos. 443, 470, 475, 492, 495, 509–11, 513–16, 525, 526, 529, 530, 533–37, 540, 555–62, 566, 567, 610, 611, 619, 621, 628–46, 660, 661, 663, 670, 672, 678, 684, 686, 693, 709, 715, 716, 725–27, 735, 737, 757, 758; also Andreev, ed., *Istoricheskii ocherk,* vol. 2, pp. 44, 51, 52, 61, 63, 79, 81, 95, 99, 144, 194, 195, 199, 201, 214, 215, 217. As with Schoonebeck, no systematic study of Picart's work, critical though it was in the development of graphic art in Russia, has been published. The most detailed survey again is in Alekseeva, *Graviura petrovskogo vremeni,* pp. 50 ff.—which is the source of 1737 as the year of Picart's death (elsewhere given as 1732).

32. *Opis. I,* no. 18; *Opis. III,* no. 411.

33. *Opis. I,* no. 1: also no. 5 and appendix 6 (pp. 534–40). For Peter's participation in the preparation and publication of the geometry of 1708–1709, see his correspondence with various officials in *PiB,* vol. 7, pt. I, no. 2371, and pt. II, pp. 731–34; also pt. I, no. 2402, and pt. II, p. 815. On the introduction of the new "civil" type, see Peter's correspondence especially with his agent in Holland, in *PiB,* vol. 4, pt. I, no. 1281, and pt. II, pp. 961–63; vol. 5, no. 1545, and pp. 413–17: also no. 1763, no. 1803, and pp. 710–13; vol. 8, pt. I, no. 2824, and pt. II, pp. 936–40: also no. 2840 and pp. 952–55.

34. *Opis. I,* no. 24; *Opis. II,* p. 347. A second edition of this manual was published at Moscow in 1710: *Opis. I,* no. 44. For Peter's role, see correspondence in *PiB,* vol. 4, nos. 1374, 1453; vol. 5, nos. 1544, 1545; vol. 6, no. 2023; vol. 8, pt. I, nos. 2525, 2545, and pt. II, pp. 562–68.

35. *Opis. I,* no. 28.

36. *Opis. I,* nos. 10, 16, 34; *PiB,* vol. 8, pt. I, no. 2932, and pt. II, p. 1057.

37. *Opis. I,* nos. 22, 42; *Opis. III,* no. 4; *PiB,* vol. 6, no. 1998; TsGADA, F. 396, op. 2, d. 1008, l. 343.

38. *Opis. I,* nos. 29, 61, 720. See further Cracraft, *Revolution in Architecture,* pp. 140, 141, 151, 160–61, 243, and, detailing Peter's personal supervision, p. 152.

39. Cracraft, *Revolution in Architecture,* pp. 182–84 and fig. 86.

40. *Opis. I,* no. 51; *Opis. II,* nos. 115, 204: also *Opis. III,* no. 332; *Opis. I,* appendix 4 (pp. 524–27); *Opis. I,* no. 718.

41. *Opis. I,* no. 444; subsequent editions at nos. 465, 500, 684, 760, 792. A facsimile of the St. Petersburg 1763 edition of *Ustav morskoi,* complete with original frontispiece, was reprinted in Moscow in 1993, to mark the three-hundredth anniversary of the Russian navy.

42. *Opis. I,* appendix 3 (pp. 515–23); also M. A. Alekseeva, "Graviury 'Knigi Marsovoi,'" in Alekseeva, *Russkoe iskusstvo* (1974), pp. 190–99, 206–9.

43. *Opis. II,* appendix 1, no. 20 (pp. 295–99); *Opis. I,* appendix 1 (pp. 528–33); and Borzin, *Rospisi petrovskogo vremeni,* pp. 30–34, reproducing the eighty emblems that were significant in Petrine period imagery.

44. J. Staehlin (Stahlin), *Original Anecdotes of Peter the Great* (London, 1788), p. 117.

45. For Blicklant's work, see *Opis. I,* nos. 19, 43 (a book on the knightly orders of Europe originally illustrated by Schoonebeck), 49; and, for his part in designing the Summer Garden in St. Petersburg, Cracraft, *Revolution in Architecture,* p. 184. For de Witte's work, see *Opis. I,* no. 22, and appendix 3 (p. 516); also Vasil'ev and Glinka, eds., *Pamiatniki russkoi kul'tury,* nos. 563, 697, 737.

46. Uspenskii, *Tsarskie ikonopistsy,* 2:104–11; also O. A. Belobrova, "K biografii 'Gosudareva ikonnika' Fëdora Evtikhieva Zubova," in Podobedova, ed., *Drevnerusskoe iskusstvo,* 2:168–74, which concentrates on F. Zubov's work as a miniaturist, with new documentation; and Briusova, *Russkaia zhivopis' 17 veka,* pp. 44–47, with figs. 30, 31, 32, and colored pls. 105–11.

47. Lebedianskii, *Aleksei Zubov* (1981), is the standard biography, superseding Lebedianskii's own *Gravër petrovskoi epokhi* (1973). Lebedianskii states that more than 100 works can be unconditionally attributed to Aleksei Zubov, "significantly more" than to any other Russian graphic artist of the Petrine period (*Aleksei Zubov,* p. 6).

48. Uspenskii, *Tsarskie ikonopistsy,* 1:95, 100; TsGADA, F. 396, op. 2, kn. 987, l. 350.

49. Lebedianskii, *Aleksei Zubov,* p. 12.

50. TsGADA, F. 396, op. 2, kn. 990, ll. 209–12.

51. Cracraft, *Revolution in Architecture*, fig. 69 (p. 130): Lebedianskii, *Aleksei Zubov*, attributes this work, dated 1710, to Zubov (p. 15).

52. Zubov's etching of the Poltava triumph, dated 1711 (= second variant), is reproduced in Lebedianskii, *Zubov*, pls. [1] and [2]; in Vasil'ev and Glinka, eds., *Pamiatniki*, pl. 36; and in Kaliazina and Komelova, *Russkoe iskusstvo*, pl. 162. Lebedianskii suggests that this work is the "first realistic depiction of an event contemporary to the artist in Russian representational art" (*Zubov*, p. 15); but it is uncertain to what extent Zubov relied in its execution (one to two years after the event) on his own sketches of the time, if any, and on Picart's two earlier etchings of the same event; the depiction, following the European fashion, is also highly stylized. For the first variant (dated to August–December 1710) as well as the second of Zubov's etching of the Poltava triumph together with one of Picart's versions, all three having "much in common," see Alekseeva, *Graviura petrovskogo vremeni*, pp. 118–20, with reproductions of all three.

53. TsGADA, F. 396, op. 2, d. 974, ll. 458–60.

54. The print shop of the St. Petersburg Press 1711–27 and the work there of Zubov and Picart (and of A. I. Rostovtsev) is the subject of an extended essay with numerous illustrations in Alekseeva, *Graviura petrovskogo vremeni*, pp. 111–70.

55. See also Alekseeva, "Brat'ia Zubovy," p. 354; and T. P. Dagaeva, "Vin'etki s vidami Sankt-Peterburga v izdaniiakh petrovskogo vremeni," in Gavrilova, ed., *Russkaia grafika*, pp. 5–11.

56. The two etchings are juxtaposed in Vasil'ev and Glinka, eds., *Pamiatniki*, pls. 34, 35.

57. Lebedianskii, *Zubov*, p. 21 and pls. [7–9]; also Vasil'ev and Glinka, eds., *Pamiatniki*, no. 710 and pl. 32; and Kaliazina and Komelova, *Russkoe iskusstvo*, nos. 166–67.

58. The two works are juxtaposed in Vasil'ev and Glinka, eds., *Pamiatniki*, pl. 22.

59. G. N. Komelova, "'Panorama Peterburga' —graviura raboty A. F. Zubova," in Komelova, ed., *Kul'tura petrovskogo vremeni*, pp. 111–43; for Buzhinskii's speech, see also *Opis. I*, no. 243. The *Panorama* and two fragments therefrom are reproduced in large format in Kaliazina and Komelova, *Russkoe iskusstvo*, nos. 168–70; and, less well, in Alekseeva, *Graviura petrovskogo vremeni*, foldout between pp. 140–41, and pp. 150, 151.

60. Alekseeva, "Brat'ia Zubovy," p. 356.

61. Lebedianskii, *Zubov*, p. 34; see also Alekseeva et al., *Portret petrovskogo vremeni*, pp. 212–13.

62. P. Pekarskii, *Nauka i literatura v Rossii pri Petre Velikom*, vol. 2 (SPb., 1862), no. 140 (p. 192); *Opis. II*, no. 122; Alekseeva et al., *Portret petrov-skogo vremeni*, p. 219; and Alekseeva, *Graviura petrovskogo vremeni*, especially pp. 79 ff., with twenty-one reproductions of I. F. Zubov's work. For Iavorskii, see Cracraft, *Church Reform*, pp. 112 ff., especially pp. 130–32, 162–64.

63. See also the frontispiece to the Gospel book printed at L'viv in 1683 or 1690 and now in the possession of the church of the Intercession in Moscow, as reproduced in Smith and Budaragin, *Living Traditions* (n. 1 above, this chapter), p. 18.

64. M. A. Alekseeva, "Zhanr konkliuzii v russkom iskusstve kontsa XVII-nachala XVIII v.," in Alekseeva, ed., *Russkoe iskusstvo* (1977), pp. 16–29, with nineteen numbered illustrations: cf. no. 13 (by Ivan Zubov) with no. 9 (by Picart) and especially no. 19 (by Schoonebeck). Alekseeva makes somewhat the same point regarding the superiority of no. 19 (ibid., p. 19).

65. Ibid., no. 16 (printed on silk); also Alekseeva et al., *Portret petrovskogo vremeni*, p. 217; and Alekseeva, *Graviura petrovskogo vremeni*, p. 95. For another such catch-up effort, see Ivan Zubov's etched portrait of Peter II of 1728, in ibid., p. 92; and compare these with his etched portraits of Peter I and Catherine of 1721, in ibid., p. 91.

66. Alekseeva, "Maloizvestnye proizvedeniia," pp. 440–41, with illustration.

67. Alekseeva, "Brat'ia Zubovy," pp. 341–46.

68. E. I. Gavrilova, "'Sankt Piterburkh' 1718–1720 godov v naturnykh risunkakh Fëdora Vasil'eva," in Alekseeva, ed., *Russkoe iskusstvo* (1974), pp. 119–40 and illustrations 76–102.

69. And is doubted by Kaliazina and Komelova, *Russkoe iskusstvo*, p. 162 and n. 2 (p. 253), who attribute the series instead to "various masters" (p. 253), including Vasil'ev (p. 163 and nos. 139–41).

70. V. Uchastkina, *A History of Russian Hand Paper-Mills and Their Watermarks*, ed. J. S. G. Simmons (Hilversum, Holland, 1962), p. 15.

71. TsGIAL, F. 1329, op. 1, kn. 24, l. 134.

72. Uchastkina, pp. 4–6, 15–47.

73. D. Piper, "A Commentary on the Development of Portraiture," in S. Wise, ed., *European Portraits 1600–1900 in the Art Institute of Chicago* (Chicago, 1978), p. 9. See further L. Campbell, *Renaissance Portraits: European Portrait-Painting in the 14th, 15th and 16th Centuries* (New Haven, 1990); and J. Pope-Hennessy, *The Portrait in the Renaissance* (New York, 1966).

74. Briusova, *Russkaia zhivopis' 17 veka*, color plate no. 106.

75. Novitskii, "Parsunnoe pis'mo," pp. 384–403.

76. E.g., Ovchinnikova, *Portret*; Grabar' et al., *Istoriia russkogo iskusstva*, vol. 4 (1959), pp. 450–58; etc.

77. S. Collins, *The Present State of Russia: In a Letter to a Friend at London* (London, 1671), p. 65.

78. Unattributed, 1680s, now at GRM: see Alekseeva et al., *Portret petrovskogo vremeni*, pp. 116–17; also Hughes, *Sophia* (n. 17 above, this chapter), pp. 143–44 (dating the portrait to 1689, year of the climactic contest for power between Sof'ia's party and Peter's); and Ovchinnikova, *Portret*, p. 103, with reference to two more extant oil portraits of Sof'ia in *parsuna* style.

79. Artist unknown, now at GOP: see Boldov and Vladimirskaya, *Treasures of the Czars*, p. 60.

80. Chubinskaia, "Novoe ob evoliutsii portreta," pp. 317–20; Tananaeva, *Sarmatskii portret*; Bilets'kyi, *Ukraïns'kyi portretnyi zhyvopys*. I follow Piper in making a distinction between "effigies," or "images that make primarily a social or professional identification of their subjects" and in which their "quality as work of art is secondary," and "portraits proper," or images in which "the greater the quality of the art the more convincing and disturbing the painting will be as evocation of a unique human being": Piper (n. 73 above), p. 13, citing B. Berenson.

81. E.g., Sharandak, *Russkaia portretnaia zhivopis'*, p. 21.

82. Chubinskaia, "Novoe ob evoliutsii portreta," pp. 321–27; Moleva and Beliutin, *Zhivopisnykh del mastera*, pp. 9–26; Alekseeva et al., *Portret petrovskogo vremeni*, pp. 124–37; Gavrilova, "O metodakh atributsii," pp. 45–59. The inventory of 1739 is at TsGADA (F. 1239, op. 3, ch. 81 [1739], No. 41172, l. 465).

83. G. V. Esipov, ed., *Sbornik vypisok iz arkhivnykh bumag o Petre Velikom*, vol. 1 (M., 1872), nos. 483, 558, 568, 590.

84. Staehlin (n. 44 above), p. 116.

85. V. F. Levinson-Lessing, "Pervoe puteshestvie Petra I za granitsu," in Komelova, ed., *Kul'tura petrovskogo vremeni*, p. 27; J. Scheltema, *Anecdotes historiques sur Pierre le Grand, et sur ses voyages en Hollande dans les années 1697 et 1717*, trans. N. P. Muilman (Lausanne, 1842; first published in Dutch, 1814), pp. 128–29.

86. Levinson-Lessing, p. 19; Cracraft, *Revolution in Architecture*, p. 148.

87. Scheltema, pp. 103–6 and passim.

88. Splendidly brought out by G. S. Keyes et al., *Mirror of Empire: Dutch Marine Art of the Seventeenth Century* (Cambridge and Minneapolis, 1990).

89. See Kaliazina et al., *Dvorets Menshikova*, no. 82 (p. 89); also Alekseeva et al., *Portret petrovskogo vremeni*, pp. 28–29.

90. W. Guerrier, ed., *Leibniz in seinen Beziehungen zu Russland und Peter dem Grossen* (SPb. and Leipzig, 1873), no. 8 (p. 8); also Levinson-Lessing, p. 8. Levinson-Lessing does not connect

the portrait in question with that reproduced in Alekseeva et al., *Portret petrovskogo vremeni*, p. 119, whose inscription in Latin says that it was painted of Peter "cum magna Legatione huc Regiomontem [Königsberg] venit medio May. Anno MDCXCVII." This quarter-length portrait (now at GRM), rather Polish in style, might as well have been painted in Moscow.

91. Reproductions abound: see further Andreeva et al., *Portret petrovskogo vremeni*, p. 235 (engraving by P. Schenk, 1697); pp. 228, 231 (etchings by P. Picart et al., 1717); p. 186 (enamel miniature, artist unknown, ca. 1700); and pp. 140, 141, 147, 170 (unattributed oil paintings of the early eighteenth century). As noted above (Chap. 3, n. 125), another authoritative source lists sixty-five separate portraits of Peter of the "Kneller type" etched and/or engraved in the earlier eighteenth century.

92. *Arkhiv Kn. F. A. Kurakina*, vol. 4 (Saratov, 1893), p. 31. An engraving of ca. 1717 by P. Gunst after Kneller's portrait of Kurakin is reproduced in Kaliazina and Komelova, *Russkoe iskusstvo*, p. 11.

93. *Arkhiv Kurakina*, 4:131–32; vol. 1 (SPb., 1890), p. 33. For Kurakin's recruitment of architects, see Cracraft, *Revolution in Architecture*, pp. 149–50; and for Peter's library, E. I. Bobrova, *Biblioteka Petra I: ukazatel'-spravochnik* (L., 1978).

94. Cracraft, *Revolution in Architecture*, pp. 164–65, 184; V. N. Stroev et al., *200-letie Kabineta Ego Imp. Velichestva, 1704–1904: Istoricheskie issledovaniia* (SPb., 1911), pp. 109–10.

95. Trubnikov, "Pëtr Velikii i 'Strashnyi Sud,'" pp. 13–18.

96. Cracraft, *Church Reform*, pp. 21–27.

97. *Pokhodnyi zhurnal [Petra I] 1717 goda* (SPb., 1855), pp. 8, 9.

98. J. R. Martin, *The Ceiling Paintings for the Jesuit Church in Antwerp*, vol. 1 of L. Burchard, *Corpus Rubenianum* (Brussels and New York, 1968), p. 42; Martin has "reconstructed" the ceiling cycle, lost in a fire in 1718, from contemporary verbal and visual material, including Rubens's own oil sketches. In 1773, with the suppression of the Jesuit order, the building became the parish church of St. Charles (Carlo) Borromeo; the two altarpieces were acquired by Empress Maria Theresa of Austria and are now at the Kunsthistorisches Museum in Vienna. For later photographs of the church, see also H. Colleye, *Les Églises baroques d'Anvers* (Bruselles, 1935), pls. 1–22.

99. P. F. Buchet, *Abrégé de l'histoire du Czar Pierre Alexiewitz* (Paris, 1717), pp. 200–201.

100. Esipov, 2:3–90 passim.

101. Angremy et al., *France et Russie*, no. 257 (pp. 169–70), where the painting is mistitled *The Battle of Poltava*. The painting was long in the pos-

session of the Panin family, prominent in Russia from the time of Empress Elizabeth.

102. Garshin, "Zh.-M. Nat'e," pp. 433–38; Vasil'chikov, *O portretakh*, pp. 30–31. Jacob Staehlin, in St. Petersburg from 1735 to 1775, says that he saw the Nattier portraits "more than once" in the gallery of Count Vorontsov, chancellor of Empress Elizabeth, and that the Rigaud portrait was in a collection sent from Paris to St. Petersburg, where it was bought by the future Catherine II (*Anecdotes*, pp. 118, 119). Vasil'chikov found reference to a Rigaud portrait of Peter I in a catalog of the Imperial collection of 1774, sometime after which it was "lost without trace" (*O portretakh*, p. 31); he located (1872) the Nattier portraits at the Imperial palace of Tsarskoe Selo, considering that of Catherine to be the original but that of Peter, a copy— "by whom and when executed, it is impossible to say" (ibid., pp. 69–73). Both portraits are now at GME, that of Catherine signed by Nattier, that of Peter only tentatively attributed to him: cf. Angremy et al., *France et Russie*, nos. 258, 259 (pp. 170–71); Alekseeva et al., *Portret petrovskogo vremeni*, pp. 68–71; also ibid., p. 185, for another enamel miniature (of 1724) of Nattier's Catherine. Rather rusticalized versions of Nattier's Peter (attributed) and Catherine were etched by Ivan Zubov in 1721 (ibid., pp. 215–16; also Alekseeva, *Graviura petrovskogo vremeni*, p. 91).

103. Scheltema, p. 306.

104. Cf. Stasov, *Gallereia Petra*, pl. XIX with caption (artist identified as "Adam van Gelder"); also R. Portal, *Pierre le Grand* (Paris, 1961, 1969), p. 19 (full-page reproduction, artist "A. de Gelder") and p. 310.

105. Stasov, *Gallereia Petra*, says the portrait was a gift of the Russian ambassador to Holland in the nineteenth century, hence its location (by 1903) at the Rijksmuseum (p. 27). The overall style of the portrait, the subject's pose and face, fits the "Caravaque type" named after portraits by the French artist Louis Caravaque, who was hired in Peter I's later years and whose work was much imitated in Russia thereafter (cf. Andreeva et al., *Portret petrovskogo vremeni*, pp. 40–41, 64, 80, 156, 157, 159, 174, 221). The Rijksmuseum doubts the attribution to de Gelder and suggests rather "Russian school? 1st half 18th century": see P. J. J. van Thiel et al., *All the Paintings of the Rijksmuseum in Amsterdam: A Completely Illustrated Catalogue* (Amsterdam, 1976), p. 697 (A 116).

106. V. G. Andreeva, "Andrei Matveev," in Alekseeva, ed., *Russkoe iskusstvo* (1974), pp. 143–44. Cf. Vasil'chikov. *O portretakh*, pp. 60–64, and Andreeva et al., *Portret petrovskogo vremeni*, p. 66, both of which unreservedly attribute the portrait (fig. 62) to Karl Moor. Moor's "lost" portrait may be that later referred to by the American scholar

and diplomat, Eugene Schuyler: "It [Moor's oil portrait of Peter of 1717] was for many years supposed to be lost, but I discovered it at Amsterdam in the possession of a private family, where it had come by inheritance from the painter Liotard, to whom it had been given by the artist [Moor] himself" (Schuyler, *Peter the Great, Emperor of Russia*, 2 vols. [London, 1884], 1:vi).

107. See Wassiltschikoff, *Portraits russes*, 2:114–29, for some forty-seven examples as of 1875. It is also the frontispiece of Schuyler's monumental work of 1884 cited above (n. 106).

108. Nikulina, "Neopublikovannyi portret," pp. 21–23; Alekseeva et al., *Portret petrovskogo vremeni*, p. 67.

109. Scheltema, p. 305.

110. Staehlin, *Anecdotes* (n. 44 above), p. 69; J. Barrow, *A Memoir of the Life of Peter the Great* (London, 1832), p. 277.

111. Staehlin, pp. 69–70; also Scheltema, p. 307, indicating that Xsel was recommended to Peter by Silo (who was introduced to Peter, in 1697, by Nicolaas Witsen). See further Koskul', "Adam Silo," pp. 12–31, with reproductions of seven marine paintings by Silo.

112. Raskin, *Petrodvorets*, p. 302; also Cracraft, *Revolution in Architecture*, pp. 184–90 and pls. 59A–D. Known survivors of Peter's collection include a Rembrandt now at GME, *David's Farewell to Jonathan* (1642): see Loewinson-Lessing, ed., *Rembrandt*, no. 13 (commentary by Yu. Kuznetsov); a still-life by Jan Fyt, also now at GME: Metropolitan Museum, *Paintings from the Hermitage*, p. xiv and no. 41 (p. 90); two Dutch marine pieces now at the Menshikov Palace Museum: Kaliazina et al., *Dvorets Menshikova*, nos. 108, 109 (pp. 110–11); and dozens of easel paintings still at (or returned to) Monplaisir: Raskin, *Petrodvorets*, pp. 287 ff.

113. Cf. J. Brown, *Kings and Connoisseurs: Collecting Art in 17th Century Europe* (New Haven, 1995).

114. Esipov, 2:77.

115. Staehlin, pp. 70–71, 383.

116. F. V. Malinovskii, "Iakob fon Shtelin i ego zapiski po istorii russkoi zhivopisi XVIII veka," in Alekseeva, ed., *Russkoe iskusstvo* (1977), pp. 173–76, 181–82, and nn. 12–20 (pp. 200–201). For Xsel's surviving work at the Summer Palace and in the Peter-Paul church, all recently restored, see Borzin, *Rospisi petrovskogo vremeni*, pp. 112, 113, 114, 138, 140, 141, 142. For the Peter-Paul church itself, the most important architectural monument of the Petrine period, see Cracraft, *Revolution in Architecture*, especially pp. 156–57 and pl. 25.

117. The full text of Staehlin's *Notes on the History of Painting in Russia* in Russian translation is printed in Malinovskii, pp. 180–99, followed by

Malinovskii's own editorial notes (pp. 199–211). Staehlin's original text, in German, French, and Russian, in forty-nine folios, is preserved at GPB (OP, F. 871, No. 6).

118. TsGADA, F. 9, otd. II, kn. 36, ll. 562, 573–74; also Stroev, ed., *200-letie Kabineta* (n. 94 above), pp. 111–16.

119. Kaliazina et al., *Dvorets Menshikova; also* Lauritzen and Hansson, "Menshikov Palace." The standard biography of Menshikov is N. I. Pavlenko, *Poluderzhavnyi vlastelin: Istoricheskaia khronika o zhizni spodvizhniki Petra Pervogo A. D. Menshikova* (M., 1991).

120. Staehlin, *Anecdotes*, p. 119.

121. TsGADA, F. 9, otd. II, d. 58, l. 79.

122. Vasil'chikov, *O portretakh*, pp. 27–28, 33–34, 74, 81; Stasov, *Gallereia Petra*, pp. 15–16, pl. XIV; Wassiltschikoff, *Portraits russes*, 2:111–13; Vasil'ev and Glinka, eds., *Pamiatniki russkoi kul'tury*, nos. 145, 148, 151, 173, 174, pl. 8; Alekseeva et al., *Portret petrovskogo vremeni*, pp. 94–95 (and cover), 102, 103, 104, 148, 185; Borzin, *Rospisi*, p. 105 (and frontispiece); Kaliazina and Komelova, *Russkoe iskusstvo*, p. 117 and nos. 89, 112, 113, 114. Also, cf. our figs. 65 and 82 (left/obverse).

123. Malinovskii edition, pp. 181–83.

124. TsGADA, F. 17, d. 266, ll. 3ob.–4: this is a somewhat later copy of Caravaque's original contract, to be found in a file of documents (delo 266, forty-four leaves) dated 1723–1749 concerning "Court painter Liudvig Karavak."

125. Ibid., l. 1.

126. Ibid., ll. 5, 7–8 (also ll. 9–10).

127. Ibid., ll. 16, 24–25.

128. Ibid., ll. 17–18.

129. Malinovskii edition, p. 183.

130. Veretenikov, "Karavak," with six illustrations; Vasil'chikov, *O portretakh*, pp. 84–86, 109, 11; Wassiltschikoff, *Portraits russes*, 2:144–53; Stasov, *Gallereia Petra*, p. 17, pl. XVI; L. Réau, *Pierre le Grand* (Paris, 1960), pp. 138–41; A. L. Veinberg, "Dva neizvestnykh portreta raboty Lui Karavakka," in Alekseeva, ed., *Russkoe iskusstvo* (1971), pp. 229–37 and pls. 125–30; Alekseeva et al., *Portret petrovskogo vremeni*, pp. 40–51, 221; Andremy et al., *France et Russie*, p. 172 (no. 262); and Kaliazina and Komelova, *Russkoe iskusstvo*, nos. 115–118.

131. TsGADA, F. 9, otd. II, kn. 30, l. 441.

132. Ibid., F. 17, d. 303, ll. 6–7.

133. Ibid., F. 9, otd. II, d. 45, l. 96; also *Rbs*, 2:670.

134. TsGADA, F. 9, otd. II, d. 31, ll. 206–7, 227.

135. Lebedeva, *Ivan Nikitin*, with forty-three plates; also Alekseeva et al., *Portret petrovskogo vremeni*, pp. 72–87; and Kaliazina and Komelova, *Russkoe iskusstvo*, nos. 94–101. For a more popular treatment, see Moleva, *Ivan Nikitin*, with twenty-nine plates; and for both Ivan and his brother Ro-

man, Moleva and Beliutin, *Zhivopisnykh del mastera*, chap. 2.

136. On the difficulties of attribution, see I. G. Kotel'nikova, "Novyi portret raboty Ivana Nikitina," and S. V. Rimskaia-Korsakova, "Atributsiia riada portretov petrovskogo vremeni na osnovanii tekhniko-tekhnologicheskogo issledovaniia," both in Komelova, ed., *Kul'tura petrovskogo vremeni*, pp. 183–90, 191–99.

137. Malinovskii edition, p. 184.

138. V. G. Andreeva, "Andrei Matveev," in Alekseeva, ed., *Russkoe iskusstvo* (1974), pp. 141–57 and pls. 103–12; and more fully, Il'ina and Rimskaia-Korsakova, *Andrei Matveev*. See also Moleva and Beliutin, *Zhivopisnykh del mastera*, chap. 3, especially pp. 86–111; Alekseeva et al., *Portret petrovskogo vremeni*, pp. 58–65; and Kaliazina and Komelova, *Russkoe iskusstvo*, nos. 105–109, 111, for Matveev's works and career.

139. Its full title, at the time, was Academy of the Arts of Painting and Sculpture (*Accademie der schilders ende beltsnydersconste*): see Z. Z. Filipczak, *Picturing Art in Antwerp, 1550–1700* (Princeton, 1987), pp. 166 ff.

140. Angremy et al., *France et Russie*, p. 216, no. 341. Both paintings are reproduced in Andreeva, "Matveev," figs. 106, 107 (both at GRM).

141. Alekseeva et al., *Portret petrovskogo vremeni*, pp. 90–93, 9–10; also Moleva and Beliutin, *Zhivopisnykh del mastera*, chap. 2.

142. Ibid., pp. 205–6, 242.

143. Andreeva, "Matveev," p. 151.

144. Kocherova, "Ob Ivane Nikitine," pp. 230–35; also Alekseeva et al., *Portret petrovskogo vremeni*, pp. 88–89.

145. Ibid., pp. 18–19; Moleva and Beliutin, *Zhivopisnykh del mastera*, p. 223.

146. Ibid., pp. 82–86, 247 (here spelled Odol'skii); Alekseeva et al., *Portret petrovskogo vremeni*, pp. 20–21, 176–77, 203.

147. Cf. Gollerbakh, *Portretnaia zhivopis'*, and Kuz'minskii, *Razvitie russkoi portetnoi zhivposi*, both brief but authoritative treatments of the rise of portraiture in Russia in which this role is fully recognized—as it generally is not in later Russian (Soviet) scholarship.

148. Malinovskii edition, p. 183. See also Alekseeva et al., *Portret russkogo portreta*, pp. 26–27 (Wedekind's portrait of Catherine I); and Zharkova and Plotnikova, *Gos. Tret'iakovskaia Gallereia*, pl. 1 (posthumous portrait of Tsar Michael).

149. Cracraft, *Revolution in Architecture*, pp. 186–91, with further references—although that to Bartenev and Batazhkova, *Russkii inter'ër* (n. 119, p. 352) is incomplete. See also Roche, "Risunki Nikolaia Pino," pp. 2–21, with thirty illustrations; Kaliazina, "O dvortse Apraksina," pp. 131–40; Kaliazina, "Novye printsipy," pp. 102–21; N. V.

Kaliazina, "Monumental'no-dekorativnaia zhivopis' v dvortsovom inter'ere pervoi chetverti XVIII v. (K probleme razvitiia stilia barokko v Rossii)," in Alekseeva, ed., *Russkoe iskusstvo* (1977), pp. 55–69; V. V. Antonov, "Zhivopistsy-dekoratory Skotti v Rossii," in Alekseeva, ed., *Russkoe iskusstvo* (1979), pp. 69–107; Borzin, *Rospisi*; Angremy et al., *France et Russie*, pp. 280–83 (nos. 404–11: Nicolas Pineau); Kaliazina et al., *Dvorets Menshikova*; Kaliazina and Komelova, *Russkoe iskusstvo*, pp. 14–91; and Ducamp, ed., *Imperial Palaces*, 4 vols.

150. Fëdorov-Davydov, *Russkii peizazh*, pp. 11–48.

151. Barsamov, *More v russkoi zhivopisi*, pp. 6, 11 ff.

152. Sadoven', *Russkie khudozhniki batalisty*, pp. 3–23; Vereshchagina, *Khudozhnik vremia istorii*, chap. 1. Note that the attribution by Sadoven' of two battle pictures to Ivan Nikitin (Sadoven', pp. 19–22) is decisively rejected by Lebedeva, *Ivan Nikitin*, pp. 93–95. For references to the establishment under Peter of tapestry in Russia, see Chapter 5.

153. Cf. Gorina, ed., *Russkaia zhanrovaia zhivopis'*.

154. Luzhetskaia, *Tekhnika maslianoi zhivopisi*, especially pp. 9, 16–19.

155. G. N. Komelova, "Pervyi russkii miniaturist—G. S. Musikiiskii. Materialy k istorii portretnoi miniatiuri pervoi chetverti XVIII veka v Rossii," in Alekseeva, ed., *Russkoe iskusstvo* (1974), pp. 168–82 and illustrations 119–34; Vrangel', "Ocherki po istorii miniatury"; Mikhailova and Smirnova, *Portretnaia miniatiura*, with 128 plates. See also, for illustrations, Kaliazina and Komelova, *Russkoe iskusstvo*, pp. 154–55 and nos. 129–38, 181, 192; Alekseeva et al., *Portret petrovskogo vremeni*, pp. 183–90; Angremy et al., *France et Russie*, pp. 357–65, 367; Allenov et al., *Moscow Treasures*, pp. 102, 132–41; Taylor, *Russian Art at Hillwood*, pp. 13, 26–42 passim, 54–60; and Boldov and Vladimirskaya, *Treasures of the Czars*, pp. 150, 153, 204–5, 208, 210–11, 238, 240–45. G. Reynolds, *English Portrait Miniatures*, rev. ed. (Cambridge, 1988), is a study of the earlier miniature tradition in Europe, where it flourished from the sixteenth century: for Charles Boit in particular, see pp. 87–89. See also D. T. Johnson, *American Portrait Miniatures in the Manney Collection* (New York, 1990) for the history of this art and its spread to the United States in the eighteenth and nineteenth centuries. Since this volume went to press, the catalog of an exhibition (at the Walters Gallery, Baltimore) of some 121 specimens of enamelry made in Russia taken from three American collections has appeared: A. Odom, *Russian Enamels: Kievan Rus to Fabergé* (London, 1996), splendidly illustrated; nu-

merous of these items from the seventeenth, eighteenth, and earlier nineteenth centuries (see especially nos. 5–19, 37–41, 43, 44, 46–57, with Odom's commentaries) further document the main points we have made here.

156. Cf. B. Ceysson et al., *Sculpture: The Great Tradition from the Fifteenth to the Eighteenth Century* (New York, 1987), beautifully illustrated; and, more specialized, J. Pope-Hennessy, *Italian High Renaissance & Baroque Sculpture* (New York, 1985).

157. F. Haskell and N. Penny, *Taste and the Antique: The Lure of Classical Sculpture, 1500–1900* (New Haven and London, 1981); Haskell and Penny, *The Most Beautiful Statues: The Taste for Antique Sculpture, 1500–1900* (Oxford, 1981).

158. Gorbunova and Saverkina, *Iskusstvo drevnei Gretsii i Rima*, pls. 96–97.

159. See Cracraft, *Revolution in Architecture*, pp. 211–13, for Bergholtz in the Summer Garden. An illustrated survey of the "rise of sculpture [skul'ptura] in Russia including the volumetric [obemnoe: three-dimensional] representation of the human being [in] the Petrine era," is in Kaliazina and Komelova, *Russkoe iskusstvo*, pp. 92–113; see also V. V. Kirillov, "Skul'ptura," in Aleksandrov et al., eds., *Ocherki russkoi kul'tury*, pp. 70–110; and Alekseeva et al., *Portret petrovskogo vremeni*, pp. 243–55.

160. Iu. Iul' (J. Juel), *Zapiski*, ed. M. Shcherbatov (M., 1910), p. 203.

161. Contemporary printed descriptions of these collections include: *Selecta numismatica antiqua ex museo Jacobi de Wilde* (Amsterdam, 1692); *Gemmae selectae antiquae e museo Jacobi de Wilde* (Amsterdam, 1703); *Catalogus van goud, zilvere modern Medailles . . . Antique Beelden, Urne en andere Antiquiteyten . . . Uit het Kabinet van den Wel-Edele Heer Mr. Nicolaas Witzen* (Amsterdam, 1728). Evidence of Witsen's geographical-ethnographic activity in Russia is in his book, *Noord en Oost Tartarye*, 3d ed. (Amsterdam, 1705), with dedication to Peter. The book is replete with engravings of native peoples, urban views, maps, etc.

162. Details from O. Ia. Neverov, "Pamiatniki antichnogo iskusstva v Rossii petrovskogo vremeni," in Komelova, ed., *Kul'tura petrovskogo vremeni*, pp. 37–53; for the etching in question, ibid., p. 17.

163. Ibid., pp. 38–45. On the formation of Peter's Siberian collection, including the famous "Scythian gold" (with objects of ancient Greek workmanship), see S. I. Rudenko, *Sibirskaia kollektsiia Petra I* (M./L., 1962) (= No. D3–9 of *Arkheologiia SSSR: Svod arkheologicheskikh istochnikov*), with twenty-six plates; and M. P. Zavitukhina, "K voprosu o vremeni i meste formirovaniia sibirskoi kollektsii Petra I," in Komelova, ed., *Kul'tura petrovskogo vremeni*, pp. 63–69; also, Metropolitan

Museum of Art, *From the Lands of the Scythians: Ancient Treasures from the Museums of the U.S.S.R. 3000 B.C.–100 B.C.* (New York, [1972]), items 1–165, with thirty-three color plates.

164. Neverov, "Pamiatniki antichnogo iskusstva," pp. 46–50; also S. O. Androsov, "O kollektsionirovanii ital'ianskoi skul'ptury v Rossii v XVIII veke," *Trudy gos. Ermitazha* 25 (1985), pp. 86–91.

165. I. S. Sharkova, *Rossiia i Italiia: torgovye otnosheniia XV–pervoi chetverti XVIII v.* (L., 1981), pp. 153, 154.

166. TsGADA, F. 9, otd. II, kn. 33, l. 418.

167. Arkhipov and Raskin, *Rastrelli*; also Petrov, *Equestrian Statue*; and Kaliazina and Komelova, *Russkoe iskusstvo*, nos. 75–78, 80–84, for excellent reproductions of his major works.

168. SIRIO, 69:748–59.

169. For B. F. Rastrelli's work in Russia, see Cracraft, *Revolution in Architecture*, pp. 169–70 and passim.

170. N. Pavlov-Sil'vanskii, *Proekty reform Petra Velikago* (SPb., 1897), pt. 2, p. 16.

171. Reproduced in Ceysson (n. 154 above), p. 180.

172. SIRIO, 34:240–42.

173. *Dnevnik Kameriunkera F. V. Berkhgol'tsa, 1721–1725*, trans. I. F. Ammon, 3d ed. (1902–3), 3:84–85; 4:15–16, 21–22.

174. Cf. R. E. McGrew, *Paul I of Russia, 1754–1801* (Oxford, 1992), p. 24.

175. Petrov, *Equestrian Statue*, p. 75. On Rastrelli's famous full-length portrait statue of Peter in wax, made shortly after his death by order of Empress Catherine, see Sharaia, *Voskovaia persona*.

176. N. N. Vrangel', *Istoriia skul'ptury* (SPb., 1911: = vol. 5 of Grabar' et al., *Istoriia russkago iskusstva*); also Vrangel', "Skul'ptory XVIII veka," pp. 251–97.

177. Cf. Chekalov, *Narodnaia derevannaia skul'ptura*, especially chap. 4, with twenty-two illustrated examples dated to the sixteenth (six) and seventeenth (sixteen) centuries; also Rydina, *Drevnerusskaia melkaia plastika*, with ninety-one plates illustrating low-relief icons in stone, silver, ivory, and wood of the fourteenth and fifteenth centuries from Novgorod and central Russia.

178. Makovskii, "Dve podmoskovnyia Golitsyna," pp. 24–37; T. A. Gatova, "Iz istorii dekorativnoi skul'ptury Moskvy nachale XVIII v.," in Alekseeva, ed., *Russkoe iskusstvo* (1973), pp. 31–44.

179. Vrangel', "Skul'ptory," pp. 254–55; Roche, "Risunki Nikolaia Pino," pp. 2–21, with reproductions of thirty designs by Pineau; Angremy et al., *France et Russie*, pp. 280–83; Cracraft, *Revolution in Architecture*, pp. 186–91 and fig. 88.

180. As depicted in an etching by A. I. Rostovtsev of 1725, reproduced in Kaliazina and Komelova, *Russkoe iskusstvo*, no. 172.

181. Kube, "Mramornyi biust," pp. 63–71, with two plates.

182. Chekalov, *Narodnaia derevannaia skul'ptura*, with fourteen illustrated examples dated to the eighteenth century. See also N. V. Mal'tsev, "O dereviannoi skul'pture Velikogo Ustiuga," in Alekseeva, ed., *Russkoe iskusstvo* (1973), pp. 141–46 and pls. 73–77; and Vlasova, *Permskaia skul'ptura*, with 113 plates. Vlasova stresses how rapidly the "winds of change from St. Petersburg reached the easternmost borders of Russia," how the "pronounced influence of Baroque and classicist styles" was "duly reflected in the local arts and crafts [of the Perm' region]. New subject matter was introduced and artistic methods were substantially expanded" (p. 158).

Chapter 5

1. Rakov et al., *Materialy k bibliografii*, with 4,564 positions, remains the basic bibliographical guide to the history of the St. Petersburg Academy of Fine Arts (*Akademiia Khudozhestv* = AKh). The most important items relating especially to the Academy's earlier years, and consulted here, include: Olenin, *Kratkoe istoricheskoe svedenie* (1829), the first published history of the Academy and written by its president from 1817 to 1843; Rovinskii, "Akademiia Khudozhestv," pp. 45–76; Petrov, ed., *Sbornik materialov*; Kondakov, *Iubileinyi spravochnik*; Iaremich et al., *Akademicheskaia shkola*; Moleva and Beliutin, *Pedagogicheskaia sistema Akh*; Sysoev et al., *225 let Akh*; and more specialized works cited below. One-volume general histories include: Isakov et al., *Akademiia Khudozhestv*; Zotov, *Akademiia Khudozhestv*; and Lisovskii, *Akademiia Khudozhestv*. In English, see Kemenov, *Academy of Arts*.

2. N. Pevsner, *Academies of Art Past and Present* (Cambridge, 1940; reprinted New York, 1973); and C. Goldstein, *Teaching Art: Academies and Schools from Vasari to Albers* (Cambridge, 1996). For recent studies offering suggestive parallels to what happened in St. Petersburg, see Z. Z. Filipczak, *Picturing Art in Antwerp, 1550–1700* (Princeton, 1987), especially pp. 166 ff.; and I. Pears, *The Discovery of Painting: The Growth of Interest in the Arts in England, 1680–1768* (New Haven, 1988), especially pp. 119 ff.

3. TsGADA, F. 9, otd. I, kn. 53, l. 570.

4. Moleva and Beliutin, *Pedagogicheskaia sistema*, pp. 19–22; E. I. Gavrilova, "O pervykh proektakh Akademii khudozhestv v Rossii," in Alekseeva, ed., *Russkoe iskusstvo* (1971), pp. 220–23.

5. Quoted in I. Chistovich, *Feofan Prokopovich i ego vremia* (SPb., 1868), p. 260.

6. Moleva and Beliutin, *Pedagogicheskaia sistema*, pp. 14–18.

7. TsGADA, F. 9, otd. II, d. 57, ll. 48–50.

8. *Opisanie dokumentov i del khraniashchikhsia v arkhive Sviateishago Praviltel'stvuiushchago Sinoda*, vol. 1 (SPb., 1868), cols. 470–71.

9. TsGADA, F. 17, d. 270, ll. I–III ob., 1–5 ob.; Gavrilova, p. 223.

10. Moleva and Beliutin, *Pedagogicheskaia sistema*, pp. 19–20.

11. *Materialy dlia istorii Imp. Akademii Nauk*, vol. 1 (SPb., 1885), pp. 76–79; also *SIRIO* 11:558–62.

12. Quoted in P. Pekarskii, *Istoriia Imp. Akademii Nauk v Peterburge*, vol. 1 (SPb., 1870), pp. XXVIII–XXIX: cf. *Briefe von Christian Wolff aus den Jahren 1719–1753. Ein Beitrag zur Geschichte der Academie der Wissenschaften zu S.-Petersburg* (SPb., 1860), pp. 3–4; also *Materialy Akademii Nauk* 1:4–5.

13. *Materialy Akademii Nauk*, 1:14–22, 66–67.

14. *Arkhiv Kurakina*, vol. 1 (SPb., 1890), no. LVIII (p. 35).

15. TsGADA, F. 17, d. 266, l. 1.

16. *PSZ*, vol. 7, no. 4443, especially p. 222 (left column, item no. 9). For the other schools mentioned, Moleva and Beliutin, *Pedagogicheskaia sistema*, pp. 18, 22–29, 329 (n. 18).

17. E. I. Gavrilova, "Lomonosov i osnovanie Akademii Khudozhestv," in Alekseeva, ed., *Russkoe iskusstvo* (1973), p. 67; M. A. Alekseeva, "Nekotorye voprosy russkoi khudozhestvennoi zhizni serediny XVIII v.," in ibid., p. 91; Moleva and Beliutin, *Pedagogicheskaia sistema*, pp. 29–31; also *Materialy Akademii Nauk*, 1:171.

18. Gavrilova, "O pervykh proektakh," pp. 226–27; Cracraft, *Revolution in Architecture*, pp. 164–66, 245.

19. *Materialy Akademii Nauk*, vol. 2 (SPb., 1886), pp. 367–77: text in German and French.

20. Gavrilova, "Lomonosov," p. 67.

21. Ibid., p. 69.

22. *Materialy Akademii Nauk*, vol. 5 (SPb., 1889), p. 890.

23. *PSZ*, vol. 12, no. 9425 (pp. 730–39); Pekarskii, *Istoriia Akademii Nauk*, vol. 2 (SPb., 1873), pp. XXVII–XXX.

24. The standard biography is still A. Morozov, *Mikhail Vasil'evich Lomonosov, 1711–1765*, 2d ed. (L., 1952), which has little to say about the Academy of Fine Arts: see pp. 486–526 for Lomonosov the mosaicist; see also M. T. Beliavskii, *M. V. Lomonosov i osnovanie Moskovskogo universiteta* (M., 1955).

25. Gavrilova, "Lomonosov," pp. 69–73; M. N. Tikhomirov, ed., *Istoriia Moskovskogo universiteta*, vol. 1 (M., 1955), pp. 30, 66–69. Shuvalov's project for Moscow University, adopted by Senate decree of January 12, 1755, is in *PSZ*, vol. 14, no. 10,346 (pp. 284–94).

26. *PSZ*, vol. 14, no. 10, 776 (pp. 806–7); Petrov, *Sbornik materialov*, 1:1–2.

27. Ibid., pp. 9–10.

28. *M. V. Lomonosov: Polnoe sobranie sochinenii*, vol. 8 (M./L., 1954), p. 807.

29. Voltaire, *Russia under Peter the Great*, trans. M. F. O. Jenkins (Rutherford, NJ, 1983), pp. 23, 46.

30. J. T. Alexander, "Ivan Shuvalov and Russian Court Politics, 1749–63," offprint from A. G. Cross and G. S. Smith, eds., *Literature, Lives and Legality in Catherine's Russia* (Nottingham, England, 1994), with thanks to the author. See further E. V. Anisimov, "I. I. Shuvalov—deiatel' rossiiskogo prosveshcheniia," *Voprosy istorii*, 1985, no. 7, pp. 94–104; and Zotov, *Akademiia Khudozhestv*, pp. 196–98.

31. Petrov, *Sbornik materialov*, 1:1–76 passim.

32. See Angremy et al., *France et Russie*, p. 253 (no. 388) and p. 244 (color plate) for the Gillet bust, and p. 177 (no. 271) for De Velly's portrait.

33. Data from documents in Petrov, *Sbornik materialov*, 1 (budget on pp. 70–72). On Shuvalov's career, largely neglected by scholars, see also P. Bartenev, *Biografiia I. I. Shuvalova* (M., 1859).

34. K. Rasmussen, "Catherine II and the Image of Peter I," *Slavic Review* 37, no. 1 (March 1978), pp. 51–69; McConnell, "Catherine and the Fine Arts," pp. 37–57; Perkins, "Nicholas I and the Academy of Fine Arts," pp. 51–63.

35. Cracraft, *Revolution in Architecture*, p. 246 and figs. 122*A*–*B*(p. 248), pl. 63.

36. H. B. Segel, "Sumarokov," in V. Terras, ed., *Handbook of Russian Literature* (New Haven, 1985), pp. 453–54.

37. Cf. McConnell, "Catherine and the Fine Arts," p. 38.

38. Sumarokov's inaugural speech is in Petrov, *Sbornik materialov*, 1:101–2; Saltykov's was published with the Academy's *Privilegiia i ustav Imperatorskoi Akademii trëkh znatneishikh khudozhestv, Zhivopisi, Skulptury i Arkhitektury* (SPb., 1765) (copy at BL).

39. *Privilegiia i ustav*, pp. 13–46 (especially pp. 33–35).

40. Documents in Petrov, *Sbornik materialov*, 1:93–94, 159–61.

41. Pevsner (n. 2 above), pp. 181–83.

42. *Privilegiia i ustav* (n. 38 above), pp. 5–11; *PSZ*, vol. 16, no. 11,766 (pp. 170–71); Petrov, *Sbornik materialov*, 1:93–94, 114–15.

43. See Petrov, *Sbornik materialov*, 1:159 ff., for lists of students accepted by the Academy's junior school from 1764, with indications of their social status.

44. Trubnikov, "Pensionery Akademii," pp. 348–56; Trubnikov, "Pervye pensionery," pp. 67–82.

45. F. V. Malinovski, "Iakob fon Shtelin i ego zapiski po istorii russkoi zhivopisi XVIII veka," in Alekseeva, ed., *Russkoe iskusstvo* (1977), pp. 189–90; Réau, ed., *Correspondance de Falconet*, p.

205: Falconet to Catherine, St. Petersburg, Oct. 27, 1770. See further Ernst, "Losenko," pp. 3–24, with twenty reproductions; Moleva, *Khudozhniki-pedagogi,* pp. 8–41, 369–70; Angremy et al., *France et Russie,* pp. 219–22 (nos. 347–51) and 140 (pl.).

46. Malinovski edition, p. 204. This Grooth is not to be confused with his brother J. F. Grooth (1717–1801), who pursued a long and successful career in St. Petersburg (member of the Academy from 1765) as a "painter of beasts and birds" (Petrov, *Sbornik materialov,* 1:111).

47. Selinova, *Argunov;* also T. A. Selinova, " 'Istoricheskie' portrety I. P. Argunova," in Alekseeva, ed., *Russkoe iskusstvo* (1968), pp. 157–73 and pls. 89–99; Selinova, "Portrety Lazarevykh raboty I. P. Argunova," in ibid., pp. 175–82 with pls. 100–103; and Angremy et al., *France et Russie,* pp. 218–19 (nos. 345, 346) and 150 (pls.).

48. Sakharova, *Antropov,* with numerous illustrations; also Angremy et al., *France et Russie,* pp. 223–24 (no. 355); M. A. Alekseeva, "Graviury antiminsov po risunkam A. P. Antropova," in Gavrilova, ed., *Russkaia grafika,* pp. 45–53; and E. A. Mishina, "O trekh risunkakh A. P. Antropova," in ibid., pp. 54–66.

49. Il'ina, *Vishniakov;* Angremy et al., *France et Russie,* pp. 216–17.

50. Ostrovskii, "Lipetskii [town of Lipetsk, central Russia] portrety," pp. 302–10; Lebedev, "Iskusstvo portreta v russkoi provintsii," pp. 179–211; also, well illustrated, Fëdorova et al., *Iaroslavskie portrety,* and Iamshchikov, *Russkii portret;* and Vrangel', *Katalog russkoi portretnoi zhivopisi.*

51. J. Kennedy, "The Neoclassical Ideal in Russian Sculpture," in Stavrou, ed., *Art and Culture,* pp. 194–95.

52. *Materialy Akademii Nauk,* vol. 8 (SPb., 1895), pp. 471–72, 495–96.

53. Kemenov, *Academy of Arts,* p. 17; Moleva and Beliustin, *Pedagogicheskaia sistema,* pp. 296–324, 388 (n. 12).

54. Petrov, *Kozlovskii;* also Angremy et al., *France et Russie,* p. 262 (no. 403); and I. V. Linnik, "O siuzhete risunka M. I. Kozlovskogo izvestnogo pod nazvaniem 'Tesei pokidaet Ariadnu,' " in Gavrilova, ed., *Russkaia grafika,* pp. 67–71; Kozlovskii's Roman journal is printed with editorial notes in Arkin and Ternovets, *Mastera iskusstva,* pp. 45–54. For N. F. Gillet in Russia, see Vrangel', "Skul'ptory," pp. 264–65; I. A. Pronin, "Nikola Fransua Zhilli—pedagog i master dekorativnoi skul'ptury," in Alekseeva, ed., *Russkoe iskusstvo* (1979), pp. 137–44; Angremy et al., *France et Russie,* pp. 244 (pl.), 253 (no. 388); and Kennedy, passim.

55. Vrangel', "Skul'ptory," p. 265; Angremy et al., *France et Russie,* pp. 261–62 (nos. 401, 402). See further Isakov, *Fedot Shubin.*

56. For which see Ukhanova, *Severorusskaia reznaia kost'.*

57. In addition to works by Vrangel' and Kennedy already cited, see Berenshtam, "Prokov'ev, skul'ptor," pp. 167–74; Suslova, *Pavlov: skul'ptor;* and Rogachevskii, *Gordeev.*

58. L. Réau, "L'Oeuvre de Houdon en Russie," *Gazette des Beaux-Arts,* ser. 4, 13 (1917), pp. 129–54; Angremy et al., *France et Russie,* pp. 257–59 (nos. 396, 397, 398).

59. Angremy et al., *France et Russie,* pp. 253–56 (nos. 389–92), 246–47 (pls.).

60. I. de Madariaga, *Russia in the Age of Catherine the Great* (New Haven, 1981), p. 534.

61. Catherine to Grimm, December 10, 1782, as quoted in McConnell, "Catherine and the Fine Arts," p. 48.

62. Sidorov, *Risunok,* p. 69.

63. Kemenov, *Academy of Arts,* p. 17. Foreign artists working at the St. Petersburg Academy also donated important collections of their own drawings, some only recently identified as such: see, e.g., E. I. Gavrilova, "Attributsiia gruppy 'originalov' L.-Zh. Le Lorrena i L.-Zh.-F. Lagrene," in Gavrilova, ed., *Russkaia grafika,* pp. 26–44.

64. Sidorov, *Risunok,* p. 84; also *Svodnyi Katalog,* vol. 2, nos. 5634–37 (pp. 469–70); and V. A. Filov et al., eds., *Svodnyi katalog knig na inostrannykh iazykakh, izdannykh v Rossii v XVIII veke,* vol. 2 (L., 1985), p. 318: in Russian the manual is entitled *Osnovatel'nyia pravila ili Kratkoe rukovodstvo k risoval'nomu khudozhestvu,* from Preissler's original *Gründlich-verfasste Reguln oder Kurtze Anleitung zu der Zeichen-Kunst,* with fifty-four plates. See further Garshin, "Pervye shagi," pp. 197–217, 165–201, 338–59; I. A. Pronina, "O prepodovanii dekorativno-prikladnogo iskusstva v XVIII v.," in Alekseeva, ed., *Russkoe iskusstvo* (1973), pp. 76–89; E. I. Gavrilova, " 'Sankt-Piterburkh' v naturnykh risunkakh Fëdora Vasil'eva," in Alekseeva, ed., *Russkoe iskusstvo* (1974), pp. 119–40, with illustrations 76–102; M. A. Alekseeva, "Novye dannye o Elligere," pp. 64–68; and E. A. Mishina, "Gravirovannye marki russkikh bumazhnykh fabrik v XVIII veke," in Gavrilova, ed., *Russkaia grafika,* pp. 12–25.

65. G. N. Komelova, "K istorii vidov Peterburga Makhaevym", and M. A. Alekseeva, "Dokumenty o tvorchetve M. I. Makhaeva," in Alekseeva, ed., *Russkoe iskusstvo* (1971), pp. 238–68, both illustrated. Engravings after Makhaev's drawings are reproduced in Cracraft, *Revolution in Architecture,* figs. 100, 101, 107, 109, 112, 114–116.

66. Sidorov, *Risunok,* p. 97; also Flekel', *Ot Markantonio Raimondi,* pp. 280–83; and G. N. Komelova, "Russkii graver N. Ia. Kolpakov," in Sapunov

and Ukhanova, eds., *Kul'tura i iskusstva*, pp. 131–43, illustrated.

67. Angremy et al., *France et Russie*, p. 196 (and no. 307).

68. Petrov, *Sbornik materialov*, 1:172.

69. Skvortsov, *U istokov russkoi zhivopisi* (1925), p. 5; Isakov et al., *Akademiia Khudozhestv* (1940), p. 3. After 1945 or so Soviet scholars tended to be less forthright in their overall appraisals of the Academy's historical significance, evidently for extraneous ideological reasons (the Academy's alleged elitism, service to "reactionary" regimes, failure to accommodate "realism," etc.): cf. Lisovskii, *Akademiia khudozhestv* (1972), passim. Even so, Pronina, *Dekorativnoe iskusstvo* (1983), is a splendidly detailed account of the Academy's critical role in the rise of the new decorative art in Russia.

70. Olenin, *Kratkoe istoricheskoe svedenie*, p. 11.

71. Cf. S. F. Starr, "Russian Art and Society, 1800–1850," in Stavrou, ed., *Art and Culture*, pp. 87–112; Norman, "Merchant Art Patronage," pp. 93–107; and J. O. Norman, "Alexander III as a Patron of Russian Art," in Norman, ed., *New Perspectives*, pp. 25–40. Early studies include N. G. Tarasov, "Tsvetkovskaia Galereia v Moskve," *Starye gody* (December 1909), pp. 657–88, and E. Ernst, "Risunki russkikh khudozhnikov v sobranii E. G. Shvarttsa," ibid. (October–December 1914), pp. 24–56.

72. Tapestry is introduced in Cracraft, *Revolution in Architecture*, p. 190 and n. 121 (pp. 352–53). See further Trutovskii, "Russkii gobelen," pp. 298–308; Korshunova, "Sozdateli shpaler," pp. 262–77; T. T. Korshunova, "Novye materialy o sozdanii shpaler 'Poltavskia bataliia'," in Komelova, ed., *Kul'tura petrovskogo vremeni*, pp. 163–73; Iasinskaia, *Russkie shpalery: katalog*; and especially Korshunova, *Russkie shpalery: Peterburgskaia shpalernaia manufaktura*, with 187 color plates. For porcelain, an excellent introduction with full bibliography is Taylor, *Russian Art*, pp. 61 ff.

73. On these two images in Russian state symbolism down to the end of the eighteenth century, see Soboleva and Artamonov, *Simvoly Rossii*, pp. 8–50, and Khoroshkevich, *Simvoly russkoi gosudarstvennosti*, pp. 15–52. On the history of Russian state seals more generally, see Lakier, *Russkaia geral'dika*, pp. 136–74; and Kamentseva and Ustiugov, *Russkaia sfragistika*.

74. *Opis. I*, no. 26 (pp. 95–96), with frontispiece reproduced on p. 97.

75. Soboleva and Artamonov, *Simvoly Rossii*, p. 12.

76. Ibid., pp. 16–22 and fig. 5; also Alef, "Adoption of the Muscovite Two-Headed Eagle," pp. 1–21, and G. Alef, *The Origins of Muscovite Autocracy: The Age of Ivan III* (Berlin, 1986), pp. 87–88.

77. Cf. Soboleva and Artamonov, *Simvoly Rossii*, pp. 35–39 and fig. 16; and other works cited above, n. 73.

78. G. V. Vilinbakhov, "K istorii uchrezhdeniia ordena Andreia Pervozvannogo i evoliutsiia ego znaka," in Komelova, ed., *Kul'tura petrovskogo vremeni*, pp. 144–58; also V. M. Nikitina, "Russian Orders and Medals," in Allenov et al., *Moscow Treasures*, pp. 133 ff.

79. See the undated note to this effect found among Peter's papers, a contribution to a planned official history of his reign, printed in *ZAP*, p. 116: "Then too [in 1699], on the example of other Christian sovereigns, he [Peter] created a Russian order [*orden*] of the holy apostle Andrew the First-Called. *This was done because the Russian people first received the Christian faith from him*" (words in italic added by Peter himself).

80. See Soboleva and Artamonov, *Simvoly Rossii*, pp. 45–48, for Santi; also *Rbs*, 18:197–98.

81. *PSZ*, vol. 7, no. 4850.

82. Ibid., no. 4552. Earlier indications of Peter's concern in the matter in *PSZ*, vol. 3, nos. 1443, 1444, 1559, 1697, 1719; vol. 6, nos. 3534, 3789, 3864; etc.

83. Especially *PSZ*, vol. 7, no. 4344 (on judicial procedure).

84. Soboleva and Artamonov, *Simvoly Rossii*, pp. 64–76; Khoroshkevich, *Simvoly russkoi gosudarstvennosti*, pp. 53–68.

85. TsGADA, F. 286, op. 1, kn. 42, l. 984.

86. Ibid., F. 1343, op. 15, d. 377, ll. 6, 95–97.

87. The best-known compilation is Fon-Vinkler, *Gerby gorodov . . .* (1900).

88. J. P. LeDonne, *Absolutism and Ruling Class: The Formation of the Russian Political Order, 1700–1825* (New York, 1991), especially pp. 3–54, with full references.

89. E. V. Anisimov, various works, as excerpted and translated (by J. Cracraft and J. T. Alexander) in J. Cracraft, ed., *Major Problems in the History of Imperial Russia* (Lexington, MA, 1994), pp. 93–94, 128–46; see also, in this same volume, translations of the 1722 Table of Ranks (pp. 114–15), of the 1762 Manifesto of Peter III concerning the nobility (pp. 151–53), and of excerpts from Catherine II's Charter to the Nobility of 1785 (pp. 205–12).

90. Cf. M. L. Bush, *Noble Privilege* (New York, 1983), pp. 121 ff.

91. Though the social history of eighteenth-century Russia has yet to be written, there is a growing literature on these other persons and groups: see E. K. Wirtschafter, *Structures of Society: Imperial Russia's "People of Various Ranks"* (DeKalb, IL, 1994), for an introduction with copious bibliography.

92. Other useful works in English include: M. Raeff, *Origins of the Russian Intelligentsia: The Eigh-*

teenth Century Nobility (New York, 1966); P. Dukes, *Catherine the Great and the Russian Nobility* (Cambridge, 1967); R. E. Jones, *The Emancipation of the Russian Nobility, 1762–1785* (Princeton, 1973); R. D. Givens, "Servitors or Seigneurs: The Nobility and the Eighteenth-Century Russian State" (PhD diss., University of California, Berkeley, 1975); and R. O. Crummey, *Aristocrats and Servitors: The Boyar Elite in Russia, 1613–1689* (Princeton, 1983), all with further references.

93. Lukomskii, "O geral'dicheskom khudozhestve" (1911); also Lukomskii, *Russkaia geral'dika* (1915), well illustrated.

94. An introduction to the subject, organized historically, is T. Woodcock and J. M. Robinson, *The Oxford Guide to Heraldry* (Oxford, 1988). It is notable that in this as in other general accounts of heraldry, which dates to the Middle Ages in Europe, Russia enters the story only with Peter I (ibid., pp. 30–31).

95. P. Petschauer, "In Search of Competent Aides: Heinrich van Huyssen and Peter the Great," *JGO* 26, no. 4 (1978), pp. 481–502; J. Cracraft, ed., *For God and Peter the Great: The Works of Thomas Consett* (Boulder, CO, and New York, 1982), pp. 13–16, 20–23, 26, 35, 458.

96. *PSZ*, vol. 6, nos. 3877, 3890, 3896; drafts of the Instruction and related decrees are printed in *ZAP*, pp. 351–58. See also *ZAP*, no. 308 (p. 254) for Pleshcheev's appointment, dated May 2, 1722.

97. Cf. the *Obshchii gerbovnik dvorianskikh rodov Vserossiiskoi Imperii*, in ten vols. (SPb., 1798–1836; reprinted SPb., 1992–), with an eleventh volume (of a projected eighteen) first published in 1862; the illustrated English compilation therefrom, by Mandich and Placek, *Russian Heraldry*; and Lakier, *Russkaia geral'dika*, pp. 193–370, with commentary by N. A. Soboleva (pp. 371–98).

98. Mamaev, "Simvolika znamen," pp. 25–35 (based on 150 flags and banners of Petrine and pre-Petrine times in the flag collection at GME, with fourteen examples reproduced); also G. V. Vilinbakhov, "Otrazhenie idei absoliutizma v simvolike petrovskikh znamen," in Sapunov and Ukhanova, eds., *Kul'tura i iskusstvo Rossii*, pp. 7–25, with ten illustrations; Soboleva and Artamonov, *Simvoly Rossii*, pp. 104–45; and Khoroshkevich, *Simvoly russkoi gosudarstvennosti*, pp. 81–94.

99. Cf. J. L. H. Keep, *Soldiers of the Tsar: Army and Society in Russia, 1462–1874* (Oxford, 1985), especially pt. 2, with further references, notably to L. G. Beskrovnyi, *Russkaia armiia i flot v XVIII v.: Ocherki* (M., 1958); and C. Duffy, *Russia's Military Way to the West: Origins and Nature of Russian Military Power, 1700–1800* (Boston, 1981). Russia's new naval flags are schematically displayed in what may be regarded as the founding charter of the

Russian navy, Peter's *Ustav morskoi,* first published at St. Petersburg in 1720 and frequently reprinted thereafter—most recently in Moscow, 1993, to mark the navy's impending three-hundredth anniversary (in 1996).

100. An excellent new study is Iukht, *Russkie den'gi.*

101. The leading authority is I. G. Spasskii, whose works include: "Na zare russkoi numizmatiki," in Komelova, ed., *Kul'tura petrovskogo vremeni,* pp. 54–62; and, with E. S. Shchukina, *Medali i monety petrovskogo vremeni,* with sixty-eight illustrations. In English, see articles by J. L. Perkowski listed in the Bibliography, all with further references. A systematic catalog of Russian coins, beginning with those of Peter, has been compiled by Rylov and Sobolin, *Monety Rossii* (1994).

102. Iukht, *Russkie den'gi,* pp. 10–12; Perkowski, "Numismatic Curiosities," pp. 28–29.

103. J. Porteous, *Coins in History* (New York, 1969), pp. 212–16; A. I. Andreev, "Petr I v Anglii v 1698 g.," in Andreev, ed., *Petr Velikii: sbornik statei* (M./L., 1947), pp. 83–87; V. Boss, *Newton and Russia* (Cambridge, MA, 1972), pp. 9–18.

104. Iukht, *Russkie den'gi,* pp. 16–35; Rylov and Sobolin, *Monety Rossii,* pp. 1–3 (copper polushka), pp. 8–9 (copper den'ga), pp. 15–18 (copper kopeck), p. 39 (copper three kopecks), pp. 49–51 (silver kopeck, five kopecks), pp. 54–55 (silver grivna), p. 67 (silver polupoltina), pp. 74–75 (silver poltina), pp. 85–90 (silver ruble), p. 106 (gold chervonets), p. 109 (gold two rubles).

105. A. Oreshnikov, "Friazhskikh reznykh del master, serebrenik i medal'er kontsa XVII veka," in Oreshnikov et al., *Sbornik Oruzheinoi palaty,* pp. 5–10; Spasskii and Shchukina, *Medali i monety,* pp. 8–9/26 and figs. 5, 6.

106. Spasskii and Shchukina, *Medali i monety,* figs. 20, 24, 25, 41–44, 62–67; Rylov and Sobolin, *Monety Rossii,* pp. 85–90.

107. Perkowski, "Numismatic Curiosities," p. 31; Spasskii and Shchukina, *Medali i monety,* p. 9/27 and nos. 7–10; Rylov and Sobolin, *Monety Rossii,* pp. 49–51.

108. S. K. Scher and J. B. Taylor, *The Currency of Fame: Portrait Medals of the Renaissance* (New York, 1994); M. Jones, *The Art of the Medal* (London, 1979).

109. Spasskii and Shchukina, *Medali i monety,* nos. 13, 15, 31, 53; also, E. S. Shchukina, "O sozdanii medali v pamiat' vziatiia Azova raboti Ia. Boskama," in Komelova, ed., *Kul'tura petrovskogo vremeni,* pp. 159–62; and Angremy et al., *France et russie,* no. 611 (pp. 404–5).

110. Staehlin recounts Peter's visit to the Paris Mint as told to him by one of Peter's attendants on

the occasion, and adds: "Peter kept this medal in his cabinet till his death; it was then added to the cabinet of medals of the Academy of Sciences at Petersburgh, where it is still [1770s] to be seen" (*Original Anecdotes of Peter the Great* [London, 1788], pp. 60–61).

111. Cf. P. Burke, *The Fabrication of Louis XIV* (New Haven, 1992), pp. 169–77, 180 ff.

112. Chepurnov, *Rossiiskie nagradnye medali*, pp. 6–30, provides a full list (from 1702). On Russian medals marking the crucial Poltava victory, see also A. N. Luppol, "Numizmaticheskie pamiatniki poltavskogo srazheniia v sobranii Gos. Istoricheskogo Muzeia," in L. G. Beskrovnyi et al., eds., *Poltava: k 250-letiiu poltavskogo srazheniia* (M., 1959), pp. 408–15.

113. Spasskii and Shchukina, *Medali i monety*, nos. 14; 18, 19, 26–30, 32–35, 37, 38, 45–51, 54–59; 55; 60; 68. Also Angremy et al., *France et russie*, nos. 612, 613 (pp. 406–7).

114. Staehlin, *Anecdotes*, p. 391; *Feofan Prokopovich: Sochineniia*, ed. I. P. Erëmin (M./L., 1961), pp. 126–46.

115. Cf. Bagrow (L. S. Bagrov, 1881–1957), *Cartography of Russia*, and Bagrow, *Russian Cartography*, both well illustrated. Another general study is now A. V. Postnikov, *Karty zemel' rossiiskikh: ocherk istorii geograficheskogo izucheniia i kartografirovanniia nashego otechestva* (M., 1996), also well illustrated, which appeared too late to be more than cited here. Notable is the author's critique of Soviet scholarship in this field as excessively narrow and "secretive," although he retains its nationalist bias. He also accepts the view, similar to that presented here, that the Petrine period marked a decisive new beginning in Russian cartography owing to its "contact and then close interaction with western European cartography" (pp. 36 ff.).

116. See J. B. Harley and David Woodward, eds., *The History of Cartography*, vol. 1: *Cartography in Prehistoric, Ancient, and Medieval Europe and the Mediterranean* (Chicago, 1987), especially editors' preface, chap. 1 (by Harley), chap. 21 (Harley and Woodward), and extensive bibliography; also, contemporary in focus and more analytical, D. Wood with J. Fels, *The Power of Maps* (New York, 1992).

117. D. Woodward, "Introduction," in Woodward, ed., *Art and Cartography: Six Historical Essays* (Chicago, 1987), pp. 1–9 and passim.

118. Bagrow, *Cartography of Russia*, p. 116; also, Shibanov, *Ocherki kartografii*, pp. 5–11. Shibanov was among Russian scholars who believed that a "general map of the Muscovite state," a *Bol'shoi chertëzh*, later lost, was compiled around 1570 in Moscow from a series of regional maps commis-

sioned by Ivan IV (ibid., p. 7); but Bagrow remained skeptical that such a map was compiled before the end of the sixteenth century (*Russian Cartography*, pp. 4–7, 52). This view seemingly is shared by Postnikov, *Razvitie kartografii*, pp. 129, 131; and, *ex silentio*, by Kusov, *Kartograficheskoe iskusstvo*. On the other hand, analysis of certain verbal sources led B. A. Rybakov to posit, and "reconstruct," an even earlier (1497) "Chart of the Muscovite Lands" (*Chertëzh Moskovskikh zemel'*), which "map," along with another that he similarly reconstructed and dated to 1523 in Moscow, supposedly served as the "source" or "basis" of the several well-known maps of Muscovy published by foreigners in the sixteenth and early seventeenth centuries: B. A. Rybakov, *Russkie karty Moskovii XV-nachala XVI veka* (M., 1974). Postnikov considers Rybakov's hypotheses a "remarkable scientific discovery" (*Razvitie kartografii*, p. 131); but they are ignored by Kusov, *Kartograficheskoe iskusstvo*. Nor are they supported by Bagrow's purely empirical historiography of surviving maps, in his *Russian Cartography*, pt. I (pp. 1–97). See further on this and related questions S. Baron, "B. A. Rybakov on the Jenkinson Map of 1562," and B. P. Polevoi, "Concerning the Origin of the Maps of Russia of 1613–14 of Hessel Gerritsz." (both rejecting Rybakov's hypotheses), in L. Hughes, ed., *New Perspectives on Muscovite History* (New York, 1993), pp. 3–23.

119. Cf. Postnikov, *Razvitie kartografii*, p. 128; also D. M. Lebedev, *Geografiia v Rossii XVII veka (dopetrovskoi epokhi): Ocherki po istorii geograficheskikh znanii* (M./L., 1948), for details.

120. Cf. Kusov, *Kartograficheskoe iskusstvo*, p. 72.

121. Cf. Harley and Woodword, pp. 283 ff., and particularly the essay by P. D. A. Harvey, "Local and Regional Cartography in Medieval Europe" (pp. 464–501).

122. N. N. Voronin, a leading authority on Muscovite architecture, also remarks on the ambiguity of the term *chertëzh* in sixteenth- and seventeenth-century sources: it could mean, as well as a crude architectural drawing, "a map; a situational plan of a fortified town and/or its sections; a drawing of any kind, or just an image on paper" (*Ocherki po istorii russkogo zodchestva XVI–XVII vv.* [M./L., 1934], p. 58).

123. Gol'denberg, *Remezov*; also Cracraft, *Revolution in Architecture*, pp. 75–76, with further references, especially to work by V. V. Kirillov; and Lebedev, pp. 22–94, 165–74. Remezov the cartographer was of special interest to Bagrow: see his edition of Remezov's *Atlas of Siberia* (The Hague, 1958), and his *Russian Cartography*, chap. 2; and on Strahlenberg, see ibid., pp. 116–20, with a reproduction of his 1730 map of the Russian Empire fo-

cusing on Siberia (p. 119). Strahlenberg's map to-
gether with his Siberian researches were first
published in German and Swedish editions at
Stockholm in 1730, and in English at London in
1738: *An Historical-Geographical Description of the
North and eastern parts of Europe and Asia; but more
particularly of Russia, Siberia, and Great Tartary;
Both in their Ancient and Modern State . . .* (facsim-
ile reprint New York, 1970).

124. Bagrow, *Russian Cartography*, pp. 26–34,
51 ff.

125. L. Bagrow, "The First Map Printed in Rus-
sian," *Imago Mundi* 12 (1955), pp. 152–56, with re-
production (p. 153).

126. *PSZ*, vol. 4, no. 1751 (pp. 6–8). For Bruce
and his evidently critical part in making the map,
for which he was promoted to colonel, see Boss,
work cited above (n. 103), pp. 15–18; and *Rbs*,
3:416–19 (by P. M. Maikov).

127. A copy of the Latin edition is reproduced
in Bagrow, *Russian Cartography*, p. 99. Tessing died
in 1701; the plate for the Latin edition was later
sold and the map republished both singly and in
various books about Russia. The Russian edition
is known in a single copy.

128. Bagrow, *Russian Cartography*, p. 98.

129. Cf. J. B. Harley, "Maps, Knowledge, and
Power," in D. Cosgrove and S. Daniels, eds., *The
Iconography of Landscape: Essays on the Symbolic
Representation, Design, and Use of Past Environ-
ments* (Cambridge, 1988), pp. 277–312.

130. Bagrow, *Russian Cartography*, p. 100:
Schoonebeck's highly schematic etching of the Sea
of Azov (also 1701), from a map by the Swedish
engineer Christian Rugell, is reproduced on p.
101. This map and several others etched by
Schoonebeck and his assistants are reprinted in
Borisovskaia, *Starinnye gravirovannye*, pp. 175–83.

131. Ibid., pp. 170–217, reproducing various of
these maps and plans etched and printed in Rus-
sia mainly by Schoonebeck, P. Picart, and their
Russian pupils (notably, A. Zubov: cf. our Chap. 4).

132. M. I. Belov et al., *Voprosy geografii petrov-
skogo vremeni* (L., 1975); G. S. Tikhomirov, *Biblio-
graficheskii ocherk istorii geografii v Rossii XVIII veka*
(M., 1968); Shibanov, *Ocherki kartografii*, pp. 41–57
(geodesy); Postnikov, *Razvitie kartografii*, chap. viii
(the Geography Department of the Academy of
Sciences); and K. V. Ostrovitianov et al., *Istoriia
Akademii nauk SSSR*, vol. 1: *1724–1803* (M./L.,
1958), especially pp. 66–69, 102–7, 235–47, 367–73
(cartographic instruments, cartography and ge-
ography).

133. Quoted in Ostrovitianov, p. 67.

134. Cf. M. Vasmer, *Russisches Etymologisches
Wörterbuch*, vol. 1 (Heidelberg, 1953), p. 535; also
M. M. Shanskii, ed., *Etimologicheskii slovar' rus-

skogo iazyka*, vol. 2, no. 8 (M., 1982), pp. 74–75; and
P. Ia. Chernykh, *Istoriko-etimologicheskii slovar' so-
vremennogo russkogo iazyka*, vol. 1 (M., 1993), p. 382.

135. Bagrow, *Russian Cartography*, pp. 136–38. A
copy of the Delisle map is in the author's pos-
session.

136. M. A. Chabin, "La curiosité des savants
français pour la Russie dans la première moitié du
XVIIIe siècle," *Revue des études slaves* 57, no. 4
(1985), pp. 565–576, which draws on the Delisle
family archives; for the making of the Caspian Sea
map, see L. A. Gol'denberg's patriotic biography
of a Russian geodesist involved, *Fëdor Ivanovich
Soimonov (1692–1740)* (M., 1966).

137. *PSZ*, vol. 6, no. 3695. Related decrees at
PSZ, vol. 6, no. 3534 (February 29, 1720) and no.
3788 (May 22, 1721).

138. Krempol'skii, *Istoriia kartoizdaniia*, p. 11.

139. Details of his career in L. A. Gol'denberg
and S. M. Troitskii, eds., *I. K. Kirilov: Tsvetushchee
sostoianie vserossiiskogo gosudarstva* (M., 1977), pp.
5–24; Novlianskaia, *Kirilov i ego Atlas*; and Bag-
row, *Russian Cartography*, pp. 133–53.

140. Bagrow, *Russian Cartography*, pp. 139, 177;
"Kirilov's Instructions to the Geodisists" are
printed in ibid., appendix 3 (p. 263). Kirilov's role
in coordinating the Senate's cartographical activi-
ties from 1720 if not earlier is confirmed from ar-
chival sources by Gol'denberg and Troitskii, who
also found that Andrew Ferquharson (Andrei
Farvarson, in Russian), recruited by Peter in En-
gland in 1698 and now the leading teacher at the
Naval Academy, actually drafted the instructions
(Gol'denberg and Troitskii, pp. 8–9).

141. Bagrow, *Russian Cartography*, p. 142; also,
Svodnyi katalog, 1, no. 347 (pp. 67–68); and Krem-
pol'skii, *Istoriia kartoizdaniia*, pp. 11–12. Copies of
Kirilov's *Atlas* of 1737 are also at LC and NYPL.

142. On Joseph Nicolas Delisle in Russia, see
Chabin (n. 136 above) and Bagrow, *Russian Cartog-
raphy*, pp. 177–200.

143. Cf. J. N. de L'Isle (Delisle), *Mémoires pour
servir à l'histoire et au progrès de l'astronomie, de la
géographie, et de la physique . . .* (SPb., 1738); copy
at NYPL.

144. *Svodnyi katalog*, 1, nos. 344, 345, 346 (pp.
66–67); V. A. Filov et al., eds., *Svodnyi katalog knig
na inostrannykh iazykakh, izdannykh v Rossii v XVIII
veke*, vol. 1 (L., 1984), nos. 201–4 (pp. 66–67); ibid.,
vol. 2 (L., 1985), nos. 2422, 2423 (p. 371). I have
consulted copies of the 1745 *Atlas Rossiiskoi* (or
Atlas Russicus) at RL and HCL; copy also at LC.

145. Bagrow, *Russian Cartography*, p. 190.

146. Krempol'skii, *Istoriia kartoizdaniia*, p. 14.

147. McConnell, "Catherine and the Fine Arts,"
pp. 37–57. This aspect of Catherine's long reign
has been badly neglected by scholars—is virtu-

ally ignored in the standard biography in English: I. de Madariaga, *Russia in the Age of Catherine the Great* (New Haven, 1981), 700 pp.

148. Stol'pianskii, "Staryi Peterburg," pp. 33–41, 44–53, 33–42; see further works cited above (n. 71, this chapter). Successive lists of printed works for sale published by the Academy of Sciences from 1735 regularly included portraits, battle pictures, maps, and architectural views and plans, as my perusal of several such lists at the academy's library (BAN) confirmed. For art news in the *St. Petersburg Gazette,* see also M. I. Fundaminskii et al., *Gazeta "Sanktpeterburgskie vedomosti" XVIII veka: Ukazateli k soderzhaniiu* (L., 1989), pp. 192, 202–3.

149. *Zhurnal' Iziashchnykh iskustv* (SPb.): issues surveyed include those for 1823 (nos. 1–6) and several for 1825 (nos. 1–3). The first issue of 1823 refers (p. 57) to an issue of 1807: publication was perhaps interrupted by the Napoleonic wars.

150. Cf. P. P. Chekalevskii (an official of the Academy), *Razsuzhdenie o svobodnykh khudozhestv* (SPb., 1792), p. 149. See further O. V. Mikats, "Rol' Ermitazha v tvorcheskom stanovlenii masterov russkoi zhivopisi," in G. A. Printseva, ed., *Kul'tura i iskusstvo Rossii XIX vek: novye materialy i issledovaniia. Sbornik statei* (L., 1985), pp. 8–13.

151. A. I. Andreev, ed., *Istoricheskii ocherk i obzor fondov Rukopisnogo otdela Biblioteki Akademii nauk,* vol. 2: *XVIII vek: Karty, plany, chertezhi, risunki i graviury Sobraniia Petra I,* comp. M. N. Murzanova et al. (M./L., 1961), pp. 61–258; O. Beliaev (curator of Kunstkamera), *Kabinet Petra Velikago,* 3 vols. (SPb., 1800), 3:239–46; Grigorieva et al., *Hermitage Drawings and Watercolours,* "Introduction" (by B. B. Piotrovsky); V. F. Levinson-Lessing, "Ocherk istorii sobraniia," in Levinson-Lessing, ed., *Gos. Ermitazh: katalog zhivopisi,* 1:7–15.

152. W. Coxe, *Travels in Poland, Russia, Sweden, and Denmark,* 5th ed., 2 vols. (London, 1802); I quote hereafter from this edition as reprinted (yet again) in J. Pinkerton, ed., *A General Collection of the Best and Most Interesting Voyages and Travels in All Parts of the World,* vol. 6 (London, 1809), pp. 570–913. On Coxe see further A. Cross, ed., *Russia under Western Eyes: 1517–1825* (New York, 1971), p. 387 and passim.

153. Coxe, Pinkerton edition, pp. 593–94.

154. Ibid., p. 603.

155. Ibid., p. 657.

156. Ibid., p. 682.

157. Borzin, *Rospisi petrovskogo vremeni,* pp. 137–46, with photographs of these murals.

158. Coxe, Pinkerton edition, pp. 677–78.

159. Ibid., pp. 666–67.

160. A standard catalog lists over a hundred such accounts, mainly by French and British visitors, published in English alone: H. W. Nerhood, ed., *To Russia and Return: An Annotated Bibliography of Travelers' English-Language Accounts of Russia from the Ninth Century to the Present* (Columbus, OH, 1968), nos. 79–189 (pp. 24–51). For contemporary European comment on the Russian built world, particularly St. Petersburg, see again Cracraft, *Revolution in Architecture,* chap. 7.

161. Robert Ker Porter, *Travelling Sketches in Russia and Sweden, 1805–1808* (Philadelphia, 1809). Cf. E. P. Renne, "Robert Ker Porter v Rossii," *Trudy Gos. Ermitazha* 25 (1985), pp. 105–10, with reproductions of the two naval paintings. Further biographical information is in P. Putnam, *Seven Britons in Imperial Russia* (Princeton, 1952), pp. 293–304; and C. Wood, *The Dictionary of Victorian Painters,* 2d ed. (Woodbridge, England, 1987), p. 375.

162. Ker Porter, pp. 35–36.

163. Cracraft, *Revolution in Architecture,* p. 237 and pl. 67; also fig. 123 (p. 250) and pl. 34.

164. Ker Porter, pp. 45–48.

165. For splendid reproductions of the interior of the Taurida Palace, see Belyakova, *Palaces of St. Petersburg,* pp. 82–100. The Colonnade Hall, described by Ker Porter, is more than seventy-four meters long and nearly fifteen meters wide, with thirty-six Ionic columns; it comfortably holds 5,000 people (ibid., pp. 88–89).

166. Ker Porter, pp. 40–43.

167. Ibid., pp. 43–45.

168. Ibid., p. 163.

Chapter 6

1. Cf. H. D. Molesworth, *The Golden Age of Princes* (New York, 1969), for a rare synthetic look at the Baroque panoply of royal absolutism; also Baklanova, "Otrazhenie idei absoliutizma," pp. 492–507, for a brief survey of the Petrine case; and Wortman, *Scenarios of Power,* especially pp. 42–78, for the ceremonial aspect of Petrine absolutism in its European context.

2. *SIRIO* 15:245–48: G. von Mardefeld to the king, Moscow, June 9, 1724; more generally, J. Cracraft, *The Church Reform of Peter the Great* (Stanford, 1971).

3. Quoted in ibid., p. 33.

4. J. Perry, *The State of Russia under the Present Czar* (London, 1716), pp. 223–24.

5. *ZAP,* no. 16 (p. 39).

6. Cracraft, pp. 130–31; Gavriushin, *Filosofiia russkogo religioznogo iskusstva,* pp. 16–17.

7. Cracraft, pp. 211–12.

8. Ibid., pp. 279–86, 290–91, 193–94, 229–30.

9. Ibid., pp. 212, 291–92; *ZAP,* no. 158 (p. 121).

10. Cracraft, p. 212; *PSZ,* vol. 6, no. 4079 (pp. 762–63).

11. Cf. S. G. Barkhudarov et al., eds., *Slovar' russkogo iazyka XI–XVII vv.*, vol. 6 (M., 1979), pp. 54–55, 194–95.

12. Gavriushin, *Filosofiia*, p. 17; also Moleva, "Tsekhoviia organizatsiia," pp. 49–51. We met Zarudnyi (also called Zarudnev in the sources) in Cracraft, *Revolution in Architecture*, pp. 13, 16, 105–6 and n. 43 (p. 345), 130 (fig. 69), 187.

13. P. P. Pekarskii, "Materialy dlia istorii ikon-opisaniia v Rossii," *Izvestiia Imp. Arkheografi-cheskago obshchestva* 5, no. 5 (1865), cols. 330–35; also Moleva, "Tsekhoviia organizatsiia," p. 49.

14. *PSZ*, vol. 7, no. 4148 (pp. 16–17); Moleva, "Tsekhoviia organizatsiia," p. 54; Gavriushin, *Filosofiia*, p. 17; Cracraft, *Church Reform*, pp. 212–13.

15. J. Hanway, *An Historical Account of the British Trade over the Caspian Sea*, vol. 1 (London, 1753), p. 94.

16. J. Cracraft, "James Brogden in Russia, 1787–1788," *Slavonic and East European Review* 47, no. 108 (January, 1969), p. 241.

17. J. G. King, *The Rites and Ceremonies of the Greek Church in Russia; Containing an Account of Its Doctrine, Worship, and Discipline* (London, 1772; reprinted New York, 1970), pp. xiv, 33–34.

18. See Vzdornov, *Istoriia otkrytiia*, and Bobrov, *Istoriia restavratsii*; also N. Petrov, "Sorokin-sko-Filaretovskia kollektsiia"; Muratov, *Drevne-russkaia ikonopis'*; N. Sychev, "Drevnekhranilish-che Russkago Muzeia Imp. Aleksandra III," *Starye gody* (January–February 1916), pp. 2–35; Kyzla-sova, *Istoriia izucheniia vizantiiskogo i drevnerus-skogo iskusstva v Rossii*; and essays by R. L. Nichols and J. E. Bowlt on the role of old icons in respectively the religious renewal of late Imperial Russia and the contemporaneous emergence of the artistic avant-garde, in Brumfield and Velimirovic, eds., *Christianity and the Arts in Russia*, pp. 131–44, 145–50. The persistent pre-Petrine bias in Russian icon preservation is reflected, again, in the catalog of the major collection, at GTG: see Antonova and Mnёva, *Katalog*; also Antonova, *Drevnerusskoe iskusstvo Korina*.

19. Smirnova and Iamshchikov, *Drevnerusskaia zhivopis': novye otkrytiia*; Anan'eva et al., *Russkaia zhivopis' XVII–XVIII vekov*; Ivanov, *Russian Icons*, chaps. 7, 8.

20. E.g., Anan'eva et al., *Russkaia zhivopis' XVII–XVIII vekov*, p. 104. Cf. G. Ferguson, *Signs and Symbols in Christian Art, With Illustrations from Paintings of the Renaissance* (Oxford, 1961), pp. 71–76 and figs. 31–33; or J. Hall, *A History of Ideas and Images in Italian Art* (New York, 1983), pp. 180–81.

21. M. Weber, *The Sociology of Religion*, trans. E. Fischoff (Boston, 1993; first published 1963; first German edition, 1922), pp. 9, 8, 243–44, 245. For further sociological reflection on art and religion, see E. Shils, *Tradition* (Chicago, 1981), especially pp. 92 ff.

22. King, pp. xiii–xiv. On the emergence by the later eighteenth century of an elite, learned clergy in Russia, see references in G. L. Freeze, *The Russian Levites: Parish Clergy in The Eighteenth Century* (Cambridge, MA, 1977), especially chap. 4.

23. R. Lyall, *The Character of the Russians and a Detailed History of Moscow* (London, 1823), pp. cl–cli; Lyall had spent many years in Russia, knew Russian well, and did extensive research in Russian materials. Cf. R. Pinkerton, *Russia, or Miscellaneous Observations on the Past and Present State of That Country and Its Inhabitants* (London, 1833), especially pp. 54–60, devoted to icons and the enlightened clergy's attempts to cure "the prevailing sins of the Russians of all classes, connected with the invocation of saints and the use of pictures in their worship" (p. 60). Pinkerton, like King and Lyall, was also an exceptionally knowledgeable observer, having spent the years 1805–33 in Russia as an agent of the British Bible Society.

24. Gavriushin, *Filosofiia*, pp. 18 ff., 71 ff.; also G. Florovsky, *Ways of Russian Theology: Part Two*, trans. R. L. Nichols (Belmont, MA, 1987).

25. E.g., Ouspensky and Lossky, *Meaning of Icons*; Ouspensky, *Theology of the Icon*; Sendler, *The Icon*; Zibawi, *The Icon*; and Bulkin et al., *Holy Land of Russia*.

26. S. Bulgakov (1871–1944), *The Orthodox Church*, trans. L. Kesich (Crestwood, NY, 1988; first published 1935), chap. 10, "Icons and Their Cult" (pp. 139–44). The theological aesthetics of this anti-Western or antinaturalist position regarding icons were wonderfully worked out in the 1920s by Bulgakov's contemporary and friend, Father Pavel Florenskii (1882–1937?), in a series of writings which have since been revived: see N. A. Struve, ed., *Sviashchenik Pavel Florenskii: sbornik sochineniia*, vol. 1: *Stat'i po iskusstvu* (Paris, 1985); and Igumen Andronik (A. S. Trubachev) et al., eds., *Sviashchenik Pavel Florenskii: Izbrannye trudy po iskusstvu* (M., 1996), with concluding essay, "Filosofiia iskusstva Pavla Florenskogo," by V. V. By-chkov (pp. 285–333).

27. Rovinskii, *Russkiia narodnyia kartinki*, in five volumes of text-commentary and four albums (*atlasy*) of reproductions (1881), supplemented by Rovinskii, *Russkiia narodnyia kartinki*, ed. Sobko, 2 vols. (1900), remains the major work (hereafter cited *RNK*); seventy-five years after its publication P. N. Berkov counted 192 scholarly works that had appeared in its train: Berkov, "Materialy dlia bibliografii literatury o russkikh narodnykh (lubochnykh) kartinkakh (K 75-letiiu vykhoda v

svet 'Russkikh narodnikh kartinok' D. A. Rovinskogo)," *Russkii fol'klor* 2 (1957), pp. 353–62. See further Sakovich, *Russkie narodnye kartinki*, and Danilova et al., eds., *Narodnaia graviura*; also Bakhtin and Moldavskii, *Russkii lubok*; Ovsiannikov, *Lubok*, with abbreviated English text by A. Shkarovsky-Raffé; Baldina, *Russkie narodnye kartinki*, on woodcuts of the eighteenth century; Sytova et al., *The Lubok*; and Itkina, *Russkii risovannyi lubok*, on single-sheet pictures drawn and painted (in tempera) in the nineteenth century (mainly by Old Believers) and hence, as unique works by hand rather than prints, not *lubki* in the established sense of the term, even though obviously related. See also, for different perspectives, Koschmal, *Der russische Volksbilderbogen*, with its companion volume of reproductions: Koschmal, ed., *Russkija narodnyja kartinki*; and C. Claudon-Adhémar, *Image et société en Russie*. In English the main work has been done by D. E. Farrell: see her dissertation and articles derived from it listed in the Bibliography. For the word *lubok/lubochnyi*, see also F. P. Filin et al., eds., *Slovar' russkikh narodnykh govorov*, vol. 17 (L., 1981), pp. 172–73; and Filin et al., eds., *Slovar' russkogo iazyka XI–XVII vv.*, vol. 8 (L., 1981), pp. 290–91.

28. As noted in Chap. 4, Alekseeva's *Graviura petrovskogo vremeni* (1990) is the first book-length monograph devoted to the subject.

29. Ibid., p. 171.

30. See A. G. Sakovich, "Bibliia Vasiliia Korenia (1696): russkaia ikonograficheskaia traditsiia XVI–XIX vekov," in Danilova et al., eds., *Narodnaia graviura*, pp. 88–130; and Sakovich, *Kniga Korenia*, vol. 2 of which is a facsimile reprint of the Koren' "bible" now at GPB.

31. Sakovich, *Kniga Korenia*, 1:13–17; Farrell, "Origins of Popular Prints," pp. 10–12.

32. On this point see also contributions by V. Sventsitskaia and by L. Oshurkevich to Danilova et al., eds., *Narodnaia graviura*, pp. 57–87, 34–56.

33. Cf. Fëdorov-Davydov, "K voprosu lubka," pp. 78–120. Of just under 100 *lubki* dating to before 1700 reproduced by Rovinskii (*RNK*, passim), seventy-nine—over 80 percent—are strictly devotional in nature.

34. TsGIA, F. 796, op. 1, d. 178, l. 2.

35. Ibid., l. 69.

36. TsGIA, F. 796, op. 2, d. 480, ll. 52 ob., 82.

37. Ibid., op. 1, d. 178, ll. 13, 15–17ob., 19ob., 20.

38. See further Mishina, "Gruppa rannykh russkikh graviur," pp. 230–44; and M. A. Alekseeva, "Torgovlia graviurami v Moskve i kontrol' za nei v kontse XVII–XVIII vv.," in Danilova et al., eds., *Narodnaia graviura*, pp. 140–58.

39. *RNK*, vol. 3 and its companion *Atlas*, vol. 3, are replete with examples, like our fig. 93.

40. Quoting Farrell, "Origins of Popular Prints," p. 43, who is careful to minimize the political content or purpose of any such parodying: parody was a popular Russian pastime. Still, the ambivalent attitude towards Peter suggested here has been found in verbal (oral and/or textual) manifestations of eighteenth-century popular culture as well: cf. K. V. Chistov, *Russkie narodnye sotsial'no-utopicheskie legendy XVII–XIX vv.* (M., 1967), pp. 91–124; also A. F. Nekrylova, "Predaniia i legendy, otrazivshie voennye sobytiia petrovskogo vremeni," *Russkii fol'klor* 13 (1972), pp. 103–10. On festivals as represented in *lubki*, see A. F. Nekrylova, *Russkie narodnye gorodskie prazdniki, uveseleniia i zrelishcha, konets XVIII–nachalo XX veka* (L., 1984), passim; and on the "extensive carnivalesque subculture" in eighteenth-century Russia, with reflections also in *lubki*, D. Gasperetti, "The Carnivalesque Spirit of the Eighteenth-Century Russian Novel," *Russian Review* 52, no. 2 (April 1993), pp. 166–83.

41. Vasilenko, *Russkaia narodnaia rez'ba*; S. K. Prosvirkina and S. K. Zhegalova, "Raspisnye sunduki 17–18 vv.," and Zhegulova, "Khudozhestvennyi prialki," in Zhegulova et al., eds., *Sokrovishche russkogo narodnogo iskusstva*, pp. 11–41; Bogoslovskaia, *Russkoe narodnoe iskusstvo*; Voronov, *O krest'ianskom iskusstve*; Pronin, *Russian Folk Arts*; V. Kotov, "Iskusstvo Palekha i narodnaia kartinka," in Danilova et al., eds., *Narodnaia graviura*, pp. 234–51; S. Nikitina, "Ob obshchikh siuzhetakh v fol'klore i narodnom izobrazitel'nam iskusstve," in ibid., pp. 320–50; Rusakova, *Traditionnoe izobrazitel'noe iskusstvo*; etc.

42. Netting, "Images and Ideas in Russian Peasant Art," pp. 48–68.

43. A. Hilton, "Russian Folk Art and 'High' Art in the Early Nineteenth Century," in Stavrou, ed., *Art and Culture*, pp. 237–54; and further, Hilton, *Folk Art*, esp. pp. 107–13, 170 ff., 215 ff.

44. Kaliazina and Komelova, *Russkoe iskusstvo petrovskoi epokhi*; for the passages quoted, see the "Summary" (in English), pp. 261–62. Similar reservations apply to the only other overall study of the visual art of the Petrine period to be published in recent years in Russia: Evangulova, *Izobrazitel'noe iskusstvo*, a work which comprises in fact two extended essays on respectively the "artistic life" (taste, training, patronage) of the period and the "stylistic structure" of its art, the latter with semiotic overtones. Not overtly nationalistic, this work still excludes from serious consideration all of architecture, nonsecular or "religious" art, what we have called official and popular imagery, and the non-Russian origins and international nature of the new art while also advancing a complex interpretive agenda.

45. As noted in Chap. 1 (n. 88), these criteria are borrowed, or extrapolated, from essays by P. Burke and E. J. Hobsbawm, in R. Porter and M. Teich, eds., *Revolution in History* (Cambridge, 1986), pp. 5 ff., 206 ff.

46. Cf. W. J. T. Mitchell, *Iconology: Image, Text, Ideology* (Chicago, 1986).

47. A task begun, most notably, by R. Wortman, in his *Scenarios of Power;* another, very brief essay in this direction is J. Cracraft, "Money Talks? A Note on Political Stability in Late Imperial Russia," in L. Schelbert, ed., *Essays in Russian and East European History: Festschrift in Honor of Edward C. Thaden* (New York, 1995), pp. 47–60, also with further references.

Bibliography

The following list includes the most important works consulted in writing this book as well as all known scholarly works of relevance published in English. It does not include documentary sources, printed or manuscript, or highly specialized studies in Russian (or languages other than English) of strictly limited interest here; in all such cases full citations are provided in the appropriate notes to the text. Nor does the list include standard reference works, cited or uncited, or even major scholarly works of only peripheral or general interest. The list is meant to serve as a basic bibliography of Russian visual art (excluding architecture) of the period 1650–1800. (For architecture, see the Bibliography in *Revolution in Architecture*, pp. 357–64, with some overlap here.)

Alef, G. "The Adoption of the Muscovite Two-Headed Eagle: A Discordant View." *Speculum* 41, no. 1 (January 1966).

Aleksandrov, V. A., et al., eds. *Ocherki russkoi kul'tury XVIII veka*. Vol. 4. M., 1990.

Alekseeva, M. A. "Brat'ia Ivan i Aleksei Zubovy i graviura petrovskogo vremeni." In N. I. Pavlenko et al., *Rossiia v period reform Petra I*. M., 1973.

———. *Graviura petrovskogo vremeni*. L., 1990.

———. "Maloizvestnye proizvedeniia russkogo iskusstva XVII–pervoi poloviny XVIII v.: gravirovannye antiminsy." In *Pamiatniki kul'tury. Novye otkrytiia. Ezhegodnik 1982*. L., 1984).

———. "Novye biograficheskie dannye o khudozhnike Ottomare Elligere." *Soobshcheniia Gos. Russkogo muzeia* 10 (1974).

———. "Portret Tsarevny Sof'i gravera Tarasevicha." In *Pamiatniki kul'tury. Novye otkrytiia. Ezhegodnik 1975*. M., 1976.

———, et al. *Portret petrovskogo vremeni*. L., 1973.

Alekseeva, T. V., ed. *Russkoe iskusstvo barokko: materialy i issledovaniia*. M., 1977.

———, ed. *Russkoe iskusstvo XVIII–pervoi poloviny XIX veka: materialy i issledovaniia*. M., 1971.

———, ed. *Russkoe iskusstvo XVIII veka: materialy i issledovaniia*. M., 1968.

———, ed. *Russkoe iskusstvo XVIII veka: materialy i issledovaniia*. M., 1973.

———, ed. *Russkoe iskusstvo pervoi chetverti XVIII veka: materialy i issledovaniia*. M., 1974.

———, ed. *Russkoe iskusstvo vtoroi poloviny XVIII–pervoi poloviny XIX v.: materialy i issledovaniia*. M., 1979.

Allenov, M. M., et al. *Moscow: Treasures and Traditions*. Washington, DC, and Seattle, 1990.

Alpatov, M. V. *Andrei Rublëv*. M., 1972.

———. *Drevnerusskaia ikonopis'*. M., 1974.

———. "Problema barroko v russkoi ikonopisi." In A. I. Nekrasov, ed., *Barokko v Rossii*. M., 1926.

———, ed. *Andrei Rublëv i ego epokha: sbornik statei*. M., 1971.

Alpatov, M. V., and N. Brunov. *Geschichte der Altrussischen Kunst*. 2 vols. Augsburg, 1932.

Anan'eva, T. A. *Simon Ushakov*. L., 1971.

355

————, et al. *Russkaia zhivopis' XVII–XVIII vekov: katalog vystavki*. L., 1977.

Andreev, A. I., ed. *Istoricheskii ocherk i obzor fondov Rukopisnogo otdela Biblioteki Akademii nauk*. Vol. 2, *XVIII vek: Karty, plany, chertëzhi, risunki i graviury Sobraniia Petra I*. Edited by M. N. Murzanova et al. M./L., 1961.

Andreev, N. "Inok Zinovyi Otsenskii ob Ikonopochitanii i Ikonopisanii." *Seminarium Kondakovianum* 8 (1936).

————. "Mitropolit Makarii, kak deiatel' religioznago iskusstva." *Seminarium Kondakovianum* 7 (1935).

————. "O 'Dele d'iaka Viskovatago.'" *Seminarium Kondakovianum* 5 (1932).

Andreyev [Andreev], N. "Nikon and Avvakum on Icon Painting." In N. Andreyev, *Studies in Muscovy: Western Influence and Byzantine Inheritance*. London, 1970.

Androsov, S. O. "O kollektsionirovanii ital'ianskoi skul'ptury v Rossii v XVIII veke." *Trudy gos. Ermitazha* 25 (1985).

Angremy, A., et al. *La France et la Russie au Siècle des Lumières: Relations culturelles et artistiques de la France et de la Russie au XVIIIe siècle*. Paris, 1986.

Antonova, V. N., ed. *Drevnerusskoe iskusstvo v sobranii Pavla Korina*. M., 1966.

————, and N. E. Mnëva. *Katalog drevnerusskoi zhivopisi XI–nachala XVIII vv. v Gos. Tret'iakovskoi galleree*. 2 vols. M., 1963.

Arkhipov, N. I., and A. G. Raskin. *Bartolomeo Karlo Rastrelli, 1675–1744*. L./M., 1964.

Arkin, D., and B. Ternovets. *Mastera iskusstva ob iskusstve*. Vol. 4, *Russkoe iskusstvo XV–XIX v*. Edited by A. Fëdorov-Davydov. M./L., 1937.

Artsikhovskii, A. A., et al., eds. *Ocherki russkoi kul'tury XVII veka*. Vol. 2. M., 1979.

Artsikhovskii, A. V. *Drevne-russkie miniatiury kak istoricheskii istochnik*. M., 1944.

Bagrow, L. [L. S. Bagrov]. *A History of the Cartography of Russia up to 1600*. Edited by H. W. Castner. Wolfe Island, Ontario, 1975.

————. *A History of Russian Cartography up to 1800*. Edited by H. W. Castner. Wolfe Island, Ontario, 1975.

Baklanova, N. A. "Otrazhenie idei absoliutizma v izobrazitel'nom iskusstve pervoi chetverti XVIII v." In N. M. Druzhinin et al., eds., *Absoliutizm v Rossii (XVII–XVIII vv.)*. M., 1964.

Bakhtin, V., and D. Moldavskii. *Russkii lubok XVII–XIX vv*. M./L., 1962.

Bakushinskii, A. V. *Iskusstvo Palekha*. M./L., 1934.

Baldina, O. *Russkie narodnye kartinki*. M., 1972.

Barsamov, N. S. *More v russkoi zhivopisi*. Simferopol', 1959.

Bartenev, I. A., and V. N. Batazhkova. *Russkii inter'ër XVIII–XIX vekov*. L., 1977.

Bekeneva, N. G. *Simon Ushakov, 1626–1686*. L., 1984.

Belyakova, Z. *The Romanov Legacy: The Palaces of St. Petersburg*. New York, 1995.

Benois, A. *The Russian School of Painting*. Translated by A. Yarmolinsky. New York, 1916.

Berenshtam, F. "Ivan Prokof'evich Prokov'ev, skul'ptor (1758–1828)." *Starye gody* (May 1907).

Bilets'kyi, P. *Ukraïns'kyi portretnyi zhyvopys XVII–XVIII st*. Kiev, 1969.

Bird, A. *A History of Russian Painting*. Boston, 1987.

Bobrov, Iu. G. *Istoriia restavratsii drevnerusskoi zhivopisi*. L., 1987.

Bobrovnitskaia, I. A., et al. *Gosudarstvennaia Oruzheinaia palata*. M., 1988.

Bogdanov, A. P. "Politicheskaia graviura v Rossii perioda regentsva Sof'i Alekseevny." In V. I. Buganov et al., eds., *Istochnikovedenie otechestvennoi istorii: sbornik statei*. M., 1982.

Bogoiavlenskii, S. K., and G. A. Novitskii, eds. *Gos. Oruzheinaia Palata Moskovskogo Kremlia: Sbornik nauchnykh trudov*. M., 1954.

Bogoslovskaia, I. Ia. *Russkoe narodnoe iskusstvo*. L., 1968.

Boldov, A. V., and N. S. Vladimirskaya, eds. *Treasures of the Czars from the State Museums of the Moscow Kremlin*. M. and London, 1995.

Bol'shakov, S. T., and A. I. Uspenskii, eds. *Podlinnik ikonopisnyi*. M., 1903.

Borisovskaia, N. *Starinnye gravirovannye: karty i plany XV–XVIII vekov.* M., 1992.

Borzin, B. F. *Rospisi petrovskogo vremeni.* L., 1986.

Bowlt, J. E. "The Moscow Art Market." In E. W. Clowes et al., eds., *Between Tsar and People: Educated Society and the Quest for Public Identity in Late Imperial Russia.* Princeton, 1991.

Briusova, V. G. *Freski Iaroslavlia.* M., 1969.

———. *Gurii Nikitin.* M., 1982.

———. *Ipat'evskii monastyr'.* Iaroslavl', 1968; M., 1982.

———. *Russkaia zhivopis' 17 veka.* M., 1984.

Brumfield, W. S., and M. M. Velimirovic, eds. *Christianity and the Arts in Russia.* Cambridge, 1991.

Bulkin, V., et al. *The Holy Land of Russia.* SPb., 1993.

Buslaev, F. I. "Literatura russkikh ikonopisnykh podlinnikov." In Buslaev, *Sochineniia.* Vol. 2. SPb., 1910.

———. "Russkaia estetika XVII veka." In Buslaev, *Sochineniia.* Vol. 2. SPb., 1910.

Bylinin, V. K. "K voprosu o polemike vokrug russkogo ikonopisaniia vo vtoroi polovine XVII v.: 'Beseda o pochitanii ikon sviatykh' Simeona Polotskogo." *TODRL* 38 (1985).

———. "K probleme poetiki Slavianskogo barokko: 'Vertograd mnogotsvetnyi' Simeona Polotskogo." *Sovetskoe slavianovedenie,* 1982, no. 1.

———, and V. A. Grikhin. "Simeon Polotskii i Simon Ushakov: k probleme estetiki russkogo barokko." In A. V. Lipatov et al., eds., *Barokko v slavianskikh kul'turakh.* M., 1982.

Chamot, M. "Later Icon Painting in Russia." *Transactions of the Association of Russian-American Scholars in the U.S.A.* 15 (1982).

———. *Russian Painting and Sculpture.* London, 1963.

Chekalov, A. K. *Narodnaia derevannaia skul'ptura russkogo severa.* M., 1974.

Chepurnov, N. I. *Rossiiskie nagradnye medali, Chast' pervaia: Medali XVIII veka.* Cheboksari, 1993.

Chubinskaia, V. G. "Ikona Simona Ushakova 'Bogomater' Vladimirskaia,' 'Drevo Moskovskogo gosudarstva,' 'Pokhvala Bogomateri Vladimirskoi' (Opyt istoriko-kul'turnoi interpretatsii)." *TODRL* 38 (1985).

———. "Novoe ob evoliutsii russkogo portreta na rubezhe XVII–XVIII vv." In *Pamiatniki kul'tury. Novye otkrytiia. Ezhegodnik 1982.* L., 1984.

Claudon-Adhémar, C. *Image et société en Russie, 1668–1725.* Berne, 1985.

Clucas, L., ed. *The Byzantine Legacy in Eastern Europe.* Boulder, CO, and New York, 1988.

Cross, A., ed. *Engraved in the Memory: James Walker, Engraver to the Empress Catherine the Great, and His Russian Anecdotes.* Oxford, 1993.

Crummey, R. O. "Court Spectacles in Seventeenth-Century Russia: Illusion and Reality." In D. C. Waugh, ed., *Essays in Honor of A. A. Zimin.* Columbus, OH, 1985.

Danilova, I. E., et al., eds. *Narodnaia graviura i fol'klor v Rossii XVII–XIX vv. (K 150-letiiu so dnia rozhdeniia D. A. Rovinskogo).* M., 1976.

Demina, N. A. *Andrei Rublëv i khudozhniki ego kruga.* M., 1972.

———. *"Troitsa" Andreia Rublëva.* M., 1963.

Dmitriev, Iu. N. "Teoriia iskusstva i vzgliady na iskusstve v pis'mennosti Drevnei Rusi." *TODRL* 9 (1953).

Ducamp, E., ed. *Imperial Palaces in the Vicinity of St. Petersburg: Watercolours, Paintings and Engravings from the XVIIIth and XIXth Centuries.* 4 vols. Paris, 1992.

Ernst, S. "A. P. Losenko." *Starye gody* (January 1914).

Evangulova, O. S. *Izobrazitel'noe iskusstvo v Rossii pervoi chetverti XVIII v.* M., 1987.

———. "K probleme stilia v iskusstve petrovskogo vemeni." *Vestnik moskovskogo universiteta,* ser. 9. *Istoriia,* 1974, no. 3.

Farrell, D. E. "Laughter Transformed: The Shift from the Medieval to Enlightenment Humour in Russian Popular Prints." In R. P. Bartlett et al., eds., *Russia and the World of the Eighteenth Century.* Columbus, OH, 1988.

———. "Medieval Popular Humor in Eighteenth Century *Lubki*." *Slavic Review* 50, no. 3 (Fall 1991).

———. "The Origins of Popular Prints and Their Social Milieu in the Early Eighteenth Century." *Journal of Popular Culture* 17, no. 1 (Summer 1983).

———. "Popular Prints in the Cultural History of Eighteenth-Century Russia." Ph.D. diss., University of Wisconsin–Madison, 1980.

Fëdorova, I., et al. *Iaroslavskie portrety XVII–XIX vv.* M., 1984.

Fëdorov-Davydov, A. A. "K voprosu o sotsiologicheskom izuchenii starorusskogo lubka." In *Trudy sotsiologicheskoi sektsii Instituta arkheologii i iskusstvoznaniia R. A. N. I. O. N.* M., 1927.

———. *Russkii peizazh XVIII–nachala XIX veka.* M., 1953.

Filimonov, G. D. *Simon Ushakov i sovremennaia emu epokha russkoi ikonopisi.* M., 1873.

Flekel', M. I. *Ot Markantonio Raimondi do Ostroumovoi-Lebedevoi: Ocherki po istorii i tekhnike reproduktsionnoi graviury XVI–XX vekov.* M., 1987.

Flekel', M. I., and M. A. Alekseeva. *Russkaia Graviura kontsa XVII–XVIII veka.* L., 1983.

Flier, M. S., and D. Rowland, eds. *Medieval Russian Culture.* Berkeley and Los Angeles, 1994.

Floria, B. N. "Nekotorye dannye o nachale svetskogo portreta v Rossii." *Arkhiv russkoi istorii*, 1992, no. 1.

Fonkich, B. L. *Grechesko-russkie kul'turnye sviazi v XV–XVII vv.* M., 1977.

Fon-Vinkler, P. P. *Gerby gorodov, gubernii, oblastei i posadov Rossiiskoi imperii s 1649 po 1900 god.* SPb., 1900; reprinted M., 1991.

Garshin, E. M. "Pervye shagi akademicheskago iskustva v Rossii." *Vestnik iziashchnykh iskustv izdannykh pri Imp. Akademii Khudozhestv* 4, no. 3 (1886); 5, no. 2 (1887), no. 4 (1887).

———. "Zh.-M. Nat'e v ego otnosheniiakh k Rossii." *Vestnik iziashchnykh iskusstv izd. pri Imp. Akademii Khudozhestv* 6, no. 6 (1888).

Gavrilova, E. I. "O metodakh atributsii dvukh grupp proizvedenii Petrovskoi epokhi." In *Nauchno-issledovatel'skaia rabota v khudozhestvennykh muzeiakh*, pt. 2 M., 1975.

———, ed. *Russkaia grafika XVIII–pervoi poloviny XIX veka: novye materialy.* L., 1984.

Gavriushin, N. K., ed. *Filosofiia russkogo religioznogo iskusstva XIV–XX vv. Antologiiia.* M., 1993.

Georgievskii, V. T. *Freski Ferapontova monastyria.* SPb., 1911.

Gerhard, H. P. *Die Welt der Ikonen.* 3d ed. Recklinghausen, 1970.

Goleizovskii, N. K. "'Poslanie ikonopistsu' i otgoloski isikhazma v russkoi zhivopisi na rubezhe XV–XVI vv." *Vizantiiskii vremennik* 26 (1965).

Gol'denberg, L. A. *Semën Ul'ianovich Remezov: Sibirskii kartograf i geograf.* M., 1965.

Gollerbakh, E. *Istoriia graviury i litografii v Rossii.* M./Petrograd, 1923.

———. *Portretnaia zhivopis' v Rossii: XVIII vek.* M./Petrograd, 1925.

Golyshev, I., ed. *Albom risunkov rukopisnykh sinodikov.* Golyshevka, 1882.

Gorbunova, K., and I. Saverkina. *Iskusstvo drevnei Gretsii i Rima v sobranii Ermitazha.* L., 1975.

Gordeeva, N., and L. Tarasenko. *Tserkov' Pokrova v Filiakh.* M., 1980.

———. "Literaturnye istochniki dvukh ikon 1694 g. Kirilla Ulanova." *TODRL* 38 (1985).

Gorina, T. N., ed. *Russkaia zhanrovaia zhivopis' XIX nachala XX veka: ocherki.* M., 1964.

Grabar, A. *The Art of the Byzantine Empire.* Translated by B. Forster. New York, 1966.

———. "L'Expansion de la peinture russe au XVIe et XVIIe siècles." *Seminarium Kondakovianum* 11 (1940).

Grabar', I. [E.] "Ancient Russian Painting. Ikons from the 12th to the 18th Centuries." Introduction to *Ancient Russian Icons.* 2d ed. London, 1929.

———, et al. *Istoriia russkago iskusstva.* 6 vols. M., [1910–1916].

———, et al. *Istoriia russkogo iskusstva.* 13 vols. M., 1953–1969.

Grabar', I. [E.], and A. Anisimov. *Voprosy restavratsii.* 2 vols. M., 1926–1928.

Grierson, R., ed. *Gates of Mystery: The Art of Holy Russia.* Fort Worth, TX, 1992.

Grigorieva, I. S., et al. *Hermitage Master Drawings and Watercolours.* Sydney, Australia, 1978.

Gur'ianov, V. P. *Ikony Spasitelia pis'ma Simona Ushakova.* M., 1907.

———. *Litsevye sviattsy XVII veka Nikol'skago edinovercheskago monastyria v Moskve.* M., 1904.

Hamilton, G. H. *The Art and Architecture of Russia.* 3d ed. New Haven, 1983.

Hare, R. *The Arts and Artists of Russia.* London, 1963.

Haustein-Bartsch, E., ed. *Russische Ikonen: Neue Forschungen.* Recklinghausen, 1991.

Hilton, A. *Russian Folk Art.* Bloomington, IN, 1995.

Hughes, L. A. J. "The Moscow Armoury and Innovations in Seventeenth-Century Muscovite Art." *Canadian-American Slavic Studies* 13, nos. 1–2 (1979).

Iamshchikov, S. V. *Russkii portret XVIII–XIX vekov v muzeiakh RSFSR.* M., 1976.

Iaremich, S. P., et al. *Russkaia Akademicheskaia khudozhestvennaia shkola v XVIII veke.* M./L., 1934.

Iasinskaia, I. M. *Russkie shpalery XVIII-nachale XX veka: katalog vystavki.* L., 1975.

Il'enko, I. V. "Avtograf Karpa Zolotareva v tserkvi Pokrova v Filiakh." *Restavratsiia i issledovanie pamiatnikov kul'tury.* Vol. 1. M., 1975.

Il'ina, T. V. *I. Ia. Vishniakov. Zhizn' i tvorchestvo.* M., 1979.

Il'ina, T. V., and S. V. Rimskaia-Korsakova. *Andrei Matveev.* M., 1984.

Isakov, S. K. *Fedot Shubin.* M., 1938.

———, et al. *Akademiia Khudozhestv: istoricheskii ocherk.* L./M., 1940.

Itkina, E. I. *Russkii risovannyi lubok kontsa XVIII–nachala XX veka: Iz sobraniia Gos. Istoricheskogo muzeia, Moskva.* M., 1992.

Iukht, A. I. *Russkie den'gi ot Petra Velikogo do Aleksandra I.* M., 1994.

Ivanov, V. *Russian Icons.* Translated by M. L. Morse. New York, 1988.

Kaganovich, A. *Arts of Russia: 17th and 18th Centuries.* Translated by J. Hogarth. Geneva, 1968.

Kaliazina, N. V. "Novye printsipy planirovki i organizatsii inter'era zhilogo doma v Peterburge pervoi chetverti XVIII veka." *Trudy Gos. Ermitazha* 15 (1974).

———. "O dvortse admirala F. M. Apraksina v Peterburge." *Trudy Gos. Ermitazha* 11 (1970).

Kaliazina, N. V., et al. *Dvorets Menshikova.* M., 1986.

Kaliazina, N. V., and G. N. Komelova. *Russkoe iskusstvo petrovskoi epokhi.* L., 1990.

Kalishevich, Z. E. "Khudozhestvennaia masterskaia Posol'skogo prikaza v XVII v. i rol' zolopistsev v ee sozdanii i deiatel'nosti." In N. V. Ustiugov et al., *Russkoe gosudarstvo v XVII veke: Sbornik statei.* M., 1961.

Kamentseva, E. I., and N. V. Ustiugov. *Russkaia sfragistika i geral'dika.* M., 1963.

Karger, M. K. "Iz istorii zapadnykh veiianii v drevne-russkoi zhivopisi." In M. K. Karger et al., *Materialy po russkomu iskusstvu.* Vol. 1. L., 1928.

———. "Materialy dlia slovaria russkikh ikonopistsev." In M. K. Karger et al., *Materialy po russkomu iskusstvu.* Vol. 1. L., 1928.

Kazakevich, T. E. "Ikonostas tservki Il'i Proroka v Iaroslavle i ego mastera." In V. P. Vygolov, ed., *Pamiatniki russkoi arkhitektury i monumental'nogo iskusstva: materialy i issledovaniia.* M., 1980.

Kemenov, V. *The USSR Academy of Arts: Sculpture, Painting, Graphic Arts, Stage Design, Decorative Arts.* L., 1982.

Khoroshkevich, A. L. *Simvoly russkoi gosudarstvennosti.* M., 1993.

Kiselev, N. P. "O moskovskom knigopechatanii XVII veka." *Kniga: issledovaniia i materialy,* 2 (1960).

Kocherova, E. I. "Ob Ivane Nikitine—khudozhnik s partikuliarnoi verfi." In *Pamiatniki kul'tury. Novye otkrytiia. Ezhegodnik 1985.* M., 1987.

Komelova, G. N. "K istorii sozdaniia gravirovannykh vidov Peterburga i ego okrestnostei M. I. Makhaevym." *Trudy Gos. Ermitazha* 11 (1970).

———, ed. *Kul'tura i iskusstvo petrovskogo vremeni.* L., 1977.

Kondakov, N. P. *Ikonografiia Bogomateri. Sviazi grecheskoi i russkoi ikonopisi s ital'ianskoiu zhivopis'iu ranniago Vozrozhdeniia.* SPb., 1910.

———. *Russkaia ikona.* 4 vols. Prague, 1928–33.

———. *The Russian Icon.* Translated by E. H. Minns. Oxford, 1927.

Kondakov, S. N. *Iubileinyi spravochnik Imperatorskoi Akademii Khudozhestv 1764–1914.* 2 vols. [SPb., 1914.]

Korsh, E. "Russkoe serebrianoe delo XVII veka i ego ornamentatsiia." *Starye gody* (July–September 1909).

Korshunova, T. T. *Russkie shpalery: Peterburgskaia shpalernaia manufaktura.* L., 1975.

———. "Sozdateli shpaler Peterburgskoi shpalernoi manufaktury." In *Pamiatniki kul'tury. Novye otkrytiia. Ezhegodnik 1975.* M., 1976.

Koschmal, W. *Der russische Volksbilderbogen (Von der Religion zum Theater).* Munich, 1989.

———, ed. *Russkija narodnyja kartinki. Specimina Philologiae Slavicae.* Vol. 84. Munich, 1989.

Koskul', G. (H. Koskull). "Adam Silo i nekotorye niderlandskie marinisty vremeni Petra Velikago." *Starye gody* (June 1914).

Kostsova, A. S. "'Tituliarnik' sobraniia Gos. Ermitazha." *Trudy Gos. Ermitazha* 3 (1959).

Kozhina, E. F. "Dva russkikh portreta iz masterskoi Iasenta Rigo." In *Pamiatniki kul'tury. Novye otkrytiia. Ezhegodnik 1975.* M., 1976.

Krasnobaev, B. I. *Deiatel' russkoi kul'tury XVIII veka.* M., 1980.

———. *Ocherki istorii russkoi kul'tury XVIII veka.* M., 1972.

———. *Russkaia kul'tura vtoroi poloviny XVII–nachala XIX v.* M., 1983.

Krempol'skii, B. F. *Istoriia razvitiia kartoizdaniia v Rossii.* M., 1959.

Kriukova, I. A. *Russkaia skul'ptura malykh form.* M., 1969.

Kube, A. "Mramornyi biust Petra Velikogo raboty Karlo Al'bagini." *Gos. Ermitazh: Sbornik.* Vol. 1. Petrograd, 1920.

Kusov, V. S. *Kartograficheskoe iskusstvo Russkogo gosudarstva [1536–1700].* M., 1989.

Kuz'minskii, K. F. S. *Rokotov, L. G. Levitskii: razvitie russkoi portretnoi zhivopisi XVIII veka.* M., 1938.

Kyzlasova, I. L. *Istoriia izucheniia vizantiiskogo i drevnerusskogo iskusstva v Rossii (F. I. Buslaev, N. P. Kondakov: metody, idei, teorii).* M., 1985.

Labrecque-Pervouchine, N. *L'Iconostase: une évolution historique en Russie.* Montreal, 1982.

Lakier, A. [B.] *Russkaia geral'dika.* SPb., 1855; reprinted M., 1990.

Lauritzen, P., and L. Hansson. "Historic Houses: Menshikov Palace, a Princely Relic of Peter the Great's Imperial St. Petersburg." *Architectural Digest* (October 1991).

Lavrent'ev, A. V. "K biografii 'gosudareva ikonnika' Simona Ushakova." *Filevskie chteniia* 8 (1994).

Lazarev, V. N. *Andrei Rublëv i ego shkola.* M., 1966.

———. *Drevnerusskie mozaiki i freski.* M., 1973.

———. "Etiudy o Feofane Greke." *Vizantiiskii vremenik* 9 (1956).

———. *Feofan Grek i ego shkola.* M., 1961.

———. *Moskovskaia shkola ikonopisi.* M., 1980.

———. *Russkaia ikonopis' ot istokov do nachala XVI veka.* Edited by G. I. Vzdornov. 6 vols. in 1. M., 1983.

———. *Vizantiiskoe i drevnerusskoe iskusstvo: stat'i i materialy.* Edited by E. S. Smirnova. M., 1978.

———, et al., eds. *Drevnerusskoe iskusstvo: Khodozhestvennaia kul'tura Moskvy i prilezhashchikh k nei kniazhestv. XIV–XVI vv.* M., 1970.

———, et al., eds. *Drevnerusskoe iskusstvo: XVII vek.* M., 1964.

———, et al., eds. *Drevnerusskoe iskusstvo: zarubezhnye sviazi.* M., 1975.

Lebedev, A. V. "Epokha prosveshcheniia i iskusstvo portreta v russkoi provintsii." In K. M. Anderson et al., eds., *Kul'tura epokhi prosveshcheniia.* M., 1993.

Lebedev, G. *Russkaia zhivopis' pervoi poloviny XVIII veka.* L./M., 1938.

Lebedeva, Iu. A. *Drevnerusskoe iskusstvo X–XVII vekov.* M., 1962.

Lebedeva, T. A. *Ivan Nikitin.* M., 1975.

Lebedianskii, M. S. *Aleksei Zubov, 1682–1750*. L., 1981.

———. *Graver petrovskoi epokhi Aleksei Zubov*. M., 1973.

Leonov, A. *Simon Ushakov: russkii khudozhnik XVII veka*. M., 1945.

Levinson, N. "Al'bom 'Kniga Viniusa'—pamiatnik khudozhestvennogo sobiratel'stva v Moskve XVII veka." In *Ezhegodnik Gos. Istoricheskogo Muzeia [za] 1961*. M., 1962.

Levinson-Lessing, V. F., ed. *Gos. Ermitazh Otdel Zapadnoevropeiskogo iskusstva: katalog zhivopisi*. 2 vols. M./L., 1958.

Likhachëv, D. S. *Kul'tura Rusi vremeni Andreia Rublëva i Epifaniia Premudrogo (konets XIV-nachala XV v.)*. M./L., 1962.

Likhachëv, N. P. *Istoricheskoe znachenie Italo-grecheskoi ikonopisi, izobrazheniia bogomateri v proizvedeniiakh italo-grecheskikh ikonpistsev i ikh vliianie na kompozitsii nekotorykh pravoslavlennykh russkikh ikon*. SPb., 1911.

———. *Kratkoe opisanie ikon sobraniia P. M. Tret'iakova*. M., 1905.

———. *Materialy dlia istorii russkago ikonopisaniia*. 2 vols. Leipzig and SPb., 1906.

———. *Tsarskii izograf Iosif i ego ikoni*. SPb., 1897.

Likhachëva, V. D. *Iskusstvo knigi: Konstantinopol' XI vek*. M., 1976.

———. *Vizantiiskaia miniatiura: pamiatniki vizantiiskoi miniatiury IX–XV vekov v sobraniiakh Sovetskogo Soiuza*. M., 1977.

Lisovskii, V. G. *Akademiia Khudozhestv*. L., 1972.

Loewinson-Lessing, V., ed. *Rembrandt: Paintings from Soviet Museums*. Translated by V. Pozner. L., 1971.

Lukomskii, V. [K.] "O geral'dicheskom khudozhestve v Rossii." *Starye gody* (February 1911).

———. *Russkaia geral'dika*. Petrograd, 1915.

Luzhetskaia, A. N. *Tekhnika maslianoi zhivopisi russkikh masterov s XVIII po nachala XX veka*. M., 1965.

Luppol, A. N. "Numizmaticheskie pamiatniki poltavskogo srazheniia v sobranii Gos. Istoricheskogo Muzeia." In L. G. Beskrovnyi et al., eds., *Poltava: k 250-letiiu poltavskogo srazheniia*. M., 1959.

Maggs, B. W. "Firework Art and Literature: The Eighteenth Century Pyrotechnical Tradition in Russia and Western Europe." *Slavonic and East European Review* 54 (1976).

Maikov, L. [N.] "Simeon Polotskii o russkom ikonopisanii." *Bibliograf: vestnik literatury, nauki i ikusstva* 4, no. 2 (1888).

Makovskii, S. "Dve podmoskovnyia Kn. S. M. Golitsyna." *Starye gody* (January 1910).

Mamaev, K. K. "Simvolika znamen petrovskogo vremeni." *Trudy Gos. Ermitazha* 11 (1970).

Mandich, D. R., and J. A. Placek. *Russian Heraldry and Nobility*. Boynton Beach, FL, 1992.

Maslenitsyn, S. I. *Pisal Semën Spiridonov*. M., 1980.

McConnell, A. "Catherine the Great and the Fine Arts." In E. Mendelsohn and M. S. Shatz, eds., *Imperial Russia, 1700–1917: Essays in Honor of Marc Raeff*. DeKalb, IL, 1988.

Metropolitan Museum of Art. *Dutch and Flemish Paintings from the Hermitage*. New York, 1988.

Meyendorff, P. *Russia, Ritual, and Reform: The Liturgical Reforms of Nikon in the 17th Century*. Crestwood, NY, 1991.

Michalski, S. *The Reformation and the Visual Arts: The Protestant Image Question in Western and Eastern Europe*. New York, 1993.

Mikhailova, K. V., and G. V. Smirnova. *Portretnaia miniatiura iz sobraniia gos. Russkogo Muzeia*. 2 vols. L., 1974.

Mikhailovskii, B. V., and B. I. Purishev. *Ocherki istorii drevnerusskoi monumental'noi zhivopisi so vtoroi poloviny XIV v. do nachala XVIII v*. M./L., 1941.

Miller, D. B. "The Viskovatyi Affair of 1553–54: Official Art, the Emergence of Autocracy, and the Disintegration of Medieval Russian Culture." *Russian History\Histoire russe* 8, pt. 3 (1981).

Millet, G., et al. *L'art byzantin chez les Slaves: Recueil dédié à la mémoire de T. Uspenskij.* 2 vols. Paris, 1930, 1932.

Milner, J. *A Dictionary of Russian and Soviet Artists, 1472–1970.* Woodbridge, Suffolk, England, 1993.

Milner-Gulland, R., and J. Bowlt. *An Introduction to Russian Art and Architecture.* Cambridge, 1980.

Mishina, E. A. "Gruppa rannykh russkikh graviur." In *Pamiatniki kul'tury. Novye otkrytiia. Ezhegodnik 1981.* L., 1983.

Mnëva, N. E. *Iskusstvo Moskovskoi Rusi: Vtoraia polovina XV–XVII vv.* M., 1965.

Moleva, N. M. *Ivan Nikitin.* M., 1972.

———. "Tsekhovaia organizatsiia khudozhnikov v Moskve XVII–XVIII vv." *Voprosy istorii,* 1969, no. 11.

———. *Vydaiushchiesia russkie khudozhniki-pedagogi.* M., 1962.

Moleva, N. M., and E. M. Beliutin. *Pedagogicheskaia sistema Akademii Khudozhestv XVIII veka.* M., 1956.

———. *Zhivopisnykh del mastera: Kantseliariia ot stroenii i russkaia zhivopis' pervoi poloviny XVIII veka.* M., 1965.

Muratov, P. [M.?] *Drevne-russkaia ikonopis' v sobranii I. S. Ostroukhova.* M., 1914.

Murphy, D. C. "The Theory of the Visual Arts in Old Russia." Ph.D. diss., Princeton University, 1985.

Nasibova, A., et al. *The Faceted Chamber in the Moscow Kremlin.* Translated by N. Johnstone. L., 1978.

Nechaev, V. [N.] "Simon Ushakov." *Vremennik instituta istorii iskusstv v Leningrade* 1 (1927).

———. *Simon Ushakov, Izobrazitel'noe iskusstvo.* L., 1927.

Nekrasov, A. I. *Drevnerusskoe izobrazitel'noe iskusstvo.* M., 1937.

———, ed. *Barokko v Rossii.* M., 1926.

Netting, A. "Images and Ideas in Russian Peasant Art." *Slavic Review* 35, no. 1 (March 1976).

Nikolaeva, T. V. *Drevnerusskaia zhivopis' Zagorskogo muzeia.* M., 1977.

Nikulina, N. "Neopublikovannyi portret Ekateriny I raboty Karela de Moora." *Soobshchenie Gos. Ermitazha* 14 (1958).

Norman, J. O. "Pavel Tretiakov and Merchant Art Patronage, 1850–1900." In E. W. Clowes et al., eds., *Between Tsar and People: Educated Society and the Quest for Public Identity in Late Imperial Russia.* Princeton, 1991.

———, ed. *New Perspectives on Russian and Soviet Artistic Culture.* New York, 1994.

Novgorod Icons, 12th–17th Century. Oxford and L., 1980.

Novitskii, A. "Parsunnoe pis'mo v Moskovskoi Rusi." *Starye gody* (July–September 1909).

Novlianskaia, M. G. *I. K. Kirilov i ego Atlas Vserossiiskoi imperii.* M., 1958.

Nurok, A. Iu., and M. A. Orlova, eds. *Iskusstvo kontsa XVII–XVIII vekov.* M., 1976.

Odom, A. *Russian Enamels: Kievan Rus'to Fabergé.* London, 1996.

Olenin, A. [N.] *Kratkoe istoricheskoe svedenie o sostoianii Imp. Akademii Khudozhestv, s 1764 po 1829 god.* SPb., 1829.

Onasch, Konrad. *Icons.* London, 1963.

———. *Die Ikonenmalerei.* Leipzig, 1968.

Oreshnikov, A., et al. *Sbornik Oruzheinoi palaty.* M., 1925.

Ostrovskii, G. S. "Lipetskii portrety." In *Pamiatniki kul'tury. Novye otkrytiia. Ezhegodnik 1979.* M., 1980.

Ouspensky, L. *Theology of the Icon.* 2 vols. Translated by A. Gythiel and E. Meyendorff. Crestwood, NY, 1992.

Ouspensky, L., and V. Lossky. *The Meaning of Icons.* 2d ed. Translated by G. E. H. Palmer and E. Kadloubovsky. Crestwood, NY, 1982.

Ovchinnikova, E. S. *Portret v russkom iskusstve XVII veka: materialy i issledovaniia.* M., 1955.

———. *Tserkov' Troitsy v Nikitnikakh. Pamiatnik zhivopisi i zodchestva XVII veka.* M., 1970.

Ovsiannikov, E. I. *Lubok: russkie narodnye kartinki XVII–XVIII vv.* M., 1968.

Pavlenko, A. A. "Karp Zolotarev i Moskovskie zhivopistsy poslednei treti XVII v." In *Pamiatniki kul'tury. Novye otkrytiia. Ezhegodnik 1982.* L., 1984.

Perkins, E. L. "Nicholas I and the Academy of Fine Arts." *Russian History* 18, no. 1 (Spring 1991).

Perkowski, J. L. "More on the Grand Duke Georgii Mikhailovich and His Collection." *Journal of the Russian Numismatic Society* 16 (Fall 1984).

———. "Numismatic Curiosities from the Time of Peter the Great." *Numorum* (Fall 1981).

———. "Peter the Great: A Catalogue of Medals in the Smithsonian Collection." *The Numismatist* 95, no. 5 (May 1982).

Pervukhin, N. F. *Tserkov' Il'i-Proroka v Iaroslavle.* M., 1919.

Petnitska, I., et al. *Zhivopis' Vologodskikh zemel' XIV–XVIII vekov: Katalog vystavki.* M., 1976.

Petrov, N. "Sorokinsko-Filaretovskaia kollektsiia russkikh ikon." *Iskusstvo v iuzhnoi Rossi: zhivopis', grafika, khudozhestvennaia pechat'*, nos. 1, 2 (Kiev, 1913).

Petrov, P. N., ed. *Sbornik materialov dlia istorii Imp. S-Peterburgskoi Akademii Khudozhestv za sto let eia sushchestvovaniia.* 3 vols. SPb., 1864–66.

Petrov, V. N. *Equestrian Statue of Peter I by Carlo Rastrelli.* L., 1972.

———. *M. I. Kozlovskii.* M., 1977.

Plugin, V. A. *Mirovozzrenie Andreia Rublëva (Nekotorye problemy).* M., 1974.

Podobedova, O. I. *Miniatiury russkikh istoricheskikh rukopisei: k istorii russkogo litsevogo letopisaniia.* M., 1965.

———. *Moskovskaia shkola zhivopisi pri Ivan IV: Raboty v Moskovskom Kremle 40-kh–70-kh godov XVI v.* M., 1972.

———, ed. *Drevnerusskoe iskusstvo: rukopisnaia kniga.* Vols. 2, 3. M., 1974, 1983.

Pokrovskii, N. N., and E. K. Romodanovskaia, eds. *Rukopisnaia traditsiia XVI–XIX na vostoke Rossii.* Novosibirsk, 1983.

Poliakova, O. A. "Novootkrytye ikony tsarskikh izografov iz sobraniia Muzeia 'Kolomenskoe.'" In *Pamiatniki kul'tury. Novye otkrytiia. Ezhegodnik 1985.* M., 1987.

Popov, G. V. *Zhivopis' i miniatiura Moskvy serediny XV–nachala XVI veka.* M., 1975.

Popova, O. S. *Iskusstvo Novgoroda i Moskvy pervoi poloviny chetyrnadtsatogo veka: ego sviazi s Vizantiei.* M., 1980.

———. *Les Miniatures russes du XIe au XVe siècle.* Translated by A. Kishilov-Karrviv. L., 1975.

———. *Russian Illuminated Manuscripts.* Translated by K. Cook et al. L. and New York, 1984.

Postnikov, A. V. *Karty zemel' rassiiskikh: Ocherk istorii geograficheskogo izucheniia i kartografirovanniia nashego otechestva.* M., 1996.

———. *Razvitie kartografii i voprosy ispol'zovaniia starykh kart.* M., 1985.

Printseva, G. A., ed. *Kul'tura i iskusstvo Rossii XIX vek: novye materialy i issledovaniia. Sbornik statei.* L., 1985.

Pronin, A. and B. *Russian Folk Arts.* Cranberry, NJ, 1975.

Pronina, I. A. *Dekorativnoe iskusstvo v Akademii khudozhestv: Iz istorii russkoi khudozhestvennoi shkoly XVIII–pervoi poloviny XIX veka.* M., 1983.

Rakov, L. L., et al. *Materialy k bibliografii po istorii Akademii Khudozhestv, 1757–1957.* L., 1957.

Raskin, A. *Petrodvorets (Peterhof).* 2d ed. L., 1979.

Réau, L. "L'Oeuvre de Houdon en Russie." *Gazette des Beaux-Arts*, ser. 4, vol. 13 (1917).

———, ed. *Correspondance de Falconet avec Catherine II, 1767–1778.* Paris, 1921.

Roche, D. "Risunki Nikolaia Pino, prednaznachennye dlia Rossii." *Stary gody* (May 1913).

Rogachevskii, V. *Fëdor Gordeevich Gordeev, 1744–1810.* L./M., 1960.

Röhling, H. "Illustrated Publications on Fireworks and Illuminations in Eighteenth-Century Russia." In A. G. Cross, ed., *Russia and the West in the Eighteenth Century.* Newtonville, MA, 1983.

Rovinskii, D. A. "Akademiia Khudozhestv do vremeni Imp. Ekateriny II." *Otechestvennyia zapiski* 102 (October 1855).

———. *Obozrenie ikonopisaniia v Rossii do kontsa XVII veka.* M., 1903.

———. *Podrobnyi slovar' russkikh graverov XVI–XIX vv.* 2 vols. SPb., 1895.

———. *Podrobnyi slovar' russkikh gravirovannykh portretov.* 4 vols. SPb., 1886–88.

———. *Podrobnyi slovar' russkikh gravirovannykh portretov.* 2 vols. in 1. SPb., 1889.

———. *Russkiia narodnyia kartinki.* 5 vols. and 4 albums (*atlasy*). SPb., 1881.

———. *Russkiia narodnyia kartinki.* 2 vols. Edited by N. P. Sobko. SPb., 1900.

Rumiantsev, V. *Svedeniia o gravirovanii i graverakh pri Moskovskom pechatnom dvore v XVI i XVII stol.* M., 1870.

Rusakova, L. M. *Traditsionnoe izobrazitel'noe iskusstvo russkikh krest'ian Sibiri.* Novosibirsk, 1989.

Rydina, A. V. *Drevnerusskaia melkaia plastika: Novgorod i tsentral'naia Rus' XIV–XV vekov.* M., 1978.

Rylov, I., and V. Sobolin. *Monety Rossii i SSSR: Katalog, 1700–1993.* M., 1994.

Sadoven', V. V. *Russkie khudozhniki batalisty XVIII–XIX vekov.* M., 1955.

Sakharova, I. M. *Aleksei Petrovich Antropov, 1716–1795.* M., 1974.

Sakovich, A. G. *Narodnaia gravirovannaia kniga Vasiliia Korenia, 1692–1696.* 2 vols. M., 1983.

———. *Russkie narodnye kartinki 17–18 vekov (graviura na dereve): katalog vystavki.* M., 1970.

Saltykov, A. A. "Esteticheskie vzgliady Iosifa Vladimirova (po 'Poslaniiu k Simonu Ushakovu')." *TODRL* 28 (1974).

Sapunov, B. V., and I. N. Ukhanova, eds. *Kul'tura i iskusstva Rossii XVIII veka: novye materialy i issledovaniia. Sbornik statei.* L., 1981.

Sazonova, L. N. "'Vertograd mnogotsvetnyi' Simeona Polotskogo (Evoliutsiia khudozhestvennogo zamysla)." In A. N. Robinson et al., eds., *Simeon Polotskii i ego knigoizdatel'skaia deiatel'nost'.* M., 1982.

Selinova, T. A. *Ivan Petrovich Argunov (1729–1802).* M., 1973.

Sendler, E. *The Icon, Image of the Invisible: Elements of Theology, Aesthetics and Technique.* Translated by S. Bigham. Redondo Beach, CA, 1988.

Sharaia, I. M. *Voskovaia persona.* L., 1963.

Sharandak, N. P. *Russkaia portretnaia zhivopis' petrovskogo vremeni.* L., 1987.

Shibanov, F. A. *Ocherki po istorii otechsetvennoi kartografii.* L., 1971.

Shmit, F. I., et al. *Russkoe iskusstvo XVII veka: sbornik statei po istorii russkogo iskusstva dopetrovskogo perioda.* L., 1929.

Sidorov, A. A. *Drevnerusskaia knizhnaia graviura.* M., 1951.

———. *Risunok starykh russkikh masterov.* M., 1956.

Skvortsov, A. M. *U istokov russkoi zhivopisi: Katalog vystavki v oznamenovanie dvukhsotletiia so dnia osnovaniia Akademii Nauk SSSR.* M., 1925.

Smirnova, E. [S.] *Moscow Icons 14th–17th Centuries.* Translated by A. Shkarovsky-Raffé. L., 1989.

———. *Severnye pis'ma.* M., 1967.

———. *Zhivopis' drevnei Rusi.* L., 1970.

———. *Zhivopis' Obonezh'ia XIV–XVI vekov.* M., 1967.

Smirnova, E. S., and S. Iamshchikov. *Drevnerusskaia zhivopis': novye otkrytiia: zhivopis' obonezh'ia XIV–XVIII vekov.* L., 1974.

Soboleva, N. A., and V. A. Artamonov. *Simvoly Rossii.* M., 1993.

Solov'ev, N. "Russkaia knizhnaia illiustratsiia XVIII veka." *Starye gody* (July–September 1907).

Spasskii, I. G., and E. S. Shchukina. *Medali i monety Petrovskogo vremeni/Medals and Coins of the Age of Peter the Great.* L., 1974.

Stasov, V. *Gallereia Petra Velikago v Imp. Publichnoi Biblioteke.* SPb., 1903.

Stavrou, T. G., ed. *Art and Culture in Nineteenth-Century Russia.* Bloomington, IN, 1984.

Stepenovyk, D. V. *Leontii Tarasevych i ukraïns'ke mystetstvo barokko.* Kiev, 1986.

———. *Ukraïns'ka hrafika XVI–XVIII stolit': evoliutsiia obraznoi systemy.* Kiev, 1982.

Stol'pianskii, P. "Staryi Peterburg. Torgovlia khudozhestvennymi proizvedeniiami v XVIII veke." *Stary gody* (May 1913), (June 1913), (November 1913).

Stroganovskii ikonopisnyi litsevoi podlinnik (kontsa XVI i nachala XVII stoletii). M., 1869. Photographic reproduction, Slavisches Institut, Munich, 1965; also Oakwood Publications, Torrance, CA, 1992.

Suslova, E. N. *Mikhail Pavlovich Pavlov: skul'ptor XVIII veka*. M./L., 1957.

Svirin, A. N. *Drevnerusskaia miniatiura*. M., 1950.

———. *Drevnerusskaia zhivopis' v sobranii Gos. Tret'iakovskoi galerei*. M., 1963.

———. *Iskusstvo knigi Drevnei Rusi XI–XVII vv*. M., 1964.

Sychev, N. "Novoe proizvedenie Simona Ushakova v Gos. Russkom Muzee." In M. K. Karger et al., *Materialy po russkomu iskusstvu*. Vol. 1. L., 1928.

Sysoev, P. M., et al. *225 let Akademii Khudozhestv SSSR: Katalog vystavki*. 2d ed. 2 vols. M., 1985.

Sytova, A., et al. *The Lubok: Russian Folk Pictures, 17th to 19th Century*. Translated by A. Miller. L., 1984.

Tananaeva, L. I. *Sarmatskii portret. Iz istorii pol'skogo portreta epokhi barokko*. M., 1979.

Tarasenko, L. P. "Literaturnye istochniki dvukh ikon 1694 g. Kirilla Ulanova." *TODRL* 38 (1985).

Taylor, K. V. H. *Russian Art at Hillwood*. Washington, DC, 1988.

Temple, R. *Icons: A Search for Inner Meaning*. London, 1982.

Teteriatnikov, N., ed. *Russian Icons of the Golden Age, 1400–1700*. Huntingdon, PA, 1988.

Tolstaia, T. V. *Uspenskii sobor Moskovskogo Kremlia*. M., 1979.

Trenev, D. K. *Ikony tsarskago izografa Simona Ushakova v Moskovskom Novodevich'em monastyre*. M., 1901.

Trubnikov, A. "Pensionery Akademii khudozhestv v XVIII veke." *Starye gody* (July–September 1907).

———. "Pervye pensionery Imp. Akademii khudozhestv." *Starye gody* (April–June 1916).

———. "Pëtr Velikii i 'Strashnyi Sud' Memlinga." *Starye gody* (October 1910).

Trutovskii, B. "Boiarin i Oruzhnichii Bogdan Matveevich Khitrovo i Moskovskaia Oruzheinaia palata." *Starye gody* (July–September 1909).

Trutovskii, V. K. "Russkii gobelen v Moskovskoi Oruzheinoi palate." *Starye gody* (June–September 1907).

Ukhanova, I. N. *Severorusskaia reznaia kost' XVIII–nachalo XIX*. L., 1969.

Uspenskii, A. [I.] "Ivan Artem'evich Bezmin i ego proizvedeniia." *Starye gody* (April 1908).

———. "K istorii russkago bytovogo zhanra." *Starye gody* (June 1907).

———. *Piat' vnov' otkrytykh ikon kisti Simona Ushakova*. M., 1901.

———. "Russkii zhanr XVII veka." *Zolotoe runo*, nos. 7–9 (1906).

———. "Sobranie drevnerusskikh ikon XV–XVIII v." *Zolotoe runo*, nos. 7–9 (1906).

———. *Tsarskie ikonopistsy i zhivopistsy XVII v*. 4 vols. M., 1910–16.

———. "Tsarskii zhivopisets dvorianin Ivan Iëvlevich Saltanov." *Starye gody* (March 1900).

———. *Tserkovno-arkheologicheskoe khranilishche pri moskovskom dvortse v XVII veke*. M., 1902.

———. "Zhivopisets Vasilii Poznanskii, ego proizvedeniia i ucheniki." *Zolotoe runo*, nos. 7–9 (1906).

Uspenskii, L. "Iskusstvo XVII veka. Rassloenie i otkhod ot tserkovnogo obraza." *Vestnik russkogo zapadno-evropeiskogo patriarshego ekzarkata*, nos. 73–74 (1971).

———. "Rol' moskovskikh soborov XVI veka v tserkovnom iskusstve." *Vestnik russkogo zapadno-evropeiskogo patriarshego ekzarkhata*, no. 64 (October–December 1968).

Uspenskii, M. I., and V. I. *Materialy dlia istorii russkago ikonopisaniia*. SPb., 1899.

Vagner, G. K., ed. *Vizantiia i Rus': Pamiati V. D. Likhachevoi*. M., 1989.

Vakhromeev, I. A. *Tserkov' vo imia sviatago i slavnago proroka Ilii v g. Iaroslavle*. Iaroslavl', 1906.

Vasil'chikov, A. A. *O portretakh Petra Velikago*. M., 1872.

Vasilenko, V. M. *Russkaia narodnaia rez'ba po derevu*. M., 1960.

Vasil'ev, V. N. *Starinnye feierverki v Rossii (XVII–pervaia chetvert' XVIII veka).* L., 1960.

Vasil'ev, V. N., and V. M. Glinka, eds. *Pamiatniki russkoi kul'tury pervoi chetverti XVIII veka v sobranii Gos. Ermitazhe: katalog.* L./M., 1966.

Vereshchagina, A. *Khudozhnik vremia istorii: Ocherki russkoi istoricheskoi zhivopisi XVIII–nachala XX veka.* L., 1973.

Veretenikov, I. V. "Pridvornyi pervyi moliar' L. Karavak." *Starye gody* (June 1908).

Vladimirov, M., and G. P. Georgievskii. *Drevnerusskaia miniatiura.* M., 1933.

Vlasova, O. M. *Permskaia dereviannaia skul'ptura.* Perm', 1985.

Voronin, N. N., and V. V. Kostochkin, eds. *Troitse-Sergieva Lavra: khudozhestvennye pamiatniki.* M., 1967.

Voronov, V. S. *O krest'ianskom iskusstve: Izbrannye trudy.* M., 1972.

Vrangel', N. [N.] *Katalog vystavki russkoi portretnoi zhivopisi za 150 let (1700–1850).* SPb., 1902.

———. "Ocherki po istorii miniatury v Rossii." *Starye gody* (October 1909).

———. "Skul'ptory XVIII veka v Rossii." *Starye gody* (July–August–September 1907).

Vzdornov, G. I. *Art of Ancient Vologda.* Translated by N. Johnstone. L., 1978.

———. *Feofan Grek: tvorcheskoe nasledie.* M., 1983.

———. *Freski Feofana Greka v Tserkvi Spasa Preobrazheniia v Novgorode.* M., 1976.

———. "Illiustratsii k khronike Georgiia Amartola." *Vizantiiskii vremennik* 30 (1969).

———. *Iskusstvo knigi v Drevnei Rusi. Rukopisnaia kniga severo-vostochnoi Rusi XII–nachala XV vekov.* M., 1980.

———. *Issledovanie o Kievskoi Psaltyri: Kievskaia Psaltyr'.* 2 vols. M., 1978.

———. *Istoriia otkrytiia i izucheniia russkoi srednevekovoi zhivopisi: XIX vek.* M., 1986.

Wassiltschikoff [Vasil'chikov], A. [A.] *Liste alphabétique de portraits russes.* 2 vols. SPb., 1875.

Weitzmann, K., et al. *The Icon: The Byzantine Tradition in Europe, Russia, and the Near East through Seven Major Epochs.* New York, 1982.

Wortman, R. S. *Scenarios of Power: Myth and Ceremony in Russian Monarchy: From Peter the Great to the Death of Nicholas I.* Princeton, 1995.

Yamshchikov, S., ed. *Pskov: Art Treasures and Architectural Monuments, 12th–17th Centuries.* L., 1978.

Zharkova, I., et al., eds. *Gos. Tret'iakovskaia Galereia. Iskusstvo XVIII veka. Iskusstvo pervoi poloviny XIX veka.* M., 1969.

Zhegulova, S. K., et al., eds. *Sokrovishche russkogo narodnogo iskusstva: rez'ba i rospis' po derevu.* M., 1967.

Zibawi, M. *The Icon: Its Meaning and History.* Translated by R. Madigan. Collegeville, MN, 1993.

Zotov, A. I. *Akademiia Khudozhestv SSSR: kratkii ocherk.* M., 1960.

Index

Abgar legend, 40, 55, 85
Abramov, Isaak, 115
Académie des Beaux Arts, 246
Academy of Design (Florence), 210, 234, 235
Academy of Fine Arts (*Akademiia Khudozhestv*),
218, 231, 234–56, 281; aesthetic or artistic
norms, 256; architecture, 255–56; art sales,
282; collections, 242, 249; examination system,
289–90; French influence, 242–43; graphic art,
252; junior school, 245–46; Ker Porter's de-
scription, 289–91; organization of, 245; origins
and early history, 234–46; popular prints
(*lubki*), 309; sculpture, 249–52; seal of, 24fig.76;
Soviet scholarship, 347n.69
Academy of Painting and Sculpture (Paris), 146,
234, 235. *See also* Académie des Beaux Arts
Academy of Sciences, 184, 203–4, 236, 238, 239,
241; art sales, 282; cartographic project, 275
Academy of Sciences (Paris), 3, 276
Academy of St. Luke (Rome), 210, 234, 235
Adolskii, Grigorii, 215
Adolskii, Ivan, the Elder, 135fig.22B, 215–16
Aeosop's *Fables*, 25, 169, 309
Akhmetev, I. I., 309
Albaghini, Carlo, 231
Alberti, L. B., 12, 22
Alekseev, F. Ia., 217, and pl. 33
Alekseeva, M. A., 186, 306
Aleksei, Mikhailovich, Tsar, 66, 69fig.9, 86, 88,
93, 107fig.15, 108, 113, 118, 125, 126, 127, 130,
191, 204, and pls. 7 and 10
Aleksei, Tsarevich (Peter's son), 125, 187fig.55,
191, 206
Alexander I, Emperor, 287
Allard, C., 172
Almanach Royal, 3
Altar coverings (*antiminsy*), 150, 153–54, 186,
252, 299
Amsterdam: Matveev's studies in, 213; Peter
in, 131, 135, 165–70, 193–94, 197, 201–2,
205, 223
Andreeva, V. G., 55, 199
Anisimov, E. V., 262
Anna, Empress, 208, 238

Antiminsy, 150, 153–54, 186, 252, 299
Antropov, Aleksei Petrovich, 248, and pl. 27
Antwerp, 196, 235
Archangel emblem, 261
Archangel Michael cathedral, 110
Architectural views of St. Petersburg, 182fig.52,
255, and pl. 33
Architecture, 59, 106, 208–10, 281, 288, 294; Acad-
emy of Fine Arts and, 255–56; Baroque, 16;
Catherine II's program, 256
Argunov, I. P., 246, 247–48
Armory Chamber, 107–30; Avramov and, 235;
certification program, 113–14; changes under
Peter, 124, 140; church painting restoration
projects, 108, 110–11; end of icon painting sup-
port, 127, 129; engravings, 155; Europeans in,
114–21; icon repository, 112; last of the master
royal iconpainters, 124–25; origins of, 107–8;
pay scales, 109–10, 113; permanent or regular
staff, 111; provincial artists and, 103, 110;
Schoonebeck and, 169; specialties and skills,
108–9; state symbols project, 259, 261; stu-
dents of foreign painters, 121–24; training sys-
tem, 113–14; Ushakov and, 125–27; workman-
ship standards, 113
Art, as form of power, 12, 16, 20–21, 35
Art academies, 234–35. *See also* Academy of Fine
Arts; *specific academies*
Art galleries, 203, 205, 233, 281
Art history, problematic issues, 35–38. *See also*
Russian art scholarship
Artist training. *See* Training
Art magazine, 282
Art markets, 282
Astrakhan, 26
Atkinson, J. A., 303fig.91
Atlases, 277–78, 279fig.86, 280fig.87, 281n.
Autocratic political system, 29–30
Avramov, M. P., 235–36
Avvakum, Archpriest, 87, 89
Ayrmann, Hans Moritz, 2

Backhuyzen, Ludolph, 202
Bagrow, L., 272, 274, 278

367

Potemkin, G. A., sculpture collection, 288–89
Potemkin, P. I., 162, 163fig.35
Poussin, N., 286
Power, art and, 35
Poznanskii, Vasilii, 118–20, 121, 124
Preissler, J. D., 254
Preobrazhenskaia series of portraits, 192–93
Printing, 149, 253, 336n.1; European print revolution, 21–26; first Russian print shop, 169; illuminated manuscript production and, 61, 68, 70; imported books and prints, 167–69; Moscow Printing House, 153, 171, 172, 173, 184, 186; Picart's book illustrations, 170–77; popular prints (lubki), 305–11; Russian maps, 275; St. Petersburg Press (Tipografia), 175, 177, 181–84, 211, 236, 238, 254; Synod control of, 307–8; woodcut illustrations, 149–50. See also Graphic art
Print revolution, 21–26
Prokopii, 306–7
Prokopovich, Feofan, 238, 271, 283, 295, 307–8
Prokovev, I. P., 252
Protestant Reformation, 60
Provincial artists, Armory Chamber conscripts, 103, 110
Provincial church art, 93–96, 97, 102–3, 111
Pskov, 48
Pushkin, Alexander, 249
Pushkin, G. G., 108

Quentell, Heinrich, 23

Radigues, A. F., 255
Raguzinskii, S. V., 207, 210, 224
Raphael, 15, 86
Rastrelli, Bartolomeo Francesco, 224, 248
Rastrelli, Carlo Bartolomeo, 175, 207, 224–29figs.71 and 72, 238, 254
Razumovskii, K. G., 239, 241
Realism in art, 20, 37–38, 255; Soviet perspectives, 99–100
Reformation, 60, and passim
Religious conversions, 141–42
Religious imagery (general discussions): early church doctrine, 39–43; Renaissance, 13–14, 317n.36; Max Weber on, 302. See also Icons
Rembrandt, 20, 21fig.5, 202, 203, 286
Remezov, S. U., 274
Renaissance, 5–14; as anti-Gothic movement, 316n.17; Coxe's commentary, 285–86; demand for art, 319n.55; iconography, 13–14, 317n.36; theory of painting, 14. See also European art
Revolutionary change (general), 34–35, 312–13
Rigaud, Hyacinthe, 146, 147, 197, 235
Rococo style, 248, 249
Rokyta, Jan, 55–56, 73
Roman Catholicism, Russian converts to, 141–42

Romanov-Borisoglebsk, 102
Rome: Russian students in, 210, 211, 235; Tolstoi's visit, 143
Rosa, Salvator, 286
Rostov Velikii, 48, 64, 93, 102
Rostovtsev, Aleksei, 174, 177
Rowland, D., 60
Rubens, Peter Paul, 19, 196–97, 202, 286
Ruble coin, 267, 269fig.82
Rublëv, Andrei, 47, 48, 52–53, 58, 59, 66, 297, 323n.25, and pls. 2 and 3
Ruisdael, Jacob van, 20
Russia, pre-Petrine, 26–30; autocratic state, 29–30; cartography of, 1, 272–74, 349n.118; European assessments of, 1–5, 29–30. See also Europeans in; European influence on
Russian art, pre-Petrine, 4; book illustration, 149–50; European visitors' views, 71–80; graphic arts, 149–65; manuscript illumination, 61–71; popular prints (lubki), 305–11; religious imagery, 46–61; state symbols, 258–59; woodcarving, 228. See also Icons; specific visual arts
Russian (and Soviet) art scholarship, 36, 96, 99–100, 126, 150, 154–55, 218–19, 333n.87, 347n.69, 349n.115; on late 17th-century imagery, 92–106; post-Soviet assessments of Petrine era art, 311–12; Russian cartography, 349n.115
Russian atlases, 277–78, 281n
Russian cartography, 1, 125, 271–81, 349nn.115, 118
Russian Empire, 32, 216; iconology of, 271, 311–14
Russians in Europe, 130–40; art students (pensionerstvo), 208–15, 246, 290–91; early 18th century, 143–47, 195–202; late 17th century, 130–43 (see also Grand Embassy); state representatives, 144–47
Russian state symbols, 258–62

Sachavets-Fedorovich, E. P., 97
St. George, 258–59
St. Nicholas, 3, 322n.14
St. Petersburg, 34; Academy of Fine Arts (see Academy of Fine Arts); architectural views, 255; Matveev's art school, 214; panorama of, 183–84
St. Petersburg Press (Tipografia), 175, 177, 181–84, 211, 236, 238, 254
Saltanov, Bgdan, 117–18, 122
Saltykov, Alexander, 244–45
Saltykov, F. S., 225–26
Santi, Count Francesco, 260, 261–62
Savelov, Joachim, 90–91
Schijnvoet, Simon, 194
Schlüter, Andreas, 226
Schmidt, G. F., 255
Schoen, Erhard, 149, 151fig.27A